ART
P A S T

ART
PRESENT

SECOND EDITION

ART
PAST
ART
PRESENT

SECOND EDITION

DAVID G. WILKINS
BERNARD SCHULTZ
KATHERYN M. LINDUFF

PRENTICE HALL, INC.
HARRY N. ABRAMS, INC., PUBLISHERS

For our students

Project Director: JULIA MOORE
Editor: JOANNE GREENSPUN
Art Direction: DIRK LUYKX
Design: COMMUNIGRAPH: LYDIA GERSHEY, YONAH SCHURINK
Photo Research, Rights, and Reproductions: CATHERINE RUELLO

Library of Congress Cataloging-in-Publication Data

Wilkins, David G.
 Art past, art present / David G. Wilkins, Bernard Schultz,
 Katheryn M. Linduff.—2nd ed.
 p. cm.
 Includes bibliographical references and index.
 ISBN 0–13–062084–X
 1. Art—History. I. Schultz, Bernard, 1948– . II. Linduff,
 Katheryn M. III. Title.
 N5300. W64 1994
 709—dc20 93–9400
 CIP

Prentice Hall, Inc.
A Simon & Schuster Company
Englewood Cliffs, New Jersey 07632

Printed and bound in Japan

Cover: Joyce Kozloff. Section of mural for Harvard Square Subway
 Station, Cambridge, Massachusetts. *New England Decorative
 Arts.* 1984. Painted and glazed ceramic tiles (detail of fig. 653;
 photograph copyright © 1994 Joyce Kozloff; courtesy the artist)
Pages 12–13: Louise Nevelson. *Sky Cathedral* (detail of fig. 638)
Pages 290–91: Elevation of St. Peter's (detail of fig. 341)
Pages 342–43: Rembrandt. *A Man Rowing a Boat on the Bullewyk*
 (detail of fig. 412)
Page 386: Johann Balthasar Neumann. Kaisersaal, Episcopal
 Palace, Würzburg (detail of fig. 442)
Pages 404–5: John A. Roebling. Brooklyn Bridge (detail of
 fig. 491)
Pages 470–71: Jackson Pollock (detail of fig. 620)

CONTENTS

PREFACE AND ACKNOWLEDGMENTS

We have written this book especially for the person with a general interest in understanding art and art history, and for the one-semester introductory course in art history or art appreciation. Our goal has been to present a clear, concise treatment of a limited number of artistic monuments. We have chosen to emphasize the historical and cultural context which helps explain these works by placing them within a strict chronological framework. In thumbing through the book, you will note that the bold dates in the upper corner of the right-hand pages form a chronological sequence. This organization allows us to present the developments of art as they happened.

In condensing the history of art into a limited space, we have had to omit many interesting works of art; this is especially true both for the twentieth century, where some significant movements are represented by a single work, and for non-Western and non-traditional developments, which are represented by only a few monuments. At the same time, however, we have given the individual works selected a more complete treatment than is found in many survey books. Clear information about the techniques and processes of art is included because this can be crucial for understanding the work of art. We have quoted contemporary documents and comment when appropriate, believing that the words of those who lived when the art was created have a particular force and authority.

In the text that follows there are several kinds of distinct units. A section introducing art opens the text; it discusses general concepts and defines some of the terms important for understanding the material in the rest of the book. A chronological development follows, which includes introductions to major styles and periods (e.g., Egyptian, Roman Imperial, eighteenth century) and double-page units discussing works of that style or period (e.g., the pyramids, the Pantheon, eighteenth-century portraiture). Sections within the introductions discuss the status and role of the artist in each culture or period. Approximately one hundred and fifty double-page units form the basis of our text; each focuses on a key work or works and is complete in itself. Interspersed with these are boxed units on technical and other important issues (e.g., post-and-lintel construction, etching). The units on technique are positioned within the chronological sequence at the point when a new development had an impact on the evolution of art. Our dating of works of art may sometimes seem unorthodox, but we have tried to reflect new discoveries and most recent scholarship. The captions for the illustrations often include significant historical and factual information, and are best read in tandem with the main text. The maps which precede many of the sections include place names relevant to that particular section.

A word is necessary about titles, for only in the relatively recent days of inventories, reproductions, art books, and museums has it been considered necessary to give each work of art a specific, short title for identification purposes. A Renaissance artist, asked for the "title" of his or her work, would most likely have replied not with a brief phrase, but with a discussion of the meaning of the specific interpretation of the subject represented. If asked to "indentify" fig. 342, it is unlikely that Michelangelo would have replied, "The Creation of Adam." Where works are known by later, popular titles which can be misleading, such as the "Great Sphinx," the "Mona Lisa," and "The Night Watch," these titles are given in quotation marks.

The Glossary lists and defines terms and gives references to illustrations or passages in the text where the term is further explained and/or illustrated in a diagram or work of art. Seeing terms within their historical context and in relation to illustrations clarifies their meaning.

A text of this breadth requires the generous efforts and insights of many people, especially colleagues at the University of Pittsburgh and West Virginia University who willingly shared their expertise: Robert Anderson, Kahren Arbitman, William Arnett, Vange Beldecos, Urban Couch, Ann Sutherland Harris, Fil Hearn, Margaret Rajam, Patricia Rice, Matthew Roper, John Super, Thomas Tavella C.S.P., Frank Toker, H. Anne Weis, John Whitty, and John Williams all lent their authoritative understanding to different parts of the text. Graduate students at the University of Pittsburgh who offered good advice were Mark Brown and Roger Crum. Belinda Brooks, Carol Naatz, Michael Porcaro, and Lorena Sehgal gave perceptive analyses from a student's perspective, while reviewers for Prentice Hall, Inc., and Harry N. Abrams, Inc., offered many helpful suggestions.

We extend a particular recognition in our gratitude to our colleague and friend, Katheryn M. Linduff, Associate Dean for Academic Affairs and Professor of Fine Arts and Anthropology at the University of Pittsburgh, who authored the sections on Chinese, Japanese, African, Mesoamerican, American Indian, Islamic, and Indian art for this book. As we reviewed many introductory art-history texts, it became apparent that the rich artistic traditions of cultures and civilizations outside Western developments were too often given a merely descriptive treatment. Kathy has contributed substance and understanding for the reader, while adding immeasurably to our knowledge. She has been a generous partner to many aspects of our efforts.

We were fortunate that our families embraced this project with personal and professional support. Ann Thomas Wilkins added to our understanding of classical civilizations, and Rebecca Wilkins read and critiqued the manuscript at several stages. Mary Louise Soldo Schultz "field tested" the manuscript with her students and advanced discerning editorial comments.

We owe a special debt of gratitude to the personnel at Prentice Hall, Inc., and Harry N. Abrams, Inc. Norwell "Bud" Therien, Jr., at Prentice Hall supported this text from its inception, and his continuing encouragement and judicious counsel eased our task. At Harry N. Abrams we were encouraged and inspired by the professional assistance shared with us by Sheila Franklin Lieber, Joanne Greenspun, Dirk Luykx, Lydia Gershey, Yonah Schurink, Barbara Lyons, and Jennifer Bright. Some of the new drawings, made to our specifications, were created by Marlene Boyle.

David G. Wilkins
Bernard Schultz
July 1989

PREFACE AND ACKNOWLEDGMENTS TO THE SECOND EDITION

This second, revised edition of *Art Past/Art Present* evolved from the most fortunate of circumstances; its publishers, Prentice Hall and Harry N. Abrams, fully supported the modifications and additions which we proposed for this edition. Our proposals, in turn, were guided by the many readers—students, professors, and reviewers—who offered valuable insights on how the first edition of this book, published in 1990, could be improved. To all of you we extend our appreciation; we hope that your diligent efforts will find reward in this new edition.

Revisions and additions have been made throughout the text to enhance our contextual approach to the study and understanding of art history. Sixty-four new pages have been added, with sections on Minoan, Mycenaean, and Etruscan art, Ottonian art, the regional styles of Gothic architecture, late-sixteenth-century architecture, Shinto art and the art of Zen Buddhism in Japan, the Chinese imperial city of Chang'an, Khmer art, Hindu art, Islamic art of the Ottomans, and the royal art of African kingdoms. The twentieth-century section has been much enlarged and concludes with an overview of recent developments in painting, sculpture, and architecture. New sections explaining the techniques of tempera and fresco and stone and wood sculpture complement already existing pages on the techniques of oil painting, printmaking, and architectural constructions.

Among those professionals who offered guidance for this edition, we acknowledge Marcia Menihan, Robert H. Getscher, Laura Crary, Roger Crum, and Hsu Miao-lin. Revisions to the chapter on twentieth-century art and the new discussion of Post-Modernism would not have been possible without the generous and cheerful assistance of Kristina Olson; her knowledge and understanding of contemporary art were invaluable resources for us. For this edition, as well as for the first, Marlene Boyle shared her creative talents in the drawings made especially for this book.

With the increased number of contributions written by Katheryn Linduff in this volume, particular thanks go to her husband, Philip Hallen, who listened to and commented on the recitation of these pages while driving to the University of Pittsburgh.

At Prentice Hall, Norwell "Bud" Therien, Jr., brought integrity to all aspects of this project, and at Harry N. Abrams we were aided by the most professional of production teams. We are especially grateful to Julia Moore, Joanne Greenspun, Catherine Ruello, Dirk Luykx, Lydia Gershey, and Yonah Schurink for their erudite perceptions, indefatigable support, and unmatched dedication to quality.

David G. Wilkins
Bernard Schultz
Katheryn M. Linduff
September 1992

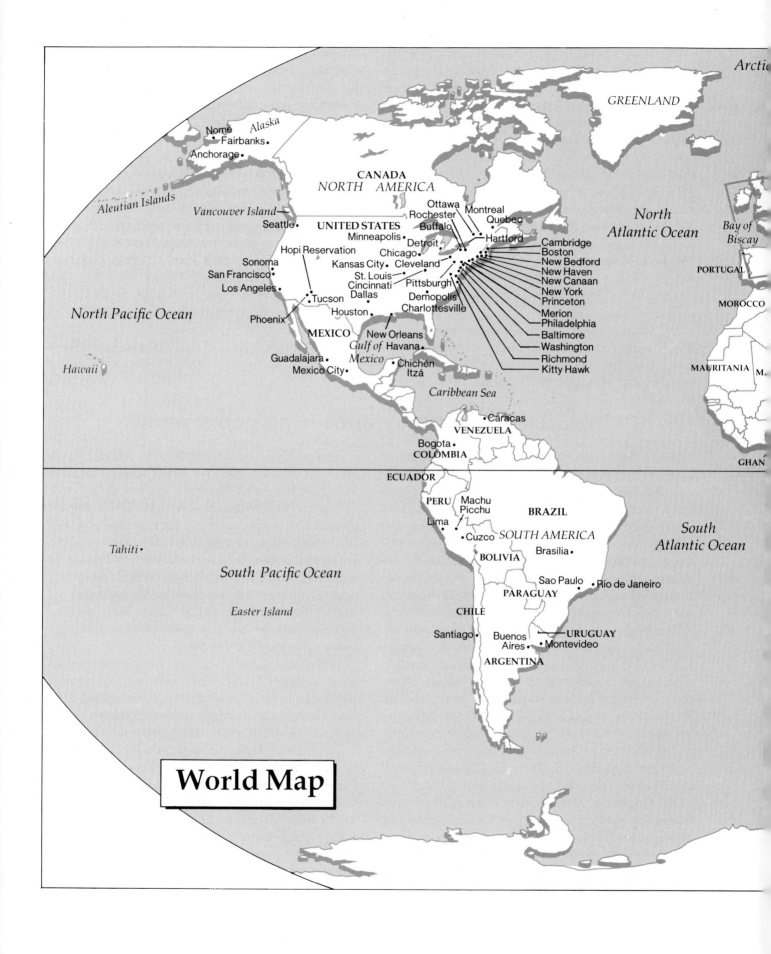

World Map

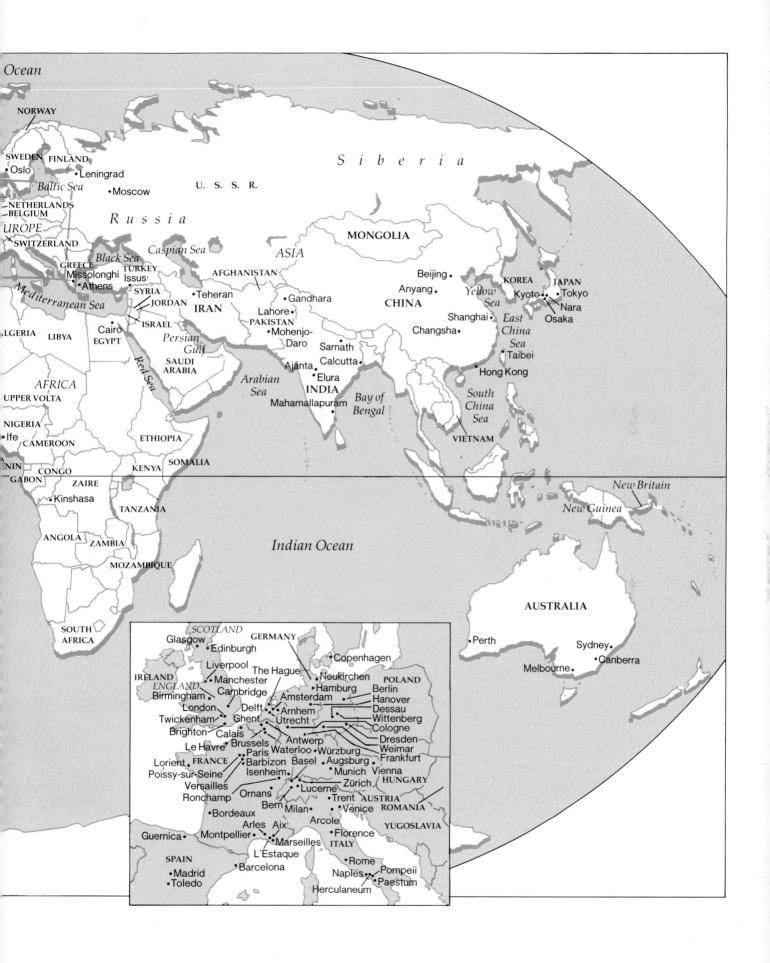

Ocean

NORWAY

SWEDEN FINLAND
Oslo
• Leningrad
Baltic Sea
• Moscow
NETHERLANDS
BELGIUM
UROPE
SWITZERLAND

GREECE
Missolonghi
Athens

S i b e r i a

U. S. S. R.

R u s s i a

Caspian Sea
ASIA

MONGOLIA

Beijing •
Anyang •
CHINA

KOREA
Yellow
Sea
Kyoto •

JAPAN
• Tokyo
Nara
Osaka

Black Sea
TURKEY
Issus

Mediterranean Sea

AFGHANISTAN

• Teheran

SYRIA
JORDAN
ISRAEL

IRAN

• Gandhara

Lahore •
PAKISTAN
• Mohenjo-
Daro

Shanghai •
Changsha •

East
China
Sea
• Taibei

LGERIA
LIBYA

Cairo •
EGYPT

Persian
Gulf

SAUDI
ARABIA

Sarnath •
• Calcutta •

• Hong Kong

AFRICA
UPPER VOLTA

Red Sea

Arabian
Sea

Ajanta •
• Elura
INDIA
Mahamallapuram •

Bay of
Bengal

South
China
Sea

VIETNAM

NIGERIA
• Ife CAMEROON

ETHIOPIA

ENIN
CONGO
GABON

KENYA

SOMALIA

New Britain

ZAIRE

Indian Ocean

New Guinea

• Kinshasa

TANZANIA

ANGOLA ZAMBIA

MOZAMBIQUE

AUSTRALIA

SOUTH
AFRICA

• Perth

Sydney •
• Canberra

Melbourne •

SCOTLAND
Glasgow •
• Edinburgh

GERMANY

• Copenhagen

Liverpool
The Hague
• Neukirchen
POLAND

IRELAND
ENGLAND
Birmingham
London •
Twickenham •
Brighton •
Le Havre
Lorient •
Poissy-sur-Seine
Versailles
Ronchamp •

Manchester
Cambridge

Delft •
Ghent

Calais •
Brussels

• Hamburg
Amsterdam
Arnhem •
Utrecht

Antwerp •

Berlin
Hanover
Dessau
Wittenberg
Cologne
Dresden
Weimar
Frankfurt

FRANCE
Barbizon
Isenheim •

Paris Waterloo
Würzburg
Basel • Augsburg
• Munich Vienna

Ornans
Bern Milan •

Lucerne •
Zürich

HUNGARY

• Trent AUSTRIA
• Venice ROMANIA

Bordeaux •

Guernica •

Arles Aix
Montpellier •
L'Estaque

Arcole
• Florence
• Marseilles ITALY

YUGOSLAVIA

SPAIN
• Madrid
• Toledo

Barcelona •

• Rome
Naples • • Pompeii
• Paestum
Herculaneum

I

INTRODUCTION

EXPERIENCING ART

In creating *Sea Wall* (fig. 1), Jennifer Bartlett has fashioned an arrangement that includes brilliantly colored boats, a low wall, a concrete-and-shell bench with supports shaped like sea horses, brightly painted three-dimensional objects that resemble cabanas or beach houses, and an expansive, panoramic painting. This is a mixed-media work, composed of a variety of different materials encompassing painting, sculpture, and sculptural forms that suggest architecture. The objects have been positioned on the museum walls and floor so that our attention is drawn as much to the composition of the en- semble as to any individual part. The installation was especially arranged by the artist for this location. The warm, luminous colors of the three-dimensional objects attract our attention, and a sense of intrigue develops as we begin to perceive the ways in which these objects interrelate with each other and with the painting behind.

The large painting, composed of three horizontal sections, depicts an evocative nocturnal setting with a sea wall and beach. Three row- boats, attached by lines to the sea wall, seem to ride the surging waves; water splashing over the wall reinforces our perception of the sea's rhythmic motion. In the painting, a concrete sea-horse bench, other boats, and beach houses are positioned like solitary sentinels on the sand.

As we study the painted scene, the artist draws us into an illusion. The objects represented suggest real objects within actual space. It is easy to be drawn into this imaginary world, despite the fact that her interpretation of the scene is not detailed. In fact, Bartlett's painting has an energy and life that a more photographic view could not have. Although the beach is empty, the scene seems animated. This effect is produced by the manner in which the artist has handled the paint, using loose, free movements of the brush to apply bold, thick lines and patches of color. Such a lively application of paint blurs the edges of objects, contributing to a dense yet vigorous atmospheric effect. Near the bottom of the painting, the brushstrokes create passages that evoke the rhythmic surge and sound of the water lapping on the sea wall and boats.

In contrast to the illusion of objects in space offered by the painting, Bartlett's three-dimensional objects share the real space in which we move and live. Although they exist outside the painted scene, these objects are openly identified with the painting. The colors of these objects, which in form are similar to the boats, beach houses, sea wall, and bench, are the same as those which distinguish the related objects in the painting. And in this particular installation, the artist has cre- ated a spatial arrangement that approximates the position and relat- ionships she gave them within the illusory space of the painting.

By inviting us to explore and discover the relationships between these sculptural forms and their counterparts in the painting behind,

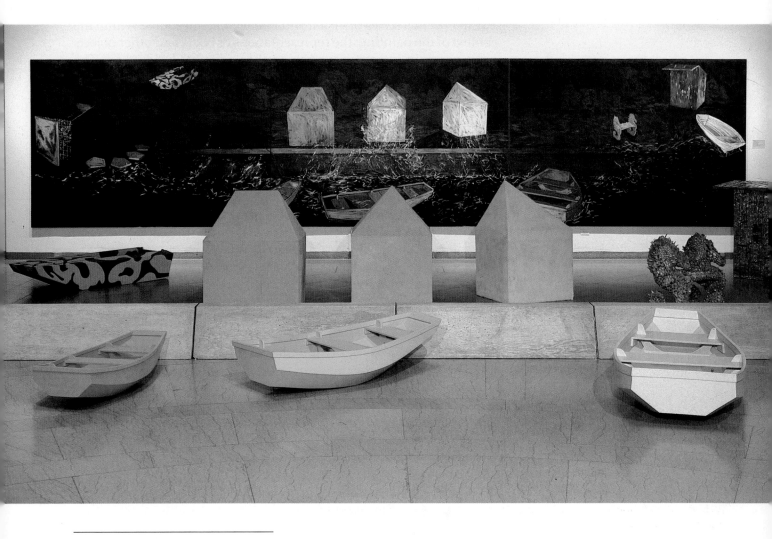

1. JENNIFER BARTLETT
Sea Wall. 1985. Mixed-media installation, as seen at the Brooklyn Museum

Bartlett poses a series of visual and intellectual questions. Within the context of the painting, the representations of boats and other objects have a certain integrity; we can easily understand the scene. The sculptural forms affect us in quite another way, for they are unconvincing as boats and beach houses: reduced in size, they lose reference to practical function, and even the sea wall seems diminished. The bright, even colors applied to the simplified forms encourage us to appreciate the forms not as common objects in our real world, but as abstract sculpture. As a result, Bartlett leads us to consider the nature of our perception and the issue of how we recognize "everyday" objects in our environment. What are the visual clues, for example, that lead us to recognize an object as a boat or a beach house?

Other, more complex observations begin to draw our attention. The colors of the beach houses in the painting are not quite the same as those on the sculptural forms. The variations of color in the beach houses in the painting and the dramatic activity of Bartlett's brush enliven their surfaces. The forms in the painting seem more "alive," less static, than do the objects on the museum floor. The camouflage boat most closely matches a sculptural form to the painted image, yet it too is distinct: this type of camouflage works within the illusionistic painting but not on the museum floor.

Bartlett's use of different media to create a complex ensemble is not a modern invention. In the past, an artist or group of artists have often joined elements of varied media to create a single composition. *Sea Wall* emphasizes the visual properties of the work of art, setting Bartlett's installation work within our recent, modern experience of art. Also modern is the manner in which Bartlett's work can evoke a personal reaction based on the experiences of the viewer. She encourages each of us to respond to this tableau as an individual with a storehouse of memories.

In this installation work, Bartlett's transformation of objects from the illusory space of the painting to three-dimensional, abstract sculptural forms challenges not only our perception of our environment, but our conception of art. In many ways, the objects in the painting seem more real and comfortable than do the abstract representations of the beach houses and boats which exist in our own real space. We begin to question the differences between illusion and reality and to contemplate the relationships that can be postulated between art and the world.

Jennifer Bartlett's *Sea Wall* installation is an intriguingly intricate work of art. The specific questions that *Sea Wall* poses express the interaction and communication which we can share with art. One way to open this communication is to ask general questions that can help lead us to an understanding of each work of art as a unique visual expression and as an historical experience. The following list

of questions is not meant to be comprehensive, and not all questions will apply to every work of art. The terms used are part of a specialized vocabulary that is useful in sharing ideas and information concerning works of art.

Questions to ask about a work of art:

Does it communicate certain emotions and feelings? What is its expressive content?

Does it belong to a clearly recognizable artistic tradition? Is it related to a particular historical style?

Who was the artist (or artists), and did the artist's individual personality play a role in the creation of the work? Does the work demonstrate individual style?

What can a visual examination and analysis of the work tell us? How can a formal analysis be useful?

How are the various visual elements of the work arranged? What is its composition?

What materials is it made of? What is the medium?

How have the artist or artists used these materials? What techniques were employed to make the work?

Did someone ask the artist or artists to create the work and did they also pay for it? Who were the patrons?

Why was it made? What purpose did it fulfill? What was its function when it was first created?

Was it created for a specific location, and did the artist adjust the composition for that location? Has the artist used collocation?

What is its subject matter? What does it represent? What is its iconography and iconology?

What can it tell us about the ideas, beliefs, or attitudes current in the period when it was created? What is its historical significance and its historical context? Who was its audience?

VIEWING ART

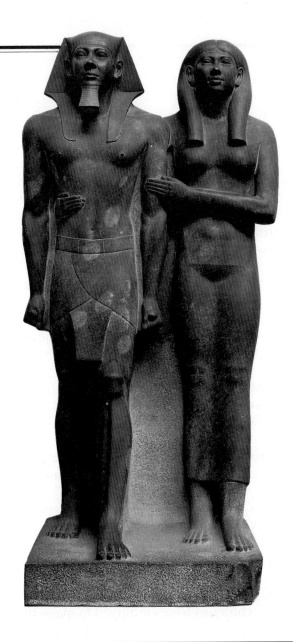

2. *King Menkure and His Queen.*
c. 2470 B.C. Schist, height 54 1/2".
Harvard–MFA Expedition, Courtesy,
Museum of Fine Arts, Boston. Found
at Menkure's temple complex, next to
his pyramid at Giza (figs. 43, 44).

Art's communicative value, which at first may seem foreign and difficult, demands an understanding of a work's visual and expressive qualities and of its relationship to its historical period. The task of art history is to ease and advance our understanding of the communication between works of art from past cultures and ourselves.

To give order to the art that has been created in the past, as well as that being created now, the modern study of art history has developed a system of classification which relies on the concept of style. Our word style is derived from the Latin *stylus*. Originally the word referred to a writing instrument, but in time the meaning changed to include the manner, or art, of writing. Each of us writes differently, and our style of writing has a personal quality related both to our individual training and to the context of our education and experience, that is, the historical period in which we live. Documents from past centuries easily demonstrate how writing styles have changed over time (see fig. 345). Historical style describes how the appearance of a work of art is tied to the period during which the work was created. Works of art from the same historical period and culture

often share similar visual characteristics. In art history, specific periods and cultures are examined within a chronology, and we view the evolution of the history of art as a succession of period styles. Thus, for example, we speak of Egyptian style and Baroque style.

Style, however, can also have a more intimate meaning, referring to the particular manner of expression used by an individual artist. This style can change as the artist's personality matures and develops. Relationships may also be discerned between the personal style of an artist and the period style of the time in which he or she lived.

Our discussion of how to approach a work of art, how to become receptive to its communication, opens with a consideration of the styles of two sculptures (figs. 2, 3). *King Menkure and His Queen* was carved in ancient Egypt about 4500 years ago; Bernini's *Apollo and Daphne* was created in Italy less than 400 years ago. The sculpture of King Menkure and his queen proclaims both stability and rigidity; the poses of the Egyptian pharaoh and his queen are confined within a rectangular composition, and there is no suggestion of movement. There is a slight hint of portraiture in their faces, but their bodies are idealized, abstracted to conform to a standard of perfection, dictated in this case by Egyptian cultural preferences. Bernini's sculpture of the mythological story of Apollo and Daphne is dramatic and dynamic. The figures express a transient moment, forever caught in time. The Baroque sculpture is also naturalistic, for the figures, drapery, landscape, and tree segments all reproduce the appearance of these forms in nature. (The term realism, which is sometimes confused with naturalism, refers to subject matter drawn from everyday life.)

These values of stability and dramatic movement characterize the stylistic differences between ancient Egyptian and Baroque art. They find expression in other media from these historical periods. Egyptian painting and architecture stress an enduring permanence. Baroque painting and architecture emphasize visual, dynamic flux.

The study of style assists us in classifying a work of art within the visual traits of a particular historical period. Formal analysis examines how the integral parts of a work of art are united to produce its historical and individual style. Our interpretation of *Menkure and His Queen* as both stable and rigid is based on a number of particular observations. The axis, an imaginary center line passing through each figure, conforms to a vertical line. The vertical or horizontal components are visually stable and appear to be balanced and in equilibrium. The vertical axes, then, combine with the rectangular composition to communicate a contained, balanced stability. The vertical axis also contributes to the stiff posture of the figures, producing a rigidity reinforced by the compact outlines of the sculpture, which is a monolithic, rectangular solid.

Bernini's sculpture is composed primarily on a strong diagonal axis. Diagonal components, which break the equilibrium of the vertical and horizontal, communicate movement. If *Menkure and His Queen* appears closed and self-contained in space, *Apollo and Daphne* seems open and expansive. This openness is due to the extension of the figures' limbs and drapery out into the immediate space; here the surrounding space is energized by the sculptural form.

Formal analysis reveals how these sculptures attain different

visual expressions, and why each makes a distinct impact on us. These different expressions are also related to the materials (media) and techniques employed in each work. *King Menkure and His Queen* and Bernini's *Apollo and Daphne* are both executed in stone, but Bernini's work is made of Italian marble, which is soft and rather easily carved, while the Egyptian work, carved by an anonymous artist or workshop of artists, is made of schist, a dense, hard, and brittle stone found in Egypt.

The examination of subject matter is expressed on two levels: the subject matter must be identified and its meaning must be assessed with regard to the work's historical context. The term iconography (from the Greek *eikon*, image, and *graphein*, to describe or to write) is used to designate the art-historical study of the specific subject matter of the work of art, while iconology (Greek for image discourse) interprets the meaning of the subject matter as it can be understood within the historical culture that produced it.

Menkure and his queen ruled in ancient Egypt, and the iconography of the sculpture is their representation as royal personages. Although the figures of Apollo and Daphne greet us with a greater naturalism, they are actually legendary figures from Greek mythology. Apollo, the god, desires the lovely Daphne, daughter of a river-god. He chases her but when he catches her, Daphne, who has prayed to be delivered from Apollo's unwanted advances, is magically transformed into a laurel tree. In Bernini's sculpture, Daphne's left side metamorphizes into a trunk, while her fingers and hair become branches and leaves. The expression Bernini puts on Apollo's face is complex: it is a mixture of joy, at the attainment of his goal, and wonder, as the hand with which he reaches to embrace Daphne touches not flesh but bark.

The theme of Bernini's sculpture is drawn from a specific literary source from ancient Rome, Ovid's *Metamorphoses* (I, 545–59), written in the early first century A.D.:

> So ran the god and [Daphne], one swift in hope,
> The other in terror, but he ran more swiftly,
> Borne on the wings of love, gave her no rest,
> Shadowed her shoulder, breathed on her streaming hair.
> Her strength was gone, worn out by the long effort
> Of the long flight; she was deathly pale, and seeing
> The river of her father, cried, "O help me,
> If there is any power in the rivers,
> Change and destroy the body which has given
> Too much delight!" And hardly had she finished,
> When her limbs grew numb and heavy, her soft breasts
> Were closed with delicate bark, her hair was leaves,
> Her arms were branches, and her speedy feet
> Rooted and held, and her head became a tree top,
> Everything gone except her grace, her shining.

As we investigate the iconology of our sculptures, we more fully enter the realm of historical significance and historical context, for religious, political, social, economic, scientific, and philosophical

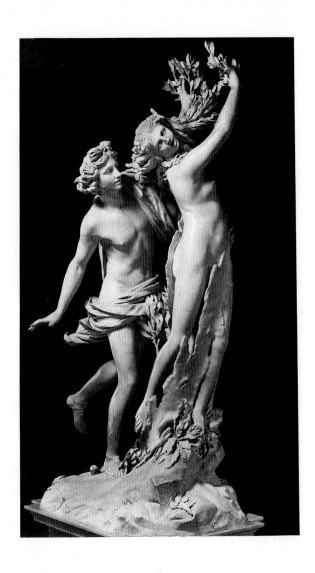

3. GIANLORENZO BERNINI
Apollo and Daphne. 1622–25. Marble,
height 96". Borghese Gallery, Rome

values can all come to bear on the interpretation of a work's meaning and function. *Menkure and His Queen* is one of several sculptures intended to provide a home for the souls of the pharaoh and his queen throughout eternity (see pp. 53–57); this is its function. Its original location was within a funerary precinct, close to the pharaoh's tomb. The stable rigid form of the sculpture conveys its expressive content, a majestic presence. More importantly, the form also affords protection from breakage over time, thus safeguarding the home of the soul in the afterlife. This enduring strength is reinforced by the use of schist as a medium. Bernini's sculpture communicates both general and particular aspects of Italian Baroque culture: it demonstrates the predilection for classical antiquity which existed in seventeenth-century Italy and, as Ovid was a popular source for learning Latin, the tale of Apollo and Daphne would have been known to all educated persons. *Apollo and Daphne* served to delight visitors and display the intellectual and artistic taste of its patron, Cardinal Scipione Borghese, an important member of the Roman aristocracy and an official of the hierarchy of the Catholic church. Discerning style, formal analysis, iconography, iconology, function, and historical context are ways in which we begin to understand the meaning of a work of art. Works of art are far from being mute, but to hear them speak, we must be open to the expression and content of their language.

ANALYZING PAINTING

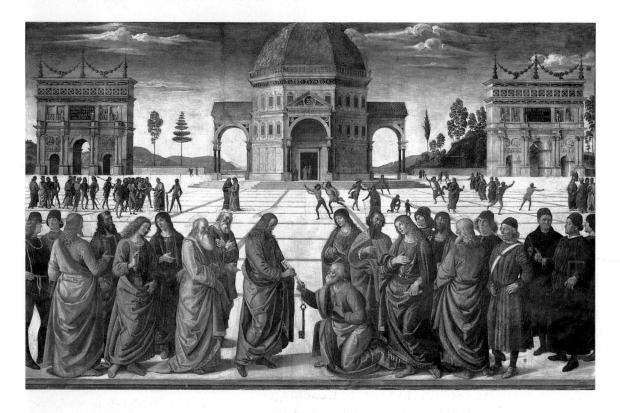

4. PIETRO PERUGINO
Christ Giving the Keys to St. Peter. 1482.
Fresco, 11 x 18'. Sistine Chapel,
Vatican, Rome. See also fig. 274

5. PIET MONDRIAN
*Diamond Painting in Red, Yellow, and
Blue*. 1921–25. Oil on canvas on fiber-
board, 56 1/4 x 56". National Gallery
of Art, Washington, D.C. (Gift of
Herbert and Nannette Rothschild,
1971)

In Perugino's *Christ Giving the Keys to St. Peter* (fig. 4), we recognize figures, landscape, and architecture from the real world. Perugino's painting is illusionistic, for the objects represented seem to be tangible and weighty and appear to exist within actual space. Mondrian's painting (fig. 5) does not have forms that resemble those in the visual world. It is non-objective or non-representational.

Traditionally, a painting can be defined as a two-dimensional surface to which liquid colors or inks have been applied. Flatness, the most distinctive attribute of paintings, is a starting point in their analysis. The flat surface is known as the picture plane, and in Mondrian's painting the colors and shapes are two-dimensional and they reinforce the flatness of this plane. In illusionistic paintings, like Perugino's, the picture plane seems transparent, like a large window.

Both paintings are made up of shapes. Mondrian's are limited to black lines and squares or rectangles of a single color. Perugino's shapes are naturalistic objects: figures, trees, a public square, and a building. In both paintings forms are organized into a composition. Perugino's composition is arranged to emphasize the figures of Christ and St. Peter in the middle. A row of apostles to either side frames them, and the Renaissance structure in the background helps draw attention to them. The receding lines of the square converge at a central point. Perugino's composition is balanced, symmetrical, and centralized. The composition of Mondrian's painting is neither centralized nor symmetrical, but it is balanced. Although Mondrian's square format is placed diagonally, his black lines are horizontal and

vertical, and they meet the edges of the painting at forty-five-degree angles. We are drawn to the edges of the composition by these angles and by the red, yellow, and blue found in these areas. These colors are placed so that they balance each other, with no single color dominating. Mondrian's composition might be described as decentralized, for it leads us to the periphery without concentrating our attention on any single area or element. His painting seems simple, but he has developed such a perfect balance that any change in color or composition would destroy the work's equilibrium.

Mondrian's composition is easier to analyze than Perugino's, for it exists completely in two dimensions. Perugino's composition must be analyzed both in terms of the patterns on the two-dimensional surface and as an illusion of three-dimensional reality. Note, for example, that when we analyze the painting as a two-dimensional object, the lines of the pavement of the square converge toward a central point, but in actual space, these lines would be parallel to each other. This controlled spatial effect is a system of creating depth (perspective) known as scientific perspective (see pp. 262–63). Other devices used by Perugino to help create his illusion are atmospheric perspective (the sky shades from blue toward white at the horizon, and the forms near the horizon are blurry and softened in color), diminution (forms in the distance are smaller), and overlapping (forms are placed in front of other forms).

Perugino's medium was fresco; Mondrian's was oil on canvas (see pp. 238–39 and 270–71). Both artists used a technique of smooth, regular brushstrokes. Because most of the forms in both paintings are sharply defined, with precisely delineated edges, they can be termed linear (the opposite effect, in which broad, free brushstrokes are used to define form, is termed painterly; for an example see fig. 361).

Perugino's colors are naturalistic, that is, taken from nature, which enhances his illusionism. Mondrian's selection of colors is restricted to red, blue, and yellow. Perugino changed the value and intensity of his colors to suggest the changes in value and intensity that result when light hits a form and creates highlights and shading; these changes are called modeling. Mondrian used pure colors, which are colors at their maximum or full intensity.

Perugino's painting was created during the Renaissance in Italy; it is one of a series of paintings of the lives of Moses and Christ which decorate the side walls of the Sistine Chapel in Rome. *Christ Giving the Keys to St. Peter* reveals the abilities of a Renaissance artist to reproduce natural effects within a harmonious and clear composition. Mondrian's painting, on the other hand, is related to his personal philosophy and to the principles of the De Stijl movement (see p. 522). While searching for a truly "universal means of expression," Mondrian wrote that beauty and harmony could only be expressed by "abstraction of form and color, that is to say, in the straight line and the clearly defined primary color." His search for pictorial balance must be related to the search for universal peace in the years following World War I. Despite their pronounced differences, these two paintings share a surprisingly similar expressive content: they are orderly, serene, and, ultimately, calming. Both artists achieve visual harmony and balance.

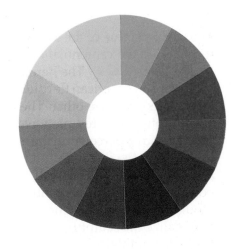

6. Color wheel. In the technical terminology used to discuss light and color, black and white are not considered to be colors. When color is seen in terms of light, black is understood as the absence of all color and white as the mixture of all colors. On the color wheel red, yellow, and blue are known as the primary colors because all other colors are made of a combination of these three hues (hue is the property which gives a color its name). Other properties that a color can demonstrate are value (relative darkness or lightness of the color) and intensity (the level of richness or saturation of the color).

ANALYZING SCULPTURE

The bronze statue of the Minuteman at Concord was commissioned to celebrate the centennial of the famous Revolutionary War battle fought there (fig. 7). The heroically scaled statue depicts the citizen soldier of the American Revolution, poised with a plough in one hand and a musket in the other. The figure stands alert and determined. The sculpture is representational, and although the medium is bronze, we can readily perceive, in the manner in which the artist has finished the surface, the illusion of different textures: the flesh suggests the anatomical structure beneath, the folds of the clothing respond to the body, and these textures contrast with the cold metallic handle of the plough. Such representational qualities help us recognize the forms and realize the sculpture's commemorative, historical purpose.

David Smith's *Cubi XIX* (fig. 8) is very different. It is a non-objective work of art, for it does not imitate actual figures or objects. In Smith's sculpture, the medium is stainless steel. Smith has brushed the surface of the steel, which gives a textural unity. The brushed steel surfaces reflect, in a diffused way, the atmospheric light around them. The appearance of the sculpture, then, changes in response to atmospheric conditions; it might appear dull gray-blue on an overcast day, or reflect a slight golden glow on a sunny day.

Both the *Minuteman* and *Cubi XIX* are examples of sculpture in the round, that is, sculpture which is fully three-dimensional and finished on all sides. Sculpture exists in real space, and space is an integral element in analyzing sculpture. Depending on the composition of the sculpture, the surrounding space can play a role in the effect and communication of the work. Although they are very different, French's *Minuteman* and Smith's *Cubi XIX* share similar compositions and a similar spatial involvement. Both sculptures have forms which develop from a vertical axis—the arms and right leg of the *Minuteman* and the rectangular and rounded steel forms of *Cubi XIX*. Both sculptures are set on bases. The large granite base of the *Minuteman* contributes to our recognition of the statue as a commemorative work; *Cubi XIX*'s base primarily offers support, but its design is in keeping with the non-objective composition. The composition of each work is also animated by a suggested movement. With the *Minuteman*, this is created by the contrast of the vertical axis of the figure with the forward diagonal of the right leg and musket. *Cubi XIX* offers an interplay of vertical, horizontal, and diagonal forms.

The compositions of French's *Minuteman* and Smith's *Cubi XIX* urge us to consider the sculptures from different viewpoints. The diagonal of the Minuteman's musket, which is reinforced by the implied movement of the right leg, creates an oblique motion which invites us to walk around the sculpture. In a similar way, diagonal elements break the planarity, or two-dimensional, view of Smith's work, drawing us around the sculpture to consider how the composition changes from varying points of view. Both sculptures make full use of the three-dimensional space in which they, like ourselves, exist.

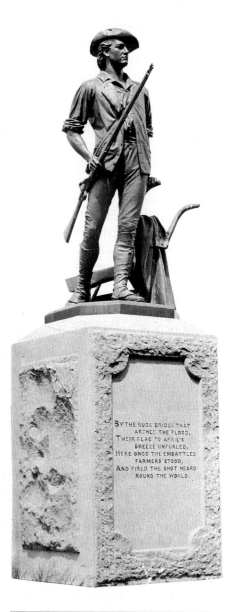

7. DANIEL CHESTER FRENCH
Minuteman. 1873–75. Bronze with granite base, height 84". Old North Bridge, Concord, Massachusetts

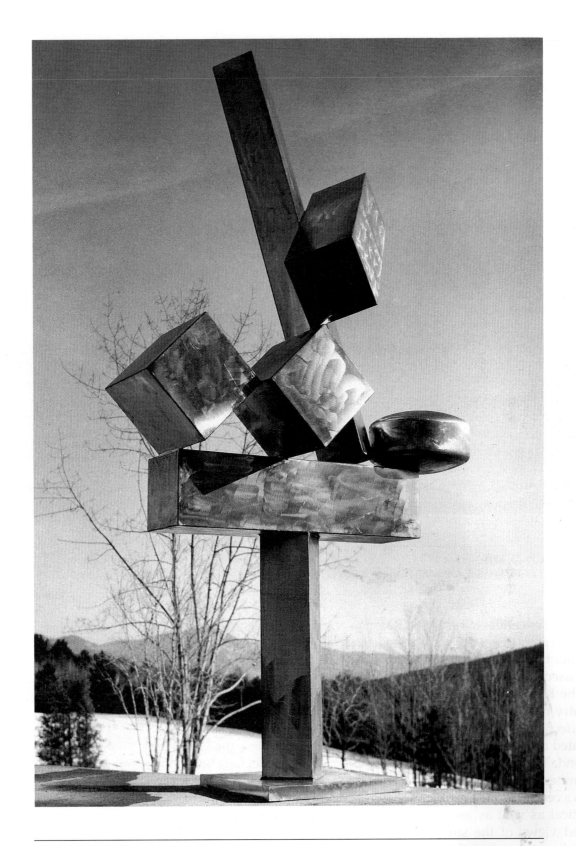

8. DAVID SMITH
Cubi XIX. 1964. Stainless steel, height 9' 5 1/8". The Tate Gallery, London. The abstract title of this sculpture reinforces its non-objective content. It is number nineteen in a series of sculptures by Smith which present variations on compositions of rectangular and cylindrical stainless-steel forms.

ANALYZING ARCHITECTURE

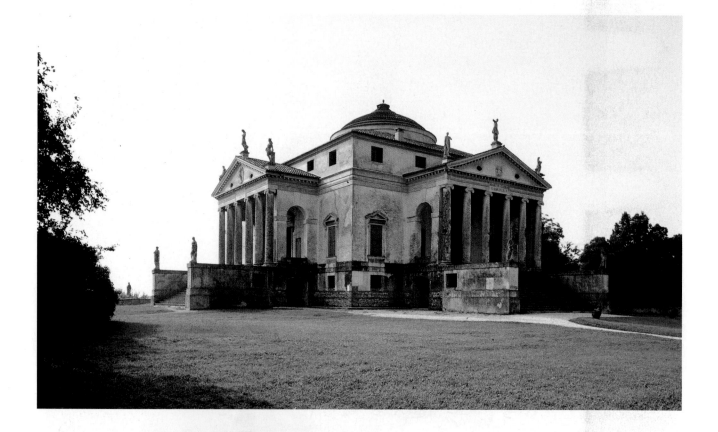

9. ANDREA PALLADIO
Villa Rotonda (also known as the Villa Capra), Vicenza, Italy. c. 1567–70

Both the sixteenth-century Villa Rotonda and the twentieth-century Fallingwater (figs. 9, 10) were designed as country homes for private patrons: the Villa Rotonda for a retired official of the Catholic church, who used the villa for receptions and entertaining, and Fallingwater for the Kaufmann family of Pittsburgh, who used the home as a country retreat. Each structure communicates a distinct architectural effect and each relates to its site (setting) in a different manner. Situated at the crest of a hill and backed by a wooded area, the Villa Rotonda is an impressive and commanding structure. Its four bold, columned porches, set at right angles to each other and extending from a central domed mass, dominate the site. These porches serve a practical as well as aesthetic function, for they afford the guests varied views of the surrounding countryside and, since each is partially enclosed on the sides, they offer the possibility of always being able to find a shady spot away from the hot Italian sun.

The most striking feature of Fallingwater is the way the structure cooperates with the site. This is characteristic of many of Wright's designs. The architect once commented: "A good building is one that makes the landscape more beautiful than it was before." In creating

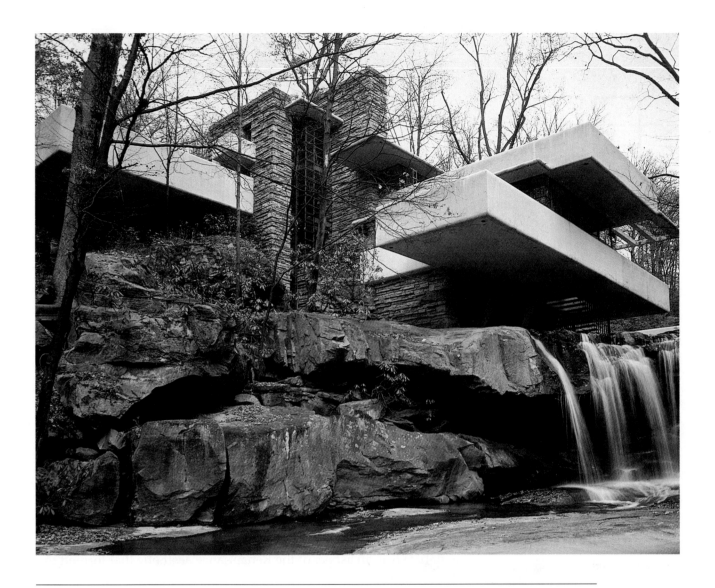

10. FRANK LLOYD WRIGHT
Fallingwater, Bear Run, Pennsylvania. 1936. Bear Run is in the Allegheny Mountains of western Pennsylvania.

Fallingwater, he integrated the design with the natural environment, while at the same time establishing in the landscape a forceful abstract arrangement of rectangular forms. The large terraces allowed the Kaufmanns and their guests to enjoy the sun and views into the surrounding forest.

The ledges of rock which form the falls at the site create a horizontal pattern. This is echoed in the thrusting, horizontal terraces above, which project out from a massive vertical core faced with local stone quarried near the site. Nature's design has been reinterpreted and reinforced by the abstract architectural forms integrated within it.

The exterior design of the Villa Rotonda expresses a stable harmony. Symmetry governs the arrangement of the architectural forms, and vertical and horizontal elements are carefully balanced. The visual equilibrium revealed on the exterior also governs the interior design. The plan (fig. 11) is composed of proportional geometric shapes; a central, circular space is circumscribed by a square plan. From the central space, halls radiate to each porch. The cross axes of

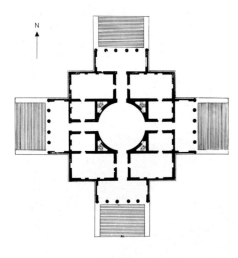

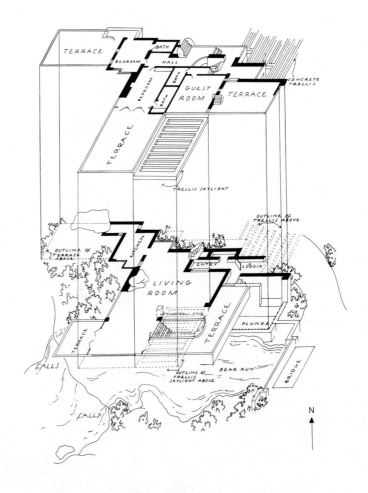

11. ANDREA PALLADIO
Plan, Villa Rotonda

12. FRANK LLOYD WRIGHT
Plan, Fallingwater

the halls are aligned with the cardinal points—north, south, east, and west. This desire to orient a building in relation to a perceived order in nature was an aspect of the Renaissance aesthetic that formed the basis of Palladio's architecture (see p. 336).

In contrast, the exterior design of Fallingwater is asymmetrical. A unified composition, however, is achieved by balancing the horizontal thrust of the terraces against the vertical massing of the central core. Another unifying feature is the adherence to rectangular forms throughout. The asymmetrical balance of Wright's exterior concept also characterizes the plan and interior (figs. 12, 13). Rooms and hallways repeat the rectangular forms of the exterior. Like the Villa Rotonda, the rooms also correspond to the cardinal points, but Wright's asymmetrical design allows for the largest room, the living room, to have a southwest exposure, which maximized the Kaufmanns' enjoyment of the afternoon sun. Wright extends the rooms of the house into the space of the environment, while in Palladio's design the distinction between the building and its environment is firmly stated.

The Villa Rotonda was built to accommodate many guests, and its plan provided easy access into and out of the building; the symmetry of the halls and rooms about the central space allowed for clearly understood patterns of circulation. Fallingwater, by contrast, was designed for a family of three, and while the living room and terraces are large, the bedrooms are small and the halls narrow. As a private home for a small family, Fallingwater had no need for expansive patterns of circulation.

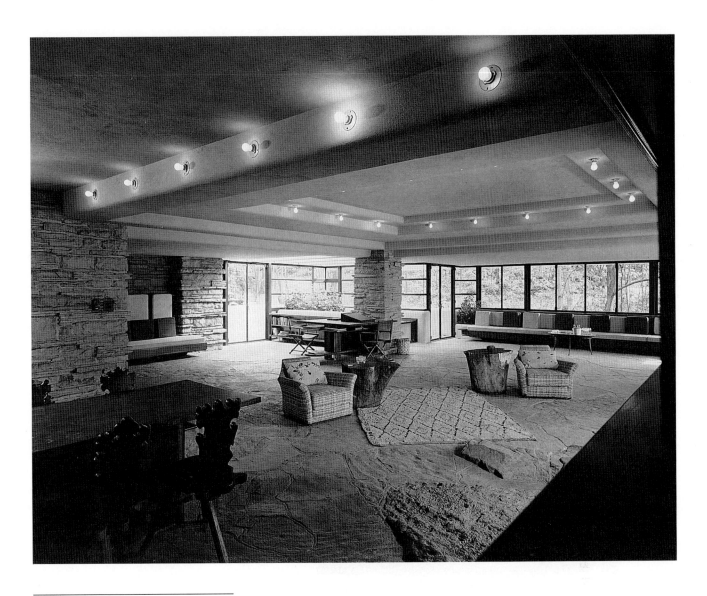

13. FRANK LLOYD WRIGHT
Interior, Fallingwater

The principles of construction used to build the Villa Rotonda have a long tradition in architectural history. They include the use of walls, the post-and-lintel system (see p. 66), and the arch (see p. 136–39). The design confers a dignity on the building which recalls the tradition of Greek and Roman antiquity.

The expressive drama of Fallingwater is bound to the design of the main terraces thrust over the waterfall. This adventurous architectural achievement was accomplished by the use of modern construction materials which have a high tensile strength, meaning that they strongly resist the strain of the architectural load and the pull of gravity. In Fallingwater, the terraces are made of concrete reinforced with steel rods. The availability of these materials gave Wright the possibility of using the cantilever (see p. 499).

Architecture serves both utilitarian and aesthetic purposes. Buildings are expressions of their time. As we encounter different forms of architecture, we would do well to follow the understanding of John Ruskin, the influential nineteenth-century English art critic, who wrote, "All architecture proposes an effect on the human mind, not merely a service to the human frame."

ART AND ARTISTS IN HISTORY

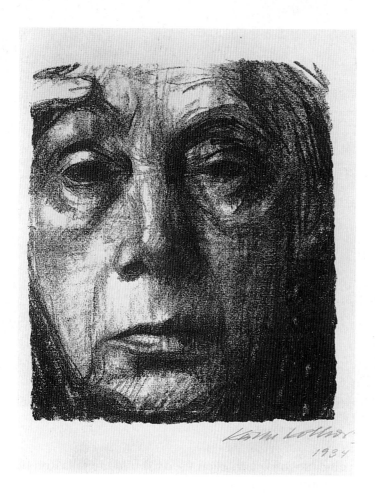

14. KÄTHE KOLLWITZ
Self-Portrait. 1934. Lithograph,
8 1/16 x 7 3/16". The German
artist Käthe Kollwitz was the first
woman to be elected to the Prussian
Academy of Arts.

The impact of this *Self-Portrait* by Käthe Kollwitz (fig. 14) is direct, honest, and penetrating. Her face occupies the entire surface, and we cannot escape from an immediate confrontation with her somber expression. Kollwitz published several series of prints depicting the social and political struggles of the poorer classes. These struggles, with which she identified, have left their physical and psychological mark on the *Self-Portrait.* As we see in this image, one of the powers of art and the artist is the representation of the world and the revelation of its spirit.

Throughout most of Western history, definitions of art were different from our modern view. The word art is derived from the Latin *ars,* meaning either manual skill or professional activity. Art had a broad definition, encompassing what we would now think of as the sci-

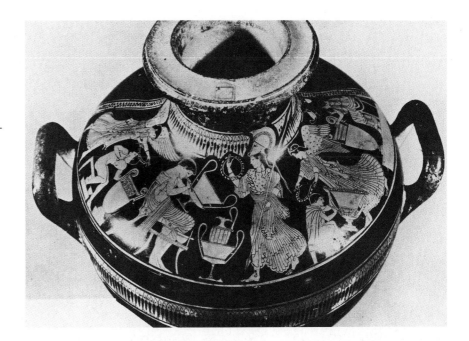

15. LENINGRAD PAINTER
Greek Potters at Work (detail). c. 450 B.C.
Greek vase. Torno Collection, Milan

ences, as well as many practical handicrafts and occupations. An artist, for example, might practice the art of painting, while a physician would practice the art of medicine.

In the classical world of ancient Greece and Rome, the making of art was generally viewed as a manual profession, taught in workshops, and it was not related to the more esteemed liberal arts, which were distinguished by intellectual, speculative thinking. Our Greek vase painting illustrates this workshop tradition (fig. 15). Apprentice vase painters, some of them female, are working side-by-side with the master of the shop. Women must have been given the lesser positions within the workshop, for no Greek vases signed by women are known.

The Middle Ages continued to identify art as a manual profession. Artists formed guilds—legal organizations rather like trade unions—which, while assuring professional standards of accomplishment, also reinforced the distinction between the mechanical, or manual, arts, which included the production of works of art, and the so-called liberal arts, which during the Middle Ages encompassed arithmetic, geometry, astronomy, music theory, grammar, rhetoric, and logic.

The traditional classification of the visual arts as mechanical arts was first transformed during the Renaissance. Both artists and writers began to emphasize the scientific and intellectual aspects of art, often applying the program of the liberal arts to the education of the artist. It was argued, for example, that arithmetic was needed by the artist for the study of proportion, and that geometry figured in the proper calculation of perspective. The artist was beginning to be seen as an educated professional versed in both the practice and theory of art. The new attitude that the artist was a skilled and educated individual was accompanied by a new social status. Artists became the companions of intellectuals, princes, and emperors.

This remarkable evolution also affected the classification of the visual arts. By the sixteenth century, painting, sculpture, and archi-

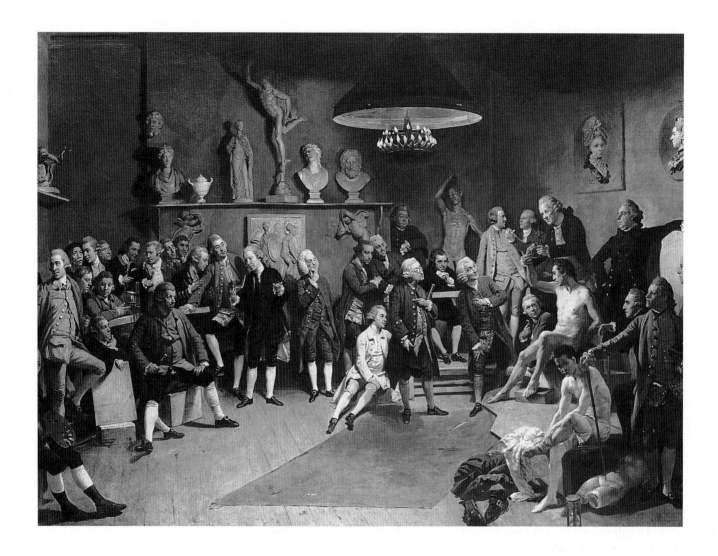

16. JOHANN ZOFFANY
The Life Drawing Class at the Royal Academy. 1772. Oil on canvas, 40 x 58".
Collection Her Majesty the Queen, Windsor Castle. Zoffany's painting shows all the members of the Royal Academy except for Angelica Kauffmann and Mary Moser, who, as women within this restrictive academic climate, were not permitted to attend the life drawing class because of the nude male models. Zoffany ingeniously included them by painting their portraits hanging on the back wall. The sculpted figure with a raised right arm, just below the lamp, is an *écorché*, a sculpture of a flayed anatomical figure used to study surface muscles.

tecture were grouped together as the arts of *disegno* (an Italian word that refers both to the making of drawings and to the concept of design), and were elevated to a status higher than other utilitarian arts. Discussion of art theory had become commonplace among intellectuals, and treatises were written to define art and to discuss its developing history. By the later sixteenth century, art academies began to replace the workshop tradition; artists were now educated in both the practical and theoretical aspects of art. Zoffany's painting depicts the male members of London's Royal Academy attending a class with live models (fig. 16). Plaster casts of the great works of classical sculpture, which were thought to exemplify the highest ideals of art, line the walls. The members of the academy are involved in rational discourse on the subject of life drawing.

The association of the arts of *disegno* with the intellectualism of the liberal arts was one of the mainstays of the new academic education given to artists. By the eighteenth century, art academies had proliferated throughout Europe. From this academic wellspring, a definition of the fine arts (*les beaux arts*) developed which included painting, sculpture, poetry, music, and dance on the basis that these are the arts that delight us. Arts which primarily served a utilitarian purpose

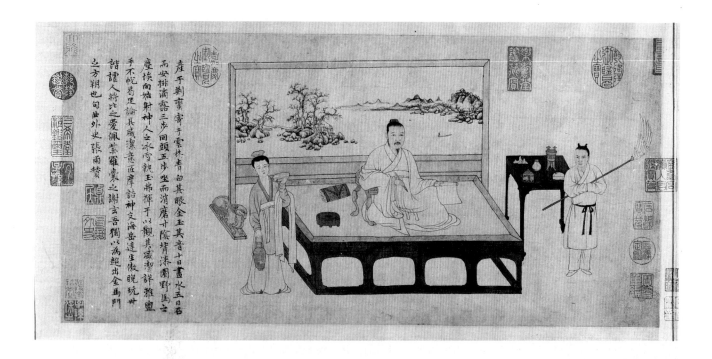

continued to be termed mechanical arts, while architecture, which was considered to combine usefulness with beauty, occupied a third, independent category.

Although our understanding of art's role within the interpretation of the fine arts is of late historical vintage, developments since the nineteenth century have already begun to question these academic definitions of art. Early in the nineteenth century, when dramatically changing economic and social conditions were transforming Western cultural values, the concept of the artist as a member of the *avant-garde* (French for vanguard) was born. Attacking the conservativism of academic training and public taste, many artists assumed roles as prophets, leading society toward a modern, often utopian, vision of life. In our time the parameters within which visual artists work have changed. Happenings and Performance Art have blurred the distinctions between the traditional media of the visual arts and other art forms, including speech, music, dance, film, and video.

In cultures outside the Western tradition, China nurtured the oldest continuous painting tradition in the world. Its historical isolation, imperial patronage, art academies (begun as early as the eighth century), and a bureaucratic elite of Confucian scholar-officials contributed to a unique tradition in the fine arts. Most Chinese artists were not only painters. Many were also poets, calligraphers, government officials, antiquarians, scholars, collectors, connoisseurs, and mystics. They were part of the cultured elite, the *wen-jen* or literati, who were the main participants in the Chinese classical tradition.

Chinese painting derived from the art of writing and is, therefore, a linear art. Its brushwork is imbued with calligraphic formulas. The highest aesthetic aim of the literati painters was to capture the spirit of what was depicted, rather than merely its appearance (see fig. 17). For these literati painters, the creative process embodied the *Dao*, or Way of Nature, with its holistic vision of organic and metaphysical

17. Chinese. *Portrait of Ni Tsan.* c. 1370 (Ming dynasty). Scroll, ink on paper. National Palace Museum, Taipei, Taiwan, R.O.C. Chinese literati painters worked alone, seated at desks in their studios. Paintings were executed on the flat surface of the table with natural bristle brushes in watercolor and ink on silk or paper. All necessary brushes, paints, and inks were close at hand.

properties. In many Chinese paintings, idea and technique are one; the act of painting and the picture itself both carry meaning. Interestingly, these literati artists did not create sculpture or architecture, which were the work of highly skilled artisans.

Among the Chinese aristocracy, painting and calligraphy were revered media for examination and for the preservation of social, political, and aesthetic values. The earliest known treatise on aesthetics was written in the second quarter of the sixth century by a man named Xie He. Called the *Gu hua pin lu (Classified Record of Ancient Painters),* it graded forty-three painters of former times into six classes. What has made the work so influential is its preface, known as the Six Canons of Painting, which were used to judge all painters and paintings. Because the language of the treatise is filled with abstract philosophic thinking and presents generalized and theoretical prescriptions for painting, the Canons have been translated and interpreted many times. An approximate translation of the Six Canons is: first, a painting must have spirit or breath of life *(qi yun);* second, the brushwork must be structurally sound; third, the painting must faithfully portray forms; fourth, a painting must have fidelity of color; fifth, it must also be a properly planned composition; and sixth, it must transmit knowledge of past painting traditions.

Canons two through five clearly concentrate on technical matters and the sixth emphasizes the transmission of and reverence for tradition. The first, animation through spirit consonance, emphasizes the need for painting to have *qi yun. Qi* was thought to be the cosmic spirit that vitalized all things; to capture its essence was fundamental for "good" painting. Each generation of artists established a sense of external and internal reality in painting which could then be challenged and reconsidered during the following period. Xie He's treatise remained the backbone of aesthetic criticism until the modern period in China, when its imperial, elitist roots were challenged by new socialist policies.

In other traditions the position of artists varies. In Africa, for example, the artist has been a prominent member of the community since prehistoric times, not only as the creator of rock pictures but also as the one who decorated implements for hunting and other daily activities. In Africa today artists still hold a respected position within their ethnic groups, although the social status is not the same everywhere. There often continues to be a sharp dividing line between the arts practiced by men and women. In most regions, men are still responsible for house building, toolmaking, and carving, while women are known for their dyeing, spinning, weaving, and pottery.

Professional techniques are usually learned and handed down from father to son or mother to daughter, and certain crafts are family enterprises. In some cases, for instance, if a young male shows talent for carving, he might apprentice with a well-known sculptor, and his family would be obligated to provide the teacher with gifts. If his skill comes to the attention of the chief, the artist is ordered to help create the elaborate attributes of chiefdom: thrones, crowns, scepters, drums, portraits (see pp. 240–41), and articles of personal adornment. Village artists live solely on the patronage of their particular chief and their talents and ideas usually conform to his wishes.

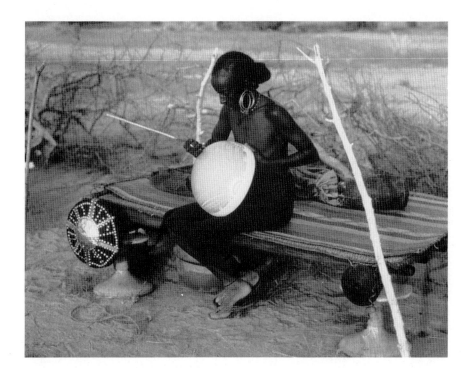

18. Wodaabe woman decorating a calabash, northeast Nigeria. c. 1981

In the case of the Wodaabe artist from northeast Nigeria (fig. 18), we see her carving a calabash, an object made from a gourd that is important in both daily and ceremonial life. Only a few are used as utensils to hold porridge and milk; a greater number are treasured as ceremonial possessions (newborn babies are traditionally bathed in calabashs) and constitute a woman's riches and source of prestige. They are covered with elaborate designs that the artist cuts into the surface after the fruit is dried in the sun until it is hard. Most of the patterns are geometric motifs: triangles, half moons, suns, and sinuous lines. The designs are passed down from generation to generation and vary only slightly according to individual imagination. The patterns are thought to protect both the receptacle and its contents.

In India, religion is the major force which stimulates art and architecture. Most systems of Indic thought consider the phenomenal world to be illusory, perceived and interpreted by the senses. These perceptions yield information of a personal rather than a universal nature. The challenge for the Indic artist is, therefore, to express concepts beyond the limits of the phenomenal world. The artist creates symbolic devices, or *murtis* (images, icons, or sculptures), which refer to the ultimate Truth and render the abstract, transcendent realm more approachable and comprehensible. Communication of universal religious ideals, not egoistic expression, is the goal of the Indic sculptor. As a result, variations on traditional artistic canons are limited, and few names of ancient artists are known. However, the task of the artist is an extremely important one, for the devotee can gain spiritual power by viewing an image or by being in the presence of a great person. Such a belief, therefore, gives the visual arts an especially important role in Indic culture.

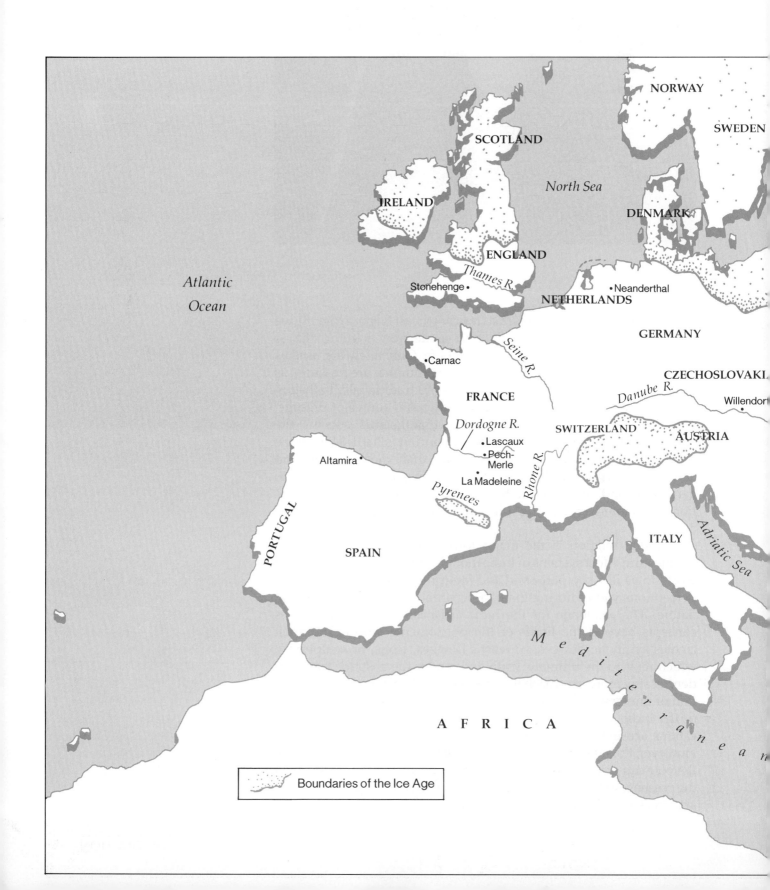

NORWAY

SWEDEN

SCOTLAND

North Sea

IRELAND

DENMARK

ENGLAND

Atlantic
Ocean

Thames R.

Stonehenge

NETHERLANDS

•Neanderthal

GERMANY

CZECHOSLOVAKI.

Seine R.

•Carnac

Danube R.

•Willendor

FRANCE

Dordogne R.

SWITZERLAND

AUSTRIA

•Lascaux

•Pech-
Merle

Altamira•

Rhone R.

•La Madeleine

PORTUGAL

Pyrenees

ITALY

Adriatic Sea

SPAIN

M e d i t e r r a n e a n

A F R I C A

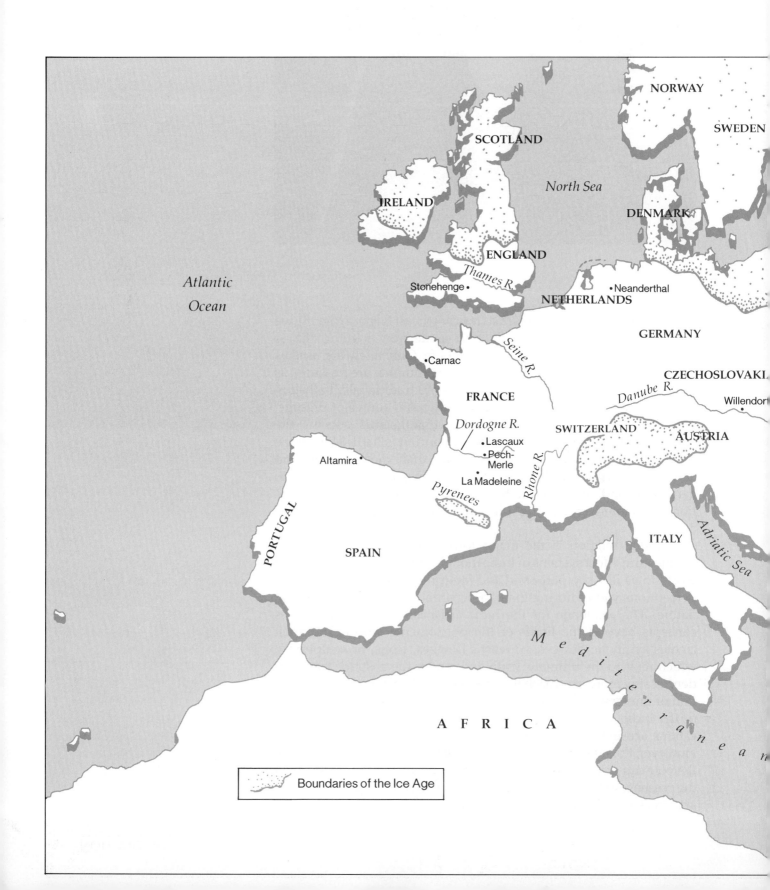 Boundaries of the Ice Age

PREHISTORIC ART

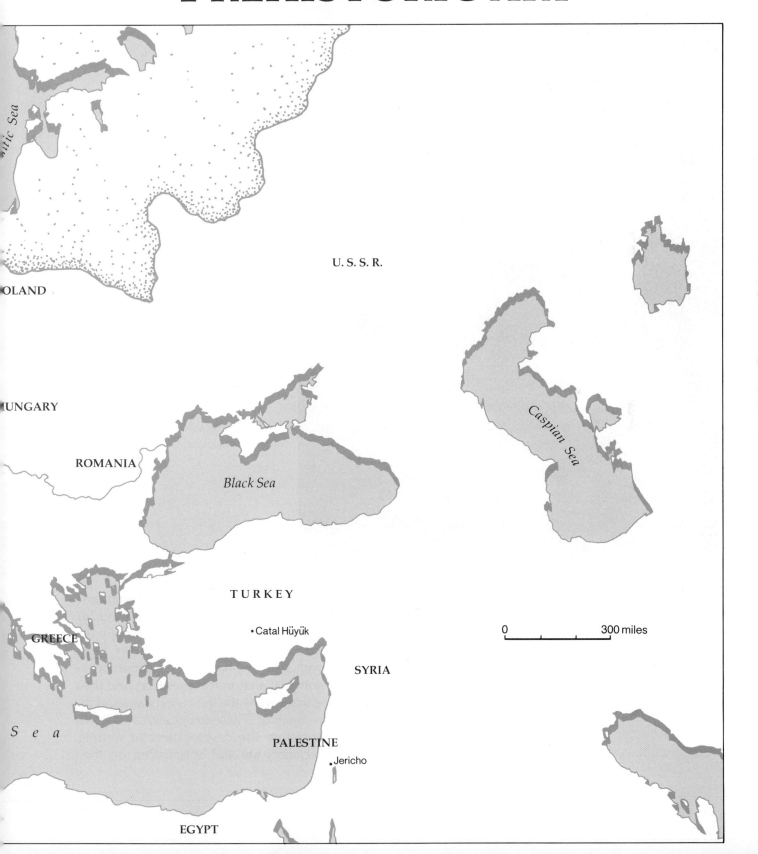

Baltic Sea

U. S. S. R.

POLAND

HUNGARY

ROMANIA

Black Sea

Caspian Sea

GREECE

TURKEY

•Catal Hüyük

Sea

SYRIA

PALESTINE

•Jericho

0 300 miles

EGYPT

INTRODUCTION

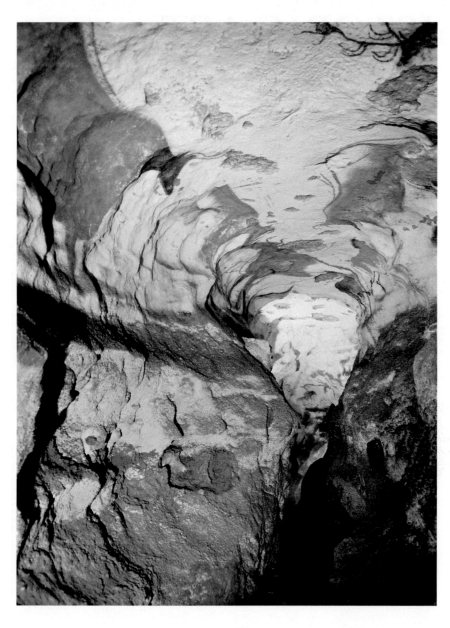

19. Paleolithic. Axial gallery, Lascaux cave, Dordogne, France. c. 15,000–13,000 B.C. Cave painting; animals are about lifesize

In a cave at Lascaux, painted animals—cattle, horses, bison, and deer—seem to roam across walls and ceilings (see figs. 19, 20, and 24). The naturalism of these images is striking, for the sensitively observed animals are represented by means of a subtle and lively application of line and color. In some areas the natural undulation of the cave's surface supports the animals' anatomical presence, and their animation would have been enhanced by the quivering flames of the lamps or torches used for illumination. These images, created in the period known as prehistory, before the development of writing, present many mysteries; specialists are still speculating on their function and meaning.

THE DISCOVERY OF PREHISTORIC PAINTING

During the summer of 1879, a Spanish archaeologist was digging near the entrance of a cave near Altamira. He was hoping to find artifacts, like the prehistoric tools with images of animals that had been unearthed in France since 1840. His young daughter wandered into the cave, and soon cries were heard. When her anxious father entered, he found her excitedly pointing to bison—animals which had disappeared from Spain more than twelve thousand years before—painted on the ceiling. Cave art had been discovered, but the paintings at Altamira would not be accepted as prehistoric until 1902; only after similar discoveries elsewhere would archaeologists accept the fact that such imagery and style could have been achieved by prehistoric people. Lascaux, the most impressive of these sites, was not discovered until 1940.

HISTORY: THE PALEOLITHIC ERA

The origins of image-making date at least as early as the Paleolithic (c. 35,000–8000 B.C.), a period which is characterized by the use of refined stone tools (the term Paleolithic, Old Stone Age, derives from the Greek words *palaios*, old, and *lithos*, stone). At this time, during the last Ice Age, glacial ice extended to areas in southern Europe, but during the warmer months, when temperatures reached 60° Fahrenheit, people probably lived in tents covered with animal skins. As cold weather approached, they sought protection in rock shelters or in mouths of caves.

Paleolithic people were migratory hunter-gatherers. They journeyed in bands of probably twenty to thirty members. Their contact with other nomadic groups may explain similarities in Paleolithic art over vast geographic areas. As they followed the migrations of animal herds, men hunted while women, in addition to bearing and caring for children, gathered mainstay dietary staples—plants, fruits, nuts, and shellfish.

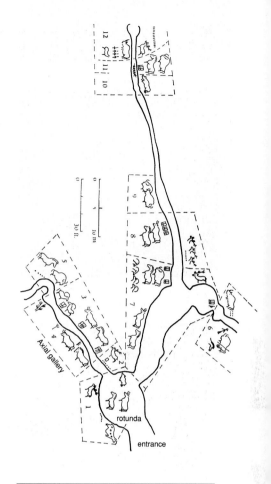

20. Paleolithic. Plan of the cave at Lascaux. Like most cave paintings, those at Lascaux are not all near the entrance and many are rather difficult to reach, supporting the theory that they are ritualistic rather than decorative.

THE "IMAGE BY CHANCE"

Painted or sculpted images of animals often make use of natural protrusions in the cave wall or floor. The human imagination was evidently inspired by areas of natural relief which suggested the forms of a particular animal; by adding paint or by carving, representational images were created. The theory that art originated in the "image by chance" was first stated by the fifteenth-century artist and theoretician Leon Battista Alberti. In his book *On Sculpture*, Alberti

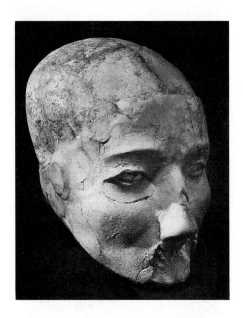

21. Neolithic. *Skull,* found at Jericho. c. 7000 B.C. Human skull with plaster and seashells. Archaeological Museum, Amman, Jordan

writes about the birth of sculpture: "I believe that the arts of those who attempt to create images and likenesses . . . originated in the following way. They probably observed in a tree-trunk or clod of earth and other similar inanimate objects certain outlines in which, with slight alterations, something very similar to . . . Nature was represented. They began . . . [to] take away or otherwise supply whatever seemed lacking to effect and complete the true likeness." Alberti had not seen cave art, but recent archaeological discoveries have lent credibility to his theory.

HISTORY: THE NEOLITHIC ERA

The Ice Age, which had dominated the experience of Paleolithic culture, began to give way to a more moderate climate about 10,000 B.C. in Europe. The warming trend increased the food supply for the hunter-gatherers. During the Mesolithic period (Middle Stone Age), techniques of gathering food became more efficient, and the cultivation of plants is likely. These developments led to the Neolithic period (New Stone Age) in about 8000 B.C. in the Near East , Africa, and Asia and about 5000 B.C. in Europe, when the domestication of plants and animals and a sedentary life-style developed. The bands of hunter-gatherers began to settle into larger, kinship-based communities, probably as a result of several factors, including defense (scenes of human conflict are found in Mesolithic rock painting), economy, and religion. Job specialization seems to have developed at this time. Architecture of stone, mud bricks, and timber provided more permanent homes, and the development of pottery for storing and protecting food also contributed to a stabilized environment. In western Europe, Neolithic peoples raised large stone monuments, as at Stonehenge (see fig. 57).

JERICHO AND ÇATAL HÜYÜK

Important remains of sophisticated Neolithic communities have been excavated at Jericho and Çatal Hüyük. The community at Jericho flourished from about 7500 B.C. It is perhaps the oldest surviving town in the Middle East. Jericho, built around a freshwater spring, a life-giving necessity in an arid region, was a settlement of homes of mud brick surrounded by massive walls for protection. Among the artifacts unearthed are human skulls covered with plaster and painted; seashells are inlaid in the eye sockets (see fig. 21). The heads were found in rooms of private homes, placed above bodies buried below. The purpose served by these Jericho skulls eludes us, but the preservation of individual remains and the almost portrait quality of some of the skulls suggest new attitudes about the worth of the individual. Perhaps these skulls were believed to house the spirit of the deceased in an ancestral worship practice.

The settlement of about ten thousand people at Çatal Hüyük, still

only partially excavated, prospered from about 6700 to about 5700 B.C. Besides agriculture and animal breeding, Çatal Hüyük was also an important center for trade. A shrine excavated at the Neolithic community of Çatal Hüyük contains a painting of a red bull surrounded by miniature human figures (fig. 22). Unlike Paleolithic cave paintings, which were executed directly on walls or ceilings, here a surface of white plaster was carefully prepared. If a new painting was required, another layer of plaster was laid over the previous painting to avoid the superimposition seen in some Paleolithic painting. The bull probably relates to a religious ritual, for it was most likely a symbol of the male deity, embodying strength and fertility; skulls and horns were found in some shrines. The bull at Çatal Hüyük lacks the naturalism and vitality of its Paleolithic predecessors. It is less descriptive of a particular animal and more a diagrammatic symbol. This transformation might be the result of a different function for the image of the bull, or it might also reflect an abstraction brought about by sequential repetitions of an earlier painting of a bull. This more schematic rendering of the animal and the increase in the number of human figures portrayed are characteristic of Mesolithic and Neolithic painting.

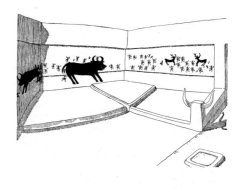

22. Neolithic. *Animal Hunt,* restoration of Shrine A III. 1, Çatal Hüyük, Turkey. c. 6000 B.C.

POTTERY

A modest clay pot is evidence of one of the most consequential transitions in the development of humanity (fig. 23). Its simple design reveals both its function, as a container for food, and, with the twisted cord impressions, the artist's desire to make the object look pleasing. (These designs were also an aid in firing.) The use of pottery was important to a stabilized living environment, where fired clay vessels were created for cooking, transporting, and storing food. Pottery also assisted economic developments, for the making of clay vessels became a specialized activity of artists, who could trade their wares for other goods within their own community; later, pottery became one of the commodities traded from one community to another.

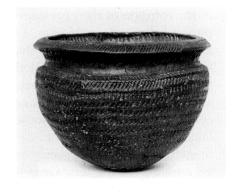

23. Neolithic. Clay pot, found in the Thames River near Hedsor, Buckinghamshire. c. 3100–2500 B.C. Terra-cotta, height 5". British Museum, London

The origins of pottery vessels are uncertain, but we now know that pots, first fashioned in the Mesolithic period, became a standardized production in the Neolithic. Early clay pots may have been molded over a round stone or hand built by coiling (building up the walls of the vessel by successively adding long ropes of clay and then smoothing the joints). The pots were usually fired in open pits over fires of wood or dung, but soon special furnaces called kilns were developed for the firing of clay objects. The patterns on some early vessels may be adapted from weaving patterns. Perhaps wet clay was used to strengthen and waterproof woven baskets, and clay vessels were then made in imitation of the clay-impregnated baskets. By approximately 3000 B.C., the potter's wheel (a small revolving platform on which clay vessels are formed), which greatly increased productivity and encouraged the development of new modes of decoration, was in use throughout the Middle East and in parts of China.

PALEOLITHIC CAVE PAINTING AND SCULPTURE

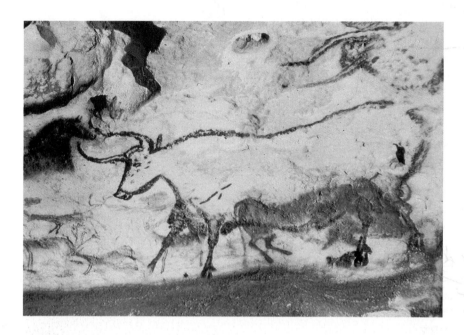

24. *Bulls*. Rotunda, Lascaux cave, Dordogne, France. c. 15,000–13,000 B.C. Cave painting

These bulls (fig. 24) are painted in the rotunda of the cave complex at Lascaux (see also figs. 19 and 20). The smaller bull, the first to be painted, is represented in a quiet pose, as if grazing; its shape is created by a solid area of color. Painted over this at some later date is the outline that defines the large bull; he seems to be ambling to the left. Only a few details, such as the eye and shoulder vein (a target for the hunter?), are drawn within the contour lines. Both images were created by artists sensitive to the anatomy and liveliness of the animals.

Sometimes Paleolithic artists drew directly on the wall with chunks of red, yellow, brown, or black minerals or earth, but more often they created liquid pigments by grinding minerals and mixing them with animal fat, vegetable oil, or bone marrow. They could apply these paints to the wall using a brush made of animal hair or a frayed stick, while dots of color could be pressed onto the wall with fingers dipped into the paint. Broader areas of color could be applied by blowing paint through a hollow reed or bone. Whatever technique was employed, the skill was remarkable, not only in the fluid execution of the painting, but also in the exacting observation and memory of the artist, who reproduced these naturalistic animal forms —some seemingly in movement—by lamp or torchlight.

Some animal images are shown pierced with spears or arrows, possibly as a practical demonstration to younger hunters. But the location of the paintings and the overpainting of images on successive occasions, perhaps hundreds or even thousands of years apart, suggest that they may have served a ritualis-

tic purpose. Perhaps in making these paintings the Paleolithic artist also acted as a shaman, a person believed to have power to affect the spiritual world. The ritual of re-creating the animals through representation may have been an attempt to capture their life spirits and to thus insure a successful hunt. Whatever their function, the images had to be both lively and identifiable by species. The relatively rare occurrence of the human figure in Paleolithic art ranges from the representational to the schematic. The majority are sticklike figures. Perhaps it was feared that too naturalistic a representation would capture the life spirit of the figure portrayed.

Our ancestors left a record of their presence in hand prints made by placing a hand against the wall and blowing pigment around it through a reed or hollow bone (see fig. 25). These prints may be "signatures" left by the artists or by those who were present during a particular ritual. Some record hands with missing fingers. Perhaps the fingers were lost due to frostbite or hunting accidents, or they may have been doubled under to form hand signals, symbols of silent communication used by the hunters to indicate the presence of game. Or possibly the hands were purposely mutilated for some ritualistic reason, such

Rotunda, Lascaux: c. 15,000–13,000 B.C.
12,000 B.C.: The dog is domesticated and used for hunting
10,000 B.C.: Human population of earth is about 3 million
8000 B.C.: Human population of earth is about 5.3 million
7000 B.C.: Wheat is domesticated

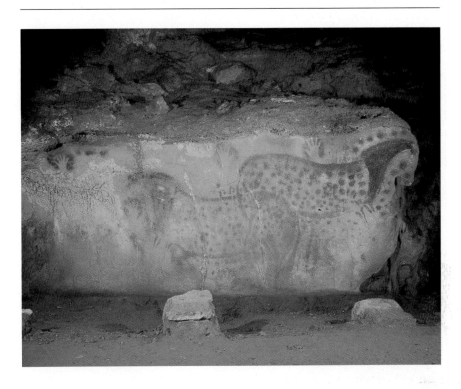

as an initiation ceremony or to pacify spirits.

One group of about one hundred fifty sculptures poses unique problems of interpretation (see fig. 26). Barely a few inches in height, these represent female figures with a pronounced emphasis on breasts, abdomen, hips, and thighs. Traditionally they have been viewed as images of fertility, perhaps for use in a ritual dealing with childbearing, and the exaggeration of those parts of the body related to procreation are often assumed to be conscious abstractions by the artist. Scholars have also suggested that these figures might represent the "ideal" Ice Age woman, with the fat accumulation desirable to conceive and bear healthy children during periods of food scarcity. Other explanations propose that these figures functioned as guardian figures or as dolls. Recent scholarship has demonstrated that as a group, they display various stages in a woman's life, from youth, maturity, and pregnancy to old age. Some archaeological evidence suggests that they were made and used by women. Our uncertainty about the function of these sculptures is directly related to the limited evidence we have about Paleolithic life and culture. Our understanding of prehistoric art is itself still evolving.

25. *Spotted Horses and Negative Hand Imprints.* Pech-Merle cave, Lot, France. c. 15,000–13,000 B.C. Cave painting, length approx. 11'. The spots of the horses are created with dots of color pressed onto the wall using fingers dipped in paint.

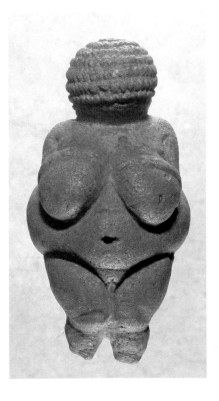

26. *Statuette of a Woman,* found at Willendorf, Austria. c. 25,000–20,000 B.C. Stone, height 4 3/8". Museum of Natural History, Vienna. Statuettes such as this one have been traditionally, but improperly, known as Venuses. Other similar figures are carved of mammoth ivory or modeled of clay. The navel of this figure is a natural indentation in the stone.

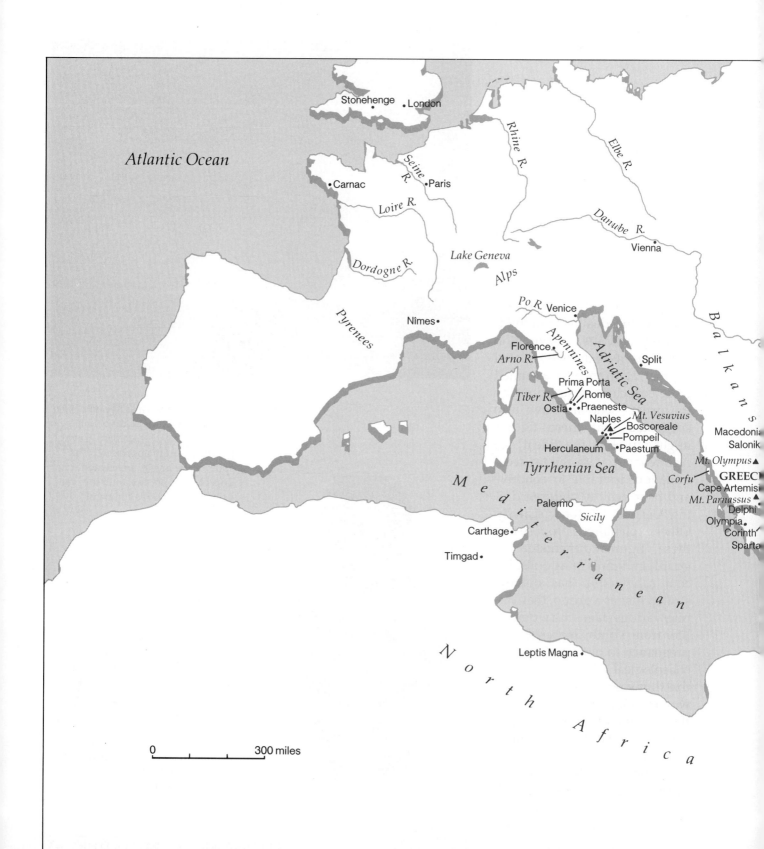

Atlantic Ocean

Stonehenge • •London

Rhine R.

Elbe R.

Seine R.

•Carnac •Paris

Loire R.

Danube R.

•Vienna

Dordogne R.

Lake Geneva

Alps

Po R. Venice

Pyrenees

Nîmes•

Apennines

Florence•

Adriatic Sea

•Split

Arno R.

Prima Porta

•Rome

Tiber R.

•Praeneste

Ostia•

Mt. Vesuvius

Naples•

Boscoreale

▲

•Pompeii

Herculaneum

•Paestum

Tyrrhenian Sea

Balkans

Macedonia

Salonik

Mt. Olympus ▲

Corfu

GREEC

Cape Artemis

Mt. Parnassus ▲

Delphi

Olympia•

Corinth

Sparta

Palermo•

Sicily

•Carthage

Mediterranean

Timgad •

Leptis Magna •

North Africa

0 300 miles

ANCIENT ART

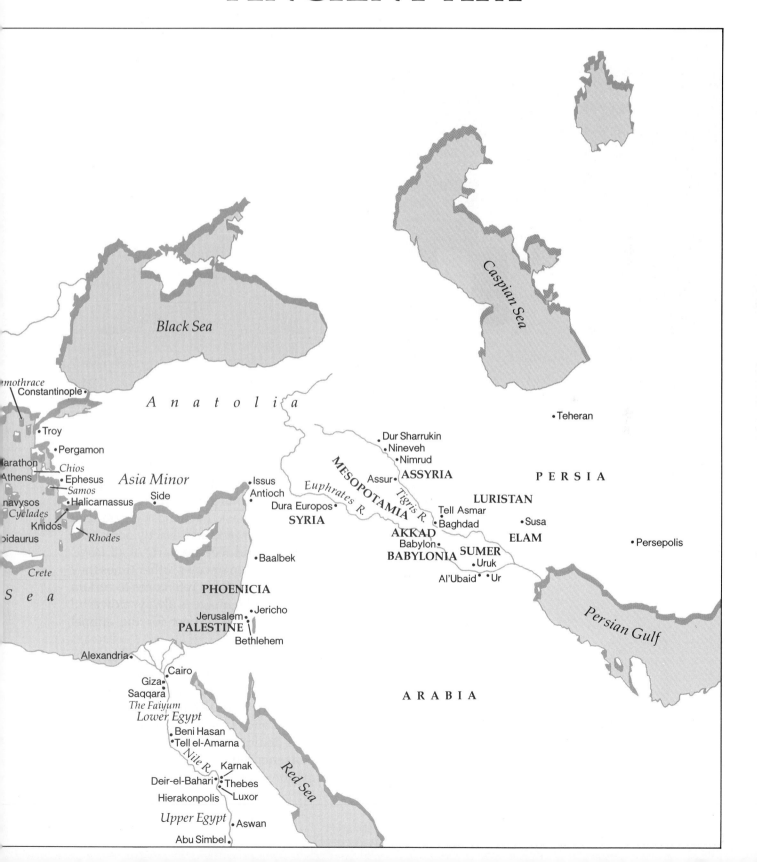

Samothrace
Constantinople •
• Troy
• Pergamon
Marathon
Chios
Athens
Ephesus
Asia Minor
Side
Samos
navysos
Halicarnassus
Cyclades
Knidos
pidaurus
Rhodes
Crete
Sea

Black Sea

Caspian Sea

Anatolia

• Teheran

• Dur Sharrukin
• Nineveh
• Nimrud
Assur • ASSYRIA

MESOPOTAMIA
Euphrates R.
Tigris R.
• Issus
Antioch
Dura Europos •
SYRIA
AKKAD
Babylon •
BABYLONIA

PERSIA

LURISTAN
Tell Asmar •
• Baghdad
• Susa
ELAM

SUMER
• Uruk
Al'Ubaid • • Ur

• Persepolis

Persian Gulf

• Baalbek

PHOENICIA

• Jericho
Jerusalem •
PALESTINE
Bethlehem

Alexandria •

Cairo •
Giza •
Saqqara •
The Faiyum
Lower Egypt

ARABIA

• Beni Hasan
• Tell el-Amarna

Nile R.
Karnak
Deir-el-Bahari •
• Thebes
Hierakonpolis
Luxor

Red Sea

Upper Egypt
• Aswan
Abu Simbel •

INTRODUCTION

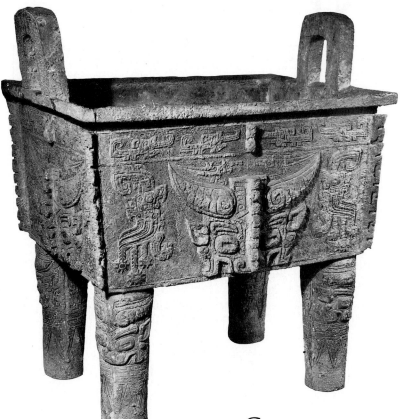

27. Chinese. *Fang ding* (ceremonial food vessel). c. 1150 B.C. (Shang dynasty). Bronze, height 24 1/2". Excavated from tomb 1004, Houziazhuang, Anyang (Henan province), China. Academia Sinica, Taipei, Taiwan, R.O.C.

Chinese bronze vessels, like this *fang ding,* immediately attract our attention because of their powerful, simple shapes and extravagant, abstract patterning (fig. 27). Careful examination reveals that what at first seems to be abstract patterning is based on the forms of animals, parts of animals, or combinations of parts of beasts and/or birds. In this case the main motif is the most famous pattern used on ancient Chinese bronzes, the *taotie,* or monster mask. Each mask is arranged in a symmetrical fashion with each part repeated exactly across the central axis; eyes, ears, an open jaw, and feet are parts of all *taotie.* Sometimes the ears resemble those of oxen or cows; other times they appear to be closer to deer, moose, or elk. Why references to certain animals were made is not known, but the image is always powerful and presumably also shows considerable respect for the animal kingdom.

This vessel (and the *guang* seen in fig. 29) were created to hold sacrificial offerings of food and wine during ancient Chinese ceremonies dedicated to the veneration of ancestors. Sets of these containers were placed on family altars, but they were also buried in tombs of members of the ruling and aristocratic classes. These early bronze vessels sometimes had inscribed dedications to the deceased; later inscriptions referred to historic events and legal transactions and are an important source of information about ancient Chinese life from

about 1000 B.C. onward. The tombs where such vessels were found also contained bronze weapons, sometimes inlaid with semi-precious stones, ceramic vessels, and objects carved from jade and other stones. These luxurious art objects were intended to confirm the political, military, and spiritual power of their patrons.

The particular piece-mold process of casting used for the production of these vessels was quite distinctive of early China. Anyang, where the *fang ding* was excavated, was the last capital of the Shang dynasty (c. 1766–1122 B.C.), and the vessel's decoration referred to the royal clan that ruled China during this period. The *taotie* on all four sides of the *fang ding*, for example, is thought to be the particular emblem of the Shang. The animal forms that create the vessel's patterns are believed to represent mediums through which communications were transmitted from earthly beings to the spirits of the ancestors. This idea is related to shamanistic religious practices in

which communication with the spirit world was aided by animals who were thought to have special powers of transcendence. A priest or holy person, often wearing a mask or ritual dress made up of animal parts (horns, feathers, skins), was understood to change not only appearance, but also his or her state of being, to transcend this world to that of the spirits (see also p. 494). Sometimes the very shape of the vessel mimicked an animal form, as in the *guang* (fig. 29).

Like many objects that survive from the world's ancient cultures, the Etruscan mirror served both a practical and a religious purpose (fig. 28). Used not only for personal grooming, these elegant, decorated mirrors were also frequently placed in or near tombs for use in the afterlife. The engraved design on the back of the mirror is drawn from the traditions of Greek mythology, which were popular with the Etruscans. It depicts Calchas, a diviner, who is shown "reading" the spots on the liver of a sacrificed animal in order to foretell the future. The naturalism evident in the figure of the winged Calchas, the surrounding grapevine, the table, and the vase represents an approach more often found in the ancient Western civilizations of Greece, Etruria, and Rome than in China or India. But the subject matter seen here—the practice of interpreting natural occurrences and objects as omens—was widespread throughout the ancient world. It is but one revelation of the complex intertwining of religious doctrine with everyday life common to these early peoples.

The Etruscans (see also pp. 78–79), whose civilization paralleled that of Greece in time, created a loosely bound federation of city-states in central Italy. They were a vigorous and religious people, and our knowledge of them largely derives from the evidence of the complex burial practices that grew from their belief in the afterlife. The deceased were apparently accompanied with virtually all the goods they might need after death.

HISTORY

As those factors which distinguished Neolithic culture, including husbandry and communal living, continued, certain areas gradually underwent a development toward a more complex, urban existence. In fertile river valleys—the Tigris and Euphrates in Mesopotamia, the Nile in Egypt, the Indus and Ganges in India, and the Huang Ho and Yangtze in China—where abundant food was available, new, large urban civilizations developed.

The first cities became administrative and/or religious centers for the surrounding territory. As these cities and their territories grew in size and population, production became specialized and a division of labor developed, often reinforcing class distinctions. In some cultures, the administrative authority of the political/military and religious classes, which often existed in a symbiotic relationship, was supported by a system of taxation or tribute. In many ancient cultures, monumental works of public architecture were symbolic of the new central governing authority.

Another key to the development of ancient civilization was the

growth of systems of writing and mathematics that evolved in response to the needs of the new urban centers. The promulgation of laws and the keeping of accounts and records helped to provide order and continuity within the new complexity of urban life. Writing and mathematics contributed to the goal of an orderly society within the complicated structure of the urban environment, but they also made possible the advent of literature and science.

These aspects of a more complex and interrelated urban life-style, or civilization, were present in different measures in societies beginning about 4000 B.C., but the development is not uniform. In Sumer and Egypt, such developments were present beginning about 4000 B.C., while in India they date to about 2200 B.C. and in China to 2000 B.C. In the Americas, settled life was known in the first millennium B.C. In western Europe, civilization emerged noticeably late, as is indicated in this text by the placement of the important Neolithic monument of Stonehenge (fig. 57) after the discussion of the developments in Sumer and Egypt. By the end of the ancient period, however, developments in Greece, Etruria, Rome, India, and China established advances in art and architecture that mark the foundation for civilization. These civilizations were characterized by a sense of self-reflection and concern for fellow human behavior as opposed to a primary preoccupation with gathering food supplies.

ANCIENT ART

What we know about ancient civilizations most frequently comes from the analyses of archaeological remains and the examination of artifacts produced by skilled artisans. Another source can be the study of literature written by ancient authors. Literary remains are virtually non-existent for some ancient cultures, however, and the fact that most of the artifacts that we study are the result of archaeological investigations also means that we must work with a very limited sample of evidence. But all early peoples produced materials which, when investigated today, can help us in our attempts to understand their most cherished beliefs about spiritual as well as political, social, and economic matters. The monumental architecture and public works (temples, baths, and granaries, for example) known in the Indus Valley and the Roman republic and empire, tell us that the parent societies cared about issues of public as well as spiritual health. In ancient Mesopotamia, Egypt, and at Teotihuacán, large-scale architectural and sculptural monuments—ziggurats, pyramids—are known to have been dedicated to the display of both political and spiritual ideals. In China, spiritual and political power was more often expressed in ritual vessels and burial practices than by architecture. In ancient societies, sculptures and paintings often represented deities and leaders, but some examples also record everyday activities. Works of ancient art and architecture were made from a wide variety of media, from common limestone to the most precious metals and gems. One can expect to find some sort of visual arts in all ancient societies, but the "perishable" arts, such as literature, dance, and

29. Chinese. *Guang* (ceremonial food vessel). 12th century B.C. (Shang dynasty). Bronze, length 12 1/4". Excavated from a royal tomb at Anyang (Henan province), China. Freer Gallery of Art, Smithsonian Institution, Washington, D.C.

music, are largely lost to us. They often must have been as significant as their more permanent visual counterparts. Study of all remains can begin to provide clues to the discovery of common and distinctive traits of human behavior worldwide.

THE ANCIENT ARTIST

In most ancient civilizations, artists—the men and women who created what we now deem to be works of art—were counted among the ranks of laborers, and their products were seen as the result of manual effort. Apprentices in workshops learned the traditional artistic forms and techniques that ensured a continuity of artistic and iconographic formulas. Most works of art were the product of a group of trained artists working together in a workshop which took advantage of a distribution of labor.

While at times rulers took pride in employing artists of significant talent, these instances did not contribute significantly to the social or economic prestige of the artist. In ancient Egypt the architect Imhotep (see fig. 47) was a member of the pharaoh's court and later he was even deified, but this seems to have been a unique development within ancient world cultures.

In Greece, the personality and individual style of a number of artists is documented. These artists gained fame, yet despite the fact that they were personally admired, their profession was still viewed as lacking the philosophical and educational values of the liberal arts. Later Roman patrons valued Greek works of art as well as Greek artists, but the Roman artist was confined to anonymity.

In China and India, embellished objects such as cast bronzes and stone carvings were designed by specialists who usually worked together as part of a team of craftspeople involved in the creation of a work. The designers, the metallurgists and casters, and the miners and carvers of jade and stone each possessed specialized knowledge of patterns, designs, and techniques which must have conferred on them a special status in their communities. Certainly teams of architectural designers/builders were similarly considered in ancient India, Mesoamerica, and elsewhere. The creation and construction of the many vast ancient religious and urban complexes was a task that required cooperation, specialization, and overall coordination—prerequisites for ancient civilization.

THE LADY FROM DAI

In China, new types of art objects began to be produced from about the sixth century B.C. onward. Sometimes these new objects also reveal new approaches to representation as well. The painted silk banner from the tomb of the Lady from Dai (fig. 30) comes from south China, near Changsha in Hunan province. It was found draped over the innermost part of four coffins. Its iconography is descriptive and

its presentation representational rather than emblematic and geometricized, as was the decor of the ritual bronzes (figs. 27, 29). What is depicted on the banner is the path of the souls after death—the underworld, the earthly realm, and the Land of the Immortals. The underworld, or watery realm, is represented by fishes and deities of that world of darkness. The soul is called back to earth, where it rejoins the other soul and is feasted by the family of the deceased. The detail here portrays the Lady from Dai as she returns to the earth. The top of the banner describes the Land of the Immortals where creation tales are told. A preoccupation with immortality and with its attainment characterize most funerary art of the later period in ancient China and reflects the patrons' interest in Daoism (see pp. 33–34).

Banners of this type were described in literary accounts; they were probably carried in funerary processions before being buried with the deceased. This is the first such banner discovered, and it is an early example of polychrome silk painting in China. Naturalistic depictions of human beings such as we see here were rare in China before the rise of Confucian humanism in the sixth century B.C. The new philosophical and moral attitudes of Confucius, with their self-reflective attitudes toward human life, clearly had a direct impact on painting. In the ancient world, the arts were a sensitive barometer of changes in social and intellectual order.

30. Chinese. *Lady from Dai with Attendants* (detail of a painted silk banner). c. 180 B.C. (Han dynasty). Silk T-shaped banner, 80 3/4" tall; 36" wide at the top. Formerly Historical Museum, Beijing

Introduction to Egyptian Art

31. Old Kingdom. *The Pharaoh Khafre.* c. 2500 B.C. Diorite, height 66"; over-life-size. Egyptian Museum, Cairo. This is one of a number of similar sculptures found in Khafre's valley temple at Giza (fig. 51), site of the three great pyramids from the Old Kingdom (see figs. 43, 44). The temple is located along the cause-way which connects Khafre's pyramid with the *Colossal Statue of Khafre as the God Hu.*

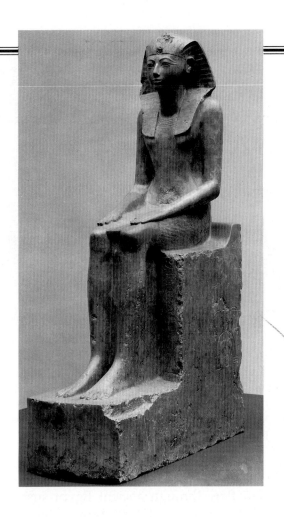

32. New Kingdom. *Queen Hatshepsut.* c. 1495 B.C. Lime-stone, height 78". The Metropolitan Museum of Art, New York (Rogers Fund and contribution from Edward S. Harkness, 1929)

The over-lifesize figure of Khafre is shown majestically seated on his throne (fig. 31). It expresses the absolute authority of the Egyptian ruler, who was known as the pharaoh. The idealized body is as architectonically rigid as the throne. There may be a hint of portraiture in the face, but the effect of the figure is grand and intimidating. Khafre's head is embraced by the wings of the Egyptian sky god Horus, represented as a falcon, to symbolize the god's divine protection.

The statue, carved from an extremely hard stone and compactly composed, gives the appearance of being able to last forever. The Egyptians believed that the *Ka*, the part of the human spirit that defined a person's individuality and that would survive on earth after death, needed a physical dwelling place. The corpse of Khafre was mummified to provide this home, but if it should decay or be destroyed, one or more sculptures of the deceased pharaoh could provide a home for the *Ka*. The solid and rigid character of this sculpture was the artist's way of meeting an extraordinary demand—that of creating a sculpture that to serve its purpose had to endure for eternity.

HISTORY

Egyptian civilization was nurtured by the Nile River as it flows northward into the Mediterranean Sea. Egypt was the "gift of the

33. New Kingdom. *Akhenaten with Nefertiti and Their Children.* c. 1370–1353 B.C. Limestone relief, 13 x 15". Staatliche Museen, Berlin

34. New Kingdom. Rock Temple of Ramesses II, Abu Simbel. c. 1257 B.C. Height of sculpture about 67'. In 1968 these gigantic figures of sandstone, cut directly into the cliff side, were raised about six hundred feet to save them from being flooded by the lake created by the Aswan Dam.

river," wrote the Greek historian Herodotus. The nine hundred miles of the Nile that flow through ancient Egypt sustained life in an otherwise arid desert region. Every summer the Nile, swollen by torrential rains, would flood its banks, depositing fertile silt to support Egypt's agricultural development. Neolithic settlements along the Nile date from as early as 7000 B.C. Agriculture was sustained by the annual flood and, later, by irrigation, while the flanking desert offered protection from foreign invaders. The economy gradually prospered, and later crop production included flax for the making of linen and papyrus for paper and rope. By the fifth millennium B.C., the settlements coalesced into distinct cultural areas. The northern area was known as Lower Egypt because of the flow of the Nile from south to north; Upper Egypt was to the south. Around 3168 B.C., a legendary king (now identified with Narmer; see pp. 58–59) forcibly united Upper with Lower Egypt, establishing a political state that endured almost continuously for over two thousand years.

This vast expanse of Egyptian history is subdivided into three major periods of political stability and cultural and economic growth known as the Old, Middle, and New Kingdoms. The Old Kingdom (c. 2686–2182 B.C.) was characterized by an expansion of the central authority of the pharaoh, who ruled over Egypt's local administrative provinces. Its economic prosperity is evident in the funerary precinct at Giza, which includes the three largest pyramids (see fig. 43). Political unrest led to the end of the Old Kingdom when an economic depression, perhaps caused in part by lavish expenditures, was compounded by a famine, and local governors of the provinces broke the central authority of the pharaoh.

The Middle Kingdom (c. 2050–1786 B.C.) saw a reunified Egypt.

The pharaoh Sesostris III strengthened the central government, and new trade routes were established, stimulating the economy. The Middle Kingdom ended when a group of foreign settlers, the Hyksos, took advantage of a weakened government and of a new weapon—the horse-drawn chariot—to establish a separate kingdom.

Within a century, however, the Hyksos were expelled and Egypt entered a final period of cultural and economic prosperity, the New Kingdom (c. 1576–1085 B.C.). The architectural remains of the New Kingdom reveal a vigorous economy, political stability, and the assured power of the pharaoh. This latter quality is reflected in the statue of Queen Hatshepsut (fig. 32), Western history's first recorded female monarch, who governed Egypt from about 1501 to 1482 B.C.

There was an important, if short-lived, disruption in Egypt during the New Kingdom. The reign of the pharaoh Akhenaten (c. 1365 B.C.), known as the Amarna period because his capital was located near present-day Tel el-Amarna, witnessed the disruption of many traditional cultural and artistic values. The relief of Akhenaten with Nefertiti and their children (fig. 33) retains some of the usual conventions of Egyptian art, such as the simultaneous combination of frontal and profile views (see p. 59). But the artist has imparted a new fluid naturalism to the figures. Unlike the earlier geometric treatment of the figure, the bodies of Akhenaten and his family are given sensuous curving forms which contribute to the relaxed intimacy of the scene. The fact that Akhenaten's queen is seen on the same scale as the pharaoh himself reveals the revolutionary equality that characterized the Amarna period. In other Egyptian periods women are

35. New Kingdom. *Throne of Tutankhamen.* c. 1350 B.C. Gold, silver, colored glass paste, glazed ceramic, and inlaid calcite, height 45". Egyptian Museum, Cairo. Tutankhamen, whom we popularly know as King Tut, was a pharaoh of relatively minor importance in Egyptian history. He succeeded to the throne following the rule of Akhenaten's son and died at an early age. Tutankhamen's fame is primarily due to the fact that his tomb furnishings were largely intact when discovered by the British archaeologist Howard Carter in 1922.

36. Diagram showing the ancient Egyptian proportional system as reconstructed for the statue of Queen Hatshepsut (fig. 32). The Egyptian workshops used a strict proportional scheme that allowed the efficient execution of painted and sculpted figures. A squared grid, drawn on the wall or on three sides of a block of stone, was used to demarcate the height and width of each figure's shoulders, waist, feet, and other body parts following a standard formula. When applied to a block of stone, this system allowed unnecessary areas of the block to be chiseled away by unskilled assistants.

shown as notably smaller in scale (see fig. 55). Following this period, the rigid conventions of older ways returned as the pharaohs established an authoritative continuity with their predecessors. The statues of Ramesses II that flank the entrance to his mortuary temple at Abu Simbel (fig. 34) recall the formal rigidity of the Old Kingdom statue of Khafre. But the colossal size of these sculptures, about sixty-seven feet high and carved from the actual cliffs of the site, reveal the grandeur typical of the New Kingdom. The Ramesses dynasty (ended 1085 B.C.) was the last significant dynastic family of the New Kingdom. During the following centuries the power and splendor of the empire abated, and in 332 B.C. Egypt was conquered by Alexander the Great.

RELIGION

Egyptian religion was a complex faith which included polytheism, magic, politics, and a steadfast belief in an afterlife. As was also true of Neolithic agricultural communities, wonder at the forces of nature and the spirit of animals led to the development of polytheism, with local gods or goddesses being affirmed in different communities. Early depictions of these deities include representations as animals, such as Horus (the sky god as a falcon), or as animal-headed humans, like Anubis (a jackal-headed god associated with mummification).

For the Egyptians, whom Herodotus described as "religious to excess," magic was as much a part of their religion as was attending the great religious festivals. Believing that the spiritual world governed all aspects of life, the Egyptians even accompanied the commonplace practice of taking medicine with ritualistic incantations. Religion was also bound to politics. The pharaoh was viewed as a god who ruled with absolute authority in secular and religious matters. Often a god or goddess worshipped by a particular pharaoh would become the center of the state religion and be imposed over local religious practices.

Much religious ritual accompanied the belief in an afterlife. Although this belief remained constant, rituals changed as a result of the complex developments in Egyptian religious practice. The most important entity of the human soul to be served in the afterlife was the *Ka*. After death the *Ka* required an earthly abode, and the body of the deceased was preserved through mummification (mummy is from the Arabic *mumiya*, meaning bitumen—a petroleum substance mistakenly believed to have been used in mummification). The process of mummification, strictly governed by religious ritual, took seventy days. The lungs, stomach, liver, and intestines were removed to separate containers called canopic jars, while the body was treated with chemical solutions to draw out moisture before being wrapped in as many as twenty layers of linen. A song inscribed on a predynastic tomb reveals the reward for the *Ka*: "The span of earthly things is a dream, but a fair welcome is given him who has reached the West." (The world of the afterlife was associated with the sunset and was therefore thought to be in the west.)

EGYPTIAN ART

Providing service to the *Ka* was a mainstay of artistic production in Egypt. Tomb walls were painted with everyday scenes (see figs. 54, 55) to re-create a pleasant environment, and small servant figures, usually carved from wood and painted to appear lifelike, performed a host of common duties. Woodworkers constructed a series of coffins which were decorated by artists. Some were carved from stone (these are called sarcophagi, from the Greek *sarkophagos*, flesh-eating stone).

In addition to the artistic preparations made especially for the use of the *Ka* in the afterlife, such precious objects as jewelry and items of personal use were placed in the tomb. The throne of the pharaoh Tutankhamen (fig. 35) displays the exquisite artistry and conspicuous wealth of the New Kingdom, while the relaxed figurative poses demonstrate influence from the Amarna period.

Although much of preserved Egyptian art relates to funerary practices, the Egyptians as a people were not concerned only with the afterlife. Tomb paintings record the labor of the lower classes and such festive occasions for the nobility as banquets with music and dancing. But even commonplace scenes often adhere to time-honored conventions of artistic practice. The visually unnatural formula used in Egyptian art to depict pharaohs and aristocrats is a combination of frontal with profile views that creates a static figure typical of Egyptian art (see fig. 56).

The relatively unchanging nature of Egyptian artistic practices reveals the stability of its civilization, yet artists were not slaves to formulas. Akhenaten caused a religious, political, and artistic revolution, but even before him, other currents brought degrees of diversity and vitality to Egyptian art, as is seen in the portrait bust of Ankhaf (fig. 37). The portrait bust as a type was related to funerary practices, probably as an additional home for the *Ka*. Ankhaf, a court official to Khafre, was buried in the necropolis at Giza. The painted image, found in the chapel of his tomb, displays a subtle surface anatomy: the deep-set eyes, swelling of the cheeks, and the diagonal lines from the nose to the corners of the mouth reveal an attentive sense of life akin to the naturalism observed in some tomb paintings. This bust contrasts with the authoritative power of royal portraiture.

37. Old Kingdom. *Bust of Ankhaf.* c. 2500 B.C. Painted limestone, partially molded in plaster, height 22". Harvard–MFA Expedition, Courtesy, Museum of Fine Arts, Boston

THE EGYPTIAN ARTIST

In Egypt, as throughout most of the ancient and medieval periods, no distinction was drawn between the artists who designed sculptures and paintings and the numerous skilled laborers in workshops who brought their concepts into being. Artists labored as members of the lower classes. The exception was the architect, who enjoyed the status of a court official. Imhotep, the first recorded artist of Western history, designed Zoser's Old Kingdom funerary complex at Saqqara (fig. 47). His fame was so great that by the New Kingdom he was deified as the god of learning and medicine.

VOTIVE PALETTE OF KING NARMER

In the past, important historical developments often led to the creation of significant works of art that interpreted or commemorated an event. It seems no accident that the first great work of Egyptian art, the *Votive Palette of King Narmer*, marks the establishment of the unified nation of Egypt. Narmer, who has been indentified with Menes, first king of the first Egyptian dynasty, appears three times. As the largest figure on side A (fig. 38), he wears the crown of Upper Egypt and brings under his control a figure who probably represents Lower Egypt. The nearby human-headed figure with six papyrus blossoms being held captive by the god Horus (shown as a falcon) almost certainly represents, in a symbolic manner, the submission of Lower Egypt to Upper Egypt. This use of symbols to represent complex ideas is an important new development in art, and one which hints at the later development of Egyptian hieroglyphs, in which figures or pictures signify words or sounds. At the bottom of side B (fig. 39), Narmer himself appears as a symbol—a horned bull,

38. Left: Old Kingdom. *Votive Palette of King Narmer* (side A). c. 3168 B.C. Slate, height 25". Egyptian Museum, Cairo. The shieldlike shape and shallow indentation reveal that this is an enlarged, ceremonial version of an everyday object, a palette used for the grinding of pigments for eye shadow. This palette was found at Hierakonpolis, a sacred city of prehistoric Egypt.

39. Right: *Votive Palette of King Narmer* (side B)

Votive Palette of King Narmer: c. 3168 B.C.
4236 B.C.: Earliest date in the traditional Egyptian calendar
4000 B.C.: Earth's population reaches about 85 million
3760 B.C.: Earliest date in the traditional Jewish calendar
3500–3000 B.C.: Wheeled vehicles in use
3000 B.C.: Earth's population nears 100 million
c. 3000 B.C.: Bronze is first produced

victorious over an enemy and the enemy's fortified city. At the bottom of side A are two more defeated antagonists and small symbols of a fortified city and a gazelle trap that suggest victories in the city and countryside. Near the top of side B, Narmer, wearing the crown of Lower Egypt and accompanied by a processional retinue, views the decapitated corpses of enemies. The central symbol at the top of both sides represents Narmer's name and his palace. It is flanked by horned animals representing the sky-mother (Hathor), in whose shrine the palette was probably dedicated. In addition to Narmer's assumption of the two crowns, union is also suggested by the joining of two fantastic, long-necked lionesses on side B, their serpentine necks intertwined to form the shallow indentation that refers to the function of the object.

A number of the most important surviving works of art from predynastic Egypt are similar palettes or fragments of palettes. The decoration is usually political in nature. Apparently the larger versions of these palettes were displayed as votives (gifts made to a god or goddess), and they may also have been used to grind and mix the pigments that adorned the eyes of the cult statue of the deity. The *Votive Palette of King Narmer* probably had several functions: as a decorative object to be used in a religious ritual; as a votive offering to the god or goddess (most likely Hathor); and as a commemoration of the military and territorial victories of Narmer. Such a union of political statement with religious ritual is typical of Egyptian art and culture.

Narmer is, in every case, represented as unnaturally larger than his subordinates and ene-

mies, a means of visually conveying importance called hierarchical (or, less correctly, hieratic) scale common in religious and political art. This emphasis and the lucid presentation make the meaning more easily comprehensible. The human figures on the palette present the human body in a design which clarifies the parts and their interrelationships—legs, head, and arms are seen in strict profile, while the torso and the eye are seen directly from the front. These demonstrate the same clarity seen in the three-dimensional figure of Khafre (fig. 31), but here they are united and suppressed into what is essentially a two-dimensional medium, low relief (see below). As unrealistic as this pattern is, it is easily read and it emphasizes strength. It would continue in Egyptian art for more than three thousand years.

RELIEF SCULPTURE

The technique of sculpting figures or forms which are part of (or, less commonly, attached to) a background is known as relief sculpture. Because the figures are very flattened, the style of carving in the *Narmer Palette* is known as low or bas-relief. There is no differentiation in color, but light hitting the delicately varied levels of relief allows us to read the forms. This technique, difficult to master, was also practiced by later artists. The Egyptians also excelled at an unusual type of low relief known as sunken relief, in

which the figures are recessed into the surface (visible in fig. 33). High relief is relief sculpture with forms that project substantially from their background (see fig. 107). During the Renaissance, sculptors perfected a pictorial relief that conveyed an illusion of depth by using a subtle transition from high to progressively lower relief (see fig. 279). In Egypt, as well as in later cultures, relief sculpture often has color added to support its design (see fig. 56).

THE ANCIENT NEAR EAST: THE ART OF THE SUMERIANS

Civilization began in Egypt and Mesopotamia at about the same time, between 4000 and 3000 B.C. Unlike the relatively stable government of Egypt, ancient Mesopotamia saw a succession of cultures, including those of the Assyrians and Persians, which will be discussed later (see p. 76).

The Sumerian civilization began to flourish about 3000 B.C., as the Sumerians brought the Tigris and Euphrates rivers under control for irrigation. A flourishing agricultural economy developed, along with trade, commercial enterprise, and technological innovation (the Sumerians are credited with the invention of the wheel). The Sumerians controlled southern Mesopotamia until about 2350, when they were conquered by another people. They regained control about 2150 B.C. and remained rulers until 2030 B.C. The Sumerians invented writing when the system of pictographic signs which they had developed for record-keeping evolved into a phonetically based system known as cuneiform. In *History Begins at Sumer,* S. N. Kramer lists thirty-nine "firsts" that he attributes to the Sumerians, including the first schools, the first historian, the first love song, and the first library catalogue. Among the Sumerians' heritage for later generations were important developments in ethics, education, and written law. Humanity's first great poem, written during the Akkadian period in Sumer, was based on an old Sumerian tale. This is *The Epic of Gilgamesh,* a tragic poem that tells of a Sumerian king's

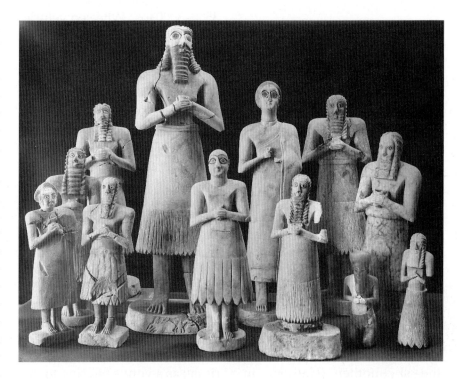

40. *Worshippers and Deities.* c. 2750 B.C. Gypsum, height of tallest figure approx. 30". The Iraq Museum, Baghdad, and The Oriental Institute, University of Chicago. These figures were found at the Temple of Abu at Tell Asmar, Iraq.

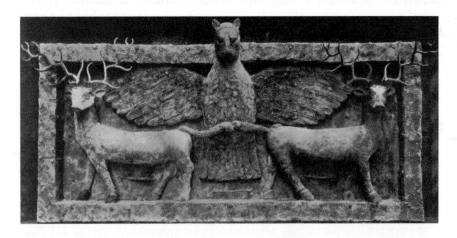

41. *The Storm God and Two Stags.* Lintel from a temple at Al'Ubaid, Iraq. c. 2500 B.C. Copper sheets over wooden core, length 94". British Museum, London

quest for glory and immortality and ends when he discovers that even the bravest heroes must face death. At its height the Sumerian civilization included more than a dozen loosely unified city-states. Each had a population of between ten and fifty thousand inhabitants. The cities were fortified with broad walls, gates, and towers, and their dominating feature was a towering religious

shrine known as a ziggurat.

Sumerian religion was polytheistic, with more than three thousand gods and goddesses. It was also animistic, encompassing virtually all aspects of nature. The divine, which was manifested in nature, was present in every object. Each city had a patron deity. Among the significant surviving Sumerian objects are simple standing figures, found in groups within a shrine, that are identified by inscriptions as representations of deities, priests, and individuals (see fig. 40). They probably do not include the cult statue of the main god or goddess, which most likely assumed a more abstract form. These figures, conical and cylindrical, are shown with their hands rigidly clasped and with enormous eyes inlaid with semiprecious blue lapis lazuli (imported from Afghanistan) or with shell. All wear the typical Sumerian costume, a simple skirtlike apron. The gods in the group are distinguished from the individuals by hierarchical scale and by the enlarged size of their eyes. The statuettes of the individuals were placed as votive offerings in temples and served, in an animistic sense, to present the life spirit of the donor in an attitude of continuous and vigilant prayer. Each was a permanent and ever-alert substitute for the donor, who may not have been allowed to enter the sacred shrine.

A potent Sumerian object is the large high-relief sculpture that presumably surmounted the entrance of a small temple (fig. 41). The central figure—a magnificent and threatening lioness-headed eagle with wings spread—is Imdugud, the force that exists within a storm cloud. This frontal deity is framed by

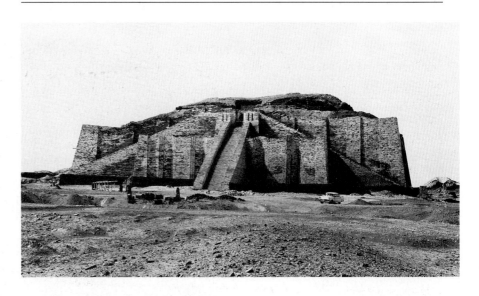

42. Ziggurat, Ur. Iraq. c. 2100 B.C. Fired brick over mud brick core, 210 x 150' at base; original height approx. 70'

two symmetrical stags, which surely represent other natural forces, to create a simple composition that is both commanding and awesome.

The most impressive structure of a Sumerian city—and of ancient Near Eastern cities in general—was the ziggurat (from the Akkadian, pinnacle or mountain-top), a high, terraced structure. The ziggurat at Ur (the Sumerian city thought to be the childhood home of the Old Testament figure Abraham) survives in the best state of preservation (fig. 42). It was built on the ruins of earlier ziggurats by several Sumerian kings, including Ur-Nammu, who wrote one of the earliest code of laws. Approximately as tall as a six- or seven-story building, it had two temples—one at the foot of the ziggurat and, on the summit, a second built entirely of blue enameled bricks. This ziggurat was dedicated to Ur's patron, the moon god Nanna-Sin. On the New Year

festival, processions would ascend the three staircases and proceed through a ceremonial gateway to the brilliantly decorated temple with its cult statue and sacrificial altar at the top. Herodotus, the Greek historian, wrote about a ziggurat when he described the "Tower of Babel": it was three hundred feet tall with, at its apex, a temple with a large couch and table of gold for use by the god when he came down to earth. The Sumerian mother goddess was Ninhursag, the lady of the mountain, and the mountains were the source for the water that nourished their country. As a humanly made sacred mountain, the ziggurat offered the king and priests the possibility of ascending during rituals to visit the residence of the gods and to ask for divine guidance in political and religious affairs. An early Mesopotamian text refers to a ziggurat as the "bond between heaven and earth."

THE PYRAMIDS

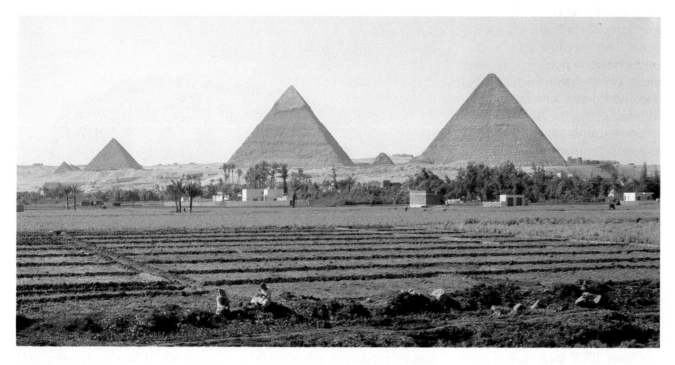

43. Old Kingdom. Pyramids of Menkure (c. 2470 B.C.; see fig. 2), Khafre (c. 2500 B.C.; see fig. 31), and Khufu (c. 2530 B.C.), Giza. Original height of the Pyramid of Khufu, 480'; length of each side at base 755'. The three great pyramids at Giza, built of limestone and granite, were viewed as architectural wonders even in the ancient world. Constructed as royal tombs, they are the best known of more than eighty pyramids built in ancient Egypt.

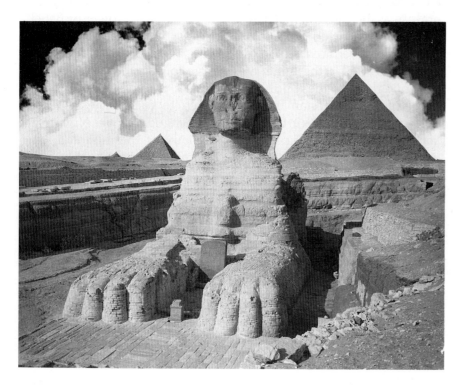

Associating the transition to the afterlife with the sunset, the great pyramids—burial places of the pharaohs—were located on the western side of the Nile River (fig. 43). Today the desert area around the pyramids reveals little of the complex of funerary temples (see fig. 51) and other grave sites which once formed this great necropolis (city of the dead); the *"Sphinx"* is part of the funerary precinct of Khafre (fig. 44). The face of the *"Sphinx"* bears the features of the pharaoh Khaf-

44. Old Kingdom. *Colossal Statue of Khafre as the God Hu,* later known as the *"Great Sphinx,"* with pyramids at Giza in the background. c. 2500 B.C. Sandstone

re, probably as Hu, the reincarnation of the sun-god Re. (The name sphinx, meaning stranger or mysterious person, by which we know the monument today, was first used by the ancient Greeks.)

Grave sites in predynastic Egypt were usually shallow pits marked with mounds of sand near the edge of the desert. By about 2900 B.C., nobles were buried in underground chambers marked by mud-brick structures called mastabas (from the Arabic *mastabah*, bench) with battered (sloped) walls (fig. 46). Mastabas contained offerings to the *Ka* and chambers for a statue of the deceased.

About 2750 B.C., during the Old Kingdom, the pharaoh Zoser commissioned Imhotep to design and construct a funerary complex at Saqqara (fig. 47). The architectural climax was a large step pyramid. This solid structure suggests the superimposition of progressively smaller mastabas.

It is not completely clear why the pyramidal form was used in this funerary context. One theory suggests that it derives from the cult image of the sun god Re, a small pyramidal stone that symbolized the rays of the sun descending to earth. A widely accepted view is that the pyramid fulfilled both spiritual and practical needs by offering a monumental and secure abode for the *Ka* and assisting the pharaoh's spirit in its ascent to heaven. A text found inside a pyramid states: "I have trodden these rays as ramps under my feet where I mount up to my mother

Uraeus on the brow of Re."

Each of the great pyramids took over twenty years to build. Labor was probably supplied by the people, who gave their time during the three months of the summer flood when their land was under water. The high waters of the Nile facilitated the transport of granite, quarried miles away. Much of the limestone was quarried at the site.

Building the pyramids was a laborious and exacting process. Surveyors would determine the cardinal directions by observing a star in the northern sky and would orient the square base with each wall facing a cardinal direction. The limestone blocks were transported, probably on a type of sled, up inclined ramps. A polished granite or gilded capstone would catch the first and last of the sun's rays. False passages were constructed to discourage grave robbers, but almost all Egyptian royal tombs were plundered in ancient times.

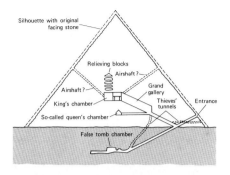

45. Section of Pyramid of Khufu. The pyramid of Khafre is the only one that preserves any of its outer dressed stone exterior. Many stones were taken from the site to build medieval and modern Cairo.

46. Mastabas. Reconstruction with section

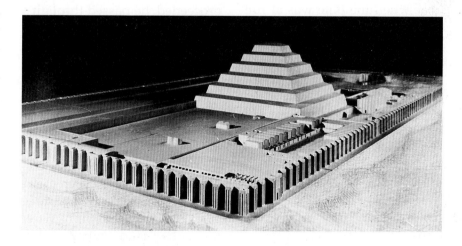

47. IMHOTEP (architect)
Old Kingdom. Funerary District of King Zoser, Saqqara. Reconstruction model. c. 2750 B.C. Height of stepped pyramid about 200'

THE EGYPTIAN TEMPLE

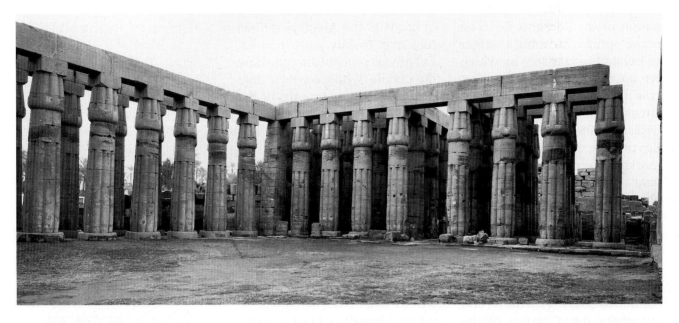

48. New Kingdom. Courtyard built by Pharaoh Amenhotep III, Temple of Amun-Mut-Khonsu, Luxor. Begun c. 1390 B.C. View of hypostyle hall from courtyard. The temple is dedicated to Amun, the sun god, his consort Mut, and Khonsu, the moon god.

The enormous New Kingdom temples at Karnak and Luxor (see figs. 48, 49, 52, 53), which are among the largest religious structures ever built, played an important role in Egyptian religion and politics, especially the annual festival of Opet, a twenty-four-day celebration of the New Year when the Nile was at full flood. At this time the pharaoh and his family would come to Karnak to participate in a procession accompanying the golden statue of Amun, the chief Egyptian deity, to the shrine of his wife (the goddess Mut) and son (Khonsu, the moon god) at Luxor. The pharaoh, identified with Amun, emerged from the pylon at dawn as the sun rose behind, framed by the pylon's flanking towers.

As is most often the case with religious architecture, the design of an Egyptian temple is based on its ritual use. Beginning with the long rows of sphinxes flanking the avenue to the entrance, the organization is axial, relating to the progress of the pharaoh's procession, and is characterized by bilateral symmetry (the forms are identical on either side of the central axis). As the pharaoh proceeded, he passed through a clear sequence of architectural spaces, beginning with the open road, flanked by sphinxes, and moving through the pylon, an entrance gate (see fig. 50) with broad battered towers and flagpoles flanking the doorway, into the sacred precinct. He then proceeded into one or more colonnaded courtyards open to the sky and framed on two or three sides by rows of columns (later pharaohs would often add additional courtyards, as at Luxor, fig. 52, where the latest open courtyard, added by Ramesses

II, is out of alignment with the earlier structures). Next he would enter a large room filled with columns known as the hypostyle hall (see fig. 49). The only light in this area would be that which filtered down from the raised roof area along the central axis, where there are long vertical openings (such a raised area with windows is known as a clerestory; for later examples see figs. 160, 232). The final sequence of rooms, all fully enclosed, became progressively smaller, lower, and darker until the priest and/or the pharaoh would enter the most sacred chamber, with the cult statue. (The Temple at Luxor was exceptional, for there were two sacred chambers; the one at the back, which was entered directly from the exterior wall, was where the sacred boat of Amun was placed after carrying the pharaoh over the Nile from

Karnak.) The hierarchical and exclusive quality of Egyptian society is expressed in these temples, for only a select few could follow the pharaoh into the courtyard, fewer yet into the hypostyle hall. The enormous walls of the sacred enclosure (more than a mile long at Karnak) served to exclude the multitude and remind them of their inferior social, political, and religious status, as did the overwhelming scale of the structures themselves.

The architecture stressed stability, weight, monumentality, and durability. These temples were meant to endure, and Amenhotep III described a temple he had built at Thebes as "an eternal, everlasting fortress of fine white sandstone, wrought with gold throughout; it is made very wide and large, and established forever." The massive stone walls were solid, without windows, and weight and stability were further expressed by the heavy cornices and battered walls of the pylon. Virtually all surfaces were covered with low or sunken relief carvings that emphasize the mass and weight of the stone. The hypostyle hall was a veritable forest of huge fat columns (at Karnak the largest were sixty-nine feet tall and twelve feet in diameter, with a circumference of almost thirty-three feet), and the effect was claustrophobic and intimidating. The solidity and austerity of these Egyptian temples seem to be direct reflections of the stable and controlled civilization that created them.

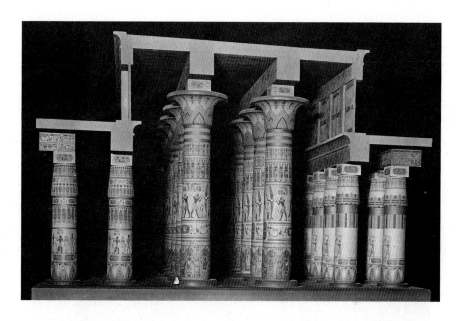

49. New Kingdom. Hypostyle hall, Temple of Amun, Karnak. Reconstruction model of central section. 1350–1205 B.C. The Metropolitan Museum of Art, New York (Levi Hale Willard Bequest, 1890)

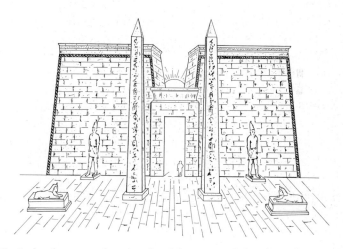

50. Typical pylon gate, showing the rising sun and the pharaoh emerging from the central doorway

POST-AND-LINTEL CONSTRUCTION

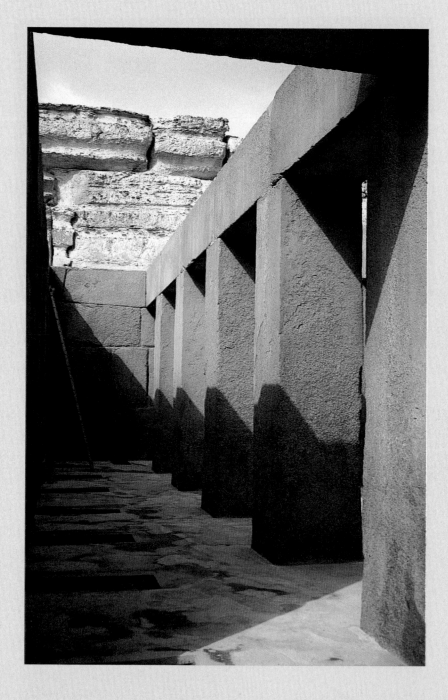

51. Post-and-lintel construction as exemplified in the Old Kingdom Egyptian Valley Temple of Khafre at Giza. c. 2500 B.C. The temple is constructed of limestone and red granite, and it was here that twenty-three portrait statues of the pharaoh Khafre, including fig. 31, were originally housed. A causeway led from the temple to the Pyramid of Khafre (see fig. 43) some six hundred yards further from the Nile.

The type of construction used for Egyptian colonnaded courtyards and hypostyle halls (see p. 64) is known as post and lintel, the post being the vertical supporting member, usually a cylindrical column, and the lintel being the horizontal member, often known as the entablature (fig. 51). The only simpler types of construction are the wall and the mound. The engineering dynamics of post and lintel are straightforward—the weight of the entablature presses downward on the column, which must be strong enough to support the entablature's weight. If the entablature is too long or lacks sufficient tensile strength (longitudinal strength sufficient to support itself without breaking), it may collapse in the middle or shear and break where it meets the column. In post-and-lintel architecture the columns are usually decorated, especially at the top, or capital. In Egypt the column and capital may resemble greatly enlarged papyrus, date palms, or bundled reeds (see figs. 48, 49; such forms may derive from the use of actual bundled reeds in early Egyptian wall architecture). Although the post-and-lintel system is simple, the rhythmic placement of the columns and the relationship of vertical to horizontal allow many architectural and aesthetic variations.

The Egyptian builder was restricted by the available materials, which included vast amounts of stone but virtually no wood. The dense and brittle nature of the local stone kept the lintels short and the columns heavy and close together. The hypostyle hall was virtually the only large enclosed space that could be constructed.

HOW TO READ ARCHITECTURAL DIAGRAMS

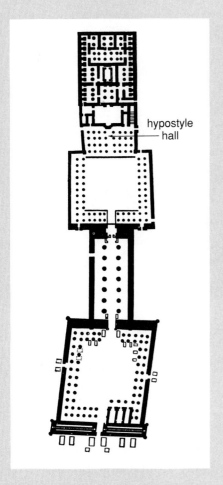

hypostyle
hall

52. New Kingdom. Plan, Temple of Amun-Mut-Khonsu, Luxor. Statistics for a similar temple precinct at Karnak reveal the tremendous scale of these projects; Karnak is 1220' long, and the sacred enclosure encompasses 62,000 acres.

53. New Kingdom. Temple of Khonsu, Karnak. c. 1080 B.C. Isometric projection with plan and longitudinal section

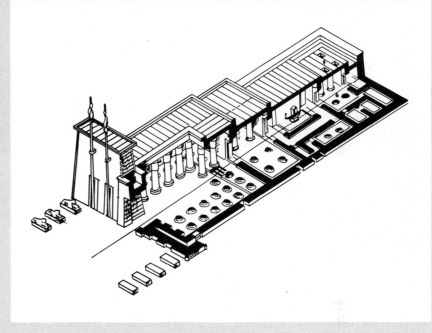

The drawings of architecture in this book are meant to aid in your understanding of principles of design and construction. Some of these diagrams reveal how a building would look if it were sliced through, as in a plan (or ground plan; fig. 52), which shows the building as if truncated by a horizontal plane approximately one foot above the floor level (solid lines are structure, with openings indicating doors and windows; lighter lines indicate floor patterns; dotted or light lines indicate the patterns of the ceiling; see fig. 230). A cross section shows the building sliced by a vertical plane from side to side (see fig. 96), while a longitudinal section slices the building from front to back (for an example see fig. 53). An elevation shows the exterior surfaces and their decoration diagramatically, not as the human eye would see them (see fig. 341). A relatively recent kind of diagram is the isometric projection, which includes both a ground plan and a view of the exterior and/or interior from a specific point of view (see fig. 53). The axonometric projection (fig. 114) is slightly less realistic than the isometric projection. Because of the artificial and two-dimensional nature of most of these diagrams, an understanding of any building requires an examination of several diagrams.

Today buildings are erected using architect's diagrams similar to those discussed above, but we still do not know much about the use of drawings by architects, engineers, and construction crews in the past. The earliest surviving examples date from the Gothic period. In some early periods architects and engineers apparently laid out the building full scale on the ground, using pegs and string or vines to mark the contours.

EGYPTIAN PAINTING AND PAINTED RELIEFS

54. New Kingdom. *Pond in a Garden*. Fragment of a painting from the Tomb of Nebamun, Thebes. c. 1390 B.C. Paint on plaster wall, 24 x 28". British Museum, London

55. New Kingdom. *Hunting Scene*. Fragment from the Tomb of Nebamun, Thebes. c. 1390 B.C. Paint on plaster wall. British Museum, London

The vast numbers of Egyptian paintings that survive—preserved by the arid desert climate—are tomb paintings on plaster and, because of the demand that tomb decoration preserve the pleasant everyday life of the Egyptians so that the *Ka* could enjoy these pleasures throughout eternity, these paintings have a broad human interest and appeal. They tell us a great deal about ancient Egyptian life and customs. When analyzed, they reveal Egyptian patterns of thinking and organizing ideas. *Pond in a Garden* (fig. 54) provides a view of a rectangular pool, with ducks, fish, lotus blossoms, and flowering and fruit-bearing trees. Completeness and clarity were demanded of the Egyptian painter, for anything not clearly included in the tomb painting would not be available to the *Ka* in the afterlife. This explains why each object has to be shown in its most easily recognized view—the pond is represented as if seen from above, while everything else is in profile. The relationships among the objects in reality are also made clear in the representation: fish, ducks, and lotus are seen as within the pool, and trees surround it. The trees are seen right side up and sideways, but not upside down—those at the bottom side of the pool are upright. The Egyptian artist worked within the strict limitations imposed by the function of the work. This approach, which is not naturalistic, uses only frontal and profile viewpoints, the characteristic points of view in Egyptian art.

The *Hunting Scene* from the Tomb of Nebamun (fig. 55) offers similar organizational and decorative principles. The marsh weeds and the water are shown in section, as if cut away and seen from the side, while all the other elements are represented in their clearest silhouette. Nebamun, accompanied by his wife and daughter (both shown much smaller in scale), holds aloft his throw stick and grasps three birds. He is portrayed simultaneously hunting and holding aloft his trophies. His cat or mongoose, trained to retrieve, is shown in midair capturing three

56. Old Kingdom. *Ti Watching a Hippopotamus Hunt.* c. 2400 B.C. Painted limestone relief, height approx. 46". Tomb of Ti, Saqqara

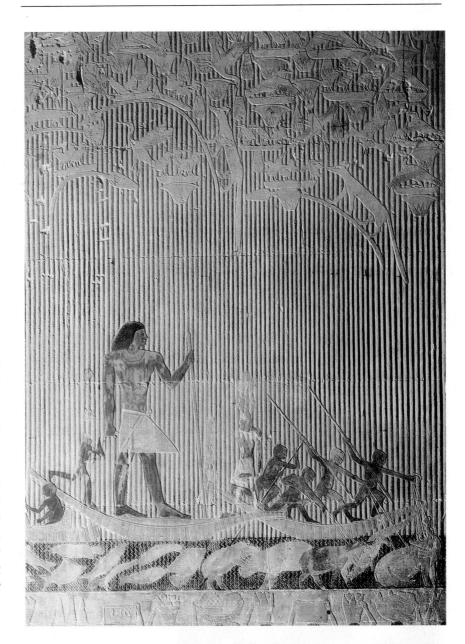

birds at once. While the bounty of game is surely exaggerated, the migration of birds and fish to the marshes of the Faiyum in winter was an annual event, and hunting, sacred to the marsh goddess, was both recreational and religious.

The hippopotamus hunt from the Old Kingdom Tomb of Ti is a painted relief which combines the naturalistic color of painting with the durability of relief (fig. 56). The parallel lines that create a foil for the organic shapes of the figures and animals indicate a setting deep in the marsh, for these are the stems of the reeds that burst into leaf and blossom near the top of the relief. In this upper area predators stalk birds, creating strikingly naturalistic patterns against the geometric stalks as well as a metaphor for the hunt taking place below.

FIGURE-GROUND

The distinct contrast that can be noted between forms and background in most works of art is called the figure-ground relationship. In our *Hunting Scene,* for example, we read the humans and the cat, birds, fish, foliage, and boat as "positive" elements—figures—isolated against a "negative" white plane—the ground—behind them. A similar effect can be noted when works of sculpture and architecture are iso-lated and stand out against or within their surroundings. In analyzing works of art, the positive-negative, figure-ground relationship is always an important component. In some modern works, artists have achieved visual ambiguity by allowing the positive and negative forms to assume virtually equal importance in the composition.

NEOLITHIC MEGALITHS

While the Egyptian civilization was prospering during the Old Kingdom, western Europe was experiencing the transformations of the Neolithic period. The potent testimony of prehistoric monuments in France and England is best evoked by the remains of Stonehenge (fig. 57), where an outermost ring of smaller stones set flush to the ground surrounds an inner ring, a cromlech, composed of large stones known as megaliths (from the Greek *megas*, large, and *lithos*, stone). The innermost megaliths form a horseshoe which defines an axis within the circular plan. The axis at Stonehenge is oriented toward the point on the eastern horizon where the sun rises on the dawn of the summer solstice. Other stones were apparently aligned to the setting sun on the winter solstice and various phases of the moonrise.

The alignment of the megaliths suggests that rituals of worship were related to celestial events, while the emphasis on

57. Stonehenge. c. 2750–1300 B.C. Megaliths and earth markings, diameter of circle 97'; height approx. 13' 6". Salisbury Plain, Wiltshire, England. Stonehenge was constructed in four stages between c. 2750 B.C. and 1300 B.C. Some of the megaliths were transported as far as one hundred ninety miles, probably by being dragged on sleds. They may have been raised using a series of levers. Earthen ramps were constructed to place the lintel stones.

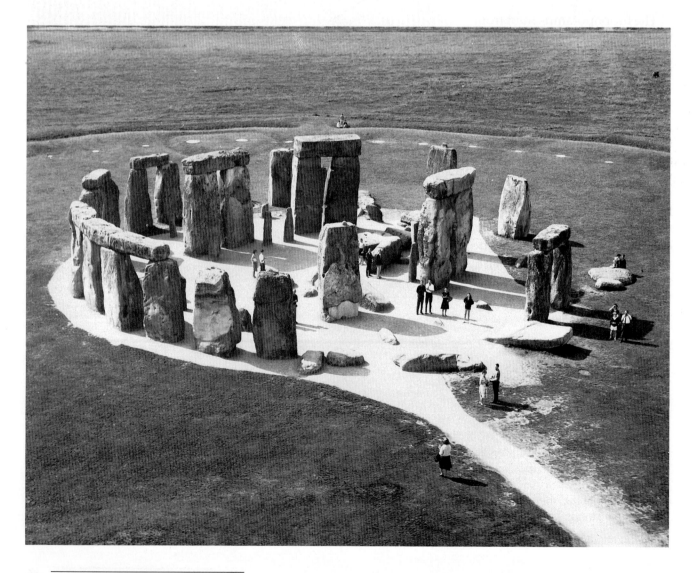

Stonehenge: c. 2750–1300 B.C.
c. 2206 B.C.: Xia dynasty founded in China
c. 1728 B.C.: Hammurabi's Code of Laws

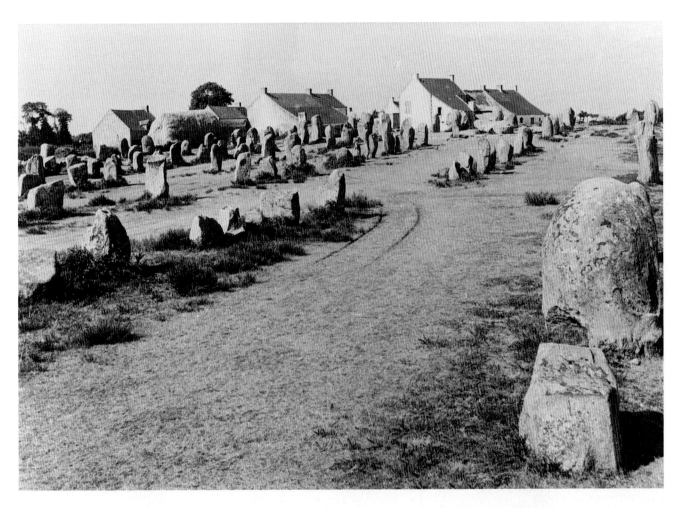

58. Stone alignment, Carnac, France. c. 3000 B.C. Megaliths, height 6' to 15'

the summer solstice implies that it was the major festival. This union of religion with celestial events is frequent in early belief systems. An understanding of the regular cycles of the seasons based on celestial observation is intimately related to the cultivation of crops, and both ritualistic and practical needs may have been served by Stonehenge.

At other Neolithic sites, from Europe, across Central to East and Southeast Asia, large upright boulders were used as individual markers or in combinations to form geometric patterns over a large land area. Near Carnac, rows of upright megaliths called menhirs (large stones) run for almost two miles across the countryside (fig. 58). Sections of eleven, ten, and thirteen lines were probably erected over different periods but may have been made to adjoin one another. The sections organize space and direct our attention toward circles which contain grave sites.

AEGEAN ART: MINOAN AND MYCENAEAN ART

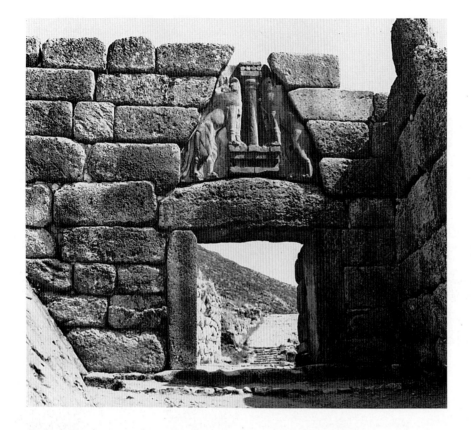

59. Mycenaean. Lion Gate, Mycenae, Greece. c. 1250 B.C. Limestone, height of carved slab 9' 6". The huge slab on which the lions are carved fills a triangular opening in the construction, which is necessary to relieve weight on the lintel. The missing heads were originally attached with dowels. It is possible that they were carved or cast from a different material, and they may have represented human heads.

60. Minoan. *Bull Leaping.* From the Palace at Knossos, Crete. c. 1500 B.C. Fresco, height approx. 32" including borders. Archaeological Museum, Heraklion, Crete. The Greek myth of Theseus and the Minotaur was born of the bull-leaping ritual demonstrated here and the labyrinthine structure of the Palace at Knossos.

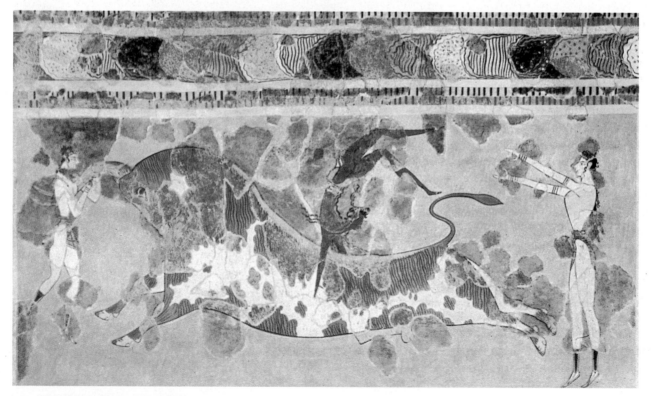

Lion Gate, Mycenae: c. 1250 B.C.
c. 1700 B.C.: Judaism is founded by Abraham
c. 1680 B.C.: Leavened bread is introduced in Egypt
c. 1500 B.C.: Silk is woven by the Chinese
1190 B C.: Troy destroyed
1122 B.C.: Chou dynasty founded in China

During the second millennium B.C., two distinct cultures flourished in the Aegean area. As in many other civilizations, the animal was an important motif, evidenced by the Lion Gate at Mycenae (fig. 59) and the *Bull Leaping* fresco from Knossos (fig. 60). The severe, hieratic treatment of the guardian lions and the fluid movement of the jumping bull are indications of the significant differences between these cultures.

The *Bull Leaping* fresco (fig. 60) depicts a ritual or ceremonial event held in the central court of the Palace at Knossos in which trained athletes would grasp the horns of a charging bull and vault over its back. An undulating rhythm defines the bull's forward motion; the line of the prominent arch of the neck is continued in the bull's elongated, curving body, lending a grace to what must have been a strenuous and dangerous activity. Bright, contrasting colors add to the vitality of the scene.

The ancient Minoan civilization, named in modern times after King Minos from Greek mythology, flourished on the island of Crete. The origins of the Minoan civilization are unclear but an early culture known as Minoan I, which developed from about 2000 to 1700 B.C., was followed by Minoan II, which ended relatively abruptly about 1400 B.C. Natural catastrophes, perhaps volcanic eruptions with related earthquakes and tidal waves, may have caused the end of both Minoan periods; these events may be the historical explanation for the story of the city of Atlantis, which is said to have disappeared beneath the sea. The earliest Minoan artifacts exhibit a preference for abstract curvilinear designs that in the Minoan II culture were joined to representational forms to create dynamic and lively images, as in the *Bull Leaping* fresco.

Minoan civilization was based on agriculture and a wide seafaring trade. The remains of palaces indicate that royal residences were combined with administrative offices, servants' quarters, and ceremonial and storage rooms. At Knossos these rooms are grouped around a central courtyard in a rambling, labyrinth-like design that seems to have developed over time without a predetermined plan, rooms being added as they were needed (see fig. 63). The interior decorations of the palace exhibit the lively, rhythmic qualities common in Minoan art; brightly colored fresco paintings depict scenes of ceremony, ritual, and the animation of animal and marine life (fig. 62).

The only entrance into Mycenae, the walled city that gave its name to the Bronze Age culture of the Mycenaeans, was through the monumental architectural gateway now known as the Lion Gate. Atop the lintel, a

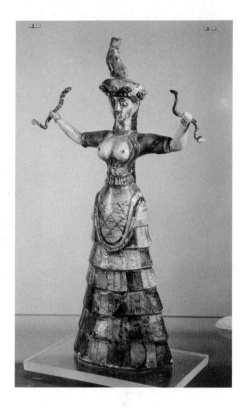

61. Minoan. *Snake Goddess* or *Priestess*. C. 1600 B.C. Faience, height 11 5/8". Museum, Heraklion, Crete. This figure was found during the excavation of the Palace at Knossos. Minoan religion remains mysterious, and it is uncertain whether the small figures of bare-breasted, snake-brandishing women like this one represent a goddess, perhaps the earth mother, or a devotee. The medium, faience, is a type of earthenware decorated with glazes.

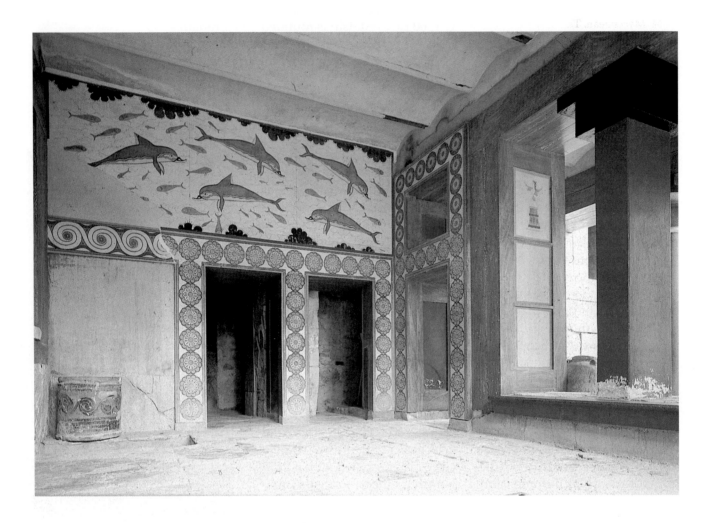

relief sculpture displays two symmetrical bodies of lions flanking a column that rests on altars (fig. 59). The scale of the relief and the stylized yet subtle animation of the lions' bodies proclaim the heraldry of royal power. It was the military force from this culture which, as the ancient Greek poet Homer wrote, "launched a thousand ships" to attack Troy.

Homer's *Iliad*, the epic poem that tells of the war between the and the Trojans and the Hellenes, including the Mycenaeans, was long considered to be a product of human imagination, but its vividness intrigued Heinrich Schliemann, a German business-

man and amateur archaeologist. In 1870 he began to excavate sites in Asia Minor, where he found the archaeological remains of Homer's Troy, and in Greece, where he excavated Mycenae. The investigations spurred by Schliemann's discoveries gave credence to the legends of ancient Greece and brought to light the robust activity of the ancient Aegean area.

The Mycenaeans were the descendants of Greek-speaking tribes who invaded the peninsula of Greece between about 2000 and 1700 B.C. They were active traders, especially with the Minoans, and Mycenaean goods have been excavated in Italy and

62. Minoan. The Queen's Megaron, Palace at Knossos, Crete. Partially reconstructed. c. 1600–1400 B.C.

63. Minoan. Plan, Palace at Knossos. c. 1600–1400 B.C.

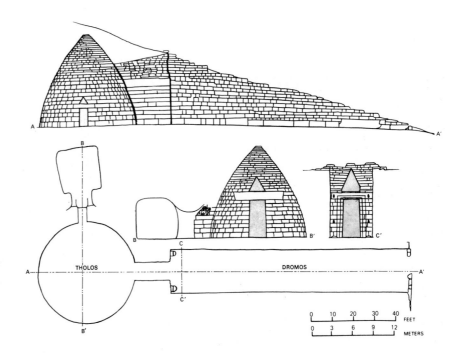

64. Mycenaean. Tholos tomb, popularly known as the "Treasury of Atreus." Plan and sections, Mycenae (after A. W. Lawrence). c. 1400 B.C. Because of their shape, such tombs are known as beehive tombs.

Syria. Mycenae was only one of a number of fortified towns that shared a common culture and language, although each was ruled by an independent monarchy. Mycenaean kings were buried in large tholos tombs accompanied by their personal treasures, including weapons. The tomb shown here (fig. 64), which is approximately forty-five feet in height, is remarkable for its size and the precision of its cut stone blocks.

Two styles are found in Mycenaean art. One was inspired by the vivacity of Minoan art, but a second style, perhaps native to the Mycenaeans, offers a more somber and abstract mode of representation. The gold funeral mask from a royal tomb at Mycenae was once probably placed over the face of a deceased king (fig. 65). While offering some individual characteristics, such as the moustache and beard, the arched eyebrows and abstracted configuration of the ears display a more severe, conceptual approach.

The Mycenaean culture ended when the Dorians entered the peninsula from the north about 1100 B.C. and conquered the Mycenaeans, but their legacy and that of the Minoans as well nourished the evolution of Greek culture.

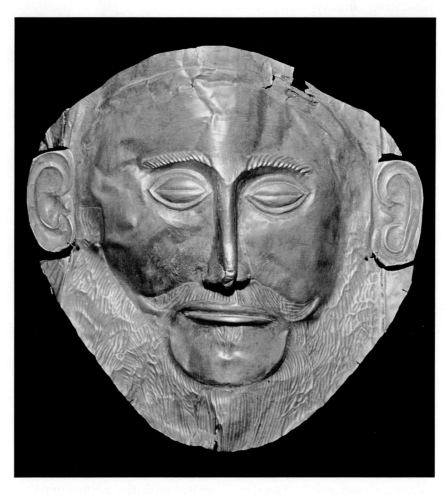

65. Mycenaean. Funerary mask found at Mycenae. c. 1500 B.C. Gold, height approx. 12". National Archaeological Museum, Athens

LATER DEVELOPMENTS IN THE NEAR EAST: ASSYRIAN AND EARLY PERSIAN ART

The *Lamassu* (fig. 66) seems to have been intended to intimidate the visitor—and especially foreign ambassadors—before they entered into the presence of the Assyrian king. The threatening content is supported by the treatment of the material, for the high polish of the stone emphasizes its density, while the patterns and fine detail of the beard and wings stress the massive scale and powerful forms. The figure is given five legs to offer a convincing solidity and physicality from both the front view, on approach, and the side, in passing.

The Assyrians and Persians successively controlled Mesopotamia. The Assyrians established a powerful kingdom in northern Mesopotamia from the ninth through the seventh centuries B.C., while the early or Achaemenid Persians were centered in southern Mesopotamia during the sixth and fifth centuries B.C. Both cultures were known for their powerful kings, who tried to conquer and control vast territories. The Assyrians in particular were feared for their atrocities during war, but the Persians, who for a brief period even conquered Egypt, tried to establish a reputation for benevolent rule and had greater success in creating a huge empire.

Assyrian and early Persian palaces were similarly decorated, with low reliefs lining the palace rooms and passages. In Assyrian palaces the themes were ritualistic, honorific, militaristic, or any subject that would impress the visitor with the unquestionable power and undeniable majesty of the royal personage. The Assyrian palace at Khorsabad covered

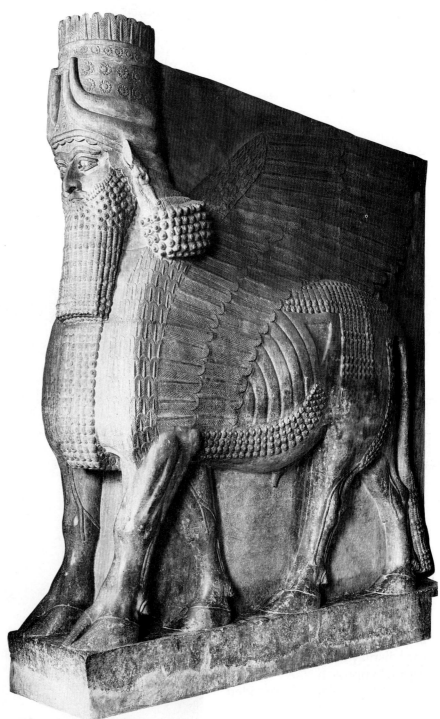

66. Assyrian. *Human-Headed Winged Bull (Lamassu)*, from the gateway, Palace of Sargon II, Dur Sharrukin (Khorsabad, Iraq). c. 720 B.C. Limestone, height 14'. The Louvre, Paris

67. Assyrian. *Dying Lioness,* from the North Palace of Ashurbanipal, Nineveh (Kuyunjik, Iraq). c. 645-635 B.C. Limestone, height of figure approx. 14". British Museum, London

Human-Headed Winged Bull: **c. 720** B.C.
1000–960 B.C.: David rules as king of Israel
776 B.C.: First Olympic Games in Greece

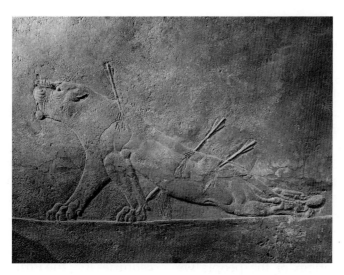

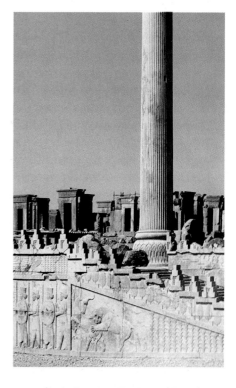

68. Early Persian. Portion of Royal Audience Hall (Apadana) and Stairway of the Palace of Darius, Persepolis, Iran. c. 500 B.C.

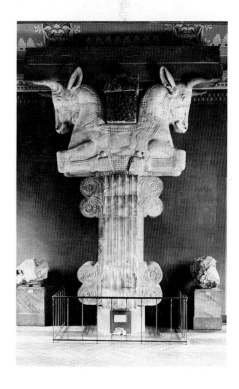

69. Early Persian. Bull Capital from the Apadana, Persepolis. Width 12'3". The Louvre, Paris

more than twenty-five acres and had more than two hundred courtyards and rooms. Here and at Nimrud and Nineveh, continuous low reliefs depicted Assyrian military victories and the subsequent pillage and carnage. The reliefs emphasized the Assyrian king's strength in battle or in sport. In one series he is shown engaged in a hunt in which lions and lionesses were released from cages. The king is represented victorious in his chariot, surrounded by dead and dying animals. In the detail pictured (fig. 67), a lioness is shown in her death throes, dragging her paralyzed legs behind her and uttering a cry or moan of death. The artist's sensitivity to the suffering of the animals is unforgettable.

The Palace of Darius at Persepolis (fig. 68) had grand staircases decorated with reliefs of seemingly endless processions and large scenes in which, following an old Near Eastern tradition, a fierce beast is represented attacking a domesticated animal. Such scenes are open to a number of levels of interpretation. On one level they probably symbolize Persian power and victory, but they may also refer to political and even to cosmic conflict. These stairs led to a sequence of magnificent square throne rooms and ceremonial chambers filled with large columns. The largest was two hundred fifty feet square with columns at least forty feet high. In form the capitals are unusual and uniquely Persian, with gigantic figures of paired bulls (fig. 69). Stylistically, the debt of the Persians to Assyrian art is evident in the contrast between bold simple masses and fine, abstract detail, but the Persian compositions have an increased refinement and elegance.

THE ART OF THE ETRUSCANS

An examination of Etruscan cinerary urns reveals a diversity in details that suggests that some were meant to represent individual portraits. The breasts on this urn (fig. 70) indicate that the deceased was a woman; details would probably have been added with paint. The urn would have had a wig made of the deceased's hair and might have worn pieces of her jewelry.

On the sarcophagus, a couple reclining on a banqueting couch engage us with beguiling smiles (fig. 71). The construction of a terra-cotta group of this scale and complexity is an impressive technical accomplishment, but equally remarkable is the representation of their relaxed positions and their inner delight. That this work's original function was as a sarcophagus suggests the Etruscans' relatively content and reconciled outlook on death. Reclining in this manner is a Greek tradition, but the representation of a man and a woman reclining together is typically Etruscan. It suggests a respect for women unknown in Greece and rare in early cultures.

The origin of the people we know as the Etruscans is debated, but by the eighth century B.C. they had established themselves in a group of cities in Etruria (present-day Tuscany) and were the most important power in Italy. These cities were fiercely independent and often had distinctive burial practices. During the seventh and sixth centuries B.C., Etruscans ruled as kings of Rome, and by the fifth century they controlled most of northern and central Italy. They were active traders, and their works in bronze, especially Etruscan armor, were exported throughout the ancient world. During the fourth and third centuries B.C., the Etruscan cities were defeated and annexed by the Romans, and the Etruscan culture was absorbed into the Roman sphere.

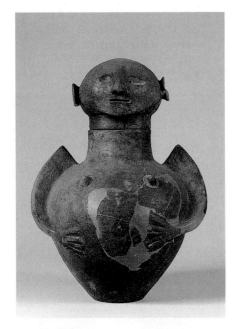

70. Canopic urn, found at Castiglione del Lago, Italy. c. 650–600 B.C. Terra-cotta. Archaeological Museum, Florence. Etruscan burial practices varied widely from city to city. A canopic urn would have contained the ashes of the deceased.

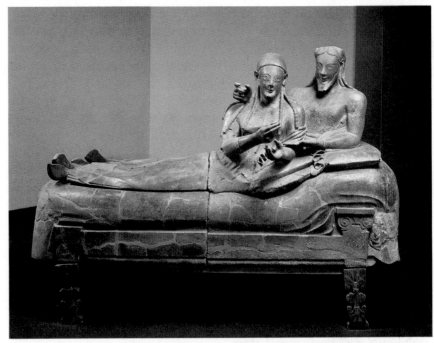

71. Sarcophagus with Reclining Couple. c. 525–500 B.C. Terra-cotta, length 79"; the figures are lifesize. Museo Nazionale di Villa Giulia, Rome. A similar sarcophagus in the Louvre in Paris has traces of color, suggesting that this one may also have been naturalistically painted.

Urn: c. **650–600 B.C.**
625 B.C.: Metal coins are introduced in Greece
597 B.C.: Jerusalem falls to Nebuchadnezzar
c. 590 B.C.: The Greek poet Sappho is writing love poems
565 B.C.: Daoism is founded by the Chinese philosopher Lao-tse

Etruscan inscriptions have been translated, but there is no surviving body of Etruscan literature, and they must be studied primarily from archaeological remains, as is the case with earlier prehistoric civilizations. Like other early Mediterranean cultures, including Egypt, the Etruscans believed that the body or ashes of the deceased should be accompanied with household and other everyday objects to guarantee a satisfying afterlife.

Knowledge of the Etruscans is largely based on their tombs, which are carved in rock or frescoed, and on the tomb furnishings, including gold and bronze objects of superb craftsmanship (fig. 28) and fine imported goods, such as Greek vases from Athens. Needless to say, most of the evidence we have concerns the life-styles of the upper class.

Many Etruscan works were inspired by Greek examples, but their style is generally bolder and simpler, and they had little interest in the symmetry so favored by the Greeks. Much Etruscan iconography emphasizes everyday activities, but there are also frequent references to Greek myths, and it is clear that divination (see fig. 28) was an important Etruscan activity. They made important technical innovations in the use of terra-cotta, especially in such large-scale pieces as the sarcophagus (fig. 71) and in figures and decoration used on architecture. Etruscan artists did not sign their works, and there seems to have been no cult of the artist, as there was in Greece.

Simple, bright colors, bold geometric and natural patterns, and clearly drawn figures combine in Etruscan tomb paintings to create a lively and vigorous effect. Typical Etruscan themes include banqueting figures—referring to the banquets that were part of the Etruscan funeral ritual—the dancers and musicians that provided entertainment, and scenes of pleasurable daily life to be enjoyed by the deceased. In the Tomb of Hunting and Fishing (fig. 72), a plethora of wildlife guarantees success in the hunt, while in the pediment the deceased are shown banqueting.

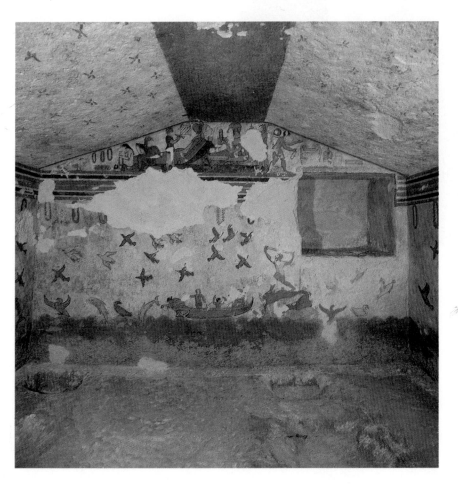

72. Tomb of Hunting and Fishing, Tarquinia, Italy. c. 510–500 B.C. Fresco

Introduction to Greek Art

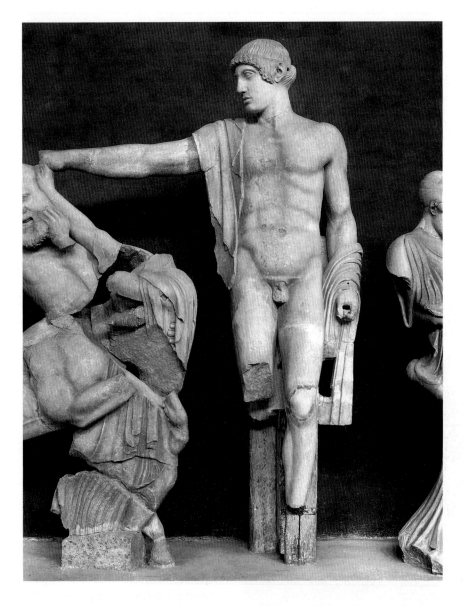

73. Severe style. *Apollo and the Battle of the Lapiths and the Centaurs*, detail from the west pediment, Temple of Zeus at Olympia. 468–460 B.C. Marble, over-lifesize. Museum, Olympia

In the midst of a chaotic combat (fig.73), the god Apollo majestically restores order. He occupies the axis of the composition, just below the apex of the temple roof. Apollo's calm yet commanding presence contrasts with the outburst of the surrounding activity.

The sculptures on the pediment of the Temple of Zeus at Olympia were completed during a period of transition. They originally decorated the triangular end (pediment; see figs. 97, 99) of the gable roof of the temple, approximately fifty feet above ground level. The composition is clear, the movement is bold and direct, and the details of anatomy and drapery are easily read by the viewer below. The sculptures illustrate a mythological subject. Among the guests at a

wedding feast were drunken centaurs (creatures who are half-human, half-horse) who attempted to abduct and rape the women. This theme had an immediate significance for the Greeks at this time. Their recent victory over the Persians (479 B.C.) was symbolically expressed in the victory over the centaurs. On a more profound level, the calm presence of Apollo represents the mastery of reasoned order over brute force. The scene had a special meaning because of its location at Olympia, for during the famous games there, a truce was observed among the Greek city-states. The ideals exemplified by the myth and its representation at Olympia promote attitudes which distinguish the Greeks from their neighbors in the ancient world.

HISTORY

About 1100 B.C., a tribe called the Dorians entered the Greek peninsula from the north. The Dorians overwhelmed the Mycenaeans, who had ruled this area for the preceding five hundred years, and gradually a new culture, historically known as the ancient Greek civilization, evolved. By the eighth century B.C., the two great Homeric poems, *The Iliad* and *The Odyssey*, had been composed, and Greece had evolved into a grouping of independent city-states. Each city-state *(polis)* commanded the loyalty of its citizens, especially in religious, military, and economic matters. Their fierce independence prevented the political unification of Greece. In 776 B.C. the first Olympic Games were held. Called once every four years, they were held in honor of Zeus, ruler of the gods. Winners gained personal fame, and achievement in sports was celebrated in such works of art as the victory vase (fig. 74), whose runners move across the surface with rhythmic energy.

During the eighth century B.C., developing commerce among the city-states led to a prosperous economy. One of the major products was pottery, and the Geometric style *Vase* (fig. 75), with its bands of severe patterns, demonstrates the artistic beginnings of the Greeks. The animals on the neck of the vase and the human figures occupying the central band conform to repeated geometric shapes and rhythms. The highly abstract human shapes represent female mourners pulling their hair at a funeral; the deceased lies on his bier. The scene relates to the purpose of the vase, which marked a grave site. Such vessels played an important role in honoring the dead. Oil, poured into them to commemorate the deceased, would flow through the open bottom and into the ground.

During the Archaic period, from the seventh century to the early fifth century B.C., trade routes expanded, and the Greeks began to colonize areas of southern Italy and Asia Minor. At this time the Greeks began to produce lifesize figurative sculpture and to construct marble temples.

The early fifth century B.C. was a time of significant artistic and political changes. In both sculpture and painting, we witness a more naturalistic rendering of the human figure. In architecture, temples

74. Archaic style. *Panathenaic Amphora with Runners.* c. 520 B.C. Painted terra-cotta, height 24 1/2". The Metropolitan Museum of Art, New York (Rogers Fund, 1914). The Panathenaic amphora was a special, large vessel given as a prize in the Olympic Games. It was filled with oil made from olives grown on special trees.

75. Geometric style. *Vase with Mourners Around a Bier.* c. 750 B.C. Terra-cotta, height 61". National Archaeological Museum, Athens. The decorated pottery vessels of the Greeks are traditionally known as vases. Vases such as this one are sometimes referred to as Dipylon vases because they were found at the Dipylon Cemetery in Athens.

undergo a process of visual refinement, giving the buildings a new sense of elegance.

In 490 B.C. the Persians invaded Greece. The city-states formed a defensive alliance and defeated the invasion force at Marathon, about twenty-six miles northeast of Athens. (After the battle, a courier ran to Athens bringing news of the victory; he fell dead of exhaustion after exclaiming, "Rejoice, we conquer." His run is commemorated in today's marathon races.) Ten years later the Persians captured Athens and sacked the Acropolis, but in 479 B.C. the Greeks defeated the Persians at the naval battle of Salamis. No peace treaty was signed until 449 B.C., and during the thirty years following the second Persian defeat, Athens, which had agreed to supply the navy for the Greek military alliance, continued to collect taxes from the other city-states. During this period Athens became the preeminent political and economic center, but only at the cost of jealousy from the other city-states.

The mid-fifth century B.C. is known as the Classical period of art and culture. Its center was Athens, where a popular politician named Pericles was continuously reelected chief general of the city from 460 to 430 B.C. The Athenian government was the first major democracy in the Western world, although only free men were allowed to vote.

Pericles used the wealth of Athens and the taxes collected from the other city-states to embark on an ambitious campaign of renewal, which included rebuilding the temples on the Acropolis destroyed by the Persians. The Acropolis (from the Greek *akros*, highest, and *polis*, city) is an outcropping of rock which dominates the center of Athens (see fig. 77). To the Greeks it was the sacred location where Poseidon and Athena had contested for control of the city below. Poseidon, god of the sea, caused salt water to flow from a spring on the Acropolis, but Athena's gift of an olive tree was deemed more beneficial to the people. Thus, tradition held, Athens took its name from the Greek goddess of wisdom. As late as the second century A.D., a saltwater spring and an olive tree could still be found on the Acropolis.

Pericles knew the value of providing an intellectual, physically healthy, and aesthetically pleasing environment for the citizens of Athens. Later, when war had broken out in Greece, he offered a funeral oration for Athenian soldiers: "Our constitution is called a democracy because power is not in the hands of a few, but of the people. Our laws secure equal justice for all in their private disputes, and our public opinion welcomes and honors talent in every brace of achievement; what counts is not membership in a particular class, but the actual ability a man possesses.

"Yet ours is no mere work-a-day city. No other provides so much recreation for the spirit—contests and sacrifices all the year round, and beauty in our public buildings to cheer the heart and delight the eye day by day.

"We are lovers of the beautiful without being extravagant, and lovers of wisdom without being soft. We regard wealth as something to be used properly, rather than as something to boast about. . . . We decide and debate, carefully, and in person, all matters of policy, for we do not think there is an incompatibility between words and deeds.

"Our city is an education to Greece."

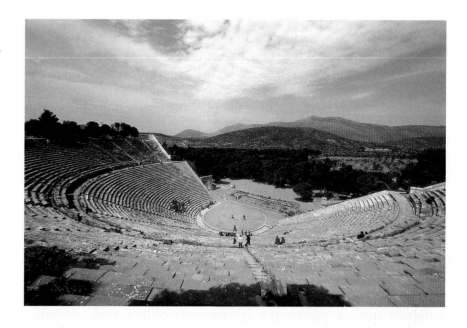

76 Theater, Epidaurus. c. 350 B.C. Diameter of the projected circle, 378'

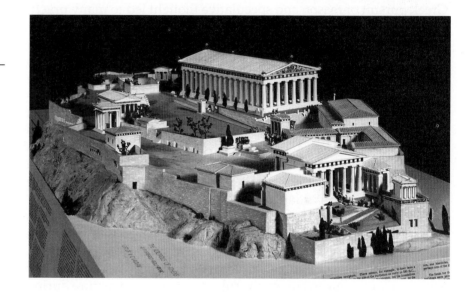

77 Acropolis, Athens. Reconstruction model. Royal Ontario Museum, Toronto, and J. Walter Graham

As the political dominance of Athens grew, so did the resentment of the other city-states. The Peloponnesian wars erupted in 431 B.C., plunging Greece into war. When the war ended in 404 B.C., the power of Athens was broken, and Sparta and Corinth assumed a more prominent role in the political affairs of Greece. By the later fourth century B.C., however, a new force from the north would command attention, and the next chapter of ancient Greek history is written by two Macedonian kings, Philip and Alexander (see pp. 105–7).

A GREEK VIEW OF THE WORLD

Although beset by internal political conflicts, the Greeks, who called themselves Hellenes, shared a common language and culture.

Greeks divided the world into two types of people, those whose native language was Greek and others, who were called *barbaroi* (barbarians). The derogatory association that we have with the term barbarian developed slowly, but as a result of the Persian wars, the Greeks continued to define how their culture was different from that of the barbarians.

INTELLECTUAL AND SCIENTIFIC ACTIVITIES

The love of wisdom of which Pericles spoke found expression in philosophy and science as well as art. From the mid-fifth through the fourth century B.C., philosophy developed from the speculative questioning of Socrates and the ideal forms of Plato to the natural observations by Aristotle. The Hippocratic medical writings, by several different authors, represent a diverse body of literature on healing practices and were the foundation of ancient medical study. The Greek pursuit of reason and speculative thought led to many practical inventions.

At the heart of this world view was the belief that human reason could define the rational order of the universe, an order which was revealed through an understanding of mathematics. In the sixth century B.C., Pythagoras wrote of the relationship between mathematics and musical harmony, noting that a stretched string, when plucked, produces a certain note by its vibration. When the string is measured and plucked at points which correspond to exact divisions by whole numbers—1/2, 1/3, etc.—the vibrations will produce a harmonious chord. If the string is plucked at any other interval, the sound will seem discordant.

To the Greeks, this discovery had a powerful impact. If the sounds of nature were governed by the order of mathematics, then the universe itself must obey the harmony of mathematical concurrences. This notion of a universal harmony that could be perceived by human reason came to govern the rules of art and architecture during the Classical period.

RELIGION

The Greeks worshipped numerous gods and goddesses who ruled over all aspects of life and death. Leader among the gods was Zeus (see fig. 88), who established the rule of the deities by overthrowing his father. Hera, wife of Zeus, was queen of the gods and protectress of women. Along with other deities, Zeus and Hera were believed to reside on Mount Olympus. Although some Egyptian gods had been represented in human form, it was the Greeks who fully anthropomorphized their deities, giving them both human form and attributes. Numerous mythological tales speak of the exploits of gods and goddesses, who often deemed it necessary to alter human affairs.

Sacrifices to the gods were joined with great festivals which might

include athletic games, such as the Olympic Games, and theatrical productions. Greek theater developed from the rituals honoring Dionysus, an important, popular god and patron of drama and song. The Greek playwrights Æschylus, Sophocles, Euripides, and Aristophanes wrote plays to be performed during an annual Athenian festival honoring Dionysus.

Greek theaters were open-air arenas. Theaters such as the one at Epidaurus (fig. 76) have semicircular rows of marble seats built into the hillside. The circular area below was the stage. The Greek theater combined practical function with harmonious design.

GREEK ART

Greek art was distinguished by a dramatic evolution over a relatively short five-hundred-year period. The abstract features of Archaic period sculptures (figs. 81, 82) were transformed into the Severe style (see figs. 73, 83, 88, 89) and then into the idealized representations of the Classical period (figs. 91, 98–100), which sought to equate the perfection of art with the harmonies of the natural order. By the time of Alexander the Great, realistic and emotionally dramatic representations were common (figs. 103, 106, 107). In painting, flat shapes (fig. 75) gave way to elements of illusionism (fig. 105), and in architecture proportions and decorative elements underwent a progressive transformation toward a more refined ideal (figs. 85, 95). The continuous process of revision characteristic of Greek art is one manifestation of the questioning Greek mind.

THE GREEK ARTIST

The Greeks valued both intellectual and physical achievements, and it is not surprising that they would begin to praise the artist as an individual with unique talents. An exceptional development in the seventh century B.C., with virtually no precedent in earlier cultures, occurred when artists began with regularity to sign their works. Such signatures are clearly an indication of personal pride. In addition, they might also be an early form of advertising. Literary sources from both ancient Greece and Rome offer descriptions and criticisms of works of art which were deemed famous. By the fourth century B.C., such references begin to include comments on the personalities of specific artists and anecdotes about their lives. An ancient discussion of Apelles, recorded by Pliny, reveals the respect enjoyed by a successful artist: "Nevertheless the painter who surpassed all those who were born before him and all those who came later was Apelles. . . . He produced volumes, which contain his doctrine. . . . He . . . was also gifted with a courteous nature and . . . was on quite good terms with Alexander the Great."

Greek Vase Painting

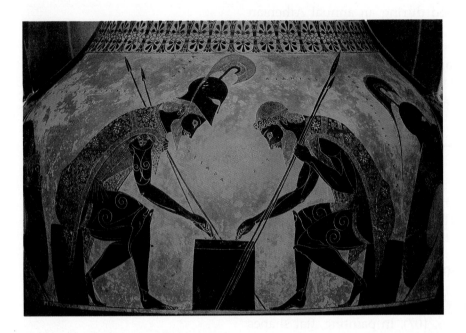

78. EXEKIAS (painter and potter)
Achilles and Ajax Playing Draughts
(detail). c. 530 B.C. Painted terra-
cotta amphora, height 24". Vatican
Museums, Rome. The stories repre-
sented on Archaic vases, which
usually told of Greek mythological
or historical events, were at first
illustrated with black figures on a
red background. Works in this style
are known as black-figure vases.

During the Archaic period, the decorative bands prevalent on earlier Geometric vases (see fig. 75) were relegated to the base and neck, and increased surface area was given to figurative narration. This vase (fig. 78) depicts the Greek warriors Achilles and Ajax playing draughts (an ancient game related to our game of checkers) during a lull in the Trojan War. The signature "Exekias painted me and made me" indicates an artist talented in both pottery and painting. This was rare in ancient Greece, for usually a division of labor was practiced in the production of vases. The composition, with its strong symmetry, and the manner in which scene and decoration are related to the shape of the vase reveal the Greek search for balance and harmony.

The various shapes of Greek vases developed according to both purpose and the Greek interest in aesthetic forms. By the Archaic period, specialized forms had become associated with specific functions as indicated in the diagram of shapes (fig. 79). After the vase was formed but before it was fired, the painter, using slip (a mixture of clay particles in water, sometimes combined with wood ash), painted the black figures in silhouette. Details of the decoration and of the figures' anatomy, drapery, and armor were made by incising lines into the surface before firing. Working with a sharp pointed tool known to modern artists as a burin, the artist engraved lines through the slip, exposing the terra-cotta color beneath. As the vase was being fired in the kiln, the air vents were closed, causing the entire vase to turn black for a period as the red iron oxide of the terra-cotta was converted into black and magnetic iron oxides. When the air vents were again opened, the iron in the clay body returned

to its red-orange color except in those areas covered by slip. In the firing, the slip had formed a glazed surface coating, sealing these areas from the air. They remained black, creating the black figures and decoration on the vase. On Archaic vases the artist delighted in decorative geometric patterns that asserted the two-dimensional quality of the figures.

Around 530 B.C. a new technique which reversed the figure-ground colors was introduced, perhaps by a student of Exekias called the Andokides Painter. Known as the red-figure style, this technique offers figures and objects silhouetted against the painted black background. Details of anatomy and costume are painted on, rather than incised into, the surface of the vase.

The vase with the *Death of Sarpedon*, signed by Euxitheos and Euphronios, was created shortly after the introduction of this new red-figure technique (fig. 80). It depicts the slain body of Sarpedon, a fallen Trojan hero killed by Patroclus, being carried from the battlefield by personifications of Sleep and Death. Hermes, who

will lead Sarpedon's soul to Hades, stands behind (*The Iliad*, XVI, 426 ff.). The figures convey a physical and emotional presence that is new to Greek vase painting. Somber facial expressions betray the tragic loss. We sense the physical strain required to lift the body, while diagonal patterns of limbs and flowing blood pull the composition downward. Details of anatomy and drapery are more naturalistically rendered, and the manner in which some parts of the body are shown as if seen in sharp recession is an early example of foreshortening (see also p. 279). The greater naturalism is made possible by use of the brush, in contrast to the incising tool employed by the black-figure painter.

The level of artistry reached in these vases testifies to a refined understanding of both functional and visual values. The black-figured amphora has two handles for carrying and an opening large enough to admit a ladle. The broad opening of the red-figured calyx krater made possible the mixing of water and wine. In each of our examples the painter has adapted the composition to the form of the vase. The arched backs of Achilles and Ajax echo the inward curvature of the amphora, while the composition on the calyx krater, with the horizontal body of Sarpedon balanced by the vertical pose of the attendants and the parenthetical effect of Sleep and Death, emphasizes the inverted trapezoidal form of the vase. It was this ability to join form, function, and decoration which made Greek vases valued objects throughout the ancient world.

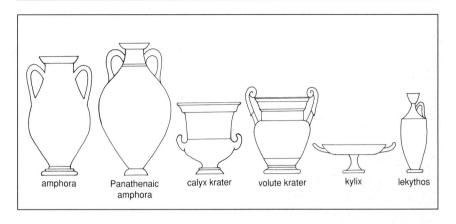

79. Typical Greek vase shapes. The amphora and Panathenaic amphora are containers to store wine, olive oil, honey, or water. The calyx krater and volute krater are bowls for mixing wine with water, which was the Greek custom. The kylix is a drinking cup and the lekythos is a container for olive oil.

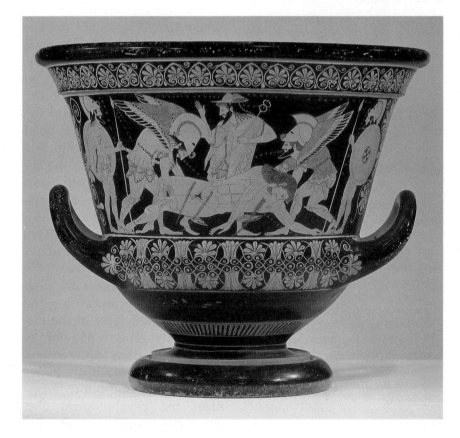

80. EUPHRONIOS (painter) AND EUXITHEOS (potter)
Death of Sarpedon During the Trojan War. c. 515 B.C. Painted terra-cotta calyx krater, height 18". The Metropolitan Museum of Art, New York (Bequest of Joseph H. Durkee, gift of Darius Ogden Mills, and gift of C. Ruxton Love, by exchange, 1972). Red-figure vases feature red figures against a black ground.

SCULPTURE: ARCHAIC STYLE AND SEVERE STYLE

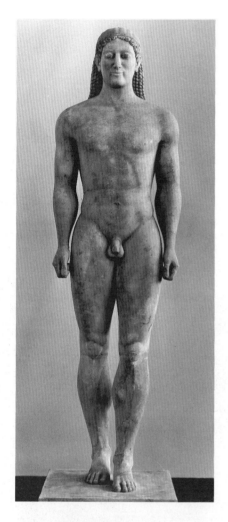

81. Archaic style. *Kouros,* from the Tomb of Kroisos, Anavysos, Greece. c. 520 B.C. Marble with red paint on the hair, headband, and pupils of the eyes, height 72". National Archaeological Museum, Athens. The inscription on the base reads: "Stop and grieve at the tomb of the dead Kroisos, slain by wild Ares in the front rank of battle."

The earliest large-scale Greek sculptures (c. 600 B.C.) are indebted to Egyptian prototypes that were certainly known to the Greeks, who had a trading station in Egypt as early as the mid-seventh century B.C. But by about 520 B.C., when the *Kouros* (youth) from Anavysos was created (fig. 81), the new direction Greek art would take was already evident. The Greek figure represents an athletic ideal and a new understanding of the organic nature of the human body. And, while the Greek figure maintains a stance derived from Egyptian models (see fig. 2), with one leg advanced and hands clenched at the sides, the stone passages, which in Egyptian figures connect the forward to the rear leg and the arms to the torso, have been carved away. The Greek figure is tense and prepared to take action, not frozen for all eternity. In contrast to Egyptian sculptures, most Greek male figures are nude. While Greek athletes competed nude at the games held during religious festivals, the nudity also demonstrates new Greek attitudes concerning the beauty and integrity of the human body. The slight smile, which suggests a confident assurance consistent with the buoyant energy of the body, recognizes the psychological and emotional aspect of human life in a manner foreign to most Egyptian art. Nude male sculptures were set up as votive offerings at shrines and were used as grave monuments. That these youthful figures were sometimes used to mark the tombs of older men suggests that they represented a philosophical and visual ideal, not a specific individual.

The style of Greek sculpture from about 650 to 480 B.C. is usually referred to as Archaic, while figures from the first half of the fifth century B.C., which in retrospect are moving toward the Classical style of the second half of the century, are now usually designated Severe style (or Early Classical style or Transitional style; c. 480–450 B.C.). The contemporary Archaic sculptures of female figures—the *Korai* (maidens)—were used almost exclusively as votive figures, and they are always dressed (fig. 82; the female nude does not become common in Greek art until the fourth century). The gentle swelling of the body beneath the drapery suggests an interest in the organic qualities of the human figure, while rich visual patterns are offered by the subtle and varied textures of pleated drapery and plaited hair. This particular example preserves much of the color which was painted on the marble to enhance both its beauty and the lifelikeness of the sculpted figure.

The *Kouros* known as the *Kritian Boy,* because it is similar to works attributed to Kritios, represents the figure in a position that combines flexed and relaxed muscles (fig. 83). Although his feet are lost, enough of the figure survives to reveal that he was represented in the relaxed and

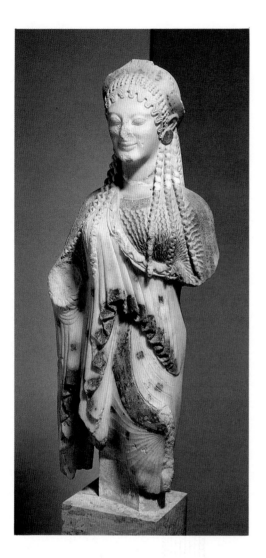

82. Archaic style. *Kore*, from Chios (?). c. 510 B.C. Marble fragment with red, blue, and violet paint, height approx. 22". Acropolis Museum, Athens. Such Archaic sculptures of female figures are much rarer than their male counterparts.

realistic position known since the Renaissance as *contrapposto*. The weight of the body is borne on one leg while the other is relaxed. *Contrapposto* (from the Latin *contrapositio*, counterpositioning) is related to a natural, relaxed stance. It has its basis in real life. *Contrapposto* affects the entire body, for the counterpositioning juxtaposes the forward, relaxed leg to the opposite shoulder, which also moves forward. The resulting figure seems to stand freely. Imaginary lines drawn across the body through knees, pelvis, and shoulders will rotate about the figure's axis. More importantly, *contrapposto* suggests the potential for movement, making possible figures that offer a new momentary quality. In addition, a sculpted figure standing in *contrapposto* becomes freestanding, a sculpture in the round, intended to be seen from many viewpoints. *Contrapposto* creates a unified figure standing in space, banishing the static Egyptian views (frontal, left profile, right profile) that had conditioned Greek sculpture at its origins.

To understand the revolutionary quality of this *Kouros*, we must try to view it as would a Greek of the period. The pose, which must have seemed startlingly new and amazingly naturalistic, is enhanced by a softness and organic unity in the articulation of the muscles. The sculptor appears to have breathed life into the stone itself. Sculpture would never be the same.

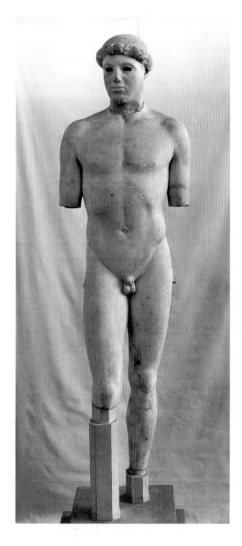

83. Severe style. *Kouros* (also known as the *Kritian Boy*). c. 480 B.C. Marble fragment, originally with inlaid eyes, height 36". Acropolis Museum, Athens

ANCIENT ART: GREEK 89

THE CLASSICAL ORDERS

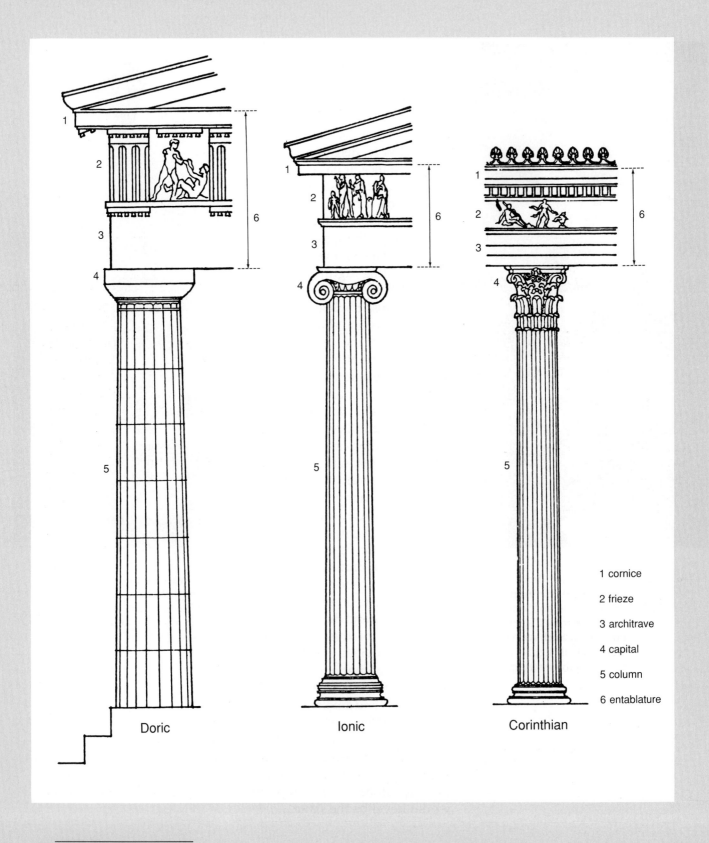

Doric

Ionic

Corinthian

1 cornice

2 frieze

3 architrave

4 capital

5 column

6 entablature

84. Diagram of Doric, Ionic, and Corinthian orders

An order gives aesthetic definition and decoration to the post-and-lintel system (see p. 66). Between the seventh and fifth centuries B.C., the Greeks developed three architectural orders—the Doric, Ionic, and Corinthian—which have been in virtually continuous use up to the present day. The Greeks' invention and development of these orders (fig. 84) reveal their philosophical and analytical approach to architecture. An order establishes the specific architectural elements, which are designed to integrate with each other and with the building as a whole, and dictates the proportional scheme governing the interrelationships of the parts. The elements of an order include the column, with its capital, and the entablature, composed of architrave, frieze, and cornice. A column is often decorated with vertical flutes, which accentuate its cylindrical and vertical quality.

The classical orders, including the later Composite and Tuscan orders, became the most basic design element for architecture. They were used not only as supports, but as decoration on buildings that were not post and lintel in construction (for example, the Roman Colosseum; fig. 135). Half-round decorative columns were often attached to a supporting or enclosing wall. These are known as half or engaged columns. When they are flattened they are called pilasters.

When an order is used, however, it offers more than merely articulation and decoration, for it also carries the cultural significance of its origins in ancient Greece, and it can impart to a building the dignity, harmony, and sense of philosophical reason that is part of our heritage from the Greek world. The orders are generally regular and predictable, and when the harmonious relationships and proportions are ignored, there is a strong sense of violation.

The Doric order, well established by 600 B.C., is vigorous and austere: its fluted columns are strong in appearance and stand directly on the stereobate (stepped platform), without a decorated base. The Doric echinus appears to be a resilient cushion tucked between the column and the square abacus, suggesting in a clear, visual manner the nature and even the idea of support. Together echinus and abacus provide a simple and muscular transition from the vertical column to the horizontal superstructure. The Doric architrave is broad and simple, and the frieze area is decorated with triglyphs which alternate with metopes (originally metopes seem to have been painted panels of terra-cotta; later they were sculpted). The ancient Roman architect Vitruvius argued that the Doric order was originally derived from wooden architecture and that the tapering of the column was based on the use of tree trunks for early columns.

The Ionic order, which was first used in the sixth century, is lighter in proportion and more elegant in detail than the Doric. Columns have richly decorated bases, and the Ionic capital is characterized by a scroll-like motif called a volute. Ionic temples often feature a continuous frieze in place of the triglyphs and metopes. The planar, frontal Ionic volutes created a problem at corners that was solved by the development, during the fifth century, of the Corinthian order, which employs a cylindrical capital decorated with acanthus leaves. The increasing elegance of the Greek orders is revealed by the constantly changing proportions of the column. In the Doric the relationship of height to diameter is usually 4:1 to 6:1 or even 7:1. For Ionic it is 7:1 to 8:1; Corinthian can be 8:1 to 9:1.

The Composite order combines the Corinthian with some Ionic features, including very small volutes, while the Tuscan order is a variant of Doric developed by the Etruscans and popularized by the Romans. The latter is unusual in its preference for a smooth column, without fluting.

DORIC ARCHITECTURE: THE SECOND TEMPLE OF HERA AT PAESTUM

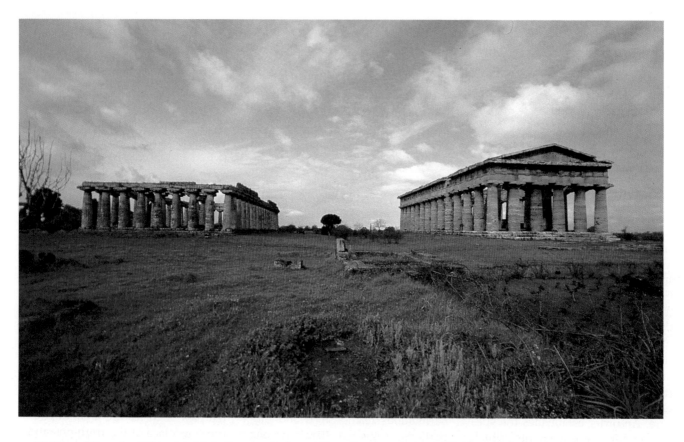

85. Second Temple of Hera (at right), Paestum, Italy. c. 460 B.C. Southern Italy and Sicily were first colonized by the Greeks in the seventh century B.C. The temples constructed in these colonies during the sixth and fifth centuries B.C. are among the best preserved examples of Greek architecture. The temple at the left is the Temple of Athena. c. 530–520 B.C.

A Doric temple (see figs. 85, 86) is an imposing structure, an autonomous object complete within itself. The architectural forms are vigorous and assertive. The vertical fluting of the columns, reinforced by the triglyphs in the frieze above, produces an upward thrust which is held in balance by the horizontal articulation of the entablature and gable roof. The visual forces are in equilibrium (see fig. 87), yet the temple is not static. Its massive forms communicate an almost muscular vitality.

The walled inner sanctuary, or *naos* (from the Greek, to dwell), would have contained the cult statue (see fig. 96). On the exterior, the perimeter of the temple is surrounded by a colonnade, or continuous row of columns, called a peristyle (from *peri*, around, and *style*, column); such temples are termed peripteral. Only priests or priestesses and attendants were allowed inside the temple, and most rituals occurred outside, at an altar in front of the temple.

A post-and-lintel system forms the peristyle, while walls enclose the *naos*. Columns support the entablature and roof. The pediments at either end of the gable roof are in some temples filled with sculpted figures. The roof was made of wooden rafters covered with terra-cotta tiles.

The earliest Greek temples were small shrines containing a cult statue. During the eighth and early seventh centuries B.C., large wooden temples with peristyles were built. By the later seventh century B.C., stone construction began to replace wood,

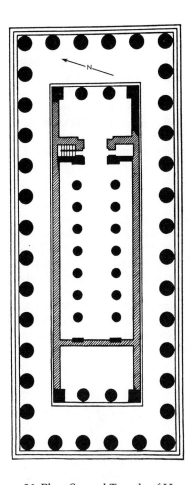

86. Plan, Second Temple of Hera

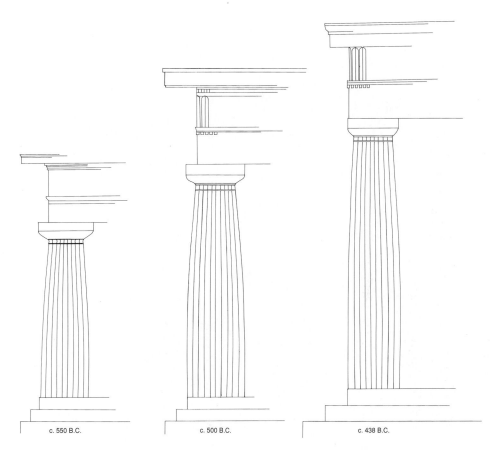

c. 550 B.C. c. 500 B.C. c. 438 B.C.

87. Diagram of the evolution of Doric proportions to scale. The changing scale and proportions of the Doric order, seen here in the evolution of the proportion of and relationship among column, capital, and entablature, reflect the search for an aesthetic harmony that was integral to Greek art.

partially as a practical response to the problem of supporting the heavy terra-cotta roof tiles. Stone construction, which coincides with the advent of monumental stone sculpture, reflects a confident new spirit of permanence and achievement.

Once the design for a temple was approved, stonecutters began to cut marble at the quarries. The blocks of stone, formed to specifications to reduce transportation weight, were moved to the construction site in specially designed carts pulled by teams

of animals. After the temple's foundation had been built to the stylobate, the peristyle was set up. Columns were constructed of unfluted cylindrical units called drums held in place by wooden centering pins. The drums for the columns and the blocks of stone for the walls of the *naos* were lifted into place with pulleys and cranes. No mortar was used to hold the stones in place. The blocks of the *naos* walls were secured by iron clamps encased in lead to prevent rusting. The roof was con-

structed of wooden beams and rafters. A beam supported the apex of the gable roof, while additional support for the roof was provided by columns inside the *naos*. Finally, as the temple neared completion, the columns were fluted. The fluting disguised the joints of the drums and, by creating patterns of shadows, reinforced the three-dimensionality of the columns.

GREEK BRONZE SCULPTURE: SEVERE STYLE

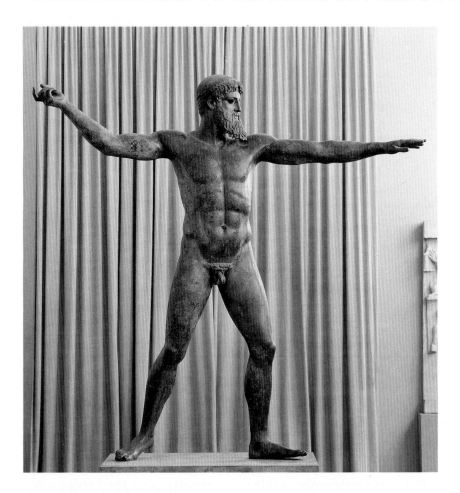

88. *Zeus.* c. 460 B.C. Bronze with inlaid eyebrows, lips, and nipples, height 82". National Archaeological Museum, Athens. Lost in an ancient shipwreck at about the time of Christ, this sculpture was found in the sea near Cape Artemision in 1926–28. It is sometimes identified as representing Poseidon, god of the sea. The eyes were originally inlaid.

89. *Charioteer*, from a votive quadriga dedicated in the Sanctuary of Apollo at Delphi. c. 477 B.C. Bronze with inlaid stone and glass eyes, height 71". Museum, Delphi. This figure and its quadriga were buried after they were damaged, perhaps in an earthquake. Of the horses and chariot only fragments survive.

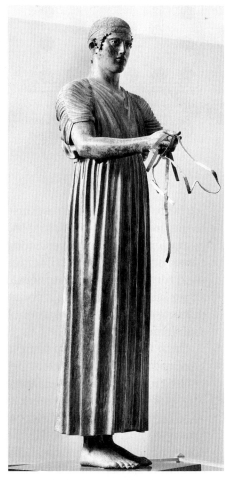

This larger-than-lifesize figure of Zeus originally held a lightning bolt, the god's symbol, in his right hand (fig. 88). His energetic movement is communicated by the tensed muscles of torso and abdomen, the distended veins, the buoyant position of the feet, and by the arms, which are outstretched for balance and to focus on the victim. The left foot is supported only on the heel and outside edge, the right touches only with the ball and toes. Three prongs in the soles held the figure in position on its base. His pose expresses the perfect physical development of the god and his complete physical control, while his severe facial expression complements the aggressive action.

Such a position would be impossible in marble, for marble's lack of tensile strength would not allow the outstretched arms, while the pose of feet and legs would not support the weight of the upper body. Because of its greater possibilities for both naturalistic effects and convincing movement, bronze was the favored sculptural medium of the Greeks after the Archaic period. But few ancient Greek bronzes have survived, since they can so easily be melted down and the bronze reused for weapons or other purposes. In this figure the color of the bronze

suggests a naturally suntanned, oiled body (the Greeks oiled their bodies when exercising), and the inlaid eyes and teeth, fringed sheet bronze eyelashes, and inlaid colored nipples reinforce the naturalistic impact.

The *Charioteer* (fig. 89) was originally part of a large votive monument that included a chariot and four horses (a quadriga). The patron was a tyrant from Sicily who commissioned the work as an offering to Apollo

and a commemoration of the victory of his team and charioteer in the Delphic Games. The subtle and delicate pose evolves from a slight twist of the upper part of the body. The figure wears the appropriate racing garment, and the artist has delighted in representing the patterns of a delicate material caught and

pleated by a belt and ribbons or straps. The head represents the ideal Greek type, with a strong nose which continues the line of the forehead, large eyes and ears, full jawline, broad cheeks, and prominent lips. The expression is alert and self-confident, with a hint of the pride appropriate to a winner.

LOST-WAX BRONZE CASTING

The earliest-known bronze monumental sculptures in Greece date from the late sixth century b.c., but these were preceded by the casting of bronze body armor, which may have suggested and supported the development of bronze sculpture. Ancient Greek bronzes are hollow-cast of an alloy of copper and tin by what is known as the lost-wax method (fig. 90). A sculptor begins by forming a mass of clay (or some other malleable material) into the rough shape of the planned sculpture, but slightly smaller. This is covered with a layer of wax of the thickness desired for the finished bronze and approximating the surface finish of the planned sculpture. This wax coating is then encased in another layer of clay. When it has dried, the wax is melted away, leaving a hollow mold between core and exterior (supports hold the two in place). Molten bronze is poured into the mold. After it cools and hardens, the mold is broken or cut away, leaving bronze which has assumed the form first created in wax.

It is difficult to cast large figures in bronze, for the bronze can cool before it has reached the full extent of the mold. The ancient Greek bronzes discussed here were cast in several sections. The *Charioteer* is composed of seven pieces and, as is common, pieces of different textures were cast individually. The *Charioteer's* right arm, for example, was cast separately and is fitted into the opening left in the sleeve when the drapery was cast. Actual cloth, impregnated with wax, may have been used to help form the draped patterns of the costume, and it has also been suggested that the ancient Greek sculptors may have created body parts using molds made from living human figures.

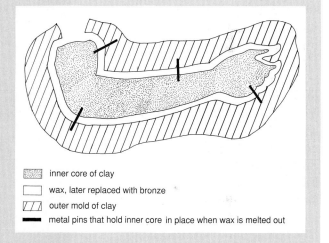

▨	inner core of clay
☐	wax, later replaced with bronze
▧	outer mold of clay
▬	metal pins that hold inner core in place when wax is melted out

90. Lost-wax bronze casting. Conjectural reconstruction of technique for right arm of fig. 89.

After casting, the bronze would be tooled and polished (worked with tools and an abrasive) to achieve the finished surface. Lips, nipples, and eyebrows were sometimes highlighted and given a realistic reddish cast by being overlaid with copper or with bronze of a high copper content. Fringed sheet bronze eyelashes, inlaid stone and glass eyes, and teeth of silver, marble, or ivory were applied after the polishing of the bronze was complete. These additional colors and materials enhanced the beauty of the work, impressed the observer with the skill of the artists, and, most importantly, played a vital role in achieving the verisimilitude desired by the Greeks. They made these beautiful and ideal figures seem even more real.

CLASSICAL STYLE SCULPTURE: THE *DORYPHOROS* BY POLYKLEITOS

"Beauty . . . arises . . . in the commensurability [proportion] of the parts, such as that of finger to finger, and all of the forearm to the upper arm, and . . . of everything to everything else, just as it is written in the *Canon* of Polykleitos. For having taught us in that book all the proportions of the body, Polykleitos supported his treatise with a work; he made a statue according to the tenets of his treatise, and called the statue, like his book, the *Canon*" (Galen, a Greek physician, writing in the second century A.D. on Greek aesthetic theory).

The firm muscular structure of the *Doryphoros* (spear carrier; originally the figure carried a spear in his left hand) is enlivened by the *contrapposto* stance (fig. 91). The specific subject of this sculpture, which probably depicts an ideal Olympic athlete, was less important than the fact that it demonstrated a system of perfect proportions. Polykleitos' text, called the *Canon* (from the Greek *kanon*, rule), established a set of ideal proportions for the human figure, and the *Doryphoros*, created to illustrate the measurements revealed in the text, is sometimes also called the *Canon* of Polykleitos. The written text is lost, but numerous copies of the statue verify its significance in the classical world.

The *Doryphoros* was considered to be an ideal figure because its proportions adhered to common fractions (exact divisions by whole numbers) of the figure's height. Since both Polykleitos'

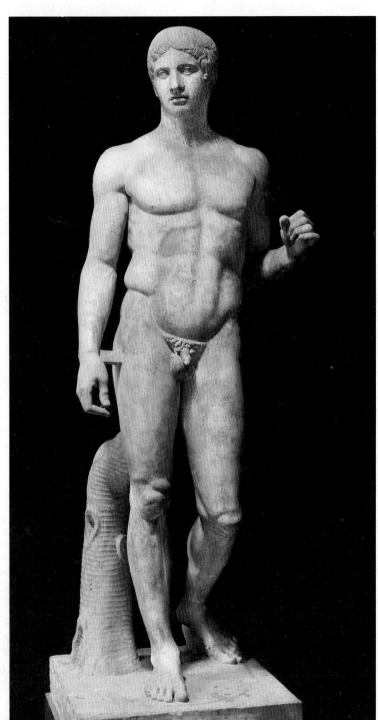

91. POLYKLEITOS (sculptor)
Doryphoros. Roman copy after a bronze original of c. 450 B.C. Marble, height 84". National Museum, Naples. This copy is generally considered to be the best version of Polykleitos' lost figure, but the spear that it once carried is missing, and the bronze original would not have had the tree trunk supporting the right leg and the marble bar supporting the right arm.

original figure and text are lost, the precise measurements of his canon remain undetermined, but the later Roman writer Vitruvius advocated a rule whereby the head (from the crown of the hair to the chin) was one-eighth of the total height, the width of the shoulders one-quarter the height, and so on, until every anatomical feature and the proportions among them are woven into a system of mathematical measurements.

A century before the *Doryphoros* was created, Pythagoras had presented mathematical proportion as the basis of musical harmony. Polykleitos' proportional system was more than a set of abstract principles, for it is related to the Greek belief in the agreement between natural and mathematical harmony, a belief that brought a new vitality to the human figure in sculpture and to the visual arts in general.

Vitruvius reported that the proportions which governed the human figure in art also determined the proportions of Greek temples: "Further, it was from the members of the body that [the Greeks] derived the fundamental ideas of measures." Vitruvius defines proportion in a manner similar to our understanding of the Polykleitian

POLYKLEITOS, *Doryphoros*: c. 450 B.C.
449 B.C.: Herodotus, *History*

Canon as "a correspondence among the measure of an entire work, and of the whole to a certain part selected as a standard." Just as the Greeks gave human characteristics to their gods, they also humanized their architecture. The relative proportions, the capital as the head of the column, and the slight muscular swelling of a Doric column (*entasis*, see p. 99), all contribute to an empathetic understanding between us and the temple. This empathy was an extension of the Greeks' rational definition of their world.

THE GOLDEN SECTION

The proportion which governs the design of the Parthenon and may also have been the basis of the Polykleitian *Canon* is 5:8, a relationship adapted by Greek artists in the fifth century as the key to visual harmony. This ratio was used to govern the relationship among the parts of a design and of each part to the whole. To the Greeks, this was known as "the division of a line in extreme and mean proportions." Since the early nineteenth century it has been called the golden section (fig. 92).

The rule of the golden section is that the size of the smaller part relates to the greater part as the greater part relates to the whole. This is stated by the algebraic equation E:F = F:A. In the diagram, the ratio of the short side of the rectangle (D) to the long side (A) is the same as the ratio of the long side (A) to the sum of the long and short sides (D+A). It follows that the proportions among the parts determine the proportions of the whole, and the resulting golden rectangle is more visually pleasing than a square or a rectangle in which the proportions of the short to the long side are 1:2. The golden section is related to certain patterns and proportional changes observable in nature, especially in botanical specimens and in such seashells as the chambered nautilus. The actual golden number is irrational, an unending decimal, but artists use 0.625 or 5:8 as a working ratio.

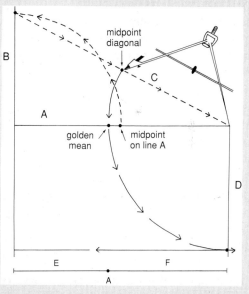

92. Diagram of the golden section and rectangle. Constructing the golden section and rectangle. The given measurement is the length of line A. Draw lines B and D perpendicular to the ends of line A. Find the midpoint on line A and with compass extend to line B. At point of intersection on line B extend a diagonal to the opposite end of line A. Find the midpoint of the newly constructed diagonal. With compass at midpoint on diagonal, extend through line A to line D. From the point of intersection extend perpendicular line back to line B. The rectangle formed is the golden rectangle.

DORIC ARCHITECTURE: THE PARTHENON, ATHENS

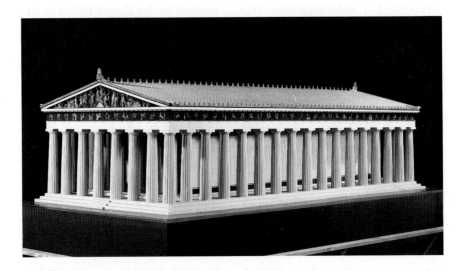

93. KALLIKRATES AND IKTINOS (architects)
Parthenon, Athens. Reconstruction model. 447–438 B.C.; sculpture completed by 432 B.C. Pentelic marble, 111 x 237' at base. The Metropolitan Museum of Art, New York (Levi Hale Willard Bequest, 1890). The temple to Athena, goddess of wisdom and fierce protectress of Athens, was built after the Persian wars, when Athens was controlled by Pericles, who insisted that the Athenians rebuild the temples after the Persians had destroyed the earlier ones. The name Parthenon means maiden, and the temple was dedicated to Athena, the maiden (parthenon was the name given to the room in a home where unmarried, virginal daughters lived). The Parthenon was the preeminent religious structure in Athens and later served as a Christian church dedicated to Mary and in the later Middle Ages as a cathedral church. After the conquest of Athens by the Turks, it served as a mosque. It was severely damaged in 1687, during a war between the Venetians and the Turks.

In the history of human accomplishment, the Parthenon on the Acropolis in Athens stands as one of the most famous monuments (figs. 93–100). Its significance is not due to its basic form, which continues the Doric temple type developed more than a century earlier (see p. 92). Rather, it is the exquisite harmony and grace of its proportions that make the Parthenon great. Its fame derives from its beauty.

The Parthenon functioned as a home for the goddess, and in its grandeur was a monument to the wealth, power, taste, and piety of Athens. The interior includes two chambers, a smaller one where the goddess's and city's treasure was stored, and the *naos*, where the colossal ivory and gold cult statue of Athena in military dress was enshrined (see fig. 96). Although all could look in from the door, only a few were allowed to enter these chambers. The rituals in honor of Athena were held outside, at a sacrificial altar to which the Parthenon was the backdrop.

The grace and beauty of the Parthenon are the culmination of

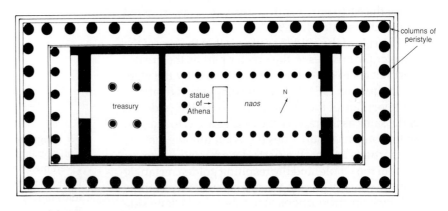

94. Plan, Parthenon

a long development within the Greek search for the ideal temple. The simple dynamics of the post-and-lintel system were a vehicle which encouraged Greek architects to examine and achieve the most satisfying equipose. Compared to the Second

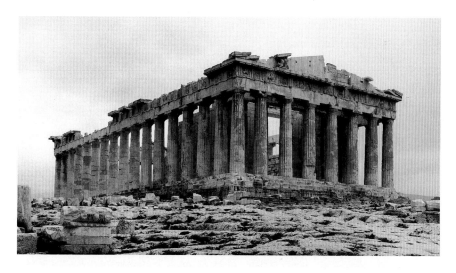

95. Exterior of Parthenon today

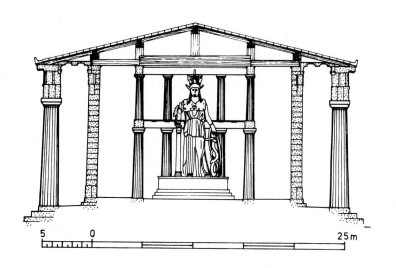

5 0 25 m

96. Section of the *naos,* Parthenon, with the ivory and gold statue of Athena by Phidias. The forty-foot statue was supported by a ship's mast; the flesh was composed of carved pieces of ivory, the dress and armor were of sheets of gold. The section shows the gable roof construction and the superimposed columns of the *naos.*

Temple of Hera at Paestum (fig. 85), the Parthenon offers a new grace and elegance.

There are a number of remarkable visual refinements in the Parthenon. All the horizontal lines—steps, stylobate, stereobate, entablature—are raised slightly in the middle, ostensibly to correct the sag that the human eye imparts to a long horizontal (such a procedure also has a practical application, for it helps the rain to run off). Like the other optical refinements of the Parthenon, the lifting of the middle of the horizontals gives the building elasticity and a sense of life. Such adjustments made the structure more difficult to engineer and construct, for each block of marble would have to be cut to fit its exact place. Other refinements include the tilting inward of the columns to enhance the effect of stability and compactness, and the placement of the three corner columns closer together to compensate for the dissolving effect of light at the corners. The entire stylobate is tilted upward at the southwest corner to make the building more impressive both from the city below and from the entrance to the Acropolis. Perhaps the single most revealing refinement is the *entasis* of the columns, which do not taper in a straight line but bulge outward about one-third of the way up from the base. This creates an effect of muscular elasticity which assists in giving the Parthenon a human, organic quality. Later copies and variations often seem rigid and cold because they lack these refinements. The Parthenon is a monument that reveals the analytical quality of the human mind and the human search for the harmonious, the ideal, and the beautiful.

CLASSICAL STYLE SCULPTURE: THE SCULPTURE OF THE PARTHENON

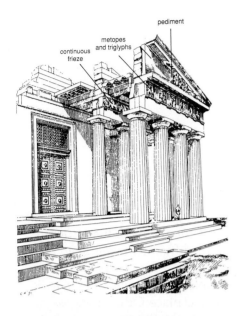

97. Diagram of the Parthenon sculpture in situ. The sculpture is attributed to Phidias and his workshop.

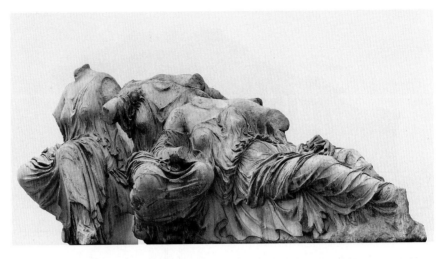

98. PHIDIAS AND WORKSHOP
Three Goddesses on Mount Olympus, from the east pediment of the Parthenon, Athens. c. 438–432 B.C. Marble, height of center figure 60"; the figures are slightly over-lifesize. British Museum, London. These three figures have been identified as Hestia, Diove, and Aphrodite. The Parthenon pediments were over ninety feet long and at the center they rose to a height of over eleven feet. The platform on which the figures were placed was about three feet deep.

The Parthenon's architectural beauty and richness were enhanced by the sculpture that was integrated into the Doric design (see fig. 97). The pediments at both ends were filled with over-lifesize figures; there were ninety-two metopes sculpted in high relief; and a continuous low-relief frieze 550 feet long encircled the outside of the *naos* wall. Like the edifice they adorn, these sculptures display complete mastery of form and technique. That they were all completed in about twelve years reveals that there must have been a large workshop of sculptors and assistants, but a general consistency of design suggests that a single sculptor was in charge, most probably Phidias, who also designed the ivory and gold statue of Athena that stood in the *naos* (fig. 96). The consistency of the sculptural conception suggests that Phidias provided drawings—perhaps on the stone itself—to guide the sculptors.

The iconographic themes are related to the dedication of the Parthenon to Athena, to the victories of the Greek over their barbarians, and to Athens's political leadership among the city-states in Greece. The east pediment presented *The Birth of Athena* (fig. 99), the west *The Contest Between Athena and Poseidon.* The metopes featured a series of battle scenes, including a battle of centaurs with men. The continuous frieze represented the procession of the Great Panathenaea, a special celebration that was held every four years, with musicians, elders, horsemen, chariots, and sacrificial cattle and sheep. It culminates in the votive offering, in the presence of the gods and goddesses on Mount Olympus, of a new robe for a venerated olivewood statue of Athena kept on the Acropolis. Such offerings were undertaken to please the goddess, so that she would favor and protect her city.

On the east pediment the dramatic birth of Athena—who sprang full grown, wearing armor, from the head of her father Zeus—is conveyed by figures who move outward from the central episode. There is a coherent unity of time and place similar to that which developed in contemporary Greek drama. The magnificent group of seated and reclining goddesses, for example (fig. 98), turn as they become aware of the birth. To

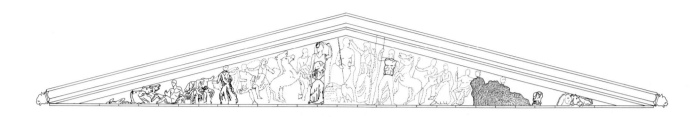

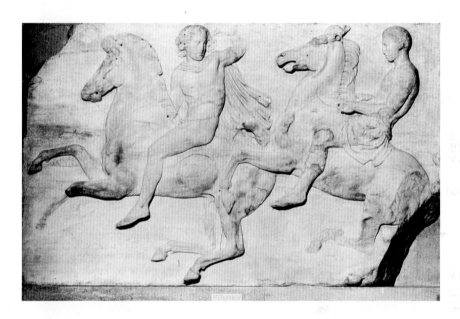

99. PHIDIAS AND WORKSHOP
East pediment of the Parthenon. Reconstruction showing *The Birth of Athena* by Phidias and his workshop. The darkened figures show the original location of the *Three Goddesses* (fig. 98). The dark lines indicate surviving fragments, the light lines are conjectural figures.

compose within the sloping pedimental shape was a challenge for the Greek artist, but these goddesses fit within the pediment; shown in graceful, natural poses, and beautifully unified as a group, they do not seem forced into the increasingly constricted space of the pediment. The voluptuous bodies are clothed in clinging drapery that is gathered and folded into patterns which emphasize the sculptural presence of the figures. The clarity of the poses is remarkable, as is the graceful and flowing role they play within the triangular composition. Filling the outermost corners of the pediment are, on the left, the sun-god's rising chariot to signify dawn and, on the right, the horses of the moon's chariot. These forms are cut off by the pediment to suggest that the realm of the gods continues beyond the restricted space of the pediment.

The Parthenon frieze is a tour de force of low-relief carving

100. PHIDIAS AND WORKSHOP
Horsemen, from the frieze of the Parthenon. Marble low relief, height approx. 43". British Museum, London

which offers the illusion of as many as six figures and horses overlapping within a relief that is no more than three inches deep (see fig. 100). The relief is carved more deeply near the top as a concession to the placement of the frieze. By thus giving the work greater readability, the Greek sculptor makes it clear that this frieze is for the enjoyment and enlightenment of the human spectator and is not merely a decoration added to the temple in honor of the goddess.

All the Parthenon's sculptures had additions made of metal, some perhaps gilded, to represent armor, straps, and other refinements, and many of the details of the figures were heightened by paint, although there is still controversy over the actual colors used. A bright blue has been proposed as the background for the pedimental figures, a red background for metopes and frieze. Color would have enhanced the beauty of the marble figures and clarified the compositions. The hair of the figures may have been gilded; the drapery hems were probably decorated with textile patterns.

SCULPTURE AND PAINTING OF THE FOURTH CENTURY B.C.

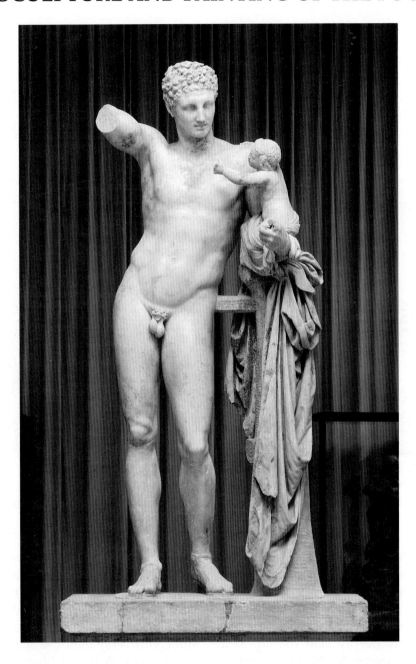

101. Copy after **PRAXITELES** *Hermes with the Child Dionysus.* 1st-century B.C. copy after 4th-century B.C. original. Marble, height 80". Museum, Olympia. The lower left leg and foot of the figure have been restored.

after Praxiteles, who was one of the dominant artists of the fourth century B.C., indicates a continued evolution toward naturalism and a new, refined elegance of the figure.

Praxiteles also sculpted a statue of Aphrodite (fig. 102), the goddess of love and beauty, for a temple of Venus at Knidos. This is one of the first lifesize figures in Greek art to depict the female nude. Her nudity is explained by the vase and drapery under her left hand: she is represented entering or leaving her bath. Lucian, a Greek rhetorician who saw the statue, observed: "So strongly has the artist's art prevailed, that the recalcitrant and solid nature of the stone has been transformed in each limb." The temple on Knidos had a back door specifically for those who wished to view the sculpture from behind, and Lucian reports, "[As we viewed the figure from behind], unforeseen amazement at the goddess' beauty seized us." The *Aphrodite*, like the *Hermes*, is freestanding and composed as sculpture in the round (see p. 24). The diagonal movement of the right arm and hand and the slightly lifted left leg create an impelling motion across and, by implication, around the body. Unlike

Hermes with the Child Dionysus (fig. 101) depicts Hermes, messenger of the gods, holding the infant Dionysus, a god and patron of drama and song. The child reaches forward, probably to grasp a bunch of grapes that Hermes held in his right hand. The articulation of muscles contrasts with that of the *Doryphoros* (fig. 91). While the *Doryphoros'* muscles are clearly marked and distinguished, those of Hermes have a softer, more natural appearance. The stance of *Hermes* reinforces this new organic unity, and the axis of the figure follows a shallow *S*-curve which adds to the sense of relaxation. What we can determine from this copy

PRAXITELES, *Hermes:* **copy after original of 4th century** B.C.
399 B.C.: Socrates is condemned to death
331 B.C.: Alexander defeats Darius
323 B.C.: Death of Alexander

102. Copy after **PRAXITELES**
Aphrodite of Knidos. Roman copy
after 4th-century B.C. original.
Marble, height 80". Vatican
Museums, Rome

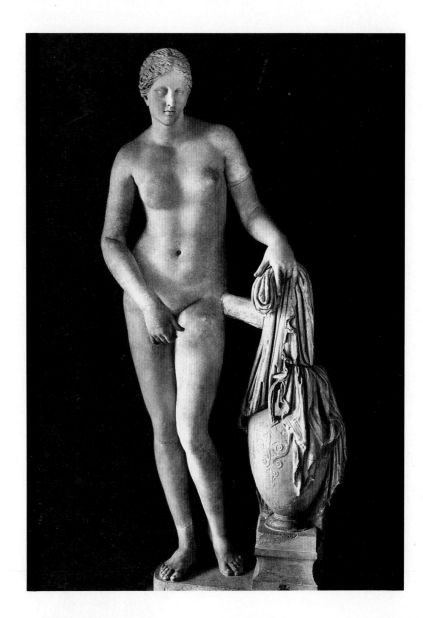

earlier Greek sculpture, which primarily has a frontal orientation, these works invite us to observe them from different viewpoints.

We know from literary sources that the sense of drama and spatial involvement which characterized fourth-century sculpture was paralleled by advances in painting, but unfortunately no certain examples of fourth-century painting survive. Ancient literary sources offer an account of accomplishments in perspective and illusionism which astonished viewers. One ancient author reports, for example, on a contest between two artists: "[Parrhasios] entered a contest with Zeuxis, and when the latter depicted some grapes with such success that birds flew up to the [painting], Parrhasios then depicted a linen curtain with such verisimilitude that Zeuxis, puffed up with pride by the verdict of the birds, eventually requested that the curtain be removed and Parrhasios' picture shown . . . when Zeuxis understood his error, [he] conceded defeat with sincere modesty, because he himself had only deceived birds, but Parrhasios had deceived him, an artist. It is said that afterward Zeuxis painted a picture of a boy carrying grapes, and when the birds flew up to them, he approached the work and, in irritation with it, said, 'I have painted the grapes better than the boy, for if I had rendered him perfectly, the birds would have been afraid'" (Pliny, *Natural History,* XXV).

The ability of painters to render the naturalism of appearance paralleled the subtle anatomical features, spontaneous attitudes, and increased spatial involvement of contemporary sculpture. These trends would develop as the influence of Greek culture spread throughout the eastern Mediterranean region.

Introduction to Hellenistic Art

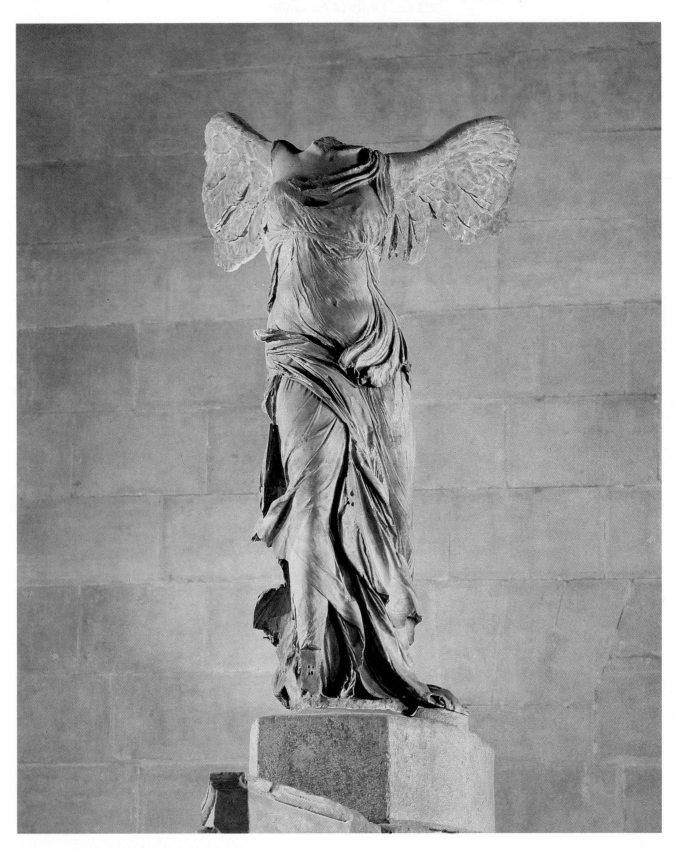

Despite the loss of head and arms, the *Winged Victory of Samothrace* expresses heroic triumph (fig. 103). The diagonal forward thrust of the body creates a dynamic effect of forward movement. The posture is strengthened by the complex and subtle patterns of drapery which envelop the figure and the contrasting position of the unfurled wings. Effects of wind are felt as the drapery both presses against the body's surface and unfurls in vigorous forms which billow into space, echoing the movement of the wings. The dramatic spatial involvement and dynamic movement displayed by the *Winged Victory* are typical of Hellenistic art.

HISTORY

In the late fourth century B.C., while the Greek city-states maintained a tenuous political stability, the hereditary kings of Macedonia, a kingdom to the north of Greece, strengthened their political power. Philip II, king of Macedonia, proposed a plan for the unification of Greece under his rule. In 338 B.C., while the Greeks debated his proposal, Philip defeated them. Philip's union of Greece with Macedonia was the initial step in a grand design to establish an empire which would include Persia. After Philip II was killed by an assassin in 336 B.C., his son Alexander, nineteen years old, ascended the throne. Following the vision of his father, he led a military campaign against Persia, defeating King Darius in 331 B.C. (see figs. 105, 368). Later conquests extended the boundaries of his vast empire south through Egypt and east to the borders of India before the still youthful Alexander died in 323 B.C.

Alexander had been educated by Greek standards, and his tutor was Aristotle, the great philosopher and natural scientist. The young conqueror envisioned a unity between the Greeks and the Persians based on the cultural values of Hellenism. After his death, Alexander's dream of unity was fractured by the reality of political conflict among his own generals. Soon his empire was divided into smaller independent powers. Common to these diverse regions, however, was the unifying influence of Greek culture.

Alexandria, founded by Alexander in Egypt in 332 B.C., became a famous center of learning. The great library there may have contained as many as five hundred thousand volumes; its holdings represented the accumulated wealth of knowledge of the ancient world. The library was part of a complex known as the museum (from the Greek *mouseios*, of the muses, referring to the ancient Greek goddesses of art and music). The major centers of art production, which were founded outside the Greek mainland, included Alexandria, the island of Rhodes, and Pergamon in Asia Minor (see p. 108).

103. *Winged Victory of Samothrace.* c. 180–160 B.C. Marble, height 96". The Louvre, Paris. This figure celebrates a naval victory, perhaps a victory of Rhodes at Side in 190 B.C. At Samothrace the statue was erected on a darker gray marble base in the form of the prow of a ship and, to give the effect of a ship coming into harbor, statue and base were set in two pools, one with a rippled marble bottom and a second with huge boulders.

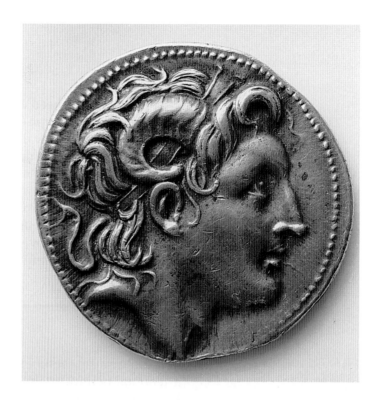

104. *Alexander the Great with Amun Horns.* Four-drachma coin, issued by Lysimachus. c. 300 B.C. Silver, diameter 1 1/8". Alexander was one of the earliest rulers to appear on coins; this example shows him with the horns of the Egyptian god Amun.

DEVELOPMENTS IN ART

The developing naturalism which characterized Greek fourth-century sculpture and painting continued through the Hellenistic period (c. 400–100 B.C.). The appreciation of art was no longer restricted to the educated citizens of the city-states; the new empathetic naturalism of art appealed to a wider audience. Displays of human emotion and drama paralleled the melodramatic staging of contemporary Greek theater.

Many portrait busts of Alexander were created to disseminate throughout the empire, and even beyond, an image of the young man as a dynamic conqueror. They emphasize his mental and physical alertness through a combination of deeply set eyes, a furrowed brow, a naturalistically open mouth, and a strong twisting of the head on the neck. A similar emotional, inspired quality is evident in coins of Alexander (fig. 104).

The Hellenistic emphasis on naturalism can be related to a changed philosophical outlook epitomized in the teachings of Aristotle. Aristotle's teacher, Plato, had viewed material objects as mere imperfect reflections of ideal forms. Aristotle, in contrast, stressed the roles of natural observation and experience in understanding reality. He sought to comprehend nature by perceiving its particular manifestations in the biological and earth sciences. The direction of Aristotle's philosophy, based on a penetrating observation of nature, parallels the realism of fourth-century and Hellenistic art.

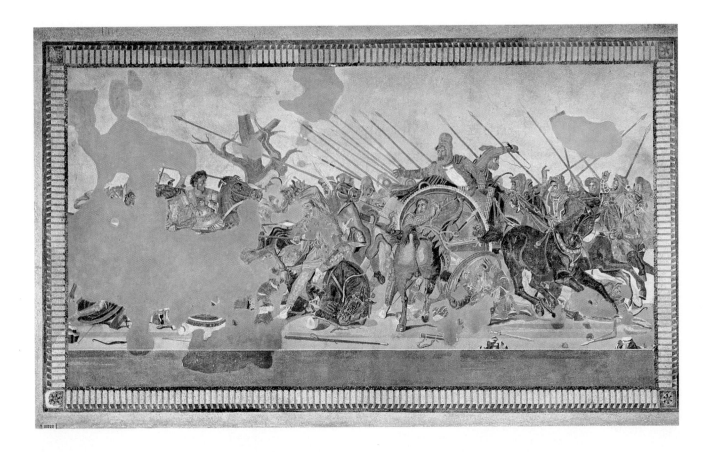

105. *Battle of Alexander the Great and King Darius of Persia.* Roman copy of Hellenistic painting of c. 300 B.C. Stone and glass mosaic, height 10' 6". National Museum, Naples. Found in the House of the Dancing Faun at Pompeii, this impressive mosaic used more than a million small *tesserae* to create the illusion of the battle. The Hellenistic original may have been by Philoxenos or Helena of Alexandria.

PAINTING

As with Hellenistic sculpture, much of our knowledge of specific works is based on literary sources and/or Roman copies in mosaic or fresco. The *Battle of Alexander and Darius* is thought to preserve the composition of a Hellenistic painting (fig. 105). The successful representation of vivid and energetic activity demonstrated in the mosaic testifies to the continuing advances in illusionism in Hellenistic painting. Alexander rides into the battle from the left, raising his spear; Darius anxiously looks back toward his pursuer. The foreshortening of the central horse and the frantic activity of the team pulling Darius's chariot add complexity to the tumult of the battle. Within the turbulent scene, the Hellenistic painter added a detail to demonstrate virtuosity: reflected in a Greek shield below Darius's chariot is the anguished face of a young Persian about to be crushed by the wheels of the chariot. The representation of death was a challenge to the Hellenistic artist (see fig. 106), and here the horror reflected on the Persian's face dramatically communicates the personal reality of battle.

HELLENISTIC SCULPTURE IN PERGAMON

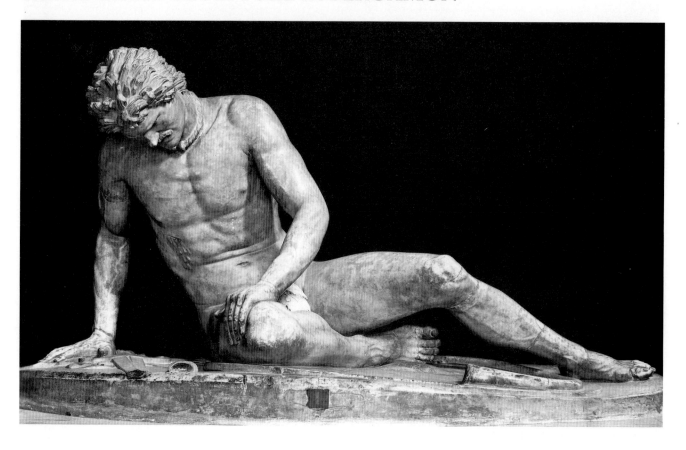

106. *Dying Trumpeter.* Roman copy after a bronze original of c. 230–220 B.C. from Pergamon. Marble, lifesize. Capitoline Museum, Rome

The *Dying Trumpeter* (fig. 106), one of a group of defeated Gauls from a large monument at Pergamon, displays the psychological and physical naturalism that characterizes Hellenistic art. Clearly distinguished as a Gaul by his matted, greasy hair, his moustache, and the torque around his neck, this soldier is shown pierced in the side with blood spewing from the wound. His face mirrors defeat, and his last moments of life are as tenuous as his upraised torso on the uncertain, trembling arm. Even in the marble copy, a keen observation of surface anatomy complements the psy-chological drama of impending death; both body and soul are rendered with unsparing reality.

During the mid-third century B.C., the Hellenistic kingdom of Pergamon, in Asia Minor, became a major political power and art center. In 263 Pergamon split from Syria to form an independent kingdom. In 230 King Attalus I of Pergamon defeated an invasion by the Gauls, who had entered Asia Minor following their invasion of Greece in 279 B.C. In defeating the foreign invaders, Attalus I was able to establish his kingdom as the principal political force in the Near East.

Dying Trumpeter: **copy after original of c. 230–220** B.C.
225 B.C.: Romans defeat the Celts
215 B.C.: Romans defeat Hannibal at Nola

During the Hellenistic period, art no longer exclusively served the worship of the gods or the embellishment of the city-states; it could extol the exploits of a political leader and so act to capture public support. This was the motivation in constructing the great Altar of Zeus and Athena at Pergamon (fig. 107). The balance between theme and form demonstrated in the earlier *Dying Trumpeter,* however, gives way by the second century to an emphasis on drama which approaches the melodramatic.

The altar was raised on a platform about twenty feet high. Approaching the steps that lead to the altar, we view a dramatic frieze in such high relief that the sculpted figures seem to kneel and fall onto the steps on which we are walking. The frieze depicts the Gigantomachy—a mythological battle between the giants and the Greek gods. At Pergamon the overt display of emotion and the convulsive interlacing diagonals of the figural composition combine to create an overwhelmingly dramatic presentation.

107. Altar of Zeus and Athena from Pergamon. c. 181–159 B.C. Marble, 120 x 113' at base; the frieze is 7' 6" high; the figures are well over-lifesize. Pergamon Museum, Berlin

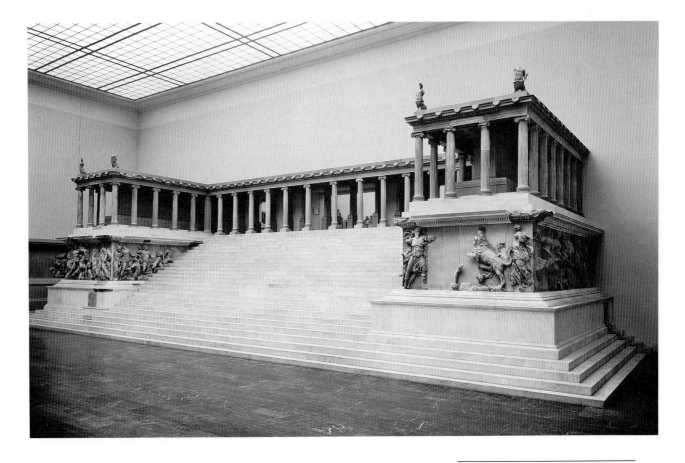

EARLY BUDDHIST ART: THE GREAT STUPA AT SANCHI

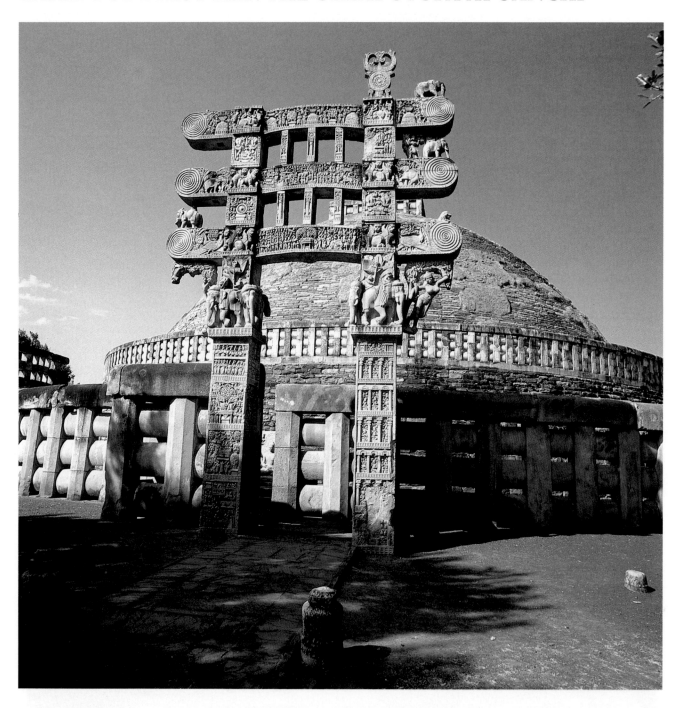

108. The Great Stupa, Sanchi, India. Begun 3rd century B.C., with later additions and enlargement. Brick and rubble originally faced with painted and gilded stucco, rails and gateways of yellow limestone. Height of dome 54'. It may be assumed that *stupas* were the first sacred Buddhist buildings and that the Great Stupa at Sanchi is the earliest surviving example. The core of the structure probably originated in the third century B.C. Here, as in many Indian *stupas*, the original building was encased in a mass of earth and stone before it was enlarged, for it was considered a sacrilege to destroy any of the original monument.

109. The *Boh* tree, sculptural detail on the south pillar of the east gate to the Great Stupa, Sanchi

The Great Stupa at Sanchi stands on a hill rising out of the plain not far from Bhopal in central India (fig. 108). A *stupa* is a burial mound; its form dates back to prehistoric times. This monumental form, as used for the burial of princes, had the shape of a large hemisphere. At an early date, this kind of tomb developed into a commemorative monument and was adopted by Buddhists as one of their main symbols and as the center of their religious compounds. The *stupa* could be an actual tomb, placed over the remains of Buddha or other holy persons, or it could act as a symbol to commemorate a sacred place, such as a site where an important event took place in Buddha's mortal life. The *stupa* played a crucial role in Buddhist beliefs for it is the very symbol of *nirvana*, or final enlightenment, the goal of every Buddhist.

All such monuments follow a similar plan (see fig. 110). They are mounds of rubble and brick faced with stone, covered with white stucco partly gilded and surmounted by a three- (or more) part umbrella symbolizing the three most basic aspects of Buddhism—the Buddha himself, Buddha's law, and the monastic order. The rail around the umbrella shaft is thought to reflect the ancient concept of marking off a precinct around a sacred tree, symbolic of vitality and fertility. On the base around the hemispherical dome is a narrow path along which processions moved. A second path is at ground level, where pilgrims could circumambulate clockwise, symbolic of walking the Path of Life around the World Mountain, following an ancient

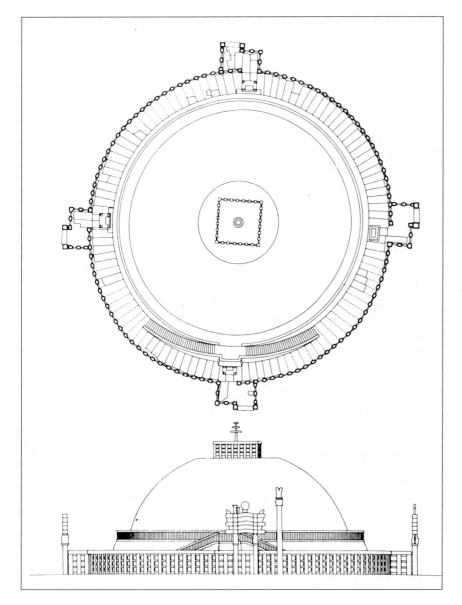

110. Plan and elevation, Great Stupa

ral form—a kind of symbolism called aniconic, or without image. His presence is suggested by symbols such as a wheel, footprints, a throne, or the *Boh* tree (fig. 109), all important emblems of his life. It was thought to be impossible to represent Buddha in human form since he had already passed into *nirvana*, an otherworldly state of being.

A richly decorated structure such as the Great Stupa took decades to complete. We can no longer see these monuments in their former splendor, with smooth white or gaily colored plaster exteriors and sculpted decoration with polychrome painting. The sculpture depicted stories quite like folk tales and brought the life of Buddha to visitors in familiar terms.

The massive domes frequently contain a system of concentric or radial supporting walls arranged by symbolic, rather than technical, considerations. They face the points of the compass and represent rays leading out from the center, a plan in the form of a *mandala*, or diagram of the cosmos. This was not visible from the exterior, but was of crucial importance for the sacred substance of the monument. Its profound importance in Buddhist belief and practice is attested by its long use and survival into the present day.

These early constructions celebrate the life of the historic Buddha, a man called Siddhartha

Indian rite of retracing the path of the sun while making offerings and ritual performances. The path is enclosed within a tall stone railing which isolates this sanctuary from the outside world. Access to it is gained through four monumental gateways some thirty-two feet in height and set at the cardinal directions. The uprights and crossbars are lavishly carved with stories from the life of

Buddha; with *jataka* tales, edifying legends in which Buddha is shown as pious and wise; and with large guardian figures called *yakshas* and *yakshis*, ancient gods and goddesses of fertility. These lively sculpted panels contrast dramatically with the massive character of the *stupa* and railing, emphasizing their presence and narrative content.

It is significant that Buddha himself is not represented in figu-

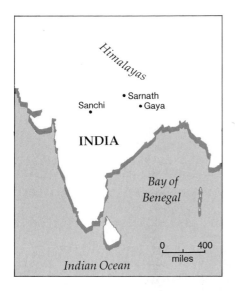

Gautama. He was born about 560 B.C. of a noble family living in the foothills of the Himalayas. He gave up his princely life of fine robes and jewels in order to seek out the cause of suffering, disease, and misery which he saw all around him. India of the sixth century B.C. was undergoing rapid and violent political and social change. As had many of his contemporaries, Prince Gautama renounced his former life and, as an ascetic, contemplated and discussed the sorrows of the world with other learned recluses on the outskirts of villages. At age thirty-five he sat under a large pipal tree in the town of Gaya and resolved not to leave his seat until the riddle of suffering was solved.

After hosts of temptations, he sank deeper and deeper into meditation and at dawn on the forty-ninth day he knew the truth, the secret of sorrow, and knew what to do to overcome it—release the mortal soul from the cycle of rebirth. He had reached *nirvana.* He remained seated under the Tree of Wisdom (the *Boh* tree) meditating on the truths he had found. He then journeyed to Deer Park (modern Sarnath) and preached his first sermon—in Buddhist phraseology, he "set the Wheel of the Law in motion." Soon he had a band of sixty ascetics who became his followers as he went on preaching the Buddhist *dharma* (doctrine). For eight months of the year they wandered from place to place, but in the rainy season they stopped to live in huts at one of the parks given by wealthy lay followers. These were the first of the great Buddhist monasteries of later times.

Buddha's quest was a personal one. He sought *nirvana*, a refined stage of enlightenment accepted by adherents of various religions of the time. *Nirvana* marked an end to the cycle of rebirth and was thought to be a state of enduring permanent bliss, called the Supreme Truth or Reality. Buddhist *dharma* claims that there is no existence without suffering, that the cause of suffering is egocentric desire, and that the elimination of desire will end suffering.

After Buddha's death at age eighty in about 480 B.C., the religion grew and changed along with the political institutions of India. The third leader of the first great Indian empire, called the Mauryan dynasty (322–183 B.C.), was named Asoka (269–232 B.C.). He expanded Mauryan political influence over much of the Indian subcontinent. According to tradition, Asoka was moved to remorse and pity by the horrors of war and came to the conclusion that true power was realized through religion, not force. Thus he became an active patron of Buddhism and supported the communities of monks. The political might of the Mauryans, as well as their patronage, brought the full institutionalization of Buddhism. A set of Buddhist religious offices (services) was created; numbers of monks occupied monasteries which acquired property; the canon was expanded, diversified, and refined. Asoka himself is said to have erected eighty-four-thousand *stupas* over the relics of Buddha throughout the empire. Thus the search for personal salvation by one man, Buddha, became an institution involving millions of people supported by one of the world's greatest ancient empires.

The *stupas* became the center of life in the monasteries, which included buildings used as lecture halls, kitchens, and hostels. Their locations and the lifeways of the monks were guided by recollections of Buddha's life. These *chaityas* (sacred locations) were to a remarkable degree coincident with trade routes of the day, as the initial spread of religion under the state patronage of Asoka was linked to commerce. Since Buddhists enjoyed the protection of the state, traders associating with them came under the same protective umbrella. Monasteries were safe havens which received the financial support of their visitors. The symbiosis between monks and traders was ultimately the agency that took this religion out of India and into China, Japan, and Southeast Asia.

Introduction to Roman Republican Art

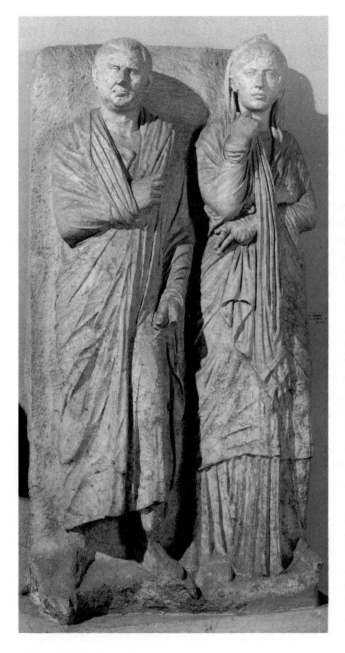

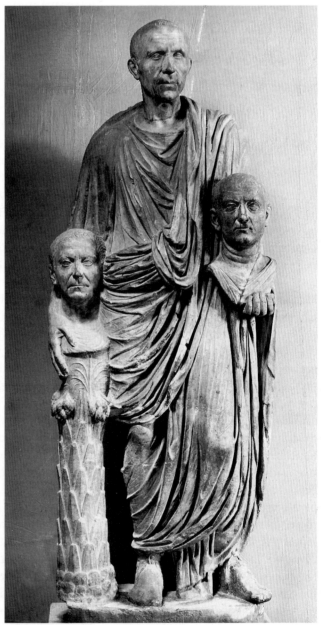

111. *Husband and Wife.* Grave relief from the Via Statilia, Rome. 1st century B.C. Marble, height 72". Capitoline Museum, Rome

112. *A Roman Patrician with Portrait Heads of His Ancestors.* c. A.D. 15. Marble, lifesize figure. Capitoline Museum, Rome. The head of the main figure is removable, perhaps because it was used in family ritual.

This high relief (fig. 111) exhibits the Roman continuation of the Mediterranean practice of marking graves with images of the deceased, but the stern man and his dignified wife communicate the austere values and virtues of the Romans of the republic, as they were defined by ancient writers: he seems sober and determined, hard and severe, demanding and uncompromising, while his wife appears dutiful and obedient, consistent with the proscribed role of women during the republic. The Romans of the early republic were self-disciplined, devout, conservative, and supporters of traditional values. They admired military valor and prized family, heritage, and the state. They respected law and legal obligations. Their language, Latin, is remarkable for its lucid order and rigid rules.

The Romans of the Republican period showed little interest in art and even later, under the Roman Empire, seldom indulged in the philosophical discussions about the nature of art that had been so important for the Greeks. But a Roman strength that persisted into the empire was their ability to absorb whatever was useful or good from other traditions, and in art the Romans owed a rich debt to the Etruscans (see pp. 48 and 78–79), the pre-Roman people who had inhabited the Italian peninsula, and the Hellenistic Greeks (see p. 105). Only in a few areas did the Romans of the republic make significant new contributions, most notably in architecture and engineering, and especially in the use of concrete and the arch and vault (see pp. 136–39).

THE PORTRAIT

The Roman interest in and devotion to the family explains the development of the individualized portrait bust. It was Roman tradition and ritual practice for patrician families to preserve wax, terra-cotta, or marble portrait heads of their male ancestors, like those held by the figure in the Capitoline Museum (fig. 112). These were kept in "the most conspicuous position in the house, enclosed in a wooden shrine" and "when any distinguished member of the family dies they take them to the funeral" (Polybius, *The Histories*). These portraits often emphasize the peculiarities of the man (moles, wrinkles, large ears) in order to capture the uniqueness of the specific person. This respect for the individual—although limited, as in most early cultures, to the male—can be related to Roman republicanism, for a system of government that encourages individual responsibility seems to lead to the development of veristic portraiture in art (for later examples see seventeenth-century Holland, p. 364, and early America, p. 398).

HISTORY

By 269 B.C., the Romans, who in the eighth century B.C. were one of several groups of people living in villages along the Tiber River, were

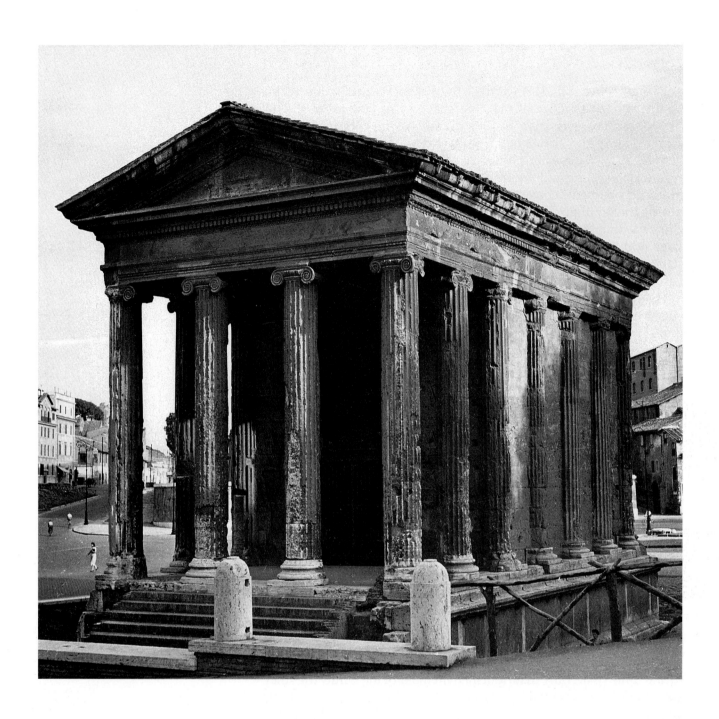

113. Temple of Portunus (formerly called Temple of Fortuna Virilis), Rome. Late 2nd century B.C.

already governing a unified state that encompassed the entire Italian peninsula. In the subsequent two centuries they defeated Carthage in North Africa and annexed Greece, Spain, Asia Minor, and the south of France. The government developed as a republic (c. 510–31 B.C.), with rule by two consuls, a hierarchy of public officials, and a senate.

The early Romans had not defined a policy of expansion, but their interest in commerce led them into contact with many of their neighbors. Eventually the Romans were forced to protect their borders and guarantee their peace after attacks from the outside. In about 390 B.C. the Gauls sacked Rome and later Carthage led Rome into war. The rapid growth of the city of Rome, which by 250 B.C. housed almost one hundred thousand people, required a vast territory to support it. The Romans were generally benevolent conquerors, who absorbed

rather than suppressed, offering citizenship to the conquered and acknowledging the significance of local traditions. Personal ambitions and the difficulties of governing vast territories and the huge city of Rome led to administrative difficulties and eventually to civil wars and attempts by military figures to seize control; the republic came to an end in 31 B.C. when Octavian, who later became the emperor Augustus, assumed power.

A REPUBLICAN TEMPLE

The Temple of Portunus in Rome (fig. 113) demonstrates the derivative nature of republican religious architecture. The high podium, restriction of steps to the front, and deep porch are related to temples created by the Etruscans, while the suggestion of a peripteral colonnade is Greek. Note, however, that only the porch columns are freestanding; those of the sides and back are merely sculpted portions of the wall structure—engaged or half columns. The temple is, therefore, not peripteral but pseudo-peripteral. This emphasizes the enclosed interior space in contrast to the emphasis on the exterior seen in the Greek tradition. The columns provide a graceful rhythm and announce that this structure is a temple, but the pseudo-peripteral design reveals the Romans' lack of interest in the aesthetic unity and logic characteristic of their Greek sources.

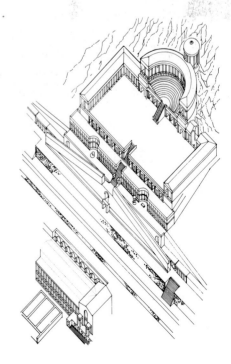

114. Sanctuary and Temple of Fortuna Primigenia, Praeneste (Palestrina), Italy. c. 80 B.C. Axonometric projection

SANCTUARY AND TEMPLE AT PRAENESTE

The innovative architecture of the Roman republic centered around great public buildings and engineering projects for which new techniques and materials were evolved which would be further developed during the empire. The arch and vault were combined with the new use of concrete (see pp. 136–39) to make possible the relatively rapid construction of such impressive complexes as the Sanctuary and Temple of Fortuna Primigenia at Praeneste (fig. 114). The design is based on the development of a sequence of public and sacred spaces along the axis followed by visitors as they moved through the sanctuary. This molding of space and control of the observer's experience will also be an important feature of Roman imperial architecture. The sacred shrine at Praeneste occupied a hillside, and Roman engineers and architects systematized the site, giving the shrine order, regularity, and clearly identified punctuation marks—the small temple facades at midpoint, the circular temple at the apex—within the aesthetic and religious experience. The semicircular steps that lead up to the final circular temple are a foil for its shape and, in addition, provide a theater for the enactment of sacred drama.

THE ROMAN HOUSE AND VILLA

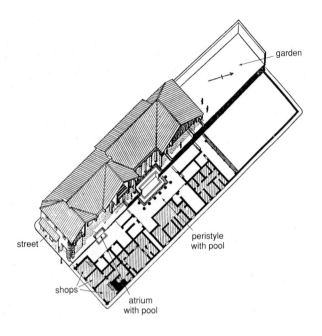

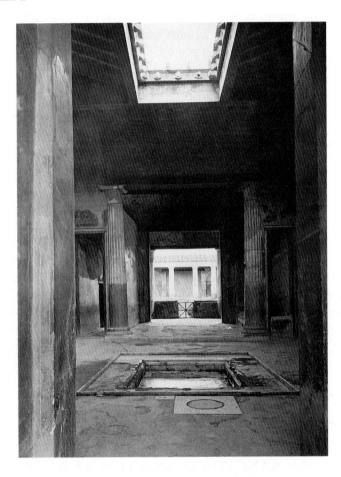

115. Isometric projection with plan and longitudinal section, House of Pansa, Pompeii, Italy. 2nd century B.C. There are shops to either side of the entrance. The women who died in this house during the Vesuvius disaster were wearing gold ear pendants, necklaces, and rings. When the eruption began, a sculpture of Bacchus was placed for safety in a copper kettle in the garden.

Most of our knowledge of Roman life is the result of materials preserved by the eruption of the volcano Vesuvius in A.D. 79. The volcanic ash and mud lava buried the seaside town of Pompeii, preserving shops, temples, houses, drainage and sewage systems, furnishings, food, and even the anguished positions of a number of the victims.

A letter by Pliny the Younger described the disaster: "The buildings were now shaking with violent shocks . . . Outside . . . there was the danger of falling pumice-stones. . . . As a protection against falling objects [the people] put pillows on their heads . . . they were still in dark-ness, blacker and denser than any ordinary night. . . . We also saw the sea sucked away and apparently forced back by the earthquake . . . a fearful black cloud was rent by forked and quivering bursts of flame, and parted to reveal great tongues of fire, like flashes of lightning magnified in size. . . . People bewailed their own fate or that of their relatives, and there were some who prayed for death in their terror of dying. Many besought the aid of the gods, but still more imagined there were no gods left, and that the universe was plunged into eternal darkness for evermore."

The houses and villas of mid-

116. Atrium, House of Menander, Pompeii. c. 70 A.D. The atrium is a feature well suited to the Mediterranean climate. The outer walls of the house were usually window-less, and the atrium allowed light and fresh air to enter, as well as rainwater, which was gathered in a central pool to flow into a cistern. The atrium functioned as a sitting room, and it usually contained the shrine for the household gods; to either side were small chambers for dining and sleeping.

dle-class and upper-class Romans followed a regular plan with rooms arranged along a longitudinal axis from entrance to garden (fig. 115). The plan is dominated by the atrium (open court). The rooms were decorated

117. *The Unswept Floor.* Roman copy by Heraclitus of a Hellenistic mosaic by Sosos. A.D. 2nd century. Mosaic fragment; the forms are lifesize. Vatican Museums, Rome

House of Pansa, Pompeii: 2nd century B.C.
214 B.C.: Construction begins on China's Great Wall
191 B.C.: Gaul (France) becomes a Roman province
101 B.C.: Chinese ships reach India

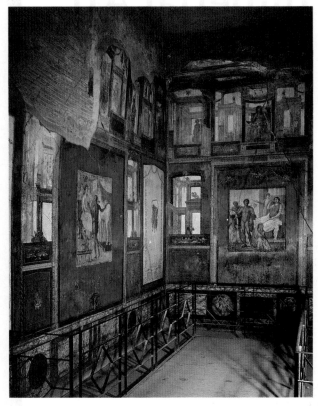

118. Frescoed room from the House of the Vettii, Pompeii. A.D. 63–79

with richly patterned ceilings and wall paintings (fig. 118), but actual furnishings were minimal. Couches, used for resting, sleeping, studying, and dining while reclining in the Greek fashion, were usually the most elaborate pieces of furniture. Virtually all houses in Pompeii had water pipes with taps, as well as pipes leading to a sewer or trench.

The floors in the main rooms were made of mosaic—small pieces of marble and stone—arranged in decorative patterns. The richest homes had floors which copied famous Hellenistic paintings or patterns. One copy of a Hellenistic mosaic featured *The Unswept Floor* (fig. 117), a realistic depiction of the debris one might find underfoot after a banquet, complete with shadows to make it more realistic—pity the poor servant who had to clean such a design after a night of Roman revelry. A mosaiced vestibule might have a chained dog and the words "Beware of the Dog," or a human skeleton and "Enjoy life while you have it."

The variation in design of the wall paintings at Pompeii reveals how fashions of decorating changed. Executed in a durable *fresco secco* technique (see p. 133), these works were intended to transform the rooms into an elegant ambience for living and entertaining. The paintings are illusionistic. The simplest seem to be walls paneled in fine marbles. In some the wall is painted away by a suggestion of continuous space. The subjects include realistic or fantastic views of architecture, landscapes, still lifes, portraits, and themes from Greek and Roman mythology and theater. The still lifes usually represent food—game, fruit, eggs—and may refer to the Roman custom of giving such food as gifts (fig. 133).

longer than any who followed him. He continued the expansion of the Roman state, as did his successors, and by the death of Trajan in A.D. 117, Rome's population was about seven hundred fifty thousand and the Mediterranean had become a "Roman lake." The difficulties of governing this enormous area and its diverse population made the Romans masters of efficiency and organization. They had little time for, or interest in, the philosophical speculations that had formed Greek art and culture. Their most significant contributions are in world government and order, encompassing such diverse issues as legal codes and city planning.

The Romans had a strong sense of their historical importance and their contributions to world history: Julius Caesar wrote an account of the Gallic Wars; the emperor Claudius wrote two lost historical works; and Augustus made a list of his accomplishments known as the *Res Gestae*. Roman attitudes toward history and art are expressed in the *Altar of Peace* (*Ara Pacis;* fig. 120) in Rome, which commemorated a particular concept, the *pax romana* (Roman peace) that had been declared by the Roman senate in 13 B.C. to express and commemorate the peace brought by Augustus to Italy and to the Roman state. They could not know that never again would peace prevail for so many years over so vast an area. The senate's declaration and the richly decorated altar were intended to bring recognition to this historic fact and to establish it as a Roman accomplishment and ideal. Augustus, accompanied by his family and friends, appears in the procession representing the altar's dedication. Although the stylistic sources for the reliefs lie in such Greek models as the Parthenon frieze (see fig. 100), Greek idealism is ignored in favor of documenting a specific historic moment and distinctive individuals. Their presence at this sacrifice reveals their piety and concord; the more important figures are in higher relief for emphasis and focus. Even the decorative motifs glorify the empire and allude to its peace-giving role, for the garlands below refer to the abundance made possible by peace.

THE CITY OF ROME

Rome, which at its largest had a population of nearly a million, was in many ways similar to a modern city. It had impressive public spaces with state buildings and religious structures, as well as shopping areas, apartment buildings of five or six stories, and rooming houses. Most of the population lived in rental housing; a fourth-century A.D. document lists 46,602 apartment and rooming houses in the city and only 1,797 private homes. The apartment houses at Ostia (fig. 121), the port of Rome, were three or four stories high with an inner garden court and balconies, similar to late-twentieth-century apartment blocks.

The emperors kept the urban populace happy by providing food, facilities, and entertainment. Elaborate programs of building in the imperial forums (fig. 122) impressed the public with the power and magnificence of the specific emperor and of the state. Theaters and amphitheaters provided places of entertainment for tens of thou-

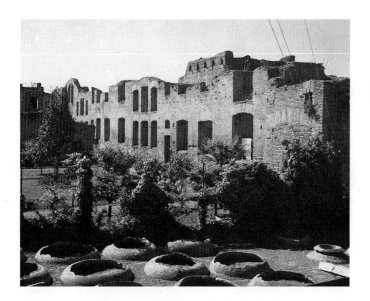

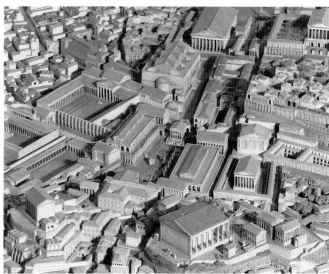

sands, and the public baths offered facilities for communal bathing and exercise, as well as for social and intellectual gatherings.

121. Left: Apartment house, Ostia. A.D. 2nd century

ROMAN IMPERIAL ART

122. Right: Roman and Imperial Forums in Rome. Reconstruction model. A.D. early 4th century. Museum of Roman Civilization, Rome. See fig. 147 for plan.

The scale and diversity of the empire (31 B.C.–c. A.D. 400) meant that Roman imperial art encompassed a variety of types and styles, especially as local traditions were incorporated into the works of art. Here we have chosen to limit our discussion almost exclusively to works of art created within the city of Rome and for its inhabitants. The majority of the artists employed by the Romans were of Greek ancestry. Greek artists were imported as early as 500 B.C., during the republic, and works of art were also ordered from artists active in Greece. The demand for Greek works, new and old, accelerated after the Romans sacked Corinth in 146 B.C. and brought a number of important Greek works to Italy.

Among the most impressive and characteristic monuments of Roman art are those which honor the empire and emperor. These are often on an enormous scale to communicate the size, power, and authority of the empire. Huge buildings and interrelated groups of buildings that express the grandiose aspirations of the empire were made possible by the new techniques of construction that had been developed during the Roman republic. The empire's use of the arch, the vault, and concrete—devices which made feasible not only the huge and magnificent monuments of ancient Rome, but also the powerful molding of space so important in Roman architecture—are among the most significant of all Roman accomplishments (see pp. 136–39).

The creation of works of art honoring and commemorating an emperor's deeds and victories was a constant challenge to artists in the service of the empire. Emperors and generals were sometimes honored with equestrian monuments; the only surviving example is the *Marcus Aurelius* (fig. 123). He has the same commanding gesture

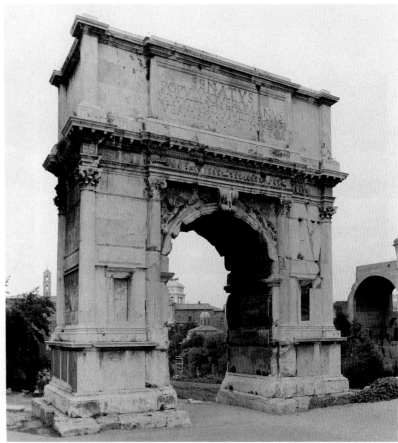

123. Left: *Equestrian Monument of the Emperor Marcus Aurelius.*
c. A.D. 161–80. Bronze, over-lifesize. Piazza del Campidoglio, Rome. Marcus Aurelius, who wrote the *Meditations,* has the longish hair and full beard that characterized the "poetic" emperor. The military type of emperor was clean-shaven with short hair. The bronze is an impressive technical accomplishment, but its preservation results from the incorrect medieval interpretation that the statue represented Constantine, the later emperor who accepted Christianity.

124. Right: Arch of Titus, Rome.
c. A.D. 81. Marble over concrete core

as Augustus (fig. 119), but here his power is emphasized by the control he demonstrates over the lively and nervous horse. Originally there was probably a figure of a defeated enemy crouching under the horse's upraised hoof.

Another commemorative monument is the triumphal arch. While its origins can be traced to republican days, the first to be called *arcus triumphalis* were the large and permanent triumphal arches erected during the reign of Augustus. Eventually there were more than fifty in Rome. The Arch of Titus (figs. 124, 125) memorializes Titus' suppression of a Jewish revolt and his capture of Jerusalem in A.D. 70–71. The arch itself is simple and handsome, with a compact and tightly knit composition of horizontal and vertical members enframing the tunnel vault. The simple basic form, an arch enclosed within a rectangle, is also enlivened by the stepped frieze, and originally the whole was surmounted by a huge bronze quadriga with the emperor's portrait. The reliefs under the arch represent, on one side, the triumph of Titus, who is shown riding in a chariot led by a personification of the goddess Roma. On the other side is the parading of the treasures of the temple in Jerusalem, including the menorah, through the streets of Rome, where the procession is about to pass under a triumphal arch (fig. 125). The deified Titus, who died shortly before the monument was completed, is shown in the center of the vault being carried to heaven on the back of an eagle.

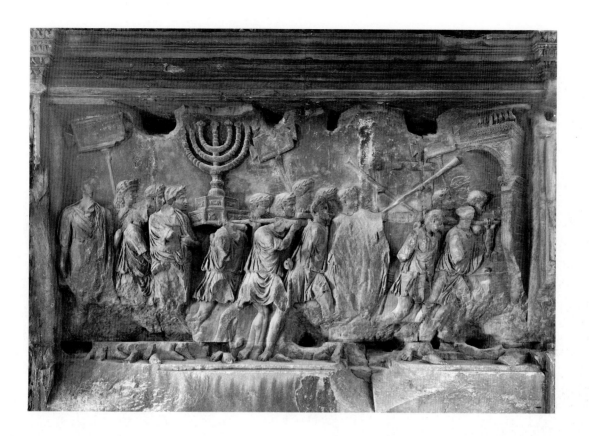

125. *The Spoils of the Temple at Jerusalem Exhibited in Rome.* Marble relief from the Arch of Titus. Height 79"

Commemorating the emperor Trajan's early-second-century victories over the Dacians in eastern Europe is a huge freestanding column (fig. 126), as tall as a twelve-story building, which was originally topped with a monumental gilded bronze statue of the emperor (now replaced with a statue of St. Peter). The column is carved with a spiraling relief that tells in detail the episodes of Trajan's campaigns and victories. The style is lively and direct, but it was not necessary that every detail of every scene be visible. The scale of the column and the length of the relief convey the extent and complexity of Trajan's exploits. Some of the upper scenes could have been read by people standing on the balconies of the courtyard of Trajan's library, which surrounded the column. Column and library were only part of Trajan's contributions to the imperial forums. Emperors embellished the imperial forums as a way of asserting their presence and impressing the people with their magnificence.

THE CONCEPT OF CLASSICAL ART

We have already learned that the term Classical period was used to designate a time within the development of ancient Greece (see p. 85). The Classical period was so named because it was seen in the nineteenth century as the summit of Greek art and culture. With the rise of art academies in Europe, beginning in the later sixteenth century, the most important monuments of ancient Greek and Roman art were viewed as manifesting the order, harmony, and clarity of the classical aesthetic. From the seventeenth century onward, the art of

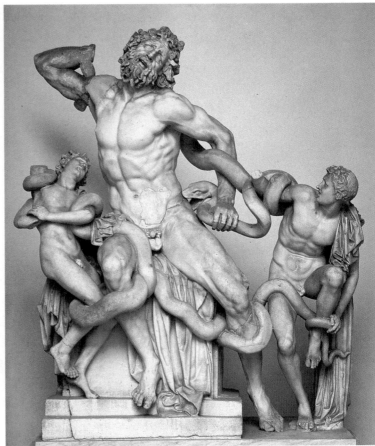

126. Left: Column of Trajan, Rome. A.D. 113. Marble, height originally 128'; length of frieze, approx. 625'

127. Right: **HAGESANDROS, ATHENODOROS, AND POLYDOROS**
Laocoön and His Sons. Early 1st century B.C.(?). Marble, height 96". Vatican Museums, Rome. This sculptural group was carved by three Greek sculptors from the island of Rhodes.

both of these ancient, or antique, cultures was viewed as exemplary, and the term classical art began to be used for these periods. Today, this broader use of the term classical encompasses the art and the civilizations of both ancient Greece and Rome.

THE ROMAN ARTIST

In ancient Greece, artists had been famous and respected, but during both the republic and the empire the artists in the service of the Roman state became anonymous laborers once again. Few artists are known by name; not a single painting bears a signature and only a few are documented as the work of a particular artist. In most cases the large and elaborate programs of Roman art seem to have been accomplished by groups of artists working together, probably in well-organized workshops, and submerging their individuality in the concept of a unified project.

Most of the few names of artists that are recorded are Greek, and these are names of sculptors. Even during the republic it was recognized that Greek sculptors represented a long-standing tradition of excellence. The famous *Laocoön and His Sons* (fig. 127), once thought to

be a work of the Greek Hellenistic period imported to Rome, is now believed to be a Roman work created by Greek sculptors working in a revival of the Hellenistic style for a Roman patron.

TECHNOLOGY AND ENGINEERING

To run a large empire, to communicate and move supplies, and to feed the masses gathered in growing cities demanded important new developments in technology and organization that ultimately affected the production and style of works of art. The Romans are famous for their roads and aqueducts, which were engineered to solve the particular problems of a specific area or terrain. Some ancient aqueducts, roads, and bridges are still in use. The arch, the vault, and concrete solved engineering and construction problems on a large scale (pp. 136–39).

The Roman interest in order, efficiency, and organization is revealed by the Roman town plan (fig. 128), which developed from Egyptian, Greek, and Hellenistic prototypes to spread throughout the Roman world, from London to North Africa. The streets are laid out in a grid pattern within fortified walls, and the center of the town is marked by the intersection of the two main thoroughfares, the *cardo*, running north-south, and the *decumanus*, running east-west. Nearby is the forum—the social, political, and commercial heart of the city. The intersecting *cardo* and *decumanus* divide the city into quarters, each of which is further subdivided by streets meeting at right angles; only irregular or large buildings such as theaters or public baths disrupted this regular plan. The Roman solution to urban design is evident in major cities of the Western world, where avenues cross streets in grid patterns.

RELIGION; MYSTERY RELIGIONS

The more important official Roman deities were derived from the gods and goddesses of the Greeks, but their names were changed: Zeus became Jupiter, Aphrodite became Venus, and Dionysus became Bacchus, for example. But the number of Roman deities continually expanded, for when the Romans conquered and annexed a new area, the local deities were usually added to the Roman hierarchy of gods. At the Pantheon in Rome (see fig. 142), there was even an altar dedicated to those gods whom the Romans had not yet discovered.

During the later empire, the religious life of many Romans was dominated by participation in mystery religions, cults which centered on a savior who promised some kind of life after death. Their widespread popularity has been seen as a reaction to the materialism and spiritual emptiness of ancient Roman life. The Greek religion had one such deity in Dionysus (the Roman Bacchus), who represented the irrational and irrepressible elements in human nature. His cult at the city of Pompeii led to the creation of one of the greatest Roman

paintings, the frescoes at the Villa of the Mysteries (see fig. 130). Other mystery religions centered around the worship of Isis, an Egyptian goddess whose temple at Pompeii included a shrine with a reservoir of holy water from the Nile, and Cybele, the Great Mother (Magna Mater). An ancient Roman temple to Mithras, a militant god-hero who represented the victorious forces of light over darkness, was discovered in London, in excavations after the bombings of World War II. Mithraism, an especially important late Roman cult, was widespread throughout the empire as a result of its popularity with members of the army.

THE END OF ROME'S EMPIRE

Political, religious, and spiritual turmoil and threats from Northern barbarians characterize the later empire. Diocletian (ruled 284–305) consolidated imperial rule, but he also banned and persecuted the Christians. Constantine lifted the ban on Christianity in 313 and later may have converted to the religion himself. But Rome lost much of its importance when Constantine shifted the imperial capital to Constantinople, which he had founded at a site on the Bosphorus named Byzantium (present-day Istanbul). In 395, at the time of the death of the emperor Theodosius I, the empire was divided in half. But while the eastern empire centered around Constantinople enjoyed political stability, the western empire was beset with uprising from Germanic tribes. One of those tribes, the Visigoths, captured and sacked Rome in 410.

LATE ROMAN SCULPTURE

Constantine's sculpted head (fig. 129) has a dramatic and intimidating impact, not just because of its enormous size, but also as a result of the powerfully abstract facial features. Portraiture has moved away from the highly realistic busts of republican and early imperial Roman art, and although Constantine's head retains certain specific physical traits, such as the thick, muscular neck and the Roman nose known from his other portraits, these realistic features are joined with abstract patterns in the perfectly coiffured hair over the forehead and the huge, staring eyes. The latter suggest Constantine's authoritarian power, his deified presence, and his ability to penetrate the world of the divine. There are indications from contemporary literary sources that the late Roman emperors, who were viewed as gods while they were living, were adorned like statues of gods and behaved in a manner which encouraged belief in their deified status.

It is difficult to determine why the new abstract patterning occurs during the late Roman Empire, a period sometimes referred to as late antiquity. It cannot be dismissed as a lack of technical ability on the part of the artist, for its use seems intentional, to promote such abstract concepts as imperial authority or divine power.

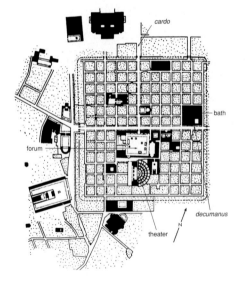

128. Plan, Thamugadis (Timgad), Algeria. Founded c. A.D. 100

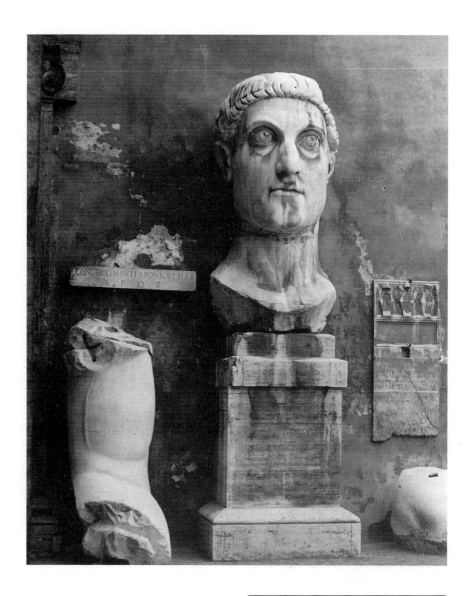

129. *Head and Arm of Constantine.*
A.D. early 4th century. Marble fragments, height of head 8' 6". Palazzo dei Conservatori, Rome. These fragments are part of a colossal statue, originally about thirty feet tall, of the enthroned emperor Constantine initially placed in the apse of the Basilica of Constantine (fig. 139). The head and limbs were carved from marble while the torso was fashioned of a brick core covered with wood and overlaid with bronze. The head once had a metal diadem.

New, spiritual attitudes entered late antiquity with the mystery cults and early Christianity. The most eloquent spokesperson for these values was Plotinus, a third-century philosopher. One of his pupils, Porphyry, wrote a life of Plotinus in which he noted the difficulty of artists who wanted to create a portrait of the philosopher: "Plotinus . . . gave the impression of being ashamed that he dwelt in a body [and] he deemed it so degrading to submit himself to being a subject for a painter or sculptor that he said to Amelius, who asked him to permit his portrait to be made: 'It is not sufficient just to carry around that image which nature has imposed on us, without making concessions to it by deciding to leave behind a more lasting image of the image, as if it were one of those things which is particularly worth seeing.'" The antiphysical attitude of Plotinus is in sharp contrast to the historical and naturalistic values which had been so prized in Roman figurative art. As in the colossal head of Constantine, inner spiritual life is deemed more significant than an exact portrait representation. We will see that such an approach is consistent with the development of Early Christian art.

ROMAN FRESCOES AND ILLUSIONISM

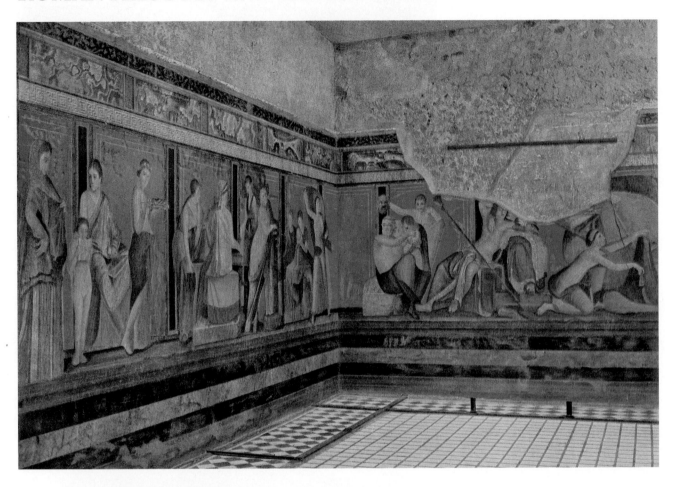

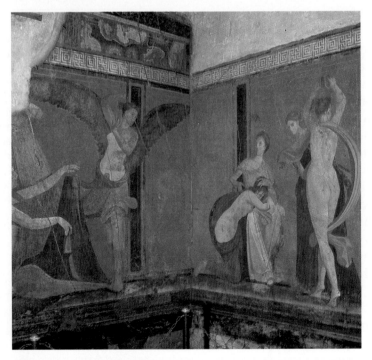

130. *The Bacchic Mysteries.* Villa of the Mysteries, Pompeii, Italy. c. 30 B.C. Fresco, size of room approx. 29 x 19'; height of figures approx. 60". Whether these paintings, which are superb in quality, are copies of a lost Hellenistic painting from Pergamon or original Roman works is still debated by experts.

131. Corner of the room in the Villa of the Mysteries, with a flagellation scene. Whipping in this context may be a ritual meant to ensure fertility.

132. *Garden.* Wall painting from the Villa of Livia, wife of the emperor Augustus, at Prima Porta near Rome. Late 1st century B.C. Fresco, height of wall 10'. Museo delle Terme, Rome. Fig. 119 was also discovered at Livia's villa.

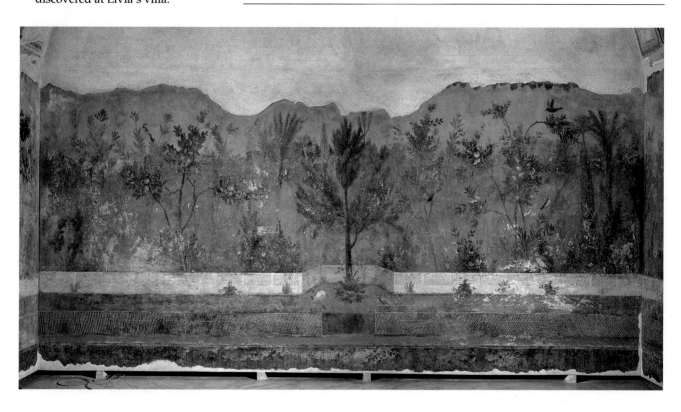

This room of frescoes (fig. 130) representing Bacchic (or Dionysiac) mysteries is exceptional in quality and subject, as well as in scale, for nearly lifesize figures such as these are rare in Roman painting. In addition, these frescoes are one of the first great examples of mural painting (painted wall decoration that is integrated with the physical space and architecture).

The secret rites depicted here have not yet been fully explained, but this painting reveals the importance of the cult of Bacchus, god of wine and fertility, in Roman life. It has been proposed that the sequence of scenes, which seems to read from left to right, represents either the initiation of a new member into the cult or the transitions in the life of a young woman when she marries and becomes a Roman matron.

The central figures, badly damaged, represent the enthroned Ariadne, to whom Bacchus gave immortality, with the god reclining on her bosom. The initiate, or bride, would be the figure entering on the far left. She is enthroned as a matron on the far right (not visible in this view). In the interim she encounters various trials and experiences. Among the dramatic episodes is the imminent unveiling of a large phallus to the right of the central figures of Ariadne and Bacchus. The regular, architectural rhythm of the paneling behind the figures sets off their poses, while the strong red background adds an element of drama appropriate for the subject.

The most dramatic episodes are represented at the two corners, where the artist took advantage of the walls meeting at ninety-degree angles to represent interacting figures. At one corner a fierce Silenus, who may be reading the young woman's fortune in the residue left in a wine cup, looks back at her as she flees in terror. At the other corner a winged figure in a spiraling movement flogs the initiate or

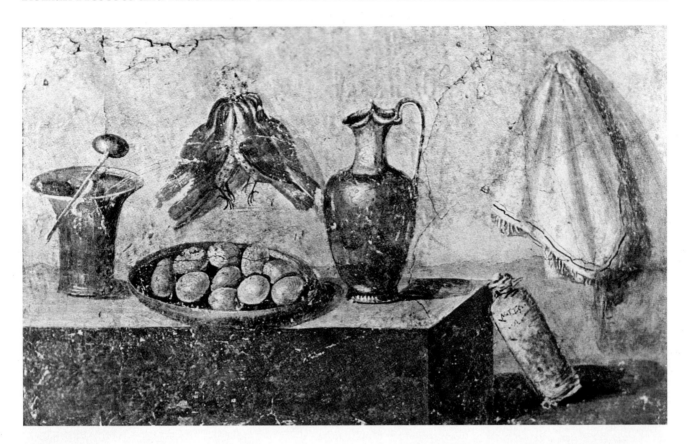

bride, who reclines on the lap of another woman (see fig. 131).

One of the most beautiful of all Roman fresco decorations is the painting that covered the four walls of a room in the Villa of Livia at Prima Porta (fig. 132). It represents a garden with fruit trees, flowers, and songbirds set off by a background of sky. The fresco has all the freshness of nature's colors: the rich greens of the garden; the varied shades of fruit, flowers, and plumage; and a wonderful blue sky. All are executed with a light touch of the brush, as if the wind were just beginning to stir this idyllic environment.

133. *Still Life with Eggs and Thrushes,* from the House (or Villa) of Julia Felix, Pompeii. Before A.D. 79. Fresco, 35 x 48". National Museum, Naples. The house where this fresco was found during excavations in 1755–57 is the largest yet discovered at Pompeii. The fresco shown here is one of a sequence of still-life paintings of food.

ROMAN FRESCO TECHNIQUE

Fresco painting (fresco is Italian for fresh), which involves painting directly on the plaster wall, was used by the Egyptians, Greeks, Romans, and later civilizations as well. When properly executed it is durable, and when it is subtly related to the particular architectural setting, as in the cycle at the Villa of the Mysteries at Pompeii, it can be both decorative and dramatic. Generally fresco painters have to cover large expanses of wall, and they often work quickly;

the sketchy and suggestive quality of most Roman and later frescoes creates a lively and vivacious effect. For a discussion of the somewhat more complex fresco technique that developed in Italy during the later Middle Ages and the Renaissance, see pp. 238–39.

The Roman fresco painter began by applying two or three layers of fine plaster to the wall surface to be decorated. The background would be painted on the top layer of plaster—sometimes while it was still

moist—and left to dry. When the paint was added to the still moist plaster, each plaster patch would reveal one day's work. Figures, ornaments, and architecture were usually added later. The natural pigments, which were made from earth, minerals, or animal or vegetable sources, were mixed with limewater. Glue and wax were sometimes added to create a hard and shiny surface. Painting onto wet plaster is called *buon fresco* (Italian for good or true fresco) and painting on the already hardened dry plaster is known as *fresco secco* (Italian, meaning dry fresco).

134. Diagram of fresco patches at the Villa of the Mysteries. An examination of the surface of the frescoes reveals that they were painted in patches that follow the outlines of the figures. In later Italian fresco technique, each of these patches would be known as a *giornata*.

ILLUSIONISM

Livia's garden room (fig. 132) is more delightful and seductive than a framed painting of a garden, for it creates the illusion that we are in a natural setting. Such illusionism also played a role in the *Still Life with Eggs* (fig. 133), for in both works the artists want to fool us into believing, albeit momentarily, that we are looking out into a real garden or at a real dish full of actual eggs. This type of illusionism, which is also known by the French phrase *trompe l'oeil* (fool the eye), is a pleasant bit of trickery. Such paintings are meant to amuse and delight us, as was already recognized by the Roman author Philostratus the Younger, writing about A.D. 300: "To confront objects which do not exist as though they existed and . . . to believe that they do exist, is not this, since no harm can come of it, a suitable and irreproachable means of providing entertainment?" The illusionism of Roman painting is inherited from an earlier tradition that developed in Greece. The sense of pleasure in experiencing illusionism is not unique to the Greeks and Romans, as is revealed by the popularity of *trompe l'oeil* in later societies and even today.

There are several criteria for a successful illusionistic or *trompe l'oeil* painting. The objects in the painting should be represented in their natural scale in a clearly structured space, as is the case with both Livia's *Garden* and the *Still Life*. In the *Garden* the artist

has carefully developed the space in overlapping levels within the pictorial space. Cast shadows define the placement of the object within the illusionistic space, as is especially evident in the *Still Life*, and the objects are naturalistically modeled with transitions from light to dark that indicate both the three-dimensionality of the objects and the source of the light (later, at the time of the Italian Renaissance, this will become known as *chiaroscuro*, from the Italian words for light and dark). Naturalistic lighting effects suggest the textures of the objects: note the different textures of the eggs and the metal vessels in the *Still Life*. Often painters will introduce an object in the immediate foreground that establishes the frontal plane of the illusionistic space; this form, known as a *repoussoir* (French, meaning to push back), can be noted in the low, openwork fence in the foreground of Livia's *Garden*. The use of the *repoussoir* in the *Still Life* is especially interesting, for the bowl of eggs seems to extend over the frontal plane of the base—the *repoussoir*—to jut out into our space. To make the illusion convincing, the subject matter is usually everyday objects that need no interpretation or explanation. The goals of such art are obvious, for the purpose, beyond Philostratus's "entertainment," is to impress us with the technical skill of the artist.

THE FLAVIAN AMPHITHEATER (COLOSSEUM), ROME

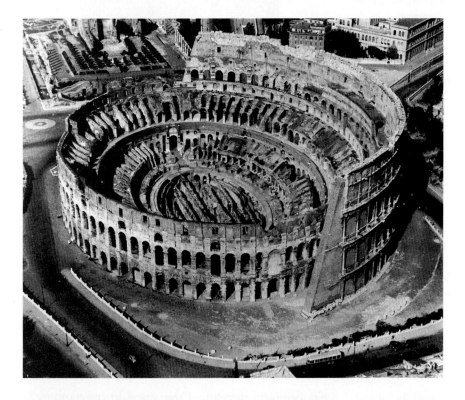

135. Exterior, Flavian Amphitheater (Colosseum), Rome. Begun A.D. 72; dedicated A.D. 80; construction completed A.D. 96. Approx. 615 x 510'. The building was damaged in later centuries, when much of the dressed stone of the outer surface was taken away to be used in the construction of other buildings.

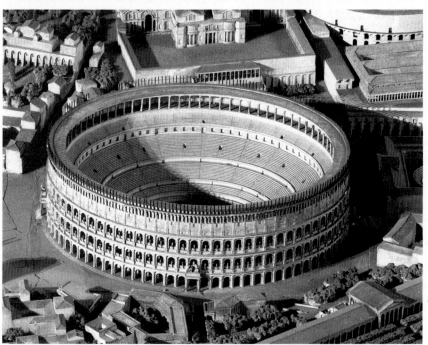

136. Flavian Amphitheater. Reconstruction model. Museum of Roman Civilization, Rome

Through the ages, the Flavian Amphitheater has conveyed the scale and strength of the Roman Empire (fig. 135). Begun by Vespasian, an honored military leader and first emperor of the Flavian dynasty, it was built in part to reassure the Roman citizenry that the cruelty and self-indulgence of the reign of Nero, the last Julio-Claudian emperor, had ended; Vespasian destroyed the lake and pleasure garden of Nero's Golden House, with its ostentatious gardens, to establish a site for the amphitheater. It was dedicated by Vespasian's son Titus with gladiatorial games that lasted over one hundred days and featured a thousand gladiators and the deaths of thousands of animals.

The Roman amphitheater or arena was so well conceived that it has become the prototype for

Flavian Amphitheater, Rome: begun A.D. 72
A.D. 43: Roman London (Londinium) is founded
A.D. 70: Titus destroys Jerusalem
C. A.D. 70: Writing of the Gospel of St. Matthew
A.D. 73: Fall of Masada

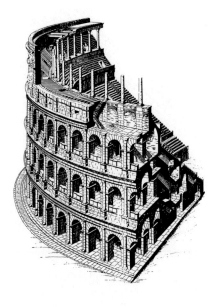

137. Flavian Amphitheater.
Isometric projection, with section

the modern sports stadium. The oval plan seems to have developed from the idea of facing and enclosing two theaters (amphitheater derives from the Greek *amphi*, around, and *theatron*, theater). The Flavian Amphitheater, the largest amphitheater of the ancient Roman world, could hold about fifty thousand spectators. They were sheltered from sun and rain by an awning rigged by sailors and supported by horizontal poles anchored in the top level. Eighty arched passageways on the ground floor allowed entrance to a double row of annular tunnel vaults (see figs. 136, 137) encircling the arena which led to interior stairs leading to vaulted passages on the upper levels. Such a plan permitted easy access and exit by a crowd of spectators.

Construction materials included travertine, brick, concrete, and tufa (see p. 139). When finished, the exterior was faced with blocks of local travertine stone held in place by iron clamps. The exterior design was unified by the repetition of arches flanked by half columns. The capitals on the three arched stories change from Doric below to Ionic and Corinthian for the second and third floors; Corinthian pilasters articulate the fourth level.

The amphitheater was an arena for displays of combat: gladiators battled other gladiators and animals, while animals, especially lions and tigers brought from Africa, were pitted against one another. Women gladiators participated until A.D. 200. The fight was usually to the death, a practice which may have evolved from an earlier Etruscan ritual in which a deceased relative was honored by a fight to the death between slaves. The floor of the Flavian Amphitheater was landscaped with trees and large rocks. Animals were raised by lifts from underground chambers, now visible after excavations. The amphitheater could be artifically flooded for contests mimicking naval battles. Although a few Romans denounced these games as bloody spectacles, most viewed them as displays of courage and virtue.

To the ruling families of Rome, the games also served a political purpose. At times, the unemployment rate reached approximately fifteen percent and, in addition to religious festivals, approximately one hundred and fifty days each year were celebrated as holidays. Providing spectacular games became a political scheme to keep an often idle population entertained and content.

During the Early Christian era some martyrdoms may have occurred here, but most public persecutions were held in the Roman circuses (arenas especially designed for chariot races). After Christianity was legally recognized by the emperor Constantine in A.D. 313, growing numbers of Christians argued against the brutality of the games. Gladiatorial contests were banned in the early fifth century, but the animal games continued into the sixth century.

Until at least the mid-fourth century, a colossal (almost one hundred feet tall) bronze statue of Nero as the Sun God stood next to the Flavian Amphitheater. In the eighth century, a popular guidebook to Rome applied the term colosseum, taken from the colossal sculpture, to the amphitheater itself, and ever since we have known it by this name.

THE ARCH, THE VAULT, AND CONCRETE

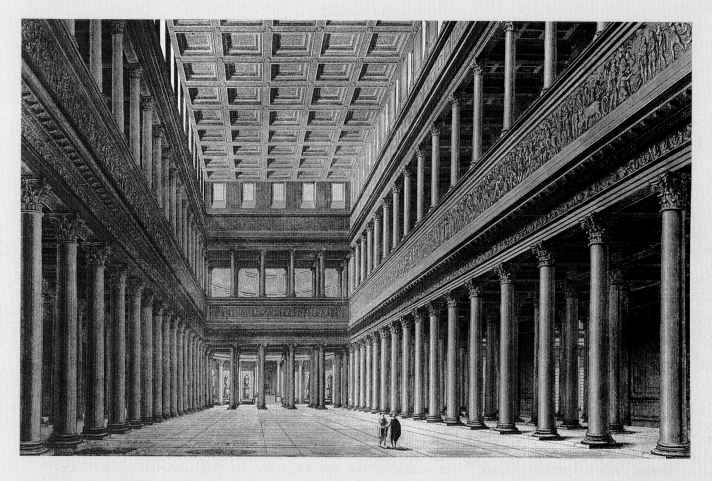

138. Interior, Basilica Ulpia, Rome. Reconstruction drawing after Canina. c. A.D. 98–117. For a plan of the Basilica Ulpia and its location within the Imperial Forums, see fig. 147.

These two reconstructed ancient Roman interiors (figs. 138, 139) are the products of two completely different systems of construction. The Basilica Ulpia (fig. 138) is a huge and impressive demonstration of post-and-lintel construction (see p. 66); the even larger and grander Basilica of Maxentius (fig. 139), begun more than two hundred years later, is built with brick and concrete using a vaulting system based on the arch. When concrete hardens, it becomes monolithic, and today some of the huge lower vaults of the Basilica of Maxentius and Constantine are still standing in Rome. Not a column of the Basilica Ulpia is in place, in part because its great columns were re-used in new construction during later centuries.

The arch was known to the peoples of the Near East, as well as to the Egyptians, the Greeks, and the Etruscans, but it was the Romans, beginning in the republic, who are famous for recognizing its utility for engineering projects and its potential for spanning large spaces to create huge public buildings (see fig. 114). While post-and-lintel construction spans an opening with a flat beam of wood or stone, an arch (fig. 140) is a means of construction by which an opening—usually semicircular—is spanned by a number of elements (stone or bricks) that are smaller than the opening itself; these elements are most often wedge-shaped blocks known as voussoirs. The central voussoir is called the keystone. All the vaults discussed below are based on the arch.

Arches and vaults are constructed upon a wooden support known as centering that can be removed and reused. The point at which the arch or vault begins to curve inward and upward is known as the springing; the blocks immediately below the springing may jut out to support the

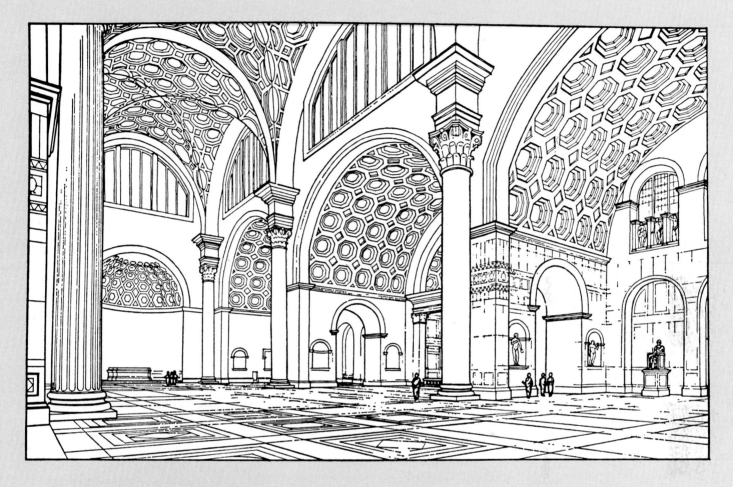

139. Interior, Basilica of Maxentius and Constantine, Rome. Reconstruction view of the interior as planned by Maxentius. c. A.D. 306–313. This basilica was begun by Maxentius and taken over by his rival Constantine, who completed it. The colossal head and arm of Constantine in fig. 129 were found here.

centering. While the dynamics of the post-and-lintel system are relatively simple, with the thrust of the weight of the lintel pressing downward on the supporting posts, the dynamics of an arch or vault create outward diagonal thrusts that must be counteracted by buttressing, providing a masonry support that counteracts the thrust (for a later example, see fig. 232).

A vault is a structural system for a ceiling and/or roof that is based on the arch. The simplest type of vault is a tunnel (or barrel) vault, a deep, continuous arch that can cover a large area. Although light can enter

at either end, the buttressing required to contain the outward thrust prohibits regular, large openings along the sides. For a bridge and aqueduct such as the Pont du Gard (fig. 141), however, short tunnel vaults provide a solution. The lowest row is made up of tunnel vaults that are deep enough to support the road and protect the foundation against the force of the river during spring floods. An identically proportioned row of arches provides the extra height needed for the aqueduct at the top, which is raised on much smaller arches, four over the wider central arch and three over

those to the sides. When tunnel vaults and arches are placed in rows, each neutralizes the outward thrust of the adjacent member, but those on the ends must be well buttressed, a function here performed by the riverbanks to either side. The Pont du Gard is, however, more than a remarkable surviving example of Roman engineering skill; its simple design, handsome proportions, and rhythmic subtlety make it an impressive work of art. (For other structures which utilize the tunnel vault, see figs. 124, 210, 247, and 386.)

The three great square vaults that spanned the central area of the Ba-

The Arch, the Vault, and Concrete

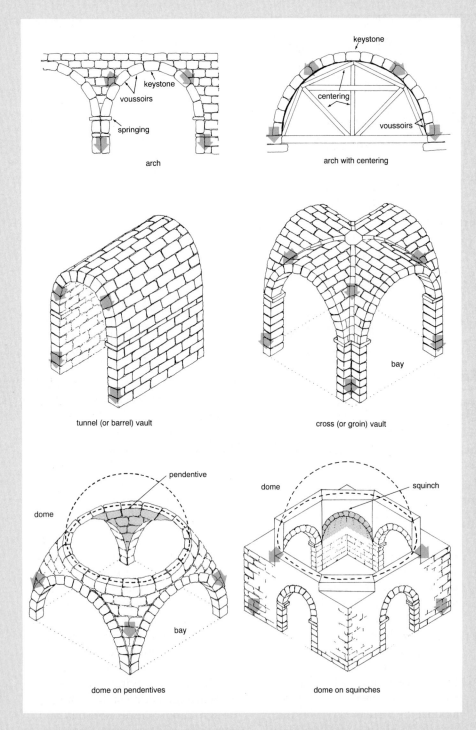

silica of Maxentius (fig. 139) were each formed by the intersection at right angles of two tunnel vaults; these are called cross (or groin) vaults. When a tunnel vault is arranged in a curving or circular configuration, it is known as an annular tunnel vault; a series of cross vaults in a curving configuration are known as annular cross vaults (see figs. 212, 224, and 230). The outward thrusts of a cross vault are concentrated at the corners, and buttressing is only required at these points. When placed in a row, as here, or in groups, cross vaults can span vast areas and still permit large windows. (For other buildings with cross vaults, see figs. 135–37, 145, 173, and 223.) The vertical members that support a cross vault are known as piers. The area between each group of piers is known as a bay.

A dome is a semi-spherical structural system that can be understood as an arch rotated one hundred eighty degrees on its axis. It must, therefore, be buttressed on all sides. The problem of light can be solved by opening the top of the dome with

140. Diagrams of a round arch, an arch with centering, a tunnel (or barrel) vault, a cross (or groin) vault, a dome on pendentives, and a dome on squinches. The arrows suggest the general direction of the outward thrusts that operate in each instance, but only the drawing of the arch demonstrates the buttressing essential in all vaulted systems.

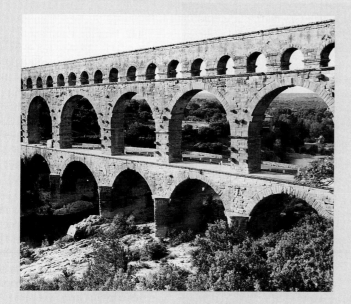

141. Pont du Gard (bridge and aqueduct), near Nîmes, France. Late 1st century B.C. Length 900'; height 162'

an oculus, as in the Pantheon (fig. 142), by piercing the edges of the dome with small windows (fig. 170) or by raising the dome on arches or tunnel vaults (see fig. 340). To attain greater height, a dome may be raised upon a drum, a cylindrical or polygonal wall that provides continuous support (figs. 287, 341).

When a dome is placed at the juncture of tunnel or barrel vaults, as occurs often in Christian church architecture (see figs. 285, 286), it must be located over a square base. The transition from the circular base of the dome to the piers or walls below has traditionally been handled in two ways. One of these is the use of four pendentives; these are curving triangular segments of a larger dome that help create a visual and supportive transition from the four supporting piers to the dome above (see figs. 170, 218). The second system uses squinches: arches, lintels, or corbels that jut across the corners to create an octagonal base for the dome (fig. 195).

In many of the finest Roman buildings and engineering projects, such as the Pont du Gard, the material used was dressed stone: each piece was cut for its specific position and no mortar was employed. Repeated arches, such as those of the Pont du Gard, meant that a certain number of stones of regularized shape could be cut, and the structure could be fabricated at the site from stones cut and marked at the quarry to indicate their specific placement.

The most revolutionary Roman innovations in arches and vaulting occur in combination with the development of *opus caementicium*— cement (fast-drying, hardening volcanic sand) used to produce concrete. Roman construction methods were transformed when the Romans began to quarry large amounts of *pozzolana*, a silicate that functioned as a natural cement, near Naples in the second century B.C. The *pozzolana* was combined with broken pieces of stone and/or brick and water to provide a building material that hardened into a solid mass. Concrete was cheap, readily available, flexible, and fire-resistant. A lightweight stone was mixed with the cement for vaults, to lighten the weight and reduce the necessity for buttressing. Cut stone and concrete were to remain the two basic building materials of Western culture until the nineteenth century.

Other materials used by the Romans include brick, mud brick, and various stones that could be quarried nearby. Near Rome two kinds of stone were common—travertine, a kind of marble, and tufa, a soft volcanic rock that hardens on exposure to air. For the finished surface of their buildings, the Romans were not satisfied with concrete, which they would usually cover with painted stucco, marble, or *opus incertum*, a facing of irregularly shaped small blocks of travertine or other stone.

The arch, vaults, and concrete were developed by the Romans precisely because they responded to the Roman demands for enormous scale, for efficiency and economy, and for flexibility. They helped to create and to convey the power and majesty of the Roman Empire.

THE PANTHEON, ROME

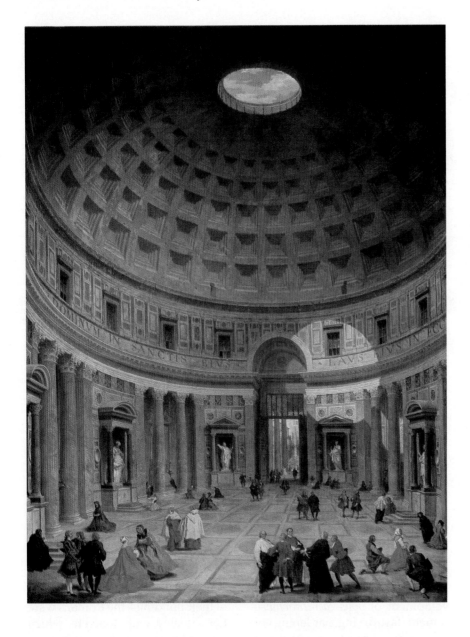

142. Interior, Pantheon. A.D. 117–125. As seen in an eighteenth-century painting by Giovanni Panini in the National Gallery of Art, Washington, D.C. (Kress Collection). Height of interior 144'. The Roman Pantheon was dedicated to all the gods of the Roman religion; its name derives from the Greek *pan* (every) and *theos* (god). The inscription on the exterior pediment ("Marcus Agrippa . . . built this") is misleading, for it refers to an earlier temple built on this site in 27 B.C. The current structure was erected by the emperor Hadrian, who, with characteristic modesty, copied the inscription from the earlier temple.

The Pantheon was regarded in ancient times as one of Rome's most distinguished temples. It joins two disparate architectural designs, a Corinthian portico and a domed rotunda (see figs. 142–44). Viewing the building from today's significantly raised street levels, the modern visitor is aware of the cylindrical walls and dome, but these were not visible in antiquity. A colonnaded forecourt and the portico, which was raised atop a flight of steps, masked these elements. The impressive entrance, with towering monolithic marble columns and huge bronze doors, gave no hint of the cylindrical walls of the rotunda. The concrete dome, the largest built in Europe prior to the twentieth century, is perfectly hemispherical, and the distance from the floor to the top of the dome is the same as the diameter of the rotunda. The interior proportions, then, are governed by the geometrical purity of a sphere (fig. 143).

A series of transverse barrel vaults hidden within the more than twenty-foot-thick walls concentrate the weight of the dome on eight massive piers. The concrete of the dome must have been poured in sections over a huge mold supported by a centering structure so complex it

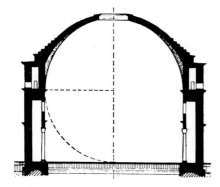

143. Section of the Pantheon, showing the stepped buttressing that contains the outward thrust of the domical vault

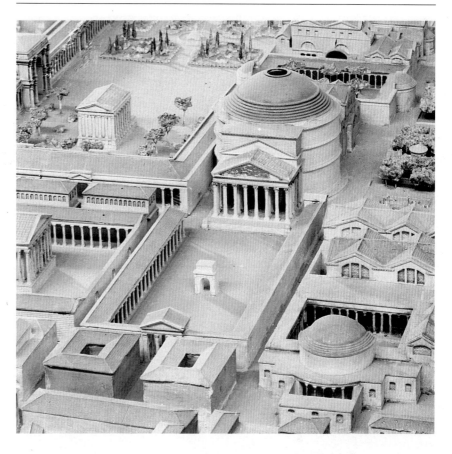

144. Conjectural reconstruction of the exterior of the Pantheon and its forecourt in ancient Roman times. Model. Museum of Roman Civilization, Rome

would have made the interior look like a dense forest of hewn lumber. The weight of the dome is relieved by a series of coffers (the recessed panels—here square—that decorate the interior surface of a vault), which also add geometrical articulation to the hemisphere. The thickness of the dome decreases from twenty feet at the springing, where it is reinforced with stepped buttressing, to only six feet at the oculus, the circular opening thirty feet in diameter at the apex of the dome. The oculus allows adequate light, and the rain which enters is drained off by small, inconspicuous openings in the floor.

The Roman gods were represented by sculptures along the walls, while the dome assumed the symbolic significance of the heavens. Perhaps the most dramatic effect of the Pantheon is the harmony it demonstrates with the natural world. As the sun passes through the sky, a natural spotlight is cast into the rotunda, progressively illuminating the interior. To the Romans, the sun symbolized the eye of Jupiter, and its penetrating presence inside the temple seemed to make the deity manifest.

The Pantheon expresses the vision of the Roman Empire. It is a technological wonder of construction—like the vast network of highways built to communicate with the corners of the empire—and materials used in its construction and decoration were transported from lands as distant as Tunisia and Egypt. The engineering achievement exhibited by the building makes possible an edifice which relates the order of Roman rule to their reverence for a universal order.

ROMAN PUBLIC ARCHITECTURE

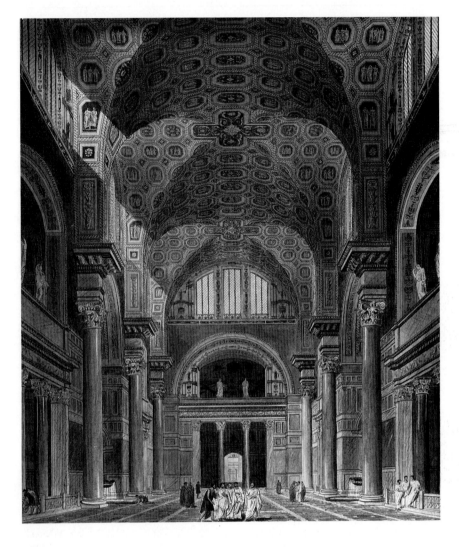

145. Central hall, Baths of Caracalla, Rome. 211–217. As seen in a restoration drawing by G. Abel Blonet

The Roman taste for grand architecture also found expression in two secular building types, the bath and the basilica. To a Roman, visiting the bath, which was built at state expense and entered for a nominal fee, was a ritual of daily life. The baths offered services which fostered both intellectual and social life. There were many baths throughout the empire, but the most elaborate were those in Rome, built by the emperor Caracalla.

The Baths of Caracalla complex covered fifty acres, and approximately sixteen hundred people could be accommodated. Initially mixed bathing was permitted, but later the sexes were segregated, with women and men bathing at different times. The plan was organized along a central axis; the *tepidarium* (warm-water pool), *calidarium* (hot-water pool, usually circular in shape), and *frigidarium* (cold-water pool) were all located on the axis (see figs. 145, 146). Gymnasia flanked the pools, and gardens, barber and hairdresser shops, libraries, and meeting rooms completed the complex. Water, transported by aqueducts from outside the city and heated by fires in basements, was passed to the pools in clay or lead pipes.

A visit to the bath usually began with physical exercise followed by a stay in the steam room. In the *calidarium* oil was used to cleanse the body. After cooling down in the *tepidarium* and *frigidarium*, a visitor would receive a massage, which completed the bath. The visitor might then take a walk in the gardens, study in the library, or attend lectures.

Lavish marble, stucco, and painted decoration embellished the interior surfaces. By the first century A.D., the Roman statesman and author Seneca, recalling the austere values of the Roman republic in *Moral Epistles*, complained that new bath structures were too ornate: "We think ourselves poor and mean if our walls are not resplendent with large and costly mirrors; if our marbles from Alexandria are not set off by mosaics ... if our vaulted ceilings are not buried in glass; if our swimming pools are not lined with Thasian marble, once a rare and wonderful sight in any temple. . . . What a vast number of statues, of columns that support nothing, but are

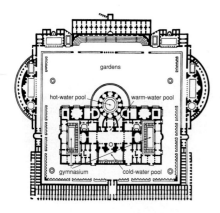

146. Plan, Baths of Caracalla

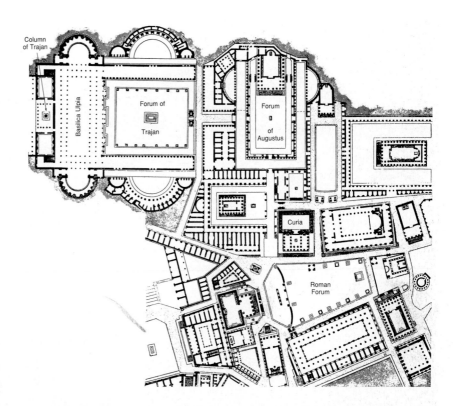

147. Plans, Roman and Imperial Forums, Rome, with the Basilica Ulpia. Compare to the reconstruction in fig. 122 and see the reconstruction of the Basilica Ulpia in fig. 138.

built for decoration, merely in order to spend money!" Most Romans would not have agreed with Seneca, for they viewed the ritual of bathing and socializing within an opulent architectural environment as one of the joys of civilized life.

Another dramatic public space created by the Romans was the basilica, which usually adjoined the forum, the public square which was the center of commercial and social activity. The Roman Forum was developed beginning in the sixth century B.C. Later, imperial forums were built by different emperors; they are unified along a longitudinal axis (see figs. 122, 147). At the northwestern end of this axis is the Forum of Trajan, with the Basilica Ulpia (fig. 138; in Roman architecture a basilica, from the Greek *basilike* [royal court], is a large building, often with an interior colonnade, used for public administration; Ulpius was Trajan's family name). Derived from earlier Greek buildings with colonnades, the basilica was entered on its longitudinal

side. The interior was divided into three areas, two side areas known as aisles or side aisles that flanked a large central axial hall called the nave (from the Latin *navis,* ship, due to its resemblance to the upturned hold of a ship). Sometimes both ends of the nave terminated with an apse, a large niche composed of a half cylinder surmounted by a half dome (fig. 139).

Given the enormous size of the building (the Basilica Ulpia is more than four hundred feet long), the Roman architect was confronted with the problem of how to light the vast interior space. To solve this problem, the wooden gable roof of the nave was raised above the aisles to

permit clerestory windows. The basilica served a variety of secular purposes for the Romans; business and administrative offices were located there and law courts met there. Often the apses contained shrines to deities. The Basilica Ulpia adjoined libraries which flanked the Column of Trajan (see fig. 126).

The Roman baths, forums, and basilicas gave the Western world a heritage of architecture and ideas. Our spas and community centers reflect the public baths on a more modest scale, while the forum survives in Italian piazzas and in our own public squares. The basilica served as the prototype for Christian churches in western Europe.

ART IN THE AMERICAS: TEOTIHUACÁN

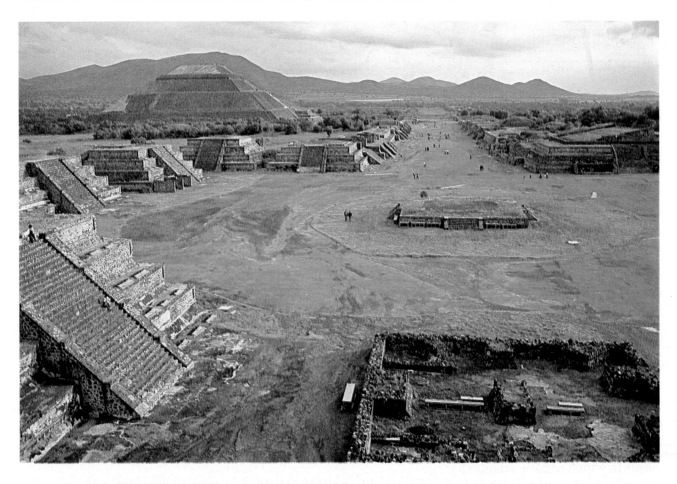

148. Aerial view of Teotihuacán, with Pyramids of the Sun and Moon, central Mexico. c. 100 B.C.– A.D. 650. The complex covers thirteen square miles.

The name of the city Teotihuacán means birthplace of the gods. Myth tells us that after the sun "died" (the sun was equivalent to an era) the gods gathered there to create a new city. Monumental architecture appeared at the site in the first century A.D. with one of the most ambitious undertakings in all of Mesoamerica—the Pyramid of the Sun (fig. 148). Built over a cave held sacred since more ancient times, the pyramid retains the stepped outline of earlier examples but here is built on a gigantic scale. The ground plan reveals a square base which

is 738 feet across. The total height, including a temple that once stood on the upper platform, is about 246 feet. Dating somewhat later in the same period is the Pyramid of the Moon. The structure is more sharply delineated on its surface and is of more modest size than its counterpart. The placement of the smaller pyramid in the northern part of the valley, on gradually rising terrain, brings the upper platform to roughly the same altitude as that of the Pyramid of the Sun.

These two edifices with their severe contours set against the

mountainous landscape on the horizon dictated the features of the city's growth. For example, the Pyramid of the Sun is oriented precisely at the point on the horizon where the sun sets over Teotihuacán the day it reaches its zenith at the summer solstice. Furthermore, the Avenue of the Dead, the city's mainline of a slightly later date, runs strictly parallel to the main facade of the Pyramid of the Sun and is perfectly aligned with the axis of the Plaza of the Moon and that of the Pyramid of the Moon. With these pyramids completed,

149. Pyramid of Quetzalcóatl
(detail of the facade with heads of
Quetzalcóatl and Tlaloc)

Teotihuacán: c. 100 B.C.–A.D. 650
320: Gupta dynasty begins to unify India
325: Council at Nicea, first ecumenical council of the Christian church
410: City of Rome is sacked

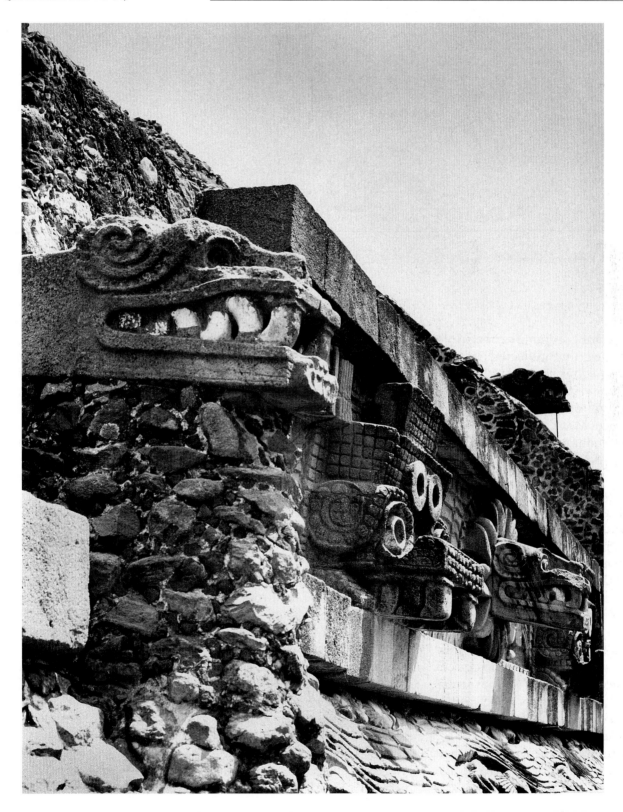

150. Representation of Tlaloc (god of rain). Fresco. Palace wall of Zacuala, Teotihuacán

a gigantic urban plan began to emerge that reflected current ideas about astronomy and the desire to identify with the semi-arid and serene landscape of this central Mexican plateau.

Fundamentals of these urban complexes were set in Meso-america by earlier peoples. The use of truncated pyramids as a temple base, the careful placement of terraces, platforms, and temples to form plazas, the skill at handling open spaces using fixed axes (probably set according to symbolic considerations) were constant from earlier periods. Such monuments are not strictly architectural since they do not function as enclosures of space; rather, they work as sculpture, with exterior space acting as a constructed, environmental art form.

Teotihuacán was an urban center which at its peak in the second and third centuries A.D.

attained a maximum population of about two hundred thousand. Teotihuacán was the civic, religious, political, and economic center for all the surrounding valleys. Also in the city were foreign enclaves, thousands of artisans in the marketplaces, and a ritual center of immense, monumental proportions. During religious festivals the city population would swell even more with pilgrims.

A second stage of building at Teotihuacán began between the second and third centuries A.D. and reflected an abrupt spurt in urban growth. The Avenue of the Dead was laid out then, and around it arose a number of ceremonial complexes. Residential sectors which were once mainly to the northwest of the two great pyramids then began to grow in all directions—outward from the Avenue of the Dead and from the broad East and West avenues

perpendicular to it. During this period an important architectural refinement was initiated, the *tablero,* a heavy, projected, rectangular molding outlined by a thick frame. This detail appeared on all religious structures whether a simple altar, ceremonial platform, small temple, or majestic pyramid.

Perhaps the most splendid example of the *tablero* is on the Pyramid of Quetzalcóatl, the plumed serpent (fig. 149). The enormous heads of Quetzalcóatl emerge from the *tableros* and alternate with heads of Tlaloc, the deity associated with water and rain whose cult apparently flourished in semi-arid Teotihuacán. Polychromed reliefs of undulating plumed serpents and seashells added to the ornamental richness of the structure. The plumed serpent, here associated with marine symbols and with the god Tlaloc, also must have been a central deity. Aside from the symbolic and aesthetic appeal of the Pyramid of Quetzalcóatl, its structure is based on technological advances. For example, the entire nucleus of the pyramid is reinforced with a skeleton of limestone. The colossal heads are deeply anchored

into the core of the *tableros* and show an incredible sophistication in the joining of stone, since use of hard metal tools was not known to these builders.

The plan of the entire city is noteworthy for its regularity of city blocks and the density of residential sectors. Apparent is the rechanneling of rivers, the existence of large reservoirs, steam baths, specialized workshops, open-air markets, administrative buildings, theaters, and areas set aside for ball games and other public functions. The layout of the city was regular and based on a module of 187 feet, which formed the standard blocks in residential areas. Multiples of the module apparently formed other compounds in the city as well and divided it into a grid which suggests the existence of rather rigorous city planning as well as a centralized ruling group, both spiritual and tem-

poral. The Palace of Zacuala— an excellent example of what must have been the luxurious residence of a rich Teotihuacán merchant or high functionary— included a chapel decorated with brightly colored mural paintings depicting Tlaloc (fig. 150). The opulence and spaciousness of the palace attest to the existence of a powerful upper class and to the importance of spiritual devotion in connection with that wealth.

Teotihuacán was apparently the most highly urbanized center of its time in the New World. The life-span of the center was roughly from 500 B.C. to A.D. 650. This period left a spectacular mark on Mesoamerica, with high points reached at Teotihuacán as well as at Monte Albán in Oaxaca and in the Maya region. Each had a planned urban center with astronomical orientation for streets and buildings, monumental architecture, and intellectual

achievements such as the perfection of the calendar, mathematics, writing, and astronomy (the latter especially among the Maya). This was a splendid age of the arts and architecture which was reflected in the pyramid-temples at Teotihuacán and Tikal, in mural painting, ceramics, and mosaics. Professional people and artisans were organized into guilds. Traders were also well organized, and in large and efficient markets goods from many regions were exchanged. Merchants carried such items as feathers of exotic tropical birds, cotton, cacao, jade, and turquoise into Teotihuacán. The society was sharply stratified, militaristic, and theocratic. The predominance of religious representations in Teotihuacán as well as the presence of altars in the central courtyards of each house testify to the importance of religion in this community. Religious, civic, and secular activities were joined in the centers, which supported priest-chieftains, nobles, merchants, poets, musicians, actors (who were highly respected and took part in religious and secular ceremonies), artists, laborers, farmers, servants, and slaves.

NORTHUMBRIA

Dublin•

•Lindisfarne

•Durham

York•

North
Sea

Cambridge•

Oxford•

•Sutton
Hoo

Winchester•

•Canterbury

London•

•Hildesheim

Amiens•

Aachen•

SAXONY

•Cologne

Bayeux•

Beauvais•

•Laon
•Reims

Chartres•

•Paris

Prague•

St. Denis•

•Tours

Bourges•

•Vézélay

Vienna•

•Autun
•Cluny

•St. Gall

Budape

Santiago de•
Compostela

Alps

•Milan

Padua•

•Venice

Bologna•

•Conques

•Ravenna

•Florence

SER

Atlantic

Ocean

Pyrenees

Tahull•

Adriatic Sea

Belg

•Toledo

•Rome

•Cordoba

•Granada

M e d i t e r r a n e a n

Atlas Mts.

ALGERIA

•Palermo
SICILY

Baltic

LIBYA

0 400 miles

ART FROM 200 T0 1400

INTRODUCTION

In its gigantic public scale and complex subject matter, the Hindu relief at Mahamallapuram (fig. 151) can exemplify the religious art that was produced in many centers throughout the world in the period between the third and fifteenth centuries. During this period, which in Europe is known as the Middle Ages or medieval period, religions such as Buddhism, Christianity, Hinduism, and Islam expanded far beyond their places of origin to find tremendous increases in numbers of followers. New centers with significant monuments were dedicated to serve the needs of religious practitioners, including priests and other members of religious hierarchies and the common people.

The site of Mahamallapuram, in south India on the shores of the Indian Ocean, was a pilgrimage center for Hindu believers. On gigantic natural outcroppings of granite, sculptors carved shrines and reliefs of immense proportions. The *Descent of the Ganges* is carved on the face of a cliff above which is a natural pool. During the rainy season, the overflow cascades down the natural cleft to be collected in a pool at the base. Over millennia this cleft has been smoothed by the flowing action of the water.

The natural phenomenon of the cleft may have inspired the Hindus, who sculpted the cliff with the creation story. Although the iconography of specific details is still much debated, all action focuses attention on the cleft near the center. This water is usually identified with the river Ganges, one of the three sacred rivers of India and thought to have life-giving powers. Representatives of all the living beings of the world—deities of the river, elephants, lions, gods, human beings, and even a cat and mice—are assembled on this great carving. The god Siva, one of the major manifestations of the godhead in the Hindu religion, appears several times to symbolize the destructive and creative conduct of nature.

In contrast to the Hindu relief is a small Christian object shaped like a church (fig. 152). The Christian content is evident in the iconography of the reliefs, which feature Old Testament prophets, Christ, and the apostles, as well as scenes from the life of Christ, including the crucifixion. This object functioned as a reliquary—a container for the bones of a holy person or for objects associated with that person (see also fig. 207). Reliquaries were displayed to the faithful, who hoped to benefit from the proximity to holy things.

HISTORY: GROWTH OF A WORLD CULTURE

The growth of powerful proselytizing religions was only one manifestation of worldwide change during this long period. A number of

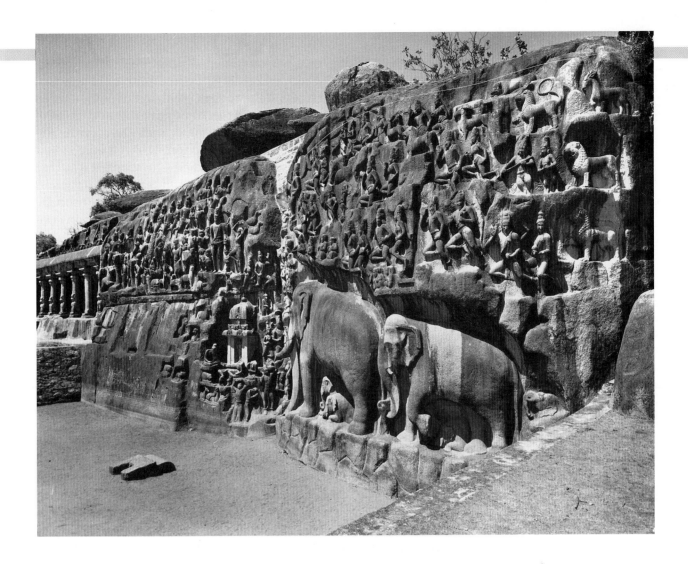

151. Indian. *Descent of the Ganges,* Mahamallapuram, India. c. 625–74 (Middle Pallava period). Carved on a granite cliff, height 20'

important political entities flourished at this time, including the Gupta rule in India; the successive Han, Sui, and Tang dynasties in China; the Maya and Aztecs in the Americas; and the Carolingian, Ottonian, Romanesque, and Gothic cultures in Europe. There was commercial, intellectual, cultural, scientific, and religious exchange on a large scale. This period saw the silk routes of commerce flourish between east and west. Marco Polo, the Venetian who visited the court of Kubla Khan in China, is only one of the many examples of contact between vastly different cultures that characterizes the period. Islam preserved much of ancient Greek and Roman literature and philosophy and then reintroduced them into European culture at the end of the Middle Ages. Islamic science, mathematics, and medicine became well known in Europe at the same time. Scientific advances included astronomical investigations in India and Mesoamerica and the invention of gunpowder in China. Other inventions were the wheelbarrow, the compass, paper, and the spinning wheel. Practical, labor-saving inventions meant that there was less need for the slave labor that had characterized much of the ancient world. As large and powerful cultures and religious traditions developed, there was also contact through wars, including the religious and commercial wars known as the Crusades. An increased awareness of diverse cultures was a hallmark of this period.

The term Middle Ages was invented during the Italian Renaissance to designate for European culture the interim period between the "new" Renaissance age and the ancient civilizations of the Greeks and Romans. The Middle Ages were then thought to be an interval of darkness and cultural inactivity. Historians today recognize the vitality of the Middle Ages or medieval period, which is considered to extend from the second century A.D. (when Christian art was first produced) until the fourteenth or early fifteenth century in Italy, and even later in northern Europe. (This term has also been used by Western scholars, perhaps inappropriately, to describe certain contemporary phases of Indian and Chinese art.)

WORLD RELIGIONS

The spiritual content of Christianity, which played a crucial role in forming the life and culture of the Middle Ages in Europe, is difficult to summarize, in part because of the many different interpretations of Christian belief that have developed. Christianity, a religion of salvation, emphasizes the inner, spiritual life, offering the promise of life after death for the soul in Paradise. Medieval Christianity emphasized belief in a single God understood as a Trinity, an indivisible unity of three persons: God the Father, the creator; Jesus Christ, his son, who assumed human form in the Incarnation; and the Holy Spirit, who is believed to be continuously active in the world. Jesus Christ is held to be the son of God, who was born to a pious woman known as the Virgin Mary. He died by crucifixion after being charged with blasphemy. Medieval Christian art often depicted the Last Judgment (see figs. 214, 215, 246), when Christ would come at the end of time to judge humanity.

The Hindu religion developed a complex set of stories to explain the workings of nature, and especially fertility and procreation. The traditions emphasize a single godhead which is capable of an infinite number of manifestations, assuming male, female, animal, and mixed animal and human forms. In personal terms the most important aspect of Hinduism is the belief in reincarnation—every individual will return to life as another living creature. Good behavior in one life will lead to a higher state of existence in the next. The religion is thought to have combined ancient beliefs about fertility with ideas derived from social customs such as hierarchy and caste. The highest order of gods is a trinity: Brahmin the creator, Vishnu the preserver, and Siva the destroyer. Images of these deities and many others and their multitudinous activities were thought of as aids in contemplation and as a focus for identification. The southern Hindu tradition, as at Mahamallapuram, and its art forms were passed along the trade routes across the seas to Cambodia and Indonesia.

Buddhism is based on the life and teachings of Siddhartha Gautama, who became an ascetic and emphasized that his followers should eliminate desire in order to achieve *nirvana* (see p. 113). Islam is a monotheistic religion based on a book of holy writings, the Koran, compiled by the prophet Mohammed in the sixth century A.D.; the prac-

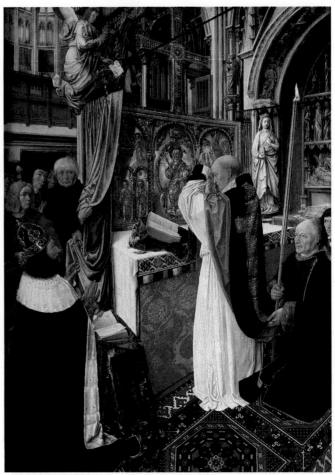

titioners of this religion are known as Muslims. God is known as Allah, and among the prophets whose writings and/or lives are included in the Koran and other Islamic writings are Abraham, Moses, Christ's mother Mary, Christ, and Mohammed (see pp. 194–97).

EUROPEAN MEDIEVAL ART

Although a unified style cannot be defined for all European medieval art, many medieval works offer a stylistic treatment that emphasizes Christian spiritual values accompanied by an intentional denial of the ancient classical traditions of naturalism, individualism, and illusionism. This is a broad generalization that offers some unity to the art produced in the diverse styles of the medieval period in Europe. In addition, the great majority of surviving European medieval works of art are directly related to and created for the rituals and practices of the Christian church.

THE MEDIEVAL ARTIST

In Europe there are few signed works of art during the medieval period before the last, or Gothic, period. The individuality of the artist

152. Left: German. *Reliquary in the Shape of a Church.* Probably made by a workshop in Cologne, Germany. c. 1170. Gilt cast bronze, enamel, and walrus ivory reliefs on a wooden core, height 21 1/2". Victoria and Albert Museum, London. This reliquary was originally in the convent of Hochelten in the Lower Rhine region.

153. Right: **MASTER OF ST. GILES** *The Mass of St. Giles.* c. 1500. Oil on wood, 24 1/4 x 18". National Gallery, London. A late-fifteenth-century painter here represents a ninth-century miracle taking place at an altar at the Church of St. Denis, near Paris.

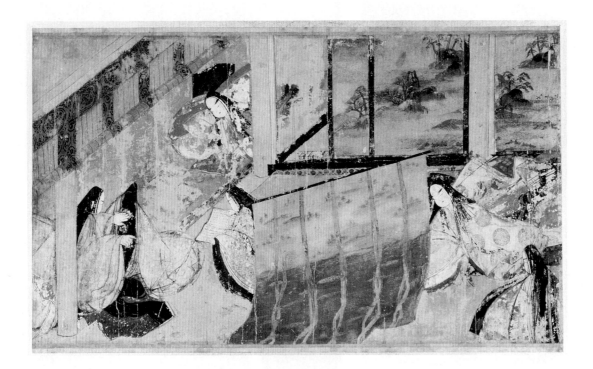

154. TAKAYOSHI (attributed)
First illustration to the "Azumaya" chapter of *The Tale of Genji.* 12th century (Late Heian period). Hand scroll, ink and color on paper, height 8 1/2". Tokugawa Art Museum, Nagoya, Japan. The world's first novel, written in Japan by Lady Murasaki, is called *The Tale of Genji.* It recounts the amorous adventures and intrigues of the young prince Genji at the court. This illustration shows a group of court women and their attendants. Naka no Kimi is having her hair combed after washing, while her half-sister, Ukifume, faces her and looks at picture scrolls and an attendant reads the accompanying text. That there had been an attempt to seduce Ukifume only hours before is not explicitly illustrated, for the painter describes a scene of refined activity.

was not an issue during a period in which individuality generally was denigrated; many of the most important medieval works were, in fact, produced by groups of artists and artisans working together. The artists of the Middle Ages included an important new class of artist: monks and nuns who, living within monastic communities, joined artistic productivity with the religious life. In Europe the crafting of manuscripts and other liturgical objects was such an important activity that abbots of monasteries and even bishops would continue to be active as artists after they had risen in the ecclesiastical hierarchy. But there were also many lay artists, who lived in the cities and were not connected to any religious order. By the tenth century we have evidence that lay artists were organizing themselves into professional organizations, rather like trade unions, called guilds.

In non-European cultures during this period, the artists worked in groups, and the large endeavors required by religious practices were produced by workshops of artists and laborers. There are isolated instances of signed works, but these are not common. The main exception to this attitude toward the artist is in China, where the status of the artist as a scholar-intellectual working within the court means that the majority of works are signed (see pp. 33, 188–91).

ART AND THE CHRISTIAN CHURCH

In Europe the dominant medieval institution—culturally, educationally, spiritually, and often politically—was the Christian church. In both east and west, some Christians withdrew from the world into monasteries and nunneries to follow a life of work and prayer. The

church developed a ruling hierarchy headed by the pope (the bishop of Rome, the first of whom had been St. Peter) and local bishops, and which included the heads of monasteries and nunneries. The expanding institutions and hierarchy of the church created a great demand for works of art.

Christianity developed a series of rites and services known as the liturgy. The central Christian rite was the mass or eucharist, a service at which the Last Supper was reenacted and salvation for repentant believers was promised. By the early fourth century this service was usually held in a church at an altar, which became the focus for the ritual and for works of Christian art. A painting (fig. 153) demonstrates the rich decoration at a medieval altar. The priest, dressed in elaborately decorated vestments, stands at an altar with a bejeweled cross, a gold altarpiece, and a brocaded altar frontal. He raises the host, a consecrated piece of bread that stands for the body of Christ. (Missing from this representation is a chalice, the vessel which held the wine standing for Christ's blood; see fig. 225.)

THE SCROLL AND BOOK

In the painting depicting the mass, an open book is prominent on the altar. The hand-lettered, decorated manuscript played an important role in Christianity and Christian art during the European Middle Ages. The Bible, the holy book of Christianity, was held to be a compendium of divine proclamations and a record of God's actions in history. It has two sections: the Old Testament, which encompasses the books of the Jewish faith, and the New Testament, composed of four versions of the life of Christ (the Gospels, written by the Evangelists—Matthew, Mark, Luke, and John) and other writings. Throughout the Middle Ages, Bibles, service books, and private prayer books were written by hand—usually on treated animal skins (vellum or parchment)—and, because they represented the word of God, they were richly adorned with fine materials and were illustrated.

Illustrated and decorated manuscripts were also an important part of religious and secular traditions in other parts of the world. Islam avoided the representation of the human figure, but copies of the Koran were decorated with spectacular calligraphic decorative patterns (fig. 372). In the Far East, novels and religious tracts were written on hand scrolls, which unrolled from right to left. Readers held the scrolls in both hands; only a small portion of the scroll was visible at any one time. The manner in which Takayoshi painted the scene illustrated here (fig. 154) is a calculatedly decorative one, using the screens, walls, and sliding panels typical of an aristocratic Japanese house to break up the composition. Such angular placement of shapes and the use of colors both bright and subtle create an agitated mood perhaps reflecting the earlier events of the day. This style of painting was called *yamato-e* (Japanese picture). The metered control with which pictures such as this were designed and executed led to a highly refined and yet vital painting style identified by the Japanese as a native style of art.

JEWISH ART: THE SYNAGOGUE AT DURA EUROPOS

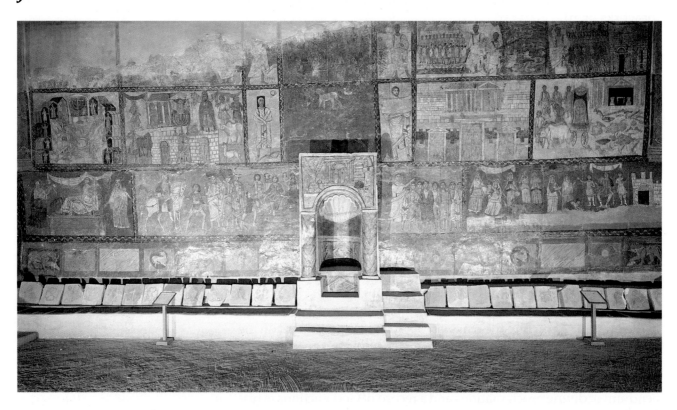

155. West wall, with the Torah niche, Synagogue, Dura Europos. Erected 244/245. Tempera on plaster, length of wall approx. 40'. Reconstruction in the National Museum, Damascus. The Roman frontier city of Dura Europos in Mesopotamia was a crossroads and minor trading center which has provided rich archaeological information, especially in its several places of worship, including a synagogue, a Christian site with a baptistery with frescoes, and temples to Bel, Zeus, and Mithras. The Torah niche is decorated with a shell, a motif taken from Roman art, where the shell is often used to signify a holy place. In this niche are placed scrolls that contain the first five books of the Bible, the sacred writings of Judaism. Attributed to Moses, these books contain the basic rules and regulations that are the basis of the Jewish faith, including the Ten Commandments, which tradition holds were given to Moses by God on Mount Sinai.

Discovered in 1932, this synagogue (fig. 155) astonished archaeologists and scholars, for its capacious house of assembly had, quite unexpectedly, figurative decoration: a complicated sequence of paintings of Old Testament scenes in bands around all four walls and a ceiling of tiles decorated with personifications, astrological subjects, animals, flowers, and other themes. Both scripture (the second of the Ten Commandments: "You shall not make for yourself a graven image [idol], or any likeness of anything that is in heaven above, or that is in the earth below, or that is in the water under the earth") and historical writings seem to imply that it is unlawful for Jews to make or have images. That this prohibition was not followed by all Jews is revealed by archaeological excavations at Dura and elsewhere and by Jewish books from the Middle Ages, such as the many beautifully illustrated Passover *Haggadah*s. The cycle at the Dura synagogue includes such scenes as Solomon receiving the Queen of Sheba, David as King of Israel, Moses receiving the Law, the Consecration of the Temple, Moses leading the chosen people out of Egypt, Mordecai and Esther, Moses and the Burning Bush, Exodus and the Crossing of the Red Sea, and even a cityscape with a representation of Jerusalem and the Temple of Solomon.

The Jewish religion is monotheistic and is based on the worship of Yahweh, or God. The origins of Judaism are traced to a covenant made between God and

Abraham, in which God promised Abraham that he would give him a mighty race of descendants and a Promised Land if his followers would stop worshipping idols. The emphasis in the services held in the synagogue and at home is on the telling of Jewish history, the reading of the laws, and the interpretation of those laws. Judaism has a strong scholarly tradition, and it is possible that the extensive narrative cycle in the Synagogue at Dura Europos was used in part as an educational tool, to illustrate and teach the history and laws of the religion.

In terms of art, Dura Europos was an unimportant provincial city, and the conventions of the figures and the use of iconographic stereotypes well known from other sites suggest that the Dura cycle was derived from a pattern book—a book of images, prepared as an artist's tool, which preserved a tradition of illustrated scenes, in this case from the Old Testament. In *Moses Giving Water to the Tribes* (fig. 156), Moses stands in a relaxed *contrapposto* position derived from ancient Greek and Roman art, but the schematic nature of the composition, with smaller figures representing the tribes of Israel placed evenly around the edge of the scene, and the unrealistic manner in which streams of water reach out to each tent are consistent with developments in Early Christian art. The Jews, a small minority at Dura, created an impressively decorated synagogue which expresses their piety and the dignity of their traditions.

Synagogue paintings, Dura Europos: 244/245
212: Roman citizenship is granted to every free born subject in the empire
248: Games celebrate the one thousandth anniversary of the founding of the city of Rome
250: Chinese invent gunpowder
250: *Arithmetica* by Diophantus of Alexandria includes first book of algebra

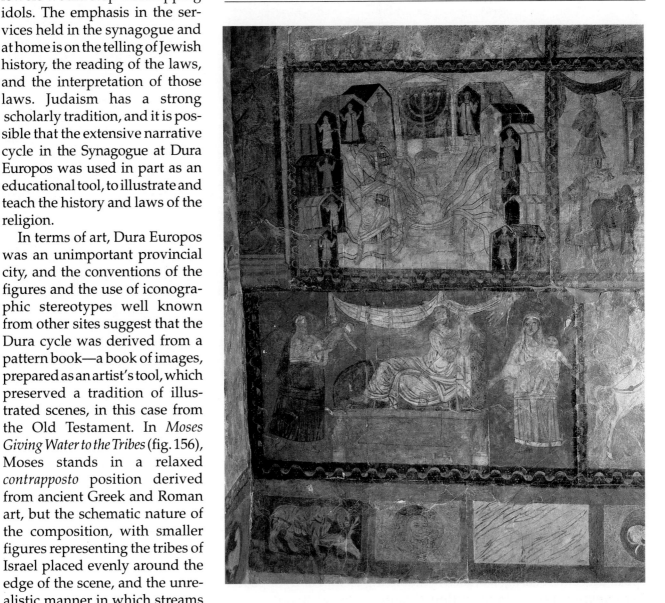

156. *Moses Giving Water to the Tribes* and *Elijah Revives the Widow's Child* (detail of fig. 155). The figures are smaller than lifesize. *Moses Giving Water to the Tribes* depicts Numbers 21:16–18, when a well was dug after God told Moses to "gather the people together, and I will give them water." In a continuous narrative that represents the widow twice and the child three times, *Elijah Revives the Widow's Child* shows the widow of Zarephath presenting her dead child to Elijah, Elijah resuscitating it, and the widow holding the revived child (I Kings 17:8–24).

Introduction to Early Christian Art

The Three Hebrew Children in the Fiery Furnace from a Christian cemetery (fig. 157) represents the Old Testament story of righteous Hebrew children who were saved by God after being thrown in a furnace for refusing to worship pagan idols. Three frontal figures, their arms raised in a position of prayer, stand amid flames. Their pleas for deliverance are answered, and a dove, symbolic of the Holy Spirit, descends bearing a branch symbolizing victory and/or peace. The message of the painting is direct: faith brings salvation.

Catacombs, underground burial complexes used by both Christians and pagans, were originally known by the Greek *coemeteria* (places of rest, from which we derive our word cemetery); later, the term *catacomba*, which initially referred to a specific cemetery in Rome, came into general use. The walls of the narrow, labyrinthine passages in the catacombs, cut from soft rock, had horizontal niches to hold the bodies of the deceased. Larger chambers, also underground, were used for funerary rites. Catacombs were not secret

157. *The Three Hebrew Children in the Fiery Furnace.* Early 3rd century. Fresco, approx. 20 x 30". Catacomb of Priscilla, Rome

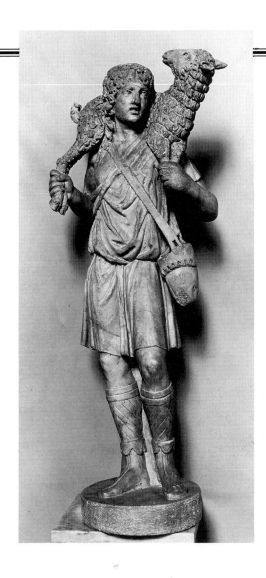

158. *Good Shepherd.* Late 3rd century. Marble (restored), height 39". Vatican Museums, Rome

burial places, as legend has it, although they may have been used as hiding places during times of Christian persecution.

The painting of *The Three Hebrew Children* expresses the faith of the early Christians by promising divine salvation in time of need and suffering. The Old Testament story was perceived as a precedent for New Testament teachings. Christians understood Christ as the Messiah who fulfilled the prophecies of the Old Testament, and theologians and artists often associated the two religious traditions. The style of the painting is suggestive and animated, continuing a Roman manner of painting using loose paint and flowing brushstrokes. Some modeling is used, but the strong outlines flatten and dematerialize the figures, and the emphasis on their large eyes enhances the spiritual intent.

HISTORY

A few years after Christ's death and resurrection, Paul (originally named Saul), a Jew who had persecuted Christians, was converted to the new faith (see fig. 394). He zealously preached the message of

Christ, converting many to Christianity. By about A.D. 40, the term Christian was first used to designate these followers of Christ's teachings, and about A.D. 70–80, when the Gospels of the New Testament were being written, Christianity broke decisively with Judaism.

By the early second century, an internal structure and hierarchy were being formed within the church, and liturgical rites for worship were developed. Although subject to periodic and often vicious persecution, the new religion, with its emphasis on spiritual values, spread rapidly. In a letter written to the Roman emperor Trajan in 110, Pliny the Younger warned of this "extreme superstition. . . . Many of all ages, of all ranks, of both sexes, are being brought into danger, and will continue to be brought. The blight of this superstition has not been confined to towns and villages; it has even spread to the country."

EARLY CHRISTIAN ART

Early Christian art (c. A.D. 150–400) developed gradually, in part because of intermittent persecution. Stylistically the new art was initially dependent on Roman and Hellenistic sources. In many cases only the Christian subject matter indicates its religious function. Early Christian artists worked in a diverse range of media. Painters not only decorated church and catacomb walls but also created book illustrations. Sculptors made marble sarcophagi and ivory carvings. A favored medium for church decoration was mosaic.

One house at Dura Europos was converted for Christian services in 231. It included a baptistery with an image of the Good Shepherd (from the parable in Luke 15:3–7) above a scene of Adam and Eve in the garden. Here Old and New Testaments are intellectually related—the Good Shepherd becomes a reference to Christian redemption, overcoming the sin of Adam and Eve. The Good Shepherd image appears often on Early Christian sarcophagi and reliefs, and even as single figures (see fig. 158), but it is uncertain whether these beardless youths represent Christ as the Good Shepherd or the more general concept of God caring for his flock. In any case, the humble modesty of the figure is consistent with the spirit of early Christianity.

THE EARLY CHRISTIAN ARTIST

Early Christian artists were challenged to express the promises and mysteries of their new faith. As in ancient Roman art and in most later medieval art, artists were laborers who worked in a communal situation, and their works are anonymous. They created the means to communicate the ideals of Christianity as it changed and became more public. These anonymous artists, at once conventional and innovative, helped effect a transition from the ancient to the medieval world.

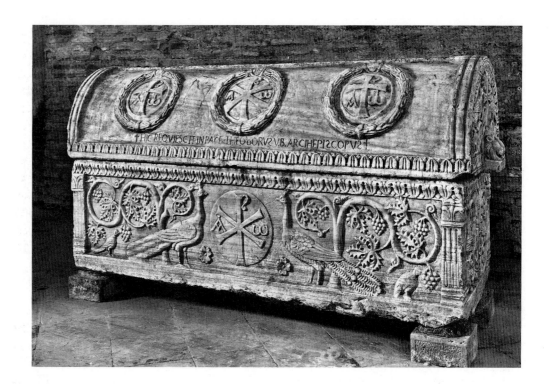

CHRISTIANITY AND SYMBOLISM

From Judaism, Christianity inherited a disposition against representing the divinity, an attitude which was also supported by Christian criticism of the pagan practice of worshipping idols. As questions arose about the appropriateness of figurative art in the early church, a vocabulary of symbols was developed to express abstractly the tenets of the new faith. For example, the anchor, referred to in Paul's letter to the Hebrews (6:19), became a symbol of resolution and hope, while the first two letters of the Greek word for Christ, X and P, were combined to form a monogram of Christ [☧]. The fish became a symbol for Christ because the first letter of each word in the phrase "Jesus Christ, Son of God, Savior" forms the Greek *ichthus*, fish.

Christian symbols alluding to salvation were especially prominent on funerary art, as seen in the later, Byzantine *Sarcophagus of Archbishop Theodore* (fig. 159). Ancient legend held that the flesh of the peacock was immune to decay and that its feathers contained the complete spectrum of colors; thus the peacocks flanking the ☧ monogram symbolize eternity. The A, alpha, and Ω, omega—first and last letters of the Greek alphabet—are placed like ornaments hanging from the ☧ monogram and crosses because Christ said, "I am Alpha and Omega, the beginning and the end" (Revelation 1:8). The curving vine and grapes refer both to God's relationship with his people ("I am the vine, you are the branches"; John 15:5) and to the wine used in the mass. The wreaths on the lid, an ancient Greek and Roman motif that refers to victory, enclose Christian symbols, suggesting the soul's desire to triumph over death.

159. Byzantine. *Sarcophagus of Archbishop Theodore.* 7th century. Marble, length approx. 72". Sant'Apollinare in Classe, Ravenna. This Byzantine work continues the tradition of symbolism of the Early Christian period.

EARLY CHRISTIAN ARCHITECTURE

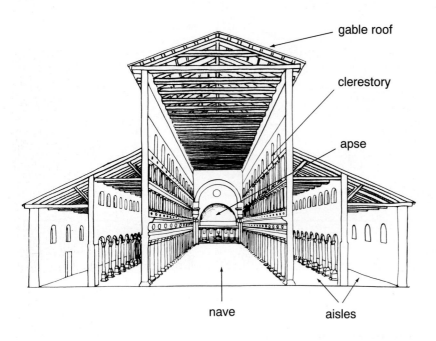

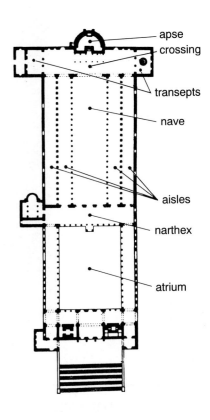

160. Nave, Old St. Peter's Basilica, Rome. Reconstruction. c. 333–390. Interior approx. 368' in length. This original basilica was demolished in the sixteenth century, when today's imposing edifice (figs. 337–41, 403–4) was begun. The earlier church then became known as Old St. Peter's.

161. Plan, Old St. Peter's Basilica

Old St. Peter's Basilica served as a prototype for developments in Christian architecture (figs. 160, 161). The plan was initially adapted from the Roman basilica (see fig. 138), which was usually entered on its long side, but the Christian church was entered through an atrium and narthex (entrance hall) on its short side. This narthex is usually on the west, and the altar was toward the east, an orientation followed in most later medieval churches.

The interior division of space, with a nave flanked by side aisles, is similar to certain Roman basilicas. Old St. Peter's has transepts (from the middle Latin *transseptum,* meaning transverse enclosure), a feature that will become traditional in Christian churches. These architectural spaces, extensions to the north

and south, meet the nave at the crossing. Transepts create a cross shape; the term cruciform (cross-like) basilica designates Early Christian churches with transepts. At St. Peter's, as in many Roman basilicas, wooden trusses supported a gable roof, and clerestory windows allowed light to illuminate the nave. The columns used at Old St. Peter's were taken from earlier Roman buildings; materials thus reused are known as *spolia* (Latin for spoils).

The size of Old St. Peter's mirrors the triumphant attitude of Christianity following the Edict of Milan in 313, which granted religious freedom to the Christians. Constantine realized the unifying strength that the newly recognized religion could bring to his reign. Many privileges, including tax exemptions

and donations of land and money, were granted the church. Constantine personally contributed to the construction of St. John Lateran in Rome (begun 313), which marks the first use of the basilica plan for Christian architecture. Constantine's support was further evidenced by his decision to build Old St. Peter's, which was both a *martyrium* (built over the grave site of St. Peter, it marked and commemorated his martyrdom) and a basilica used for worship. It is believed that the development of the transept at St. Peter's derived from the need for additional space for worshippers and pilgrims around the shrine and a desire to separate Peter's grave from other tombs in the nave.

Old St. Peter's had a plain brick exterior, but the interior

Old St. Peter's Basilica, Rome: c. 333–390
312: Constantine, after having a vision of the cross, defeats Maxentius
410: Goths sack Rome

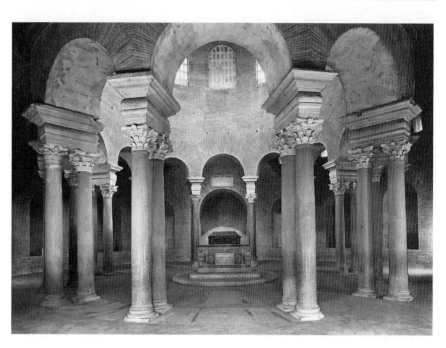

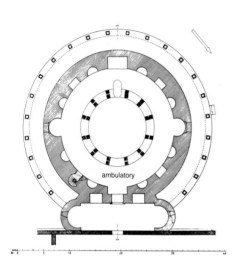

162. Plan, Santa Costanza

163. Interior, Santa Costanza, Rome. c. 354

was adorned with precious materials, including marble Roman columns, mosaics, and frescoes. The decorated interior contrasted with the exterior, reminding the visitor that the beauty of the inner spirit was more important than external, physical adornment. From the entrance, one's attention was focused on the high altar, set below an enormous arch on which a mosaic depicted Christ, St. Peter, and the emperor Constantine with the inscription: "Because under Your guidance the world rose triumphant to the skies, Constantine, himself a victor, built You this hall."

In the apse, where in a Roman basilica a statue of the emperor might be located, another mosaic displayed an enthroned Christ flanked by Sts. Peter and Paul. A reference to Christ as the supreme judge is thus found at a point where, in a Roman basilica, law had been dispensed. (In some churches the *cathedra*, or throne, of the bishop was set in the apse. These churches, the residences of bishops, are called cathedrals.) With the support of Constantine, who probably converted to Christianity near the time of his death, the flourishing Christian faith adapted the architectural forms and imperial symbolism of ancient Rome.

Another type of design adapted by the early Christians was the centrally planned structure, in which all parts of a building radiate from a central point. It was used for baptisteries and mausoleums. Santa Costanza exemplifies the centrally planned structure (figs. 162, 163). Built about 354 as a mausoleum for Constantia, daughter of Constantine, it features a central altar within a ring of paired columns that support the dome and clerestory and create a circular corridor between the domed space of the altar and the exterior walls. This passage, which at Santa Costanza was barrel-vaulted and decorated with mosaics, is called the ambulatory (*ambulare*, to walk). Four large niches in the walls define the shape of a Greek cross (a cross with four equal arms). The cross circumscribed by the circular plan symbolized salvation and eternal life for the Christian and was thus an appropriate design for a Christian tomb.

THE SHINTO SHRINE COMPLEX AT ISE

164. Shinto Shrine complex. Aerial view of Naiku (Inner) Shrine complex, Ise, Japan. Established in the late 5th to early 6th centuries. Ise, the name of the city in central Japan where the shrine is located, is used to refer to all the shrines collectively, as well as to the land on which they are situated.

Shinto is the indigenous religion of the Japanese people. The focus of Shinto is reverence for *kami*, a term used to describe both deities and the numinous quality perceived in such natural objects as trees, rocks, waters, and mountains. The spirits of deceased emperors, heroes, and other famous persons are revered as *kami*. *Kami* receive tribute at shrines in the form of food offerings, music, dance, and the performance of such traditional skills as archery and sumo.

The Ise complex includes the Naiku (Inner) Shrine (figs. 164, 166), which houses the sun goddess Amateratsu Omikami, the divine ancestor of the Japanese emperors, and the Geku (Outer) Shrine, which is dedicated to a local god. From ancient times this area has been a sacred place and pilgrimage site; it is the recognized seat of the ancestral deities of the imperial house and in modern times, under State Shinto, it has become the shrine of the entire Japanese nation.

The initial construction of the Inner Shrine is thought to date from the late fifth to the mid-sixth centuries. Because only members of the imperial family worshipped there, Ise became the center for imperial rites. In the elaborate annual ritual calendar, the Niiname-sai (first fruits festival) and the Daijo-sai (enthronement ceremony), during both of which the emperor offered pure food to the deities and consumed a ceremonial meal that the deities were thought to share, were the most important.

The *shoden* (fig. 165)—or main sanctuary of the Naiku complex—and other shrine buildings are erected in an ancient style of architecture using undecorated wooden members and a simple, thatched roof. They are raised above the ground on wooden piles, a custom associated with the humid climate of Oceania, which is thought to be the origin for this style of construction. The natural, unadorned materials of the building are believed to represent a sympathetic association between nature and architecture. According to a tradition originating with the emperor Temmu (reigned 673–86), the shrines are rebuilt every twenty years in order to approximate the cycle of growth and decay in nature. Although the custom fell into disuse in the Middle Ages, the latest rebuilding at Ise took place in 1973 and repeats precisely the laterally symmetrical, three-by-two bay plan of the earliest structure of the *shoden*, dating from 690–97.

The seasonal changes that had special significance for early cultivators greatly affected daily life in prehistoric Japan. Farmers depended on *kami* (spirit forces) to help them. They propitiated the *kami* to ensure the success of their seasonal activities: sowing, planting, harvesting. A sacred annual cycle was observed, and the rituals of *kami* worship were the mainstay of everyday activity.

Shinto Shrine complex, Ise: c. 500
444: The wheelbarrow is invented by the Chinese
488: Attila becomes leader of the Huns
c. 517: Buddhism is introduced to central China
529: Academy founded by Plato in Athens is closed
538: Buddhism is introduced into Japan

165. Front elevation of the *shoden.* Earliest structure 690–97; rebuilt 1973

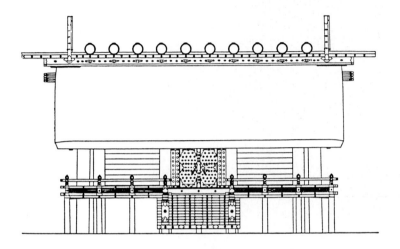

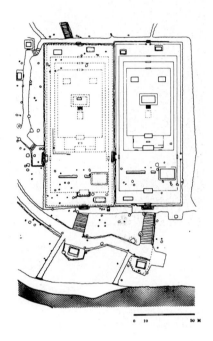

166. Plan, Naiku Shrine buildings and the old shrine compound

The earliest Shinto sanctuaries were simple piles of boulders or stones which marked the sacred dwelling places of the deities and *kami*. In early Japan, the *kami* were regarded with awe and were segregated from the secular world. Their sanctuaries became hallowed ground, and access was forbidden except on ritual occasions. Priests could approach the *kami*, but only during special rites in which they acted as mediators between human beings and the *kami* world.

In order to make the domain sacred, the physical bounds of the sacred and profane had to be demonstrated. The stone monument in which *kami* were thought to dwell was first enclosed by a ring of rocks. This "heart pillar" (*shin no mihashira*) lies buried deep in the ground at Ise and is dressed in evergreen boughs sacred to Shintoism. These *sakaki* branches symbolize the tree where the divine mirror (the "literal" body of Amateratsu Omikami) was hung and where the sun goddess was enshrined.

Two developments led to the establishment of these sanctuaries as Shinto shrines. First, the introduction of Buddhism from China via Korea in the sixth century led the emperor to welcome Buddha as a great *kami* whose visible representation was housed in an impressive Buddhist temple. This had a profound influence on the development of Shinto shrines and on the emergence of permanent shrine sanctuaries in particular. Second, the gradual deification of the emperor led to the establishment of an official Shinto shrine. At least as early as the late third and fourth centuries A.D., Yamato rulers unified the competing clan lineages in the Yamato Plain under the aegis of their lineage, the sun line. The emperor came to be regarded as a living *kami*, with his divinity surpassing that of other *kami*. With this new status for the emperor, political and religious authority were joined. This union was sanctified at the Inner Shrine at Ise. The symbol of succession from the sun goddess to the sun line, the sacred necklace of *magatama* (jewels representing the soul spirit which can enter the body of the possessor), is still the emblem of enthronement for the emperors of Japan and is kept at Ise, where Shinto doctrines were first systematically expounded. The site is still venerated, and pilgrimages are carried out today in an expression of patriotic sentiment.

Introduction to Byzantine Art

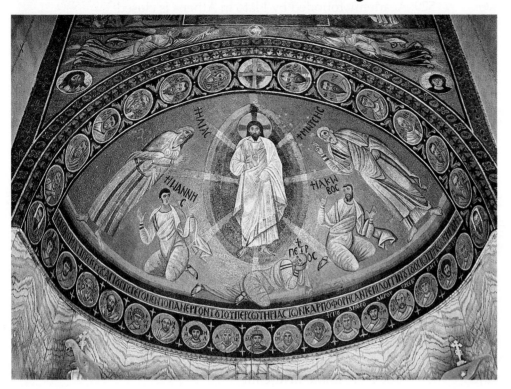

167. *The Transfiguration of Christ.*
c. 560. Apse mosaic. Monastery of St.
Catherine, Mount Sinai, Egypt. The
Monastery of St. Catherine is at the
foot of Mount Sinai where, the Old
Testament reports, God gave the Ten
Commandments to Moses. Isolated
in the Sinai Desert, the monastery,
which has been in continuous use
since the sixth century, is a repository
of early manuscripts and other works
of art (fig. 169).

The Transfiguration occurred when three apostles accompanied
Christ to the top of a mountain. While they prayed, Christ was lifted
up into the sky, surrounded by an aura of heavenly light, and
appeared flanked by the Old Testament prophets Moses and Elijah
(Matthew 17:1–13). The voice of God the Father was heard from a
cloud, "This is my beloved Son: hear him." Christ is represented on
the axis surrounded by a mandorla (almond-shaped halo) of blue
light which emphasizes his resplendent white robes (fig. 167). Moses
and Elijah symmetrically flank Christ, while the apostles below
gesture with wondrous exclamation.

At Mount Sinai the divinity of Christ is demonstrated in a scene
that has a spiritual emphasis which removes it from our physical
world. No geographic details are given, and the event is bathed in a
golden light symbolic of the spiritual enlightenment of God. Al-
though modeling is used, the shadows are linear patterns, denying
the figures the illusion of weight or mass.

HISTORY

In 323 Constantine decided to move the capital of the Roman Empire
from Rome to the eastern part of the empire, to an historic trading

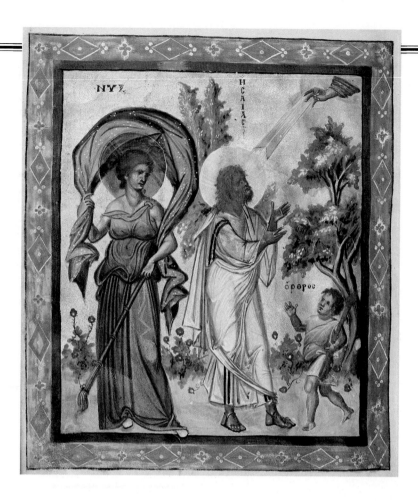

168. *The Prayer of Isaiah,* from the *Paris Psalter.* c. 900. Manuscript painting on vellum, 14 x 10 1/4". Bibliothèque Nationale, Paris

center on the Bosphorus called Byzantium (from which we derive the name for the Byzantine civilization). The eastern provinces of the empire, already strongly Christianized, had become increasingly more important, and the new capital was far from the political instability of Rome and the threats of barbarian invaders. The new capital, dedicated in 330, was named Constantinople.

Constantine's decision was a wise one. A port located at the center of regional trade routes and surrounded by rich timbered forests and agricultural fields, Constantinople developed rapidly as an economic and cultural center. This growth led to an increased military capability, and, during the reign of Justinian in the sixth century, areas of the empire that had been lost—Italy, southern Spain, and North Africa—were again brought under the emperor 's rule. Under Justinian, an intelligent and efficient emperor, Byzantine civilization prospered. His wife, Theodora, a former circus performer, gave resolute counsel in assisting to govern the empire. Justinian and Theodora shared a vision of reviving the grandeur of the Roman Empire while advancing the Christian faith (figs. 174, 175).

But Justinian's military gains proved costly and short-lived. Later the empire was reduced through uprisings in western Europe and, beginning in the seventh century, through the rapid advance of the Islamic religion, which with prophetic zeal spread the ideals of the prophet Mohammed to Arabia, Persia, North Africa, and into Spain. Gradually the influence of Roman culture in Constantinople was supplanted with Greek taste and values, and Greek replaced Latin as

the official language at court. In 1204 Constantinople was captured and sacked by the Crusaders, who ruled the area for approximately fifty years. Cultural and political stability was restored for a while, but in 1453 Constantinople surrendered to the Ottoman Turks and was later renamed Istanbul.

BYZANTINE ART

Many aspects of ancient Greek art and culture were preserved in the eastern, Byzantine empire. This influence is exemplified by a manuscript painting from the *Paris Psalter* (a book of Psalms) in which Isaiah's prayers are met by a ray of light which extends from the hand of God (fig. 168). The figures on either side of Isaiah are classical personifications: Night is a female *contrapposto* figure wearing a Greek costume and with a veil of stars over her head, while Dawn is a boy with a lighted torch. The gold background is still dominant, as it was four centuries earlier in *The Transfiguration* at Mount Sinai, but elements of landscape recalling Hellenistic and early Roman painting have been retained. The classicizing influence is more strongly stated here than in comparable manuscript illuminations from western Europe.

THE BYZANTINE ARTIST

Byzantine artists, like their Roman predecessors, were trained and practiced in a workshop system. While they constructed and decorated public buildings and churches, the collective efforts of these artists in different media were coordinated by an official overseer. As is true of much of the Middle Ages, artists worked in anonymity.

Specialized workshops produced a variety of media, including mosaics, mural and icon paintings, manuscript illustrations, and small sculpture. Large-scale figurative sculpture, one of the cornerstones of Greek and Roman art, was seldom produced during the Byzantine era, perhaps out of fear that such works would have the connotations of pagan idols. Byzantine carvers produced sarcophagi reliefs and small, exquisitely refined ivories to adorn religious and secular objects.

THE ICON AND ICONOCLASM

One unique form of painting which developed in orthodox Christianity was the icon (Greek for image). Used during religious services and to decorate churches, an icon displayed a holy person or event and was viewed as a vehicle to communicate with the spiritual world. Some icons were believed to date from the time of Christ, and the most famous were thought to be of divine origin. The *Madonna and*

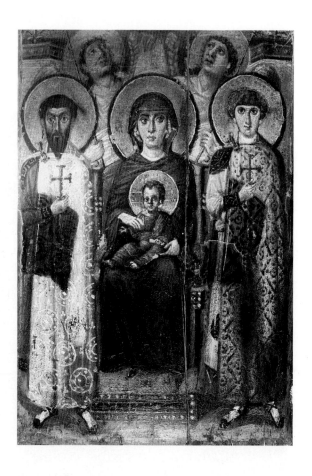

Child Enthroned with Sts. Theodore and George (fig. 169) is a rare surviving example of a sixth-century icon. The drapery patterns tend to flatten the figures, but the modeling and the attempted *contrapposto* postures seen in the saints continue the classical interest in naturalism. Above the Virgin two angels look sharply upward to God, whose hand descends into the pictorial space, emitting a strong ray of light. The static composition of the Virgin and saints, with their intense staring eyes, is characteristic of icon paintings. The medium is encaustic (from the Greek *enkaiein,* to burn in). It involves mixing dry pigments with hot wax, a technique which creates a translucent and brilliant effect.

By the later sixth century, the faithful attributed miraculous powers to certain icons. Conservative factions, called iconoclasts (image-destroyers), feared that icons had become objects of worship, which would be heretical; the divine nature of Christ, they argued, should not be represented, and to do so would be idolatrous. They were countered by the iconodules (image-venerators), who argued that as Christ had become human (the doctrine of the Incarnation), it was permissible to depict him in his human form. The dispute erupted into open and at times bloody conflict between 726 and 843, a period in Byzantine history known as the iconoclastic controversy. During this period, icons and other religious images were damaged or destroyed, accounting for tremendous losses of works of Early Christian and Byzantine art. A final victory for the iconodules occurred in 843; even today one Sunday in the Orthodox Christian church calendar celebrates the restoration of images.

169. *Madonna and Child Enthroned with Sts. Theodore and George and Angels.* 6th century. Encaustic on wood, 27 x 19 3/8". Monastery of St. Catherine, Mount Sinai

HAGIA SOPHIA, CONSTANTINOPLE

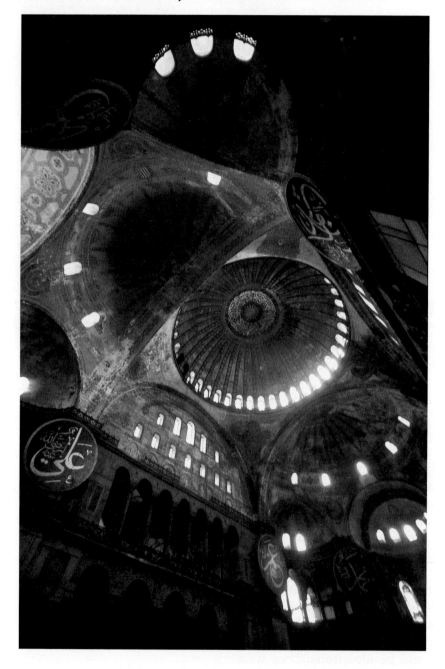

170. ANTHEMIUS OF TRALLES AND ISIDORUS OF MILETUS (architects) Interior, Hagia Sophia (Holy Wisdom), Istanbul (Constantinople), Turkey. 532–37. The plan of Hagia Sophia, 270 feet in length, covers almost one and a half acres, and the great central dome, 108 feet in diameter, crowns at a height of over 185 feet. After the Ottoman Turks captured Constantinople in 1453, Hagia Sophia was converted to an Islamic mosque. Towering minarets, from which the faithful were called to prayer, were added to the exterior, while on the interior the Christian mosaics were covered and eight huge discs with sayings from the Koran and names of Muslim prophets were added. Hagia Sophia influenced later developments in Islamic mosque architecture. Today the former imperial church and mosque is a state museum.

The interior of Hagia Sophia (fig. 170) offers a dramatic interplay of two crucial architectural elements: space and light. On entering, the visitor is astonished by the enormous interior space. Flanked by semi-domes on two sides, the central dome rests like a colossal canopy on four gigantic piers. The windows at the base of the dome create rays of light which dematerialize these supports. The high dome appears suspended, hovering in space above us.

Just as the drama of light at the Pantheon in Rome (fig. 142) represents a metaphysical joining of the physical and spiritual worlds, so too was the amplitude of light within Hagia Sophia bound to the religious purpose of the building. Originally, the light was even more intense, for the windows were successively decreased when the dome was rebuilt three times due to structural damages from earthquakes in 558, 989, and 1346. Light was an integral part of Hagia Sophia's effect, for when combined with the immense interior space and mosaics, the building created a powerful physical and spiritual experience, as recorded by Procopius, the court historian to Justinian, writing shortly after the church was decorated: "The sun's light and its shining rays fill the church. One would say that the space is not lit by the sun without, but that the source of light is to be found within, such is the abundance of light. . . . So light is the construction, the dome seems not to rest on a solid structure, but to cover the space with a sphere of gold suspended in the sky. . . . The scintillations of the light forbid the spectator's

Hagia Sophia, Istanbul: 532–37
550: St. David takes Christianity to Wales

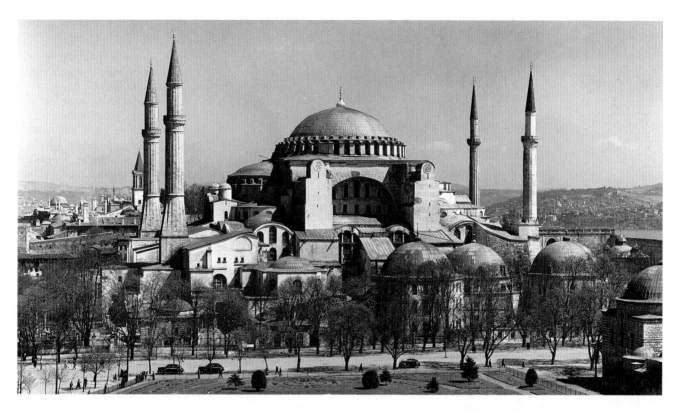

gaze to linger on the details; each one attracts the eye and leads it on to the next. The circular motion of one's gaze reproduces itself to infinity. . . . The spirit rises toward God and floats in the air, certain that He is not far away, but loves to stay close to those whom He has chosen."

This remarkable synthesis of light and architectural form was conceived by Anthemius of Tralles, an artist and scientist, and Isidorus of Miletus, an architect and engineer. During a brief six-week period, they evolved a new architectural plan that combined the longitudinal orientation of the basilica with the central plan (figs. 171, 172). Unlike Roman architects, who preferred to support a dome on a drum, Anthemius and Isidorus raised the central dome on

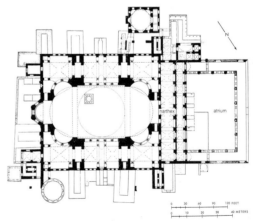

pendentives, curving triangular segments which provide the transition from the square plan of the piers to the circular base of the dome (see fig. 140), and flanked it with semi- or half domes. The huge piers reduced the load-bearing function of the walls, allowing for large amounts of window space (such non-supporting walls are known as

screen walls). That Hagia Sophia was completed in just five years demonstrates the importance of the building in Justinian's plans. It is reported that at its dedication in 537, the emperor compared his accomplishment to that of Solomon, builder of the Temple in Jerusalem, when he proclaimed, "Solomon, I have outdone thee!"

SAN VITALE, RAVENNA

The centrally planned church of San Vitale has the plain brick exterior which characterized much Early Christian and Byzantine architecture, but inside a comprehensive mosaic program synthesizes Christian iconography with imperial Byzantine politics (fig. 173). It is a complex ideological program which joins Old and New Testament scenes, symbols, decorative patterns, and imperial portraiture. The unity of the mosaic program is defined by the axial placement of a number of images and symbols of Christ on, for example, the apex of the arch and at the center of the groin vault, where a lamb symbolizes Christ and his sacrifice. The monogram ✗ leads to the most important of these references, the youthful Christ seated on the blue sphere of the universe in the apse. These align with the altar, where Christ's sacrifice is reenacted during the mass, reinforcing this programmatic unity.

The offering of bread and wine at the altar is prefigured by scenes from the Old Testament. In the semicircular area enclosed by the arch (this area is termed a lunette) to the left of the altar, Abraham is depicted feeding three angels symbolic of the Trinity. To the right Abraham is shown about to sacrifice his son Isaac, a narrative prophetic of Christ's sacrifice.

On the left wall of the apse, a rectangular mosaic depicts Justinian with ecclesiastical personnel on his left, including Maximianus, bishop of Ravenna, and civil and military personnel on his right (fig. 174). Justinian carries the vessel that held the bread for the mass; on the soldier's shield at the left border, a ✗ monogram indicates the political importance Christianity had assumed within the empire. Although the figures are frontal, their isocephalic arrangement suggests a procession. Justinian never visited San Vitale, but his significance in this, his western capital, is implied by the mosaic.

Justinian's placement, flanked by ecclesiastical and civil representatives, communicates his position as head of both church and state (in the Byzantine empire, the emperor appointed the patriarch of Constantinople). Individualized portraits are restricted to Justinian and his close associates. Although the figures overlap one another and some modeling is suggested, the scene, with its gold background, denies the illusion of real space. It is as if the earthly court of Justinian has been transfigured into a spiritual realm. As emperor, Justinian wears a jeweled crown, while as the earthly representative of God, he is shown with a halo. A decorative, rainbow-like mosaic band rises vertically above his head to descend to the opposite mosaic of the empress Theodora, shown bringing the chalice of wine to the altar, and her attendants (fig. 175).

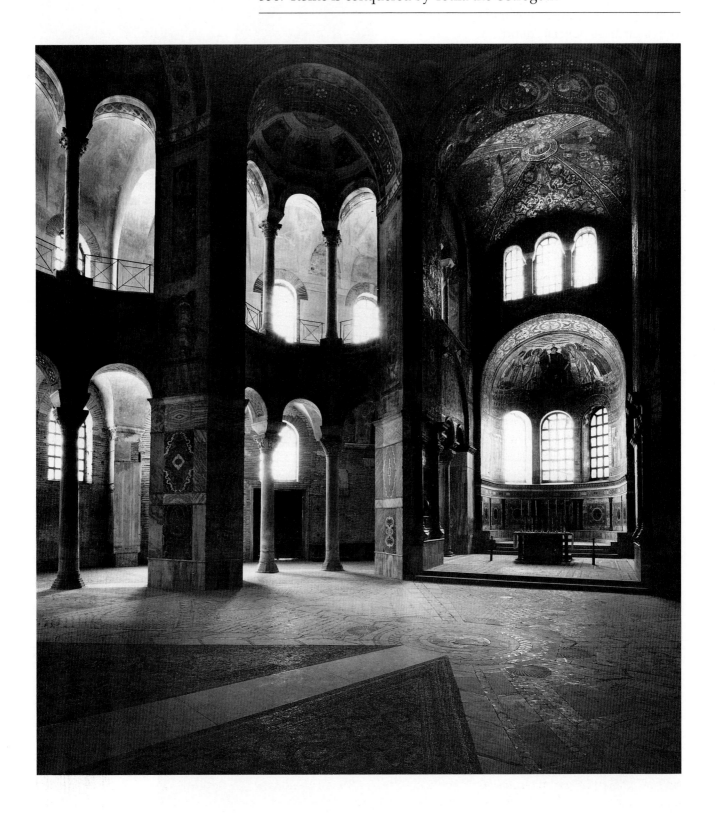

San Vitale, Ravenna

In the semi-dome of the apse, the beardless Christ hands a crown to the Early Christian martyr St. Vitalis, for whom the church was named. To Christ's left, Bishop Ecclesius, who laid the plans for the church, presents a model of the church. The complex ideological interrelationship of the mosaics is typical of Byzantine art, in which each figurative or decorative element is part of a comprehensive architectural and thematic unity.

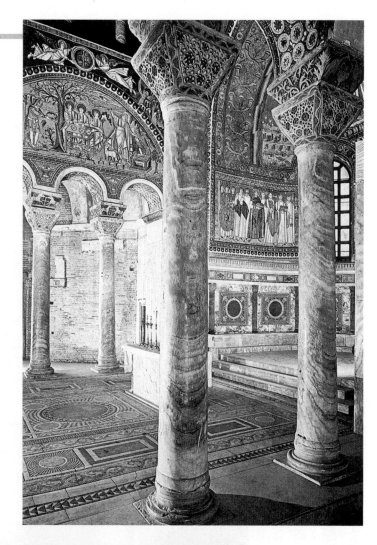

174. Right: Mosaics, San Vitale. In the lunette, *Abraham Feeding the Three Angels* is represented. Between the columns we have a glimpse of Justinian, Bishop Maxentius, and attendants and the inlaid marble decoration below the mosaics.

175. Below: *Theodora and Attendants.* c. 547. Apse mosaic, San Vitale

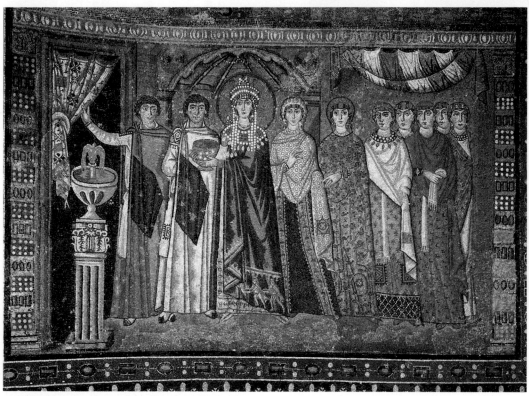

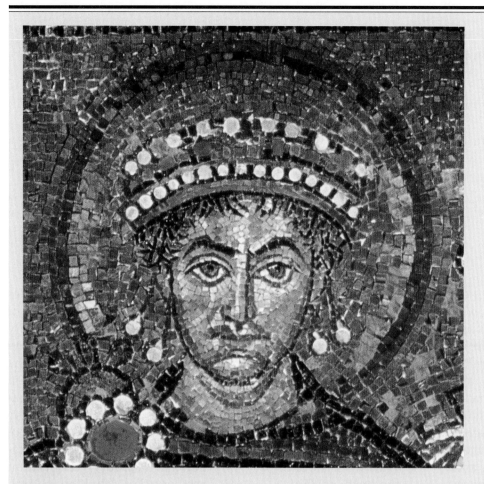

MOSAIC TECHNIQUE

The technique of mosaic seems to have developed from an earlier technique of pressing pebbles into plaster to form a durable and decorative floor covering which was common in the classical world. By the late fifth century B.C., Greek artists began arranging the pebbles into abstract and figurative designs. Soon, natural stones were replaced by *tesserae* (singular: *tessera*, from the Greek *tesseres*, a square), cut pieces of colored stone, especially marble (*tesserae* is also the word used for the pieces of stone and glass used for wall mosaics, as at Ravenna; see fig. 176). At first, Roman mosaic was used primarily on the floors of private homes (see fig. 117), but occasionally it also decorated walls. Roman wall mosaics began to use glass *tesserae* in many colors, as well as gold *tesserae*, formed by sandwiching gold leaf between two layers of glass. The early Christians used mosaics to embellish the walls of their churches, but it was during the Byzantine era that the most splendid effects were achieved, as walls and vaults were covered with glass and marble mosaics enhanced by the predominant gold background.

In creating a mosaic, the image is first outlined on the floor, wall, or vault. Successive areas of this surface are covered with fresh cement or plaster, and *tesserae* are placed into it, following the established design. As the cement or plaster hardens, the *tesserae* are held firmly in place. When *tesserae* were set into walls and vaults, care was taken to adjust each so that its surface was at a slight angle to that of the neighboring *tesserae*. As the ever-changing light from the windows strikes the polished or glass *tesserae*, the changing angles of refraction create a shimmering and ethereal effect, a vision particularly suited to the mystical values of Christianity.

The figure of the Pantocrator at Daphni (fig. 217) is an impressive example of fully mature Byzantine mosaic technique. The *tesserae* are arranged to reinforce the definition of an edge or surface; note, for example, how the curved patterns on Christ's forehead create a sense of plastic form while strengthening the vigorous facial expression. Except for the gold background, large areas of a single color are avoided. At Daphni the highlighted area of Christ's brown robe contains gold and red *tesserae* to make it seem not merely lit, but radiant.

ANGLO-SAXON METALWORK

The abstract, heavily patterned style of the *Sutton Hoo Purse Cover* is distinctive (fig. 177). In its use of valuable materials and in its emphasis on minute, fine craftsmanship, it continues the interest, typical of earlier nomadic tribes, in art that is valuable, portable, and a part of personal adornment. The most characteristic motif of Anglo-Saxon and Irish metalwork is the interlace, a complex pattern composed of a single line which intertwines and overlaps, filling completely the available space. This common motif can be found in small works made in pre-Roman Gaul (France) and in ancient Roman and Early Christian works as patterns of intertwining vines and plants. Here it has a strongly two-dimensional effect. In Anglo-Saxon art the interlaced line is often given an animal head, the mouth of which bites down on its own tail. The legs and snouts of the four beasts at the top center of the *Sutton Hoo Purse Cover* also participate in the interlace pattern.

The discoveries at Sutton Hoo confirmed the reports of rich possessions and similar burial practices found in the somewhat later Anglo-Saxon poem *Beowulf:*

And there they brought the
 beloved body
Of their ring-giving lord,
 and laid him near
The mast. Next to that noble
 corpse
They heaped up treasures,
 jeweled helmets,
Hooked swords and coats
 of mail, armor
Carried from the ends of
 the earth; no ship
Had ever sailed so brightly
 fitted,
No king sent forth more
 deeply mourned. . . .
Take these treasures, earth,
 now that no one
Living can enjoy them.

The Sutton Hoo treasury offers valuable evidence for a civilization about which we have little information. There are few written records and only limited monuments and archaeological remains. Many documented works were melted down, destroyed by fire, or lost during attacks and invasions. The Anglo-Saxons descended from Germanic tribes which emigrated to England in the fifth century. Christianity was strengthened in England in 597 when Augustine of Canterbury landed with forty missionaries and converted Ethelbert, king of Kent, and his court. Christianity and paganism existed side-by-side for a period; as late as the seventh century, an Anglo-Saxon king dedicated one altar to heathen gods and another to Christ.

The few fragments of Anglo-Saxon poetry and documentation that have survived reveal an aesthetic that delighted in luminous materials (especially gold) and in the color red. The interest in filling every available space with pattern or design seems to be related to their Germanic origin and traditions. The artists included monks, nuns, and lay people. By the end of the Anglo-Saxon period there is some evidence that craft guilds—medieval organizations of lay artists— were beginning to develop in England. When artists are mentioned, special attention is always given to the worker in precious metals, and it is on pieces of fine metalwork that we find the few artists' signatures of this period.

Sutton Hoo Purse Cover: c. 620
609: Pantheon in Rome is reconsecrated as Santa Maria Rotonda
625: Mohammed begins to dictate the Koran
638: Muslims capture Jerusalem

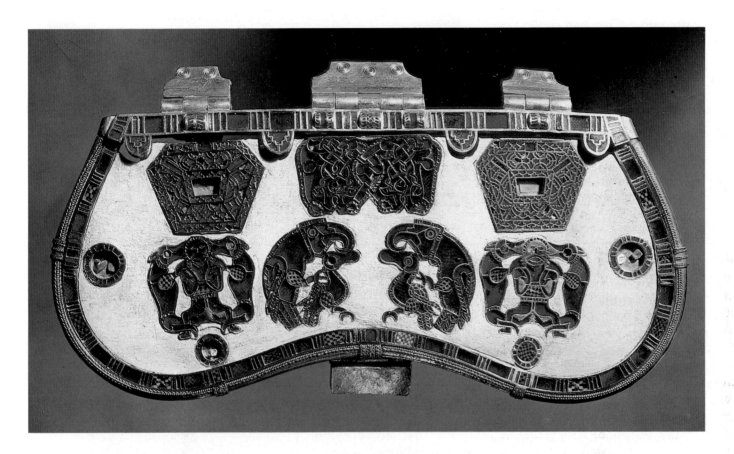

177. *The Sutton Hoo Purse Cover.* c. 620. Gold with Indian garnets and cloisonné enamels, originally on an ivory or bone background (now lost), length 8". British Museum, London. Found in 1939 in a ship-burial mound at Sutton Hoo, England, as part of the treasure of a king who probably died between 625 and 640, this purse lid of precious materials and masterful technical proficiency once adorned a cloth or leather pouch. It would have been attached to the owner's belt by hinges. When placed in the burial mound it contained gold coins and ingots. The huge ship, approximately eighty-nine feet in length, in which the treasure was buried, would have demanded thirty-eight oarsmen, and the richness of the treasure, which included a helmet, shield, spears and a sword, bowls, drinking horns, remains of a musical instrument, and twenty-six pieces of gold jewelry, revealed the important status of the deceased, who is still not identified with certainty. With the spread of Christianity, the pagan tradition of ship burial, which provided the soul with a vehicle in which to travel to the next world, gradually declined, but there are suggestions that the Sutton Hoo king may have been a convert to Christianity.

HIBERNO-SAXON MANUSCRIPT ILLUMINATION

The integration of interlace motifs into a Christian context occurred most dramatically in a series of manuscripts produced in Anglo-Saxon (English) and Irish monasteries between 600 and 800. Similarities in style and other interrelationships make it difficult to distinguish their production, which is perhaps best called Hiberno-Saxon (Hibernia was the ancient Latin name for Ireland). In some of these manuscripts, whole pages are devoted to abstract designs. These are now called carpet pages because of their resemblance to Oriental carpet patterns. In this example from the *Lindisfarne Gospels* (fig. 178), geometric panels are set within a surging sea of blue and red interlace. In the middle of each side are the confronted heads of a dog and a bird of prey. If we follow the patterns we discover that the lines forming the outer borders of the decoration are their much elongated bodies and that these lead to the corners, where their legs are intertwined with those of a beast from the adjacent side.

The techniques used by the Hiberno-Saxon monks who made these manuscripts are difficult to reconstruct, and exactly how they accomplished such minuscule regular patterns without the aid of a magnifying glass is unknown. In one of the *Lindisfarne* carpet pages, the geometric pattern was first drawn on the back of the page using a ruler and compass, and the most important points of the design were pricked through the vellum to provide a guide for the

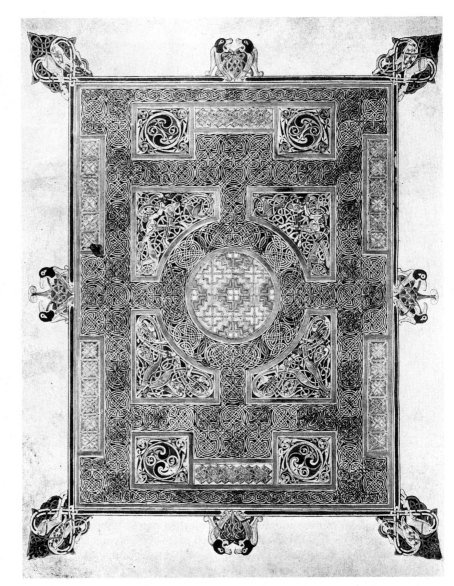

178. *Carpet Page,* from the *Lindisfarne Gospels.* Painted by Bishop Eadfrith. c. 698. Manuscript painting on vellum, 13 1/2 x 9 3/4". British Library, London. The *Lindisfarne Gospels* contains a dedication to God and local saints which also identifies the artists involved: "Eadfrith, bishop of the church at Lindisfarne, originally wrote [lettered] this book for God and St. Cuthbert—jointly—for all the saints whose relics are in the island. And Ethelwald, bishop of the Lindisfarne islanders . . . covered [bound] it . . . and Billfrith, the anchorite, . . . adorned it with gold and with gems . . . and Aldred, unworthy and most miserable priest, glossed [translated] it in English between the lines. . . . [They] made or, as the case may be, embellished this Gospel Book for God and Cuthbert." Eadfrith (bishop from 698 until his death in 721) was both scribe and decorator, a combination not atypical at this time. Another inscription reveals a typical medieval rationale for artistic creation: "Thou living God, be thou mindful of Eadfrith, Ethelwald, Billfrith, and Aldred a sinner; these four have, with God's help, been engaged upon this book."

painter. The isolation of different types of decoration into geometric areas sets up maximum contrast between the widely varied patterns: fine and broad interlace, with and without zoomorphic additions, and swelling, swirling shapes. As a result, the interrelationship of the patterns as positive and negative forms and their placement in depth (which patterns are in front of or behind others) are tantalizingly difficult to decipher. The intensive, onerous, and time-consuming nature of the design and execution is related to the austere and isolated nature of life in a Hiberno-Saxon monastery.

Monasticism flourished in Ireland earlier than in England, and Irish monastic *scriptoria* (halls where manuscripts were written and decorated) were producing important volumes by the middle of the sixth century. In England the monastic tradition was established in the early seventh century, when King Oswald founded the monastery at Lindisfarne.

The earliest surviving Hiberno-Saxon manuscripts reveal an interest in decorating the lettering in the Gospel books, a not surprising development when we remember that the words are believed to be proclamations of God. This tendency reaches its peak in the *Book of Kells* (see fig. 179). When the text in the Gospel of St. Matthew (1:22) reaches the crucial point where the Incarnation of Christ is mentioned, the letters burst out in joyful, exuberant patterns. A whole page is devoted to the three words *Christi autem generatio* (the birth of Christ), with most of the page devoted to the first three letters

Carpet Page, from the *Lindisfarne Gospels:* c. 698
687: First Doge of Venice
711: Moors invade the Iberian peninsula

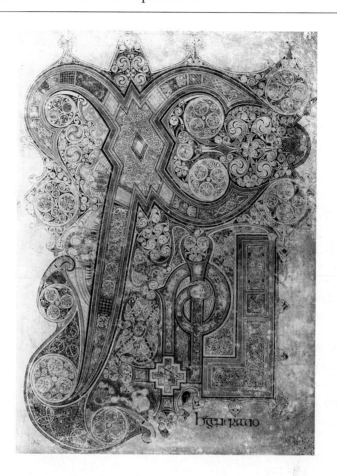

179. *Incarnation Page,* from the *Book of Kells.* c. 800(?). Manuscript painting on vellum, 13 x 9 1/2". Trinity College Library, Dublin

of *Christi (X R I).* The *X* is the dominant form, and it surges outward in bold and varied curves to embrace Hiberno-Saxon whorl patterns. Free-form interlace fills other areas, and simple colored frames set off the large initials amid the consuming excitement. The human head that forms the end of the *P* also dots the *I.* Near the lower left base of the *X* a small vignette shows cats watching while two mice fight over a round wafer similar to those used in the mass—a scene surely of symbolic intent, even if the exact meaning is lost to us today.

The pulsating vitality of the word of God and the exciting news of the impending birth of his son, Jesus Christ, is thus visually demonstrated. A twelfth-century writer who was shown a precious manuscript in Ireland—perhaps the *Book of Kells* itself—wrote: "Look more keenly at it and you will penetrate to the very shrine of art. You will make out intricacies so delicate and subtle, so exact and compact, so full of knots and links, with colors so fresh and vivid, that you might say that all this was the work of an angel and not of a man."

entation of the city, to ensure that it would be fully consonant with the natural order. Early descriptions of city planning (from the *Zhou li,* or *History of the Zhou Dynasty,* from the first millennium B.C.) report that special officers would take the shadow of the sun at noon and make observations of the North Star by night on successive days until they came to an accurate calculation of the four cardinal directions that would determine the city's orientation. No doubt, astronomers were also employed to assure that the orientation was attuned to the cosmic order.

Once properly sited and oriented, the city was surrounded by a rectangular wall of pounded earth that measured twenty-six miles in length to enclose an area of almost forty-two square miles (fig. 184). There were gates in the outer walls except on the north, and broad north/south avenues led to each of the gates on the south wall. The city was subdivided into major zones. To the extreme north was the inner city, where the emperor held court, performed rituals of office, and resided with his harem. To the east and west of the avenue leading to the central southern gate were located the imperial ancestral hall and the altar of earth.

In 634 the second Tang emperor, Taizong, expanded the city to the northeast of the inner city, beyond the city walls, where he built a complex of palaces and other buildings that came to be known as the Daming Palace. Tang texts record that Hanyuan Hall, which has been excavated, was the site of ceremonies for the New Year and the winter solstice

and that it was used for the investiture of new emperors, the changing of reign titles, and the inspection of troops and presentation of captives. Nearby was the Linde Hall (fig. 187), the other excavated Tang-period building of the Daming Palace. Both the Linde Hall and the Hanyuan have similar architectural components, including covered arcades (or "flying galleries") that enclosed each building complex, side pavilions, and platforms that raised the entire building above ground level. The Linde was a triple hall complex with a two-storied roof over the central building. The three halls lead directly from one to the next, without connecting arcades.

Beginning in the Han dynasty, ritual halls had weight-bearing walls at the sides and pillars that supported the main beams at the center. Reinforcing vertical struts that rested on the floor beams were fitted into the wall, while horizontal wooden pieces connected the struts. A wall beam was placed on top of the walls for added support. According to building regulations of the Tang, only the most important halls could have the hipped roofs seen in fig. 187. The roof was made of ceramic tiles, and those on the ridges and eave ends were glazed. Green and black tiles were excavated at the site and, based on textual evidence, we assume that the exterior wall colors were primarily red and white with gold details, a striking combination with the black and green roofs.

The remaining part of the city, more than four-fifths of the total area, was known as the outer city. It included one hundred

and ten wards, but most were predominantly residential; two were given over to marketplaces, which were built and controlled by the government. The east market connected with the roads leading to the second Tang capital of Louyang, and the west market was the center of foreign trade and foreign residence. The ancient system of walled blocks was used for the whole outer city; the ward gates opened at sunup and closed at dusk, and it was a crime to be found on the streets after curfew. The residential wards were laid out on a grid pattern formed by the crossing of north-south and east-west avenues. The sides of these streets were lined with drainage ditches and planted with shade trees. The mansions of the aristocrats and officials were concentrated in wards near the Daming Palace and the east market, while those of commoners were found in the more densely populated area around the west market. Near the city parks at the extreme southeast corner of the outer city were a number of government-controlled entertainment districts. An elevated, covered roadway connected the parks so that the emperor could enjoy outings without being seen by his subjects.

Chang'an was an international capital, and the diplomatic envoys, religious missionaries, merchants, and students from many parts of the world who congregated there brought with them foreign religions, including Zoroastrianism, Manichaeanism, Judaism, Islam, and Nestorian Christianity. The most grand and numerous of the religious complexes in Chang'an were those of

Buddhism and Daoism; some even occupied whole wards. The foreign goods brought by the city's exotic visitors were much sought after by the aristocracy, as well as the middle class.

The building of Chang'an was accomplished by able leadership in an era of peace and prosperity at home and enormous prestige abroad. In the early eighth century, Ming Huang, one of the most brilliant leaders of all Chinese history, took the throne. He cherished and upheld the Confucian order, and in 745 he founded the Imperial Academy of Letters (Han-lin Academy). Great talent and wealth were concentrated in his court. His favorite scholars, poets, and painters, his schools of drama and music, his orchestras (two of whom came from Central Asia), and his famous mistress, the beautiful Yang Guifei, were in attendance. Court painters and poets were kept busy by the emperor recording portraits and cultural and social events of court life.

During the reign of Ming Huang, the court painter Zhang Xuan was celebrated for his paintings of "young nobles, saddle horses, and women of rank." None of his work survives in the original, but one careful copy, *Court Ladies Preparing Newly Woven Silk*, is generally thought to illustrate the eighth-century Tang court tradition of scroll painting (fig. 186). In the section reproduced here, four court women of different ages are stretching and ironing a piece of newly woven silk. The dignified, realistic, and vigorous presentation is surely comparable to court life itself at that moment, but only the barest

187. Reconstruction of the Linde Hall of the Daming Palace, Chang'an. 7th century (Tang dynasty)

essentials of the scene are recorded. The location of the women in space is carefully organized, but we are not told where they are, only what their relationship is to each other. Each woman refers to and is intimately connected to another through participation in the task itself and by gesture and location in space. This section of the scroll subtly records an actual activity, but it may also refer to the broader theme of the maturation of court women from childhood (the small figure playing under the stretched silk), to adolescence, to the coming of age, to adulthood. Each step is distinguished by position, dress style, coiffure, size, and shape of figure.

The same frank realism that marks high court painting also characterizes the tomb figurines made during the Tang period. The presence of a ceramic camel in one's tomb must surely have referred to the importance of trade in the life of the deceased. The restrained energy and solidity of modeling found in the glazed ceramic camel illustrated here (fig. 185) are typical of the best of this type of sculpture, which was made for the burials of both the aristocracy and the gentry.

Late in the ninth century, Chang'an fell victim to the ravages of a rebellion; in 904 many of its buildings were razed, and the royal court activities were transported to the second capital at Louyang. Although its political importance declined, it remained a bustling trading center.

CHINESE ART: LANDSCAPE PAINTING

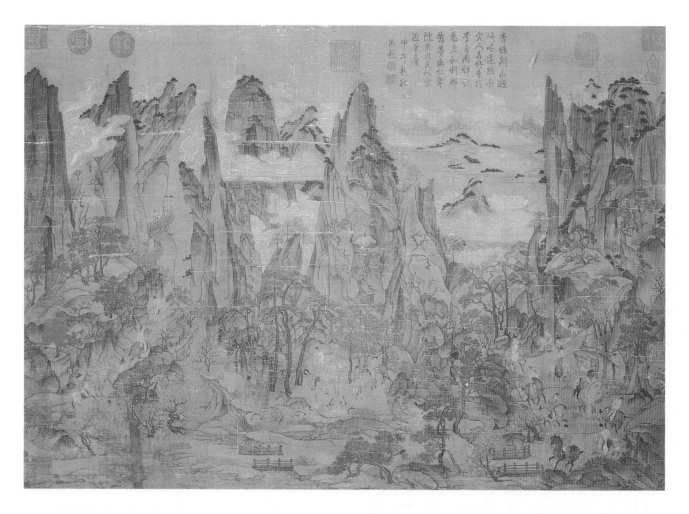

188. After LI ZHAODAO
Emperor Ming Huang's Journey to Shu. c. 755 (Tang dynasty). Hanging scroll, ink and color on silk, length 21 1/4". National Palace Museum, Taipei, Taiwan, R.O.C.

In 755 a provincial Chinese commander named An Lu-shan rebelled, marched on the capital, and forced the elderly emperor Ming Huang into exile in Shu. This much repeated subject in Chinese art (see fig. 188) celebrated the full flowering of the emperor's enlightened leadership (713–56) and his final downfall. In his liberal and extravagant court, for instance, there were eight orchestras, two from Central Asia, and four hundred horses trained to dance at banquets. His enthusiastic patronage and art collecting led painters, poets, and philosophers to new ideas and subjects. The Tang period brought landscape painting and nature poetry to life. While human beings were believed to be earthbound, clouds, rocks, and streams exuded *qi*, or breath of life. This idea was examined by artists.

To the Chinese, a picture was a mysterious thing containing the essence of the world of nature. Standards for painting were set down in the mid-sixth century by an obscure portrait painter named Xie He in his *Gu hua pin lu (Classified Record of Ancient Painters)*. In a few brief paragraphs he defined the Six Canons which became the cornerstone of all later Chinese aesthetics: spirit consonance and life movement; structural strength in the use of the brush; fidelity to object; correct color; proper placement and disposition; and transmission of ancient masters by copying with the example set by Tang artists. Landscape became the central topic for literati painters in the later dynasties.

After LI ZHAODAO, *Emperor Ming Huang's Journey to Shu:* **c. 755**
751: Arabs lose Turkestan to China
787: Council of Nicaea temporarily rejects iconoclasm

190. *Buddhist Temple in the Hills After Rain* (detail)

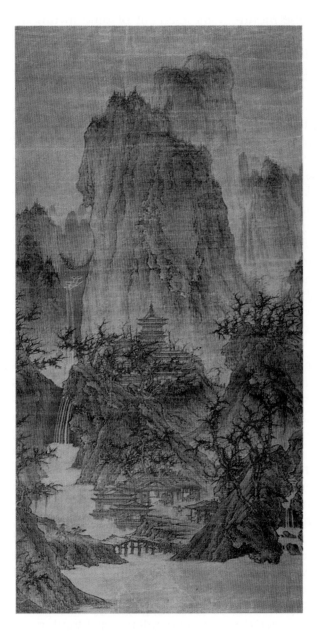

189. LI CHENG (attributed)
Buddhist Temple in the Hills After Rain. c. 950 (Five Dynasties/Northern Song). Hanging scroll, ink and color on silk, length 42". Nelson-Atkins Museum of Art, Kansas City, Missouri (Nelson Fund). The authorship of few tenth-century landscape paintings is known with certainty. Descriptions of the work of these masters by critics of their own time make attributions such as this possible, however.

In the picture attributed to Li Cheng (active from about 940 to 967), the autumn skies are clearing, leaving only mist in the low valleys and above the mountain pathways (figs. 189, 190). In the immediate foreground are a group of huts and two pavilions built over water. The buildings and figures are painted with such careful detail that we can distinguish both peasants and courtiers at their meals in the rustic inn and scholars at the wine shops gazing off into the landscape from the pavilions. The temple with its hexagonal tower occupies the very center of the painting and is parallel to the peaks which dominate the far distance and the top of the picture. Such axially symmetrical monumental configurations of mountains and water came to be associated with the imperial government in the tenth century—grand, ordered, realistic, and powerful.

Li Cheng as a person represented the ideal Chinese painter—an artist who claimed descent from the imperial clan of the Tang dynasty (618–907), was educated in the humanities through study of the *Classic Books* (ancient texts on history, philosophy, and literature), and was occupied with painting for his own delight without ambition for honors or advancement. He was a scholar and a gentleman who enjoyed a quiet life devoted to the philosophic study of Nature as opposed to merely copying forms in the out-of-doors (nature). Monochrome ink painting of landscape was the most preferred type produced by Li Cheng and his colleagues.

Like many other landscape painters of the tenth century, Li Cheng had a preference for autumnal or wintry scenes full of bleak, stony crags, gnarled trees with leafless crab-claw shaped branches, and looming distant peaks. *Buddhist Temple in the Hills After Rain* shares with other landscapes of the period a preference for monochrome ink laid on the silk in broad and jagged strokes which describe the essential outlines of forms (rocks, trees, buildings). These shapes were then broken up and modeled with washes of ink. On top of that were placed *cun,* small brushstrokes dabbed on quickly to create the sense of texture. Closely associated with calligraphy, the brush paintings of China were produced for and by the intelligentsia, who painted as an avocation.

The ideals of painting of the tenth century were written down by a contemporary of Li Cheng named Ching Hao. In his essay the *Record of Brush Methods,* or *Essay on Landscape Painting,* Ching Hao recorded his thoughts through a narrator, an old man whom he pretended to meet while wandering in the mountains. This wise man told him the six essentials of painting: first is spirit, second rhythm, third thought, fourth scenery, fifth brush, and sixth ink. This is a logical system (based on Xie He) which first lays down the concept of painting and then its expression, distinguishing further between resemblance, which reproduces the formal, outward aspects of what is depicted, and truth (or spirit), which involves knowing and representing inner reality. Correct balance between representing the visible forms of nature and expressing their deeper significance was the goal of these painters.

This doctrine of realism aims for truth to natural appearance but not at the expense of an examination of how Nature operates. In Li Cheng's painting, for instance, trees are bent and twisted but are organically constructed to expose their full skeletons—roots, trunk, and branches including, on their tips, the dormant buds ready for spring awakening. Moreover, this approach to realism explains the attitude behind shifting perspective in Chinese painting. In *Buddhist Temple* we are invited to enter the picture on the lower left and to explore as we move through the landscape. We can wander across the bridge, look down at rooftops, up at pavilions and the temple, and across to the towering peaks. One cannot take a panoramic view from a single position from outside or inside the painting, and the artist does not intend that we do so.

Rather, little by little, Nature is revealed as if we were actually walking in the out-of-doors. In this sense the painter combines the element of time in this art form in much the same way as in music. Shifting perspective allows for a journey and for a powerful personal impact on the individual viewer/participant. These paintings were meant to be visual exercises which allowed for examination of minute details as well as the structure of Nature or the Universe. The power of these great paintings is to take us out of ourselves and to provide spiritual solace and refreshment.

Guo Xi, a pupil of Li Cheng and perhaps the best known of the eleventh-century landscapists, declared in his famous essay that "the virtuous man above all delights in landscapes." The virtuous (or Confucian) man accepts the fact that his civic responsibilities to society and state tie him to an urban life as an official, but he nourishes his spirit by taking imaginary trips into nature through viewing a landscape painting. Such paintings as *Buddhist Temple* and *Early Spring* (fig. 191) describe the potential of nature in landscape form and set a standard which was followed throughout Chinese history.

The impetus for the first of these painters was found in the Five Dynasties (907–960) and the Northern Song (960–1126). A most important occurrence of the period was the initial printing of the *Classical Books,* finished in 953. For the first time the supply of books became cheap and abundant. Scholars multiplied, and the knowledge of ancient literature was more widely spread throughout the nation.

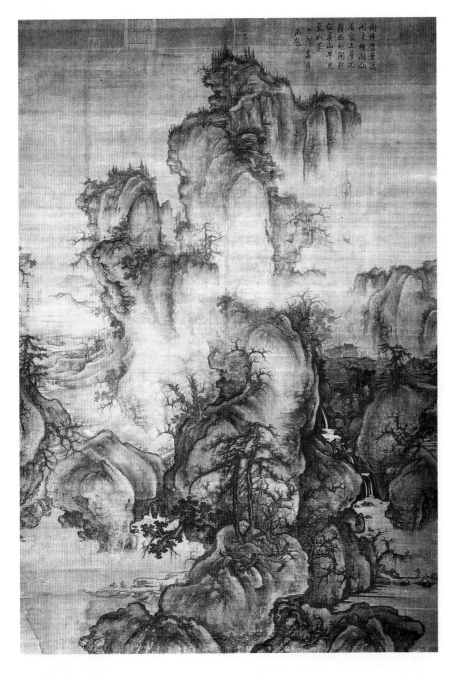

191. GUO XI
Early Spring. 1072 (Northern Song dynasty). Hanging scroll, ink and slight color on silk, length 60". National Palace Museum, Taipei, Taiwan, R.O.C.

and intellectual provided substantial and consistent patronage for the arts. The collection of the Song emperor Hui Zong (1100–1126), for example, claimed 159 paintings by Li Cheng. The Song period produced the first important academy of painting in the Far East, and among its early members were landscapists.

The Song dynasty was an age of many-sided intellectual activities—poetry, history, and especially philosophy. Characteristic of Song thought was the return to older Chinese sources, a conscious archaism, and cultural introspection. The renaissance of classical literature branched off into the formation of a new system of philosophy called neo-Confucianism, enveloping traditional moral and ethical teachings with Daoist thinking about Nature and the cosmos, especially as presented in the *I-jing (Book of Changes).* No distinction was made between the law of Nature and moral law. The world was thought to be inspired by the Supreme Ultimate (or what the Daoists called the Way), which the neo-Confucianists called *li* (law), a moral law identical to the ethical code upon which human conduct should be modeled. These Song thinkers were also interested in correspondences in Nature. The manifestation of *li* in painting included faithfulness to Nature as well as conventionalized symbols for the representation of rocks, foliage, bark, water, and so forth. *Li* also governed the way a picture was put together. Painters of the tenth and eleventh centuries were interpreters of *li*, and landscape became the principal subject for their consideration.

The consequences of the expansion of the literate class were manifest in the Song, when Chinese lands were reunited into the third centralized empire in Chinese history. The unification of the empire was the work of policy rather than conquest, a powerful submission of an aristocracy weary of disunion and aware of its own cultural identity. The acknowledged, ancient civil-service examination system returned civilians to positions of prestige and power in government lost under previous military dictatorships. The prevailing pacifist policies and a series of enlightened sovereigns who were tolerant, humane, artistic,

HINDU ART: THE CAVES AT ELLORA

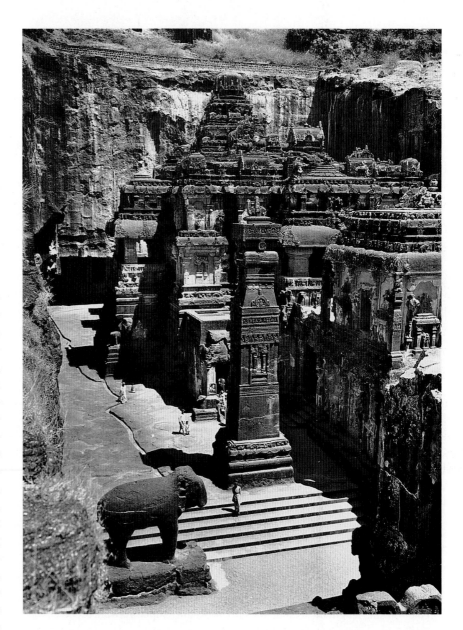

The Kailasantha Temple (the popular name given to the entire eighth-century complex) is carved to resemble a freestanding temple complex behind a high screen wall (fig. 192). Although some sections are dedicated to different Hindu gods, the monument is literally a "magic mountain" in living rock where the theme of Mount Kailasa, the sacred mountain abode of Siva and his consort Parvati, is repeated several times. The architects and sculptors who were attempting to represent the universe in this massive stone cutting oriented the structure to correspond to the four cardinal directions—the world compass. At the core of the temple is the place intended for individual worship in the Hindu faith; here was buried a box containing earth, stones, gems, herbs, roots, metals, and soils that was intended to tie the temple to ancient fertility beliefs and to emphasize the vitality of the religion.

The temple is an achievement of sculpture rather than architec-

192. Aerial view, Kailasantha Temple, Ellora, India. Height 96'. Early medieval period (Rashtrakuta dynasty), c. 760–800, with later additions. The site at Ellora has thirty-four Hindu, Buddhist, and Jain rock-cut temples that date from the mid-sixth to the tenth centuries. The earliest temples, dedicated to the worship of the Hindu god Siva, include elaborate pillared halls leading to shrines in the rear wall housing *lingams* (stylized phallic symbols of Siva's procreative energies). By A.D. 600, the caves became a center for Buddhist worship, with Buddhist images carved both in the shrines of pillared halls and in the apsidal *chaitya* worship hall, where the Buddha is carved on the front of a monolithic stupa. Later, about 675 to 720, three-storied Buddhist caves focused worship on multiple Buddhas and other deities. A second wave of Siva worship in the eighth century included the building of the Kailasantha Temple under the patronage of the Rashtrakutan ruler, Krishna II, who ruled from 757 to 783.

Kailasantha Temple, Ellora: c. 760–800

751: Chinese troops defeated by the Muslims in Central Asia
778: Roland, commemorated in the *Song of Roland*, is killed fighting the Basques
794: Capital of Japan moved to Kyoto

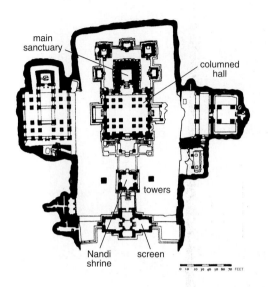

main sanctuary

columned hall

towers

Nandi shrine screen

0 10 20 30 40 50 60 70 FEET

193. Plan, Kailasantha Temple. The plan reveals the layout more clearly than any view. At the entrance, a large stone screen demarcates secular from religious space. This is followed by the Nandi Shrine flanked by the two towers, three porches leading to a columned hall that functioned as a gathering place, and the shrine itself. Five subsidiary shrines on a second-story terrace outside the main sanctuary are dedicated to various deities associated with Siva. The sides of the tremendous pit are carved to create subsidiary shrines in the vertical walls: the Shrine of Absolutions (or the Shrine of the Three Rivers) with representations of the three sacred rivers; a long series of sculptures at the rear; a second-story temple carved in the rock with a set of reliefs relating to Siva; a series of reliefs of avatars (incarnations) of Vishnu and aspects of Siva on the ground floor, surrounding the sides and completely enclosing the back end; and a two-story complex on the right, once connected by a bridge to a porch, with representations of the Great Goddess (Devi) and the Seven Mothers. Numerous smaller shrines complete the group. Although some have argued that the building of this great complex took place over a long period of time, it does represent a single architectural and sculptural conception.

ture. It is composed of a court 276 feet long and 154 feet wide and a central tower reaching a height of 96 feet. The sheer physical problem of carving this tremendous temple from the living rock is awesome. Since the sculptors began working at a height above the tower, the total depth of the cut was about 120 feet—as high as a twelve-story building.

Upon entering this massive complex, one is aware of the contrast of the strong sunlight and deep blue shadows cast by the surrounding mountainside, which dramatize the movement of space along the pathways and across the sculptural reliefs. The sculptural representations gesture wildly to enhance an overall sense of exaltation for the believer. The boldness of conception and the skill in execution suggest centuries of tradition in

which carving techniques and an understanding of the rock medium were developed, enabling craftworkers to push this southern Indian type of rock-cut temple to its limits.

Hinduism encompassed a broad variety of beliefs and practices; not all were shared by all Hindus and some even contradicted each other. In fact, the religion is unique in its tolerance of diversity. Completely decentralized, it has no hierarchy of clergy and no supreme authority—unlike Christianity, Islam, and Buddhism. The roots of the religion can be found four thousand years ago in India, and as it developed it absorbed and reinterpreted the beliefs and practices of diverse groups of people. Assimilation occurred differently in various parts of India, and today, as in the past, the subcontinent is

a great repository of a heterogeneity of beliefs. That the worship of deities is a highly personal activity is reflected in the plan of Hindu temples as well as in their sculptural reliefs. For instance, several of the shrines at the Kailasantha Temple do not have an interior sanctuary at all. (The Nandi Shrine and the main shrine are open only on the second level.) Even when they are entered, the interior space is so small that an individual approach to the sacred images is required. Hinduism's personal approach to the gods is indicated in the thousands of different manifestations of the deity. Today this religion is vital to hundreds of thousands of people in India, Sri Lanka, Pakistan, and East and South Africa, as well as in some islands in the Caribbean and Southeast Asia.

ISLAMIC ART: THE MOSQUE AT CÓRDOBA

In its present form, the interior of the Mosque at Córdoba is a vast space, 584 feet on the north-south axis and 410 feet on the east-west axis (fig. 194). It covers an area of 240,000 square feet, a space larger than any known church, including St. Peter's in Rome. This interior, unlike that of Christian churches, is viewed neither as a home of the gods nor as a place for liturgical worship. It is a place where the faithful gathered for prayer, all facing Mecca together to emphasize the unity of the faith.

Today Islam is the religion of more than four hundred million persons inhabiting large areas in Asia, Africa, and parts of Europe. Islam is a term which refers to the religion and to the whole body of believers (Muslims) and the countries in which they live. The youngest of the world's great religions, Islam developed in Arabia in the sixth century A.D. The area had been a frontier of the Roman Empire and was a land of independent nomadic tribes, a few trade outposts, and conflicting religious traditions.

The founder of Islam was Mohammed, who was born in Mecca in about 570 and believed himself to be a prophet of divine revelation. He was forced to flee in 622, but established himself in the rival city of Medina, where he gathered converts and condoned the *jihad* (holy war) as a means of collecting supplies to support his followers. In 630 he returned in triumph to Mecca. The Muslim calendar dates from his flight, or *hegira*. After his death in 632, the religion gained mo-

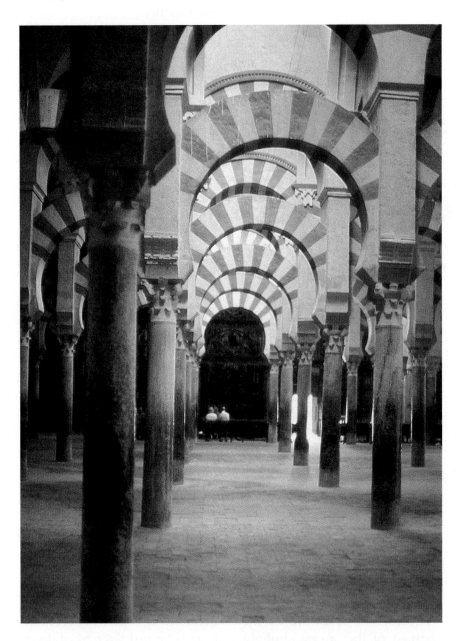

194. Interior, Mosque, Córdoba, Spain. Begun 786. This is a view across the hypostyle hall, looking west.

mentum and began to spread in Arabia and the Near East. Soon Islam became a powerful theocracy and a foe of institutions of the Western medieval world, which derived their ecclesiastical support from Latin and Greek branches of Christendom.

Mohammed himself set up no priesthood and no organized church. However, the Koran, in which were collected the sayings of God as they were revealed to Mohammed in Arabic, became the guide for all life's endeavors. The "Five Pillars" of Islam set

Mosque, Córdoba: begun 786
777: Charlemagne fails in his attempt to invade Muslim Spain
781: Christian monasteries are built in China

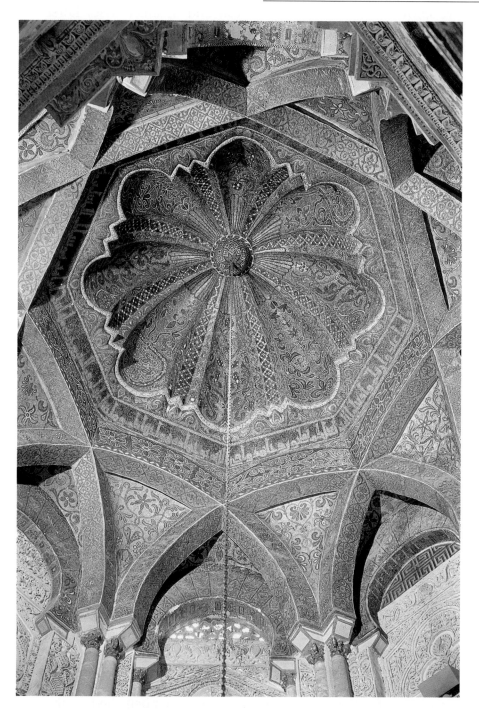

195. Central mosaicked dome of the *madksourah,* which marks the entrance to the *mihrab* niche. 961–76. Colored stucco, tile, and glass mosaic. Mosque, Córdoba. From the chain in the center of this dome a silver lamp with one thousand glass-cupped oil lamps was once suspended. The ceiling of the small *mihrab* niche itself is covered with a single large piece of stone carved in the shape of a shell.

out duties for all believers. First, one must recite the creed, "There is no god but God; Mohammed is the Messenger of God." Second, there is the duty of worship and prayer after ritual washing and while facing the direction of Mecca, five times a day and in the mosque on Fridays. Third, one must completely abstain from food, drink, and sexual activity in the daylight hours during Ramadan, the month (ninth) when Mohammed first received revelations from God. Fourth is the duty of almsgiving. Fifth is the duty of *hadj,* a pilgrimage to Mecca which every Muslim should undertake before death.

In point of time, Islam followed Judaism, Christianity, and Buddhism in its formulation. Islam acknowledges these great religions and believes itself to be the fulfillment of them. Indeed, Muslims believe that Abraham, Moses, and Christ all preached Islam, but that their followers changed their teaching into the religions of today. In the Muslim view, only Mohammed's preaching preserved, unchanged, the message of God. Characteristic of Islam is the blending of ethnic and universal elements. It opens its ranks to all, stressing the brotherhood of the faithful before Allah (God), regardless of race or culture. It was, however, a national religion, firmly centered in Arabia and its political aspirations. The warriors who set out to conquer the earth for Allah did not expect to convert the unbelievers to Islam. Their aim was to rule, to enforce obedience

to themselves as servants of the One True God. Those who wanted to share the privileged status could join Islam but had to become Arabs by adoption. They had to learn the Koran in Arabic and to adopt the social, legal, and political framework of the Muslim community. Unlike the Buddhists, the Arabs absorbed the conquered and their cultural heritage and adapted them to Islam.

Early in the history of the religion, no demands were made on the visual arts. Mohammed condemned idolatry, and the Koran placed statues among the handiwork of Satan. Painting and representation were not specifically mentioned and will figure in later art. During the fifty years following the death of the prophet, a Muslim place of prayer could be a Christian church or Persian columned hall taken over for the purpose, or even a rectangular field surrounded by a fence or ditch. These were the first mosques, or places for prayer.

Mosques of all periods have one element in common: the marking of the *qibla,* the direction to which Muslims must turn in prayer. That wall faces Mecca and was marked by a colonnade and by the entrance which was placed opposite it. By the end of the seventh century, Muslim rulers of conquered domains began to erect mosques and palaces on a large scale as visible symbols of power which were intended to outdo all pre-Islamic structures in size and splendor. They drew on craftworkers gathered from Egypt, Syria, Persia, and even Byzantium, whose designs and decoration echo

their background and expansive spirit.

By the eighth century, within a hundred years of the death of Mohammed, the Muslims had conquered and converted most of the Near East and the African provinces of Byzantium as well as Spain, where they captured Toledo in 711. The Muslims entered Spain as a military force and lacked women, so nearly all took Spanish wives. Furthermore, during this time many Christians converted to Islam and retained their Romance language, giving Islamic culture in Spain a unique flavor soon reflected in architecture as well.

The greatest monument of the reign of the first Muslim ruler of Spain, Abdu'r-Rahman I (756–88), was the Mosque at Córdoba, which he built in one year, 786–87. The building was necessitated by the increased numbers of Muslims who needed a place of worship. Abdu'r-Rahman purchased part of the site from the Christians, saving only the Roman and Visigothic marble pillars which had been taken by the Christians from even earlier buildings. These pillars and the arches above were incorporated into this splendid mosque and became famous as an architectural invention. The superimposition of two tiers of arches gave added height and spaciousness. This feature was repeated by a succession of rulers as they enlarged the mosque in 832–48, 961, and 987, until it was converted back to Christian use after the reconquest of Córdoba in 1236.

The interior "forest of columns" in the mosque, with red-

and-white Moorish (North African and Spanish style) horseshoe-shaped arches extending apparently endlessly in all directions, is unique, although the overall plan is a traditional Muslim one (see figs. 194, 196). It has a crenelated, rectangular perimeter enclosing a forecourt with a basin for ritual ablution, a covered colonnade, and a hall for prayer. The *qibla* is hollowed out in one place in the form of a sacred niche, or *mihrab*. Overlooking the courtyard is the *minaret,* the tower from which the *muezzin* (crier) calls the faithful to prayer five times a day.

In 961 the calif El Hakam II, mindful of his capital's prestige, bestowed upon the mosque its greatest jewel. At the end of the main aisle he built a superb, gleaming *mihrab,* preceded by a triple *madksourah,* or enclosure reserved only for the calif. The enclosure is roofed by three ribbed domes which rest on a most unusual series of interweaving multilayered arches (see fig. 195). All these interior areas are faced with mosaics against a background in gold.

Unlike Christianity or later Buddhism, the Islamic faith did not permit figurative representations of God or his prophets, and these mosaics, like most Islamic art, are stylized. No living creature is represented on Islamic religious structures, and the Koran is embellished with a luxurious, calligraphic version of Arabic lettering called Kufic (mistakenly named after the belief that the script originated in Kufa, Iraq). Kufic script, complemented by abstract ornamental designs, became the main

decoration in the form of inscriptions on mosques, secular buildings, and even utilitarian objects in metal, clay, and weavings in wool (carpets). This Islamic preference for linear surface decoration was fully used in the interior decoration of mosques. At Córdoba, the dome before the *mihrab* is typical, for it includes a stylized gold inscription in Kufic script at its base and a web of ornament above and below made up of a variety of designs all disciplined by symmetry, repetition, and rhythmic order.

Following prayer in the mosque, the man who led the worship or his representative might speak on secular matters. This Arabic respect for learning contributed to advances in astronomy, mathematics, medicine, and optics through centuries of support of its scholars. Such secular and religious traditions continue in the modern world and predominate in Egypt and Syria, Saudi Arabia, Turkey, Albania, Iraq, Pakistan, Afghanistan, Iran, the Yemen, Indonesia, Malaysia, Morocco, Tunisia, and Libya.

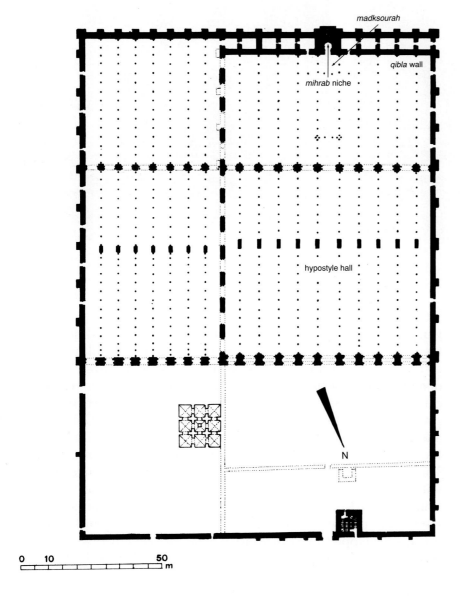

196. Plan, Mosque, Córdoba. This plan shows the enlargements of 832–48, 961, and the final expansion of 987.

Introduction to Carolingian Art

197. *St. Matthew,* from the *Coronation Gospel Book.* Produced at Aachen, Germany. Early 9th century. Manuscript painting on vellum, 12 3/4 x 10". Kunsthistorisches Museum, Vienna. This manuscript is said to have been found in the Tomb of Charlemagne when it was opened by Otto III in the year 1000. It is written on purple-stained vellum, which was reserved for the most important manuscripts.

198. *St. Matthew,* from the *Gospel Book of Archbishop Ebbo of Reims.* Produced in Reims, France. 816–35. Manuscript painting on vellum, 10 1/4 x 8 3/4". Bibliothèque Municipale, Épernay, France

During the reign of Charlemagne (Carolus, or Charles the Great), there was an interest in reviving the political unity and cultural ideals of the Roman world. Two images of St. Matthew (figs. 197, 198) demonstrate how the art of this era—known as Carolingian art— could revive aspects of classical style and yet remain true to medieval principles. The figure of Matthew in the *Coronation Gospel Book,* ancient in type, wears a toga and is seated naturalistically at work. Modeling creates a sense of three-dimensionality and illusionism. The artist has clearly been inspired by a model from a source imbued with the spirit of Hellenistic illusionism. In contrast, St. Matthew from the *Ebbo Gospels* shows the inspiration of Roman models in the seemingly spontaneous technique, but here the fluid strokes of the brush—developed in Roman art to suggest movement—express a frenzy of divine inspiration that threatens to subsume both figure and landscape. Shimmering gold highlights on the toga, hair, and landscape heighten the liveliness, for they appear and disappear with changes in the reflected light.

199. *Apocalyptic Vision of Christ in Majesty, with Four Old Testament Prophets and the Four Evangelists,* frontispiece to the Gospels from the *Vivian Bible.* Produced in Tours, France. 845–46. Manuscript painting on vellum, 19 1/2 x 13 5/8". Bibliothèque Nationale, Paris. This Bible, which has eight full-page illustrations and a number of other decorations, was dedicated and presented to King Charles the Bald by Abbot Vivian and the monks of St. Martin of Tours, probably in 846. It is also known as the *First Bible of Charles the Bald.*

These two disparate styles merge in the dramatic image of the Apocalyptic Christ in Majesty from the *Vivian Bible* (fig. 199). The naturalism of classical style is evident in the modeling of the figures and the representation of movement, but the mystical and otherworldly quality of medieval art is present in the conceptual, geometric composition of a frontal, hypnotic Christ seated on a cosmic globe surrounded by Old Testament prophets and the Evangelists, the latter represented both as human figures and by their animal symbols. The prophets hold scrolls to indicate the Old Law, while the Evangelists have the books symbolic of the New Law. The abstract patterns that suggest spiritual excitement are ever-present in the impulsive movement of the drapery patterns, but none is so fantastic as Christ's, which offers a swirling whirlpool at the center of the composition.

HISTORY

The term Carolingian refers to the reigns of Charlemagne and his immediate successors, although in terms of art the particular qualities of Carolingian art did not endure long after his empire was divided by three grandsons in 843. Charlemagne, whose seal read *renovatio Romani imperii* (the revival of the Roman Empire), intended to create a Holy (that is, Christian) Roman Empire. He greatly expanded the Frankish kingdom he inherited, establishing a buffer between his kingdom and the Islamic threat in Spain and the East. On Christmas Day 800, Pope Leo III crowned Charlemagne emperor of Rome at St. Peter's Basilica.

Charlemagne's renewal included an interest in reform and education and a demand for order and efficiency. He codified law, issuing legal decrees from his capital at Aachen. He established a stable currency, ordered the creation of schools throughout his empire, reformed monastic life, corrected the calendar, established a large library, and encouraged the production of corrected copies of manuscripts, including the Bible. He required the use of a new, more easily readable style of lettering that is the basis of the typeface still used in most books. Literacy was a major goal, in part because it would enable people better to understand Christian doctrine and to participate in church services. Charlemagne could read, but Einhard, his biographer, tells how he also wanted to learn to write, and that he kept notebooks under his pillow, so that "he could try his hand at forming letters during his leisure moments."

CAROLINGIAN ARCHITECTURE

Charlemagne's Palace at Aachen included a chapel (fig. 200), a centrally planned structure based on the most important church in the last Roman capital in the west, San Vitale in Ravenna. Charlemagne received permission from the pope to remove columns and capitals from structures in Rome and Ravenna to incorporate into his palace complex. To emphasize the Christian nature of his rule, Charlemagne modeled his throne on that of Solomon, described in the Old Testament, and placed it in the Palace Chapel opposite the altar.

The Carolingian ideal of a world that would combine the greatness of the ancient past with the Christian vision is revealed in a letter sent to Charlemagne in 799: "If many people became imbued with your ideas a new Athens would be established in France—nay, an Athens fairer than the Athens of old, for it would be ennobled by the teachings of Christ, and ours would surpass all the wisdom of the ancient academy. For this had only for its instruction the disciples of Plato; yet, molded by the seven liberal arts, it shone with constant splendor. But ours would be endowed with the sevenfold fullness of the Holy Spirit, and would surpass all secular wisdom in dignity."

200. ODO OF METZ
Interior, Palace Chapel of
Charlemagne, Aachen. 792–805

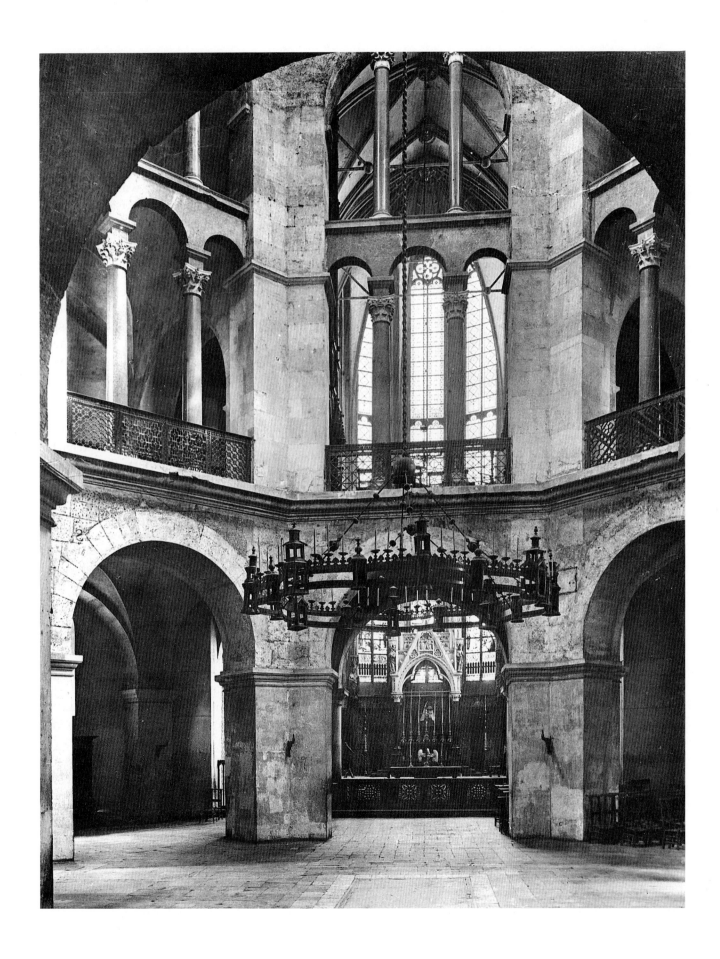

THE MEDIEVAL MONASTERY

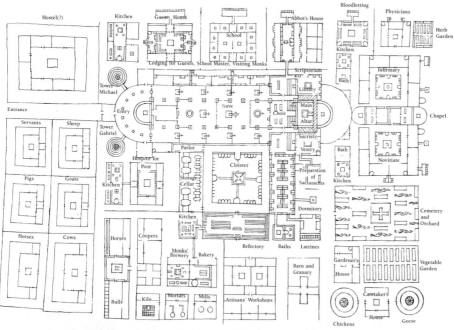

201. St. Gall monastery plan. c. 819. Traced and drawn on five pieces of parchment sewn together, 44 x 30". Monastery Library, St. Gall, Switzerland. The St. Gall plan, traced from another plan now lost, represents an ideal formula to be adjusted for the particular site and needs. It even suggests the appropriate location of furnishings. Its logical and orderly design may be related to the reforms of the monastic system within the Carolingian empire, discussed at meetings in Aachen in 816 and 817. Not a document that normally would have been saved, it may have survived only because a life of St. Martin was written on the back.

The monastery was perhaps the single most important institution in Europe during the medieval period. The St. Gall plan reveals the complex and varied needs of a monastic community (fig. 201). The central structure is the church itself, which has a basilical form following Early Christian models; the nave and side aisles provide additional altars needed because each priest was required to say mass daily. At the western end of the church plan is a smaller apse with two towers forming a westwork. A Carolingian innovation in church design, it created an impressive entrance and

was the source from which the traditional two-towered church facade would develop.

The subsidiary structures include a separate house for the abbot who ruled the monastery and for the monks, a complex attached to the church which included a dormitory, latrine, bathhouse, refectory (dining hall), and a cloister for walking and meditation. Outbuildings housed kitchen, mill, bakery, drying house, brew house, storerooms, barns, workrooms for artisans, and other facilities necessary for a self-sufficient community of approximately one

hundred. There was also a separate chapel and housing for those who were preparing to become monks. A separate house, with its own kitchen, served special visitors. The services that the monastery provided the public included an infirmary, complete with herb garden, and its hospital for the poor. Usually there was a hospice to shelter travelers. In an area adjacent to the main altar were the library and the *scriptorium*, where manuscripts were copied and illustrated. The orchard served as the monastic cemetery. The complex seen here would have been surrounded by vast fields worked by the monks and hired laborers.

Monasticism has its roots in the early days of Christianity in the Middle East and Egypt, when many Christians retreated into the desert or lived in caves in order to spend their life praying, remote from the distractions and temptations of the world. Many chose to live a life of complete isolation, but some banded into communities that mark the beginnings of the monastic tradition. During the sixth century, St. Benedict gathered so many followers that he wrote a rule (c. 535–40) for their behavior. It became the basis for later medieval monastic organization, in part because Charlemagne imposed it on all monasteries in his empire; by the seventh century, a variant of the Benedictine rule was in use for women. Benedict required that the monks remain within the monastery for life and

St. Gall monastery plan: c. 819
782: Arab forces attack Constantinople
790: Irish monks reach Iceland
814: Death of Charlemagne
826: Crete is conquered by Muslim pirates from Spain

that they observe poverty, chastity, and obedience. A simple, humble garment and hairstyle were specified. The monks swore obedience to an elected abbot; daily life was a well-organized regimen of work, study, and prayer. There were at least eight daily services of psalms, hymns, and prayers. Work included all aspects of labor. Many monks and nuns became skilled in the arts, but Benedict's rule warns against the pride that could accompany artistic achievement: "Let such craftsmen as be in the monastery ply their trade in all lowliness of mind if the abbot allow it. But if any be puffed up by his skill in his craft . . . such a one shall be shifted from his handicraft, and not attempt it again until such time as he has learnt a low opinion of himself, and the abbot bids him resume."

Through an emphasis on literacy and education, which were required to participate fully in the Christian life, the monasteries played a vital role in continuing and preserving the Western heritage. A number of the greatest ancient works of literature, science, and philosophy survive only in copies handwritten by monks and nuns.

In the course of the Middle Ages there was a proliferation of monastic orders, but their rules were similar. Most were located in the country, away from the temptations of city life and far from other human beings. In the thirteenth century, two new orders, the Franciscans and

Dominicans, were approved by the pope. They emphasized public service in the urban environment, and their monasteries were established within the cities to serve the sick and the poor.

No monastery was built that exactly followed the design of the St. Gall plan, in part because any complex of such scale would evolve slowly over time and in relationship to the peculiarities of the particular setting. The Romanesque monastery at Cluny, however, can be studied as an example of a fully developed medieval monastery. Cluny, the mother church of a

reformed Benedictine order which played an important role in monastic renewal during the eleventh and twelfth centuries, became one of the most important centers for learning and patronage of art in Europe. It was famous for the splendor and beauty of its services, and its third church, begun about 1085 and consecrated in 1131–32, was, with a length of 555 feet, the largest church in all Europe (fig. 202). The monastic complex at Cluny has virtually all the same facilities as the St. Gall plan; especially impressive is the space given over to the huge infirmary.

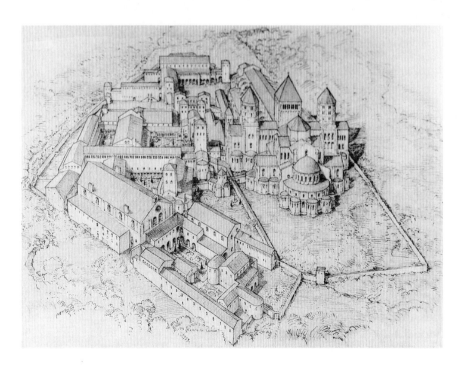

202. Monastery, Cluny, France. Reconstruction of the Romanesque monastery and third church, as they looked c. 1157. The church and monastery were largely destroyed by Napoleonic edict in 1810.

OTTONIAN ART

203. *Christ Washing the Feet of St. Peter*, from the *Gospel Book of Otto III*. c. 1000. Manuscript painting on vellum, 8 x 6". Bavarian State Library, Munich. This Gospel Book, created for Emperor Otto III, is lavishly decorated with twenty-nine full-page illustrations of the life of Christ and a double-page portrait of the patron.

The bold exaggeration of the arm and hand of Christ in this manuscript painting (fig. 203) reveals the Ottonian artist's determination to create a representation that is simultaneously clear and dramatic. The emphasis is on Christ's divinity, as seen in the gesture of blessing, rather than on the mundane theme of the washing of the feet. The placement of Christ's haloed head in the center of the composition, against an empty gold field, emphasizes his majesty. The complicated architectural forms, inconsistent in perspective and out of scale with the

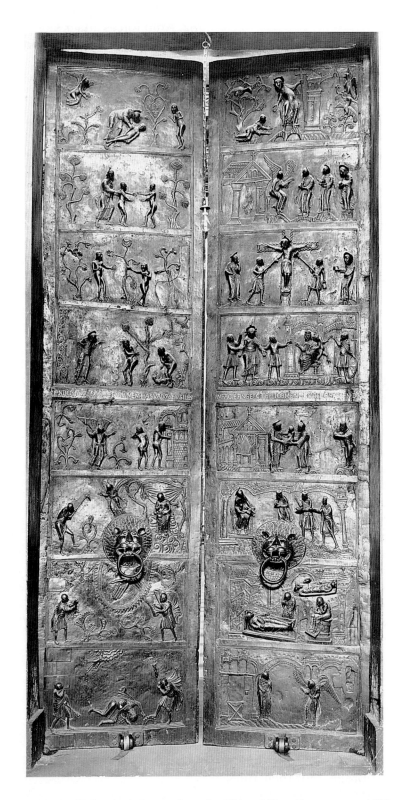

204. Bronze Doors with Scenes from the Old and New Testament. c. 1015. Bronze, height approx. 15'. St. Michael's, Hildesheim, Germany. These doors and a huge bronze candlestick, 12' 6" tall, were commissioned by Bishop Bernward (later St. Bernward). The candlestick, decorated with scenes from the life of Christ, is a Christianized version of ancient Roman Imperial triumphal columns (fig. 126).

Christ Washing the Feet of St. Peter: **c. 1000**
988: Christianity introduced into Russia
1002: Leif Ericsson explores the coast of North America
1006: Muslims settle in India
1010: The *Shah-nama*, Persia's great epic poem, is completed

figures, are intended to inform the viewer that this is an indoor scene. The busy patterns of the drapery add energy, and the emphatic, staring eyes of the participants suggest that something very significant is taking place. That Christ is clean-shaven reveals the influence of Early Christian or Byzantine models.

Like Charlemagne, the Saxon prince Otto I wanted to revive the ancient Roman Empire, and he brought Germany and most of northern Italy, including Rome, under his control before being crowned emperor by the pope in 962. Otto established a centralized government, and his lineage—his son, Otto II, who married a Byzantine princess, and his grandson, Otto III—ruled until 1002. Their reforms in education and monasticism were similar to those of Charlemagne, and Ottonian art flourished until at least the middle of the eleventh century.

Ottonian patrons and artists revived elements of iconography and style from the Carolingian tradition, as well as from the ancient Roman, Early Christian, and Byzantine periods. There were some large-scale architectural projects, and several active centers for manuscript illustration, ivory carving, and work in gold and bronze.

The imperial connotations of Ottonian rule are clear in the bronze candlestick and doors at Hildesheim. The bronze doors (fig. 204), the first cast in Europe

in centuries, have sources in both ancient Roman and Byzantine art. The figures have a lively intensity expressing strong emotions and psychological interaction; in the most famous of these scenes, fourth from the top on the left side of the door, Adam confronts an accusing God. Adam in turn points to Eve, who tries to put the blame on the dragonlike serpent crawling on the ground.

The choir of St. Michael's is raised so the monks can conduct their services while the pilgrims continue to have access to the relics in a crypt below. The alternation of paired columns with piers in the nave arcade is new

(fig. 205) and may be an attempt to divide the nave into more clearly defined units. The nave is higher and narrower than in earlier churches, creating a pronounced vertical emphasis. On the exterior, turrets at the transepts and two crossing towers create a fortresslike massing of monumental forms, pierced by small windows, that predicts the later developments of Romanesque art (fig. 211). The Ottonian revival, as short-lived as Charlemagne's, demonstrates the importance of political and economic stability for the production of fine works of art and architecture.

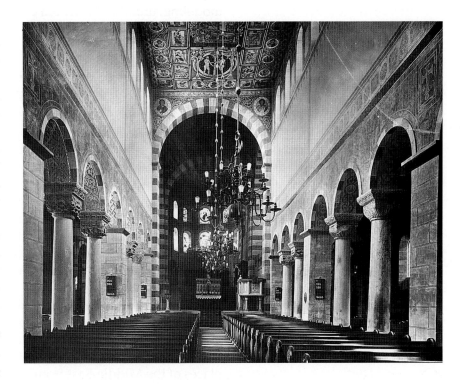

205. Interior, St. Michael's, Hildesheim. 1001–1031. Badly damaged by bombing during World War II, St. Michael's has been restored.

Introduction to Romanesque Art

The term Romanesque (Romanlike) was first used in the nineteenth century to designate medieval art of the tenth to the mid-twelfth centuries, which is distinguished by a European-wide revival of monumental architecture, sculpture, and mural painting. In the Tahull apse painting, the enthroned *Christ in Majesty*, surrounded by a mandorla, is symmetrically flanked by angels and the symbols of the Evangelists (fig. 206). A row of standing saints below includes the Virgin Mary. The hierarchical presentation and the iconlike stare of the figures associate the painting with the Byzantine tradition (see fig. 175). But here the abstraction of earlier medieval art is intensified, for the drapery folds have a life of their own; instead of being used to reveal the body beneath the drapery, they flutter and fold in abstract patterns. And, rather than flowing together into an organic unity, each body part is treated independently, with heads and hands exaggerated in scale. Foreshortening is avoided, as is evident in the unnaturalistic rendering of Christ's book, with the inscription, "I am the light of the world." The simple and direct presentation, harsh modeling, unnatural but bold colors, and frontal stiffness combine to create a commanding composition.

HISTORY

During the tenth century, Europe stirred with revived economic, social, and cultural life. The wanderings and attacks of the barbarian tribes, a source of conflict and political unrest for centuries, abated, due in part to their conversion to Christianity. Following the 1054 split between the Roman and Byzantine churches, the Roman church consolidated its religious and political power in western Europe. England was united with much of France after the Norman conquest in 1066, and Norman victories in southern Italy and Sicily freed those areas from Byzantine control. The new political stability fostered an expanded economy.

The church gradually increased its influence in secular affairs, coming into conflict with the feudal nobility. The power and energy of the church were manifested in the enormous undertaking of the Crusades, which began in the 1090s in an attempt to free the Christian places of the Middle East from the Muslims. The *reconquistà*, the war waged against the Muslims in Spain, led to the capture of Córdoba by the Christians in 1236.

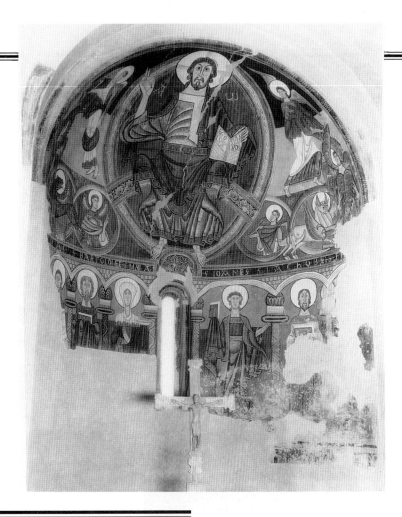

206. *Christip in Majesty with Angels, Symbols of the Evangelists, and Saints,* from San Clemente, Tahull, Spain. c. 1123. Apse fresco, diameter of apse approx. 13'. Museo de Arte de Cataluña, Barcelona

ROMANESQUE ART

The mainstays of earlier medieval workshop production—manuscript illumination, ivory carving, and metalwork—continued throughout the Romanesque period. More significant is the widespread revival of monumental architecture and art which distinguishes the eleventh century.

THE ROMANESQUE ARTIST

Artists, benefitting from the economic growth of the period, organized guilds to ensure quality and control in the production of art and the training of apprentices. Guilds offered protection for the artists as a group, encouraged a greater amount of self-regulation, and promoted an increased social prestige. Few works are signed and dated.

ART AND THE PILGRIM

The pilgrimage, which earlier in the Middle Ages had been prescribed for the atonement of sin, became a regular feature of Christian life during the Romanesque period. The pilgrim would travel over

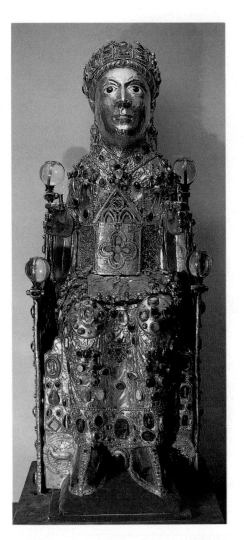

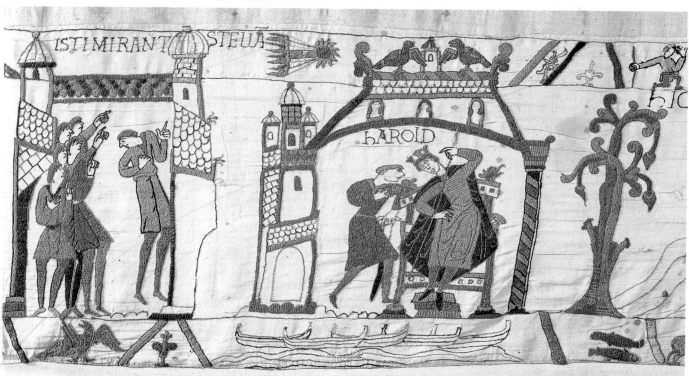

defined routes, known as the pilgrimage roads, either to Rome or to Santiago de Compostela in western Spain. At St. Peter's in Rome or the Church of St. James in Santiago, the pilgrim would invoke God's intercession. Along these routes, monasteries, which since the earlier medieval period had functioned as centers of learning and hospitality, sheltered the pilgrims. Developments in church architecture responded to the needs of both the clergy and the pilgrims.

To prepare spiritually for their destination at Santiago or Rome, pilgrims would visit churches along their routes, where they could pray before the relics of saints. These relics were usually encased in precious reliquaries such as that of Ste. Foi at Conques (fig. 207); many of the jewels that adorn her golden cloak were gifts from pilgrims.

MANUSCRIPT ILLUMINATION

The illumination of manuscripts continued to be a significant medium of painting during the Romanesque period. The figure of St. Mark in the Corbie Gospels (fig. 208), which displays the same intense color and bold outlines as the monumental apse painting from Tahull, is enlivened by an abstract curvilinear design. The saint, seated in his study, turns to grasp a scroll from his symbol, the lion. Framed within an arch, the scene is animated by the twisted body of the lion, whose contorted movement is echoed in the drapery around the arch and the diagonals of Mark's robe. The contrast between the stable framing of the scene and these lively patterns creates a dynamic interpretation of divine inspiration.

THE *BAYEUX TAPESTRY*

This unique embroidered narrative (fig. 209) depicts the events which led to the Norman invasion of England and the victory at Hastings in 1066. Our detail shows the English king Harold enthroned in his castle. A messenger informs the king that his rival William has ordered a fleet of ships to be built in order to cross the English Channel. In the sky to the left of the castle is Haley's Comet, which was visible in England in late April 1066; here it signals impending disaster and should have been understood by Harold as a warning. The inscription reads: *Isti mirant[ur]stellam* (these men marvel at the star).

The sequence of historical events is narrated in a lively, engaging manner. The curving axes of the figures of King Harold and the messenger animate the scene, while the abstract tree to the right, with its undulating rhythm, demonstrates the continuation of Anglo-Saxon interlace motifs and asserts an organic vitality which permeates much of the work. The limited colors are used decoratively rather than descriptively, and the abstract rhythms of the composition enliven the historic narrative.

ROMANESQUE ARCHITECTURE: STE. FOI AT CONQUES

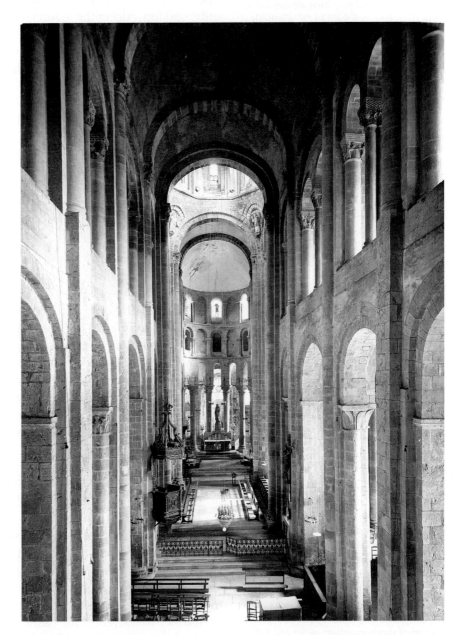

Viewing the crossing and the apse of Ste. Foi from the nave (fig. 210), we can immediately see why nineteenth-century historians coined the term Romanesque to describe this style of architecture. The use of round arches and stone vaults is reminiscent of ancient Roman building practice, and, like Roman architecture, the monumental scale establishes an austere, massive presence. The wooden truss roof common in Early Christian and Carolingian architecture has now given way to the favored construction feature of Roman architecture, the vault. At Ste. Foi, the barrel vault of the nave is reinforced with transverse arches (arches that traverse the nave). On the exterior, vertical buttresses make the interior rhythm of the bays readable from outside (fig. 211). On exterior and interior, then, the articulation of the individual bays creates an order and unity characteristic of Romanesque architecture. The transverse arches also make it possible to construct a thinner barrel vault, allowing for larger windows. Romanesque stone vaulting also served other purposes, for it helped prevent the spread of fire, a prevalent threat

210. Nave, Ste. Foi, Conques, France. c. 1080–1120. The monastic church of Ste. Foi was located along one of the pilgrimage roads to Santiago de Compostela. The present Romanesque structure was built around an older church probably begun during the Carolingian period. Although located along the pilgrimage routes, Conques later remained isolated from the urban development that affected many other medieval towns and, with the exception of two nineteenth-century towers, the church has been spared the restoration activity that so often transformed medieval architecture. The church is dedicated to a third-century virgin martyr, Ste. Foi (known in English as St. Faith), whose relics were brought to Conques about 870 (fig. 207).

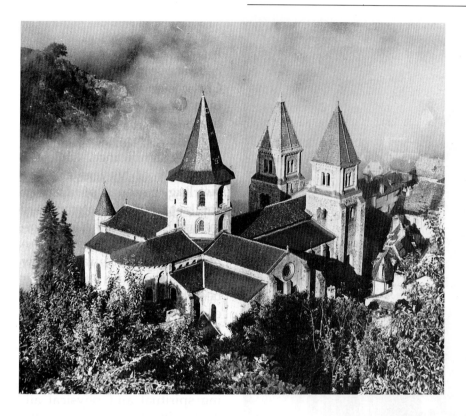

211. Aerial view, Ste. Foi, Conques

212. Plan, Ste. Foi, Conques

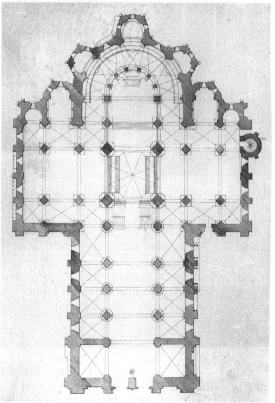

with wooden truss-roof buildings, and it acoustically enhanced the liturgical chants of the monks.

Another feature of the Romanesque pilgrimage church was the use of a semicircular ambulatory (see fig. 212). Adapted from ancient Roman and Early Christian centrally planned buildings, it is here used to solve a particular problem. At churches with monastic foundations, it was necessary that the monks occupy the area around the high altar for numerous services. The ambulatory connecting the side aisles in one continuous passageway allowed masses of pilgrims to move through the church, stopping to pray and venerate relics in the apsidal chapels without disturbing the monks.

Introduction to Gothic Art

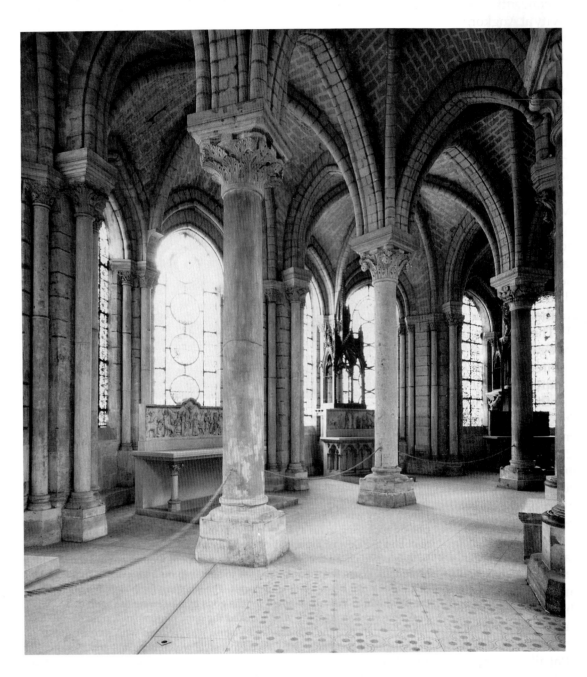

223. Interior, St. Denis, near Paris. Built under the direction of Abbot Suger. 1140–44. This view shows the ambulatory and radiating chapels. Here, where Gothic architecture was invented, we see the distinctive attributes of the style in the union of pointed arches, ribbed groin vaults, and large stained-glass windows.

The Gothic style was first defined in architecture, and architectural motifs appear throughout Gothic painting, sculpture, and the decorative arts. Gothic is easily identifiable because of its unique vocabulary: pointed arches, ribbed cross vaults, flying buttresses, cluster piers, and glowing stained-glass windows. Gothic architecture seems to have been invented by Abbot Suger, friend and adviser to the French kings Louis VI and VII, when he rebuilt the facade, ambulatory, and radiating chapels of the Royal Abbey Church of St. Denis

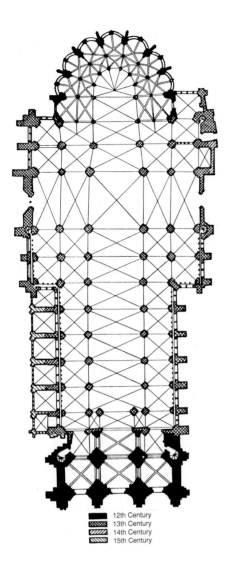

12th Century
13th Century
14th Century
15th Century

224. Plan, St. Denis, as it exists today, showing the various building campaigns. Abbot Suger rebuilt the facade (consecrated 1140) and the chapels and ambulatory (1140–44); from 1231 to 1281 the old Carolingian nave and upper choir were rebuilt in the mature Gothic style.

225. *Abbot Suger's Chalice.* c. 1140. Silver gilt and agate, with jewels, height 8". National Gallery of Art, Washington, D.C. (Widener Collection). The beauty of Suger's architecture is reflected in the costly vessels he had made for liturgical use. This chalice was created by adding a rim, foot, and handles to an ancient agate cup made in Alexandria in the second century B.C. It was originally inscribed *Suger Abbas* (Abbot Suger). For a view of equally rich objects on an altar at St. Denis, see fig. 153.

(figs. 223, 224). The beauty of the Gothic style and the importance of St. Denis, the royal French church where the coronation regalia were stored and kings and queens were buried, helped to popularize the new style throughout France. The brilliant colors of the large stained-glass windows of chapels and ambulatory were designed to lead the sensitive observer to contemplate divine things and imagine the glories of the heavenly Jerusalem, the holy "City of God" in Paradise. In other words, the architecture was intended to help the worshipper

rise from the physical, material world to an immaterial, spiritual realm. Light is a frequent metaphor for the divine in theological and mystical writings, and Suger wrote with mystical ecstasy about how his new architecture created a "crown of light" at St. Denis:

> For bright is that which is brightly coupled with the bright,
> And bright is the noble edifice which is pervaded by the new light;
> Which stands enlarged in our time,
> I, who was Suger, being the leader while it was being accomplished.

ABBOT SUGER

In an inscription over the west portal of the facade, Abbot Suger gives himself credit for the rebuilding of St. Denis; no artists' or architects' names are mentioned. His new vision of architecture is based on his belief that the material beauty and splendor of the church would lead worshippers to a new understanding of God and the spiritual realm, as is further clarified in an inscription on the golden doors of the west facade of the abbey:

> Marvel not at the gold and the expense but at the craftsmanship of the work.
> Bright is the noble work; but, being nobly bright, the work
> Should brighten the minds, so that they may travel, through the true lights,
> To the True Light where Christ is the true door.

Suger specifically compared the church at St. Denis to the Holy Jerusalem, the City of God: St. Denis and other, later Gothic cathedrals suggest the Paradise that awaits the pious Christian.

HISTORY

Growth during the Gothic period and financial and social developments meant that life changed dramatically for much of the population. The development of international banking was centered in rapidly growing urban centers. Paris was the mercantile center of Europe, and its popular annual trade fairs brought together Europeans of many cultures. Among the merchandise bought and sold were works of art. The complex life in the cities led to better-educated administrators and bureaucrats.

That artistic preeminence in Europe should be centered in France during the later Middle Ages is not unexpected, for during the twelfth and thirteenth centuries Paris was the leading intellectual center in Europe and the capital of a strong monarchy (the Capetian line of French kings ruled from 987 to 1316). The University of Paris,

the model for late medieval universities, including Oxford, Cambridge, and Padua, became the center for a new rational approach to philosophy and theology known as Scholasticism, which examined, questioned, clarified, and codified Christian dogma and practice. Thomas Aquinas, a professor at the University of Paris, wrote the *Summa Theologica,* an encyclopedia which set out to systematize and encompass all knowledge on theology and the world.

The Crusades, which had begun in the late eleventh century, continued into the Gothic era, but with little political or military success. They were a significant financial and manpower drain on western Europe, but they encouraged the development of banking, of new methods of taxation, and of a more complex money economy. In western Europe, many scientific and philosophical developments resulted from contact with the Islamic culture.

GOTHIC ART

Like so many other art-historical terms, Gothic originally had a pejorative connotation. It was coined during the Italian Renaissance to refer to the whole of medieval art, which, from the perspective of the Renaissance, seemed crude and without reason. Judged to be the work of barbarians, medieval art was called Gothic after the Visigoths, an early Germanic people who sacked Rome in 410. During the Gothic period itself, the new architecture was known as *opus modernum* (modern architecture), *opere francigena* (French architecture), or pointed architecture.

Gothic art is elegant, highly decorated, and characterized by the use of sumptuous, colorful materials. Architecture included churches, urban monastic complexes, and castles. Sculpture was focused on church portals and on elaborate tombs with architectural frames. Painting was largely limited to manuscript illuminations. The decorative arts—secular and liturgical—encompassed works in gold and other fine materials (see fig. 225), including ivory and precious gems. Increasing personal wealth meant that secular works—personal jewelry, tapestries, and ivory boxes and mirror backs—became more common.

The figural pose that characterizes Gothic art is revealed in the *Madonna of Jeanne d'Evreux* (fig. 226). The Madonna stands in the Gothic "hip-shot" position, in which one hip juts out to support the Christ Child; the effect is less naturalistic than elegant, giving the body a flowing S-curve shape. The small head of the Madonna is also a Late Gothic mannerism. In typical Gothic fashion, the body is completely covered by heavy drapery. The small scale of this statuette, its precious materials, and its delicate figure type and flowing drapery patterns reveal the sophistication and elegance of the fully developed Gothic style.

The *Annunciation* page from a Parisian book of hours (fig. 227) reveals the elaboration of decoration common in Gothic art. The Annunciation was traditionally one of the most ornate of all pages, for it is the moment of the Incarnation, when the seed of God was

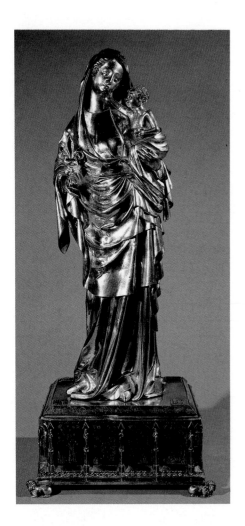

226. *Madonna of Jeanne d'Evreux.* 1339. Silver-gilt with enamel, height 27". The Louvre, Paris. This work was presented to the Abbey of St. Denis by the French queen Jeanne d'Evreux. The stylized iris held by the Madonna is the symbol of French royalty, the fleur-de-lis.

placed in the womb of the Virgin Mary and Christ was conceived and became flesh. In prayer books it is represented before the texts for Matins, the first service of the day, and therefore serves as a frontispiece not only to that important service, but to the whole of the book. Here the artist sets the scene in an elaborate churchlike structure, complete with altar and altarpiece; all the architectural motifs are Gothic. Although Gabriel holds a scroll bearing his message, Mary looks upward toward God, from whose figure emerges the dove of the Holy Spirit. Old Testament prophets, whose writings were held to predict the virgin birth and the coming of Christ, appear in the upper stories of the Gothic structure. Baby angels playing musical instruments populate the elaborate floral motifs of the borders. Typical of the growing interest in symbolism is the use of a number of complex symbols that elaborate on the content of the narrative. The caged bird behind Mary, which at first seems to be merely a household decoration, is a symbol for Christ's Incarnation, when his soul was "caged" within a physical body, while the mating birds in the border refer by contrast to the non-sexual manner by which God's seed was placed in Mary's womb. The spider and ladybug may refer to the devil, who was understood as ever-present.

THE GOTHIC ARTIST

During the Gothic period, the vast majority of works of art were not signed, but we begin to find references to specific artists in a few documents and inventories, where named artists are praised for their skill. A number of the architects/contractors who designed and constructed the cathedrals are known from inscriptions and documents. Some traveled widely: the Frenchman William of Sens was called to England to rebuild Canterbury Cathedral, and Villard de Honnecourt went to Hungary and Switzerland. Several artists are noted as active in more than one medium; Master André Beauneveu, who was working for King Charles V of France in 1364, was a painter, sculptor, designer of tapestries, and a consultant to architectural projects. Nevertheless, the majority of Gothic artists were anonymous. Later, during the Italian Renaissance, the art historian Giorgio Vasari would be puzzled by the Gothic artist's "indifference to fame."

THE FRANCISCANS

The urbanization of Europe was accompanied by significant developments in monasticism that shifted the emphasis from rural retreats of work, prayer, and meditation to large complexes within the city where the monks could serve the poor and sick and preach the word of God in the language of the people. In the early thirteenth century, St. Francis of Assisi founded a popular new mendicant (begging) order, the Franciscans, which emphasized poverty and humility. The sermons and writings of his followers reveal a new emphasis on

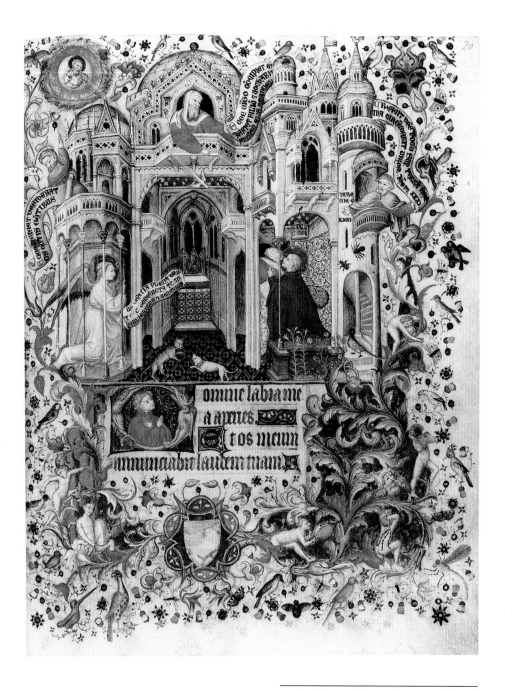

227. *Annunciation*, from the *London Hours*, created in Paris by an Italian artist. c. 1400–1410. Manuscript painting on vellum, 9 x 6". British Library, London. This book of hours was made for the Parisian market, for it features the particular devotions and saints common in Paris. The coat of arms at the bottom of each page was left blank in order to be painted later with the arms of the purchaser, revealing that the book was made for the art market and was not commissioned by a specific patron.

human emotion in interpreting the lives of Christ and the saints. Legend tells us that Francis developed the tradition of the Christmas pageant to make Christianity more immediate and meaningful for the populace. This is related to the contemporary widespread development of religious drama, the famous mystery plays. A Franciscan monk, writing in the late thirteenth century about the birth of Christ, urges a special kind of imaginary participation. He speaks directly to the reader, advising: "You too . . . kneel and adore your Lord God and then His mother, and reverently greet the saintly old Joseph . . . beg His mother to offer to let you hold [the baby Jesus] a while. Pick Him up and hold Him in your arms. Gaze on His face with devotion and reverently kiss Him and delight in Him" (*Meditations on the Life of Christ*).

THE GOTHIC CATHEDRAL: CHARTRES

Entering a great Gothic cathedral is a thrilling, emotional, and—many would say—spiritual experience. The emphatic verticality of a Gothic nave urges us upward, and it is easy to experience a sense of weightlessness and immateriality, a physical condition that can be related to spiritual enlightenment (see fig. 228). Space seems to expand not only upward, but outward to the sides as well, as we look both upward and through the nave arcade into the side aisles. Space, of course, is also a dominant experience in such earlier architecture as the ancient Roman Pantheon (fig. 142), whose simple and monumental union of dome and cylinder is in sharp contrast to the complex interrelationships and forms of varied sizes of the Chartres interior. In the Gothic structure the experience of space is much less lucid, and the ultimate effect, a combination of height, dark corners, and glowing stained-glass windows, is mystical and otherworldly.

From its foundations, sunk twenty-five feet or more into the earth, to the height of its vaults and roof (at Beauvais, the tallest of all cathedrals, the vaults peak at 157 feet over the floor and the roof reaches 223 feet above the street), the Gothic cathedral is a monument to the determination, engineering daring, and physical energies of patrons, architects, and builders. Despite construction campaigns that lasted over decades and even centuries, not one of the great French Gothic cathedrals was ever fully completed; the vision of patrons and

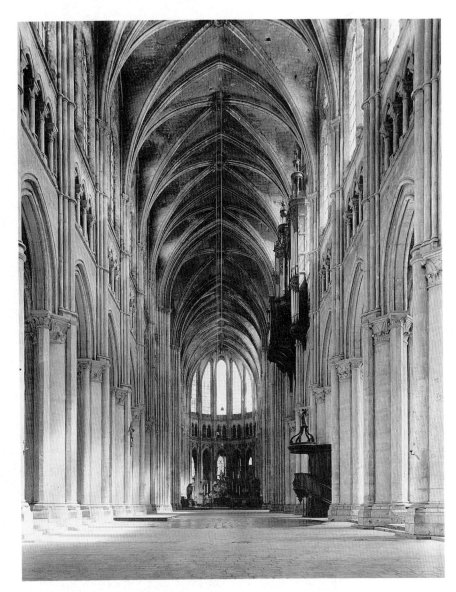

228. Nave, Cathedral of Notre Dame, Chartres, France. 1194–1220. Chartres Cathedral is the most memorable of French Gothic cathedrals not only for the superb quality of its architecture and sculpture, but because it alone preserves virtually all its original stained-glass windows. Begun again after a fire in 1194 destroyed the earlier cathedral (except for the west facade, with its sculpture, the crypt, and some of the stained glass, including *"Notre Dame de la Belle Verrière"*; fig. 241), the new construction was largely completed by 1220.

architects was too ambitious— too glorious—to be realized.

The high, narrow nave of the Gothic cathedral is the climax of a long tradition in Christian art in which architects tried to create a physical space that would express the spiritual goals of the Christian religion. The Gothic interest in ever increasing height, lightness, and slenderness of proportion is evidenced by the statistics, arranged chronologically, that follow on page 226.

Cathedral, Chartres: 1194–1220
1189: Third Crusade to the Holy Land
1209: Founding of Cambridge University
1210: St. Francis founds the Franciscan order

229. View of the nave wall, Chartres Cathedral

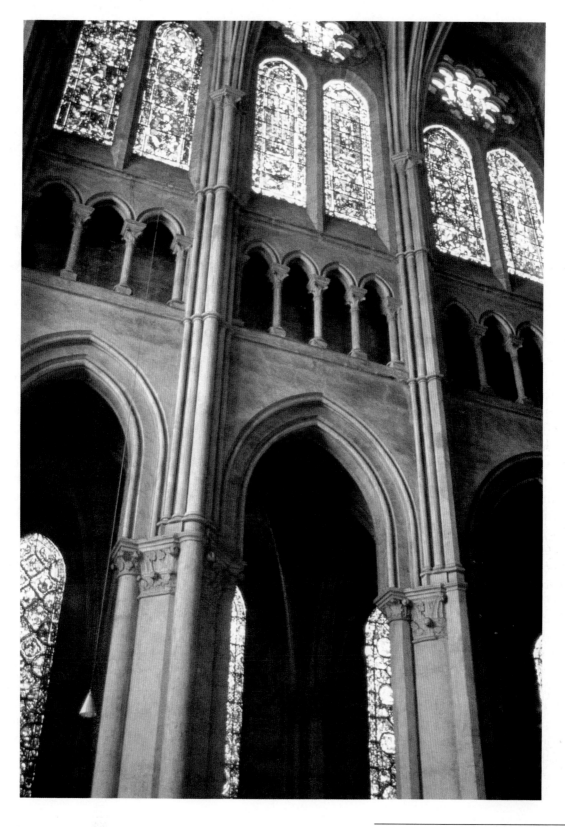

The Gothic Cathedral: Chartres

	approx. height of the nave vaults	approx. width of the nave	proportion of nave height to width
Laon, Cathedral 1160–1205	80'	37' 6"	2.13:1
Paris, Notre Dame 1163–96	115'	40'	2.88:1
Bourges, St. Étienne 1195–c. 1270/80	117'	44'	2.66:1
Chartres, Notre Dame 1194–1220	120'	45' 6"	2.64: 1
Reims, Notre Dame designed 1210	125'	46'	2.72:1
Amiens, Notre Dame designed 1220	144'	48'	3:1
Beauvais, Cathedral (vaults before apse) designed 1230s	157'	47'	3.36:1

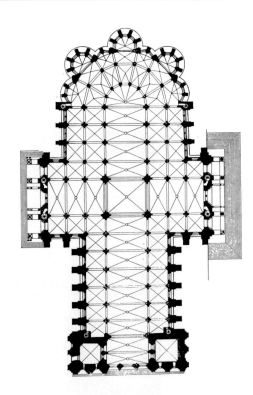

230. Plan, Chartres Cathedral

A taller church was thought to please God. In addition, it could fuel the rivalry between neighbors, for during the Middle Ages the local cathedral was the emblem not only of the sanctity of the town's population, but of their wealth, power, and pride as well.

The unique combination of pointed arch, ribbed groin vault, and flying buttress (see p. 228) defines Gothic architecture. Although each of these elements had been used earlier elsewhere, it is their combination into a coherent and rational system that is new in the Gothic period. The pointed arch, seen everywhere in Chartres's interior (fig. 229), continuously directs our attention upward. The ribs of the vaults help define the parts of the architectural structure and also create a series of lines that keep the eye moving. The rational basis of Gothic architec-

ture demands that each element be explicable and interrelated (as in the Gothic philosophical system known as Scholasticism), and each vault is related to and visually supported by a colonnette (a thin column) that begins at floor level. Groups of colonnettes turn the supporting piers into cluster piers. The interior elevation (fig. 232) is composed of a nave arcade, a triforium (a narrow gallery which opens the structure where normally there would be an expanse of wall), and an enormous, window-filled clerestory.

In most structures, we are aware of a continuous and relatively dense wall surface which is punctured and punctuated by doors and windows, but in the Gothic cathedral there is so little wall, and what remains is so dissolved or disguised by the linear patterns of ribs and colonnettes, that windows and wall

are no longer alternatives. They are unified into an energetic skeleton with huge openings filled with vibrantly colored stained-glass windows. The flying buttress—hidden from an interior view by the stained-glass windows—is clearly visible on the exterior and adds lightness and visual energy to the exterior (see fig. 234).

The ideal Gothic church would have had seven spired towers—a twin-towered western facade (a development from the Carolingian westwork; see fig. 231), a tower at the crossing, and twin towers at both north and south transepts. Such a massing of vertical forms pointing upward suggests the dissolution of the mass of the structure and a denial of gravity consistent with the motivations and aspirations of the cathedral builders.

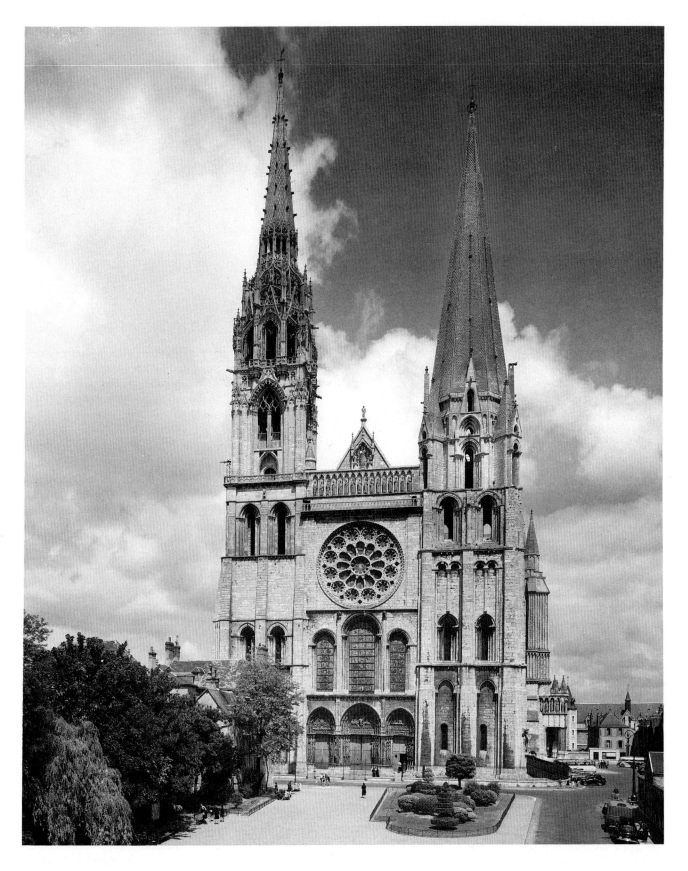

231. West facade, Chartres Cathedral. The mismatched towers of the Chartres facade give it a distinctive personality and reveal the changing nature of the Gothic style. The shorter, transitional Romanesque-Gothic tower was completed before the fire of 1194, while the elaborately decorated, fully Gothic example was not begun until 1507. For sculptures from the facade, see fig. 239.

GOTHIC ENGINEERING

1. bay
2. nave
3. aisle
4. nave arcade
5. clerestory
6. cluster pier with colonnettes
7. triforium
8. buttress
9. flying buttress
10. wooden roof

232. Isometric projection and cross section showing the structure and parts of Chartres Cathedral

233. Plan and drawing of a Gothic rib vault. The pointed arches enable the openings on each side to reach a unified height. Compare this to the cross vault in fig. 140.

The Gothic cathedral is based on complex engineering principles (fig. 232). It is founded on the dynamic interaction/equilibrium between the outward thrust of the high cross vaults and the flying buttresses that contain this thrust. The desire for both height and maximum window surface led to the creation of a structure aptly described as "skeletal"; every element is manipulated to help meet these goals.

The Gothic cathedral is the result of the union of three distinct constructional elements:

The pointed arch: its very design gives a vertical emphasis, and the angle at which the sides meet at the apex focuses attention at the point of its greatest height. The pointed arch makes possible the unity of space characteristic of a Gothic structure. Since a pointed arch can rise to any height despite its width (unlike a round arch), it can vault a bay of virtually any shape—such as those of Abbot Suger's ambulatory. In addition, the outward thrust of a pointed arch is more vertical than that of a rounded arch, meaning that a lighter buttress is necessary and that larger areas of wall can be replaced with stained-glass windows.

The ribs of the vault: these not only make the vaults appear lighter; they allow for a physically lighter structure. The ribs were constructed first and, because of their weight-bearing potential, the surfaces of the vault can be composed of lighter materials. These surfaces, sometimes called the web, or infilling, seem stretched, like a fabric or skin, between the linear, skeletal supports of the ribs (see fig. 233).

The flying buttress: an invention which, by transferring the thrust and weight to an exterior support some distance from the wall, permits a lighter structure and a greater expanse of windows (fig. 234). In earlier architecture, heavy buttresses, greatly thickened parts of the wall surface, cut down on the amount of light which reached the windows and gave the structure a ponderous exterior appearance.

The structural dynamics of the Gothic cathedral—which today we can analyze with machinery and study through models—were explored by Gothic architects by building three-dimensional models of arches and buttresses. At times the Gothic desire for height and lightened structure led to difficulties. At Beauvais Cathedral, the choir vaults peak at 157 feet above the floor, making the interior of the church as tall as a 15-story building; they collapsed due to inadequate foundations, piers, and buttressing and were rebuilt with additional supports and buttresses. A huge crossing tower—perhaps 500 feet tall—was then built, but when it collapsed, work stopped, and Beauvais today consists of little more than an apse.

REGIONAL STYLES OF GOTHIC ARCHITECTURE

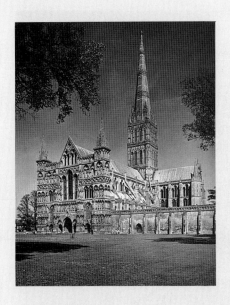

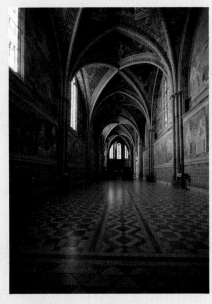

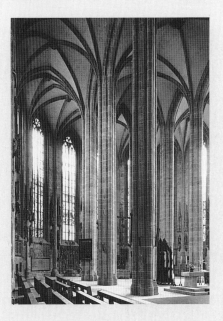

234. English Gothic. Exterior, Cathedral, Salisbury. 1220–70. The high crossing tower and the flying buttresses were added in the fourteenth century.

235. Italian Gothic. Nave, San Francesco, Assisi. 1228–53. The Church of San Francesco was begun in 1228, as soon as St. Francis, who died in 1226, was canonized. The walls are covered with fresco cycles of the Old and New Testaments and, on the lowest level, the life of St. Francis.

236. German Gothic. Nave and choir, St. Sebald, Nürnberg. 1361–72

The French Gothic style spread rapidly, and by the mid-thirteenth century buildings all across Europe demonstrated Gothic qualities. But local traditions, native artistic practices, and regional cultural factors often meant that these buildings also had individual characteristics. The ability of Gothic architecture to express late medieval attitudes is revealed by its pervasive popularity as an architectural style. This is especially remarkable in light of the political connotations that Gothic had because of its origins at the French Royal Abbey Church of St. Denis.

In England the emphasis in religious architecture is on length rather than height, and at Salisbury (fig. 234) the nave, which is only 81 feet tall, is 449 feet long; on the interior a strong cornice enhances the effect of horizontality. Salisbury's nave is crossed by two transepts, a typical English motif, and the climax behind the high altar is not the French polygonal apse with radiating chapels, but a flat wall surface pierced by Gothic pointed windows. On the exterior, the facade is lower and broader, and the emphasis is on the central crossing tower rather than on the two-towered western facade seen in France (fig. 231).

In Italy the Gothic arch was used for doors and windows, and the pointed, ribbed cross vault was common, but at San Francesco (fig. 235) the small windows and the emphasis on a continuous wall surface seem diametrically opposed to the diaphanous window walls of the French examples. Rather than the shallow rectangular bays of the French Gothic, Italian churches often feature square or nearly square bays, and the triforium is often eliminated. Clarity replaces complexity, and there is a feeling of solid physical presence and massive bulk.

Typical of Late Gothic developments in Germany is the hall church (see fig. 236). The aisles often reach the same height as the nave, and the piers can seem thin and insubstantial in the midst of the open and airy surrounding spaces.

None of the developments of the Gothic outside of France has the same emphasis on engineering and structural complexity seen in the French sources; in fact, most Gothic churches outside France lack flying buttresses, and seldom do their patrons and architects desire to attain either the height or the narrowness of proportion of the French examples.

GOTHIC SCULPTURE

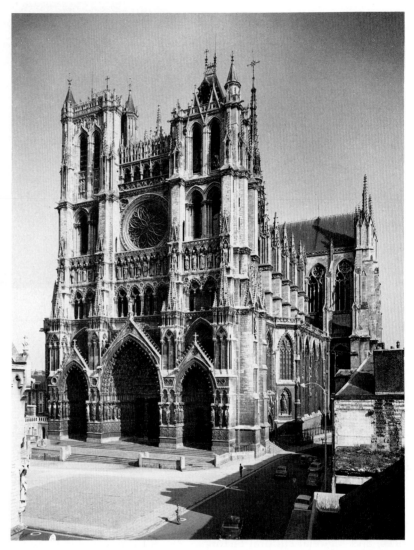

238. West facade, Amiens Cathedral. c. 1225–35

237. *Beau Dieu*. c. 1225–35. Stone. Trumeau figure, central portal, west facade, Cathedral of Notre Dame, Amiens, France. The popular name for this rather severe figure of the blessing Christ is the *Beau Dieu*, the Beautiful Lord. Like most Romanesque and Gothic portal sculpture, this figure was originally polychromed.

As they entered the main, western door of the Cathedral of Amiens, the faithful were greeted by the trumeau sculpture of Christ holding a book and mak-ing a gesture of blessing (fig. 237). The book, probably the Gospels, symbolizes Christ's words and deeds, but this image of the teaching Christ is also combined with the victorious Christ, as represented in the lion and the dragon trampled under his feet. In Christian tradition, the dragon symbolized the Devil, and in this context the lion was understood as a symbol of the Antichrist.

Unlike Romanesque trumeau figures, with their lively abstract patterns, the Amiens Christ is not only naturalistic, but quiet and stately. The simple vertical-ity of the figure echoes the inher-ent architectonic role of the tru-meau, the drapery falls in a na-turalistic manner, and Christ's face has been given a human, solemn dignity.

As in Romanesque church

facades, sculpted figures populate the exterior of Gothic churches, not only on the three western portals, but on as many as six transept entrances as well. The west facade at Amiens reveals how figurative sculpture and applied decoration have increased (fig. 238). The deep porches contain rows of jamb and archivolt figures; narrative reliefs decorate many other areas. The sculptures represent figures and scenes from the Bible, including both the Old and New Testaments, as well as more secular themes, such as the signs of the zodiac and the labors of the months. The facade as a whole is intended to represent all God's creation. Its order, as commanded by the axial figure of Christ on the trumeau, reflects the divine order of the world.

The earliest Gothic portal sculptures, the *Ancestors of Christ* at Chartres, already display significant differences from their Romanesque predecessors (fig. 239). The elongated figures are columnar, for their restricted poses reflect the vertical columns behind them and of which they are a part. Drapery folds fall in abstract, linear patterns unrelated to underlying anatomical structure. These drapery patterns are unlike those of Romanesque figures, which are lively and expressive. The drapery at Chartres quietly reinforces the figures' verticality. The faces of the Chartres jamb figures, while still somewhat stylized, convey a softer and more naturalistic quality than, for example,

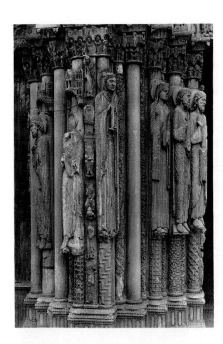

239. *Ancestors of Christ.* c. 1145–55. Stone. Column figures, right jamb, central door (royal portal), west facade, Chartes Cathedral

240. *Vierge Dorée.* c. 1250. Stone. Trumeau figure, south portal, Amiens Cathedral. This sculpture is popularly known as the *Vierge Dorée* (The Gilded Virgin) because parts of the figure were originally decorated with applied gold leaf.

the severe face of Christ in the tympanum at Vézelay (fig. 213).

As portal sculpture developed through the Gothic period, especially into the thirteenth century, the figures began to be realized in higher and higher relief and began to lose their columnar orientation. The Amiens Christ exemplifies the increasing naturalism of early-thirteenth-century Gothic sculpture, while retaining the serious dignity which characterized the jamb figures at Chartres from about eighty years earlier. The *Vierge Dorée* at Amiens dates about twenty years later than the Amiens Christ (fig. 240). A new, relaxed elegance characterizes the sculp-

ture. The figural proportions are elongated, and Mary's body follows an exaggerated curve created by the tilt of the hip to support the arm holding the Christ Child. The drapery, falling in broad folds, contributes to the statue's elegance and emphasizes her sophisticated pose. A warm, affectionate smile plays across Mary's delicate face as she gazes at the child. The reverent dignity of the *Beau Dieu* and the human charm of the *Vierge Dorée* express the diverse vitality which occurs in the development of Gothic sculpture. The figures that decorate Gothic portals reintroduced monumental figural sculpture to western Europe.

GOTHIC STAINED GLASS

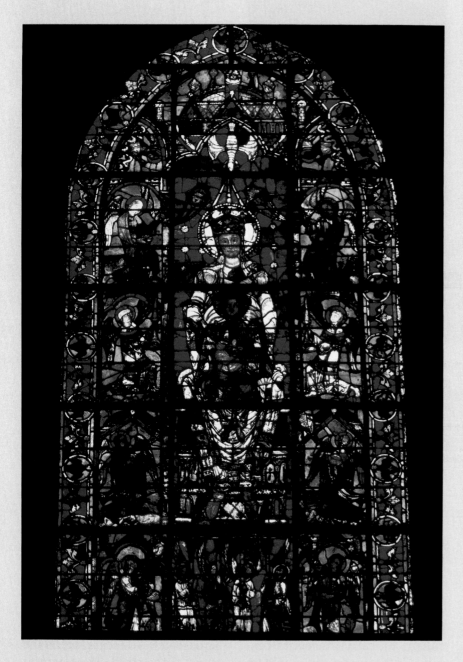

241. *"Notre Dame de la Belle Verrière."* 12th century (central portion); 13th century (surrounding angels). Stained glass, approx. 16' x 7' 6". Cathedral of Notre Dame, Chartres, France. This popular and venerated window is known as *"Notre Dame de la Belle Verrière"* (Our Lady of the Beautiful Window). The Enthroned Virgin and Child section which forms the central portion of this famous window was saved when the cathedral of Chartres burned in 1194. As the cathedral was being rebuilt in the new Gothic style of the thirteenth century, the earlier window was flanked by panels with angels in a more fully Gothic style.

The brilliant contrast between the blues and reds of *"La Belle Verrière"* establishes a dynamic equilibrium, and the other colors and the black paint used to define faces, drapery, and other details enrich and dramatize the window (fig. 241). The glowing, gemlike windows that decorate a Gothic structure help create the ideal of the church as a metaphor for the heavenly Jerusalem, which was described in the Bible as having foundations composed of precious stones (Revelation 21:19).

"La Belle Verrière" exemplifies two styles—the transitional style between Romanesque and Gothic and the fully mature Gothic style. The axiality of Mary and the Christ Child (whose faces have been restored) is eased by the slight tilt of Mary's head. In contrast, the angels in the side panels are more animated, and the pieces of colored glass used to form the image have bolder, more varied colors.

Like the exterior sculptural program of a Gothic church, the figurative imagery of a stained-glass window instructed the people through symbolic imagery and narratives from the Old and New Testaments. But with stained glass, this instructive purpose was uniquely joined with a spiritual, almost mystical, effect. When we enter the church, we leave an outside environment, in which the light level is approximately nine thousand lumens, for an interior space where the level is only a few lumens, even on a bright day. As our eyes adjust to the dark, cavernous space, a radiance of light seems to burst from the windows, where images executed in stained glass appear suspended in an aura of colored light. As light passes through these windows, it causes them to glow with a radiant richness

and to cast beams and spots of color throughout the interior.

Abbot Suger wrote about how the sumptuous quality of Gothic objects brought him into the mystical presence of the divine: "Thus, when—out of my delight in the beauty of the house of God—the loveliness of the many-colored gems has called me away from external cares, and worthy meditation has induced me to reflect, transferring that which is material to that which is immaterial, on the diversity of the sacred virtues: then it seems to me that I see myself dwelling, as it were, in some strange region of the universe which neither exists entirely in the slime of the earth nor entirely in the purity of Heaven; and that, by the grace of God, I can be transported from this inferior to that higher world in an anagogical manner."

STAINED-GLASS TECHNIQUE

The origins of stained-glass windows, which are composed of pieces of colored glass joined by lead strips (fig. 242), are uncertain. Colored-glass windows and windows made of thin stone through which light could filter were already in use in Early Christian and Byzantine churches, and, although stained-glass windows became more common during the Romanesque period, it was only during the Gothic that they became a crucial and integral part of the architecture and a major means of artistic expression.

The colored glass is produced by adding metallic oxides to the molten glass (pot metal glass) or by fusing a layer of colored glass onto clear glass (flashed glass). During the Late Middle Ages, the design for a window would be drawn in chalk on a flat table. Pieces of glass were cut to fit each small shape or area of the design. The details of faces and drapery were added by painting in black enamel, which was then fused to the glass by firing. The fragments of glass were assembled, with lead strips bonding them in place, over the design. As these glass and lead designs were heavy, armatures of iron bands were used to strengthen and support the window when it was installed in the church. Stained glass is one of the most radiant and vibrant media in the history of human expression.

242. Photograph of a craftsperson making a stained-glass window. He is fitting the lead strips, which in section are shaped like a sideways H around the glass. The original design, used to determine the shapes of the glass pieces, is visible in the foreground.

GIOTTO, *MADONNA ENTHRONED*

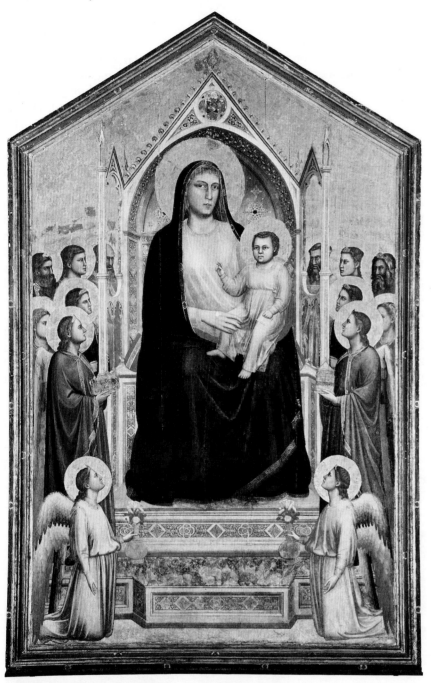

243. GIOTTO
Madonna Enthroned with Angels and Saints. c. 1300. Tempera on wood, 10' 8" x 6' 8 1/4". Uffizi Gallery, Florence. Originally painted for the church of Ognissanti (All Saints) in Florence, this panel is sometimes called the *Ognissanti Madonna.*

contemporaries. A comparison between their compositions of the Madonna and Child reveals the significance of Giotto's innovations (figs. 243, 244). The scale and simple composition of Cimabue's painting create an impressive and severe effect consistent with the expressions of the faces. In his work, Giotto reestablishes the connection between the art of painting and the nature of objective reality, an attitude not evident in painting since ancient Roman illusionism. Giotto's figures are represented as massive, weighty forms that seem to exist within a spatial continuum in which gravity is an inescapable factor. These large, bulky figures have strongly modeled, naturalistic drapery, as seen in the flowing folds of the angels kneeling in the foreground (unfortunately, the darkening of the blue of the Madonna's robe and the repainting of her knees and lap have deprived the central figure of some of its original sense of weight and presence).

The heavy marble throne of

Once Cimabue thought that
in painting
He commanded the field,
and now Giotto has the
acclaim.

As this quotation from Dante's *Divine Comedy* reveals, Cimabue was once the most important painter in Florence. His style represented the final statement of the Byzantine influence in Italy. Dante wrote that it was soon superseded by the revolutionary style of Giotto, an assessment that we share with Giotto's

244. CIMABUE
Madonna Enthroned with Angels and Prophets. c. 1285. Tempera on wood, 11' 7" x 7' 4". Uffizi Gallery, Florence. Tradition has it that Cimabue was the teacher of Giotto. The two Florentine painters are used by Dante to elucidate the fleeting nature of fame.

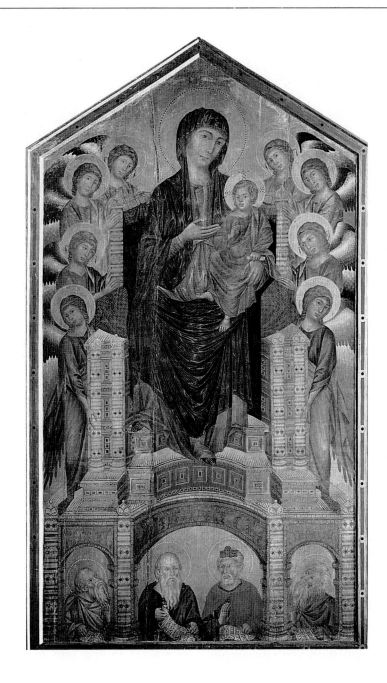

Giotto's Madonna seems solidly fixed in space; Cimabue's wooden throne is lighter and less rational (there are no back legs). In both Cimabue's and Giotto's panels the figures to the sides overlap, but in Giotto's they seem to stand solidly on the ground; Cimabue's angels are placed in an abstract decorative pattern. The placement of Giotto's figures in space is clearly structured: the kneeling angels overlap the standing angels who, in turn, overlap the throne, and in the grouping of saints Giotto lets some of the haloes overlap shoulders and even faces. Giotto surrounds the Madonna and Child with figures placed to create a natural, believable effect, with no loss of dignity or emphasis.

Equally important for Giotto's revolution is the new responsiveness of the figures, which even in this hieratic subject is of such intensity that a dramatic effect is created. The angels respond to the impressive presence of the Madonna and Child with spontaneous expressions of awe. The Madonna and Child have nei-

ther the remoteness nor the insubstantiality seen in Byzantine art, and their parted lips and direct gazes convey a significant human presence.

Giotto's painting, with its recognition of both the physical and the psychological natures of human activity, is in direct contrast to the schematic composition and

expressionless figures of Cimabue's panel. Giotto transformed the art of painting; by emphasizing the concept of the "painting as a window," he established an approach which would endure until the revolutionary experiments of Cézanne and the Cubists in the late-nineteenth and early-twentieth centuries.

GIOTTO, THE ARENA CHAPEL FRESCOES

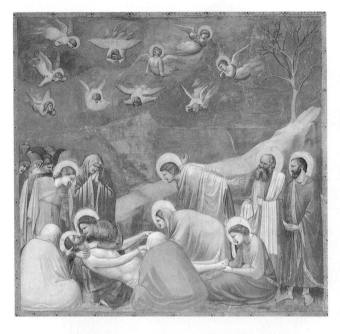

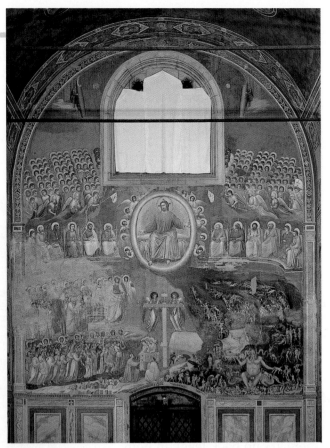

245. GIOTTO
Lamentation. c. 1303–5. Fresco, approx. 72 x 78". Arena Chapel, Padua, Italy. The Arena Chapel was built and decorated for Enrico Scrovegni, a wealthy Paduan businessman. It was attached to the Scrovegni Palace, which had been built on the site of the ancient Roman arena of Padua, hence the name Arena Chapel.

246. GIOTTO
Last Judgment. Fresco, approx. 33' x 27' 6". Arena Chapel. Filling the inside of the entrance wall, and therefore the last thing viewers see as they leave, is this panoramic representation of the *Last Judgment* at the end of time when, in Christian dogma, Christ will appear as the judge.

As in his *Madonna* (fig. 243), the figures in Giotto's *Lamentation* offer an illusion of weight and mass not seen in painting since antiquity. At the same time, they convey a convincing drama and expression of emotion (fig. 245). Through gesture and placement, the composition, with its simple friezelike arrangement and sloping hillside setting, focuses attention on the dramatic core of the narrative, the heads of the Virgin and Christ in the lower left corner. Two heavy figures seen from the back enframe this tender and private moment and communicate the tragic loss and mute pain appropriate to the agonized farewell of a mother to

her son. The simple landscape of barren hill and dead tree supports the expressive figures. The Lamentation and the related theme of the Pietà, which are not mentioned in the Bible, are subjects that develop with the demand for a more emotional religious art in the late medieval period.

Giotto's *Lamentation* cannot be understood as an isolated composition and must be examined in relation to its context. In the Arena Chapel (fig. 247), Giotto painted a continuous cycle of thirty-eight scenes from the lives of the Virgin and Christ which starts at the top and, reading left to right, spirals around to culmi-

nate in six final scenes on the left wall. The cycle as a whole has a continuous left-to-right development, and this last section begins with an exceptionally strong left-to-right movement in a representation of Christ carrying the cross. This is halted by the centralized composition of the *Crucifixion,* but even it does not prepare us for the *Lamentation,* where Giotto forces our attention backward and downward to the conjunction of the heads of the Virgin and Christ. Giotto demands that we stop and concentrate on the *Lamentation.* The impact of the event is conveyed to us not only by the variety of human emotions expressed by

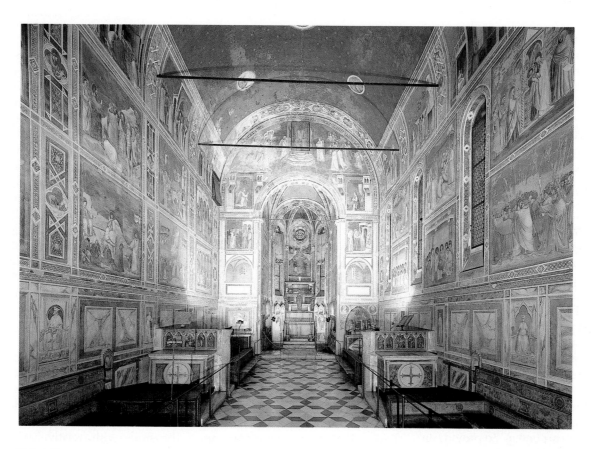

247. GIOTTO

Frescoes, Arena Chapel. The Arena Chapel has windows only on the right-hand wall, as seen in this view; the left is completely filled with the bands of narratives. Below are figures of the virtues and vices. High on the triumphal arch is a fresco of God sending Gabriel to earth and, to either side, the kneeling figures of Gabriel and the Virgin at the moment of the Annunciation and Incarnation. The vault above is decorated with blue sky, gold stars, and holy figures appearing in circular frames.

Christ's followers as they gather around his body, but by the reflection of these emotions in the angels who flood the sky with grief. Such a strong emphasis on experience and empathy is surely related to the preachings and writings of the followers of St. Francis.

In the *Last Judgment*, Christ appears in the center, flanked by saints and angels; below, on his right hand, are the blessed, while to our right are the damned (fig. 246). Near the center, to the left of the cross that marks the dividing line between Paradise and eternal damnation, is a representation of Enrico Scrovegni offering his chapel, represented as a model held by a monk, to the Virgin. Scrovegni's purpose in having the chapel erected and painted is thus clarified, for in making this offering he hoped to atone for the sins of his father, who had accumulated a huge fortune by charging exorbitant rates of interest, a sin called usury that the church condemned.

There are references to virtues and vices in other areas of the chapel. They appear as figures in *grisaille* (gray and white, simulating sculpture), which alternate with illusionistic marble panels.

The Renaissance artist Lorenzo Ghiberti said the Arena Chapel was "one of the glories of the earth," and the modern artist Henri Matisse announced that, on looking at a scene in the Arena Chapel, "I understood at once the feeling which radiates from it, and which is instinct in the line, the composition, the color."

TEMPERA AND FRESCO TECHNIQUES

During the fourteenth and fifteenth centuries, Giotto, Masaccio, Piero della Francesca, Mantegna, Botticelli, and other Italian artists created paintings in fresco and in tempera, two techniques that were as distinctive in appearance as they were in execution. Fresco (see pp. 132–33) and tempera both have their origins in antiquity; in fourteenth-century Europe, they were well-established as alternative techniques understood and used by the same artist but often for different settings and purposes.

The use of tempera paint, which dates back to the Egyptians, was well-established by the later Middle Ages. The support used for tempera paint is usually wood (see fig. 248). Large panels such as those of Giotto and Cimabue (figs. 243, 244) are composed of planks glued together, with an integral frame constructed at the same time. This totality would be designed by the artist and produced by carpenters. To provide an appropriate surface for the paint, the wood panel was covered with linen or canvas and several layers of fine plaster. Onto this surface the painter would draw the preliminary designs, probably with charcoal. The final design would be scratched into the plaster surface, following the outlines of the forms to be painted. Thin sheets of gold leaf would be applied, using red glue, to the background areas. The paint used was composed of ground pigments combined with egg and perhaps a little vinegar; the paint, which dried quickly, was applied methodically in numerous thin coats to prevent flaking.

The finished paintings are characterized by rich colors against a luminous gold ground. Many later painters enhanced their work by elaborately decorating the gold background; using carving tools, they impressed floral and Gothic decorative patterns into the surface of the gold to create borders and halo designs that caught the light and shimmered on the reflective surface.

As in tempera painting, the creation of a fresco demanded a number of sequential steps (see fig. 249). The work would be commissioned and a legal contract drawn up. At this point the painter would probably be advanced money to pay for the purchase of necessary materials. Small drawings might be prepared; these could be shown to the patron for approval before the contract was signed. After the contract was signed, scaffolding would be erected, and a layer of rough plaster (*arriccio*) was applied over the brick or stone wall surface. To mark the subdivisions, a string soaked in red color would be snapped horizontally and vertically. The artist then made preliminary charcoal drawings on the *arriccio*. These drawings would be reinforced with pale ocher paint and the charcoal erased. The ocher painting would be reinforced in *sinopia* (red paint); such full-scale compositional drawings are called *sinopie*. At this point the *sinopie* could be viewed and approved by the patron. The final layer of fine plaster (*intonaco*) would then be applied.

In the true fresco technique (*buon fresco*), a patch of plaster large enough to be completed the next day is applied at the end of a day's work. Each daily patch is known as a *giornata* (Italian for day). They were usually applied in sequence, beginning with the upper left area of the wall, then moving across the top, and ending with the lower right (fig. 269).

As the wetness of the plaster changed in the course of the day, this had to be taken into account by the painter. When the plaster is quite wet, the paint will sink into the plaster surface (up to 1/4 inch) and bleach slightly. If the artist is painting a large passage of drapery beginning in the morning and ending in the afternoon, during the later part of the day a little water will have to be added to the paint so that the last areas to be painted will not be darker in hue. As the plaster dries, a chemical reaction takes place: the carbon dioxide of the air combines with the calcium hydrate in the plaster, producing calcium carbonate. After all the *giornate* are painted, haloes are gilded. *Fresco a secco* (color with glue in the vehicle—egg white or lime) is used for some details. Blue is usually applied in this fashion.

The process and the end results of fresco and tempera are different. Fresco, for example, is faster than tempera. No wooden frame has to be built and gessoed, and the artist works on a large scale with a bigger brush and with a relatively thin paint that applies easily. This technique is also much cheaper than tempera, partly because of the speed involved in its execution and the fact that the materials with which the painter works are less expensive. Tempera is slower because it is a finer technique, meant to be seen close up, and, because the colors dry rapidly, only one thin coat can be applied at a time and each color must be built up in layers. While tempera works were painted in the *bottega* (shop), frescoes had to be painted directly on the wall, where both the artist and the patron assumed they would be forever. This concept of painting in place meant that the painter frequently took into consideration the architecture and lighting of the setting.

Tempera paintings are usually brilliant in color, with deeply saturated hues, while frescoes tend to be

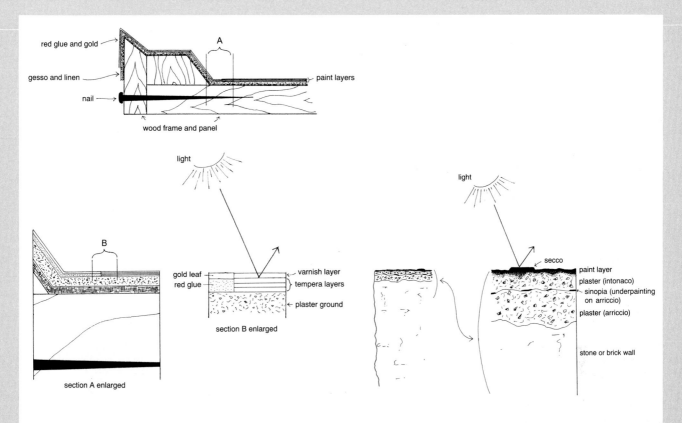

248. Schematic diagrams of a section of a typical late medieval tempera painting. Tempera paint is opaque, and the arrow suggests that light penetrates only the translucent varnish layer on the surface of the tempera.

249. Schematic diagram of sections of a typical late medieval fresco painting. The arrow suggests how light does not penetrate the surface of a fresco painting.

slightly washed out, of higher value, and less deeply saturated because the pigment sinks into the plaster. Brighter colors are used for tempera paintings because finer pigments are employed in this medium and they are meant to be seen close up; in fresco, cheaper, more earthy pigments are used, partly because large quantities are necessary.

Tempera is more conservative; it discourages experimentation because the entire conception must be worked out before the carpenter begins to construct the panel. Fresco encourages experimentation because it is easily corrected if the artist's first effort is not acceptable: the still-damp plaster can be scraped off and the artist can start again the next day. While fresco invites spontaneity, tempera is so methodical that the artist is encouraged to be very precise. Fine detail can be emphasized, whereas frescoes are frequently high on the wall and forms are therefore suggested rather than spelled out in detail (see fig. 270). The fresco technique favors a broad style of painting, which is more exciting than the accuracy and precision of the tempera technique. The distance between the viewer and the painted wall also allows fresco painters to be more dramatic and to use a few prominent gestures to communicate ideas and expression. Frescoes are generally larger; the figures are usually about lifesize. This means that frescoes are usually more illusionistic.

Both media are durable, partly because of the care with which they are executed. Both represent careful refinements of experiments over many years, and they are sound technically. However, frescoes will deteriorate if moisture seeps through from behind, and the wood support of the tempera panel can warp, crack, or rot. Another common difficulty with frescoes is that fine details painted in the *fresco a secco* technique can flake away.

One motivation for an artist to work in both media is the fact that fresco painting is not feasible in the winter, when the increased humidity in Italian churches meant that the plaster did not dry quickly enough (documents survive that tell us about frescoes that grew moldy rather than drying). During the winter the painter could be busy in the *bottega*, making tempera paintings.

THE ROYAL ART OF AFRICAN KINGDOMS

The main subject of Ife art is the human head, rendered realistically but with the regularized features of an idealized portrait (fig. 250). The *Head of Queen Olokun* is presented with a serene and regal countenance which comes from a sculptural tradition known first in clay and then in metal. The more than fifteen million Yoruba-speaking people who now live in Nigeria and the Popular Republic of Benin are the descendants of the makers of this head. They have a long history in West Africa. They were, and continue to be, one of the largest and most prolific art-producing groups of Africa.

Their urbanism is ancient and legendary, probably dating from as early as A.D. 800–1000, according to excavations at two city-sites, Owo and Ife. These were only two of numerous city-states headed by sacred rulers (both men and women) and councils of elders and chiefs. The city-states best known for their sculpture and cultural life were Ife, Benin, and Owo. Ife is regarded by the Yoruba as the place of origin of life itself and of human civilization, and the dynasty of kings there remains unbroken to the present day. It is probably the oldest continuous kingship in the world.

Ife, situated in the southwest of what is now Nigeria, is the oldest of these city-states. Its first settlement dates from the eighth century, but little is known about its rise to power. By 1100, artists at Ife had already developed a refined and highly naturalistic sculptural tradition in terra-cotta and stone that was soon followed by works in copper, brass, and bronze. The terra-cotta heads and works cast in brass found at Ife are known to date between the eleventh and sixteenth centuries.

South of Ife was the kingdom of Benin, which built its capital at Benin City. When the Portuguese arrived there in 1485, the highly organized Benin society was headed by a wealthy and militarily powerful monarch called the Oba. He lived in a large city with a regular grid pattern of tree-lined avenues. The king was supported by a large aristocracy and an efficient group of bureaucrats. Artists and craftworkers, including metal casters and ivory carvers, were organized into guilds, worked exclusively for the king, and lived in special compounds in the city. The system was maintained until 1897, when a British expedition sacked and destroyed the city. The British soldiers went to Benin City to avenge the death of an English consul who was killed when he entered the city in violation of the orders of the king. The Benin leader had forbidden the visit of foreigners because he was absorbed in rituals in honor of his ancestors. The thousands of works of art taken as booty were sold in London to cover the cost of the expedition and are now in the major museums of Europe.

The art of Benin is court art, the principal aim of which was the glorification of the ruler. Each newly enthroned Oba ordered brass memorial heads to be cast in honor of his father (fig. 251). These heads are not individual-

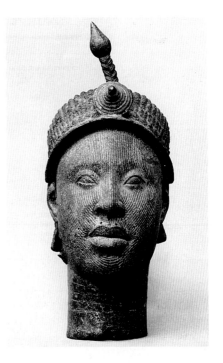

250. *Head of Queen Olokun*. Ife. 11th–15th centuries. Clay and brass, height to top of ornament c. 36". British Museum, London. The metal used to cast the heads found at Ife is often called bronze but, as an alloy of copper and zinc, it is more properly classified as brass.

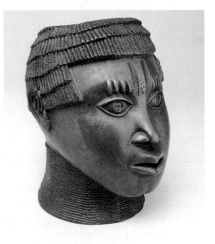

251. *Altar Head*. Benin. 17th century. Cast alloy of copper and iron, height 8 3/4". Edo peoples, Benin kingdom, Nigeria. National Museum of African Art, Smithsonian Institution, Washington, D. C.

Head of Queen Olokun: 11th–15th centuries
1167: Founding of Oxford University
1220: First giraffe is shown in Europe
1364: Aztecs build Tenochtitlán in Mexico
1470: Portuguese sailors arrive in the Gold Coast

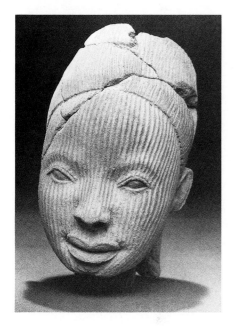

252. *Female Head.* Owo. 15th century. Terra-cotta, height 6 7/8". Yoruba peoples, Ugba' Laja site, Owo, Nigeria. Nigeria National Museum, Lagos

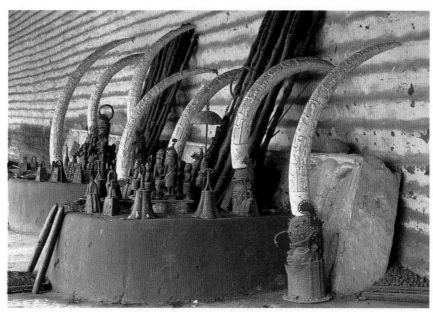

253. Royal Ancestral Shrine, Benin, Nigeria. Ancestral shrines for Benin kings in the present-day palace compound display brass commemorative heads that support elaborately carved ivory tusks. Ivory was precious, its whiteness symbolizing purity and peace. The monarch, or Oba, received one tusk from every elephant killed in the kingdom. Carved tusks were also a symbol of longevity, and some were as long as six feet. Numerous other ritual objects rested on the altars, including cast brass bells and figurative sculpture.

ized portraits intended to portray a particular monarch, but rather their function is to memorialize both a king and all kings. They are testimonies to royal descent and were one of the six essential items (the others include wooden heads, the royal sword, brass bells, sculpted leopards, and carved ivories) to sit on the ancestral altar of the palace to emphasize the king's prestige and power (fig. 253). As commemorative images, they represented the enduring power of inherited leadership.

The kings were believed to have both divine and Edo (the local tribe) lineage, and all beings, whether living or spiritual, were thought to possess life force, or *ase*. Priests, initiates, diviners, rulers, and elders could learn to use *ase* for the benefit of themselves and those around them.

The tangible world of the living (*aye*) interacted with the invisible realm of the spiritual forces (*orun*), which included gods, ancestors, and spirits. The tangible and spiritual aspects of all kings were meant to be realized in the brass heads.

Another kingdom, Owo, maintained close ties to Ife and also experienced the powerful artistic and cultural influences of Benin City. Excavations at Ugba' Laja uncovered the ruins of a thatched-roof mudhouse, thought to be a shrine, that contained objects associated with rites of sacrifice—terra-cotta heads (fig. 252), incomplete small figures, fragments of larger figures and groups, ceramic pots, iron implements, and polished stone axes. In technical execution and style, the head from Ugba' Laja falls within the naturalistic tradition also characteristic of the art of their neighbors, the Ife. The vertical striations that line the face represent the scarification that was performed to signify the rite of passage to adult life. The heirs of this sculptural tradition remain active and influential as artists in West Africa today.

15th-19th Centuries

V

FIFTEENTH-CENTURY ART

INTRODUCTION

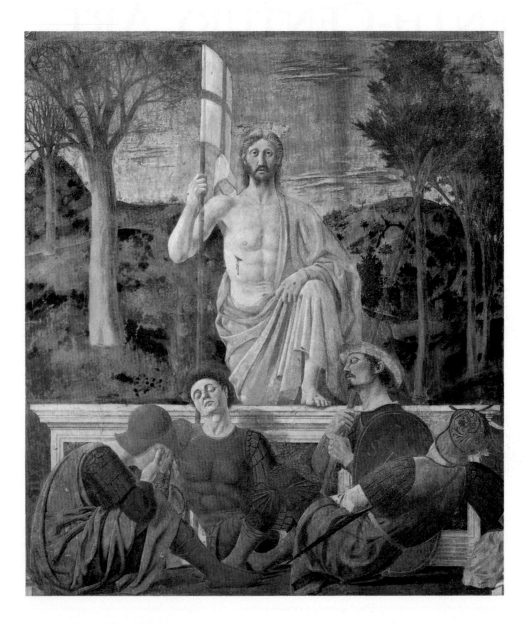

254. PIERO DELLA FRANCESCA
Resurrection. c. 1460. Fresco,
96 x 78"; the figures are approximately
lifesize. Pinacoteca, Sansepolcro

These two paintings (figs. 254, 255) demonstrate some of the important artistic developments in fifteenth-century painting in Italy and Flanders. Both are large, with lifesize figures, and offer a naturalism not seen in painting since the time of the ancient Romans. The figures are realistically proportioned, seem to have weight and to occupy illusionistic space, and suggest the potential for movement; in addition, they are charged with emotional and psychological tensions that demand a response from the viewer. Piero's resurrected Christ fixes us with a compelling gaze, while in Rogier's painting waves of emotion sweep through the followers of Christ as they receive the body being lowered from the cross. They weep, convulse, and faint.

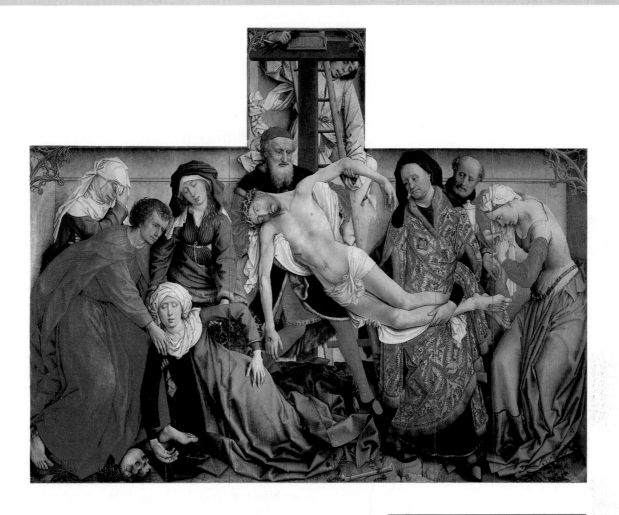

255. ROGIER VAN DER WEYDEN
Deposition. c. 1435–38. Oil on wood,
7' 2 5/8" x 8' 7 1/8". The Prado, Madrid

Yet significant differences between the two works suggest the artistic and cultural distinctions between Italy and Flanders in the fifteenth century. Piero's Christ is like a Greek god—his handsome musculature and dignified bearing can be compared to the *Apollo* from Olympia (fig. 73). Such an interest in classical motifs and types is seldom found in Flemish painting. Piero's forceful triangular composition, with Christ's head at the apex and the sleeping soldiers grouped below, reveals the Italian concern with harmony and order. Rogier's composition is much more visually complex, and its flowing forms weave a pattern of pathos and despair. This concentration is reinforced by Rogier's Flemish attention to precise detail, made possible by new developments in oil painting (see pp. 270–71).

FROM THE MIDDLE AGES TO THE RENAISSANCE: NAMING THE STYLES

The transition from the Late Middle Ages to the Renaissance in the cosmopolitan centers of Flanders and Italy was a gradual one, and many aspects of Renaissance society and art only evolved slowly from medieval traditions. Historians still debate if fifteenth-century

Flemish painting is best understood as a late manifestation of the Gothic or as a Northern version of the Renaissance. As neither Gothic nor Renaissance is a completely appropriate stylistic term for these Flemish works, they are here identified under an independent designation, fifteenth-century Flemish painting. In Italy, and especially in Florence, new Renaissance ideas dominate the production of art during most of the fifteenth century. This period is generally known as the Early Renaissance, to distinguish it from the late fifteenth and early sixteenth centuries, when the culmination of earlier ideas resulted in the period called the High Renaissance (see pp. 297–98).

HISTORY: FLANDERS IN THE FIFTEENTH CENTURY

In Flanders, an area roughly equivalent to present-day Belgium, a prosperous new merchant society based on the wool trade and banking was established during the fourteenth and fifteenth centuries. The flourishing city of Bruges was the most important center, and the presence of foreign bankers, such as the Medici from Florence, made it the banking capital of northern Europe. Other important centers included Ghent and Tournai. As in Italy, trade guilds controlled manufacturing, as well as the production of works of art.

Flanders was distinguished by a rich and diverse culture which included a revolutionary school of composers that dominated European musical developments throughout the century. Northern intellectuals, however, were not very interested in the revival of classical antiquity, so important to the Italians, and in Flanders some arts, especially architecture and the decorative arts, remained Gothic well into the sixteenth century.

HISTORY: FLORENCE IN THE FIFTEENTH CENTURY

Leonardo Bruni, a scholar versed in Latin and Greek and chancellor of Florence from 1427 until his death in 1444, praised Florence as "the new Athens on the Arno." He likened the civic values of his time to those fostered in democratic Athens and in Rome during the republic. But while Bruni praised Florentine republicanism, contrasting it to the despotic rule in other Italian city-states, in actuality Florence was led by an oligarchy of commercial interests. The Florentine government was eventually dominated by the Medici family, whose wealth was derived from banking and commerce. Beginning with Cosimo de' Medici, the family consolidated the reins of power behind a facade of republicanism. His descendants firmly tightened their political control, and Lorenzo, known as Lorenzo the Magnificent, ultimately ruled as a benevolent tyrant. Toward the end of the century, the domination of the Medici and the conspicuous wealth and humanist interests of the Florentine citizenry were challenged by the fiery sermons of the Dominican friar Girolamo Savonarola. Following the exile of the Medici in 1494, Savonarola assisted in

restoring a more representative form of government. But as Savonarola continued to act as the harsh conscience of Florence, the church and some of the citizenry turned against him, and he was executed for heresy in 1498. Florence maintained her republic until 1512, when the Medici again regained control.

THE IDEA OF A RENAISSANCE

Our use of the term Renaissance (French for rebirth) is drawn from a conception of history found in the writings of the sixteenth-century Italian painter, architect, and writer Giorgio Vasari, whose historical fame rests primarily on his *Lives of the Most Eminent Painters, Sculptors, and Architects*, a history of Italian art and artists. Vasari champions the works of ancient Greece and Rome, describing medieval art as a "disastrous decline," and argues that in Italy during the fifteenth and sixteenth centuries "art has been reborn and reached perfection in our own times." Vasari's concept influenced the French historian Jules Michelet, who in 1855 gave the title *La Renaissance* to a volume of his *Histoire de France* and thereby extended the idea of the Renaissance to embrace a cultural phenomenon which included northern Europe. Michelet's Renaissance was characterized by "the discovery of the world and the discovery of man."

For Italian Renaissance artists, the models of classical antiquity provided an impetus for artistic transformation, but it would be a mistake to view these artists as merely copying ancient works of art. They adapted the classical aesthetic to the attitudes of their own times, creating works of art distinctly different from those of antiquity. This "rebirth" of the antique encompassed not only works of art, but also the recovery of ancient texts and classical literary style. In addition, Leonardo Bruni's careful reading of antique texts and his application of ancient civic values to his own time led to a new historical consciousness fundamental to the growth of Renaissance humanism.

HUMANISM

The Renaissance concept of humanism (as distinct from modern concepts of humanitarianism and secular humanism) had a profound philosophical foundation. The title humanist was originally applied to a teacher of humanistic studies, a curriculum which included rhetoric, grammar, poetry, history, and moral philosophy. Humanism was integrated with Christianity; it sought to supplement faith by insisting on the dignity of the individual and the human potential for achievement. Although the development of humanism was centered in Florence, by mid-century most of the important courts in northern Italy had been significantly influenced by humanism.

Humanist values are visually exemplified on the *Tomb of Leonardo Bruni* (fig. 256), the Florentine statesman and champion of humanist

education. An effigy of the deceased Bruni rests atop a bier supported by two eagles, standards of ancient Rome. Crowned with laurel, the ancient symbol of honor and victory, and with his hands embracing his *History of the Florentine People*, Bruni lies eternally in state. On the sarcophagus below is a Latin inscription in classical lettering: "At Leonardo's passing, history grieves, eloquence is mute, and it is said that the Muses, Greek and Latin alike, cannot hold back their tears." These antique literary references are reinforced by the classicizing architecture of the tomb. The Corinthian pilasters and round arch may refer to the ancient Roman triumphal arch (see fig. 124). Over the arch two putti hold aloft Bruni's coat of arms. The relief of the Virgin and Child within the arch is the only reference to Christianity. Such a union of ancient traditions and Christian theology was one of the primary goals of humanism. It had an influence on many works of art, including Botticelli's *Birth of Venus* (fig. 306).

ART THEORY

Humanism also played an important role in the development of art theory. Leon Battista Alberti, well educated in humanistic studies, was attracted to the new work of such Florentine artists as Filippo Brunelleschi, Donatello, and Masaccio. He noted that these artists revived classical art, and using a literary approach that joined his knowledge of the principles of classical poetry and rhetoric, he wrote about the new art in *De pictura (On Painting)* in 1435. This cornerstone of Western art theory discusses the noble purpose of painting, the painter as an educated professional, and the use of mathematical principles, including scientific perspective (see pp. 262–63), in painting. *On Painting* gave art and artists a new dignity and opened the way for a new level of literary discussions on art.

THE UNION OF THE CLASSICAL AND THE NATURAL

Natural observation, an important feature of fifteenth-century art, was addressed by the late medieval artist Cennino Cennini in his practical manual for painters, *The Craftsman's Handbook*. He recommended learning to draw from the works of recognized masters: "Now you must forge ahead again, so that you may pursue the course of this theory. . . . Having first practiced drawing for a while . . . take pains and pleasure in constantly copying the best things which you can find done by the hand of the great masters." Having established the importance of studying masterpieces, Cennini turned to nature: "Mind you, the most perfect steersman that you can have, and the best helm, lie in . . . copying from nature. And this outdoes all other models; and always rely on this with a stout heart, especially as you begin to gain some judgment in draftsmanship." To the Renaissance artist, copying from nature led not only to the heightened perception gained from meticulous observation, but also to an attempt to understand the

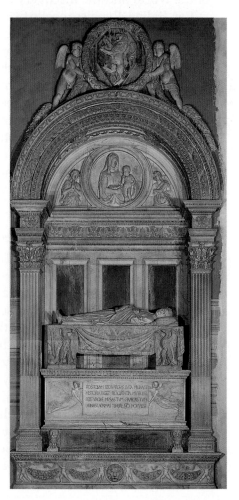

256. BERNARDO ROSSELLINO
Tomb of Leonardo Bruni. c. 1445. Marble with traces of paint and gilding, height to top of arch 20'. Santa Croce, Florence

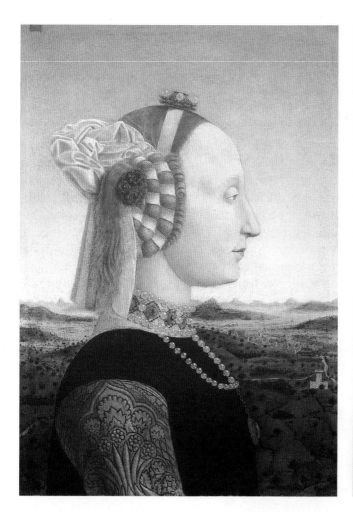 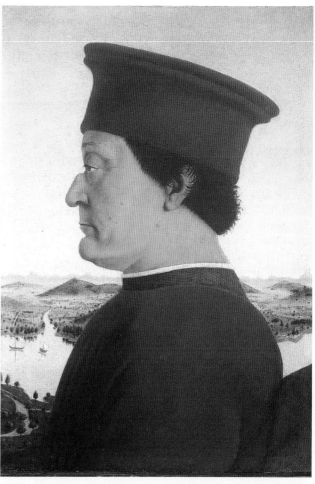

257. PIERO DELLA FRANCESCA
Battista Sforza; Federigo da Montefeltro.
1474. Oil and tempera on wood, each
18 1/2 x 13". Uffizi Gallery, Florence.
Federigo da Montefeltro, the patron,
ruled Urbino from 1444 until 1482. His
wife, Battista Sforza, bore Federigo
eight daughters and one son. Federigo
was a soldier and a prolific patron of
artists and architects.

principles that govern the order and processes of nature. This sympathy with the natural world was a decisive aspect of Renaissance art.

Donatello's equestrian monument of *"Gattamelata"* (fig. 258) combines naturalistic observation with a well-known antique type, as exemplified by the *Marcus Aurelius* (see fig. 123). An ambitious feat of bronze casting, it was the largest sculpture cast in bronze since antiquity. With the bronze *David* (fig. 290), probably commissioned for the Medici Palace courtyard (fig. 288), Donatello revived the lifesize, freestanding, nude figure. The acceptance of nudity in art is related to the humanist insistence on the dignity of the individual and the view that the human figure is a microcosm of the macrocosm, a smaller, symbolic reflection of the larger universe.

INTELLECTUAL AND SCIENTIFIC ACTIVITY

The Gutenberg Bible—the first complete book to be printed using independent, movable type—was made between 1450 and 1456. By 1460 woodcuts were being used for illustrations in books and, as an inexpensive method of producing illustrated books in large quantity, they contributed to the development of the sciences. Knowledge was more easily shared when a printed illustration could offer an exactly

repeatable image, unchanged by the hand of a copyist. Through the medium of printing, knowledge would reach a level of dissemination only recently overcome by modern media, including the computer.

PATRONAGE

During the fifteenth century, artists and workshops received a variety of secular and religious commissions, and both rulers and the mercantile class viewed patronage as an important activity of the responsible and enlightened citizen. Devotional images, portraits, mythological subjects, and secular decorations were commissioned by individuals to adorn their family chapels, private palaces, or town houses. In Flanders it became common for donors and family members to be

258. DONATELLO
Equestrian Monument of Erasmo da Narni, called *"Gattamelata."* c. 1445–53. Bronze, originally with gilded details, height 12'2". Piazza del Santo, Padua. Erasmo da Narni was a famous mercenary general who was employed by the Venetian government to raise and lead its armies; his nickname means honeyed cat.

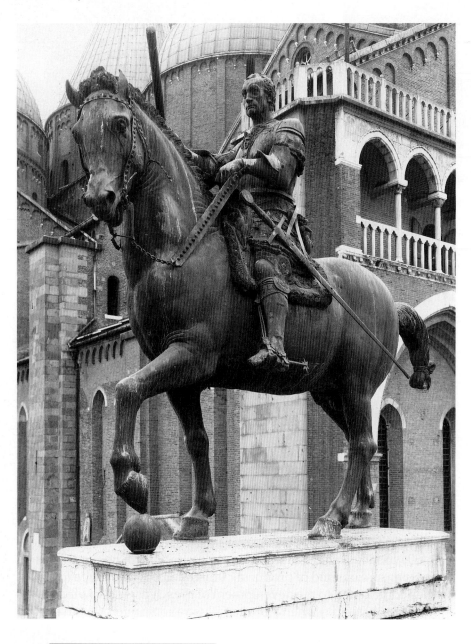

represented in the wings or at the sides of works they commissioned (see fig. 265).

In Florence, Cosimo de' Medici was generous in his support of libraries. He took an avid interest in the art of Donatello, and his patronage of scholars may have supported the formulation of Neo-platonism, a humanistic philosophy which sought to fuse Plato's ideals with Christian thinking. Cosimo's grandson, Lorenzo the Magnificent, collected antique works of art and encouraged commissions for Florentine artists; he was also a friend and supporter of the young Michelangelo. Such involvement with the arts was not solely altruistic, for support of humanist scholarship and the arts demonstrated benevolence and was useful in forming public opinion and securing fame. Moreover, given the political intrigue and conflict of the time, it was an advantage for rulers to surround themselves with intellectuals as advisers.

Rulers often commissioned portraits. Piero della Francesca gave his patrons, the rulers of Urbino (fig. 257), an almost omnipotent presence. They seem elevated above everyday affairs, and the broad landscape backgrounds suggest the extent of ducal power. On the reverse they are shown on triumphal carts surrounded by virtues. The use of allegory is thus combined with the commitment to naturalism so apparent in the unidealized representation of Federigo's profile, which was disfigured in a tournament.

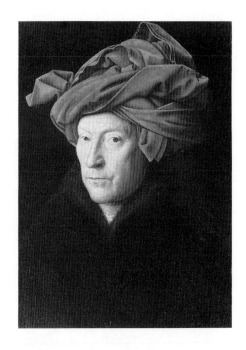

259. JAN VAN EYCK
Self-Portrait. 1433. Oil on wood, 10 1/4 x 7 1/2". National Gallery, London

THE FIFTEENTH-CENTURY ARTIST

The new self-consciousness that can be perceived in fifteenth-century society had an important influence on attitudes about artists. In contrast to the prevalent medieval attitude that the artist was a humble craftsperson serving God, some Renaissance artists were viewed as trained intellectuals, versed in the classics and geometry. Artists became famous; in 1481 Cristoforo Landino listed some Italian and Flemish artists, praising them for their skill and innovations, and suggested that Donatello could be "counted among" the ancient masters—the highest praise possible at the time. Artists began to sign their works with more frequency, and one artist, Lorenzo Ghiberti, wrote his autobiography.

During the first half of the fifteenth century, Flemish and Italian artists began to create self-portraits, a sure indication of their new status. In 1433 Jan van Eyck depicted himself wearing a fantastic headdress—a tour de force of painting—and looking out at us with a penetrating gaze (fig. 259). On the frame are Van Eyck's motto (The best I can do) and the date. Artists even began to include self-portraits within their works. Lorenzo Ghiberti's "*Gates of Paradise*" (fig. 280) have both a self-portrait (fig. 260) and a Latin inscription that praises the "marvelous art" with which Ghiberti made the work. The new dignity accorded the artist in the fifteenth century is a foundation upon which the later conception of the artist as an inspired genius is based.

260. LORENZO GHIBERTI
Self-Portrait, from the *East Doors of the Baptistery* (see fig. 280). 1425–52. Gilded bronze, approx. height 3". Museo dell'Opera del Duomo, Florence

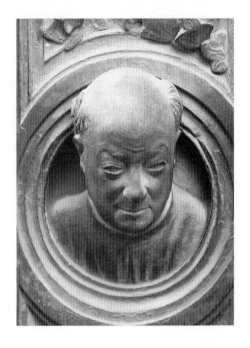

EARLY RENAISSANCE SCULPTURE IN FLORENCE

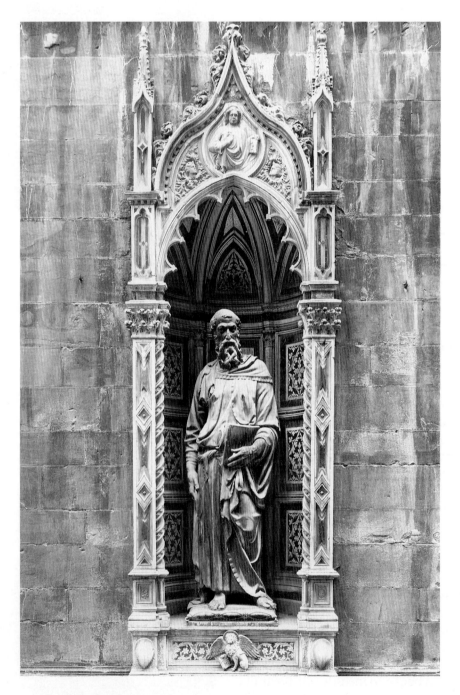

261. DONATELLO
St. Mark. c. 1411–15. Marble, originally with limited polychromy and metal details, height 94". Formerly on Orsanmichele, Florence. This statue of the Evangelist was commissioned by the Guild of Linen Weavers and Peddlers, a trade guild, for their niche, one of fourteen niches assigned to the Florentine guilds on the civic granary and shrine of Orsanmichele. The figure is shown in its original Gothic setting.

Donatello's *St. Mark* (fig. 261) overlooked a Florentine street, surveying the urban scene. His expression conveys a questioning intelligence. It is reported that when Michelangelo saw the work, he proclaimed "that he had never seen a figure which had more the air of a good man than this one, and that if St. Mark were such a man, one could believe what he had written." In other words, for Michelangelo the *St. Mark* expressed integrity. In medieval art the Evangelists had been depicted as figures receiving divine inspiration (see figs. 197, 198). Donatello's Renaissance interpretation emphasizes the more human attributes of wisdom and reason. In addition, Donatello's *St. Mark* attains the dignity we accord an individual, for in physiognomy and body type he suggests a specific, compelling personality. The revival of antiquity, so important for the Italian Renaissance, is readily apparent, for *St. Mark* is closer to ancient Greek and Roman figures than any figure created during the long interval of the Middle Ages. The emphatic *contrapposto* of the saint, which helps establish his naturalism,

DONATELLO, *St. Mark:* **c. 1411–15**
1394–97: Manuel Chrysoloras teaches Greek in Florence
1405: Florence buys Pisa
1410: Ptolemy's *Geography* is translated into Latin
1415: Jan Hus is burned at the stake for heresy

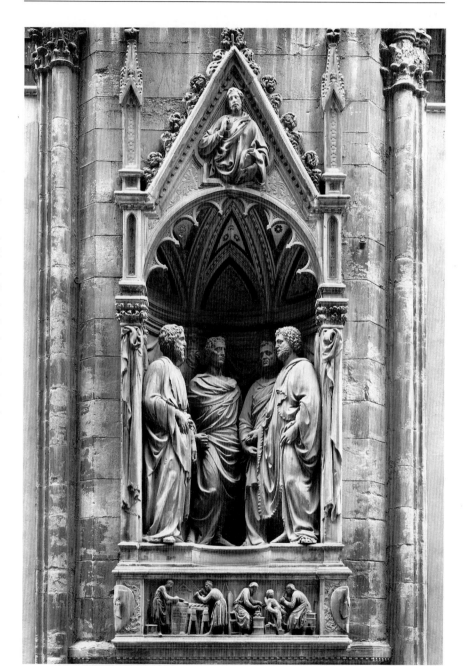

262. NANNI DI BANCO
Four Saints. c. 1410s. Marble, height 72". Orsanmichele, Florence. This grouping of four saints was commissioned by the Guild of Sculptors and Stone Masons for their niche at Orsanmichele.

was influenced by ancient examples (see fig. 91).

The *Four Saints* by Nanni di Banco (fig. 262) on the same civic structure represent Christian stonecarvers who, during the late Roman Empire, were put to death when they refused to make a pagan idol. Their serious demeanor and the open mouth and oratorical gesture of the figure on the right suggest that Nanni has depicted the moment in their legend when they debate whether to compromise their religious beliefs or submit to death. Nanni's inspiration from ancient Roman models is obvious in the heads, one of which has a stubbly beard, and in the drapery folds of the togas. While such an interest is consistent with Renaissance attitudes, Nanni's antique references could also be viewed as part of his effort to establish historical veracity. What could be more appropriate than to emulate ancient Roman models when creating representations of figures who had lived in the late antique period? The new Renaissance respect for historical accuracy may have played a role in the conception of this sculptural group.

THE LIMBOURG BROTHERS, *TRÈS RICHES HEURES DU DUC DE BERRY*

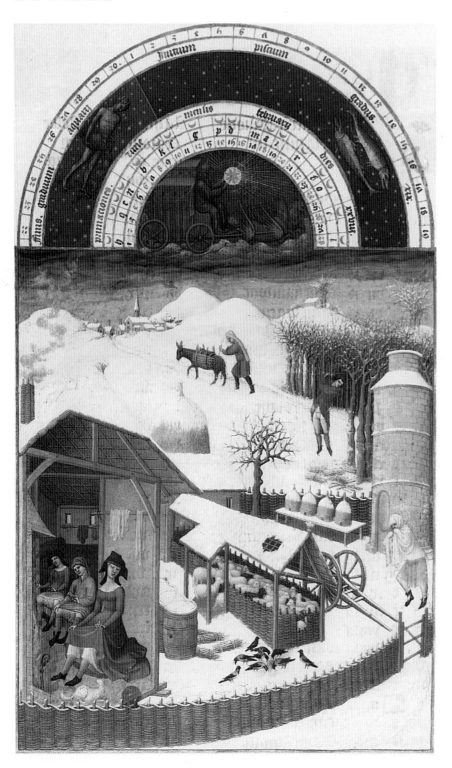

263. THE LIMBOURG BROTHERS *February*, calendar page from the *Très Riches Heures du Duc de Berry*. Before 1416. Manuscript painting on vellum, 11 3/8 x 8 1/4". Musée Condé, Chantilly, France. This manuscript is listed in an early inventory as "The Very Rich Hours of the Duke of Berry." The patron was John, duke of Berry (and brother of King Charles V of France), whose library included more than three hundred manuscripts. The artists were three brothers—Pol, Herman, and Jean Limbourg. The calendar pages, which traditionally accompany the listing of saints' feast days, include the labors of the month and zodiac signs with various astrological calculations.

The puff of frosty breath from the mouth of the figure hurrying across the farmyard and the smoke curling from the chimney are the kinds of subtle details that characterize the comprehensive realism developing in Flemish painting at the beginning of the fifteenth century (fig. 263). The traditional calendar page for February showed people sitting by a fire, but the Limbourg brothers' representation encompasses a modest farm, complete with dovecote, beehives, and sheepfold, set within a vast snowy landscape with a distant village. Several figures reveal the peasants' restricted winter activities. The sky is no longer merely a flat blue background, but offers at-

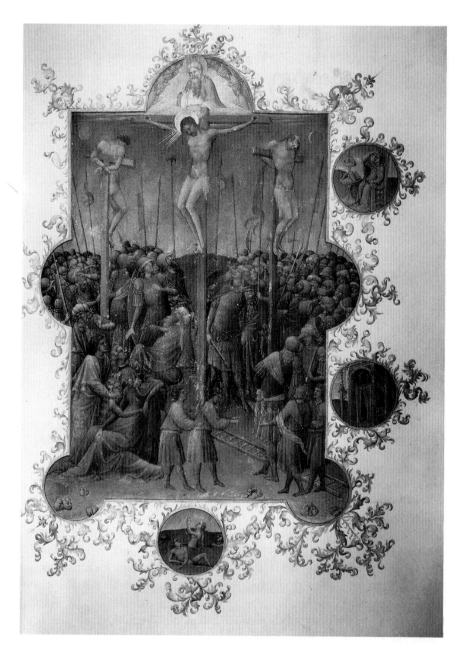

264. THE LIMBOURG BROTHERS
Crucifixion in the Darkness of the Eclipse, from the *Très Riches Heures.* Before 1416. Manuscript painting on vellum, 11 3/8 x 8 1/4". Musée Condé, Chantilly, France

mospheric mid-winter effects that reveal the Limbourgs' study of natural phenomena.

The Limbourgs' attention to naturalistic effects also extends to biblical stories. Taking inspiration from the passage in Matthew's Gospel that, at the time of Christ's crucifixion, "there was darkness over all the land" (27:45), they created a panoramic crucifixion scene in tones of gray that suggest the naturalistic effects of an eclipse (fig. 264). In a blaze of gold, blue, and red, God the Father appears to bless his dying son. In the top right rondel, an astronomer surveys the heavens, searching for an explanation for this unexpected phenomenon.

The *Très Riches Heures* marks a final phase in the development of manuscript painting in the North. This sumptuous manuscript, with one hundred thirty illustrations, includes devotions for different periods of the day (a book of hours). The heightened interest in representing naturalistic lighting effects, panoramic landscapes, and precise details explains why this manuscript has been so admired and its compositions so often copied by later artists.

ROBERT CAMPIN, *THE ANNUNCIATION*

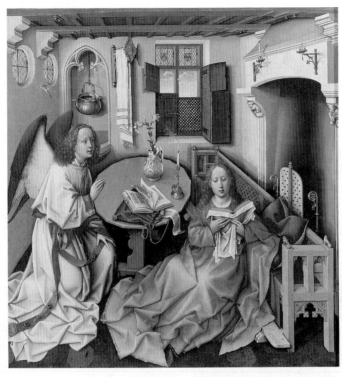

265. ROBERT CAMPIN
The Annunciation with Patrons; St. Joseph in His Workshop. c. 1425–30. Oil on wood, 25 1/4 x 24 7/8" (center); 25 1/4 x 10 3/4"
(each wing). The Metropolitan Museum of Art, New York (The Cloisters Collection). The patron who commissioned this
work is represented kneeling in the left wing; his wife, beside him, has been painted over the green grass, suggesting that
she was added after the picture was finished, probably at the time of their marriage. It was perhaps at this same time that
Campin made the work even more realistic by painting over the gold leaf that had originally filled the central windows,
substituting sky, clouds, and coats of arms in stained-glass windows that indicate the patron was a member of the Ingel-
brechts family. This work is often referred to as the *Mérode Altarpiece* because it was owned by the Mérode family during
the nineteenth century. Robert Campin is sometimes known as the Master of Flémalle.

This folding triptych (three-part altarpiece or devotional picture; fig. 265) represents a further development of the revolutionary new qualities evident in Flemish manuscript painting at the beginning of the fifteenth century (see figs. 263, 264). Perhaps most startling is the precision with which objects and figures are rendered. Naturally lit, they are modeled with subtle transitions from light to shadow that make them seem three-dimensional and weighty. This naturalism results from the union of the fine detail of oil paint with a revolu-

tionary precision of observation on the part of the artist (see p. 270). It almost seems as if no artist had ever seen shadows with such clarity before—certainly no artist had ever rendered them so precisely. Such naturalism demands intense concentration in both vision and technique.

Accompanying this naturalism of representation is the realistic depiction of the subject, for a biblical event from the distant past is set in a fifteenth-century Flemish house. Gabriel enters to announce to a distinctly Flemish

Mary that she will be the mother of the Son of God, while Mary's husband, Joseph, a carpenter, is shown in a fifteenth-century workshop in the right wing. Campin's depiction of this setting offers valuable evidence about woodworkers' shops and tools, including a folding shelf on which Joseph offers a mousetrap for sale directly from his shop. As secular as this may seem, locating the Annunciation within a contemporary setting is intended to make the sacred events more comprehensible and meaningful. Such an ap-

proach to religious iconography is paralleled in popular devotional literature and is probably also related to the representation of such subjects in contemporary religious theater.

To understand Campin's interpretation, we must look beyond the dazzling surface realism, since a pervasive symbolism (sometimes called disguised symbolism) gives a religious content to virtually every object in the painting. The three lilies on a single stalk that decorate the Virgin's table, for example, refer to the Christian Trinity; the bud is Christ. An especially intriguing symbol is Joseph's mousetrap, for it expresses the late medieval notion that God married the Virgin to a devout older man to prevent the Devil from discovering that her child was the Son of God; in such an explanation Joseph became a "mousetrap" set by God.

The candle on the Virgin's table (fig. 266), just extinguished, releases a puff of smoke that suggests that the painting represents a precise moment in time. Light is a common metaphor for divinity, and the light of the Virgin's candle is extinguished because of the entry into the room (and into the world) of divine light in the person of Christ, who appears as a minuscule baby entering on rays of light through a round window on the left. The candle might also refer to the late medieval custom of the bridal candle, which was extinguished when the marriage was consummated. The blowing out of the candle and the presence of Christ within the Virgin's chamber would then express the moment of the Incarnation. Notice that this religious content is expressed by everyday objects and that, in keeping with his naturalistic bias, Campin has not used haloes for his figures.

Robert Campin's style is known from a small number of paintings, all of which are similar in their use of ordinary people as models, their depiction of drapery with sharp, rather abstract folds, and their crowded compositions which avoid empty spaces (*horror vacui*).

There was a revolution in 1423

CAMPIN, *The Annunciation:* **c. 1425–30**
1422: England resumes war with France
1427: Thomas à Kempis, *The Imitation of Christ*

in Tournai, where Campin lived, and a new democratic government, led by representatives of the craft guilds, was established. This democratic, mercantile culture certainly helps to explain the middle-class setting and virtues of Campin's *Annunciation* triptych, with its delight in a typical household and the inclusion of Joseph as a hardworking husband and father.

266. ROBERT CAMPIN
The Annunciation (detail)

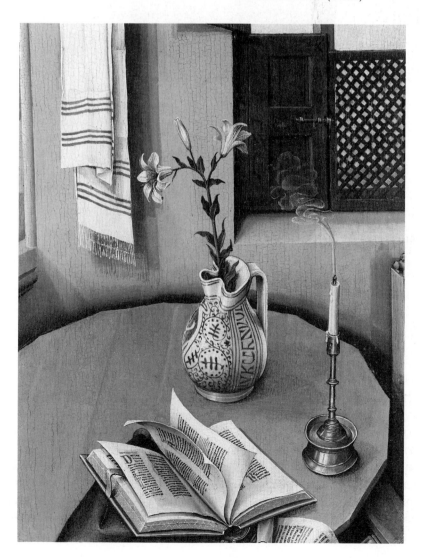

EARLY RENAISSANCE PAINTING: MASACCIO

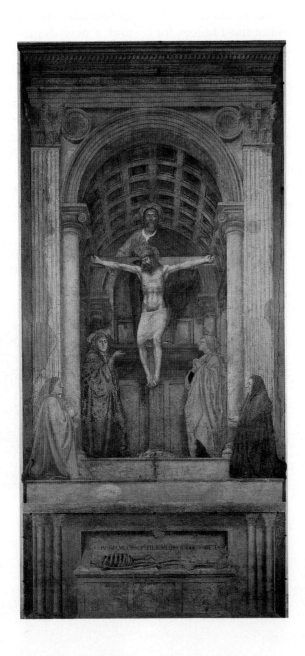

267. MASACCIO
The Trinity with the Virgin Mary, St. John, and Two Donors. c. 1425–28. Fresco, 21' 10 1/2" x 10' 5"; the figures are approximately lifesize. Santa Maria Novella, Florence. On the vertical axis, God the Father holds the cross, presenting his crucified son to us. A flying dove, symbol of the Holy Spirit, hovers between their heads. At the foot of the cross stand Mary and John the Evangelist; Mary's gesture and outward glance engage our attention. The kneeling profile figures are the donors who commissioned the painting. Their identity remains uncertain, although he wears the red robe of a Florentine official. The bottom portion of the painting contains a skeleton resting on a ledge. Above the skeleton, an inscription in classical lettering reads: "I was once what you are; what I am, you will be." The inclusion of the skeleton and the inscription add a *memento mori* (a reminder that all must die) context to the theme. Such references to human mortality were popular in the fourteenth and fifteenth centuries, when plagues often ravaged the populace.

The triangle, symbol of the Trinity, becomes the unifying compositional form in Masaccio's *Trinity*, with the head of God the Father forming the apex and the donors comprising the base (fig. 267). The triangular composition, popular in the Early Renaissance, is also visually clear and easy to read. This clarity is supported by the illusionary space created by the use of scientific perspective (see pp. 262–63). To the viewer positioned in front of the painting, the effect is of an actual chapel with real figures. The architectural forms are closely related to the Renaissance architecture being developed by Filippo Brunelleschi at this time (see p. 272). He may well have assisted Masaccio with this aspect of the painting. The clarity of the composition is combined with boldly three-dimensional figures recalling those painted by Giotto. Masaccio here has advanced the

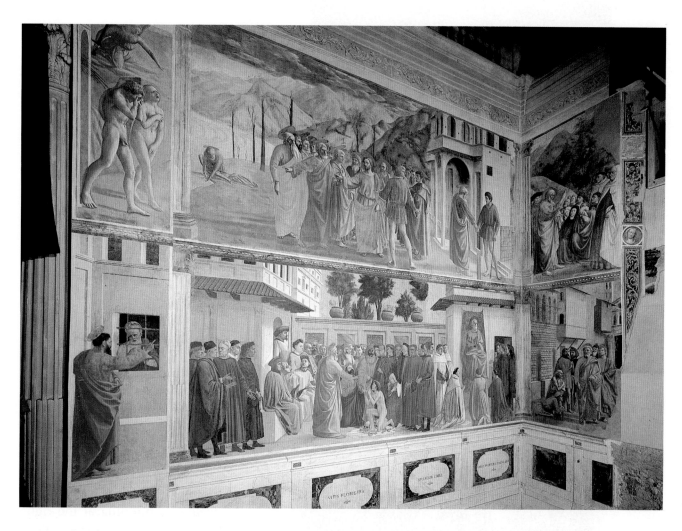

268. Left and portion of rear walls of Brancacci Chapel, Santa Maria del Carmine, Florence, with frescoes by Masaccio (c. 1425–28), Masolino (c. 1425–28), and Filippino Lippi (1484). Height of each register 96". Scenes shown here include *The Expulsion of Adam and Eve* and *The Tribute Money* by Masaccio (top register, left wall), the *Preaching of St. Peter* by Masolino (top register, back wall), *St. Peter in Prison* by Filippino Lippi (lower register, left scene on left wall), *The Resurrection of the Son of Theophilus and the Chairing of St. Peter* by Masaccio and Filippino Lippi (lower register, main scene on left wall), and *St. Peter Healing with His Shadow* by Masaccio and Masolino (lower register, back wall).

innovations of Giotto by combining them with the coherent illusory space which distinguishes Renaissance painting.

A short time before he was commissioned to paint *The Trinity*, Masaccio was employed with another artist, Masolino, in decorating the Brancacci Chapel with scenes primarily from the life of St. Peter. In *The Tribute Money* (Matthew 17:24–27), Christ and his apostles are confronted by a tax collector who requests that a temple tax be paid (fig. 268). Christ instructs Peter to go to the edge of the sea, to our left, where he finds the necessary coin of tribute in the mouth of a fish. To the right, Peter pays the tax collector, an act prophetic of Christ's words, "Pay to the emperor what belongs to him, and pay to God what belongs to God" (Matthew 22:15–22). Because three different episodes take place within the unified space of the composi-

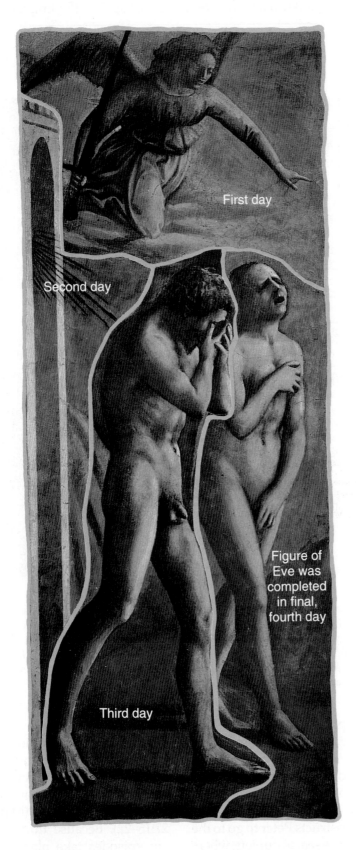

269. *Giornata* diagram for *The Expulsion of Adam and Eve*

tion, *The Tribute Money* exemplifies continuous narration, a thematic device which had been used in ancient Roman painting and sculpture (see fig. 126).

The perspective of *The Tribute Money* contributes to a unity of organization, while the boldly modeled figures reveal a light source that corresponds to the real light that falls into the chapel from a single window on the altar wall. The building at the right, which obeys the laws of scientific perspective, draws our attention to the head of Christ, while atmospheric perspective envelops the trees and hills of the background. Within the logic of this spatial illusionism, Masaccio's figures act out the story with simple, direct, and dignified movements.

Masaccio's sculpturesque modeling and bold figurative presentation are especially evident in *The Expulsion of Adam and Eve* (fig. 268). Having disobeyed God, Adam and Eve are driven

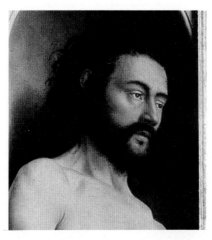

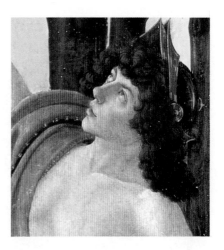

270. Head of apostle, detail from *The Tribute Money* (fig. 268). Fresco

271. Head of Adam, detail from *The Altarpiece of the Lamb* (fig. 277). Oil on panel

272. Head of Mercury, detail from Botticelli's *Realm of Venus* (fig. 305). Tempera on panel with oil glazes

by guilt and shame. In Masaccio's interpretation, Adam hides his face in his hands, leaving his genitals uncovered. Masaccio thus emphasizes the psychological rather than the physical nature of Adam's shame. The figure of Eve, which was inspired by an ancient sculpture of the Modest Venus, conceals her nakedness, but throws her head back in a moan as she bewails their fate.

Masaccio's figures, instilled with psychological presence, recall the human gravity of Donatello's sculpture, while the classicizing architecture and use of scientific perspective reveal his relationship with Brunelleschi. Although he died in his twenties, Masaccio translated into paint the Renaissance innovations of Donatello and Brunelleschi, and he influenced later generations of Renaissance artists, including Michelangelo. An epitaph, composed in the sixteenth century, recognized Ma-

saccio's contribution: "I painted, and my picture was lifelike; I gave my figures movement, passion, soul: they breathed" (Annibale Caro, as cited in Vasari's *Life of Masaccio*).

The speed of Masaccio's execution is indicated in the *giornata* diagram for *The Expulsion of Adam and Eve* (fig. 269), which indicates that it was completed in only four days. The breadth and simplicity of Masaccio's painting technique are also revealed in the classically inspired head of an apostle from *The Tribute Money* (fig. 270).

To understand the three different painting techniques—fresco, oil, and tempera—available to fifteenth-century European painters, we can compare this head (fig. 270) with the head of Adam, painted in oil by Jan van Eyck (fig. 271), and the head of Mercury, painted in tempera with oil glazes, by Botticelli (fig. 272). While each head offers its own distinctive reality, the bold

masses of Masaccio's head contrast with the finer detail that characterizes the other two heads. Masaccio's apostle, rendered in fresco, is broadly and quickly painted with strong contrasts of light and dark to create a powerfully modeled form. Van Eyck's head of Adam, painted in oils, shows the artist's interest in representing surface texture: notice the cracked lips, the wrinkles of the forehead, and the masses of curls that make up the moustache, beard, and hair and which seem to be composed of individually painted hairs. Botticelli's Mercury is painted with tempera with some use of oil glazes; here the artist is less interested than Masaccio or Van Eyck in modeling to create an effect of mass, but his drawing of the head, tilted back into space and slightly foreshortened, is very convincing. Using oil glazes, Botticelli captures the translucency of the human eye when it is struck by light.

SCIENTIFIC PERSPECTIVE

273. PAOLO UCCELLO
Perspective Drawing. c. 1430–40. Pen and ink on paper, 13 3/8 x 9 1/2". Gabinetto dei Disegni, Uffizi Gallery, Florence. Vasari tells us that Uccello delighted in making such complex studies, and that he would often work late into the night, "seeking to solve the problems of perspective." When called to bed by his wife, Uccello would reply, "Oh, what a sweet thing is this perspective!"

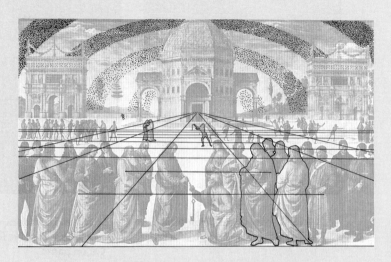

274. Diagram of Perugino's *Christ Giving the Keys to St. Peter* (fig. 4) showing the orthogonals and transversals of the scientific perspective scheme. The gradually shaded areas in the background indicate the blurring and color modulations characteristic of atmospheric perspective.

Uccello's *Perspective Drawing* is a virtuoso rendering of a geometricized chalice which is at least partially transparent (fig. 273). The geometricized rings at the top and base are derived from Uccello's studies of a wire- or wicker-frame construction (*mazzocchio*) that was wrapped with cloth to create a type of male head gear popular in the fifteenth century. Perhaps it was the faceting of the skeletal structure of this headdress which led Uccello to study the chalice with a similar geometric, linear emphasis.

The study of perspective, the rendering of figures or objects in illusory space, was an important innovation in Renaissance art. Perspective had been a conscious development in ancient Greek painting, and many examples of Roman art attest to the accomplished use of perspective in antiquity. During the Middle Ages, however, the pictorial reproduction of the physical world became less significant within a culture that emphasized spiritual and otherworldly values. Perspective gradually became valued in the later Middle Ages, but a coherent system allowing artists to determine the relative diminution of size of figures and objects was lacking.

That problem was solved by Filippo Brunelleschi, the Early Renaissance architect (see p. 272). Around 1415 Brunelleschi demonstrated a scientific perspective system (also called linear and vanishing-point perspective) in two lost paintings. His new perspective system was incorporated in works by other artists, including Donatello's *Feast of Herod* (fig. 275) and Perugino's *Christ Giving the Keys to St. Peter* (figs. 4, 274).

Within the complex architectural structure of the *Feast of Herod*, Donatello narrates the dramatic events surrounding the beheading of St. John the Baptist. His use of scientific

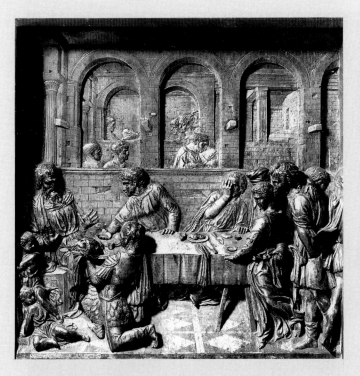

275. DONATELLO
Feast of Herod, from the Siena baptismal font. c.1425.
Gilded bronze, 23 1/2" square. Baptistery, Siena.
Donatello uses continuous narration to depict the story
of the beheading of John the Baptist. Within the distant
arch in the left background, the just-severed head is
given to a servant, while in the left foreground it is
presented to Herod, who recoils in horror. In the right
foreground, Salome still sways with the rhythms of
her dance.

276. Diagram of the orthogonals of the perspective
scheme of Donatello's *Feast of Herod*

perspective assists in visually unify-
ing these events. The diagonal lines
created by the recession of architec-
tural elements parallel to each other,
such as those of the floor in the fore-
ground, converge at a vanishing
point. The convergence of these di-
agonal lines, which are called
orthogonals, helps Donatello deter-
mine the exact diminution of figures
and architecture (fig. 276).

Scientific perspective is based on
the assumption that parallel lines
receding from us seem to converge
at a point on the horizon. This is the
basis for the meeting of the orthog-
onals at the vanishing point. Scien-

tific perspective also assumes that
the diminution in size of objects is in
direct proportion to their distance
from us, and that space is, therefore,
quantifiably measurable.

What Brunelleschi arrived at
through empirical study, Alberti
stated with theoretical reasoning in
his book *On Painting*. By construct-
ing orthogonal lines crossed by trans-
versals (lines which recede parallel
to the picture plane) on the planar
surface of a painting or relief, a re-
ceding modular grid pattern is cre-
ated. This pattern establishes a co-
herent, mathematically measurable
illusory space within which the art-

ist can determine the proportional
diminution of objects distant from
the viewer. Brunelleschi's system
was widely used by many Renais-
sance artists, including Ghiberti and
Leonardo (see figs. 279 and 311). In a
fully developed example of Renais-
sance illusionistic painting, such as
Perugino's *Christ Giving the Keys to
St. Peter* (figs. 4, 274), scientific per-
spective is combined with atmos-
pheric perspective for a unified ef-
fect that encompasses vast spaces,
correctly proportioned figures, and
the subtle qualities of the sky and
distant landscape as they appear to
the eye.

HUBERT AND JAN VAN EYCK, *THE ALTARPIECE OF THE LAMB*

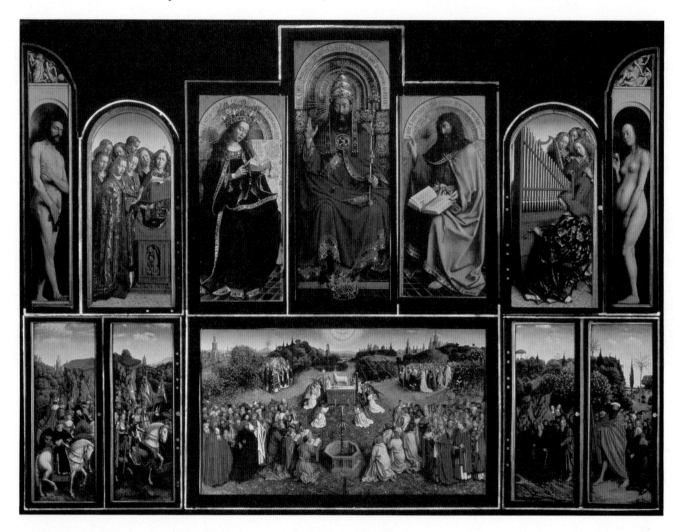

277. HUBERT AND JAN VAN EYCK

The Altarpiece of the Lamb (interior). Completed 1432. Oil on wood, 11' 5 3/4" x 15' 1 1/2". Cathedral of St. Bavo, Ghent. This work is also known as the *Ghent Altarpiece*. An inscription on the frame identifies the patron as Jodocus Vijd, the date of completion as 1432, and the painters as Hubert and Jan van Eyck. Hubert died before September 18, 1426, and the role each brother played in the conception and execution of the many panels has been much debated. Scholars today generally agree that the altarpiece includes a number of works by Hubert, some of which may have been left unfinished at his death, which Jan combined into a totality, adding works conceived by Jan (in particular, the figures of Adam and Eve) to complete the altarpiece. This may explain the juxtapositions in figural scale between the parts of the altarpiece. The luminous technique and fine detail that unify the painting are considered to be the work of Jan, who by the sixteenth century had been credited with the invention of oil painting.

The iconography is complex. The lower panels represent the Triumph of the Lamb of God, with crowds of saints pressing inward to worship the symbolic lamb on the altar. The upper panels include God the Father in the center flanked by the Virgin Mary and St. John the Baptist, musical angels, and Adam and Eve. Above Adam and Eve are small *grisaille* scenes of the story of Cain and Abel.

Adam and Eve were among the few subjects that permitted Northern artists to represent the nude, but Jan's virtually lifesize figures are unprecedented. Jan's commitment to realism here confronts traditional restrictions, for while the figure of Adam is clearly based on a nude model (notice the sunburned face, neck, and hands; see fig. 271), Eve is an imaginative re-creation based on contemporary ideals rather than on observation of a live model. The small, high breasts and bulbous abdomen are Gothic stylizations. The emphasis on the large abdomen stresses the role of childbearer assigned to women in the fifteenth century.

In scale and wealth of detail, this large, hinged polyptych (multi-paneled altarpiece) is an overwhelming accomplishment—the work of years—and the most impressive of all early Flemish paintings (figs. 277, 278). The diverse scale and size of the panels and the variety of subjects represented allowed the Van Eycks to paint Flemish interiors, vast landscapes, illusionistic sculpture, portraits of living donors, the male and female nude, elaborate brocades, bejeweled and gold embroidered borders, and musical instruments. Jan van Eyck's ability to re-create the visual world in oil paint is staggering, but among the wealth of details offered by the *Ghent Altarpiece*, the most unforgettable may be the artist's self-portrait in the studio, which is reflected in one of the innumerable pearls in the papal crown worn by God the Father, the central figure of the interior. This tour de force of painting is one of several "reflected" self-portraits found in the work of Jan van Eyck (see also fig. 283). Jan's pride in his accomplishments is also evident in his *Self-Portrait* (fig. 259), one of the first independent self-portraits in the history of art.

Jan van Eyck's ability to represent textures as if they were real is based on his acute examination of light and how it reacts differently when it strikes and reflects from various surfaces. He composed his paintings to emphasize this, juxtaposing materials to contrast textures and heighten his illusion. Jan van Eyck's figures seldom express strong or dramatic emotions. The wonder that his paintings generate comes from his ability to observe reality and to convey in oil paints the excitement of vision.

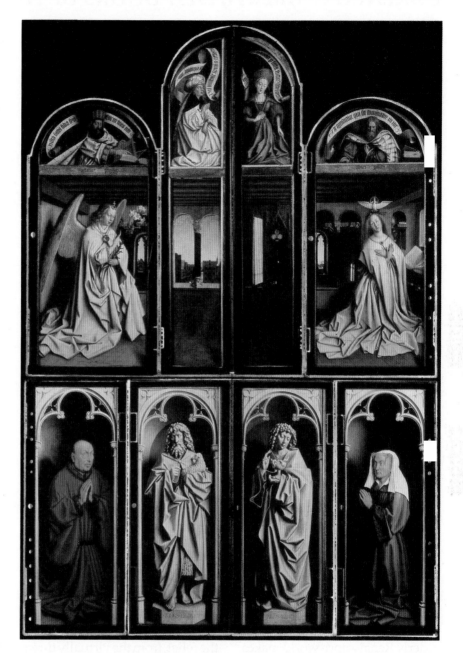

278. HUBERT AND JAN VAN EYCK
The Altarpiece of the Lamb (exterior). Oil on wood, 11' 5 3/4" x 7' 6 3/4". The donors of the altarpiece, Jodocus Vijd and Isabel Borluut, are shown in the lower panels, kneeling before Sts. John the Baptist and John the Evangelist, patrons of the city of Ghent. In the upper register is a scene of the Annunciation; the topmost panels show representations of the Old Testament prophets Zachariah and Micah and two pagan sibyls.

LORENZO GHIBERTI, *EAST DOORS OF THE BAPTISTERY*

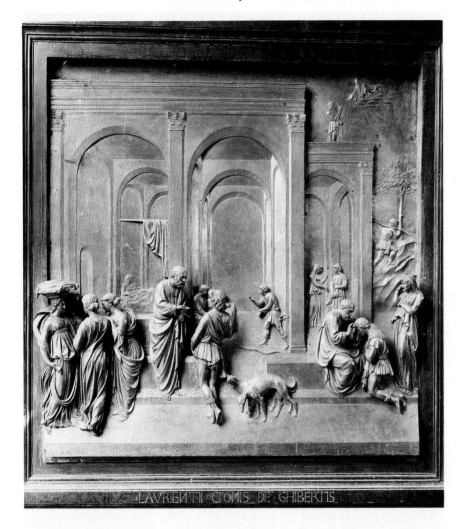

279. LORENZO GHIBERTI
The Story of Jacob and Esau, from the *East Doors of the Baptistery*. c. 1429–37. Gilded bronze, 31 1/4" square. Museo dell'Opera del Duomo, Florence. The story of Jacob and Esau, from the Old Testament book of Genesis (25:19 through 28:5), tells how Jacob and his mother, Rebecca, conspired to steal the birthright of Jacob's twin brother, Esau, by deceiving the boys' father, the old and nearly blind Isaac. In Ghiberti's representation, the scene of the arranged blessing of Jacob is shown at the right, with Rebecca looking on, while the central figures represent the moment when Isaac and Esau discover the deception.

Ghiberti represents the story of Jacob and Esau with grand, classicizing architecture and graceful figures gathered into beautiful groupings (fig. 279). His ideal and orderly Renaissance world makes no reference to the treachery and emotional trauma inherent in the Old Testament narrative. Ghiberti chose to subordinate these unpleasant realities to his Renaissance interest in harmony. The fifteenth-century concern for fine detail and exquisite finish is obvious in every area of the relief, from the delicate Corinthian capitals of the loggia to the shaggy fur of Esau's dogs in the foreground. The regular recession of the Brunelleschian scientific perspective (see pp. 262–63) and the subtle diminution in the height of the relief, from the virtually three-dimensional figures of the left foreground to the low relief figure of Rebecca praying in the upper right corner, create a convincing, controlled illusion. The four female figures in the left foreground, who pose with such exquisite grace, play no role in advancing the narrative and have been added by Ghiberti to enhance the beauty of the work of art.

In his autobiography Ghiberti states that when he was offered the commission for the doors (fig. 280), "I was given a free hand to execute it in whatever way I thought would turn out most perfect and most ornate and richest." In this he seems to be following the precepts of the theorist Leon Battista Alberti, who, in *On Painting*, had defined the qualities of the perfect narrative painting (*istoria* or *historia*) in the following manner: "The first thing that gives pleasure in a '*historia*' is a plentiful variety. Just as with food and music, novel

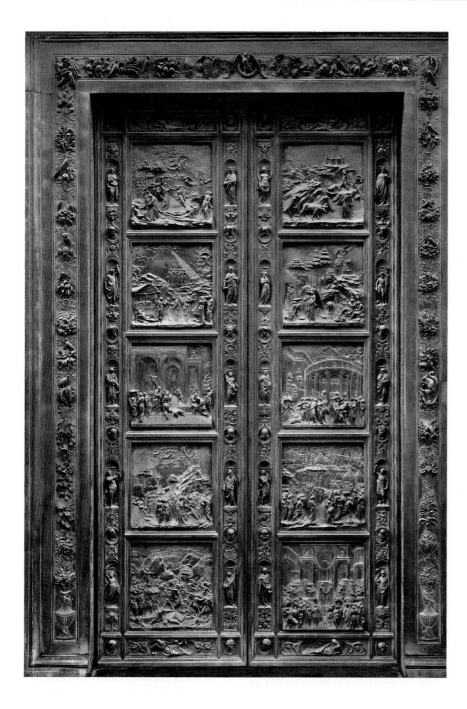

280. LORENZO GHIBERTI
*East Doors of the Baptistery (*also known as the *"Gates of Paradise").* 1425–52. Bronze and gilded bronze, 18' 6" x 12'. Museo dell'Opera del Duomo, Florence. Ghiberti's doors are the last of three sets of doors made for the portals of the Florentine Baptistery. His themes are drawn from the Old Testament. The doors were commissioned in 1425 and erected in 1452. The creation of wax models for the ten narratives has been dated 1429 to 1437, and the finishing of the details consumed most of the 1440s. Ghiberti employed a large work-shop of assistants and apprentices to help him with the doors, which were by far the most expensive sculptural work produced in Florence during the fifteenth century. Most of the individual panels represent several scenes of a continuous narrative within a single architectural or landscape setting. For Ghiberti's self-portrait on the doors and a reference to the Latin inscription, see p. 251. The area between a baptistery and a cathedral was known as the *paradiso,* which helps to explain the name attributed to Michelangelo, who supposedly said that Ghiberti's doors were worthy to serve as the "Gates of Paradise."

and extraordinary things delight us for various reasons but especially because they are different from the old ones we are used to, so with everything the mind takes great pleasure in variety and abundance. . . . I would say a picture was richly varied if it contained a properly arranged mixture of old men, youths, boys, matrons, maidens, children, domestic animals, dogs, birds, horses, sheep, buildings and provinces."

JAN VAN EYCK, *THE ARNOLFINI WEDDING PORTRAIT*

Giovanni and Giovanna, represented being married in a room in their home, are witnessed by the two required officials, seen reflected in the mirror on the back wall (figs. 281, 283). One of these is the Flemish painter Jan van Eyck, as revealed by his florid Gothic signature above the mirror, "Jan van Eyck was here, 1434."

The single candle in the chandelier, which is lit despite the brightness of the day, is a symbol that expresses the divine presence of Christ, who oversees the sacrament of marriage. The bride and groom wear elegant and, to our eyes, exotic costumes. His huge hat and fur-trimmed cape reveal his wealth, as do the yards and yards of material in the bride's train, which she elegantly holds up in a pose which emphasizes her abdomen and stresses the idea that she will soon be ready to bear children. Her hair is forced into nets to create the fashionable "horns" of the period, and her headcovering is trimmed with elaborate ruffles of material. Both figures have covered their heads as a sign of respect and sanctity, for while the sacrament of marriage is taking place, their bedchamber has become a sacred

place. For the same reason they have taken off their shoes, following the example of Moses, who removed his sandals when he met God in the burning bush on Mount Sinai (Exodus 3:1–10).

Jan van Eyck's composition is simple and symmetrical, stressing the individuality of the two figures and, in the joined hands on the central axis, their incipient union. Art-historical investigation has determined that the symbolism of the objects in the painting amplifies its meaning: the clear glass beads hanging on the wall and the fruit near the window refer to the bride's purity, while St. Margaret, represented in the statuette near the bed, is here as the patron saint of women in childbirth. The dog (fig. 284) offers mixed messages, for it can be interpreted as a symbol of marital fidelity or an emblem of erotic desire; that it is symbolic and not an actual pet is suggested by the fact that it is not reflected in the mirror.

There is no similar wedding portrait in all of Italian or Flemish fifteenth-century painting, and why the patrons commissioned the work is unknown. One theory proposes that since the groom is

holding the bride's right hand in his left, this was a left-handed or morganatic marriage, in which the bride was of inferior social status. Van Eyck's panel certainly functions as a visual document, in the legal sense, of this particular contract. But Van Eyck might also be representing Arnolfini in the midst of saying the oath, ready to join his right hand to the bride's to seal a normal contract. Scholars continue to offer new suggestions about the function of this painting. Whatever its meaning, the desire of this couple to record their union has given them immortality.

281. JAN VAN EYCK
Wedding Portrait of Giovanni Arnolfini and Giovanna Cenami. 1434. Oil on wood, 32 1/4 x 23 1/2". National Gallery, London. The figures are identified in an early inventory that also reveals that the frame, now lost, was decorated with verses from the writings of the ancient Roman poet Ovid. Giovanni Arnolfini was a wealthy Italian businessman who lived in Flanders.

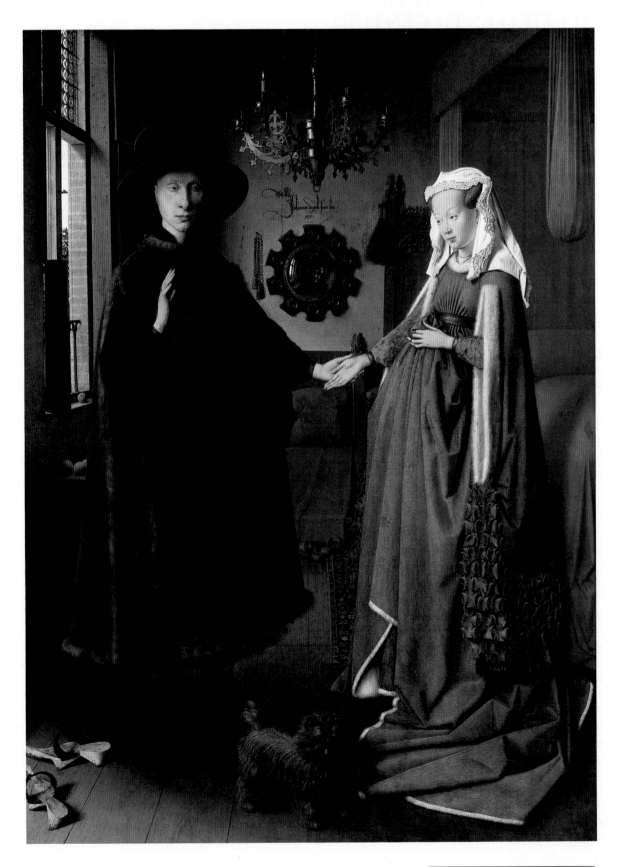

THE DEVELOPMENT OF THE OIL TECHNIQUE IN FLANDERS, EARLY FIFTEENTH CENTURY

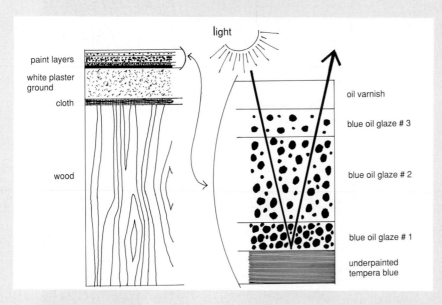

light

paint layers

white plaster ground

cloth

wood

oil varnish

blue oil glaze # 3

blue oil glaze # 2

blue oil glaze # 1

underpainted tempera blue

282. Schematic diagram of a section of a Flemish fifteenth-century oil painting, demonstrating the luminosity of the medium. The arrow suggests how light penetrates translucent oil glazes.

The details from Jan van Eyck's *Arnolfini Wedding* display impressive virtuosity (figs. 283, 284). The contrasting textures of the various materials are convincingly illusionistic. Such precise detail is made possible not only by the artist's acute perception, but by the development of oil paint as a primary vehicle, a step which revolutionized Flemish painting in the early years of the fifteenth century.

None of the materials used here are new. A traditional wooden panel covered with a layer of cloth and a fine layer of white plaster functioned as a support. Van Eyck probably explored compositional ideas by drawing on the plaster with charcoal and "erasing" unsuccessful designs with a feather. He would then have reinforced a satisfactory composition with fine lines created with a brush dipped into tempera paint. The pigments used to create the color are the same powdered materials used

by artists working in tempera (see pp. 238–39). Oil as a drying vehicle had been known and used since ancient times. During the medieval period, oil was the final layer given a tempera painting to create a luminous surface finish. Here it is used as the primary vehicle.

Oil is a translucent vehicle; the suspension of the particles of powdered pigment in a translucent vehicle is shown in the diagram of a section of a Flemish panel painting (fig. 282). When it is applied in many thin layers (glazes), light will penetrate the layers and be reflected, creating a gemlike brilliance of color. This new resonant richness makes Flemish oil paintings such as those of Van Eyck and Campin distinctly different in appearance from their tempera antecedents.

Oil dries more slowly than tempera and its speed of drying can be further slowed by adding turpentine, permitting the artist to blend

colors to create the subtle tonal modulations that help suggest light falling on an object. Van Eyck's fine detail is accomplished by using oil and soft, fine brushes, and the resulting imperceptible transitions from color to color and the smooth surface finish offer virtually no hint of the artist's brushstrokes.

The greater resonance of color and the new realism of Flemish paintings are also due to the changed color palette. In tempera painting a particular hue, such as red, would be mixed with white to achieve the transitions from shadow (red) to highlight (white). In the oil technique, the same red would usually be mixed with black to accomplish the change from highlight (red) to shadow (black). In tempera paintings, then, colors are modeled upward toward white, while in oil paintings most colors are modeled downward toward black. The greatest intensity of a hue in tempera painting is in the shadows, while in oil it occurs between shadow and highlight. Most importantly, the scheme used in oil paintings is closer to what we observe in reality. Flemish painters learned this laborious craft as apprentices. Only years of watching and practice could prepare a young artist for a career working in such a painstaking and methodical technique. The results

of their fine and patient craftsmanship are evident in the superb condition of many of these paintings today.

To learn how to paint like Campin and Van Eyck took more than technical skill, however, for the artist had to learn how to see—how to distinguish the distinct patterns of light and shadow observable on such different surfaces as velvet, wood, brass, and glass in various lighting conditions. In the work of these two artists, the precision of depiction is intimately related to the fact that all these objects are mirrors of religious truths. A candle is not just a candle and a triple lily is more than a floral oddity. Like other techniques, the development of the fine oil technique of the Flemish masters was a response to a distinct need: they created a technique which would allow them to endow objects with a magical potency—a dazzling realism—that could suggest the deeper meanings that lie behind observation. Their new style is rooted in the complexities of medieval symbolism and theology, but it contains a seed of the new Renaissance concern with the individual and the world. It is no surprise that the motto of Jan van Eyck, painted on the frame of his *Self-Portrait* (fig. 259), is "Als ich can" (The best I can do).

283, 284. JAN VAN EYCK
The Arnolfini Wedding Portrait (details)

LEONARDO DA VINCI, *THE LAST SUPPER*

311. LEONARDO DA VINCI
The Last Supper. c. 1495–98. Oil, tempera, and varnish on wall, 14' x 28' 10 1/2"; the figures are over-lifesize. Refectory, Santa Maria delle Grazie, Milan. The Dominican monastery of Santa Maria delle Grazie was patronized by Lodovico Sforza, duke and ruler of Milan, who commissioned Leonardo to paint *The Last Supper*. This view shows the painting in the course of restoration.

312. LEONARDO DA VINCI
The Last Supper (detail). The recent restoration of Leonardo's painting has brought to light subtle details of facial expressions and radiant colors which had been covered by earlier restorers, who repainted rather than cleaned the surface.

According to Leonardo da Vinci, "Painted figures ought to be done in such a way that those who see them will be able to easily recognize from their attitudes the thoughts of their minds." Leonardo's *Last Supper*, painted in the dining hall of a monastery, exemplifies his maxim that figures should express emotional

LEONARDO DA VINCI, *The Last Supper:* c. 1495–98
1492: Christopher Columbus lands at San Salvador and Cuba
1492: Death of Lorenzo the Magnificent
1492: First known reference to smoking tobacco

and psychological realism (figs. 311, 312). The stable and calm figure of Christ, who is both on the axis and the focal point of the scientific perspective construction, forms a triangle which, while symbolic of the Trinity, also gives visual stability to the composition and contrasts with the activity of the apostles who flank him. Christ's followers are composed in four groups of three apostles each.

The agitated movement of the apostles reveals their psychological turmoil in reaction to Christ's declaration, "I say unto you, that one of you shall betray me" (Matthew 26:21). The impact of these words on the apostles is understandable when we realize that they had left their families, friends, and professions to follow Christ. Now, when celebrating a Passover meal, Christ announces that one of them will be a betrayer. The apostles' reactions are shown in different physical attitudes that reveal such psychological responses as surprise, piety, uncertainty, and faithfulness.

The powerful emotional drama that we perceive in the *Last Supper* is but one level of meaning in Leonardo's complex painting. In earlier Last Supper paintings, Judas had been shown on our side of the table, removed from the space occupied by Christ and his apostles. Leonardo, however, kept Judas with his fellow apostles. The fourth figure from the left, he is shown recoiling from Christ.

Judas is the only figure whose face is lost in shadow, a subtle indication that he is lost from the light of Christ.

Leonardo has joined the depiction of these two different, yet active, episodes with a third. The hands of Christ are directed toward the bread and wine on the table, suggesting the institution of the Eucharist.

The activity of these dramas is contained within a masterful organization. Light from the upper left (following the placement of windows in the hall) defines the figures. The grouping of the apostles on either side of Christ provides symmetry, while the positioning of the apostles in four groups discloses the numerical symbolism of the spiritual (three is the number of the Trinity) and material (four is the number of the elements) components of creation. This expression of universality, contained in number symbolism, is also apparent in the number twelve: in keeping Judas with the eleven faithful apostles, Leonardo retains the integrity of the number twelve, which refers not only to the apostles, but also to the months of the year and the hours of day and of night, extending the numerical symbolism to include the cycles of time.

It is now difficult to discern the subtle details which Leonardo intended, for in an attempt to achieve a new subtlety in mural painting, Leonardo, always the inventor, mixed his

pigments with a combination of oil, tempera, and varnish, producing a paint that proved disastrous almost from the start. Later attempts at restoration have even further dimmed our vision of this masterpiece. However, we can glean some sense of its intended effect from surviving preliminary drawings. The study for the head of Judas exhibits an acute understanding of anatomy and physiognomy (fig. 313). Such detailed, descriptive observation, found in numerous studies, was joined to a unified, yet complex narrative interpretation.

313. LEONARDO DA VINCI
Study for the Head of Judas. 1495–97. Preparatory drawing for *The Last Supper*. Red chalk on red prepared paper, 7 1/8 x 5 7/8". Royal Library, Windsor Castle. Leonardo draws attention to the figure's neck in reference to Judas's suicide by hanging after he betrayed Christ.

ALBRECHT DÜRER

The increasing contact between Italian and Northern artistic traditions is demonstrated in Dürer's *Adam and Eve* (fig. 331). The precise detail of the heavily wooded background reflects Northern tradition, while the use of antique models for the figures reveals Dürer's contact with Italian Renaissance art (Dürer went to Italy twice, in 1494–95 and again in 1505–7). Dürer's difficulty in blending these two distinct styles is evident, for the figures, which resemble sculptures rather than living beings, seem out of place in this dense forest setting. Dürer, who studied proportional systems for the human body from nature and from classical and Italian Renaissance sources, completed two volumes of a proposed four-volume *Treatise on Human Proportions*. The diverse animals in the background symbolize the various "humors," fluids within the body that were believed to control personality. The rabbit stands for the lust or lechery of humanity, which will become active as soon as Adam takes a bite of the apple held by Eve.

Dürer's prints brought him international fame, and during his lifetime he was recognized as the leading German artist and the greatest living printmaker. When Dürer was in Venice in 1505–7, the senate offered him a regular salary if he would become a Venetian citizen. He received many commissions and was employed by Maximilian I, the Holy Roman Emperor. In 1520–21 Dürer traveled to the Netherlands, where he saw a

room full of Aztec gold treasures sent back by Cortes. He praised these exotic objects, writing, "I have seen nothing that rejoiced my heart so much as these things, for . . . I marveled at the subtle ingenuity of men in foreign lands." He had sympathies with the Protestant movement, and when he heard a rumor that Luther had been murdered, he wrote, "If Luther is dead, who will explain the Gospel to us now?"

In Dürer's *Knight, Death, and the Devil* (fig. 332), the central figure, dressed as a Renaissance knight, is an allegorical representation of the Christian soul. He is every human being, riding through life, which is shown as a landscape filled with terrors. The Devil is a hideous horned monster, and the skeleton of death, his crown entwined with serpents, brandishes an hourglass as a reminder of the inevitability of death. These imaginative creations belong to a Northern tradition, but the knight and his sturdy mount are inspired by classical and Renaissance works Dürer had seen in Italy.

Opposite: *Adam and Eve*. 1504. Engraving, 9 7/8 x 7 5/8" (for a detail see fig. 334). Dürer, one of the first artists to sign and date his works, may have done so because of the lively business in forgeries of his prints.

DÜRER, *Adam and Eve*: **1504**
1504: Columbus returns from his final voyage
1504: Erasmus, *Instructions for the Christian Soldier*

Dürer's impressive engravings were intended for a sophisticated audience of wealthy print collectors, but he also produced more reasonably priced and easily understood prints in series for a popular audience—the *"Small" Life of the Virgin Mary*, the *"Large"* and *"Small" Passions*, and the *Apocalypse*. These works, executed in the bolder and more direct medium of woodcut, were printed in large quantities to be sold at fairs and carnivals, as well as by Dürer and his agents. The subject matter is both more traditional and more direct, as in

the *Four Horsemen of the Apocalypse* (fig. 333), drawn from Revelation 6:1–8. Death ("on a pale horse") in the foreground and the other riders follow John's description: Famine has a pair of scales, War a sword, and "the conqueror" (Pestilence, or the Plague) carries a bow. Dürer's powerful patterns reinforce the relentless motion of the horsemen as they ravage humanity. The Apocalypse and Last Judgment were popular themes just before 1500, when it was feared time would end and Christ would appear to judge humanity.

332. ALBRECHT DÜRER
Above left: *Knight, Death, and the Devil*. 1513. Engraving, 9 5/8 x 7 1/2". Dürer called this print *The Rider*, but scholars have related the symbolism to Erasmus's handbook, *Instructions for the Christian Soldier*, published in 1504. The initials, with the *A* encompassing the *D*, create a unique monogram, an indication of Dürer's pride in his work.

333. ALBRECHT DÜRER
Above right: *Four Horsemen of the Apocalypse*. c. 1497–98. Woodcut, 15 1/2 x 11" (for a detail see fig. 335). The *Apocalypse* series, of which this is a part, was based on the Book of Revelation. It consisted of fifteen prints with relevant texts on the back in German or Latin.

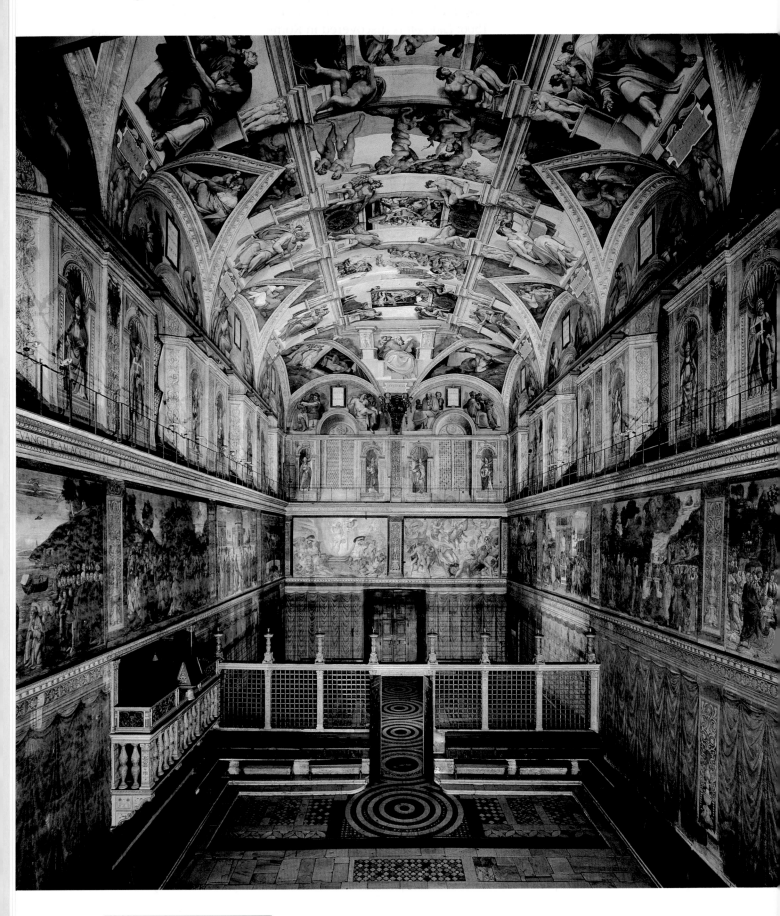

344. MICHELANGELO BUONARROTI

Opposite: Sistine Chapel Ceiling (after cleaning). 1508–12. Fresco, 131 x 41'. Sistine Chapel, Vatican, Rome. The Sistine Chapel, named after its builder, Pope Sixtus IV, was constructed in the late 1470s. The walls were decorated by such leading artists as Perugino (fig. 4), Botticelli, and Ghirlandaio with scenes from the lives of Moses and Christ. Originally the vault was simply decorated with gold stars on a blue ground.

345. MICHELANGELO BUONARROTI

Sonnet with a caricature of the artist standing, painting a figure on the ceiling over his head. c. 1510. Pen and ink, 11 x 7". Casa Buonarroti, Florence. In the sonnet Michelangelo complains of the physical difficulties of painting the Sistine Ceiling in terms that reveal he painted standing, not lying down.

ignudi, but their primary role is to embellish Michelangelo's cycle.

As our eyes ascend from the first level of ancestral figures toward the histories, the figures in each horizontal level are distinguished by an increasing freedom of movement. In Neoplatonic philosophy (see p. 251), unrestricted figural movement was symbolic of the freedom of the human soul to ascend to the divine, for as the soul ascended, it was believed to be less and less restricted by the bonds of earthly matter: the eloquent movement displayed by the *ignudi* is a metaphor for the freedom of the soul.

The symbolism of our aspiration to join God is conveyed by the central histories, which relate God's love in the acts of creation and in the story of Noah. The cycle runs backward in time, but it has an internal logic. Michelangelo begins with the sin and disobedience of Noah, the most righteous man God could find on earth, to stress the sinfulness of all humanity. What redeems this human sin is the love of God, with which the cycle concludes in the first moment of the Creation. God's initial act of love, dividing Light from Darkness, is painted directly over the altar.

RAPHAEL, STANZA DELLA SEGNATURA

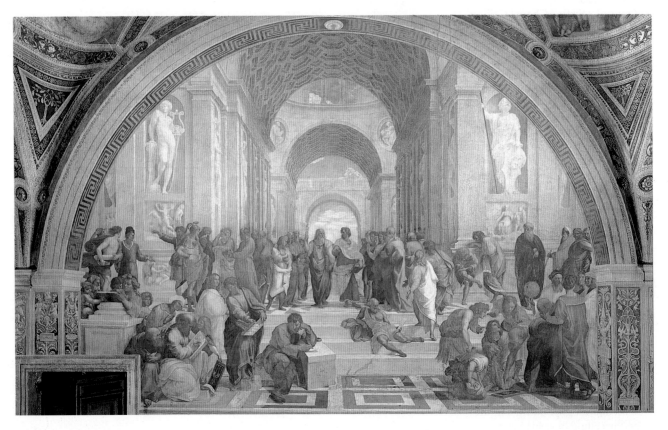

346. RAPHAEL
Philosophy (popularly known as *The School of Athens*). 1509–11. Fresco, 19 x 27'. Stanza della Segnatura, Vatican, Rome

Raphael's *Philosophy* has long been viewed as the ideal of High Renaissance painting (fig. 346). Figures representing venerated ancient philosophers in a consummate variety of postures are composed within a classicizing architectural setting. The use of scientific perspective, within a lucid and impressive setting, directs our attention to the two main figures in the center. The coffered vaults and the niches with sculpture remind us of the decoration of the baths of ancient Rome (see fig. 145) and of Bramante's new church of St. Peter's (fig. 337), being erected nearby at that very moment by the same patron.

The philosophers in the center are the gray-haired Plato, holding his *Timaeus*, a book on the origin of the universe, and Aristotle, who holds his *Nicomachean Ethics*. Plato points heavenward to indicate his philosophical approach to the world of ideas, while Aristotle gestures over the earth to suggest that the universal can only be understood through examining the natural world. Other philosophers can be identified by their attributes. Euclid the geometrician, seen bending over a compass and board in the right foreground, has the features of Bramante, a close friend of Raphael who secured this commission for the

young painter from Pope Julius II. Vasari suggests that Bramante designed the architectural setting of this particular scene for his friend. Plato bears a resemblance to the elderly Leonardo, who was in Rome at this time. Raphael himself engages our attention, for in his self-portrait near the right border he looks out at us. By portraying the historical personalities from antiquity with the visages of contemporary people, Raphael gave personal meaning to the ideal of the Renaissance as a revival of classical values.

Another portrait is the brooding, melancholic figure in the left central foreground who, pen in

hand, appears self-absorbed. His inclusion was an afterthought, for he was painted on a fresh patch of plaster. The figure represents the ancient philosopher Heraclitus, who expressed the solitary, pensive nature of the creative temperament. In pose the figure recalls the prophets from the Sistine Ceiling (fig. 344), while the face suggests that it is a portrait of Michelangelo. Raphael added the figure in homage to the older master, probably after the partially completed Sistine Ceiling was unveiled in August 1511.

Theology presents groupings of saints in heaven and theologians on earth, all gathered around a central axis which descends from God the Father, Jesus, and the

RAPHAEL, frescoes, Stanza della Segnatura: 1509–11
1514: Papal proclamation against slavery and the slave trade
1515: Thomas More, *Utopia*

Holy Spirit to the bread of the Eucharist displayed on the altar (fig. 347). Raphael's composition suggests an apse, and the fresco visually embodies the concept that it is persons—in heaven and on earth—who comprise the

church. *Philosophy* and *Theology* face each other in the Stanza della Segnatura, expressing the union that the Renaissance forged between Christian theological values and the classical philosophical tradition.

347. RAPHAEL
Stanza della Segnatura. 1509–11. *Theology*, known as the *Disputà*, is on the wall opposite *Philosophy*, and in the lunette over the window are three Virtues. The room originally functioned as Julius II's study and personal library; only later did it receive the name by which it is known today. The themes chosen for the walls—Philosophy, Theology, Justice, and Poetry—relate to its use as a library. The ability of the High Renaissance to simplify and clarify is evident in this program, which encompasses the four basic realms of scholarship and literature. It has also been suggested that the four themes refer to the pope's interest in Truth (*Philosophy* and *Theology*), Goodness (*Justice*), and Beauty (*Poetry*). Early sources reveal that Pope Julius II himself designed this impressive program.

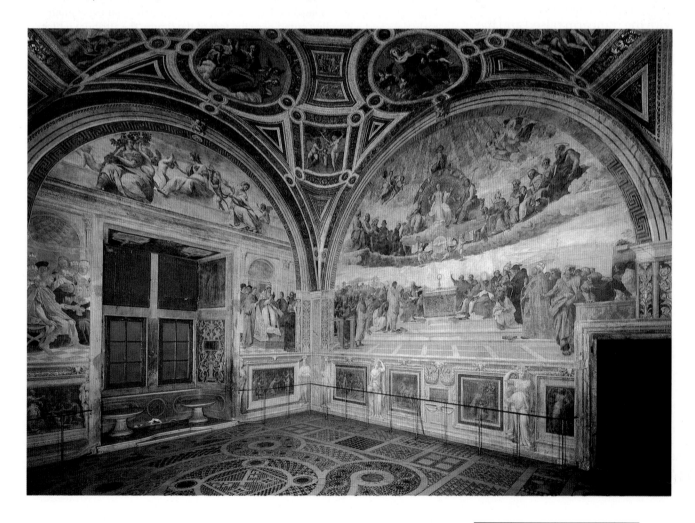

HIGH RENAISSANCE PAINTING IN VENICE

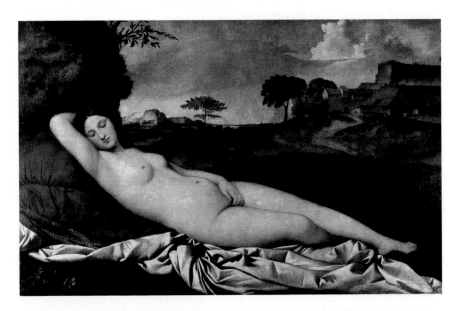

348. GIORGIONE (completed by TITIAN)
Sleeping Venus. c. 1510. Oil on canvas, 42 3/4 x 69"; the figure is lifesize. Staatliche Gemäldegalerie, Dresden. The painting was apparently damaged at an early date and a kneeling cupid near the feet of the figure, the attribute which identified the figure as Venus, was painted over. An early source suggests that Titian completed both the cupid and the landscape. Giorgione, who died in the great plague of 1510, may have left the work unfinished. The face of Venus has been repainted, probably in the nineteenth century.

Giorgione's *Sleeping Venus* helped establish the reclining female nude as a standard type in the history of European art (fig. 348; for a later example, see fig. 499). This subject is obviously erotic, and Giorgione's composition accentuates the sensuous quality of the female body by contrasting the swelling forms of the upper contour—head, breast, abdomen, and wrist—with the long curve of the bottom edge of the figure. The elegant slenderness of Venus's body is emphasized by her pose, with the right arm raised and the right ankle and foot hidden behind the left. The shimmering white drapery and deep red pillow accentuate and enhance the warm flesh tones of the body, isolating the figure in a verdant green landscape with a luminous Venetian sky and clouds. Giorgione established a new oil painting technique in which the forms are rendered without detail (see p. 326). In the *Sleeping Venus*, the technique emphasizes the delicacy and softness of the body. The landscape setting removes the figure from the more erotic setting of a bed, and by representing Venus with her eyes closed, as if asleep, Giorgione

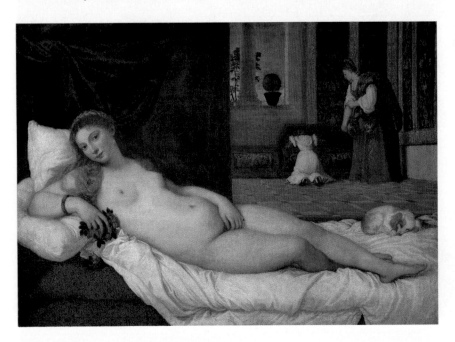

349. TITIAN
Venus of Urbino. 1538. Oil on canvas, 47 x 65". Uffizi Gallery, Florence. The work was painted for Guidobaldo II della Rovere of Urbino. Although a letter from Guidobaldo to his agent refers to the painting not as Venus, but as "la donna nuda" (the nude woman), the roses in her hand and the myrtle, symbol of Venus, growing in the pot in the background support an identification with Venus. The dog at her feet has been recognized as an emblem of marital fidelity.

GIORGIONE (and TITIAN), *Sleeping Venus: c. 1510*
1501: Venetian printers use movable type to print music
1504: Venetian monopoly on the spice trade is broken by Portugal
1508: The League of Cambrai is formed to attack Venice
1516: Jewish "ghetto" is established in Venice

encourages the male patron and his friends to observe her beauty without embarrassment. At the same time, such a pose establishes a certain distance and restraint, and the kneeling cupid may have served as a guardian figure. The ultimate effect is of a slender figure dreaming in a warm Italian landscape.

It is not surprising that one of the first paintings of the sensuous nude was created in Renaissance Venice. Venice, "Queen of the Adriatic," was the most cosmopolitan city in Europe. It was famous for its exotic buildings, fine food, and beautiful courtesans.

Titian's painting (fig. 349) was modeled on Giorgione's, perhaps at the request of the patron. The same red, white, and green tones enhance the flesh of the painted figure, but now the setting is an interior, complete with a bed with rumpled sheets and bed curtains. Now the nude is awake: she looks directly at us, posing without embarrassment. Titian's ability to suggest texture is especially evident in the locks of wavy red hair which flow onto her shoulders. The maids in the background are gathering her garments from a Renaissance chest.

Giorgione's *Tempestuous Landscape* is a difficult work, and scholars have long debated its specific iconographic meaning (fig. 350). A young man and a nude woman nursing a child occupy the foreground; their relationship is inexplicable, but the "soldier"

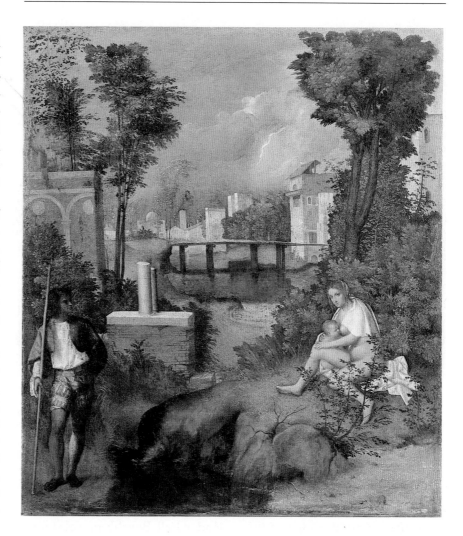

350. GIORGIONE
Tempestuous Landscape with a Gypsy and a Soldier (traditionally known as *The Tempest*). c. 1505–10. Oil on canvas, 30 1/4 x 28 3/4". Accademia, Venice. A reference to the painting in 1530 calls it "the little landscape on canvas with the tempest [and] gypsy and soldier."

seems to be watching over the "gypsy." The landscape which dominates the composition offers both ruins and contemporary buildings. A lightning bolt crosses the background, and the trees are dramatically silhouetted against the eerie light of the stormy sky. The main purpose of this painting may be to set a mood rather than tell a story, and perhaps we appreciate it best by surrendering logic to feeling. That an emotional sensation should be the main purpose of a work of art is a new idea in the history of art, but one which seems consistent with the Venetian interest in the suggestive and poetic.

HIERONYMUS BOSCH, *"GARDEN OF EARTHLY DELIGHTS"* TRIPTYCH

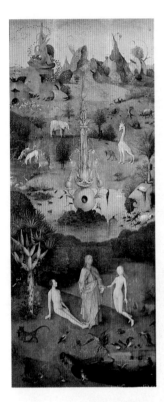 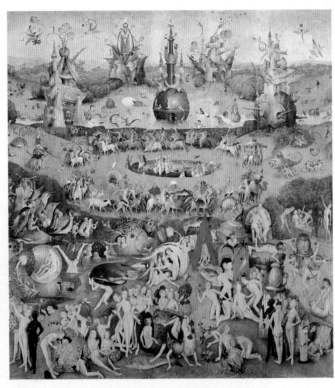

351. HIERONYMUS BOSCH
The Creation of Eve in the Garden of Eden; "Garden of Earthly Delights"; Hell (interior of the *"Garden of Earthly Delights"* triptych). c. 1510–15. Oil on wood, 86 5/8 x 76 3/4" (center); 86 5/8 x 38 1/4" (each wing); the figures in the foreground of the central panel are approximately ten to fourteen inches tall. The Prado, Madrid. The iconography of the work has been much debated, and there is no general agreement as to its meaning or exact purpose. The work may have been commissioned by Hendrik III for the palace of the House of Nassau in Brussels, where it was hanging in 1517. In this setting the painting must have been a novel secular decoration and a focus for intellectual discussions.

The left and right wings of the interior of Bosch's triptych represent traditional Christian subjects (see fig. 351). The left wing shows the Garden of Eden, with God the Father creating Eve as Adam looks on, while the right wing presents a vision of the devastation of hell after the Last Judgment. Placed between these views of humanity's past and future is the central panel, which has been interpreted as representing the present, when humanity indulges the sins, begun in the Garden of Eden, that will lead to hell. Bosch's moral stance seems evident, and few of the hundreds of naked figures cavorting in the expansive garden of the central panel express even momentary delight. In the central section of the detail (fig. 352), a man looks up guiltily as he embraces a woman, while nearby figures greedily gather around a giant floating berry. A pearl seeps from between the legs of a couple lying within a giant shell carried by another man. Hundreds of unexpected episodes and surprising details capture our admiration for the painter's imagination in expressing humanity's determined perversity. In the landscape are real and imaginary birds and beasts, including the owl, symbol of perverted wisdom (it can see only in the dark), and huge raspberries, strawberries, and other fruits, whose multiple seeds hint at rampant promiscuity. The work is executed in seductive pastels. It has been suggested that the theme here is humanity before the great flood, when God, grieving "that he had

BOSCH, *"Garden of Earthly Delights"* **triptych: c. 1510–15**
1509: Erasmus, *In Praise of Folly*
1517: Luther's Ninety-five Theses

made man on the earth," destroyed all but Noah and his family (Genesis 6:5–6; 6:11–13). Whatever the exact theme, seldom in the history of humanity has the role of evil in the world been more astonishingly and unexpectedly depicted.

In light of the iconography of the main panel, a reexamination of the wings reveals unusual details. The birds, beasts, and plants that inhabit the Garden of Eden include composite creatures that suggest that even in Eden unnatural cross-fertilization has taken place. Life in God's creation is violent: the animals and birds of Paradise already stalk and devour each other. The delighted expression on Adam's face as he ogles the newly cre-

ated Eve suggests that, in Bosch's interpretation, sexual pleasure is the first thought of the first man.

The devils that populate Bosch's *Hell* provide further evidence that he is the first great artist of the fantastic. The ponds in the left and center panels give way in *Hell* to a wasteland, above which rises an edifice created by a combination of a dead tree and a man that represents the "tavern of lost souls." The Devil is enthroned as a frog with a bird's head who endlessly devours sinners. They are excreted only to face further torment. Although the triptych as a whole is related to Last Judgment paintings, it offers no view of souls in Paradise. In this world, there is no redemption.

Details about Bosch's life help little in clarifying his art. His grandfather and father were both painters. Bosch himself seems to have had a successful life. He was a member of the Brotherhood of Our Lady, a pious religious group, and through his wife he owned a large estate. Internationally known, he received commissions from the archduke of Austria, and his works were collected by important connoisseurs. It has been suggested that the tree-man in the center of *Hell* is a self-portrait. The face, which is in sharp contrast to the other, generalized figures, looks askance at the suffering around him. Bosch has been claimed by the twentieth-century Surrealists as their true ancestor (see p. 534).

MATTHIAS GRÜNEWALD, *ISENHEIM ALTARPIECE*

353. MATTHIAS GRÜNEWALD
St. Anthony; Crucifixion; St. Sebastian; with the *Lamentation* below (exterior of the *Isenheim Altarpiece*). c. 1512–15. Oil on wood, 9' 9 1/2" x 10' 9" (center); 8' 2 1/2" x 3' 1/2" (each wing); 2' 5 1/2" x 11' 2" (base). Musée d'Unterlinden, Colmar, France. The altarpiece was painted for the chapel of the monastic Hospital of St. Anthony at Isenheim, near Colmar. The hospital specialized in treating patients with skin diseases, including leprosy and syphilis, and the monastery chapel was a pilgrimage shrine for those suffering from such diseases. Given the mission of the hospital, the scars and sores on Christ's body are especially poignant and appropriate. In the late medieval period it was believed that all physical illness was a manifestation of spiritual illness, and the first step in treating patients at the Hospital of St. Anthony was to bring them before this crucifixion to pray. Grünewald's representation of Christ was created so that patients could identify with his sufferings.

Grünewald's monumental *Crucifixion* depicts the gruesome details of Christ's death with unsparing realism (fig. 353). Christ is dead; his head falls dramatically to the side, the blood pouring from the wound in his side begins to congeal, and his body is covered with wounds from the flagellation. The weight of his body pulls down on the crossbar, and the torture wrought by the nails in his hands and feet is painful to see. The lower abdomen is violently compressed, while the rib cage almost bursts through the skin as a result of the anguished death by suffocation brought about by crucifixion. As the Bible relates, darkness envelops the scene. The painting also

GRÜNEWALD, *Isenheim Altarpiece:* **c. 1512–15**
1513: Ponce de Leon plants orange and lemon trees in Florida
1513: Balboa discovers the Pacific Ocean
1513: First European ship lands in China
1519: Leonardo da Vinci dies in France
1520: Raphael dies in Rome

emphasizes the suffering of Christ's mother and Sts. John the Evangelist and Mary Magdalene. St. John the Baptist points to Christ, stating, "He must become more important, while I must become less important" (John 3:30). The dark sky and red garments add drama.

The choice of subjects and their interpretation can be directly related to the position and role of Grünewald's altarpiece within the monastic and hospital complex at Isenheim. Usually the wings would be kept closed to emphasize Christ's death and Sts. Sebastian, invoked by sufferers of the plague and other diseases, and Anthony, patron saint of the monastery. When the *Crucifixion* panel was opened (notice that Grünewald has painted Christ's body to the right of the

opening), the joyful scenes of the *Annunciation, Mystical Nativity,* and *Resurrection,* painted with vivid, luminous colors, became visible (fig. 354). Certainly these inner panels would have been shown on the feast days of the subjects celebrated here—the Annunciation, Christmas, and Easter. And since Christ's resurrection is celebrated every Sunday, they would most likely have been visible on a weekly basis as well. The innermost decoration, with sculpted figures and two scenes from the life of St. Anthony, would have been shown on Anthony's feast day.

The contrasts between the various layers of the altarpiece are explicit. In the *Resurrection,* an immediate contrast to the grisly *Crucifixion,* Christ's body is healed and his wounds have

become glowing, rubylike jewels. He rises weightless and triumphant while the soldiers guarding the grave fall helplessly in confusion below. The restored beauty of Christ's body would have encouraged hope on the part of the hospital's patients. Even in the joyful scenes, however, a sense of the crucifixion as Christ's destiny is found, for the cloth in which Mary holds the Christ Child in the *Mystical Nativity* is the same tattered fabric that serves as his loincloth when he is crucified.

354. MATTHIAS GRÜNEWALD
Annunciation; Mystical Nativity with Musical Angels; Resurrection (Isenheim Altarpiece with the first set of wings open). When these wings were opened, the innermost figures, depicted in sculpture, were visible.

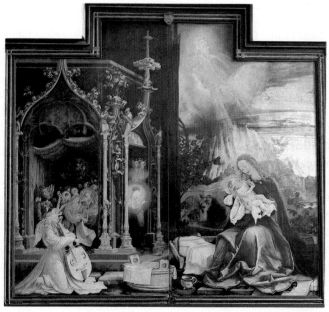

TITIAN'S ALTARPIECES

355. TITIAN
Madonna of the Pesaro Family. 1519–26. Oil on canvas, 16' x 18' 10";
the figures are approximately lifesize. Santa Maria Gloriosa dei
Frari, Venice. The main patron was Jacopo Pesaro, who led papal
troops to victory over the Turks in 1502. The armored figure with
the banner and the turbaned Turkish prisoner allude to Pesaro's
victory.

356. Titian's *Madonna of the Pesaro
Family* as seen in situ in its original
frame in the Church of Santa Maria
Gloriosa dei Frari, Venice. Titian's
painting was created to be placed
here, in the left side aisle, and his
asymmetrical composition is in part
inspired by the viewpoint from
which one approaches the altar.
Titian's huge columns are related to
those of the nave of the Gothic
structure. X-rays have revealed that
Titian tried several solutions to
the painting's architectural setting,
including one that continued the
architectural forms of the painting's
frame, before deciding to use
dramatic columns to relate his
painting to its largest architectural
context.

Titian's *Pesaro Madonna* pio-
neered a dynamic new composi-
tional mode that was champi-
oned by Venetian painters dur-
ing the sixteenth century (fig.
355). Nothing in earlier Renais-
sance art prepares us for this
asymmetrical composition, with
the Madonna set off to one side
before grandiose columns seen
in diagonal recession. The six
male members of the Pesaro fam-
ily who gather below, the patron
Jacopo on the left and five others
to the right, are introduced to the
Madonna and Child by Sts. Peter
and Francis. The movement in-
herent in Titian's composition is
also found in the twisting figure
of St. Peter at the center and in

TITIAN, *Madonna of the Pesaro Family:* **1519–26**
1517: Cairo is sacked by the Turks
1521: Martin Luther is condemned by an edict passed at Worms, Germany
1523: Turkeys introduced into Europe
1529: Martin Luther writes hymns, "Away in a Manger" and "A Mighty Fortress Is Our God"

the Madonna and Child, who direct their attention in opposing directions. The chubby Christ Child kicks his foot and plays with his mother's veil with a liveliness unusual in religious art.

Titian's *Assumption and Coronation of the Virgin* maintains the symmetrical, triangular Renaissance composition, but it accomplishes an effect of dynamic spontaneity through movement, strong color, and painterly brushstrokes (fig. 357). The composition is like a target, with the standing figure of the Virgin Mary placed within a circle created by the semicircular frame and a ring of clouds and flying *putti* below. Above, God the Father sweeps in with open arms to welcome and crown her. The main figures of God the Father and the Virgin wear garments of a brilliant red, and the Virgin's dominance is enhanced by the strong blue cloak that enfolds her. Titian's triad of primary colors is consistent with High Renaissance practices in Rome. Before a realistic blue sky below, two apostles stand out in the group due to their red garments and eloquent gestures. They create the base of Titian's compositional triangle. The combination of rich color with a simple composition is perfect for the altarpiece's position, which demands that it be legible from the main entrance of the church. The ultimate effect is of grandeur and visual richness.

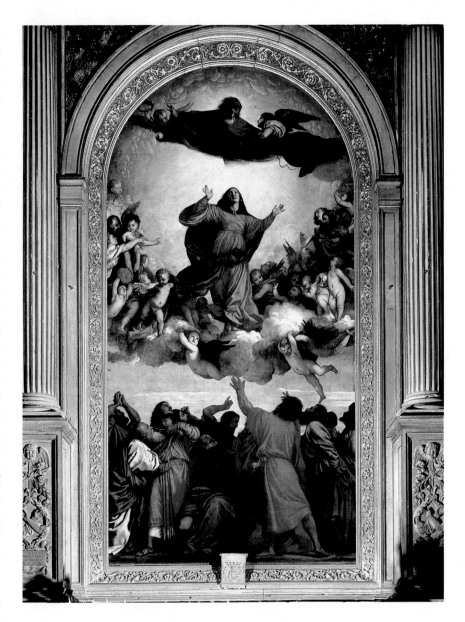

357. TITIAN
Assumption and Coronation of the Virgin. c. 1516–18. Oil on wood, 22' 6" x 11' 10"; the figures are over-lifesize. Santa Maria Gloriosa dei Frari, Venice. This huge altarpiece is still in situ in its original Renaissance frame on the main altar of the Frari in Venice. Despite the rivalry of the light that flows in from the Gothic apse windows, the painting's composition is even discernible from the entrance to the church, some three hundred feet away.

VENETIAN PAINTING TECHNIQUE

The detail from Titian's *Pesaro Madonna*, although substantially reduced in size, reveals the new suggestive, painterly style of painting pioneered in Venice during the first years of the sixteenth century (fig. 358). The traditional techniques of Renaissance painting, tempera on wood panel and fresco, had proved unsatisfactory in the humid Venetian climate, and by about 1500 oil painting on canvas was becoming the accepted medium. The development of a new style and technique in oil painting began with Giorgione (see p. 318), who softened his forms and blurred edges, partly as a result of the influence of Leonardo da Vinci, who visited Venice in 1500. Titian, Giorgione's pupil and friend, went further to develop a style using bold, large strokes that had a profound impact not only on later Venetian painters but on many other artists in later centuries, including Rubens and Velázquez. Titian's lively, painterly brushstrokes are consistent with his interest in movement and asymmetrical compositions.

In creating a large painting such as the *Pesaro Madonna*, Titian would first paint or stain the canvas a medium brownish-red. He would then boldly outline his forms in dark paint and reinforce them by modeling them in monochrome, from white to black. After this underpainting dried, Titian would add layer upon layer of colored translucent oil glazes (varnish, often with a small amount of color), building up a rich, sonorous color through

358. TITIAN
Madonna of the Pesaro Family (detail of fig. 355)

359. MATTHIAS GRÜNEWALD
Mystical Nativity with Musical Angels (detail of fig. 354)

their superimposition. Tradition has it that Titian once exclaimed that he used "glazes, thirty or forty!" to achieve this rich effect.

Titian's looser painting technique, as seen in the detail from the *Madonna of the Pesaro Family* (fig. 358), gives pictorial unity because of the continuous texture of brushstrokes. In contrast, the detail from the painting by Grünewald (fig. 359) demonstrates hidden brushstrokes, an emphasis on precise detail, and the creation of the illusion of varying textures. Grünewald's style represents a continuation of the oil technique first developed by Robert Campin and Jan van Eyck (see pp. 256–57; 264–65; 270–71).

Later in Titian's life his brushstrokes became even more bold, and he used large, thick strokes *(impasto)*, often of pure color, to define form. In the *Rape of Europa* (figs. 360, 361), *impasto* is evident throughout, and especially in the scales of the fish in the foreground, the feathers of the cupids flying at the top, Europa's drapery, Zeus's crown, the mountains, and the quickly sketched figures of Europa's abandoned friends, waving from the distant shore. The shape and direction of the brushstroke reinforce the movement of the figures and the directional patterns of the composition. While Titian's rich strokes and bold color accentuate the painting's surface, the diminution of the distant figures and the solidly depicted Europa produce a dramatic effect of space enhanced by the sky in the distance.

360. TITIAN
Rape of Europa. c. 1559–62. Oil on canvas, 73 x 81". Isabella Stewart Gardner Museum, Boston. One of a series of *poesie* (poetic mythological themes) painted for King Philip II of Spain, this picture depicts the moment when Zeus, having disguised himself as a bull, abducts a princess. Titian was inspired by the story as it is told in Ovid's *Metamorphoses* (II, 870–75). The unexpected nature of the abduction is expressed in the awkward position of Europa, who seems about to slip off the back of the bull/Zeus.

361. TITIAN
Rape of Europa (detail of fig. 360)

LATER MICHELANGELO AND THE DEVELOPMENT OF MANNERISM

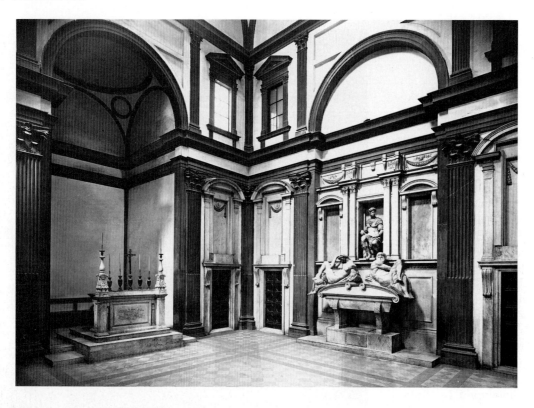

362. MICHELANGELO BUONARROTI
Medici Chapel, including the *Tomb of Giuliano de' Medici* and the altar wall. 1524–34. Marble, size of entire bay 23 x 15';
length of reclining figures approx. 7'. New Sacristy, San Lorenzo, Florence. The Giuliano de' Medici commemorated here
was the son of Lorenzo the Magnificent and brother of Pope Leo X, who, in part, sponsored Michelangelo's work at San
Lorenzo, the Medici family church in Florence. Michelangelo never saw the Medici Chapel sculptural and architectural
ensemble as we see it today; it was assembled by assistants following his designs and instructions. On the wall opposite
the *Tomb of Giuliano,* Michelangelo designed a similar tomb for Lorenzo, the grandson of Lorenzo the Magnificent. Lorenzo
is depicted as Contemplative Life, with allegories of *Dusk* and *Dawn* beneath his idealized portrait.

Michelangelo's Medici Chapel introduces a new vitality to the interrelationship between sculpture and architecture in sixteenth-century art (fig. 362). In the *Tomb of Giuliano de' Medici*, an idealized portrait of Giuliano as Active Life is seated, clad in ancient Roman armor. Resting atop the sarcophagus are allegories, the female *Night* and the male *Day*. Michelangelo's plan called for two allegories of rivers, to be placed on a platform below.

The allegories of the times of day symbolize the passage of time as it consumes mortal life, while the river allegories were perhaps intended to represent the Arno and Tiber to refer to Medici power in Florence and Rome. In his position above, Giuliano transcends both time and matter, fulfilling the spiritual ascent of Neoplatonism and the resurrection to eternal life celebrated in masses for the dead (a fresco of Christ's resurrection was intended for the altar wall).

The figures of *Night* and *Day* are twisted in a manner related to *contrapposto*. This type of posture became known later in the century as the *figura serpentinata* (serpentine figure). Although developed during the High Renaissance, this pose became a hallmark of Mannerist art.

In the Medici Chapel, the poses are further enlivened by the visual activity of the walls, where flat walls give way to planes which articulate different levels of surfaces. The cornice is segmented to extend forward

into the space of the chapel. The "movement" of these architectural forms establishes a vibrant interplay between the architecture, the sculpture, and the space of the chapel.

The Medici Chapel expresses Michelangelo's genius and demonstrates his ability to create a new aesthetic within a given artistic vocabulary. Much of the visual energy and artistic license which develop in Mannerist art and architecture is derived from this freedom of expression.

In 1534 Michelangelo left Florence for Rome, never to return. Rome at mid-century was a changed city. The sack of Rome in 1527 by imperial troops had been brutal. The impact felt from the Reformation caused further turmoil. The psychological climate was leaden.

Michelangelo was commissioned to paint a *Last Judgment* in the Sistine Chapel, where he had painted the ceiling earlier. But while the ceiling expressed God's love and the promise of salvation (fig. 344), now pessimism broods (fig. 363). Christ, on the axis and surrounded by an aura of light, looks toward hell and raises his right hand against the wicked. Mary recoils next to him, "slightly timid in appearance and almost as if uncertain of the wrath and mystery of God" (Ascanio Condivi, 1553). Angels blow trumpets to announce the day and awaken the dead.

In the bottom register, to our left, the dead rise, some being pulled from their graves. To our right, the damned are being dragged down to eternal torment. Above, figures ascend to heaven, where the elect flank Christ. In the semicircular lunettes at the top, angels wrestle with the instruments of Christ's

MICHELANGELO, Medici Chapel: 1524–34
1534: Henry VIII breaks with the Roman church
1534: St. Ignatius Loyola founds the Jesuits
1534: Sir Thomas More is beheaded

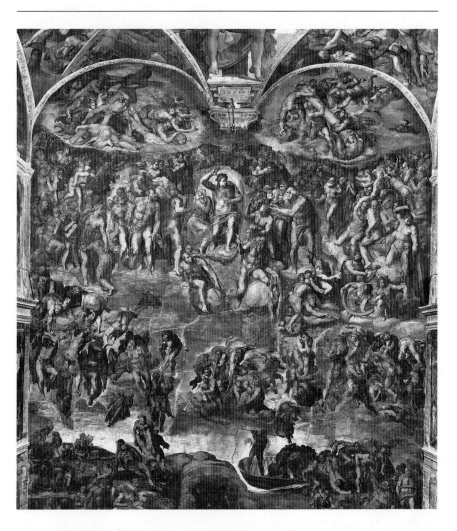

363. MICHELANGELO BUONARROTI
The Last Judgment. 1534–41. Fresco, 48 x 44'. Sistine Chapel, Vatican, Rome. Originally, many of the figures in the *Last Judgment* were nude, but in the climate of the Counter-Reformation, some observers found nudity offensive in a papal chapel. Between 1559 and 1565, drapery was added to many of the figures.

passion. Around Christ, martyrs brandish the weapons used to torture and kill them.

To the right of Christ, St. Bartholomew, who was flayed, looks to Christ. He holds a knife in his right hand, while his flayed skin hangs from his left hand. The face on the skin was identified as Michelangelo's self-portrait only in 1925. The anguished facial features, which reflect Michelangelo's tortured spirit, add a highly personal message to the painting.

Of Michelangelo's *Last Judgment*, Condivi, the artist's friend and biographer, wrote: "In this work Michelangelo expressed all that the art of painting can do with the human figure, leaving out no attitude or gesture."

MANNERISM

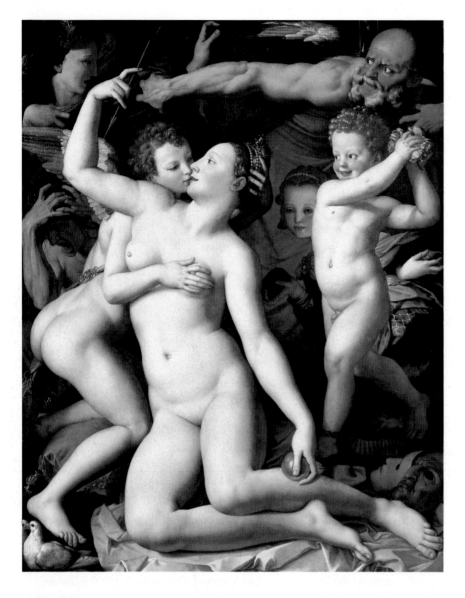

364. AGNOLO BRONZINO
Allegory of Time and Lust. c. 1545.
Oil on wood, 61 x 56 3/4". National
Gallery, London. Much about this
painting remains a mystery to us.
Although the circumstances of its
commission are unknown, it may
have been made for the Medici to
be given to King Francis I of France.

Bronzino's *Allegory of Time and Lust* is a visually and iconographically complex painting (fig. 364). At the top, allegories of Time and Fraud pull back a blue curtain, revealing the central figure of Venus, who, exposed by a cool, harsh light, is being caressed by her son, Cupid. Additional allegorical figures, including Deceit, to the right, behind the *putto,* and Jealousy (recently interpreted as representing Syphilis), demonstrate the results of lust. The precise iconography of the work is still debated; this difficulty of interpretation reveals the complex intellectual themes of Mannerist art. The crowded figures and exceptionally varied poses address a new style of highly artificial composition and unusual spatial effects.

Mannerism often invited the knowledgeable viewer to appreciate the subtle and hidden conceits of the work. Mannerist art was not intended to appeal to a mass audience. The works of Michelangelo and Raphael provided a starting point for the Mannerists, who developed selected ideas and forms to achieve a stylized, artificial elegance.

Cellini's *Saltcellar* reveals the artist's delight in demonstrating both technical accomplishment and artistic invention (fig. 365). In its graceful refinement, the *Saltcellar* reflects the conspicuous wealth and manner of sixteenth-century European courts. In its decorative treatment of counterbalanced nude figures and complex iconographic details, it demonstrates the visual and thematic complexities which

BRONZINO, *Allegory of Time and Lust:* **c. 1545**
1536: Lower California is discovered by Cortes
1542: Pope Paul III establishes the universal Inquisition
1546: Death of Martin Luther
1554: Palestrina publishes his first book of music for the mass

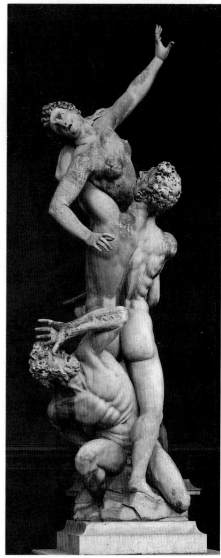

366. GIAMBOLOGNA
Rape of the Sabine Woman. Completed 1583. Marble, height 13' 6".
Loggia dei Lanzi, Florence. The theme is drawn from an event which occurred in the early development of ancient Rome, when the Romans abducted Sabine women as wives.

365. BENVENUTO CELLINI
Saltcellar of Francis I. 1543. Gold and enamel, 10 1/4 x 13 1/8". Kunsthistorisches Museum, Vienna. Cellini's saltcellar (a receptacle for table salt) was made for the French king Francis I.

occur in Mannerist art. The work was created to delight both the eye and the mind.

Giambologna's *Rape of the Sabine Woman,* with its twisting, spiraling, upward movement, was titled only after its completion (fig. 366). Contemporary sources reveal that the artist was initially inspired not by a subject, but by the challenge to compose a group of multiple interlocking figures in dynamic movement. Giambologna's solution, based on a use of the *figura serpentinata* (see p. 328), offers effective and varied visual expressions when viewed from different positions. The rhythmic interplay of the figurative forms, emphatically stressed along diagonals, contributes to the work's dynamism, while the spiraling movement compels us to walk around the sculpture to view its varied presentations. This complex and energetic spatial involvement is a characteristic of late-sixteenth-century sculpture; it continues the course set earlier by Michelangelo's exaggerated figural style. But whether the sculpture is monumental or more intimate, the dazzling display of the artist as virtuoso performer is apparent.

EARLY LANDSCAPE PAINTING

367. PIETER BRUEGEL THE ELDER
December Landscape (commonly known as *Hunters in the Snow*). 1565. Oil and tempera on wood, 46 1/8 x 63 3/4".
Kunsthistorisches Museum, Vienna. This landscape is part of a series of six that represented different times of the year;
five survive today. They probably were originally displayed in the home of a wealthy Antwerp banker.

Bruegel's *December Landscape* (fig. 367) emphasizes nature not only by the vast sweep of the terrain but also by the manner in which the season—as expressed in the landscape—dominates and controls the activities of the peasants. Trudging peasants with a pack of motley dogs lead us into a village scene with skaters in the middle ground. The landscape culminates with distant, atmospheric peaks reminiscent

of the Alps that Bruegel crossed on a trip to Italy. The leaden gray-green of the sky and its subtle transformation in the colors of the frozen ponds, in combination with the stark, silhouetted trees and birds, evoke the time of year, the kind of day, and even the temperature of the moment.

In earlier periods, landscape was often viewed as an adversary, a frightening and unpredictable element populated with

thieves and the unknown. With the exception of some ancient Roman frescoes and mosaics, landscape as a theme developed only late in the history of art. These examples from the sixteenth century are some of the first paintings to convey appreciation for landscape.

One of the first artists to show an interest in the expressive power of landscape was the German painter Altdorfer. His mas-

PIETER BRUEGEL THE ELDER, *December Landscape:* **1565**
1558–1603: Queen Elizabeth reigns in Britain
1569: The Mercator projection map of the world is published in Flanders

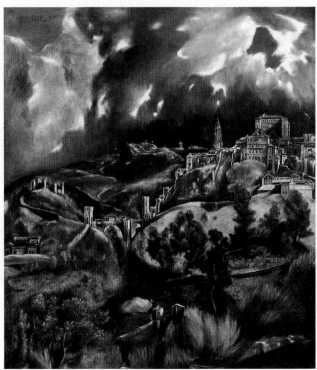

368. ALBRECHT ALTDORFER
Left: *Battle of Alexander and Darius.* 1529. Oil on wood, 62 1/4 x 47 1/4". Alte Pinakothek, Munich. Altdorfer 's panoramic landscape combines natural observation with historical fantasy. Its ostensible subject is the famous ancient battle at Issus, where Alexander the Great defeated the Persian king Darius in 331 B.C. The painting was commissioned by the city of Regensburg at the request of Duke Wilhelm of Bavaria. This historical theme almost certainly refers to the sixteenth-century hope that German troops would be able to stop the advance of the Turks into Europe.

369. EL GRECO
Right: *Toledo.* c. 1600–1610. Oil on canvas, 47 3/4 x 42 3/4". The Metropolitan Museum of Art, New York (Bequest of Mrs. H. O. Havemeyer). El Greco, who was born on the island of Crete and who studied in Venice, lived in Toledo, Spain, from about 1575 until his death in 1614.

terpiece is a landscape which is also a history painting (fig. 368). The global scope of the landscape is tied to Altdorfer 's historical narrative, for he wants to suggest that the battle at Issus was a struggle for control of the known world. This earthly conflict seems to take on an even cosmic significance, for Altdorfer presents a struggle between the setting sun and the rising moon as they vie for superiority in the background.

The configuration of hills, valleys, and monuments in El Greco's painting identifies the city as Toledo (fig. 369), but both the natural forms and the city's structures have been stretched and verticalized to create a nervous effect that is heightened by the somber colors and stormy sky. Along the banks of the river and on the hillsides are tiny human figures who are dominated and threatened by the landscape. El Greco's vision of the city where he lived is less a portrait than a vehicle to convey a mood of drama and, perhaps, religious ecstasy.

PIETER BRUEGEL THE ELDER

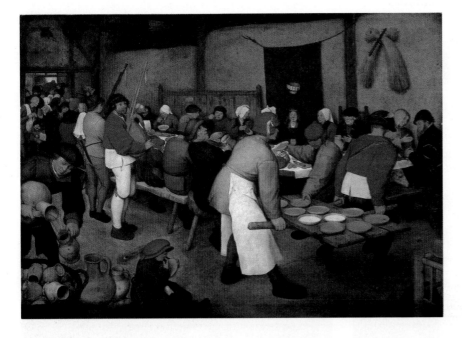

BRUEGEL, *Peasant Wedding Feast:* **c. 1566**
1565: Tobacco is introduced into Britain
1578: China's population reaches 60 million

370. PIETER BRUEGEL THE ELDER
Peasant Wedding Feast. c. 1566. Oil on wood, 44 7/8 x 64 1/8". Kunsthistorisches Museum, Vienna. The bride is the smug woman seated in front of the suspended cloth with a crown above her head. To either side are the groom and the couple's parents. To the right a priest is in conversation with a distinguished-looking man who probably represents the landowner for whom these peasants worked.

In his *Peasant Wedding Feast*, Bruegel emphasizes the rustic nature of peasant life (fig. 370). In the huge, grain-filled barn of a prosperous landowner, a wedding feast is being celebrated. In the right foreground, two men carry food on a huge makeshift tray composed of a door balanced on two sticks. A guest reaches eagerly to pass the plates. The composition is based on the strong right-to-left diagonal recession of the table, which is opposed by the movement of the figures carrying the food. The lower right corner offers a glimpse of a chair; the left has a figure pouring beer into a miscellany of jugs and a child licking its fingers. Bruegel's palette, with simple browns set off by white, red, and the abundant gold of the grain, suggests the rich simplicity of peasant life.

For the twentieth-century observer, Bruegel's paintings of peasant life provide a fascinating source of knowledge about lower-class life, but the function of these paintings for Bruegel and his contemporaries is uncertain. Details of the present picture suggest some criticism of peasant life: the smugness of the bride, the gluttony of the participants, the fact that the priest and the landowner have withdrawn from the rest of the crowd. In the absence of evidence to the contrary, however, it is reasonable to suggest that Bruegel was recording, not condescending. He may have decided to record the local traditions which enrich daily life specifically because they represent the actual and expected.

Bruegel was a friend of intellectuals and his works were collected by connoisseurs. He also designed prints, including copies after works by Bosch and works in Bosch's style. Bruegel traveled as far as Italy. He died, only in his late thirties or early forties, in 1569. During Bruegel's lifetime the Netherlands was engaged in a long battle for independence against foreign overlords. Some of his paintings representing the horrors of war refer to this conflict, and in some, specific details convey the dignity of the local populace and the oppression of the Spanish. In this light, it is tempting to question whether Bruegel's emphasis on local traditions in the peasant paintings could also have a patriotic connotation. The peasant pictures represent the vitality of Northern life, but without any obvious reference to the Spanish overlords who governed the subservient nation.

ISLAMIC ART OF THE OTTOMANS

371. Prayer rug. Second half of 16th century. Silk warp and weft with cotton and wool pile, 68 x 50". The Metropolitan Museum of Art, New York (The James F. Ballard Collection, Gift of James F. Ballard). The composition symbolizes the gardens of Paradise. In the central compartment hangs a mosque lamp designating a *mihrab*. The four hexagonal buildings above the central niche represent heavenly pavilions, perhaps the domiciles of the souls of the righteous.

jewelers, metalsmiths, woodworkers, tailors, hatmakers, and bootmakers, were created to respond to the needs of the palace. Each society had a chief, a deputy chief, master workers, and apprentices. All were paid daily wages by the state. The most influential of these groups was the *nakkashane* (imperial painting studio), which formulated the decorative themes and designs that were first employed in manuscripts, such as the pages of the Koran illustrated here (fig. 372), and then transmitted to various court arts, from architectural decoration and furnishings to metalwork, textiles, ceramics, and rugs. The *nakkashane* was the creative source for the Ottoman court style. Its influence could be felt in all parts of the empire.

The most conspicuous feature of Ottoman court art of this period is the representation of nature in depictions of flora in perpetual growth. This theme, executed in styles that reflected both mystical and naturalistic approaches, was meant to highlight the essence of nature—beauty and perpetuity. Objects produced in the imperial workshops re-created an enchanted forest inhabited by mythical creatures and naturalistic flora.

Prayer rugs, or *seccades*, are characterized by their small size and stylized decor (see fig. 371). They were meant to be used by one person in private devotion or as part of a group. They all include a depiction of a *mihrab* niche (see pp. 196–97), identified by arches supported by columns. The niche oriented the *seccade*—and the worshipper—toward Mecca.

372. Illuminated frontispiece of a Koran. Transcribed by Ahmed Karahisari in 953; illuminated edition for Suleiman I, 1546–47. Gold marginal drawings, watercolors on folios, each 11 7/16 x 7 5/16". Topkopi Sarayi Museum, Istanbul. The Ottomans, like other Islamic societies, regarded calligraphy as the noblest of the arts. To copy the holy book, the Koran, was considered an act of piety and devotion.

These works (figs. 371, 372) were produced in court-supported workshops during one of the most powerful and vast empires in world history, the Ottoman Empire (1299–1922). During the mid-sixteenth century, this Turkish empire, under the leadership of Sultan Suleiman I (1520–66), extended in the west to Greece, Albania, and Yugoslavia; into central Europe; across North Africa; to the central, historic Islamic lands of Saudi Arabia and the regions along the Arabian Gulf and the Red Sea. The Ottoman sultan—the central political leader, chief military officer, and protector of Islam—was also guardian of Mecca, Medina, and Jerusalem, the holy cities of the Islamic world, and ruled over the cultural centers of Damascus and Cairo.

The centralized administrative structure of the Ottoman state was also applied to artistic production. Societies of artists, including calligraphers, painters, bookbinders,

LATE-SIXTEENTH-CENTURY ARCHITECTURE

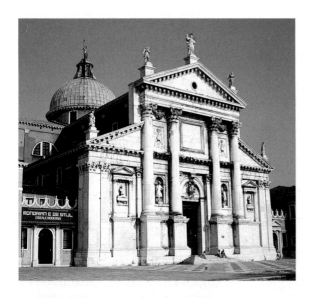

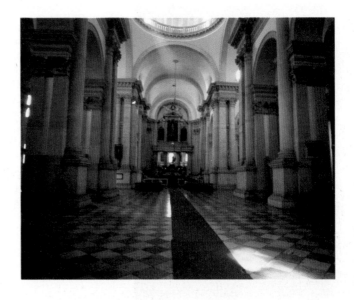

373, 374. ANDREA PALLADIO
Facade and interior, San Giorgio Maggiore, Venice. Begun 1566. Andrea di Pietro della Gondola was given the nickname Palladio, an allusion to Pallas Athena, the Greek goddess of wisdom.

The imposing church of San Giorgio Maggiore, with its white marble facade radiant against the blue sky and water, is built on an island just across the lagoon from the main public square of Venice (fig. 373). Renaissance architects had long wrestled with one major problem of facade design for basilica churches: how to reconcile the different roof heights of the nave and side aisles within a visually coherent design. Palladio's novel solution was to superimpose one classical temple front, reaching the height of the nave, over another, broader temple front, which spans the width of the side aisles. The use of the giant order unifies the double-tiered arrangement, while the pediments create a dynamic, axial accent. The facade is vigorous and simple. Its commanding scale and Renaissance harmony carry especially well from the public square near San Marco.

The articulation of the facade design is carried through the interior (fig. 374). Shorter pilasters, corresponding to those on the lower, broader temple front on the exterior, face the side aisles, while a giant order of pilasters and engaged columns face the nave, crossing, and apse.

Palladio's designs, whether for ecclesiastical or secular architecture, such as the Villa Rotonda (fig. 9), express visual harmony. Palladio's proportional systems were derived from musical scales, and they governed the interrelationship of all of the parts of a building as a totality.

Palladio had an incalculable influence on later developments in Western architecture because his ideas were published in editions illustrated with ground plans, sections, and elevations of his buildings. Palladio's *Four*

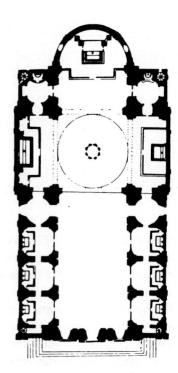

375. GIACOMO DA VIGNOLA
Plan, Il Gesù, Rome. 1568

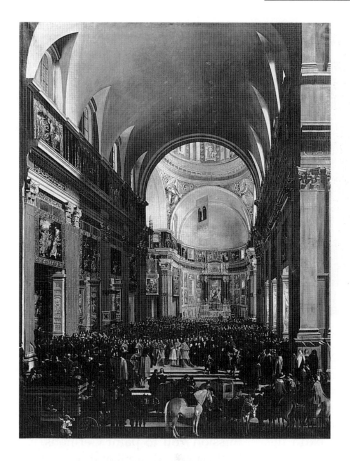

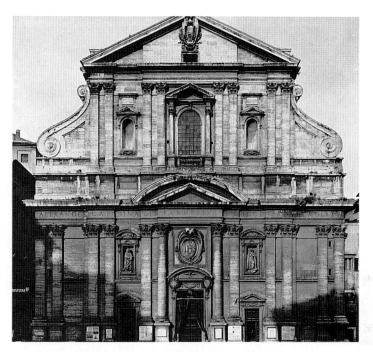

377. GIACOMO DELLA PORTA
Facade, Il Gesù, Rome. c. 1575–84. Although Vignola had submitted a design for the facade, the Jesuit who was in charge of the church's construction, Father Giovanni Tristano, chose Della Porta's design instead.

376. GIACOMO DA VIGNOLA
Interior of Il Gesù, as represented in a 1639–41 painting by Andrea Sacchi and Jan Miel, which shows a visit to the church by Pope Urban VIII. The painting is now in the Galleria Nazionale d'Arte Antica, Rome. Between 1672 and 1685, Gaulli and Bernini decorated the nave ceiling with the *Triumph of the Name of Jesus* (fig. 388).

Books on Architecture, first published in 1570, found their way into many great European and American libraries, including those of Robert Adam and Thomas Jefferson (see pp. 388 and 400–401).

The concerns of the Counter-Reformation and the Council of Trent found an important architectural expression in Il Gesù, the main church of the Jesuit order in Rome (figs. 375–77). Vignola's design emphasizes the importance of having a unified congregation during services. The side aisles are transformed into chapels that open off the nave, and the transepts have been shortened, creating a monumental interior space that is both compact and unified.

The classical vocabulary of columns, entablatures, and pediments on the facade (fig. 377) has its roots in Renaissance designs, but Della Porta's combination offers a new sense of drama. The pilasters, engaged columns, and half-columns create a sequence that builds, visually and literally, toward a climax at the central door, which is framed by both a rounded and a triangular pediment and emphasized by a broken cornice. On the upper story, a temple facade has a similar effect. The design, created by the dynamic interplay of architectural elements, will be further developed by Baroque architects in the seventeenth century.

VERONESE AND THE IMPACT OF THE COUNTER-REFORMATION

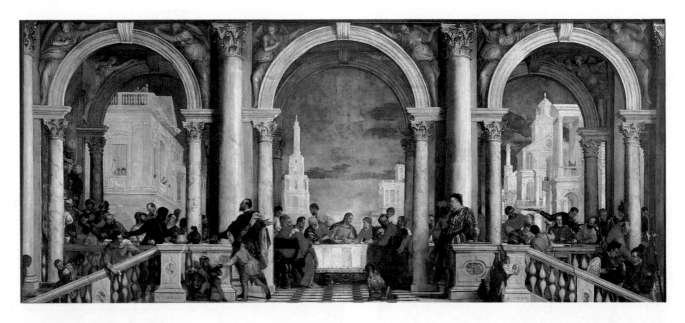

378. PAOLO VERONESE
Last Supper/Feast in the House of Levi. 1573. Oil on canvas, 18' 3" x 42'. Accademia, Venice. Veronese continued to paint in the Venetian High Renaissance style.

At first glance, this huge and sumptuous painting by Veronese (fig. 378) seems to represent a secular banquet. The setting is a palatial loggia, and the figures at the table are surrounded by richly costumed servants. However, Veronese created this work in response to a commission to paint a Last Supper for a monastic refectory in Venice. His interpretation of the Last Supper was questioned by the patron, at which point Veronese was called before one of the Inquisition tribunals established by the Catholic church (see pp. 295–96). The transcript from his trial survives, giving us rare insight into a confrontation between the needs of the Counter-Reformation church and the nature of artistic freedom in the Renaissance.

Veronese is asked to describe the painting and to defend the inclusion of so many extra figures in the composition:

Inquisitioner: What is the significance of those armed men dressed as Germans, each with a halberd [battle weapon] in his hand?
Veronese: We painters take the same license the poets and jesters take.... They are placed here so that they might be of service because it seemed to me fitting that the master of the house, who was great and rich, should have such servants.
Inquisitioner: And that man dressed as a buffoon with a parrot on his wrist, for what purpose did you paint him on that canvas?
Veronese: For ornament, as is customary....

Inquisitioner: Did anyone commission you to paint Germans, buffoons, and similar things in that picture?
Veronese: No, milords, but I received the commission to decorate the picture as I saw fit. It is large and, it seemed to me, it could hold many figures.
Inquisitioner: Are not the decorations which you painters are accustomed to add to paintings or pictures supposed to be suitable and proper to the subject...? Does it seem fitting at the Last Supper of the Lord to paint buffoons, drunkards, Germans, dwarfs and similar vulgarities?
Veronese: No, milords.
Inquisitioner: Do you not know that in Germany and in other places infected with heresy [Protestantism] it is customary with various pictures... to mock

VERONESE, *Last Supper/Feast in the House of Levi:* **1573**
1572: Protestant Huguenots are massacred in France
1575: Thomas Tallis and William Byrd publish music

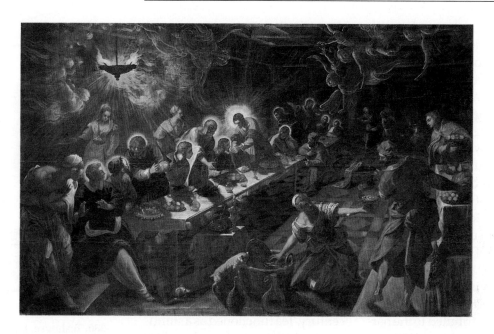

379. JACOPO TINTORETTO
Last Supper. 1592–94. Oil on canvas, 12' x 18' 8". San Giorgio Maggiore, Venice (see p. 336 for a discussion of San Giorgio Maggiore). Tintoretto's painting is stylistically related to Mannerist developments.

. . . and scorn the things of the Holy Catholic Church in order to teach bad doctrines to foolish and ignorant people? . . .
Veronese: Illustrious Lords, I do not want to defend it, but I thought I was doing right. I did not consider so many things and I did not intend to confuse anyone.

The tribunal contended that Veronese's *Last Supper* lacked decorum because the inclusion of so many extra figures was inappropriate to the subject. It was suggested that the secular elements could be viewed as an attempt to confuse and belittle the church's authority. Veronese's additional figures should be understood as a reflection of the extravagances of Venetian society rather than the ideas of the Reformation, and the artist based his defense on artistic license. He argued that artists should have the right to adorn and decorate their work as they saw fit. Ultimately he satisfied the tribunal by changing the name of the painting to suggest that it represented another New Testament story, the feast in the house of Levi (Luke 5:29–39), in which Christ dined with tax collectors.

Tintoretto's *Last Supper* (fig. 379) shares elements with Veronese's painting, such as the inclusion of a number of servant figures and animals, but it offers an emphasis on the mystical content of this subject that is in keeping with the attitudes of the Counter-Reformation church. The strong diagonal of the table is a departure from the traditional Last Supper format, in which the table was placed parallel to the picture plane (see fig. 311). The powerful thrust of the table into space creates a visual tension which complements Tintoretto's dynamic treatment of the theme. Christ rises, his head surrounded by an intense glowing halo, to offer the bread, predicting the Eucharist, to the apostles. The space of the room is energized and spiritualized by ethereal angels, whose transparent, swirling forms emphasize the spirituality of Christ's act. The visual drama of the painting demands an emotional response from the viewer, while its didactic role promotes the Counter-Reformation ideal of the church as the path to salvation.

THE ART OF ZEN BUDDHISM

During the fifteenth and sixteenth centuries, a period of civil disorder in Japan, one could find islands of repose and tranquility in many bustling urban centers. As one stepped through the gate into the precinct of a temple or teahouse (fig. 380), one was led from the ordinary world into a realm devoted to repose and beauty. At the teahouse, the host invited friends of like artistic tastes not only to partake of tea, but also to enjoy an inspired choice of art objects. The ceramic (fig. 382) and lacquer wares used for serving the tea, scroll paintings (fig. 381), and the garden (fig. 383) all contributed to the harmony of the experience. With the changing seasons and moods, this experience could never be recaptured in quite the same way again.

The animating spirit of the age was Zen, a meditative sect of Buddhism (see pp. 181–82). It was the religion of the samurai, who were the patrons of the arts associated with *cha no yu*—the art of tea. The Zen sensibility for beauty is primarily concerned with inner rather than outer form. This meant that each object was intended to speak directly to the heart or fulfill the spirit. Recognition of inward form required mental discipline that was based on the ephemeral, the transiency of life. Zen taught that there was no Buddha except the Buddha in your own nature, and that only through meditation could you realize your own Buddha nature. You achieved enlightenment—an intuitive identification of spirit and object—when you realized unity with yourself and with all things. Zen doctrine, simple and direct, had an immediate appeal to the pragmatic, military samurai. The arts were inspired by the Zen apprehension of the spiritual identity of all things, by an appreciation of direct, intuitive perception, and by aesthetic standards that stressed subtlety, allusiveness, and restraint. The tea ceremony and the related arts of monochrome landscape painting and garden architecture were especially favored by Zen artists and patrons.

Tea was brought to prominence by monks who went to China to study Zen Buddhism in the twelfth century. Tea functioned as a stimulant to aid their study and meditation and was considered a medicinal beverage. Tea made its way into the society through the teachings of Zen to become the focus of gatherings of the nobility and the samurai and, eventually, the common people.

The most famous and revered Zen tea master, Sen no Rikyu, lived in the sixteenth century. He developed a set of aesthetic ideals that became the basis for Japanese etiquette and taste as part of the tea ceremony. The ceremony had four requirements: harmony, respect, purity, and tranquility. Two all-important tea ceremony qualities were *sabi* (studied nonchalance) and *wabi* (quiet simplicity). The choice of unadorned, unpretentious tea utensils represented a pursuit of these qualities in material form. The goal was to recognize and appreciate (or create) with discriminating taste the inherent characteristics of all things associated with tea. The makers of these objects were

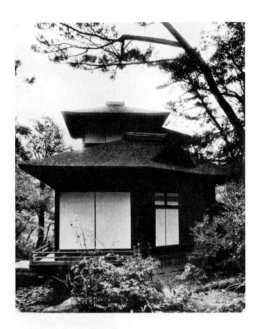

380. Teahouse, Japan. c. 1573–1615 (Momoyama period). Hara Collection, Yokohama. The teahouse, usually small and humble in appearance, was designed out of natural materials in order to blend with its setting. The interior, where the tea ceremony took place, was entered through an entrance that was usually so small that guests had to bend low or even crawl through its opening. This gesture was presumably symbolic of shedding one's status. In the soft interior light, guests were to admire the painting or calligraphy hanging before them and eat the sweets and sip the bitter tea prepared for them by the host and tea master.

some of the most talented artists of Japan.

Japanese gardens, which were attached to private homes as well as monasteries, were planned to correspond to the essentials of Zen beliefs. Because they were a means for Zen self-examination, spiritual refinement, and ulti-

1578: Catacombs of Rome are discovered
1581: Russian conquest of Siberia
1592: Pompeii is discovered
1607: Monteverdi writes *Orfeo,* considered the first opera

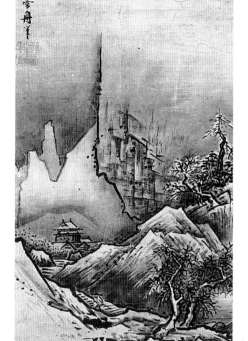

381. SESSHU
Winter Landscape. c. 1500 (Ashikaga period). Hanging scroll, ink and slight color on paper, height 18 1/4". Tokyo National Museum. In 1431, at age eleven, Sesshu entered a Zen monastery and was ordained early as a priest. He became a student of Zen priest-painters, and in 1468 he went to China for a year, where he studied Chinese landscape painting and was honored as a Zen priest. From 1481 to 1484 he made pilgrimages all over Japan to study landscape. His paintings, which gained him a wide reputation in Japan, differ in temperament and effect from the Chinese paintings that he knew so well (compare fig. 188). Sesshu's paintings, spontaneous and natural, deemphasize complexity; *Winter Landscape* is both direct and simple. His brushstrokes, firm and bold, are thought to be animated with the spirit of transience because they are executed rapidly and spontaneously. These qualities are essential to the Zen conception of the transience of the spirit and of life.

382. Cold water jar *(mizusashi).* 16th century (Momoyama period). Shino ware, stoneware with glaze over painted iron oxide decoration, height 7". Seattle Art Museum (Eugene Fuller Memorial Collection)

mate enlightenment, they were not created for idle viewing or simple pleasure. In the dry garden at the Daisen-in temple in Kyoto, which is attributed to Soami—a painter, poet, and practitioner of broad aesthetic knowledge and talent—stones and gravel represent a course of water falling over a waterfall (to the right), racing along a mountain riverbed, and finally flowing into a broad river (at the bottom). It was thought to preserve an individual, spontaneous expression and could, therefore, never be copied or even approximated. It was an object of meditation.

The gardens associated with homes and areas surrounding the teahouses are usually "wet" gardens. Guests could wander through them, appreciating the qualities of nature emphasized in the design, before eventually arriving at the rustic, intimate house where tea would be served. All such activities, as well as the arts used in such rituals, required an expression of restraint, vitality, and intimacy that captured the "inner form" of life's spirit so essential to the core of Zen thought and practice.

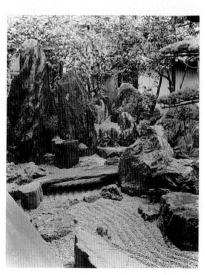

383. Attributed to SOAMI
Dry garden of the Daisen-in of Daitoku-ji, Kyoto, Japan. Early 16th century (Ashikaga period). The garden is sited on a small space on the east side of the building. Its depth from the edge of the veranda, where one would meditate upon it, to the clay wall opposite is no more than ten feet.

VII

SEVENTEENTH-CENTURY ART

INTRODUCTION

384. GIANLORENZO BERNINI
David. 1623. Marble, height 65".
Borghese Gallery, Rome

In their representation of vivacious movement and in the manner in which they engage our attention, Bernini's *David* and Hals's *Merry Drinker* (figs. 384, 385) are characteristic of much of the art produced during the seventeenth century. In his depiction of the Old Testament hero David, Bernini has caught the figure coiled in space like a taut spring, about to sling the stone at the giant Goliath. His bursting energy urges us to step aside. In Frans Hals's painting a man invites us to join him in a drink: we impulsively want to reach out and grab the glass he holds so precariously. The loose brushstrokes and warm, golden color enhance the movement and naturalism of the painting.

In creating his tour de force, Bernini, an Italian, was certainly aware

that his work would be compared to the sculptures of David by his two great predecessors, Donatello and Michelangelo (figs. 290, 324). He rivals their accomplishments by representing a new moment in the David narrative. His choice of the moment of greatest action is consistent with much of seventeenth-century art. Frans Hals's painting is a work virtually without precedent, in part because it is the product of a new and unique society—the mercantile, bourgeois, Protestant nation established in the Netherlands in the seventeenth century. Despite significant differences in medium, size, and function, these works are similar in the artists' determination to involve us in the action they represent and in their emphasis on depicting arrested motion.

The art of the seventeenth century, however, is not this simple. The two qualities cited above, which are part of a movement within the century known as the Baroque (see below), are not shared by all seventeenth-century works, in part because of increasingly complex and diverse developments in history.

HISTORY

Europe had become steadily more prosperous in the course of the sixteenth century, partly as a result of the influx of wealth from the Americas and the development of new markets in the New World. European wealth continued to increase in the seventeenth century, especially in areas with stable governments and strong commercial and trading interests. The centers of European financial power gradually shifted northward, to the rapidly growing cities of Amsterdam, Paris, and London.

Much of the pluralism of seventeenth-century art can be related to historical developments, for it is during this century that many of the national identities recognized today were consolidated as the map of Europe assumed territorial divisions similar to those of the twentieth century. New, or newly powerful, national entities had a profound influence on artistic developments.

The establishment of the new republic of the Netherlands was perhaps the most dramatic historical development of the seventeenth century. By 1609 the rebels from the northern Netherlands won their independence after a decades-long war against Spanish Catholic overlords. The new nation was unlike any other in Europe, for it was a true republic, with no traditional hereditary aristocracy. It was governed by merchants, who quickly developed a sound commercial basis for the economy. By providing goods at more reasonable prices, they developed markets all over Europe and in the New World. Although the Netherlands became largely middle class, a number of successful businessmen achieved great wealth. Amsterdam became the fastest-growing city in Europe, and the Netherlands soon had a more highly urbanized population than any other European country. In addition, it became Europe's leading maritime power, establishing

385. FRANS HALS
The Merry Drinker. 1628–30. Oil on canvas, 31 7/8 x 26 1/4". Rijksmuseum, Amsterdam

the East and West India companies and taking control of much of international commerce, including a monopoly on the spice and the slave trades. The Dutch were both Protestant and tolerant, and Jews who fled Poland, Spain, and Portugal during this period largely settled in the Netherlands. Amsterdam also became a lively intellectual community and the most important book-publishing center in Europe. It was in the Netherlands that the new philosophy of the Frenchman René Descartes, which was founded on the principle of universal doubt, was published. It should be no surprise that important new developments in art occurred here.

By the end of the seventeenth century, France, with a population of approximately nineteen million, was the largest nation in Europe and the strongest and wealthiest. Reunited by King Henry IV at the beginning of the century, the monarchy consolidated its power under a series of energetic and able administrators—Richelieu, Mazarin, and Colbert—during the reigns of Kings Louis XIII and XIV. Under Louis XIV, the Sun King, who ruled until 1715, the centralization of power and wealth under the monarchy was completed. The power of the traditional nobility in France was broken, and the king governed as a supreme and autocratic ruler. By the end of the century, France

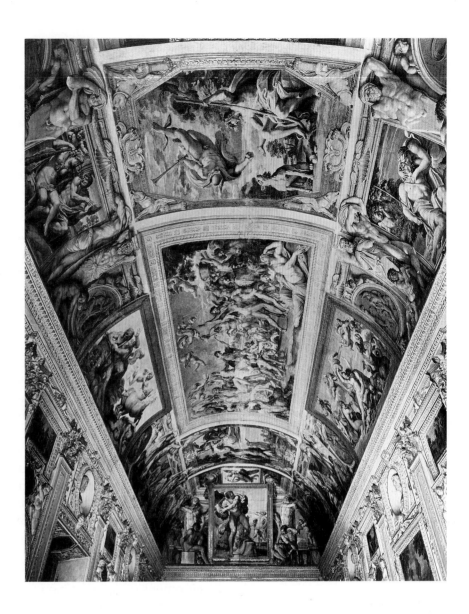

386. ANNIBALE CARRACCI
Ceiling, Farnese Gallery. c. 1597–1604.
Fresco, 67 x 20'. Farnese Palace, Rome

had an army of 150,000 that was feared throughout Europe.

The decline of Spain as a European power, which had begun in the sixteenth century, continued. Spain's economy was stagnant, despite its important territories. It still controlled the southern Netherlands (or Flanders, roughly equivalent to today's Belgium) and all of Italy south of Rome, including the huge shipping port of Naples. But the conservative rigidity of the Spanish court restricted growth. The Spanish Netherlands remained Catholic and under the control of a traditional aristocracy, but it had been substantially weakened by its foreign overlords, and the country's outstanding Baroque artist, Peter Paul Rubens, found his most important commissions outside his homeland.

The central and northern portions of the Italian peninsula were still controlled by local city-states, the largest of which were Milan and Venice. Here, too, the economy stagnated, with Venice gradually losing its traditional maritime supremacy in the Mediterranean to English and Dutch shippers, whose prices were substantially lower. The most powerful political force in Italy was the papacy in Rome,

which during the seventeenth century flourished under a series of dynamic and ambitious popes. They rebuilt Rome with glorious Baroque monuments, fought Protestantism, and reasserted the authority of the Catholic church.

Germany was devastated by the Thirty Years' War (1618–48), which destroyed the power of the Holy Roman Empire and killed at least one-third of its population. Political turmoil consumed energies in England, where the important collector and art patron King Charles I was overthrown and beheaded in 1648.

INTELLECTUAL AND SCIENTIFIC ACTIVITY

The explosion of printed information that followed the invention of movable type in the fifteenth century led to greatly increasing levels of literacy. By the end of the seventeenth century, almost half of the adult male population of Europe was literate. In addition, scientific questioning, more possible after the Reformation, led to important advances in medicine and the other sciences by such major figures in scientific theory and invention as Bacon, Galileo, Newton, Harvey, Hobbes, Kepler, Locke, Leeuwenhoek, Descartes, and Pascal. Many of the European capitals developed academies and learned institutions in science and in other areas, which began publishing scholarly periodicals. In literature, poetry and drama found a new, more vivid and emotional expressiveness in the works of Milton, Corneille, Molière, Racine, and Shakespeare. The caricature, a humorous or critical portrait based on exaggeration, had been invented earlier, but it was popularized and developed by Bernini and Annibale Carracci. In Florence a group interested in reviving ancient Greek drama offered musical presentations which gave the primary impetus to the development of opera. One of the first of these was Jacopo Peri's *Euridice*, which was performed at the marriage by proxy of Marie de' Medici to King Henry IV of France in 1600 (see p. 360). One of the guests was the artist Rubens.

THE STYLES OF SEVENTEENTH-CENTURY ART

Given the complexity of these historical and intellectual developments, it should not be a surprise to learn that seventeenth-century art encompasses a number of different styles. The most typical style is known as the Baroque, a term sometimes confusingly applied to all art produced in the seventeenth century. In painting, this style is characterized by asymmetrical compositions, powerful effects of movement, and strong lighting in combination with dramatic interpretations of subject matter. Similar effects in sculpture are accomplished, often with rich materials and surprising light sources from hidden windows. In Baroque architecture, the classical orders continue to be used as vocabulary, but they are arranged in new patterns that are dynamic and energetic. The Baroque is a style that was

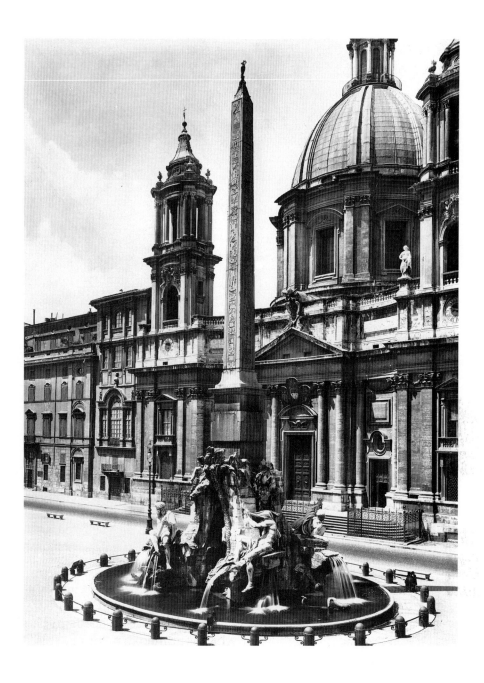

387. GIANLORENZO BERNINI
Fountain of the Four Rivers. 1648–51.
Marble and travertine, with Egyptian
obelisk. Piazza Navona, Rome

especially suited to the goals of autocratic rulers or the Counter-Reformation Catholic church. The exact origins of the word baroque are not clear, but it seems to have first been used to describe works of art in the eighteenth century, when it became a derogatory term for works that were considered strange, irregular, and irrational.

During the seventeenth century there is also interest in continuing the classicism of the High Renaissance, although with a greater complexity of composition and in a grander and more highly decorative manner. These stylistic qualities were usually reserved for subjects drawn from classical mythology or history. This style can be called Baroque Classicism. A typical example is Annibale Carracci's ceiling fresco decoration for the Farnese Palace in Rome (fig. 386). The theme is mythological (the loves of the ancient gods), and although his sources of inspiration include Michelangelo, Raphael, and classical sculpture, the effect is more complex and ornate. Examples of

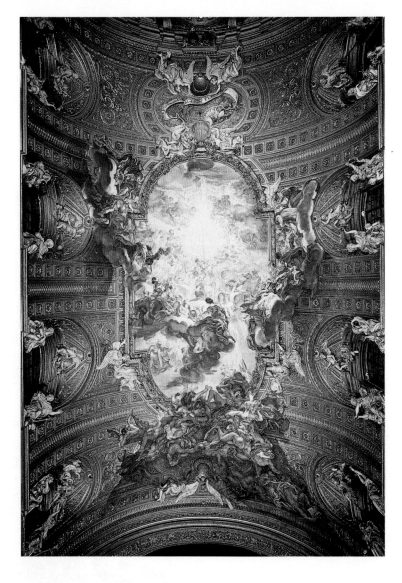

388. GIOVANNI BATTISTA GAULLI (assisted by GIANLORENZO BERNINI)
Triumph of the Name of Jesus. 1672–85. Ceiling fresco with gilded stucco surround and white stucco angels by Antonio Raggi. Il Gesù, Rome. Gaulli is also known by the nickname Baciccio. This decoration fills the blank ceiling seen in fig. 376.

Baroque Classicism in architecture are Versailles (fig. 428) and Christopher Wren's St. Paul's Cathedral in London.

A third style that needs to be recognized is the Dutch Baroque, which is limited to painting. This style is represented by thousands of Dutch paintings of Dutch subjects, characterized by their realism and naturalism. Although some of these paintings can be shown to have certain elements in common with Baroque works elsewhere (as was demonstrated with Hals's *Merry Drinker,* above), Dutch Baroque paintings are noted for their relatively small scale, and their choice of everyday subject matter. Mythological and religious paintings were usually avoided. The exception is Rembrandt, who cannot be characterized as a Dutch Baroque artist (as the style has been defined above) and whose style at different times in his life has affinities with both the Baroque and with Baroque Classicism.

Some seventeenth-century works overlap categories, and some fall outside the three which have been defined here (as do those of the Spanish painter Velázquez). Our stylistic distinctions are merely an aid in understanding the complex art of this century. These distinctions will be refined and expanded in subsequent discussions of individual works, but one should resist the temptation to assume that seventeenth-century works of art can be easily categorized.

SEVENTEENTH-CENTURY ART

In Italy, Flanders, and Spain, countries that remained Catholic, the Counter-Reformation (see pp. 295–97) led to the production of dramatic Baroque religious images, especially of subjects that fostered and supported Catholic beliefs: the lives of Christ and the Virgin Mary, the miracles and martyrdoms of saints, and the lives of monks, nuns, and priests. Elaborate cycles of paintings of religious subjects and dramatic sculptural groupings were produced for churches throughout the Catholic world. Architecture in these areas generally followed the same enthusiastic Baroque style.

In the Netherlands, the prevailing religion of Calvinism, which forbade the representation of God or Christ, led to a virtual moratorium on the production of religious subjects (again, Rembrandt stands as a distinct exception). At the same time, the absence of aristocratic or civic patronage meant a decline in interest in mythological subjects. The lively artistic production in the Netherlands specialized in naturalistic paintings of Dutch subjects—landscapes, genre themes, still lifes, portraits—for the home. There was little interest in grand architectural or sculptural projects.

In the countries which had a strong court and aristocracy—France, Flanders, Spain—and in the Italian cities of Florence, Naples, Rome, and Venice, the production of portraits and history paintings continued to provide an important livelihood for painters. Royalty, such as King Charles I of England or Marie de' Medici, queen of France, the noble families of Rome, and members of the clergy, not to mention the papacy, provided lucrative commissions for artists. France offers the best example of art and architecture in the service of autocracy since the ancient Roman Empire.

Although fountains had played a role in urban planning and garden decoration since ancient Roman times, new possibilities in fountain design were explored by that inventive Baroque genius, Bernini. His most triumphal fountain, in the Piazza Navona in Rome (fig. 387), has an ancient Egyptian obelisk raised over a huge rocky landscape with four monumental figures—each as big as Michelangelo's *David*. They symbolize what at the time were considered to be the four main rivers of the world, the Danube, Nile, Rio della Plata, and Ganges. The theme of the fountain, a papal commission, is consistent with the Counter-Reformation, which suggests that all the peoples of the world will be converted to Catholicism through the efforts of an energetic papacy and the revived church of the Counter-Reformation. Bernini forces the water of the fountain to cascade in sheets to create the maximum noise and splash. The water, integral to his conception, is incorporated into both the design and the theme. He even incorporates the drain into his design, for a smiling, cavorting fish "swallows" the water, adding yet another sound to this lively complex. The fountain has a new excitement and energetic dynamism consistent with Baroque attitudes.

389. JUDITH LEYSTER
Self-Portrait at the Easel. c. 1635. Oil on canvas, 29 3/8 x 25 5/8". National Gallery of Art, Washington, D.C. (Gift of Mr. and Mrs. Robert Woods Bliss, 1949)

GIANLORENZO BERNINI'S WORKS FOR ST. PETER'S

As a glowing dove of the Holy Spirit descends, angels and golden rays fill the apse of the church, and the columns of the canopy *(baldacchino)* over the high altar appear to writhe with excitement (fig. 403). We seem to be witnessing a miracle.

Bernini's *Baldacchino* solved some important problems. It provided a focal point for the vast interior by marking the burial spot of St. Peter and the high altar of the basilica, without blocking the view to the apse or overwhelming the interior. The dark bronze and gilded highlights stand out against the white marble of the basilica's architecture, as do the dynamic spiral columns and the beautiful angels, curving volutes, and scallops with tassels—all emulating temporary cloth *baldacchinos*—of the top. Later, Bernini's *Baldacchino* became a frame for the *Cathedra Petri*, a multi-media climax at the end of St. Peter's which enshrines, like a huge reliquary, a wooden and ivory chair thought to be the papal throne used by St. Peter. Four figures of early theologians—Sts. Ambrose, Athanasius, John Chrysostom, and Augustine—support the reliquary just as they had approved the primacy of St. Peter and the Roman church in their writings. One of Michelangelo's windows has been changed by the addition of a stained-glass, alabaster, and gilded stucco representation of the Holy Spirit surrounded by golden rays and *putti* which sweep out with Baroque splendor to dominate Michelangelo's Renaissance apse.

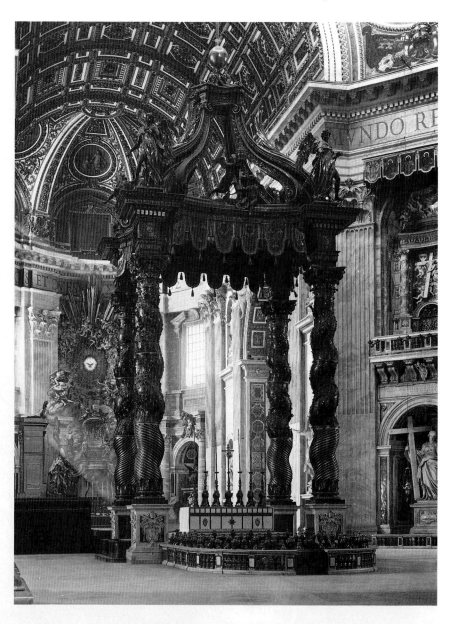

403. GIANLORENZO BERNINI
Baldacchino. 1624–33. Bronze with gilding, height 93' 6"; *Cathedra Petri.* 1656–66. Marble, bronze with gilding, stucco, alabaster, and stained glass. St. Peter's Basilica, Vatican, Rome. Bernini's use of twisted columns is based on the altar railing of Old St. Peter's, which had ancient twisted columns believed to have decorated the great Temple of Solomon in Jerusalem.

Bernini's colonnade, which shapes the piazza in front of St. Peter's, is more than just an impressive entrance to the basilica, for it also serves to define the space where the faithful gather to receive the papal blessing (fig. 404). Bernini's design is based on an oval with a width of almost eight hundred feet. As we enter this huge and richly decorated space, the broad axis creates a

BERNINI, *Baldacchino:* **1624–33**
1628: Harvey publishes on the circulation of the blood
1633: The Inquisition forces Galileo to retract his defense of the Copernican system

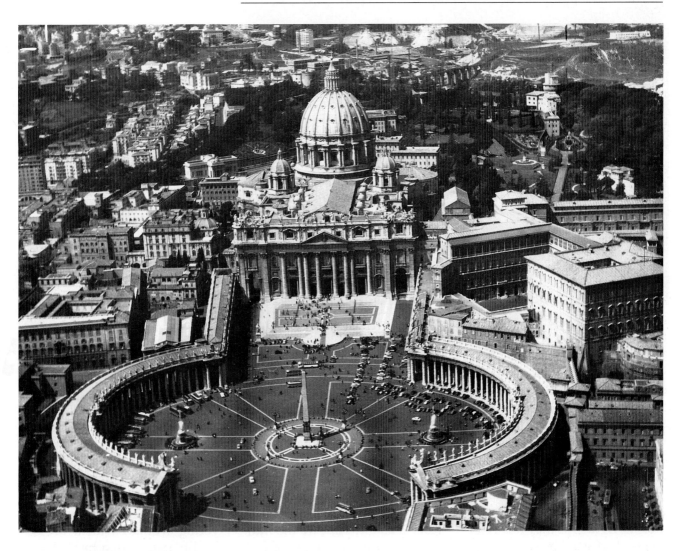

404. GIANLORENZO BERNINI
Colonnade, St. Peter's, Rome. Begun 1656. Travertine, longitudinal axis approx. 800'. A drawing reveals that Bernini conceived of the sides of the colonnade as the arms of St. Peter's, and that the design is meant not only to define and contain but to embrace as well.

dynamic effect, and space seems to expand to either side. When Bernini built the piazza, the area was surrounded by medieval houses and narrow, winding streets, an approach which would have rendered the spatial explosion of the piazza even more impressive. Huge travertine columns—284 placed in rows of 4—define the piazza without closing it off from the surrounding areas. As a result, it can be quickly emptied when a crowd wants to disperse.

Bernini, who was appointed main architect for St. Peter's in 1637, worked on the building and its decoration for forty-two years, until his death. Among his other works are two papal tombs, another tomb, the altar decoration of the Chapel of the Holy Sacrament, and the nave decorations. From the ancient Roman bridge that was the ceremonial entrance to the Vatican, which Bernini and his assistants adorned with statues of angels in the 1660s, to the dramatic *Cathedra Petri,* works by Bernini transformed St. Peter's from a Renaissance structure into a Baroque experience.

THE DUTCH BAROQUE GROUP PORTRAIT

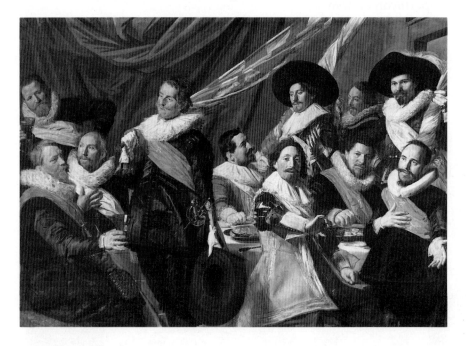

405. FRANS HALS
Banquet of the Officers of the Civic Guard of St. George. 1627. Oil on canvas, 5' 10 1/2" x 8' 5 1/2". Frans Halsmuseum, Haarlem. The various civic militia groups of the first half of the seventeenth century descend from groups that played a crucial role in gaining the independence of the Netherlands. They continued to have important functions, including guarding the city and keeping order, and it became traditional that they have their portraits painted. Often, as here, they are shown at the annual banquet given them by the city.

The boisterous members of Frans Hals's militia seem to be inviting us to join their celebration (fig. 405). Just to the right of center, a man holds his glass upside down; he was a brewer, and the artist suggests that he is more than slightly inebriated. The vivacious activity of Hals's lifesize figures as they turn, converse, and gesture seems completely spontaneous. Hands are raised, mouths are open, and figures glance in various directions. The suggestion of movement is enhanced by the diagonals in the composition, by repeated strokes of strong color, and by the use of bold diagonal brushstrokes.

The group portrait had its first important development in the democratic, bourgeois Netherlands, and its first great master was Frans Hals, who overcame the inherent repetitiveness of this subject, in which an artist

had to paint a group of individuals, all about the same age and all of whom wore the same or similar costumes. The democratic traditions of the Netherlands demanded that the individuals be shown as equals, and usually each paid the painter an identical amount to be included. Hals is able to capture the individuality of each member, as well as the exuberant union that joins the group into a whole.

Rembrandt's *"Night Watch"* is surely the most famous painting known by a completely misleading name. The scene is not represented taking place at night, and the correct title is *The Militia Company of Captain Frans Banning Cocq* (fig. 406). Rembrandt's dramatically composed and lit portrait of the members of this Amsterdam militia company offers a radical solution to the problems of the militia portrait. Rembrandt

subordinates the democratic ideal to pictorial drama and focus, creating a sense of unified action. The moment chosen is not the indulgent banquet, but the captain and lieutenant ordering the militia to march. The other members of the company, as well as certain additional figures—a young woman with a dressed bird hanging from her belt (the bird's claws were the emblem of the militia guild), a boy firing a rifle, and others—are gathered in seemingly spontaneous groupings. Bold light and lightly colored costumes emphasize the main figures and give focus to the composition. A number of subordinate figures are virtually lost in shadow. They were added by Rembrandt to create variety; they were not militia members who had paid to be included. The composition, rich and complex, is truly Baroque. The figu-

HALS, *Banquet of the Officers of the Civic Guard of St. George:*
1627
1626: Purchase of Manhattan island
1630: Bubonic plague kills 500,000 Venetians
1636: "Haarlem" is founded by Dutch settlers on Manhattan island
1643: Death of Louis XIII

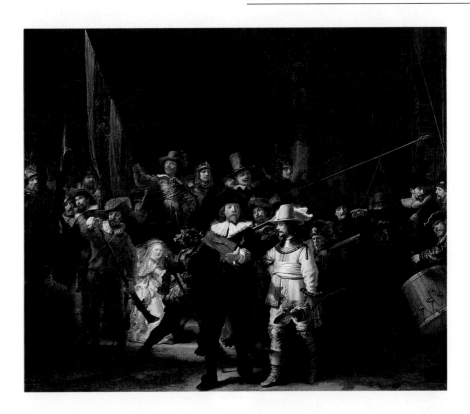

406. REMBRANDT
The Militia Company of Captain Frans Banning Cocq. 1642. Oil on canvas, 12' 2" x 14' 7". Rijksmuseum, Amsterdam. This group portrait, Rembrandt's largest surviving work, is usually known, inaccurately, as *"The Night Watch"* because layers of dirty varnish once made it seem like a night scene. The painting was part of a series of group portraits of militia companies that decorated a great hall in the headquarters of the Amsterdam civic guard. The patrons were members of Cocq's company, each of whom paid a sum consistent with his prominence in the painting. In the eighteenth century, the painting was cut down, and as a result, the composition was transformed. Rembrandt's group portrait was commissioned for a specific position. To reconstruct the angled view that a spectator would have had when approaching the work from the only doorway in the room, hold this book at an angle so that the painting is to your right and sharply receding. This clarifies a number of elements in Rembrandt's composition, including the glance and gesture of Captain Cocq, who, it can now be understood, was looking toward the spectator. Rembrandt adjusted his composition to gain maximum effectiveness given the intended location of his painting. The other civic militia portraits in the same hall included the artist's self-portrait, and Rembrandt, with wit, represented himself in the back of the crowd. All we see is an eye, part of his nose and forehead, and a painter's beret.

ral composition is set off by the off-center gateway—a reference to an ancient triumphal arch—in the background.

No documentary evidence supports the myth that the members of the company were unhappy with Rembrandt's brilliant and unexpected solution to the problem of the group portrait. The painting was praised in the seventeenth century; one of Rembrandt's pupils wrote: "It will outlast all its competitors, being so artistic in conception, so ingenious in the varied placement of figures, and so powerful that, according to some, it makes all the other pieces there look like decks of playing cards."

Rembrandt was the most famous Dutch artist of the seventeenth century and virtually the only one with an international reputation. As a young man he hoped to be a history painter, but his earliest success came as a painter of group and individual portraits. In 1642, the year of this group portrait, his wife Saskia died, leaving him with an infant son to raise. His art had already shown signs of change, and after 1642 he sought subjects and techniques that would satisfy a personal need for profundity and emotional depth (see figs. 415–17).

BAROQUE ARCHITECTURE: FRANCESCO BORROMINI

This dome by Borromini almost appears to be a hallucination (fig. 407). The hovering oval form, with its elastic coffers, seems to bear no relation to the heavy, solid stuff of architecture. If we blink, will it disappear, descend, or snap back into a circular shape with regular coffering? Startling and unbelievable architecture is typical of the works of Borromini. His Baroque monuments tantalize us with their energy, complexity, and tension. The oval form used here is one which has an inherent dynamism, for an oval establishes an axial direction and presents a variation in curvature, but Borromini also exaggerates the diminution of the coffering to suggest that the dome is larger than reality and, by adding hidden windows at the base of the dome, he creates a floating, levitating sensation. The excitement generated by the dome at San Carlo is resolved by the circle in the middle of the lantern, which is decorated with a triangle, symbol of the Trinity and emblem of the Trinitarian order that commissioned the church.

The demand that we be involved, the effect of captured movement, and the dramatic lighting of this architecture are consistent with the Baroque innovations examined in the paintings of Caravaggio and his followers. This small church is only one example of Borromini's brilliant inventiveness in creating new and exciting experiences within the classical vocabulary of architecture.

The complexity that charac-

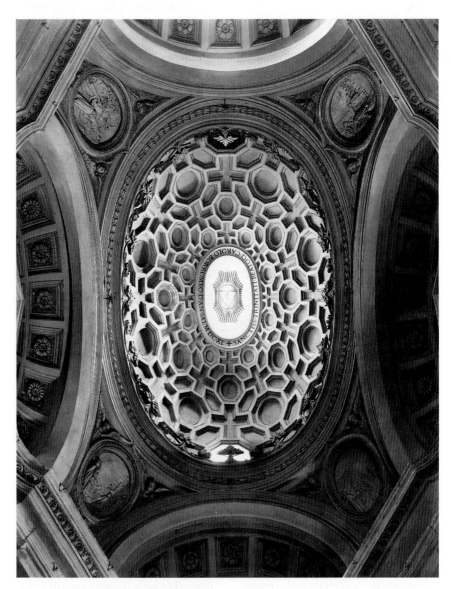

407. FRANCESCO BORROMINI
Dome, San Carlo alle Quattro Fontane, Rome. 1638–41. Dedicated to a recently canonized saint, Carlo Borromeo, this church is also named after its location at an intersection with four fountains (*quattro fontane*).

terizes the interior of San Carlo (fig. 408) rivets our attention as we try to discern the logic and order we expect in a building based on the classical orders. The entablature is composed of contrasting flat and concave sections that surge around the small interior, while the patterns of columns and of triangular and semicircular pediments create two overlapping and interlocked systems. The design is both logical and brilliantly complex. Architectural historians have analyzed the mathematical formulas on which Borromini based his structures. In this case he evolved his

BORROMINI, Dome, San Carlo alle Quattro Fontane: 1638–41
1635: Boston's public Latin School opens
1639: Smithfield hams from Virginia are sold in London

30 feet

408. FRANCESCO BORROMINI
Plan, San Carlo alle Quattro
Fontane. 1638–41. Note how
Borromini has located his church
within the irregular space available
to him.

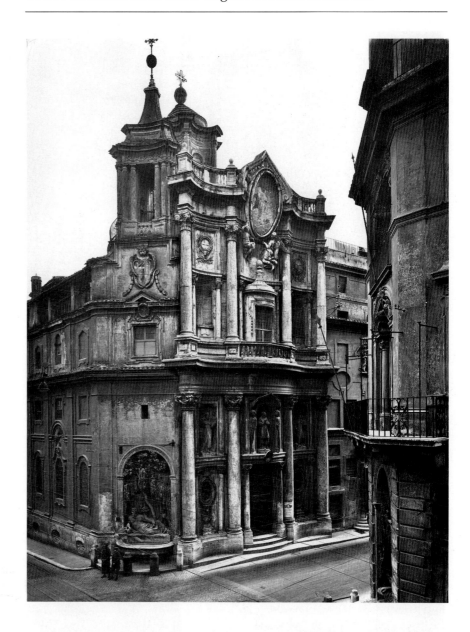

409. FRANCESCO BORROMINI
Facade, San Carlo alle Quattro
Fontane. 1665–67. Although the
facade was completed long after
the rest of the church, it is probably
based on plans Borromini had
drawn earlier.

design from the triangle, symbolic of the Trinitarian order. At its most basic level, then, the shape of San Carlo alle Quattro Fontane has a form and an iconographic content that can be related to both a particular religious order and the Christian religion in general.

The facade predicts the interior in the grouping of four evenly spaced columns, in the undulation of the surging entablature, and in the scale of the lower story of columns (fig. 409). When one is standing in the narrow street before the church, however, the complex energies of contrasting concave and convex forms overwhelm any sense of logic. The upper row of columns completely masks the dome, making it a total surprise for the unsuspecting observer.

BERNINI, *ECSTASY OF ST. TERESA*

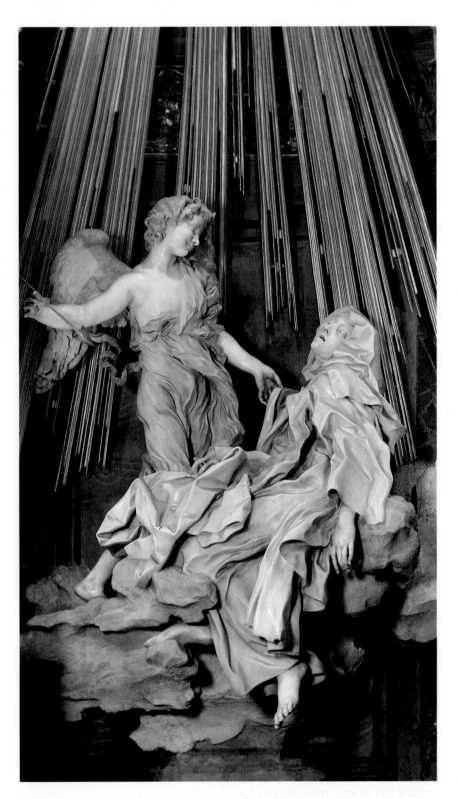

"It pleased the Lord that I should sometimes see the following vision. I would see beside me . . . an angel in bodily form. . . . He was . . . short and very beautiful, his face so aflame that he appeared to be . . . all afire. . . . In his hands I saw a long golden spear and at the end of the iron tip I seemed to see a point of fire. With this he seemed to pierce my heart several times . . . he left me completely afire with a great love for God. The pain was so sharp that it made me utter several moans; and so excessive was the sweetness caused me by this intense pain that one can never wish to lose it, nor will one's soul be content with anything less than God. It is not bodily pain, but spiritual, though the body has a share in it—indeed a great share" (St. Teresa, *Autobiography*).

410. GIANLORENZO BERNINI AND WORKSHOP
Ecstasy of St. Teresa. 1645–52. Marble and bronze, height approx. 11' 6"; the figures are over-lifesize. Cornaro Chapel, Santa Maria della Vittoria, Rome. Teresa, a sixteenth-century nun and a leading personality in the Counter-Reformation church in Spain, founded a new, stricter reformed group of Carmelite nuns known as the barefoot Carmelites. For this reason she is represented as barefoot in Bernini's sculpture. She wrote a number of works about the mystical life, including a popular and widely read *Autobiography* in which she detailed the visions and ecstasies she experienced.

BERNINI, *Ecstasy of St. Teresa:* **1645–52**
1648: Taj Mahal is completed in India
1650: World population is about 500 million

Bernini has visualized Teresa's words and experience in his sculpted altarpiece (fig. 410), capturing in the saint's pose and facial expression the combination of "sweetness" and pain she describes so vividly and physically. Her figure seems to convulse, her arm is limp, and her head slumps back, her mouth open and her eyes half-closed. The figure of the angel smiles radiantly, and its drapery ripples with flamelike folds that evoke Teresa's words.

Bernini's interpretation, however, encompassed more than just Teresa's description of this single ecstasy. It relates this experience to other aspects and events of her life and to contemporary attitudes about ecstasies and saints. Teresa's miraculous death, as described by those who witnessed it, is evident here in the beauty Bernini gives the saint. Although her homeliness is documented, at the moment of her death, when she was in her sixties, witnesses testified that she became youthful and beautiful, and that she died while in a state of ecstatic love for God. The relationship between ecstasy, death, and fervent love of God, and the ideal of the marriage of the soul with the divine are revered parts of the mystical tradition which has its roots in the Old Testament love poetry of the Song of Songs. Teresa herself had written a commentary on the Song of Songs in which she related Christian death and ecstasy to the soul's desire to expire in the anguish of divine love. Bernini shows the saint

levitating, transported off the ground by heavenly clouds. Levitation is described by Teresa in the context of other ecstasies she experienced after attending mass. By levitating the figure, Bernini makes his sculptural group more impressive and its effect more momentary, while in the context of Teresa's life he also refers to her devotion to the Eucharist, an appropriate emphasis in an altarpiece.

Bernini's representation of the ecstasy of St. Teresa is itself a miraculous apparition, for the large white figures of the angel and the saint float above the altar. Originally they must have glowed in a gentle, mysterious light that flowed dimly down on golden rays from a window filled with stained glass. Today electric lights have been added, which make the lighting more dramatic than Bernini intended.

The vision of the miraculous ecstasy is enhanced by the enshrinement of the altarpiece group in a pedimented tabernacle of brilliant multicolored marble that is the centerpiece of a visually sumptuous chapel complex, every detail of which was designed by Bernini (see fig. 411). The back wall is covered with marble paneling which is broken by the surging pediment of the tabernacle that undulates outward and upward. The ceiling is frescoed with a burst of heavenly light, and angels seem to pour down into the chapel, accompanying the angel in Teresa's ecstasy. The altar frontal is a gilded bronze and lapis-

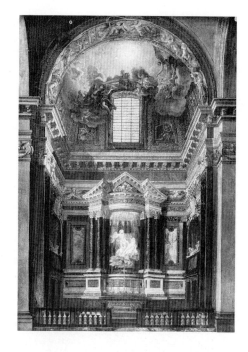

411. *The Cornaro Chapel.* 18th-century painting. Staatliches Museum, Schwerin

lazuli relief of the Last Supper, while the floor tombs are decorated with inlaid figures of gesticulating skeletons in foreshortening, as if those buried below were being resurrected by the saint's ecstasy.

Bernini unites painting, sculpture, and architecture in a beautiful totality, one which breaks down the barriers between the world in which we live and the work of art. The altarpiece and tabernacle invade our space, demanding that we become involved. A text on a banderole held by angels on the entrance arch offers words which, Teresa wrote, were spoken to her by Christ during one of her visions: "If I had not already created heaven I would create it for you alone."

THE ART OF DRAWING: REMBRANDT

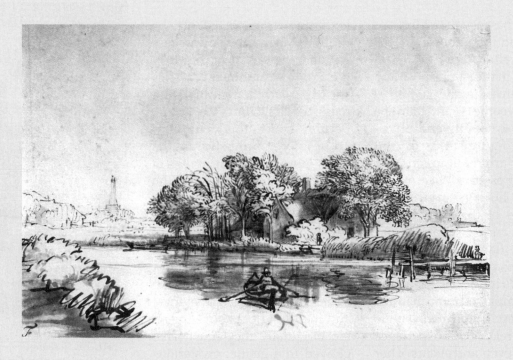

412. REMBRANDT
A Man Rowing a Boat on the Bullewyk. c. 1650. Quill pen and brown wash heightened with white, 5 1/4 x 7 7/8".
Devonshire Collection, Chatsworth. The location is a tributary of the Amstel River, near Amsterdam, with the
spire of the Ouderkerk (Old Church) in the background. The white used here is an opaque paint that allowed
Rembrandt to suggest white highlights.

The freshness of nature is captured in Rembrandt's spontaneous drawing of this still tributary near Amsterdam (fig. 412). A few quick pen strokes capture the wind as it riffles the leaves of the trees around the cottage. Rembrandt applied wash (ink thinned with water) with a brush to achieve the darker shadows that give weight to the mass of the cottage and create the reflection of the trees and cottage on the surface of the water. A thin wash at the top suggests the sky, and a dark mass in the lower left corner establishes the *repoussoir*. Rembrandt's economy of means captures the flux of nature.

Throughout the centuries, artists have made and used drawings for a great variety of purposes (see p. 280). We normally think of drawings as being preparatory—studies made in the process of creating a larger, more finished work in another medium—and such is often the case. Although almost all drawings created before the Renaissance are lost, this does not mean that artists in earlier periods did not use preparatory drawings. Egyptian and Greek stone-carvers, for example, probably drew guidelines on the four sides of their blocks of stone before they began carving, and their contemporaries surely made some kind of sketch or drawing prior to beginning to paint or to build a building. Many later paintings are based on drawings on the plaster or canvas surface (known as underdrawings because of their position under the finished work). Artists have also made drawings as records of completed works, often as a means of documenting their production. Finely finished drawings were sometimes made to be presented to collectors and friends. These are known as presentation drawings. Drawings were first systematically collected during the Renaissance, when the artist was recognized as a genius whose every creative effort was worth preserving.

There are many media in which drawings have been executed: charcoal, lead pencil, pen and ink, chalk in various colors, metalpoint, and pastel. Wash, watercolor, and gouache (see p. 457) are also considered drawing techniques, even though they are liquid media applied with a brush. Although paper is the most widely accepted support for drawings, artists have also used vellum, parchment, and other materials.

413. REMBRANDT
Saskia in a Straw Hat. 1633. Silver-point drawing on white prepared vellum, 7 1/8 x 4 1/8". Kupferstich-kabinett, Staatliche Museen, Berlin. The drawing is inscribed: "This is drawn after my wife, when she was 21 years old, the third day after we were engaged—8 June 1633." Rembrandt and Saskia were married in 1634.

Hundreds of drawings were executed by Rembrandt in virtually every drawing medium that was available to him. While some can be identified as studies for paintings or etchings, the majority are sketches of genre scenes, landscapes, and animals. All the evidence suggests that Rembrandt made his drawing of *A Man Rowing* for his own pleasure, for none of his landscape paintings are endowed with this kind of naturalism. We know from an inventory of his possessions that

414. REMBRANDT
Two Women Teaching a Child to Walk. c. 1637. Red chalk drawing on rough grayish paper, 4 1/8 x 5". British Museum, London

Rembrandt sorted his drawings and stored them by subject. The implication is that when he began a new painting or etching, he could look through his drawings for inspiration drawn from life.

When Rembrandt made a drawing of his fiancée, Saskia, shortly after they became engaged, he chose the difficult technique of silverpoint on specially prepared vellum (fig. 413). During the fifteenth and sixteenth centuries, drawing with sharpened points of silver (or gold) on specially prepared paper or vellum had been common, but by the seventeenth century, this medium was rare. The virtue of this particular technique is that it creates a very fine line. It was especially favored by artists interested in precision, such as Van Eyck, Dürer, and Leonardo.

Silver- and goldpoint demand a special proficiency, for the drawn lines cannot be erased or changed. Before the silver oxidizes and darkens, the shimmering lines are precious and even sumptuous. Rembrandt has chosen the perfect medium to capture forever the face of his fiancée.

In a drawing executed with soft red chalk, Rembrandt has, with incredible economy, captured a hesitant child, wearing a padded hat for protection, in the process of learning to walk (fig. 414). The child is encouraged by two women, one of whom, on our right, betrays her age by her stiffness. There is no setting, nor is there a single extraneous detail. It is a tiny drawing of the utmost simplicity, but the moment of life that it captures is precious.

REMBRANDT

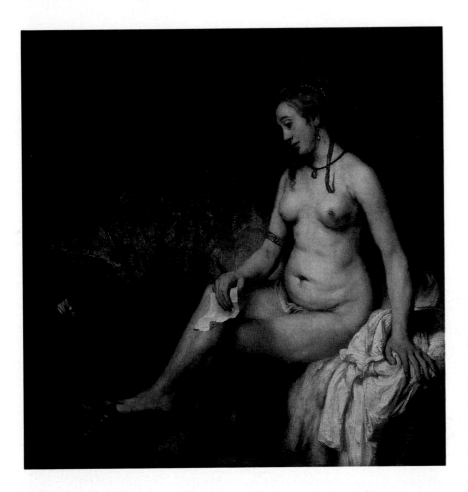

415. REMBRANDT
Bathsheba with King David's Letter.
1654. Oil on canvas, 55 7/8 x
55 7/8". The Louvre, Paris. A
repeated motif in the Old and New
Testaments is the sinfulness of
humanity; the Old Testament king
David, slayer of Goliath and the
author of the Psalms, is no excep-
tion. After David had forced a
married woman, Bathsheba, into
his bed, he connived to have her
husband, Uriah, killed in battle so
he could marry her. In Rembrandt's
painting, Bathsheba holds the
message from David, who has
summoned her to the palace, while
her maid prepares her for this first
meeting with the king.

Rembrandt's later works are characterized by subjects of universal human significance, as in this example of the story of Bathsheba (fig. 415). The main subject here is the female nude, but the interpretation emphasizes her inner emotions and meditation. Rembrandt has overturned tradition by painting a nude figure that is more emotional than physical, more thoughtful than sensuous. In keeping with the Dutch interest in naturalism, his model is a mature and dignified woman, one who is capable of understanding the profound implications of the king's demands. Despite the secondary figure at her feet, Bathsheba is alone in her predicament.

Dutch artists in general avoided emotionally complex themes, but the restriction on religious subjects and the general disinterest in historical and mythological themes in the Netherlands were irrelevant to Rembrandt, who, perhaps in reaction to the unemotional art being created by other Dutch artists, chose to probe deeply into human life for subject matter and to paint religious subjects if their emotional content interested him.

Rembrandt's works often have a direct and sympathetic correlation with the events of his life and the people whom he loved. The model for Bathsheba is probably Hendrickje Stoffels, Rembrandt's second, common-law wife, whom he was unable to marry because of financial restrictions in the will of his deceased wife, Saskia. In 1654, the same year that Rembrandt painted *Bathsheba*, Hendrickje was called before the council of the Reformed Church and barred from receiving communion because she was living with a man to whom she was not married. The connection between Hendrickje's difficulties and the Bathsheba story are indirect, but the human predicament is related.

The *Return of the Prodigal Son* is Rembrandt's largest history painting (fig. 416). The impressive figures are over-lifesize. The son, in rags and worn-out shoes, has thrown himself to his knees to indicate his repentance. The aged father bends over him, pulling the young man toward him

with stiff hands. The son gently lays his head on his father's chest and closes his eyes. Time seems to stop. The richness of their inner experience is in part expressed abstractly by the textures of the *impasto* with which Rembrandt paints their garments and by the warm, sonorous colors. Christ's parable used the human story to illustrate a moral: God will forgive sinners who repent. Rembrandt uses the same story to emphasize a human experience—the forgiving love of a parent for a child.

REMBRANDT, *Bathsheba with King David's Letter:* **1654**
1648: End of the Thirty Years' War in Germany
1649: King Charles I of England is beheaded
1652: War is declared between England and Holland

Rembrandt's painting of a couple who face us and embrace each other is one of his final testaments to the power and beauty of love (fig. 417). There has been lengthy scholarly debate about the iconography of this image, and whether it is based on a biblical story or perhaps a theatrical source is still not certain. It is probably not a commissioned portrait, given the historical costumes worn by the figures. Nevertheless, the message Rembrandt intended is clear: the power of the love, spiritual and physical, between two human beings. The composition has a simplicity reminiscent of the High Renaissance, for the two figures are joined in an indissoluble pyramidal entity. The paint seems to have been applied as much with a palette knife as with a brush, and the surface is richly textured. The depth of Rembrandt's translucent glazes makes the red and gold of their garments seem to glow from within, a visual metaphor for the love that joins them.

416. REMBRANDT
Return of the Prodigal Son. c. 1662–68. Oil on canvas, 8' 8" x 6' 8". Hermitage Museum, St. Petersburg. We have seen in other examples how Christ's parable of the prodigal son (Luke 15:11–32) was popular with the followers of Caravaggio, and especially with the Dutch Caravaggisti (fig. 396). Here Rembrandt represents the most profound moment in the parable: the son, reduced to complete poverty, returns home to discover that his father, who still loves him, will forgive him.

417. REMBRANDT
"The Jewish Bride." c. 1662. Oil on canvas, 47 7/8 x 65 1/2". Rijksmuseum, Amsterdam. The traditional name is an eighteenth-century invention.

PRINTMAKING: ETCHING AND DRYPOINT

Rembrandt presents us not with a specific biblical subject, but with an interpretation of Christ as a humble and gentle teacher who stands within the crowd in a city street to preach (fig. 418). He is surrounded by people of all ages, rich and poor, and in Rembrandt's representation they react as individuals to Christ's words. Some ponder his meaning, others seem uninterested. A child busies himself drawing in the dust in the foreground.

Rembrandt's technique is etching, and this is one of a number of prints produced from the same plate for collectors of prints. It is the etching technique which permits the creation of blurred lines and a soft, atmospheric quality not possible in woodcut or engraving. Etching is not a new technique—Dürer and other printmakers had experimented with its possibilities—but it was Rembrandt who first realized its potential for expression.

Etching is an intaglio technique (see p. 309), and the same thin copper plate used for engraving functions as the print form (fig. 419). To create an etching, one must cover the plate with an etching ground, an acid-resistant, resinous mixture. The artist scratches through this ground with a steel etching needle, creating lines that expose the copper. When the design is completed (or when the artist wants to test the progress of the composition), diluted acid (nitric, iron chloride, or hydrochloric) is poured over the plate or it is dipped into an acid bath. The acid eats into the copper, creating grooves where the needle has scratched through the ground. The ground is then cleaned off and the plate is inked and printed, as in the process for printing an engraving. If the results are unsatisfactory or in-

418. REMBRANDT

Christ Preaching. c. 1652. Etching with drypoint and burin, 6 1/8 x 8 1/8". Rembrandt was internationally famous as a printmaker during his own lifetime, and his prints regularly sold for high prices. Less than twenty years after Rembrandt's death, the Florentine art historian Filippo Baldinucci would write: "This artist truly distinguished himself . . . in a certain most bizarre manner which he invented for etching on copper plates. This manner too was entirely his own, neither used by others nor seen again; with certain scratches of varying strength and irregular and isolated strokes, he produced a deep chiaroscuro of great strength."

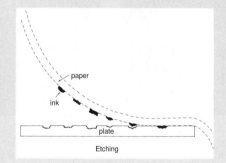
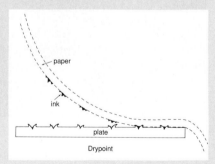

419. Diagrams of the etching and drypoint techniques. The more blurred lines of the drypoint technique are the result of the burr of the drypoint line.

complete, the ground can be reapplied, the design can be strengthened or completed with the needle, and the acid bath can be used again. Another alternative is to strengthen the lines by using the burin (as in

engraving) and/or drypoint (see below). Only about fifty excellent and two hundred reasonably good prints can be made from an etched plate.

An eighteenth-century development in the etching process was the soft-ground etching, which uses a greater percentage of tallow or wax in the ground. A thin sheet of paper is laid over the ground, and a drawing is made on the paper. When the paper is lifted, a soft, grainy impression is left on the plate. The plate is then etched, using a weak acid bath.

The etching technique encouraged freedom and spontaneity, for the etching needle moves easily through the ground to scratch the plate (unlike the concentrated pressure needed to push the burin through the resistant copper to create an engraving). While an etched line lacks the sharp and precise quality of an engraved line, its blurriness creates the atmospheric effect that we admire in Rembrandt's work. Rembrandt's earliest printed works were pure etchings, sometimes with the use of the burin for strengthening. Later, to achieve an even greater effect of atmosphere, he began to add lines in drypoint, as is the case in *Christ Preaching*.

Drypoint is the technique of scratching directly onto the copper plate with the etching needle (fig. 419). This creates grooves which have tiny raised ridges of copper, known as the burr, to either side, where the expelled material is forced by the needle. These drypoint ridges catch the ink and create rich areas of deep, soft shadow. The necessary pressure applied by the press during printing will wear down the burr rather quickly, and only about ten good and twenty reasonably good impressions can be made. In *Christ Preaching*, drypoint lines are

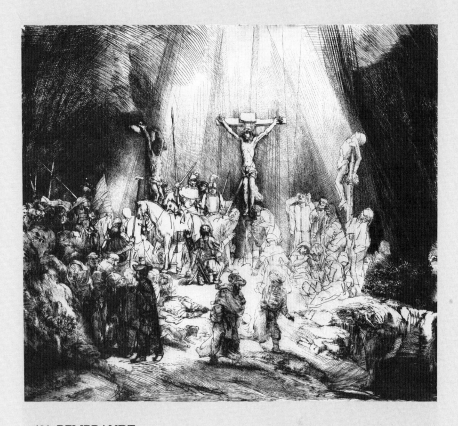

420. REMBRANDT
The Three Crosses. 1653. Drypoint and burin (first state), 15 1/4 x 17 3/4".
Rembrandt made successive changes to the plate in producing this print.

visible in the beard and hair of Christ and in the deep shadows of his drapery.

A few of Rembrandt's last prints are executed entirely in drypoint, with an additional use of the burin for certain sharp details. Rembrandt's last print was probably the large *Three Crosses* (fig. 420), which he worked on over a period of years. He created three successive stages, known as states, in 1653 by reworking the plate and a final, almost completely reworked state in the early 1660s. It is a profoundly moving personal interpretation of the crucifixion based on the text in Luke 23:44–47: "And it was about the sixth hour, and there was a darkness over all the earth until the

ninth hour. And the sun was darkened, and the veil of the temple was rent in the midst. And when Jesus had cried with a loud voice, he said, Father, into thy hands I commend my spirit: and having said thus, he gave up the ghost. Now when the centurion saw what was done, he glorified God, saying, 'Certainly this was a righteous man.'"

The centurion is kneeling, to suggest that Rembrandt is representing the very moment of the death of Christ. The powerful shaft of light is a momentary blaze, a heavenly response to Christ's words and his death. In this late work Rembrandt avoids painstaking detail to emphasize powerful emotional experiences.

DIEGO VELÁZQUEZ

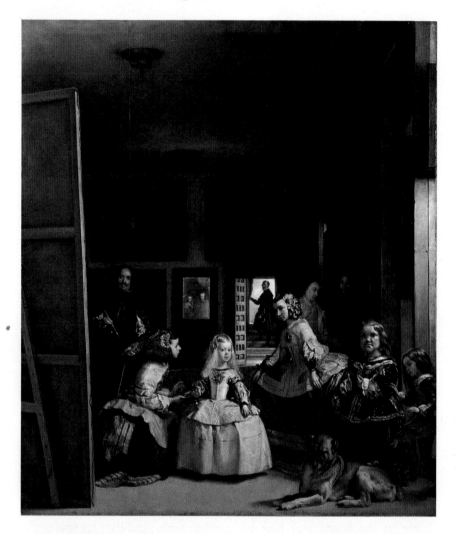

421. DIEGO VELÁZQUEZ
Las Meninas (The Maids of Honor). 1656. Oil on canvas, 10' 5" x 9'; the figures are lifesize. The Prado, Madrid. The cross on Velázquez's chest indicates that he has been made a Knight of the Order of Santiago. As Velázquez did not receive this honor until 1659, three years after the painting was dated, the cross must have been added later.

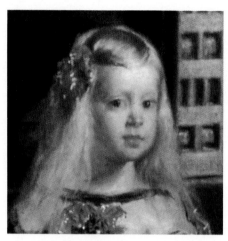

422. DIEGO VELÁZQUEZ
Las Meninas (detail)

For just a moment Velázquez's painting convinces us that the little princess and her attendants—including dwarfs and a large dog—are posing just for us (figs. 421, 422). Although *Las Meninas* is a large picture, its subject seems intimate and even casual. We glimpse a view into a large dark room in the palace, where the painter is at work on a huge canvas. He looks out and leans back, raising his brush as he prepares to apply a stroke of paint. In the foreground is the five-year-old Margarita, daughter of King Philip IV, surrounded by her maids *(las meninas)* and the dwarfs and developmentally disabled who were a traditional part of life at the Spanish court. With the exception of the princess, all these figures are represented in the midst of movement, as is Velázquez. Note especially the figure to the right who, one hand raised, awakens the dog, which slowly raises its head. Velázquez's illusionism attempts to convince us that we are seeing reality.

But is the princess posing for us? The shimmering surface on the back wall is a mirror which reflects the figures of King Philip and his queen, Mariana. A real mirror, of course, would have reflected the whole room, but

VELÁZQUEZ, *Las Meninas:* 1656
1656: Pendulum clock is invented
1657: London's first chocolate shop opens

423. DIEGO VELÁZQUEZ
Portrait of Juan de Pareja. 1650. Oil on canvas, 32 x 27 1/2". The Metropolitan Museum of Art, New York (Fletcher Fund, Rogers Fund, and Bequest of Miss Adelaide Milton de Groot, by exchange)

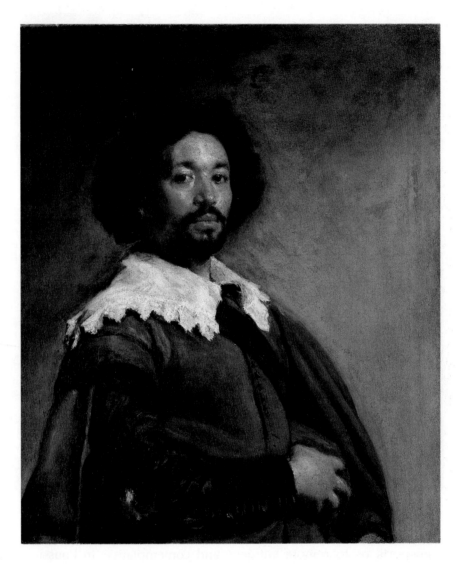

Velázquez, with artistic license, includes this reference to his royal patrons as the sole element that reminds us that this is indeed a painting.

In Velázquez's *Portrait of Juan de Pareja* (fig. 423), the sitter looks out with calm and assured dignity. Velázquez's loose brushstroke and subtle light create an effect of immediacy and, again, reality. The painting is a coloristic triumph, for within a restricted palette of white, black, grays, and beiges, Velázquez creates an impressive variety of tones. The restriction of color is no accident, for this portrait of one of Velázquez's assistants was a practice piece. Velázquez was in Rome, buying paintings and ancient sculptures for King Philip, when he received the commission to paint a portrait of Pope Innocent X. This particular portrait was a difficult task, for the pope, who had a ruddy complexion, had to be painted wearing red papal garments, seated in a red chair in a setting dominated by red hangings. To prepare himself for this challenge, Velázquez posed a similar problem by painting Juan de Pareja, who was of Moorish descent, using a restricted color palette based on his flesh tones. The picture was a sensational success. After it was exhibited at the Pantheon, Velázquez was elected to the Rome Academy. One contemporary remarked that while all the other paintings in the exhibition were art, "this alone was truth."

NICOLAS POUSSIN

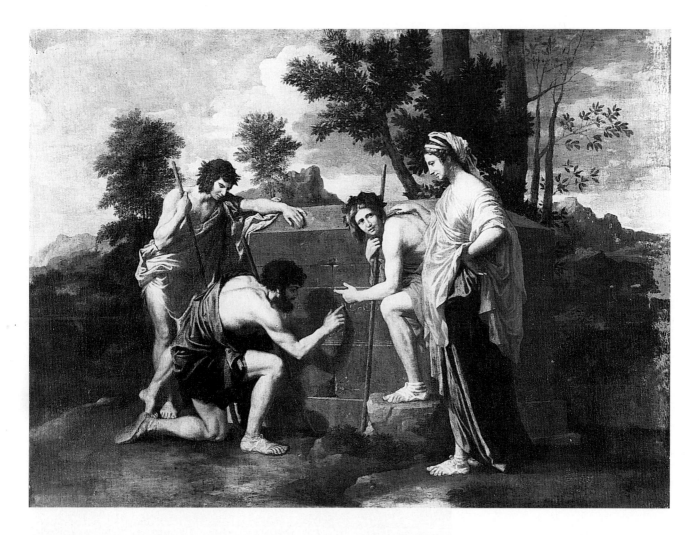

Poussin's idealized painting transports us to remote antiquity, where we stand with shepherds and a shepherdess by a monumental tomb (fig. 424). Arcadia is an idyllic region in Greece, where, during the ancient golden age, it was believed that humanity had lived peacefully and harmoniously with nature. To the shepherds who lived there, life seemed perfect until they discovered a tomb and realized that death is a reality that they will someday have to confront. Despite the dramatic implications of the subject, the mood of the painting is calm and contemplative. In Poussin's approach, even death becomes philosophical.

Poussin's style is consistent with his intellectual interpretation of the subject. The composition is lucid and the poses of the figures are clearly articulated and interrelated. To assure satisfying compositions, Poussin worked them out by arranging miniature wax figures on a stage in a small box until he was pleased with their disposition. The colors are cool and simple, the light regular and undramatic, and the brush-

424. NICOLAS POUSSIN
The Arcadian Shepherds. c. 1660.
Oil on canvas, 34 1/4 x 47 1/4".
The Louvre, Paris. The inscription on the tomb is *Et in Arcadia Ego*—Even in Arcadia I [Death] am to be found.

stroke controlled. The influence of the High Renaissance style of Raphael is evident, and the costumes and facial types reveal Poussin's careful study of ancient art. Poussin's paintings are among the finest examples of Baroque Classicism. The landscape is based on the area around Rome, which Poussin knew well.

Nicolas Poussin was probably the most classical, intellectual, and philosophical painter of the seventeenth century. Although born in France, he spent most of his mature life in Rome. A close circle of similarly minded French friends there and in Paris were the patrons for his well-studied, thoughtful compositions. He preferred heroic or stoic themes from antiquity.

Poussin's landscapes always include a narrative subject, usually one drawn from antiquity. In the *Body of Phocion Carried Out of Athens*, the landscape is clearly not taken from nature (fig. 425). Poussin has rearranged nature to provide the properly sober, clear, and balanced setting for his profound theme.

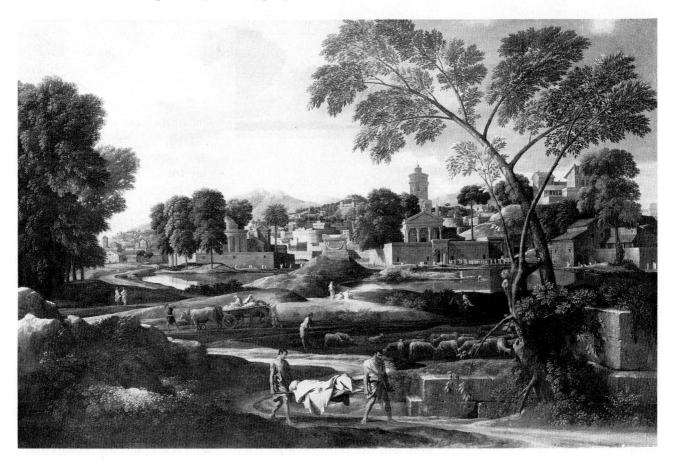

425. NICOLAS POUSSIN
Landscape with the Body of Phocion Carried Out of Athens. 1648. Oil on canvas, 47 x 70 1/2". The Louvre, Paris. Phocion was a loyal Athenian general whose character was in many ways like that of Poussin: he was stern, prized economy, and was dedicated to truth. His austerity and moral rectitude, however, made him hated by the popular faction in Athens, who, when they gained power, had Phocion executed on a false charge of treason and decreed that his body had to be carried outside the city for burial. This is the event shown in Poussin's painting. Later Phocion was given honorable burial in Athens.

DUTCH STILL-LIFE PAINTING

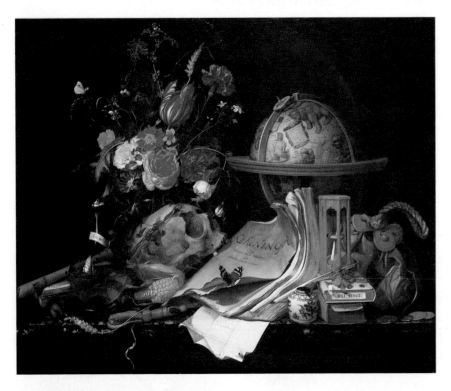

426. MARIA VAN OOSTERWYCK
Still Life with a Vanitas Theme. 1668. Oil on canvas, 29 x 35". Kunsthistorisches Museum, Vienna. Maria van Oosterwyck did not come from an artistic family, but tradition tells us that she was determined to become a still-life painter. She developed an international reputation and produced works for Louis XIV of France and the members of other European royal houses.

Realistic still-life painting is a democratic art—one needs no background in aesthetics or art theory to appreciate Maria van Oosterwyck's ability to render the butterfly that lights on the book or the mouse nibbling at the grain, not to mention the fresh flowers, skull, and globe (fig. 426). There is even a fly on a book to the right and a self-portrait of the artist reflected in the flask to the left. It was in the democratic Netherlands that such still lifes were most fully appreciated, and the market for pictures such as this one was so large that artists could become specialists in still-life painting and hone their skills

so as to produce increasingly more brilliant depictions of objects in ever more elaborate profusion.

Sixteenth- and seventeenth-century art theorists, however, largely ignored still-life painting, as they did also the painting of landscape, genre, and portraits. These types of art were considered unimportant because they were merely copies from nature. A painter's most significant accomplishment, they argued, was a history painting, the conception, design, and execution of which demanded intellectual prowess and academic training. The painter of histories also

needed an understanding of anatomy and experience in drawing the male nude. Still-life, landscape, portrait, and genre paintings were considered to be much less valuable than history paintings and generally sold at much lower prices.

During the seventeenth century a number of women artists excelled at still-life painting, in part, perhaps, because this was a category of art in which they could succeed without threatening the long-established dominance of male artists. Since at this time women were not admitted to the academies, they hardly had the option of receiving training in creating history paintings. The two artists examined here were both products of the more liberal Dutch culture, but during the sixteenth and seventeenth centuries there are documented French, Flemish, and Italian women still-life artists as well.

The theorists, of course, underestimated still-life painting. To select the forms of a still-life painting and arrange them into a satisfying composition, with coordinating and contrasting patterns of textures and colors, demands different skills from those required of the history painter. And still-life paintings are not always purely decorative displays, devoid of any deeper meaning. The title of Van Oosterwyck's painting reveals that it forms part of a distinguished tradition of seventeenth-century paintings on the theme of Vanity, one of the minor vices, that expressed the transience of the things of the world and the inevitability of death. Such paintings were especially popular in the

Netherlands, where the tradition of complex symbolism goes back to Van Eyck (see p. 268). In the most impressive of these compositions, of which Van Oosterwyck's is an example, each element contributes its own special content to the meaning of the whole. The hourglass, for example, refers to the inexorable passage of time. The fly is a symbol of sin, ever present in the world, and the mouse symbolizes evil. The large book is labeled "Reckoning. We live in order to die. We die in order to live."

An early source tells us that Van Oosterwyck was very pious, and the underlying Christian hope of her *Vanitas* is expressed in these words and in the butterfly, symbol of the resurrection of Christ and the salvation of mankind. Although the skull is an obvious reference to death, when it is wreathed in ivy, as here, it refers to life after death. All these objects and symbols are united in a masterful composition which takes maximum advantage of contrasting forms, colors, and textures.

Rachel Ruysch's *Flower Still Life* (fig. 427) is arranged along a prominent diagonal which is enhanced by the curving stems of the blossoms at the upper right and lower left. The simple centrality of the vase and niche is enlivened by the diagonal recession of the table and by the contrast in light to either side. On the right, a light area silhouettes the forms and emphasizes their irregularity, while on the left a completely different effect is accomplished by setting off the complexity of many small blossoms against the dark background. Ruysch's father was pro-

VAN OOSTERWYCK, *Still Life with a Vanitas Theme:* **1668**
1669: Jan Swammerdam, *History of the Insects*
1670: Minute hands are first used on watches
1675: Anton van Leeuwenhoek invents the microscope

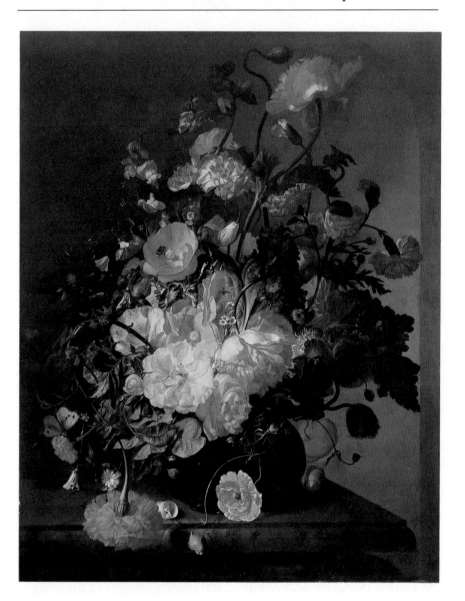

427. RACHEL RUYSCH
Flower Still Life. After 1700. Oil on canvas, 30 x 24". Toledo Museum of Art. Rachel Ruysch is ranked among the greatest still-life painters in the Netherlands, and her international reputation continued after her death. She was apprenticed to an important still-life painter at the age of fifteen and by eighteen was active as a painter in the same genre. From 1708 to 1716 she was court painter to the Elector Palatine in Düsseldorf.

fessor of anatomy and botany, and his collection of scientific specimens may have inspired her inclusion of the insects found so often in her paintings. She depicts them with impressive accuracy, a technical precision that reveals her participation in the new scientific interests and investigations of the seventeenth century.

THE PALACE AT VERSAILLES

428. LOUIS LE VAU AND JULES HARDOUIN-MANSART
Garden facade, Palace of Versailles, France. 1669–85. Begun by King Louis XIV, who decided to enlarge a royal hunting lodge eleven miles southwest of Paris, Versailles officially became not only the main royal residence in 1682, but the governmental seat as well. The administrator, J.-B. Colbert, who also advised Louis on political, economic, and religious matters, and the painter Charles Lebrun were in charge of the artists and workmen—sometimes as many as thirty thousand at one time—who created the buildings and grounds. At its height, the palace served a court that totaled almost twenty thousand people, including nine thousand soldiers quartered in the town and about four thousand servants who lived within the palace itself.

The palace of the French kings at Versailles is the largest and most emulated royal residence in the world (fig. 428). It has hundreds of rooms, and its facade is almost a half-mile long; the garden encompasses two hundred and fifty acres. Its impressive scale actually made a political statement, for it was intended to assert for the French populace and nobility, as well as for foreigners, the power of the French monarch. In some ways the very creation of Versailles may have played a role in establishing and perpetuating that power.

The expansive length of the garden facade itself makes a powerful architectural statement, but the architects faced the problem of how to articulate such a long structure. They decided not to break the mass in any dramatic way and chose to emphasize the horizontal sweep by articulating the second floor with pilasters. They created punctuation points with columned pavilions that jut out only slightly from the mass of the structure, with sculpture decorating their cornices. The design and ornament are completely classical, in keeping with the French interest in drawing a relationship between the principles of order and control and the rule of the French monarchy.

The Salon de la Guerre offers a rich scheme of multi-media Baroque decoration (fig. 429). A huge oval stucco relief over the fireplace with a monumental equestrian figure of Louis XIV immediately draws our attention. Below, dark bronze reliefs represent prisoners in chains, while above, gilt stucco angels trumpet his fame and offer him the hero's crown. The relief in the fireplace shows the muse of history, Clio, recording Louis's triumphs. The combination of materials—stucco, bronze, gilded stucco, and marble—and the parquet floors, mirrors, paintings on the ceiling, and a crystal-and-gold chandelier testify to the wealth of the king, while the iconography emphasizes his imperialistic ambitions. Such a room was, of course, primarily a setting for court ritual and would be in use especially on those occasions when its particular iconography would be most effective.

In the great park, ponds and pathways seem infinite, and at each crossroad there are several choices of direction in which to proceed (fig. 430). The vistas and paths offer surprises: fountains,

LE VAU and HARDOUIN-MANSART, Versailles: begun 1669
1664: Heinrich Schütz, *Christmas Oratorio*
1666: Great Fire of London
1667: Brooklyn is chartered
1667: Milton, *Paradise Lost*
1670: Molière, *Le Bourgeois Gentilhomme*

430. ANDRÉ LE NÔTRE
Plan of the gardens and park, Versailles (17th-century engraving). Designed 1661–68; executed 1662–90. Note that the main streets of the town of Versailles, at the bottom of the map, converge on the palace to emphasize its significance. André Le Nôtre, son of a royal gardener, became the greatest designer of formal gardens and parks in seventeenth-century Europe. The layout of the garden uses radiating diagonals and dramatic long vistas.

429. JULES HARDOUIN-MANSART, CHARLES LEBRUN, AND ANTOINE COYSEVOX
Salon de la Guerre (Room of War), Palace of Versailles. Begun 1678. This room, at one end of the Hall of Mirrors, is a pendant to the Room of Peace at the opposite end; the decoration of these rooms celebrated recent French victories. The sculptor Coysevox is responsible for the huge stucco relief of *King Louis XIV on Horseback* over the fireplace. The painted ceiling, the theme of which is France at war, is by Lebrun. The Hall of Mirrors was named for the large mirrors opposite the arched garden windows. As decoration, this room had bejeweled trees and gold and silver furniture, but these were melted down in 1689 and 1709 to help pay for French wars.

basins, terraces, flights of steps, sculptural groups, flowerbeds, hedges, and even small architectural monuments. Nature on a vast scale has been tamed and ordered, to provide a place of pleasure for the king and his court. Although the most basic purpose of the park is the same as that of the palace—to reflect the glory of the French monarchy and the king's centralized authority—Le Nôtre has also been sensitive to the delights of nature that such a park can offer to the observer. The plan informs us of the general layout, but Le Nôtre's park was not designed to be seen from above, but by the human spectator, walking, choosing pathways and vistas.

LANDSCAPE PAINTING

431. JACOB VAN RUISDAEL
The Dutch Landscape from the Dunes at Overveen. c. 1670. Oil on canvas, 21 7/8 x 24 3/8". Mauritshuis, The Hague

During the seventeenth century, the flat expanses of the Netherlands, reclaimed from the sea and wrested from Spanish domination, were painted thousands of times by Dutch painters. These paintings were avidly collected by the proud and patriotic citizens of the new nation. Although there had been a sporadic interest in landscape among North-

ern painters during the sixteenth century, now, for the first time in the history of Western art, landscape became a truly popular theme. In the seventeenth century, the Netherlands was more highly urbanized than any other European nation, and the nostalgia felt by city dwellers for open countryside may have been an additional factor in explain-

VAN RUISDAEL, *The Dutch Landscape:* **c. 1670**
1669: Antonio Stradivari makes violins in Cremona, Italy
1670: André Le Nôtre lays out the Champs-Elysées in Paris
1675: Native American population drops to about 20,000

ing the popularity of landscape painting.

Despite its relatively small size, Ruisdael's painting captures the salient features of the Dutch countryside: land, sky, and a changing relationship between light and shade (fig. 431). More than two-thirds of the canvas is given over to the clouded sky, which is the dominant feature of the Dutch countryside. The sky becomes the mediator by which we perceive the land as well. As the clouds rush by, the earth is intermittently revealed by patches of bright light.

Ruisdael's landscape is precisely identifiable, for the Gothic church that rises among red tile roofs in the background is St. Bavo in Haarlem. The ubiquitous Dutch windmills, so necessary to keep the land drained of excess water, dot the countryside, and in the foreground we see small figures stretching linen to be bleached, a proud reference to the prosperous Haarlem linen industry. The function of this realistic image is clear: to represent and exalt the local countryside and its livelihood.

Although other seventeenth-century painters occasionally demonstrate an interest in landscape—Poussin with his classical landscapes (see fig. 425) and Rubens with his views of the Flemish countryside—these are exceptions, and only in the Netherlands did a truly national school of landscape painters develop. Although the Dutch seem to have preferred realistic views of local scenery, Dutch painters also produced a variety of other types of landscape painting, including seascapes with Dutch vessels and rather fantastic views of wild scenery. A number of Dutch artists settled in Rome, where they painted views of the sun-drenched Italian countryside which were popular back home.

The sixteenth-century Flemish interest in landscape found a worthy successor in Rubens, whose landscapes have the same tumultuous vitality and visual excitement as his religious, mythological, and allegorical pictures. In his landscapes, he puts us in contact with the growth and energies of the world of nature. In his *Landscape with Het Steen* (fig. 432), the rising sun is a shimmering silver-yellow disk near the right edge of the painting. A hunter and his dog in the foreground draw our eyes to a stump, which in turn leads us to an undulating row of trees that surge into the landscape toward the fresh, glowing morning sky. Simultaneously, a peasant family going to market in the shadowy left foreground draws our attention to the opposite direction. Rubens's personal energies and his understanding of the dynamic and ever-changing nature of landscape are united in this splendid work.

432. PETER PAUL RUBENS
Landscape with Het Steen. c. 1636. Oil on panel, 51 5/8 x 90 1/4". National Gallery, London. Het Steen was Rubens's country estate, which he bought in 1635.

VIII

EIGHTEENTH-CENTURY ART

INTRODUCTION

Boffrand's interior design for the Princess's Salon (fig. 433) exemplifies the decorative exuberance of the Rococo style, which in the eighteenth century succeeded the Baroque. The decoration of the oval room is animated with carved and painted woodwork, stucco, and a series of integral paintings depicting the tale of the mythological

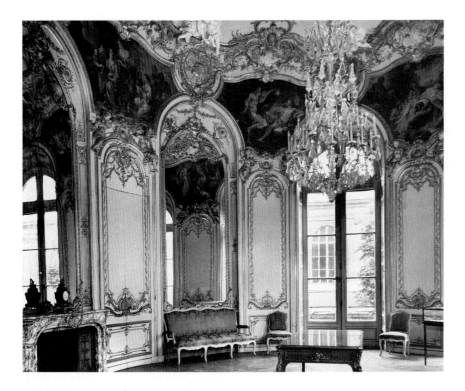

433. GERMAIN BOFFRAND
Salon de la Princesse, Hôtel de Soubise, Paris. 1736–39. The term *hôtel* in this context refers to the lavishly adorned town houses of the French aristocracy.

434. ROBERT ADAM
Fireplace niche, Entrance Hall, Osterley Park House, Middlesex, England. Begun 1761. Adam's adaptation of classical architectural forms was so successful that one phase of the English Neoclassical style is known as the Adamesque.

lovers Cupid and Psyche. The web of gold woodwork and stucco ornament creates a light, airy sensation that seems to transform the white walls into thin screens, while the undulating movement of the curving cornice joins the rhythm of the delicate arches to further enliven the interior. The effect is elegant and ebullient.

Just slightly more than twenty years later, the English architect Robert Adam began remodeling Osterley Park House. The fireplace niche in the entrance hall (fig. 434) demonstrates Adam's use of an alternate eighteenth-century style, Neoclassicism, in which the ornamentation is based on antique prototypes, from the pilasters and coffered half dome to the wall moldings. The axis is visually reinforced by the Neoclassical relief set over the fireplace, while the flanking niches with their antique sculptures balance the composition and add further references to the cultures of classical antiquity. In contrast to Boffrand's Rococo interior, Adam's Neoclassical design is disciplined and controlled. The antithesis between these designs confirms the enormous artistic contrasts of the eighteenth century.

HISTORY

"It was the best of times, it was the worst of times, it was the age of wisdom, it was the age of foolishness, it was the epoch of belief, it was the epoch of incredulity, it was the season of Light, it was the season of Darkness" (Charles Dickens, *A Tale of Two Cities,* first published 1859). The memorable opening lines from Dickens's novel about the French Revolution can describe the eighteenth century as a whole. It was a century of social, cultural, and artistic contrasts, prodigious scientific and technological advances, and sweeping political changes. Historians often refer to the close of this century as the period which marks the beginning of our modern world.

Politically, the century opened with the dominance of France under Louis XIV. Rigaud's Baroque portrait (fig. 435) conveys the solemn majesty of his authority and the opulence with which the French monarchs were surrounded. After Louis XIV's death in 1715, however, France's military and political influence began to abate. Frederick the Great, who came to the throne in Prussia in 1740, seized opportunities to expand and establish the German states as the premier military power on the Continent. To check Prussia's growing political and military strength, France and Austria entered an alliance. In the resulting conflict, known as the Seven Years' War (1756–63), Prussia was victorious. France's holdings and influence in the New World were diminished when Quebec surrendered to the English in 1759 (see fig. 454), effectively ending the French and Indian War in North America. Austria was defeated in the Seven Years' War but prospered in the latter part of the century, under Maria Theresa and her son, Joseph II, to become one of Europe's most distinguished cultural centers.

435. HYACINTHE RIGAUD
Portrait of Louis XIV. 1701. Oil on canvas, 9 x 6'. The Louvre, Paris

England's economic stability and political importance grew steadily through the century. By the 1750s England was established as an important maritime power, and the victory over the French in America made the English masters of much of North America. By the close of the century, England enjoyed the highest per-capita income in western Europe as the new industrial economy took root. London's population grew to over one million, the first modern city to reach that size. At the same time, King George III, who ruled from 1760 to 1820, saw the power of the monarchy wrested away by Parliament. Increased taxation led the American colonies to declare independence in 1776 and, with French assistance, the defeat of the British at Yorktown in 1781 won the Revolution for the colonies. A peace treaty was signed between England and the new American nation in 1783.

The growing desire for self-rule, one of the features of the philosophy of the Enlightenment (see below) in response to the authoritarian rule of Europe's traditional absolute monarchs, also affected developments in France. During the reign of Louis XVI and his wife, Marie Antoinette, lavish government expenditures led to economic depression. As relations between the French aristocracy and the people deteriorated, a National Assembly was formed in 1789 to compose a written constitution for France. During the French Revolution, a constitutional monarchy was established, but internal political factions and outside military pressure threatened the new government. Within France, hostility against the aristocracy rose to a fever pitch by 1792, and in the series of bloody executions which followed, even Louis XVI and his queen were guillotined. Within this context of domestic uncertainty and foreign wars, a young military commander, Napoleon Bonaparte, rose in power and, at the age of thirty in 1799, was made first consul of the French Republic.

INTELLECTUAL AND SCIENTIFIC ACTIVITY

The eighteenth century has been called the Age of Enlightenment. The influence of the Catholic church declined, and philosophical investigations were directed less to theological than to secular and scientific issues. Descartes's belief in the supremacy of human reason and the centrality of the natural sciences, which dates from the seventeenth century, was inherited and advanced by eighteenth-century philosophers. The Enlightenment meant faith in human reason, natural human rights, science, and progress toward a utopian society. This joining of the natural sciences with philosophical questioning strengthened the belief in empiricism, a view that human knowledge was pragmatically gained from experience and sensation. The foremost proponent of empiricism from the late seventeenth century was the English writer John Locke. Locke's treatises on government, based on his experience with the rise of parliamentary government in England, avowed that a nation's power derived from its people. The people entered in a social contract with their government and retained the right to dissent and withdraw support if their government proved no longer responsive to their will and needs.

Locke's political philosophy guided the American Revolution and the drafting of the U.S. Constitution and, through Voltaire, assisted in fomenting the French Revolution.

Empiricism also fertilized the growth of the natural sciences. Building on Isaac Newton's observations and discoveries, advances continued in physics, mathematics, and astronomy. In 1759 Edmund Halley's name was given to the comet which returns every seventy-six years. Zoology, botany, and mineralogy were established as scientific disciplines. The chemist Antoine Lavoisier was the first to demonstrate correctly the process of combustion; he later named the reactive element, essential for life, oxygen. Constant improvements in such devices as the telescope, microscope, barometer, and thermometer allowed for greater accuracy in scientific observation.

Technology benefited from this increasing scientific knowledge. New processes in metallurgy contributed to the use of iron as a building material, and the perfection of the steam engine by James Watt in 1769 brought Europe closer to the momentous and far-reaching economic and social changes of the Industrial Revolution.

EIGHTEENTH-CENTURY ART

The Rococo and Neoclassical styles dominated the visual arts during the eighteenth century. The term Rococo, derived from the French *rocaille* (literally meaning rock-work or rubble), was first used to designate a style of French art associated with the reign of Louis XV. In early-eighteenth-century France, charm and finesse were the hallmarks of an artificial code of social behavior. The Rococo's light, ornamental elegance, as exemplified in Elizabeth Vigée-Lebrun's portrait (fig. 436), complemented the artificiality of aristocratic values and tastes.

The Neoclassical style, first named in the mid-nineteenth century, developed as an alternative to the Rococo. Fueling the Neoclassical style at mid-century was a reawakened interest in classical antiquity, spurred by the rediscovery of Herculaneum in 1738 and Pompeii in 1748 (see p. 118). The revival movement of Neoclassicism is sometimes understood as the first step in the development of Romanticism (see pp. 412–13).

The most eloquent spokesperson for Neoclassical taste was the German art historian Johann Winckelmann, who had his portrait painted by Angelica Kauffmann, one of the most famous artists of the period. He viewed the rationality and ideality of classical art as the summit of artistic achievement. In his influential *Thoughts on the Imitation of Greek Art in Painting and Sculpture* of 1755, Winckelmann wrote: "Good taste, which is spreading more and more throughout the world, had its beginning under a Greek sky.... To take the ancients for models is our only way to become great, yes, unsurpassable if we can. As someone has said of Homer: he who learns to admire him, learns to understand him; the same is true of the art works of the ancients, especially the Greeks."

Neoclassical art was well suited to the changing political realities of

436. ELIZABETH VIGÉE-LEBRUN
Portrait of Marie Gabrielle de Gramont, Duchesse de Caderousse. 1784. Oil on wood, 41 3/8 x 29 7/8". Nelson-Atkins Museum of Art, Kansas City, Missouri. Elizabeth Vigée-Lebrun was one of the foremost artists of Louis XVI's court. In her writings, Vigée-Lebrun reveals that the natural, loose curls of the sitter were the artist's idea and that when the Duchesse chose to appear at a party wearing her hair in this style she revolutionized hairstyles at the French court.

the late eighteenth century. Compared to the lighthearted and aristocratic elegance of Rococo art, the Neoclassical style offered a restrained, solemn design which was intended to convey a moral dignity. As ancient classical edifices first bore witness to the representative governments of Athens and Rome, what better style was there to emulate during the new age, which asserted that each individual had natural rights—or, in the words of the Declaration of Independence, "inalienable rights"—and that among these were a voice in government? To the Neoclassicists, the art and history of the classical world offered models to be used as guides for human behavior and achievement.

THE EIGHTEENTH-CENTURY ARTIST

The education of artists in academies (see p. 32) was now firmly established in Europe. The Royal Academy of Painting and Sculpture in Paris, founded in 1648, flourished, sending promising students to Rome to study classical art. Its primacy was gradually challenged by the Royal Academy of Arts, founded in London in 1768, which also championed Neoclassicism. The guiding spirit of England's Royal Academy was Sir Joshua Reynolds, a painter who had spent two years in Italy studying both ancient and Renaissance arts (see fig. 448). As the Royal Academy's first president, Reynolds delivered fifteen *Discourses*, which expressed his views on learning the "grand style" of art, and outlined an education based on imitating the perfection of nature as revealed through classical and High Renaissance art: "The moderns are not less convinced than the ancients of [the] superior power existing in art; nor less sensible of its effects. . . . The *gusto grande* of the Italians, the *beau ideal* of the French, and the *great style, genius,* and *taste* among the English, are but different appellations of the same thing. It is this intellectual dignity . . . that ennobles the painter's art . . . we must have recourse to the ancients as instructors . . . they will suggest many observations, which would probably escape you, if your study were confined to nature alone." Reynolds also recommended the study of the "great masters" of the Italian Renaissance: "I would chiefly recommend, that an implicit obedience to the Rules of Art, as established by the practice of the great masters, should be exacted from the young students. That those models, which have passed through the approbation of ages, should be considered by them as perfect and infallible guides; as subjects for their imitation, not their criticism."

Although the Royal Academy was founded to raise the status of both the arts and the artists, its conservative dogmatism, as revealed by Reynolds's preemptory language, began to be viewed by some as a constrictive environment. The tradition of the academy, which in the later sixteenth century had begun as part of a liberating ambience for the artist, was now becoming a conservative cloak, dictating proprieties in subject matter and form. One academic priority was history painting, which was promoted as the most noble of artistic expressions. History painting drew its iconography from the classical past

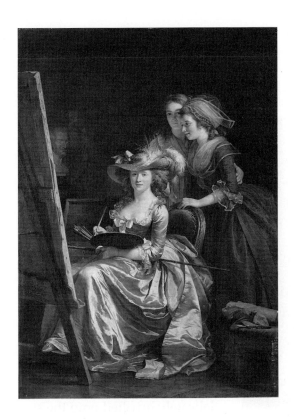

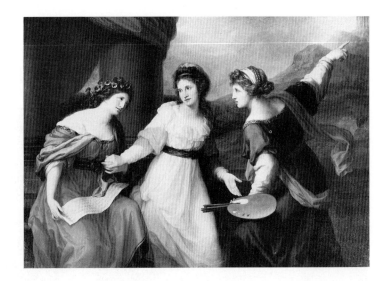

438. ANGELICA KAUFFMANN
Self-Portrait Hesitating Between the Arts of Music and Painting. 1794. Oil on canvas, 58 x 86". Nostell Priory, Yorkshire

437. ADÉLAIDE LABILLE-GUIARD
Portrait of Madame Labille-Guiard and Her Pupils. 1785. Oil on canvas, 82 3/4 x 59 7/8". The Metropolitan Museum of Art, New York (Gift of Julia A. Berwind). Labille-Guiard was instrumental in convincing the French Academy to lift its quota on women members, who had been limited to four, and to allow women professors.

and, less often, the more recent past. Themes were selected which could be interpreted on several levels. Academic history painters most often picked themes that exemplified an elevated code of human behavior. Such themes were considered appropriate for the "grand style" or the "grand manner" in art.

To truly understand the "grand style," every artist who aspired to gain professional fame felt compelled to make a tour of the antiquities of Italy. We can understand the importance of viewing the actual artistic remains of the classical and Renaissance past from the letters of Benjamin West (see p. 403), an American painter who, en route to London, traveled from 1760 to 1763 through Italy. West later wrote to another American artist, John Singleton Copley, advising him on what to see in Italy: "In regard to your studies in Italy my advice is as follows: That you pursue the higher Excellences in the Art, and for the obtaining of which I recommend to your attention the works of Ancient Sculptors, Raphael, Michelangelo, Correggio, and Titian, as the Source from which true taste in the arts have flowed. "

Eighteenth-century artists' self-portraits reflect the vitality of the different art styles which characterized the Age of Enlightenment. Adélaide Labille-Guiard's painting (fig. 437) continues the Rococo style into the latter years of the century. Noted for her abilities as both an artist and a teacher, she depicts herself, in elegant dress, at her easel with two attentive students. An early self-portrait by Angelica Kauffmann (fig. 438) shows the young artist between figures representing the classical allegories of Music and Art. Kauffmann, who was an accomplished musician, here adapted the Neoclassical style to demonstrate her dilemma at having to choose between a career in music or in painting.

EIGHTEENTH–CENTURY PAINTING

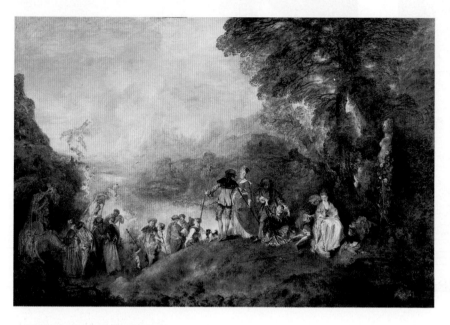

439. ANTOINE WATTEAU
A Pilgrimage to the Island of Cythera. 1717. Oil on canvas, 51 x 76 1/2".
The Louvre, Paris. As Watteau's reception piece for the French Royal Academy,
this painting was listed as "une fête galante," a new category of painting in
which elegant aristocratic men and women are represented partying in a
landscape setting.

Watteau's *Pilgrimage to Cythera* combines reality and fantasy to express the transitory nature of romantic love (fig. 439). Delicately scaled couples in eighteenth-century dress move slowly toward a fanciful ship that will return them from the island of Cythera, mythical home of Venus, goddess of love. The statue of Venus at the right has been adorned with garlands by these pensive lovers, who came to worship at her shrine and engage in the rituals of her cult. Their reluctance to leave pleasure behind is expressed in their gestures and poses, while the muted colors and light brushstroke express the transience of love. The composition moves from the statue of Venus to the vessel of departure, reversing our normal reading direction and heightening the bittersweet nature of the departure. Watteau simultaneously conveys the poetry of love and suggests how remote it is from everyday reality. Romantic love survives only in the world of the imagination.

Fragonard's painting, on the other hand, reaffirms the pleasures of lovers' games (fig. 440). The painting was commissioned by Baron de Saint-Julien, who specified the details of the subject. His mistress is in a swing pushed by a bishop, "so high that her slipper falls off the tip of her foot and her skirt shoots upward for the delight of the indiscreet eyes of a charming youth reclining among the flowers beneath her; happily there hovers above him a cupid whose gesture enjoins him to keep the secret of what he has seen." The theme incorporates a pun, for the baron served as the government representative who collected the taxes paid by the church. His title was *Receveur général des biens du clergé* (receiver general of the "goods" offered by the clergy). Fragonard's pastel palette, which centers around the pink dress and the blue-green trees, and the delicate lightness of his brushstroke express the frivolity of the subject.

The qualities seen in these two works help to define Rococo painting. The colors are unusually light and the thin paint is delicately brushed onto the surface. The figures are generally small and delicate in proportion, and the composition creates a flowing, idyllic movement. Themes are superficial scenes from court life and especially romance.

Hogarth's series of paintings on *Marriage à la Mode* presents a satirical view of modern life (see fig. 441). It exposes the difficulties of a loveless "city" marriage of convenience. The serious nature of Hogarth's social criticism of both the *nouveau riche* and the nobility is evident throughout the series, which begins with the signing of the marriage contract between the daughter of a rich, social-climbing merchant and an impoverished nobleman (Count Squanderfield). In a sequence of six scenes, their debauchery progresses through adultery, the murder of the husband by the wife's lover (Silvertongue), and her death by suicide, leaving their only child an orphan. Our scene shows the husband returning at 1:20 P.M. with a hangover after a

night on the town. The dog sniffs at a woman's cap hanging from his pocket. His pose is meant to suggest sexual exhaustion. The wife's pose and the overturned chair and scattered music suggest that her lover is the music teacher, who seems to have departed quickly. Extravagance is evident in the ugly mantelpiece, with its ostentatious display of bric-a-brac, and the stack of bills held by the clerk. The painting over the mantel features a figure of Cupid, Venus's assistant, blowing a bagpipe—an inharmonious phallic symbol—amid ruins. The venereal disease that will ultimately infect their child is already evident in the black spot on the husband's neck. In style, the looseness of Hogarth's brushstrokes in the original paintings is indebted to the example of contemporary French painting.

440. JEAN-HONORÉ FRAGONARD
Happy Accidents of the Swing. 1767. Oil on canvas, 31 7/8 x 25 3/8". Wallace Collection, London

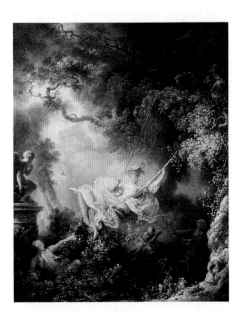

WATTEAU, *A Pilgrimage to the Island of Cythera*: 1717
1700: The population of London, Europe's largest city, reaches 550,000
1717: Handel's *Water Music* is performed on the Thames
1719: Defoe, *Robinson Crusoe*
1721: J. S. Bach, *Brandenburg Concertos*
1728: Gay, *The Beggar's Opera*
1748: Fielding, *Tom Jones*

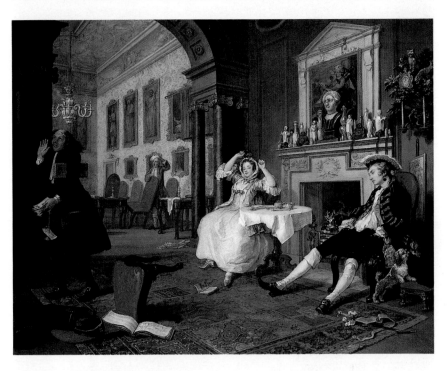

441. WILLIAM HOGARTH
Marriage à la Mode, Scene II. 1743. Oil on canvas, 27 1/2 x 35 3/4". National Gallery, London. This is the second scene in a series of six. To Hogarth's contemporaries, "à la mode" implied something fashionable but cheap and short-lived. The series was subtitled *Modern Occurrences in High Life.* Hogarth's painted series on moral subjects were reproduced as popular engravings. The artist compared himself to dramatists and novelists, saying that he "considered subjects as writers do," adding, "My picture was my stage and men and women my actors." The inspiration of contemporary English theater (Gay) and literature (Fielding, Defoe) on Hogarth is well documented. In two earlier series Hogarth chronicled *A Harlot's Progress* (1728–30), which follows an attractive young girl from her arrival in London, where she is discovered by a procuress, to her death and *A Rake's Progress* (1735), in which a weak young man wastes the father's fortune, ending up in an asylum, probably the infamous English Bedlam.

Romantic love—its dreams and disappointments, pleasures and pains, realities and fantasies—becomes a central theme in Rococo art. The variety of interpretation, demonstrated in these three examples, and the probing character of the representations reveal important changes as the themes of art are broadened, revealing an expanded interest in the psychological and emotional states that affect people in their everyday lives.

ROCOCO ARCHITECTURE AND SCULPTURE

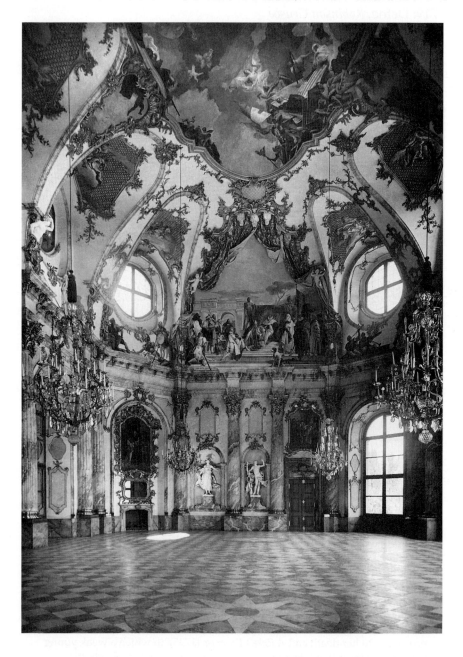

442. JOHANN BALTHASAR NEUMANN
Kaisersaal (Imperial Hall), Episcopal Palace, Würzburg, Germany. 1735–44. The frescoes by Giambattista Tiepolo (1751–52) represent scenes glorifying the twelfth-century German emperor Frederick Barbarossa and the bishop of Würzburg. The stuccowork is by Antonio Bossi. The Italian painter Tiepolo spent three years in Würzburg decorating this official residence of the prince-bishops of Würzburg.

The Kaisersaal documents the life of the aristocracy in the eighteenth century (fig. 442). One must imagine it filled with the elaborate furniture of the period, its crystal chandeliers lit with flickering candles. The shape of this elegant salon is too complicated to be either an oval or an octagon, but it is surmounted by a high oval dome pierced by windows. The columns seem to be a beautiful pink marble but, like most such columns in Rococo buildings, they are stucco painted and polished to give the illusion of marble. The lightness of the architecture is enhanced by the large irregular frescoed oval and by two scenes enframed by elaborate, gilded curtains. Painted figures and animals by Tiepolo wander out onto the entablature to chat, sit, and look down at us.

The Rococo style in architecture developed in France at Versailles about 1700 and flourished in southern Germany in part because of political connections. The palace at Würzburg was built by a family of local hereditary prince-bishops who set out to surpass Versailles (see fig. 428). The Rococo style is perhaps at its most exuberant here, where all restraint seems to evaporate in gilded decoration, fake marble columns, and an indissoluble union of painting and architecture. Although it owes its origins to the classical vocabulary of the Renaissance, the Rococo offers a new lightness of color and of movement and a new delicate scale of ornament, which are in contrast to the more ponderous forms and colors of Baroque architecture.

Equally exuberant is the church nicknamed Die Wies near Munich (fig. 443). Here Rococo architec-

NEUMANN, Kaisersaal: 1735–44
1732: Benjamin Franklin's *Poor Richard's Almanack* is issued
1739: John Wesley founds the Methodist movement
1741: Handel, *The Messiah*

ture and decoration become a visionary premonition of the heavenly Jerusalem. Die Wies is a pilgrimage center where devout Catholics of all classes worship at the shrine of a miraculous statue of Christ. Virtually every surface is decorated—this is architecture that does not let the eye rest and, like the French Gothic style (see fig. 229), its celestial metaphor is in part accomplished by an attempt to deny visually the weight of architectural forms. The white gilded stucco capitals have a flamelike movement, and irregularly shaped windows pierce the walls. The openness and lightness of the oval "nave" area contrast with the colors of the architectural climax at the altar,

where the statue is enclosed within a shrine of red and white columns. The vault is pierced with curving, Rococo openings that let light in from windows in the outer wall. This denial of the principles of vaulted architecture makes Die Wies seem like an apparition not dependent on normal structural systems. Nor is it subject to the force of gravity. The exuberance of Catholic Rococo architecture may be in part a reaction to the severity characteristic of contemporary Protestant architecture.

At Rohr (fig. 444), a light-filled white and gold nave directs attention to the richer colors of the columns behind the high altar that enframe a monumental sculptural group. While gesticu-

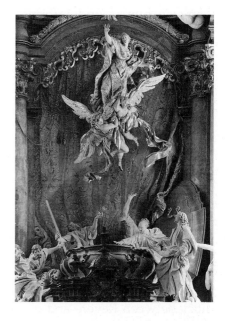

444. EGID QUIRIN ASAM
Assumption of the Virgin (detail). 1721–23. Painted and gilded stucco and stained glass. Monastery Church, Rohr, Germany

443. DOMINIKUS ZIMMERMANN
Interior, Die Wies, Germany. 1745–54. The frescoed vault and stucco decoration are probably by Johann Baptist Zimmermann, the architect's brother. The exterior of this structure is rather plain, and the contrast between exterior and interior is an important part of the architectural experience.

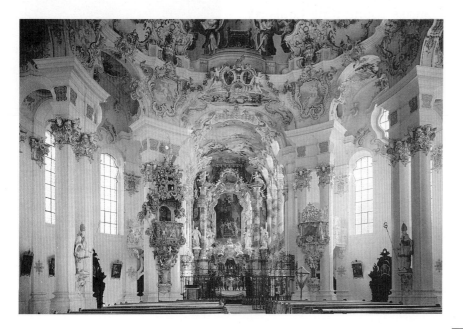

lating apostles surround a Rococo sarcophagus, we gasp as we seem to witness the Virgin being carried to heaven by angels. The architecture seems to open and a golden stained-glass window offers a portal to heaven. Since the Renaissance, religious drama had used special effects of lighting (candles, torches, fireworks) and theatrical machinery to make transcendent miraculous events seem more realistic and more dramatic, and one of the most successful Counter-Reformation tools employed by the Jesuits in southern Germany was the use of sacred theater as a teaching device. Asam's *Assumption* is a permanent version of one of these theatrical representations.

EIGHTEENTH-CENTURY PORTRAITURE

Copley's honest and informal portrait of the Boston silversmith and engraver Paul Revere represents both the New England work ethic and Copley's artistic joy in rendering exact visual detail (fig. 445). The darkened background focuses our attention on Revere and the tools and products of his trade in the foreground. He wears the simple work clothes of an artisan. Such a straightforward approach, which dignifies labor and craftsmanship, was in keeping with Puritan values. Copley convincingly portrays a sense of immediacy between Revere and ourselves. It is as though we have discovered Revere deep in thought, almost as if he has forgotten the engraving of the teapot and is now engrossed in the contemplation of more difficult issues. Revere's eyes meet ours, and his raised right eyebrow seems to signify an acknowledgment of our presence. It is clear that Copley delighted in the naturalistic representation of figures and objects. Note how the sharp, detailed reflection of Revere's fingers in the silver teapot contrasts with the diffused reflection of his shirt on the polished wooden worktop.

Copley and Benjamin West (see fig. 454) are acknowledged as America's first significant artists. Copley's fame in the colonies was established primarily on his ability as a portraitist. His sensitive observation and carefully developed talent earned him a distinguished reputation and a significant financial income, both in the colonies and in

445. JOHN SINGLETON COPLEY
Right: *Portrait of Paul Revere.* c. 1768–70. Oil on canvas, 34 7/8 x 28 1/2". Museum of Fine Arts, Boston (Gift of Joseph W., William B., and Edward H. R. Revere). Paul Revere was a political activist in Boston. His famous night ride to warn Bostonians of the advance of the British army occurred on April 18, 1775. Copley's family was sympathetic to the British, and the artist left the colonies forever on the eve of the Revolution.

446. ROSALBA CARRIERA
Below right: *Portrait of Louis XV as a Young Man.* 1720–21. Pastel on paper, 18 1/2 x 14 ". Museum of Fine Arts, Boston (The Forsyth Wickes Collection)

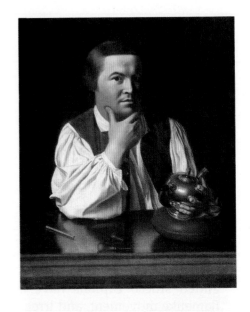

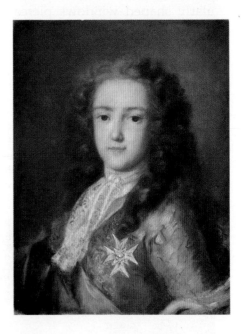

his later career in Britain. Although portrait painting ranked behind history and religious painting in the academic classification of subject matter, it was an economic mainstay for many artists.

Rosalba Carriera's painting of France's young King Louis XV demonstrates the elegant grace of Rococo portraiture (fig. 446). The soft, delicate effect is achieved not only by the blending of high valued colors, but also by the use of pastel as a medium. Carriera, a Venetian artist, was a master of pastel portraits. Her influence in France and Italy popularized the medium in the eighteenth century.

In England two competing artists excelled in portraiture: Sir Joshua Reynolds, president of London's Royal Academy (see p. 392), and Thomas Gainsborough. Our two portraits,

which display the abilities and different approaches of these two artists, both represent Sarah Kemble Siddons, a popular and accomplished actress of the period (figs. 447, 448).

True to his philosophy that painting should aspire to the "grand style," Reynolds chose to depict Siddons as a classical al-

447. THOMAS GAINSBOROUGH
Below: *Portrait of Sarah Siddons.* 1783–85. Oil on canvas, 49 3/4 x 39 1/4". National Gallery, London

448. SIR JOSHUA REYNOLDS
Below right: *Allegorical Portrait of Sarah Siddons as the Tragic Muse.* 1784. Oil on canvas, 93 x 57 1/2". Henry E. Huntington Library and Art Gallery, San Marino, California

COPLEY, *Portrait of Paul Revere: c.* **1768–70**
1750: World population is about 750 million
1760: Population of American colonies is about 1.6 million
1762: Catherine the Great becomes czarina of Russia
1764: Mozart, age eight, writes his first symphony
1770: Boston "Massacre"
1778: Death of Voltaire

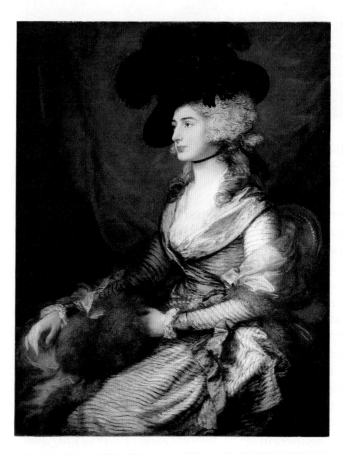

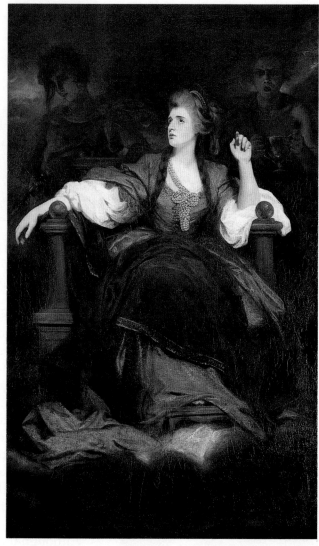

legorical figure, the muse of tragic drama. She sits on a throne, head and eyes raised as if in response to divine, creative inspiration. Behind her are figures symbolizing Pity and Terror, the attributes of tragic drama. Reynolds's composition directly recalls Michelangelo's figures of prophets and sibyls on the Sistine Chapel Ceiling (see fig. 344), demonstrating his adaptation of Renaissance masters.

When Gainsborough painted the same celebrated actress, he chose to portray her as an elegantly dressed, confident woman. The painting, which recalls the tradition of Venetian and Baroque portraiture, is a sumptuous treat for our eyes. The blues and whites of her dress enhance the warm, golden tones of her shawl and muff, while the magnificent black hat is silhouetted against a deep red curtain. Gainsborough's painterly technique and luxurious colors create an impressive portrait of a dynamic woman.

THOMAS JEFFERSON AND NEOCLASSICAL ARCHITECTURE IN THE UNITED STATES

"You see I am an enthusiast in the subject of the arts. But it is an enthusiasm of which I am not ashamed, as its object is to improve the taste of my countrymen, to increase their reputation, to reconcile them to the respect of the world, and procure them its praise" (Thomas Jefferson, in a letter to James Madison, 1785). Jefferson's Virginia State Capitol (fig. 449) must have surprised many Richmond residents, for it was the first public building in the youthful American republic to be modeled on the classical temple form. Jefferson designed the building while he was serving as U. S. minister to France, where he was inspired by both French architects already working in the Neoclassical style and the ruins of the ancient Roman civilization in Gaul. He was especially influenced by a Roman temple at Nîmes, in southern France, which is similar to the Temple of Portunus (see fig. 113)

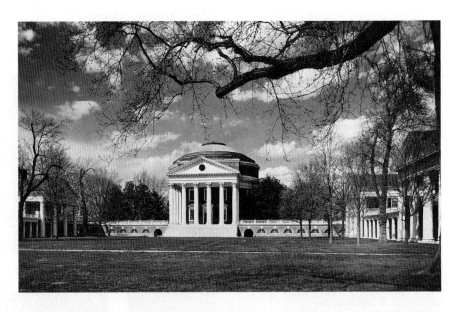

450. THOMAS JEFFERSON
University of Virginia, Charlottesville. 1817–26

in Rome. Jefferson wrote in a letter that he had gazed at the temple for hours, "like a lover at his mistress." While maintaining its basic design, he greatly enlarged it for the Virginia State Capitol. The resulting structure, with its Ionic portico, pediment, and classical proportions, confers a solemn, dignified appearance, appropriate, as Jefferson himself believed, to the ideals of a young democratic nation.

Although the Neoclassical architectural style flourished throughout the Western world, it was particularly meaningful in the United States, as the nation adopted a democratic form of government following the Revolution. The emulation of Roman buildings was viewed as an appropriate vehicle to express architectural dignity and command public respect. For

Jefferson, public architecture demanded a moral content. The nobility of the Neoclassical edifice would serve as a guide to the behavior and aspirations of the young Republic. The Neoclassical architectural style in the United States is also known as the Federal Style because of its prominent use for government buildings.

In 1817 Jefferson, now a former president, began planning the first state university in America. His design for the University of Virginia harmonizes the stateliness of the Federal Style with the practical needs of an educational community (fig. 450). The mall is dominated by the Rotunda, an adaptation of the ancient Pantheon in Rome (see fig. 144). The Rotunda contained the library, while the individual pavilions along the mall each

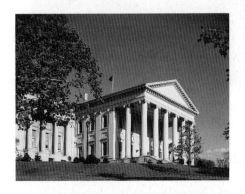

449. THOMAS JEFFERSON
State Capitol, Richmond, Virginia. 1785–89. The side wing seen here and a pendant on the other side are later additions.

JEFFERSON, State Capitol: 1785–89
1783: First successful hot-air balloon flight
1784: Steam is first used to power textile machinery
1786: Mozart, *Marriage of Figaro*
1787: U. S. Constitution is signed
1790: Washington, D.C., is founded
1790: U.S. population is almost 4 million

housed a different academic discipline, including living quarters for the faculty and classrooms.

Jefferson's design for his country home, Monticello, demonstrates the adaptability of Neoclassical architectural features to domestic buildings (fig. 451). The use of antique architectural elements is evident, but Jefferson's sources for the composition here are also drawn from the Renaissance, particularly the villas of Andrea Palladio. The Villa Rotonda (see fig. 9) and others inspired the main block, with its domed ballroom, while other Palladian villas in the countryside around Venice were the source for the wings that reach out to embrace the landscape and unify the house with the farms and countryside which support the estate. Soon houses throughout America would sport Doric, Ionic, and Corinthian porticoes as an indication of America's democratic ideals.

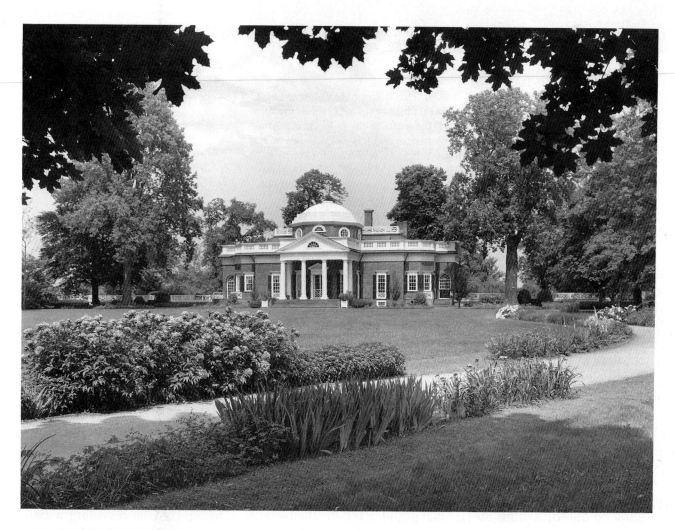

451. THOMAS JEFFERSON
Monticello, Charlottesville, Virginia. 1768–82; remodeled 1796–1809. The Italian name Monticello (little mountain) was adopted by Jefferson because of the hilltop setting of his home.

NEOCLASSICAL PAINTING

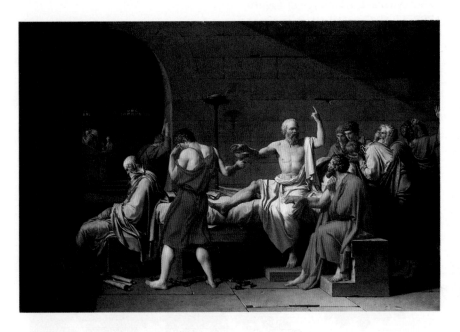

452. JACQUES-LOUIS DAVID
Death of Socrates. 1787. Oil on canvas, 51 x 78". The Metropolitan Museum of Art, New York (Wolfe Fund, 1931). The liberal philosophy of Socrates, the fifth-century B.C. Athenian philosopher, stressed the worth of the individual over that of the state in a manner which upset Athenian officials. Because he could not be brought to trial for his philosophical beliefs, he was tried for "impiety," found guilty, and ultimately sentenced to death. It was clear that he could have gone free if he had renounced his teachings, but Socrates himself pointed out that death had been the verdict of a legitimate court. Following Athenian practice, he drank hemlock. The painting was commissioned by a lawyer at the French Parliament.

Heroic suicide may seem to be a contradiction in terms, but the purpose of David's theme (fig. 452), painted in the unsettled years in France before the Revolution, was to demonstrate the need to live by principles and the heroism of the stoic virtue of absolute self-sacrifice. David depicts a heroic, muscular Socrates reaching for the cup of poisonous hemlock held by a distraught disciple. With an exclamatory gesture, Socrates points upward, insisting on the truth of his ideals. On viewing the painting, one contemporary observer remarked, "This is the triumph of virtue which is raised higher than all other things by a heroic courage and an inspired soul."

While the theme of the death of Socrates is taken from the classical past, David's choice and interpretation of subject are strictly contemporary, and within the cultural context of late-eighteenth-century France would have been easily understood. In 1758 the philosopher and writer Denis Diderot had detailed a proposed drama on Socrates' death that popularized the theme with artists and writers. Socrates' unwavering devotion to his ideals provides the theme for this history painting. Both the lesson and David's representation were acclaimed by critics and the public. The work offered a guide for moral behavior in the troubled social climate of France. David became a supporter of the French Revolution, and the *Death of Socrates* illustrates his belief that paintings "of heroism and civic virtue offered the eyes of the people [will] electrify its soul, and plant the seed of glory and devotion to the fatherland." The crisp modeling of the figures creates precise, linear, sculptural forms, revealing David's academic training and approach, while the planar space of the painting suggests that ancient relief sculpture may have been one of David's inspirations.

The Swiss painter Angelica Kauffmann (see fig. 438) also championed the virtues of history painting. The theme of Kauffmann's *Cornelia* (fig. 453) is drawn from Roman antiquity. Cornelia was renowned as a devoted mother. When a friend who had just displayed her own jewelry asked to see Cornelia's gems, Cornelia presented her two sons. The personal and emotional implications of the theme are clear, and it should perhaps be pointed out that Kauffmann selected and successfully represented a subject that would be recognized as revealing a particular feminine insight. Kauffmann's elegant, yet disciplined Neoclassical compositions gained

DAVID, *Death of Socrates:* **1787**
1787: Dollar currency is introduced in the U.S.
1788: The *Times* of London begins publication
1791: Mozart, *The Magic Flute*

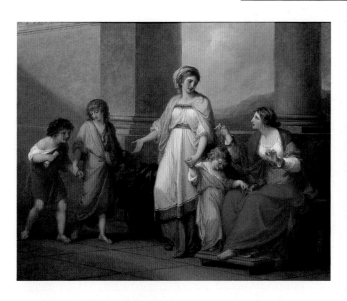

453. ANGELICA KAUFFMANN
Cornelia, Mother of the Gracchi. 1785. Oil on canvas, 40 x 50". Virginia Museum of Fine Arts, Richmond (Williams Fund, 1975)

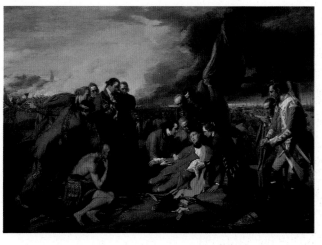

454. BENJAMIN WEST
The Death of General Wolfe. 1770. Oil on canvas, 59 1/2 x 84". National Gallery of Canada, Ottawa (Gift of the Duke of Westminster). The story of the death of the British commander James Wolfe on the battlefield at Quebec in 1759 was inspirational. After three months of stalemate, Wolfe had led his troops to victory over a much larger French force but, mortally wounded, he died in the arms of his officers at the moment of victory.

her an international reputation.

Benjamin West's *Death of General Wolfe* (fig. 454) popularized a new concept within the category of history painting, for West represented the figures in contemporary costume, avoiding the antique clothing and setting which, traditional academic rules held, could elevate a subject to its universal significance. West's earliest biographer tells that Sir Joshua Reynolds, president of the Royal Academy, had advised West to "adopt the classic costume of antiquity, as much more becoming the inherent greatness of . . . [the] subject than the modern garb of war," and that West had replied: "The event intended to be commemorated took place on the 13th of September, 175[9], in a region of the world unknown to the Greeks and Romans, and at a period of time when no such nations, nor heroes in their costume, any longer existed. The subject I have to represent is the conquest of a great province of America by the British troops. . . . If, instead of the facts of the transaction, I represent classical fictions, how shall I be understood by posterity! . . . I want to mark the date, the place, and the parties engaged in the event; and if I am not able to dispose of the circumstances in a picturesque manner, no academical distribution of Greek or Roman costume will enable me to do justice to the subject."

Earlier masterpieces inspired the work's impressive composition, which was stimulated by a serious study of classical sculpture and of the works of Renaissance and Baroque artists. West's painting, a popular success, pioneered an important change in the representation of contemporary history. Although he avoids classical costume, West does refer to tradition in including the Native American as a personification of America. The painting successfully communicates the tragedy of the death of Wolfe, an event which inherently demonstrated the universal values of self-sacrifice, courage, and patriotism. King George III commissioned a copy of West's painting and made him the official history painter at the court.

NINETEENTH-CENTURY ART

INTRODUCTION

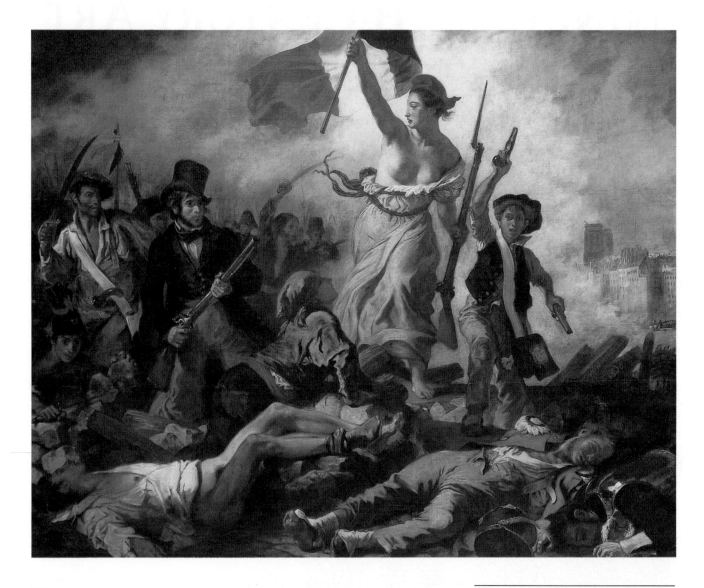

455. EUGÈNE DELACROIX
Liberty Leading the People. 1830. Oil on canvas, 8' 6 3/8" x 10' 8". The Louvre, Paris

The ideal of revolution, so important for the development of the modern world and so central to the history, ideology, and art of the nineteenth century, is expressed in two paintings by Delacroix and Monet (figs. 455, 456). Delacroix's subject celebrates the July Revolution of 1830, when an uprising of Parisians mounted a revolutionary red, white, and blue flag—the tricolor—on the spires of Notre Dame and forced the abdication of King Charles X and the adoption of a new charter that doubled the number of citizens who elected the legislative chamber. This was a modest but important triumph for the liberals, lower bourgeoisie, and skilled workers who had led the revolt. In Delacroix's painting, the personification of Liberty, holding the tricolor, leads an army of Parisian rebels over the bodies of their dead comrades toward victory. Delacroix's technique is likewise

revolutionary, for in reaction to the sharp linearity of the prevailing Neoclassical style (see p. 402), he introduces blurred edges, strong colors, and loose brushstrokes in an active style appropriate to his modern subject. Of Delacroix's significance, the later painter Paul Cézanne would say, "We all paint differently because of him."

From later in the century, Monet's revolutionary painting expresses new Impressionist ideals. In defiance of the attitudes that had endured since the Renaissance, the Impressionists asserted that subject matter in a work of art was not more important than the work's purely visual qualities. Monet chose this particular cityscape not in response to patriotic fervor, for example, but because he was challenged by the problem of how to represent the visual effect of the

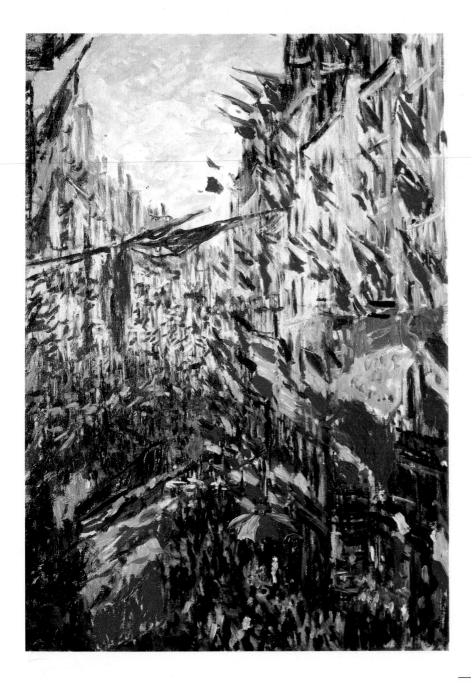

456. CLAUDE MONET
Rue Saint-Denis Festivities on June 30, 1878. 1878. Oil on canvas, 29 7/8 x 20 1/2". Musée des Beaux-Arts, Rouen

brilliant colors and the ever-changing movement offered by the flags. Monet's goal was to capture a visual "impression" of what the eye sees, regardless of subject. Traditional critics were as upset by this attitude about subject matter as they were by his loose brushstrokes.

HISTORY

Economic, technological, and political revolutions dominate the history of the nineteenth century in Europe and America. The Industrial Revolution, with its mechanization of production in factories, transformed life for a large percentage of the population. The rapidly expanding lower and middle classes, concentrated in the cities near their factory jobs, organized to demand democracy and more humane treatment. The institutions, life-styles, and class structures that resulted had an important impact on art. The spirit of reform that began in the nineteenth century extended into the twentieth, eventually leading to universal suffrage.

During the nineteenth century the world seemed to become a smaller place as steam-powered trains and ships led to increased world trade. The expansion of communications with the establishment of cheap newspapers and periodicals, printed on high-speed printing presses, and the development of the telegraph and telephone led to international awareness. A world culture gradually evolved, prompted by world trade and centered around the great international fairs held in the second half of the century. More and more artists traveled from America to Europe to be trained, and soon even painters from Pittsburgh were trying to exhibit at the Salon in Paris and the Royal Academy in London. Inexpensive reproductions of works of art were widely disseminated. The importation of Asian works of art into Europe and America had a significant impact not only on the development of art, but on popular taste and collecting as well (see fig. 457).

Napoleon dominated European history in the first decade of the nineteenth century, leading French armies to victory until he controlled all of Europe. Only Britain, which defeated Napoleon's navy at Trafalgar, was able to repel the French. Napoleon was proclaimed emperor of France in 1804 and king of Italy in 1805. Determined to break the traditional and historic power of the Catholic church and its clergy, Napoleon closed monasteries and destroyed symbols of ecclesiastical and monastic power. To enlarge his own private collections and those of the French state, he appropriated many works of art. He attacked Russia in 1812 and took Moscow, but in retreat his army was virtually annihilated. Napoleon abdicated in 1814, returned briefly to power in 1815, and was defeated by the English at Waterloo. The new European borders set at the Congress of Vienna in 1815, after Napoleon's defeat, established a balance of power that endured until World War I.

The French Revolution and later revolutionary uprisings in France in 1830 and 1848, as well as the success of the new democracy in America, gave impetus to other revolutionary movements. Through-

out Europe there was an increased demand for "liberty, equality, and fraternity (nationalism)." There were eleven revolutionary uprisings in major European cities in 1848–49. The nineteenth-century demands for revolution, however, would reach their most significant outcome with the Russian Revolution of 1917. Great Britain remained stable and the British Empire underwent tremendous expansion accompanied by an astonishing financial development—the result of peace, industrialization (see below), and the world market provided by the empire. The power of the British naval and merchant marine was unrivaled. In America, rapid expansion and industrialization led to prosperity and optimism, but this mood was dissipated by the divisive Civil War (1861–65), and after the war America became increasingly dependent on European culture. By the end of the nineteenth century, nationalistic desires for unification in Italy and in Germany had succeeded.

THE INDUSTRIAL REVOLUTION

By the mid-nineteenth century, Britain led the world in the mechanized production of inexpensive goods for mass public consumption. Such production became the financial base for England's expansion during the century. Simultaneously the Industrial Revolution spread through much of Europe and into America. When power-driven machinery revolutionized the production of textiles, entrepreneurs established huge mills in which hundreds of workers manufactured vast amounts of cheap fabric. Factory-made nails and milled lumber, produced by the power-driven sawmill, revolutionized the housing industry in America. The rapid spread of the railroads transformed transportation, the delivery of merchandise, and communications.

The new industrial production was celebrated in a series of great international exhibitions, beginning with the Great Exhibition of the Works of Industry of All Nations at the Crystal Palace in London in 1851 (see fig. 490). This exhibition emphasized England's role as the world's greatest manufacturing center. It also brought together handicrafts and manufactured goods from all over the world.

The Industrial Revolution raised standards of living for large groups of people, but it also contributed to problems of unemployment. The terrible working conditions and life in the cities are documented in contemporary novels by Victor Hugo (Les Misérables) and Charles Dickens (Oliver Twist). The isolation and alienation of the individual in modern, urban society are expressed by the barmaid, who probably also worked as a prostitute, in Manet's Bar at the Folies-Bergères (fig. 458). The Industrial Revolution also transformed art, for the mass production of cheap prints developed a new audience for art. Reproductions of paintings were available virtually everywhere. Illustration flourished, led by such entrepreneurs as Currier & Ives in America. The mass production of furniture and other household goods led to a reaction in the second half of the century, when the finely finished works of the individual craftsperson were exalted in the Arts and Crafts and Art Nouveau movements.

INTELLECTUAL AND SCIENTIFIC ACTIVITIES

The social and financial inequities that resulted from industrialism led to a number of responses—socialism, anarchism, utopian movements, and revolutionary communism. The latter was explicitly defined by Karl Marx and Friedrich Engels in the *Communist Manifesto*, published in 1848.

Intimately connected with industrialization were advances in science, engineering, and technology. Science replaced philosophy as the most influential university discipline. New scientific theories, especially Charles Darwin's controversial *The Origin of Species* (1859), with its message of the "survival of the fittest," deeply affected attitudes about religion and the meaning of life.

The explosion of activity in the fields of literature and music makes it impossible to mention all the important figures at work during the nineteenth century. Some of the artistic movements had parallel developments in literature and music. Romanticism in literature was expressed in poetry, historical novels, fantasy and horror tales, and romance and adventure stories. Among its titanic figures are Lord Byron in England, Johann Goethe in Germany, Victor Hugo in France, and Aleksander Pushkin in Russia. Romanticism and Realism are united in the works of Dickens. The Romantic movement in music includes Frédéric Chopin (who even wrote a "revolutionary étude"), Johannes Brahms, Richard Wagner, and Pëtr Tchaikovsky. Impressionism is paralleled in music in the compositions of Claude Debussy. Art criticism flourished, and partisans of both conservative and "modern" art developed.

NINETEENTH-CENTURY ART

The subjects of nineteenth-century painters ranged from historical, mythological, and religious themes to scenes of the everyday life of the working classes. By the end of the century, even the vulgar characters and activities of a popular dance hall had become acceptable as a theme for art (see fig. 459). The development of exhibitions, such as those at the Parisian Salon and London's Royal Academy, and of art galleries in every major city in Europe and America meant that more and more painters and sculptors were producing works for exhibition and for the general art market. As the percentage of commissioned works declined, there was a growing division between artist and public, and the gulf between conservative and revolutionary artists, who assumed the title of avant-garde, gradually became wider. Although the development of photography robbed the painter of a traditional means of support, the elite continued to commission painted portraits. Landscape became a particularly popular subject, perhaps because it was such a good vehicle for expressing aesthetic theories (see p. 422). Despite the significance of the Industrial Revolution, scenes of industry were relatively rare.

The popular print developed with the growth of newspapers and

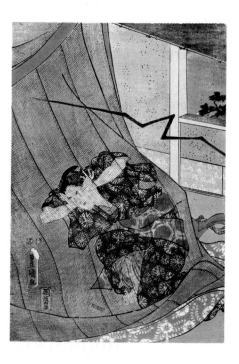

457. KUNISADA
A Woman Frightened by Thunder. 1849-53. Woodblock print. This print was part of a large collection of more than 200 Japanese prints owned by the Post-Impressionist painter Vincent van Gogh; the artist owned 165 prints by Kunisada alone. Japanese prints were a formative influence on many French nineteenth-century painters, especially Manet, Monet, Degas, Toulouse-Lautrec, and Van Gogh. The bold silhouetting and complex patterning of their designs (especially evident here in the pattern of the mosquito netting over the designs of the woman's costume), the truncation of the forms (note the flying reed shade in the upper right corner and the lightning bolt that flashes into the room), the unusual, high viewpoint, and the diagonal recession of the architectural settings all had a distinctive effect on the development of modern French painting.

458. ÉDOUARD MANET
A Bar at the Folies-Bergères. 1881–82.
Oil on canvas, 37 1/2 x 51". Courtauld
Institute Galleries, Home House
Trustees, London. Many of the
barmaids who worked at the Folies-
Bergères were also prostitutes. Manet's
composition presents this woman as a
commodity that is as readily available
as the goods on the bar. At the same
time, however, her expression creates
a strong sense of the woman as an
individual with a personal emotional
life. In Manet's oil sketch for the
painting, the background is more
easily read as a mirror reflection; in the
final version the reflection of the
woman and her customer is changed
to emphasize the unreality of painting
and the flatness of the pictorial
surface. In describing the painting
while it was in the studio, Georges
Jeanniot, one of Manet's friends, noted
that "he did not copy nature at all
closely; I noted his masterly simplifi-
cation. . . . Everything was abbrevi-
ated." This painting was exhibited at
the Paris Salon in 1882.

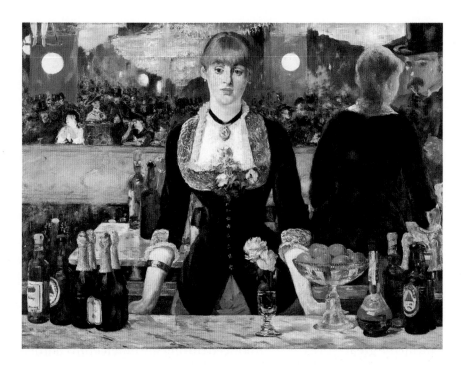

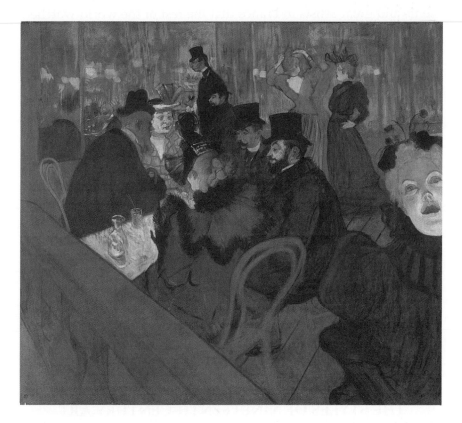

459. HENRI DE TOULOUSE-LAUTREC
At the Moulin Rouge. 1892. Oil on canvas, 48 3/8 x 55 1/4". The Art Institute of
Chicago (Helen Birch Bartlett Memorial Collection). The dramatic lighting of the
face in the foreground, which reflects the strong color of the cabaret's gas lighting,
reveals the Impressionist interest in the realistic rendering of light.

periodicals to become a prominent vehicle for social protest (see p. 424). The photograph, invented in the nineteenth century, was used both as a journalistic and as a documentary tool. In sculpture, the heroic monument dominated the century and was considered to be the primary challenge of the sculptor (see figs. 460, 461, 465), but the diversity of the century is seen in examples of traditional architectural sculpture and works that demonstrate revolutionary attitudes about sculpture (see fig. 506). In architecture, new forms were demanded by the dramatically increasing pressure of population and business crowded in great urban centers. Impressive technological and engineering advances made possible the skyscraper, the railroad station, and the great bridges (see fig. 491) and monuments of the later nineteenth century.

THE PRIMACY OF FRANCE

Not all the great works of art produced during the nineteenth century were made by French artists, but it was developments in France that gave names to most new movements, and much of the art created elsewhere reflected French styles. There was a sequence of movements and great artists in France that the rest of the world watched with interest, enthusiasm, and dismay. The annual art exhibitions of the French Salon were the most famous in the world and the ones in which virtually all serious artists desired to be included. To be represented in a Salon could make one's reputation.

Conservative interests dominated the Salon exhibitions, however, and when the Salon jury of 1863 rejected a number of works which we would consider modern, there was such an outcry that a special exhibition of the rejected works, known as the Salon des Refusés, was established: "Numerous complaints have reached the Emperor on the subject of works of art which have been refused by the jury of the exhibition. His Majesty, wishing to let the public judge the legitimacy of these complaints, has decided that the rejected works of art are to be exhibited in another part of the Palace of Industry. This exhibition will be voluntary, and artists who may not wish to participate need only inform the administration, which will hasten to return their works to them. This exhibition will open on May 15. Artists have until May 7 to withdraw their works. After this date their pictures will be considered not withdrawn and will be placed in the galleries" (*Proclamation of the Salon des Refusés*, 1863).

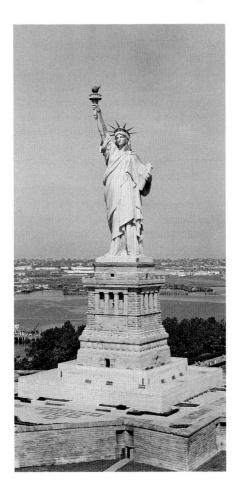

460. FRÉDÉRIC-AUGUSTE BARTHOLDI
Liberty Enlightening the World (now known as *The Statue of Liberty*). 1870–86. Hammered copper over wrought-iron pylon designed by Gustave Eiffel; height from base to top of torch 111' 6". New York Harbor

THE STYLES OF NINETEENTH-CENTURY ART

The basic styles defined in this century receive their names from terms applied to paintings—to French paintings in particular. The new style at the end of the eighteenth century, Neoclassicism, continued in popularity well into the nineteenth century, especially in the arts of architecture and sculpture (see p. 416). It received a special

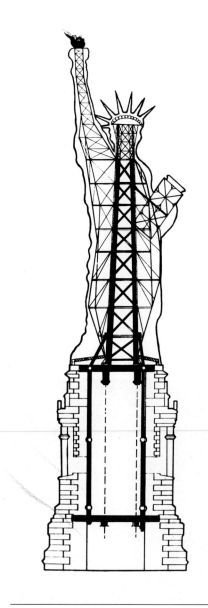

461. GUSTAVE EIFFEL
Diagram of the construction of *The Statue of Liberty*

impetus from Napoleon's enthusiastic support for a variation of Neoclassicism known as Empire, which supported his new status as emperor. Soon, however, the rational and lucid order of the Neoclassical style and its belief that art should express universal truths were challenged by a style that might be considered its opposite, Romanticism. This style, with its expression of spontaneous, strong, and even violent individual feelings, is in part based on a new distrust of rationalism. In architecture, Romanticism, in combination with a new interest in history and historical precedent, helps explain the interest in reviving earlier styles, especially the Gothic Revival (see p. 426), so important in American and European architecture. Some critics would even include the Neoclassical style within the general category of Romanticism.

In France, Romanticism was challenged by two styles: Academic Art and Realism. Academic Art is the term applied to the conservative and even reactionary art—heroic, moral themes rendered in exact verisimilitude—that prevailed in the French Salon exhibitions and in the French academies. Realism encompasses everyday subjects rendered with emphatic boldness. By denying to art the exalted mission preached in the academies, Realism was considered to be revolutionary. Realist attitudes about subject matter and technique influenced the Impressionists, who set out to represent a momentary impression of light, color, and atmosphere in paintings of contemporary subjects. A number of painters who went through an Impressionist phase but later moved on to other styles are known as Post-Impressionists. The end of the century saw the beginnings of Expressionism. There were styles in architecture and the decorative arts which can be subsumed in the general category of Victorian, which implies a heavy, often fussy, elaborately decorated style of rich materials, complex silhouette, and varied textures and colors. A reaction to the Victorian style and to the industrialization of the arts appeared in the Utopian style of the Arts and Crafts Movement as invented by William Morris and in the effulgent Art Nouveau style.

Amid the eclecticism and variety of late-nineteenth-century art, some uniquely personal styles developed that would influence early modern art, including those of the Post-Impressionists and of the self-taught artist Henri Rousseau. Rousseau was working as a toll collector (hence his nickname, "Le Douanier," or "customs officer") when, in his early forties, he retired to devote himself to painting. Such works as *The Sleeping Gypsy* (fig. 462) are a synthesis of artistic naïveté, innocent vision, and serious purpose. While *The Sleeping Gypsy* recalls the exoticism of romantic artists, the direct rendering of the forms, the sparse and planar landscape, and the naive foreshortening create an almost hallucinatory scene. This mood of fantasy, achieved through the honest intentions of the artist, who insisted that he painted images "from life," was to appeal to Picasso and the avant-garde of Paris, who befriended Rousseau in 1908. The author Guillaume Apollinaire expressed the modernist appreciation of Rousseau when he observed: "His paintings were made without method, system, or mannerisms. From this comes the variety of his work. He did not distrust his imagination any more than he did his head. From this came the grace and richness of his decorative compositions."

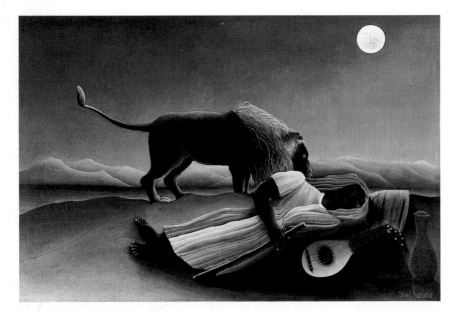

THE NINETEENTH-CENTURY ARTIST

The nineteenth century saw an increased sense of the individuality of the artist as a creative and expressive personality. The logical outcome of this was more personalized and revealing self-portraits, as in Goya's portrait of himself on the verge of death (fig. 463). By the end of the century, the revealing personal drama evident in Van Gogh's self-portraits (fig. 464) is not unexpected, although his particularly dramatic evolution from Impressionism could not have been predicted. The modern conception of the artist as a political and social liberal and a revolutionary is largely a product of such nineteenth-century personalities as Théodore Géricault, Gustave Courbet, and James McNeill Whistler. In the Renaissance, artists had worked hard to convince their upper-class and noble patrons that they were individuals worthy of recognition and status. In the nineteenth century, artists began to emphasize their bonds to the middle and lower classes. Georges Seurat planned to write a book about his principles and techniques which would enable anyone to paint a masterpiece.

Throughout the nineteenth century, the educational and professional opportunities which were opening for women, however slowly, increased the ranks of women artists. The number of women whose works were exhibited in the French Salon swelled from fewer than thirty earlier in the century to almost eight hundred in just over seventy-five years. As waa true of the eighteenth century (see p. 393), many American artists studied and worked in Europe. Among them were a group of women sculptors whom the writer Henry James collectively named "the white marmorean flock." James identified the leader of this group as Harriet Hosmer. A friend of Hosmer's described the artist as a woman who, "at the very outset of her life, refused to have her feet cramped by the little Chinese shoes, which society places on us all, then misnames our feeble tottering, feminine

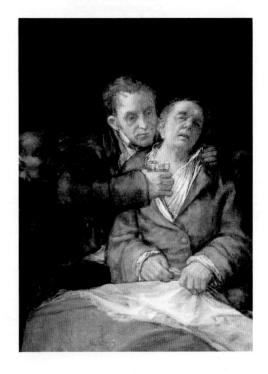

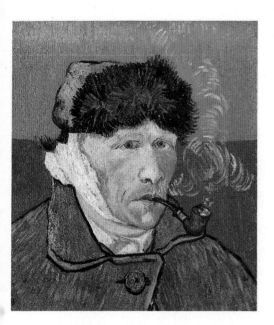

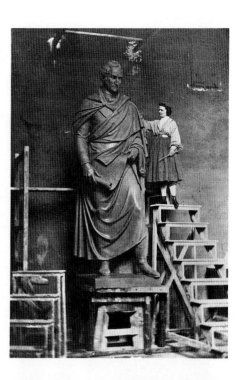

464. VINCENT VAN GOGH
Self-Portrait with Bandaged Ear and Pipe.
1889. Oil on canvas, 20 1/8 x 17 3/4".
Private collection

465. Photograph of Harriet Hosmer
in Rome, at work on the clay model
of *Thomas Hart Benton*, c. 1862. The
completed work in bronze, in
Lafayette Park, St. Louis, Missouri,
was dedicated in the spring of 1868.

grace." Hosmer, known for her vigorous and independent personality, journeyed to Rome in 1852 to study the revered arts of antiquity and the Renaissance and to be part of an international community of artists. By the end of the decade, her studio was an established part of the European art scene, and she enjoyed a range of patrons from Europe, England, and America.

As a sculptor, Hosmer struggled to cast aside stereotypical and sexist attitudes toward women artists. Her Neoclassical sculptures of women offered nineteenth-century audiences representations of feminine strength, and when she received the commission from the state of Missouri for a colossal statue of Thomas Hart Benton (fig. 465), Hosmer wrote, "Your kindness will now afford me an ample opportunity of proving to what rank I am really entitled as an artist unsheltered by the broad wings of compassion for the sex." Hosmer's statue of Senator Benton exemplifies the Neoclassical ideal of joining the values of antiquity—here demonstrated by the pose, drapery, and scroll—to subjects of the contemporary world.

Hosmer welcomed another American sculptor, Edmonia Lewis, to Italy in the 1860s. Lewis's mother was a Native American from the Chippewa tribe, while her father was an African-American who worked, in Lewis's words, as a "gentleman's servant." Nicknamed "Wildfire," Lewis spent much of her youth with her mother's tribe, but at the insistence of her brother she became a student at Oberlin College. Following an incident of racial violence directed against her, Lewis traveled to Boston in 1863. There she developed her talents as a sculptor and her views as an abolitionist. *Forever Free* (fig. 466) was created shortly after Lewis arrived in Italy; it depicts the moment of the triumph of freedom for African-American slaves, whose chains of bondage have just been broken. As a sculptor, Lewis was engaged not only by the theme of her works, which later would be expanded to reflect her Native American heritage, but also by the compositional challenge of creating multifigured groups.

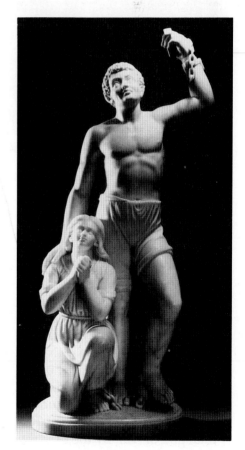

466. EDMONIA LEWIS
Forever Free. 1867. Marble, height 41 1/4".
The Howard University Gallery of Art,
Washington, D.C. This work was
formerly titled *The Morning of Liberty.*

THE CONTINUATION OF NEOCLASSICISM

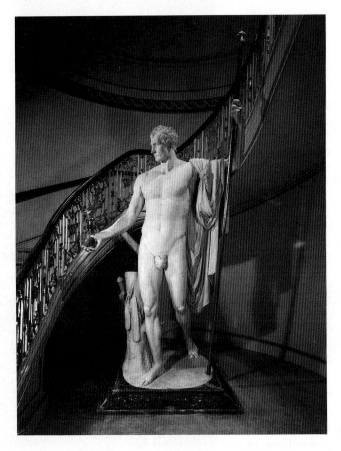

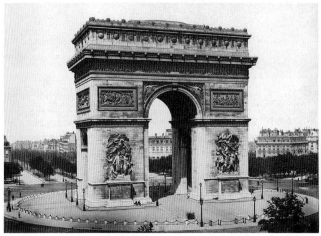

467. ANTONIO CANOVA
Left: *Napoleon*. 1806. Marble with gilded bronze staff and figure of victory, height 11'. Wellington Museum, London. This work was commissioned by Napoleon, who wanted to be immortalized by Canova, then considered Europe's greatest artist. The sculpture was bought by the British government and presented to the victorious duke of Wellington, who defeated Napoleon at Waterloo.

468. JEAN-FRANÇOIS-THÉRÈSE CHALGRIN AND OTHERS
Above: Arc de Triomphe, Paris. 1806–36. Height 164' without staff. Inspired by ancient Roman triumphal arches, Napoleon decided to commemorate his military victories with the largest arch ever built. It was not completed until long after his downfall. For one of the sculptures on the arch, see fig. 474.

How well sculpture conveys political concepts, and how quickly the political situation changes, are revealed in Canova's monumental representation of Napoleon, commissioned by the emperor himself in 1802 (fig. 467). Napoleon is represented nude in the guise of Mars, ancient Roman god of war. By the time the sculpture was delivered, in 1811, Napoleon's position had become less secure. The heroic concept no longer seemed completely relevant, and Napoleon decided not to put the work on public display. After Wellington defeated Napoleon, he acquired the statue as a trophy of victory, as well as a reminder of how quickly the powerful can fall. It is still displayed in Wellington's home in London.

Throughout the nineteenth century, Neoclassical architecture was popular, especially for public buildings and monuments. The Arc de Triomphe (fig. 468) is Napoleon's inflated and grandiose version of the ancient Roman arches, which honored victorious emperors, and its function is exactly the same. Unfinished at his death, the sculptures added after it was completed honor instead the heroic people of the French Revolution.

The style of Ingres's *Jupiter and Thetis* demonstrates the continuing impact of the Neoclassical mode in painting (fig. 469). The sculpturesque modeling of the heroically posed Jupiter and the crisp drapery folds of Thetis's garment reveal Ingres's academic training. Painted while Ingres was working at the French Academy in Rome, *Jupiter and Thetis*

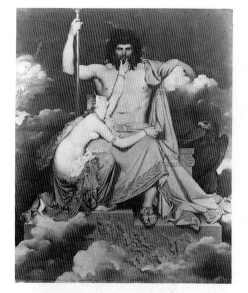

469. JEAN-AUGUSTE-DOMINIQUE INGRES
Jupiter and Thetis. 1811. Oil on canvas, 11' 4 5/8" x 8' 5 1/4". Musée Granet, Aix-en-Provence. This painting, based on an episode from the Trojan War delineated in the *Iliad*, depicts Thetis, a sea nymph and mother of Achilles, pleading with Jupiter to look favorably upon a request she has delivered from Achilles.

CANOVA, *Napoleon:* **1806**
1800: Volta invents the electric battery
1800: World population reaches 870 million
1800: U.S. population is 5.3 million; China's population is 295 million
1803: Louisiana Purchase greatly enlarges U.S.
1804: Napoleon crowned emperor of France
1804: Beethoven, Third Symphony (*Eroica*)

470. HORATIO GREENOUGH
George Washington. 1832–41. Marble, height 12'. National Museum of American History, Washington, D.C. Commissioned by Congress in 1832, this colossal work was intended for the Capitol Rotunda. Greenough, America's first famous sculptor, was an expatriate who worked in Italy, where his designs were carved by native stonecarvers. The *George Washington* was only completed and delivered in 1841, by which time the enthusiasm for Neoclassical sculpture in America had passed.

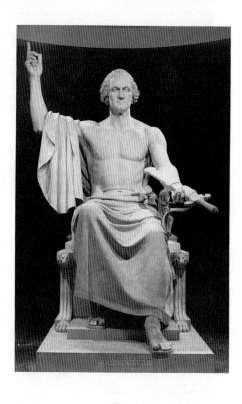

was sent back to the academy in Paris. The references to antiquity go beyond the theme, for the pose of Jupiter, the Roman equivalent of the Greek Zeus, king of the gods, was derived from the lost ancient cult statue of Zeus from his temple at Olympia. Created by Phidias, this was a magnificent sculpture of ivory and gold considered one of the finest artistic accomplishments of classical civilization.

This lost statue of Zeus was also the inspiration for Greenough's monumental sculpture of George Washington (fig. 470). In a typical Neoclassical effort to aggrandize and immortalize Washington—to clarify his significance for later generations— Greenough posed the great founder as the most powerful Olympian god. With rhetorical gestures, Washington offers us a sword and points upward in a declaratory manner, much like David's determined Socrates (see fig. 452). Most nineteenth-century Americans would not have known Greenough's source, and without this reference, the statue seemed at best ridiculous. The abrupt juxtaposition of Washington's face set on an idealized semi-nude body led to a disappointed reaction from the statue's patrons and the public. Blaming the harsh interior light of the Rotunda of the U.S. Capitol, Greenough had the sculpture moved outdoors, where it proved to be even less appreciated. The history of Greenough's *George Washington* reveals the increasingly rapid manner in which style and attitude can change— an important characteristic of the modern world. This impressive sculpture, with its monumental scale and commanding composition, continues to convey the heroic and even godlike characteristics often ascribed to Washington during the period of the early Republic.

FRANCISCO GOYA

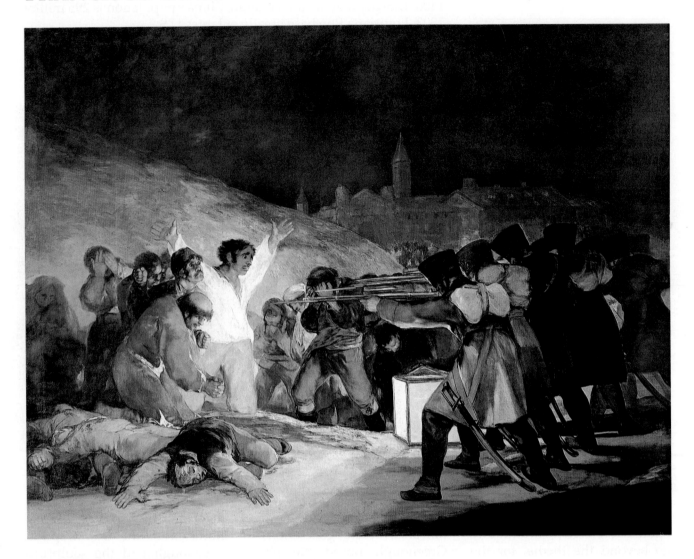

471. FRANCISCO GOYA
The Execution of Madrileños on the Third of May, 1808. 1814–15. Oil on canvas, 8' 9" x 13' 4"; the figures are lifesize.
The Prado, Madrid. Madrileños is the name given to the residents of Madrid. Napoleonic troops occupied Spain from
1808 to 1814, and this painting is one of a pair by Goya representing an uprising against the French in Madrid on May
2, 1808, and the execution of rebels and a number of innocent victims during the night of May 2–3. This was a decisive
act in the consolidation of French power in Spain, and the French commander, Napoleon's brother-in-law Murat,
announced that "yesterday's events have given Spain to the emperor." But the riots of May 2 also marked the begin-
ning of Spanish resistance to the French occupation throughout the country (underground warfare is still called
guerrilla warfare, from the Spanish term for little war). In 1814, after Napoleon had been defeated, Goya petitioned
the new Spanish government for support to "perpetuate with his brush the most notable and heroic actions or events
of our glorious insurrection against the tyrant of Europe." The two paintings were commissioned in 1814.

Despite Goya's commission to perpetuate the "most . . . heroic actions of our glorious insurrection," *The Execution of Madrileños on the Third of May, 1808*, is a brutal and unsettling painting (fig. 471). It emphasizes a confrontation between helpless individuals and the inhuman power of an anonymous authority. The universality of Goya's interpretation overwhelms the specific event of the title. These Spaniards are not heroes, but victims—perhaps even innocent victims—rounded up to be murdered by French troops. Goya represents the terror and helplessness they feel as they confront death from a faceless firing squad. More victims come slowly up the hill, testifying to the extent of the French brutality. Goya simultaneously commemorates history and condemns war and its effect on the individual.

The simple composition and focused light concentrate our attention on the terror and desperate helplessness of the central figure. The night setting, dramatic *chiaroscuro* contrast, and right-to-left composition heighten the drama, and Goya's loose brushstroke emphasizes the writhing movement of the victims. The color scheme is dull, with the exception of the red for blood splashed on the left foreground.

Goya published several series of prints, including a large group now known as *The Disasters of War*. Begun during the Napoleonic occupation and continued

472. FRANCISCO GOYA
Great courage! Against corpses! c. 1810–15. Etching, 4 x 6" (no. 39 from *The Disasters of War* series). Goya's title for this series was *The Fatal Consequences of Spain's Bloody War with Bonaparte and Other Striking Caprichos*. The titles of the etchings in this series evoke Goya's intent: *With reason or without it; One cannot bear to see this; No one can know why; They cry in vain; And there is no remedy; This is worse, Even worse, Barbarians!; Cartloads to the cemetery; Bury and shut up; I saw this; Why?*

in the repressive political period after the French withdrawal, they were not published until 1863, after Goya's death. In some of these prints the nationalities of the French and Spanish soldiers are clear, but which are the torturers and which the tortured alternates. Other scenes, like the one reproduced here (fig. 472), are less specific; they provide Goya's comments on the terrible inhumanity created by war. Even the title condemns the futility and

terrible cruelty of this act. Many of the prints represent atrocities Goya witnessed during the occupation, and his cry of "Enough!" resonates across the centuries. The creation of these prints may have helped the artist deal with his emotions of helplessness, frustration, and sorrow, but the demons he expelled remain to haunt us. The etching medium, with its rough, scratchy lines, here serves as a most appropriate vehicle for Goya's expression.

ROMANTIC REVIVAL ARCHITECTURE

481. SIR CHARLES BARRY AND AUGUSTUS W. N. PUGIN
Houses of Parliament, London. Begun 1836; opened 1852; completed 1870. Barry, who won the 1835–36 competition to design the new Houses of Parliament, hired Pugin to help with the detailing. The resulting Gothic Revival complex even has Gothic Revival inkwells and coatracks.

The decision to rebuild the Houses of Parliament in the Gothic Revival style (fig. 481) was not based solely on aesthetic grounds. A more profound cultural and moral basis declared that the Gothic style was historically appropriate, for it had flourished in England during the late medieval period. And, more important for the nineteenth century, the Gothic was understood as a style that expressed spiritual goodness, truth, and the properly reverent relationship between humanity and God.

And, of course, the Gothic was understood as the quintessential Christian style. One critic in 1836 described it as "a style of architecture which belongs peculiarly to Christianity . . . whose very ornaments remind one of the joys of life beyond the grave; whose lofty vaults and arches are crowded with the forms of prophets and martyrs and beatified spirits, and seem to resound with the choral hymns of angels and archangels . . . the architecture of Christianity, the sublime, the glorious Gothic."

The Romantic architects of the nineteenth century revived a multitude of historical styles, but each was understood within a specific cultural, moral, and historical context that encompassed both the nineteenth century and the period when the style originated. The Greek Revival in America, for example, as witnessed in a house in Demopolis (City of the People), Alabama (fig. 482), and in hundreds of banks, courthouses, churches, and homes throughout America, was a response to a movement to

BARRY and PUGIN, Houses of Parliament: begun 1836
1837–1901: Reign of Queen Victoria
1840: Penny post is established in England

482. Unknown architect
Gaineswood, Demopolis, Alabama. 1842–c. 1860. The heritage of the early-nineteenth-century American enthusiasm for things Greek survives in structures in the Greek Revival style in stone, wood, and stucco, in coordinating furniture and decorative arts, and in such place names as Demopolis; Troy, New York; Olympia, Washington; and Sparta and Athens, Michigan.

483. ALEXANDER JACKSON DAVIS
William Rotch House, New Bedford, Massachusetts. 1845

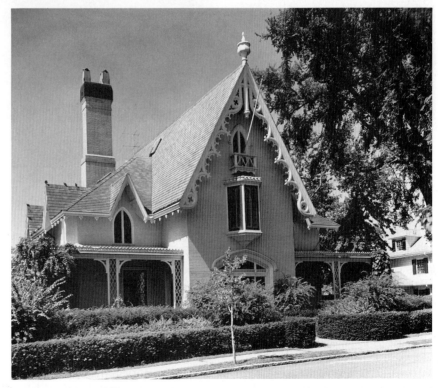

find an architectural style appropriate for the political ideals of the young nation. Thomas Jefferson had championed the Neoclassical style (see p. 400), but the early nineteenth century turned more directly to the monuments of ancient Athens, history's first documented democracy, for inspiration. American architects and publishers produced how-to books with plans and elevations for Greek-style houses and churches, and all across America buildings with handsome Doric porticoes—some in stone but many in wood, like this one—were erected.

In America the Greek style was gradually supplanted in popularity by the Gothic Revival style. A. J. Davis's home in New Bedford, Massachusetts (fig. 483), is decorated with the architectural vocabulary invented in the later Middle Ages for the great French Gothic cathedrals. The cusping along the eaves and the lacy patterns of the porch posts—cut from wood—are an American version of the gilded ornamentation on a medieval Gothic reliquary. The widespread popularity of this "carpenter" Gothic movement and other revival styles can be explained in part by the cheap pattern books produced by architects and publishers that brought such fantasy within the range of every pioneer with a saw.

ROMANTIC PAINTING IN AMERICA

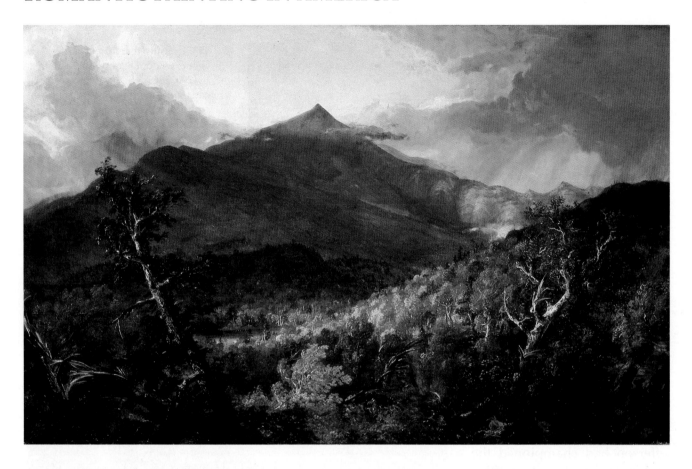

"A landscape is great in its proportion as it declares the glory of God, not the works of man" (Asher B. Durand, *Letters on Landscape Painting*). Enthusiasm for the God-given beauty and richness of the American landscape is the subject of Cole's painting (fig. 484). A dramatic natural confrontation is emphasized as the sweeping peak soars victorious above the clouds. The season is autumn, when the American landscape offers a special coloristic splendor not found in the landscapes of Europe. Schroon Mountain is located near the source of the Hudson River in New York State, and after visiting there in 1837, Cole wrote: "The scenery . . . has a wild sort

of beauty . . . quietness—solitude—the world untamed . . . an aspect which the scene has worn thousands of years. . . . I do not remember to have seen in Italy a composition of mountains so beautiful or pictorial as this."

Cole's emphasis on the uniqueness of American scenery is significant, for in his paintings nationalistic spirit was joined to the ideal of the American landscape as a new Garden of Eden— a God-given paradise which would guarantee America's future greatness. Cole himself was to write: "Those scenes of solitude from which the hand of nature has never been lifted affect the mind with more deep-toned emotion than aught which

484. THOMAS COLE
Schroon Mountain, Adirondacks.
1838. Oil on canvas, 39 3/8 x 63".
Cleveland Museum of Art (Hinman
B. Hurlbut Collection). The mayor
of New York City wrote, "I think
every American is proud to prove
his love of country by admiring
Cole."

the hand of man has touched. Amid them the consequent associations are of God, the Creator. They are his undefiled works, and the mind is cast into the contemplation of eternal things." Later the landscape painter Asher B. Durand wrote that every American family should own a painting of the American landscape, counseling that it should hang in the parlor, over

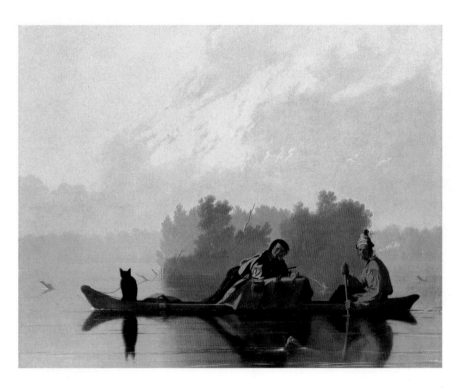

485. GEORGE CALEB BINGHAM
Fur Traders Descending the Missouri. 1845. Oil on canvas, 29 x 36". The Metropolitan Museum of Art, New York (Morris K. Jessup Fund, 1933). Bingham's original title for this work was *French Trader and Half-Breed Son.* There is still debate about the identification of the tethered animal. In a later version of this same theme, however, it is clearly a bear cub.

seemed an especially democratic art, for its meaning was immediately accessible to the public, without scholarly reference.

In Bingham's painting (fig. 485) our romantic, atmospheric view of the wide American river is momentarily disrupted as a dugout canoe moves downstream, close to us and in sharp focus. The trailing smoke from the trader's pipe reveals the speed of the current. The old trader and his son look at us with contrasting expressions—the boy seems bemused, the father serious.

Bingham's composition places the canoe parallel to the picture plane to emphasize both the horizontal vastness of the mighty river and its right-to-left movement. A surprising percentage of the painting is given over to the sky, where the sudden luminosity of dawn highlights the wispy clouds. The subdued colors and blurred forms of the atmospheric setting give emphasis to the foreground forms, which are richer in color and pattern and more precisely executed. These are in turn blurred themselves in the splendidly painted reflection. Bingham's painting of life on the frontier, an evocation and exaltation of the American west, was intended for an audience in the urbanized cities of the east.

the table where the family Bible was kept.

America's first painters had concentrated on portrait painting (see p. 398), an art which flourishes in democratic, mercantile societies. In the late-eighteenth and early-nineteenth centuries, however, a number of painters went to Europe to study, returning home full of enthusiasm for Neoclassical history painting (see p. 402). They soon discovered that the intellectual subjects of history painting held little appeal for the American public or patrons. Beginning in the 1820s American scenery was identified as the ideal subject for American artists, and it was Thomas Cole who was recognized by his contemporaries as the first great painter of the American landscape. Landscape

FRENCH REALISM: GUSTAVE COURBET

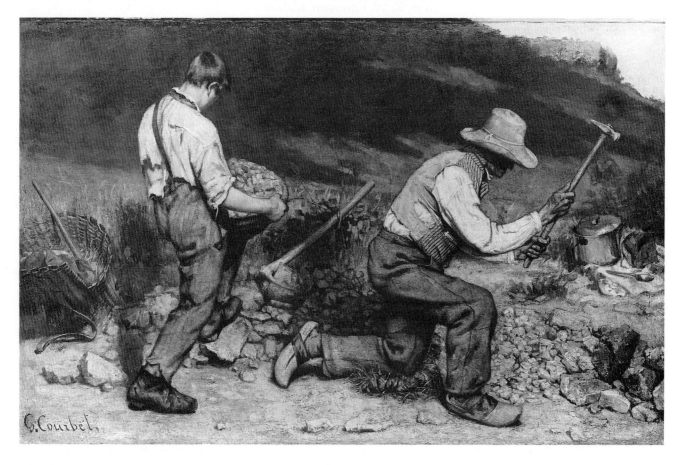

486. GUSTAVE COURBET
The Stone Breakers. 1849. Oil on canvas, 5' 3" x 8' 6". Formerly Gemäldegalerie, Dresden (destroyed in 1945)

"The art of painting can consist only in the representation of objects visible and tangible to the painter. An epoch can be reproduced only by its own artists. I mean by the artists who have lived in it. I hold that the artists of one century are fundamentally incompetent to represent the things of a past or future century. . . . It is in this sense that I deny the existence of an historical art applied to the past" (Gustave Courbet, 1861).

To our eyes, there is nothing offensive about Courbet's *Stone Breakers* (fig. 486), for the scene of a youth assisting an older man in breaking stones for a roadbed is a genre subject, an objective view of life in the mid-nineteenth century. When it was first exhibited, however, *The Stone Breakers* shocked and angered critics and public alike. During the Neoclassical and Romantic eras, the significance of a painting was judged by the didactic virtue of its theme and by the painter's adherence to academic rules of composition and execution. Courbet broke these rules, insisting that the only goal of the artist was to reproduce "objects visible and tangible to the painter." To those schooled in the traditional attitudes about art, however, truly commonplace figures and subjects seemed trite, even vulgar.

Courbet's words were given an even fuller expression in *A Burial at Ornans* (fig. 487). We stand at the side of a grave during a funeral in Courbet's hometown, outside Paris. Virtually without comment, Courbet records the visual facts: a priest and attendants reciting prayers, the mourners and a gravedigger, a dog, and a hole in the ground in the immediate foreground. No spiritual promises of an "eternal reward" are apparent here. The emotional pulse of Romantic painting has given way to simple, direct observation.

COURBET, *The Stone Breakers:* 1849
1846: Potato famine in Ireland
1848: Marx and Engels, *Communist Manifesto*
1848: First convention of women's rights, New York
1848-49: Revolutions in France and elsewhere

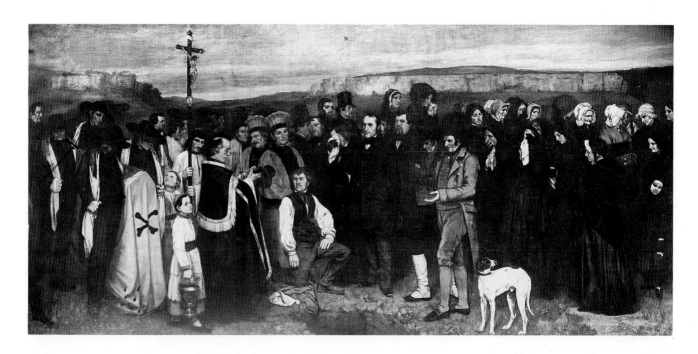

487. GUSTAVE COURBET
A Burial at Ornans. 1849. Oil on canvas, 10' 3 1/2" x 21' 9". Musée d'Orsay, Paris

When Courbet's *Burial at Ornans* and another large painting were rejected by the jury of the Universal Exposition of 1855, an infuriated Courbet withdrew the eleven pictures they had accepted and had his own exhibition building constructed, where, with customary bravado, he held a one-man show in competition with the official exhibition. The so-called Realist Manifesto, which may have been written in part by the Realist writer and critic Champfleury, was actually the introduction to the catalogue of Courbet's private exhibition: "The title of 'realist' has been imposed upon me, as the men of 1830 had imposed upon them the title of 'romantics.' Titles have never given a just idea of things; were it otherwise, the work would be superfluous. Without

trying to clear up the degree of correctness of a qualification which no one, one must hope, will be asked to understand exactly, I will limit myself to a few words of explanation to cut short any misunderstanding.

"I have studied the art of the masters and the art of the moderns, avoiding any preconceived system and without prejudice. I have no more wanted to imitate the former than to copy the latter; nor have I thought of achieving the idle aim of *art for art's sake.* No! I have simply wanted to draw from a thorough knowledge of tradition the reasoned and free sense of my own individuality.

"To know in order to do: such has been my thought. To be able to translate the customs, ideas, and appearance of my time as I see them—in a word, to create a

living art—this has been my aim."

In a letter, Courbet wrote to a patron that Realism was "a holy and sacred cause, which is the cause of Liberty and Independence." Throughout the 1850s Courbet's paintings gained greater public acceptance, although critics also became more vociferous, accusing him of being a propagandist for leftist or socialist causes. Courbet's redirection of subject matter toward the realism of the commonplace was an important influence on younger French artists, especially Édouard Manet and the Impressionists (see pp. 440 and 446).

ACADEMIC ART

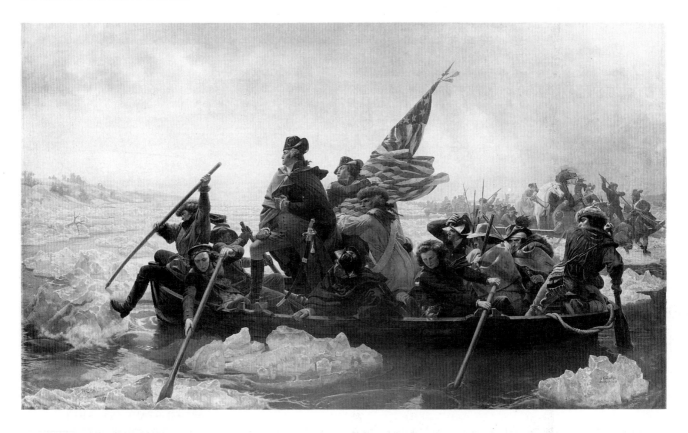

488. EMANUEL LEUTZE
Washington Crossing the Delaware. 1851. Oil on canvas, 12' 5" x 21' 3". The Metropolitan Museum of Art, New York (Gift of John S. Kennedy, 1897). When this painting was exhibited in New York in 1852, fifty thousand people paid to see it, and the wide sale of a reproductive engraving made this one of the most famous images in America. Leutze worked hard to make his painting authentic, but history buffs will note a number of errors.

Washington Crossing the Delaware (fig. 488) reveals the Academic approach to history painting, with its blend of a serious subject, historical fact (or what passes for historical fact), artistic manipulation, precise detail, and a carefully digested blend of elements studied from the High Renaissance and Baroque masters. Although he had grown up in America, Leutze returned to his native Germany to spend many years teaching and studying at the influential academy at Düsseldorf. Many American painters studied there, returning to America to advocate the strict and precisely painted realistic style for which the Düsseldorf academy and Leutze were famous.

The highest goal of Academic painters was to create history paintings of significant moral import, paintings which would document the past and provide inspiration and guidance for the future. In his painting, Leutze set out to express the significance of Washington's crossing of the Delaware. His success can be judged by the manner in which his treatment continues to capture the public's enthusiasm. It is through this painting that generations of schoolchildren have come to understand a famous national event; rather than representing history, Leutze's painting has formed it. The success of the picture is based on its precise and studied realism, a style which makes its historical theme convincing. Even more important is the striking composition, with a

LEUTZE, *Washington Crossing the Delaware:* **1851**
1845: Wagner, *Tannhäuser*
1850–59: U.S. receives 2.5 million immigrants
1851: First submarine cable, under the English Channel
1861: Most of Italy is united as one kingdom

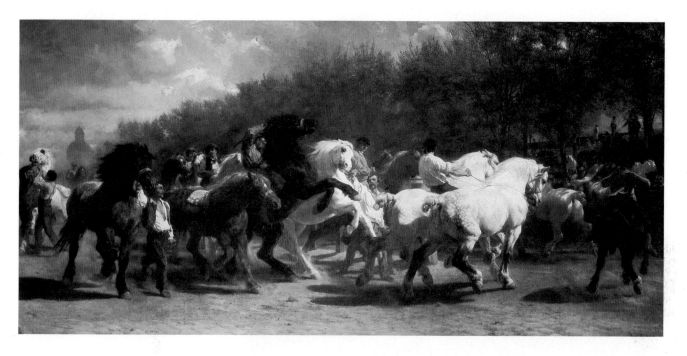

489. ROSA BONHEUR
The Horse Fair. 1853; retouched 1855. Oil on canvas, 8' x 16' 7 1/2". The Metropolitan Museum of Art, New York (Gift of Cornelius Vanderbilt, 1887). Like many women artists in the period before 1900, Rosa Bonheur was the daughter of an artist. She and her sister and two brothers all began receiving art lessons while young; Rosa, the eldest and most success- ful, began to study at the Louvre at the age of fourteen and by nineteen was exhibiting in the Paris Salons. Her works received great critical and popular success. In 1865 the empress of France awarded her the Cross of the French Legion of Honor, declaring "genius has no sex." The youthful horse trainer in the center, wearing a black cap, may be a self-portrait.

valiant Washington shown stand- ing heroically against the wind.

Rosa Bonheur's *Horse Fair* (fig. 489) was one of the most famous paintings of the nineteenth cen- tury. After creating a sensation at the Salon of 1853, it toured to crowds in America for three years. The painting's success can be attributed to its academic re- alism, which extends from an expert understanding of animal anatomy (Bonheur went often to horse fairs, disguised as a boy, to draw from the living animals) to

the precise rendition of the pebbles in the foreground. The effective composition is the re- sult of numerous studies of de- tails and of the whole design. Most impressive is the powerful movement of the horses and men that surges, almost uncontrolled, across the breadth of this huge painting. Bonheur here modified her usually fine brushstroke for a bolder stroke to enhance the ef- fect of rippling energy, and the natural colors of the horses are heightened by contrast with the

brilliant colors worn by the grooms. Paintings and sculptures of animals were popular in the nineteenth century, in part be- cause they functioned as meta- phors for the more human con- tent that painters were reluctant to represent. The combination of grace and power in Bonheur's beautiful horses communicates an ideal of energy and vitality.

NEW MATERIALS AND ENGINEERING IN ARCHITECTURE

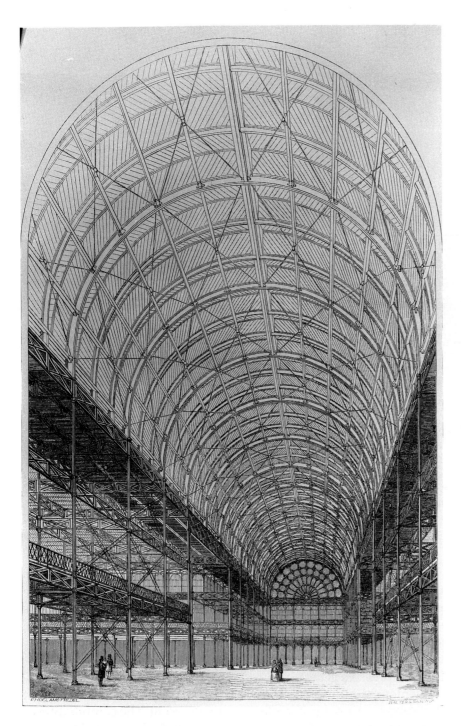

Interior, The Crystal Palace,
London. 1850–51 (destroyed). Cast
iron, wrought iron, and glass,
length 1,848'; width 408'.
Engraving by R. P. Cuff after W. B.
Brounger. Drawings Collection,
Royal Institute of British Architects,
London. The Crystal Palace was an
enormous structure erected to
house the Great Exhibition of
the Works of Industry of All
Nations—the first in a great series
of nineteenth-century international
exhibitions that presaged the
world's fairs of our own day. The
largest single enclosed volume
erected up to that date, it covered
almost one million square feet of
floor space. It was later disassem-
bled and rebuilt on another site.

The Crystal Palace (fig. 490) dem-
onstrates two new developments
that transformed architecture
during the second half of the nine-
teenth century: the importance
of new, artificial materials and the advantages of prefabrication.
This huge structure of prefabri-
cated cast-iron membering and
glass was made and erected in
nine months, proving the speed
and economy of such a proce- dure. The basic module used in
the design of the building was
not based on aesthetic principles
but on a practical fact: the maxi-
mum size of the glass which could
be manufactured was approxi-
mately four feet. The cast-iron
components were based on the
larger module of twenty-four
feet, and no single prefabricated
part was allowed to weigh more
than a ton. Because it was intended
to be a temporary, utilitarian
structure (the exhibits of machin-
ery and other works of art and
industry were the focus), the ref-
erences to earlier architectural
styles demanded in nineteenth-
century building were not re-
quired. One perceptive critic
pointed out that "here the stan-
dards by which architecture had
hitherto been judged no longer
held good,"but the fact remains
that the Crystal Palace was not

491. JOHN A. ROEBLING
Brooklyn Bridge, New York.
1869–83. Stone piers with steel
cables, maximum span 1,595'

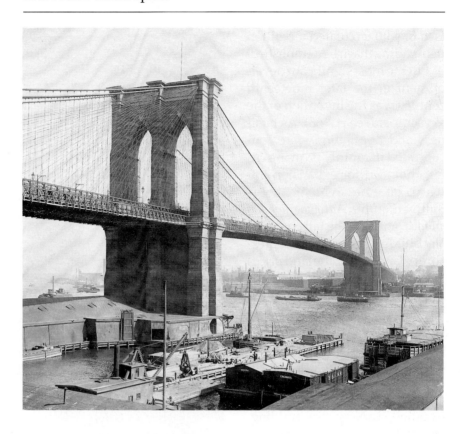

considered to be architecture with a capital *A*. There was no re-evaluation here, as there was with virtually all other nineteenth-century structures of significance, which were endowed with references to traditional architectural styles (see p. 426).

The new technological investigations and accomplishments of the nineteenth century were widely published in books and technical journals and thus their impact could be immediate and universal. Metal and glass were at first held to be fireproof, but iron proved to be susceptible to melting and collapse in a conflagration. Ironically, the Crystal Palace itself was ultimately destroyed by fire, but only in 1936.

The Brooklyn Bridge pioneered another new material—steel (fig. 491). The advantages of using metal for bridges were first realized in a cast iron bridge erected in England in 1779. In bridge-building, cast iron was subsequently replaced by wrought iron, and wrought iron by steel. The Brooklyn Bridge is more than half again as long as any earlier bridge, and its four huge cables are formed from parallel galvanized drawn steel wires that were spun in place to create an ultimate strength of 71.5 tons per square inch. But despite the modern technology that made this huge span possible, the dramatic masonry supporting piers were given Gothic arches.

Before he won the competition to build a temporary structure for the Universal Exposition of 1889, Gustave Eiffel had established an international reputation as an engineer and designer of bridges, locks, and the skeleton for *The Statue of Liberty* (see fig. 460). The purpose of his tower (fig. 492) was to provide a dramatic and unforgettable symbol for the exposition and, by elevators, to make it possible for fairgoers to have fabulous views of Paris. But Eiffel also set out to design a pleasing structure, and he disguised the underlying modern grid frame on which the work is engineered with sweeping curves and dramatic proportions. Even so the design was

criticized as a monstrosity, and the architect Charles Garnier (see p. 438) circulated a petition demanding that it be demolished.

But the most significant development in the later nineteenth century was the invention of the skyscraper (see p. 466). As business and population were concentrated in rapidly growing cities, the need for expansion upward became evident. Louis Sullivan, in his *Autobiography of an Idea*, wrote: "The tall commercial building arose from the pressure of land prices, the land prices from pressure of population, the pressure of population from external pressure." In 1852 Elisha G. Otis invented the Otis safety elevator, which he demonstrated at a New York industrial fair in 1854. By 1857 the first commercial passenger elevator had been installed in a New York building, and in 1861 Otis made a significant improvement by patenting a steam-powered elevator. Before Otis's invention, the height of a building had been limited by how many flights of steps the owner was willing to make his clients climb. With an elevator the height was limited only by the potentials of the material available and the economics of high construction.

Most urban structures were of heavy masonry (that is, stone or brick) construction, and the taller the building, the heavier the lower stories had to be to support the tremendous weight of the increased height. All this changed with the development of the load-bearing steel cage, based on the new lower price of steel due to the invention of the Bessemer process (1855), and of reinforced concrete.

492. GUSTAVE EIFFEL
Eiffel Tower, Paris. 1887–89. Wrought-iron superstructure on a reinforced concrete base, original height 984'; current height 1,052'. Eiffel's design was the winning entry from seven hundred submissions in a competition to design a temporary structure for the Paris Universal Exposition of 1889, which celebrated the one-hundredth anniversary of the French Revolution. Until the erection of the Empire State Building in 1930–32, the Eiffel Tower was the tallest structure in the world.

NEW STRUCTURAL PRINCIPLES IN ARCHITECTURE: LOAD-BEARING STEEL-FRAME CONSTRUCTION AND REINFORCED CONCRETE

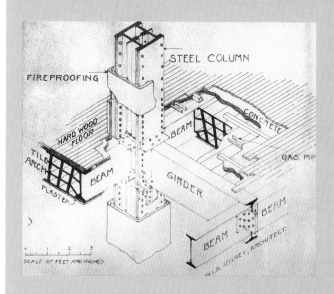

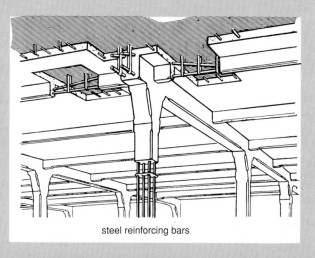

steel reinforcing bars

431. FRANÇOIS HENNEBIQUE
Diagram of monolithic reinforced-concrete joint; patented 1892

493. WILLIAM LE BARON JENNEY
Detail of steel-frame construction, as used in the Fair Store, Chicago. 1890–91

Load-bearing steel-frame construction (fig. 430) is based on an earlier development in wood, the balloon frame, in which wood joists are joined horizontally and vertically to create grids which become a skeletal structure for the building. Both outer "skin" and inner walls are attached to and hang from this skeleton. Load-bearing steel-frame construction employs the same method, but the load-bearing members are prefabricated steel I-beams. In constructing tall buildings, the steel frame offers several significant advantages. The high tensile strength of steel, for example, makes possible a substantial reduction in both the amount of material needed and the thickness of the walls. In a brick or stone walled structure, each story that is added to the height means a significant increase in the thickness of the walls at the base: "It was inherent in the nature of masonry construction to fix a new limit of height; as its ever-thickening walls ate

up ground and floor space of ever-increasing price, as the pressure of population rapidly increased" (Louis Sullivan, *The Autobiography of an Idea*, 1926). Steel is much stronger, and its tensile strength means that the finished building will have the elasticity necessary to allow it to move and respond to the pressure from high winds, a problem in a masonry building, which will topple because it cannot sway.

Reinforced concrete (fig. 431), in which concrete is strengthened by embedded wire rods or mesh, was developed in France in the second half of the nineteenth century. The steel gives the concrete an impressive tensile strength. It is a remarkably flexible material and can be formed at the site, during construction, or prefabricated. As is typical of the nineteenth century, this economical new construction method was first used only for utilitarian structures such as mills.

REVIVAL ARCHITECTURE, LATE NINETEENTH CENTURY

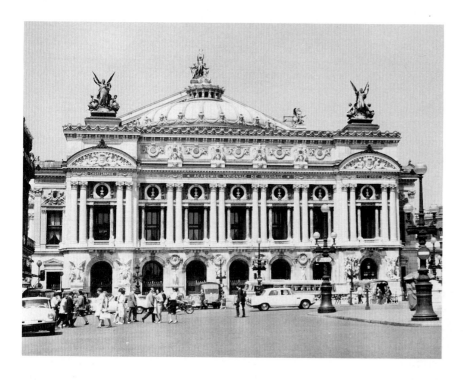

495. CHARLES GARNIER
The Opera, Paris. 1861–75

Many mid- to late-nineteenth-century buildings impress us by their scale, richness of materials, and inventive abundance of historical references. The style of Charles Garnier's design for the Paris Opera (fig. 495) can be termed Second Empire Italianate Neo-Renaissance/Baroque, revealing the eclecticism of this building which, in its visual effect, seems so unprecedented. More sumptuous than any Baroque structure, it established a standard of extravagant decoration for cultural institutions which would have a wide impact, affecting even the development of the motion picture "palace" in twentieth-century America. The opulence of the exterior, with its sculptures (see fig. 504), mosaics, and gilded details, is continued in the interior with a magnificent grand staircase, foyer, and auditorium. Garnier stated his philosophy in pointing out that a "staircase crowded with people was a spectacle of pomp and elegance" and that "by arranging fabrics and wall hangings, candelabra . . . and chandeliers, as well as marble and flowers, color everywhere, one makes of this ensemble a brilliant and sumptuous composition." This is the kind of architecture that is popularly termed Victorian, whether it was built within the empire of Queen Victoria or not.

Richardson's courthouse and jail (fig. 496), erected for one of the world's great industrial centers, uses a modern version of the Romanesque style which avoids decoration to emphasize mass, weight, and solidity. The heavily rusticated walls, corner pavilions, and tall, centralized tower of the courthouse express the enduring authority of law and government. In contrast, the jail offers irregular masses, a lively silhouette, and unexpected placement of openings, effects which may refer to lawlessness and a lack of order. This "iconography" is not accidental, for the building specifications from the Allegheny County commissioners indicated that "the buildings should suggest the purpose for which they were intended." A low bridge, copying examples in Venice, allows a secure transfer of the accused to trial in the courthouse. Richardson's particular, personal use of the Romanesque style (see p. 210) had a widespread popularity in the 1880s. Perhaps its sheer weight and architectural presence were reassuring after the disruptive trauma of the Civil War. Richardson's first biographer wrote of the courthouse: "It is as new as the needs it meets, as American

496. HENRY HOBSON RICHARDSON
Allegheny County Courthouse and Jail, Pittsburgh. 1884–88.
Richardson died without seeing these buildings completed; when he realized that he was seriously ill, he wrote: "Let me have time to finish Pittsburgh and I shall be content without another day." This illustration reproduces a print of Richardson's design that he submitted to win the competition for the project. It preserves the original appearance of the entrance portals and the steps, which are today modified.

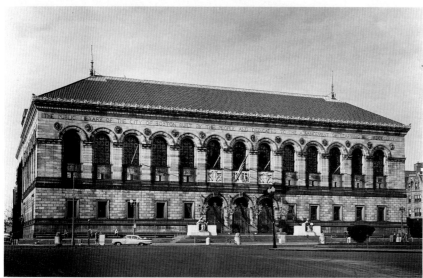

497. MCKIM, MEAD, & WHITE
Public Library, Boston. 1887–95

as the community for which it was built. Yet it might stand without loss of prestige in any city in the world." Richardson himself was most pleased with its mas-sive scale: "If they honor me for the pigmy things I have already done, what will they say when they see Pittsburgh finished?"

In the closing decades of the nineteenth century, a monumental classical style was re-created in the works of America's most popular architectural firm, McKim, Mead, & White. Their white granite Boston Public Library (fig. 497) seems like a grandiose Renaissance palace. A row of impressive rounded arched windows emphasizes the second floor. The inspiration from Renaissance palaces is perhaps not purely aesthetic, for the trustees' commission was for a "palace for the people." A dignified inscription across the facade expresses the building's public purpose and patrons: "The Public Library of the City of Boston Built by the People and Dedicated to the Advancement of Learning." This is the most important building of a movement sometimes known as the American Renaissance.

ÉDOUARD MANET

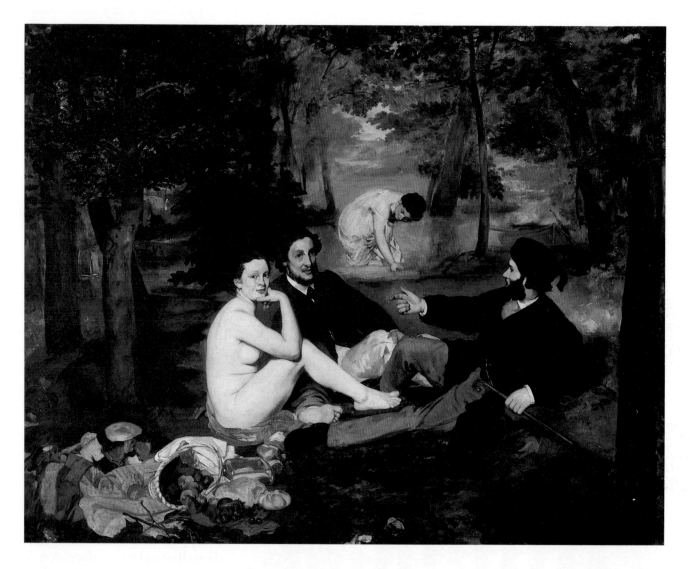

498. ÉDOUARD MANET
Le Déjeuner sur l'herbe (The Picnic).
1863. Oil on canvas, 7' x 8' 10".
Musée d'Orsay, Paris

"A commonplace woman of the demimonde, as naked as can be, shamelessly lolls between two dandies dressed to the teeth. These latter look like schoolboys on a holiday, perpetrating an outrage to play the man, and I search in vain for the meaning of this unbecoming rebus. . . . This is a young man's practical joke, a shameful open sore not worth exhibiting this way. . . . The landscape is well handled . . . but the figures are slipshod" (a critique of *Le Déjeuner sur l'herbe*, 1863).

Manet's *Déjeuner sur l'herbe* of 1863 (fig. 498) created a scandal, even at the Salon des Refusés (see p. 412). Its iconography is perplexing. We are unashamedly confronted by a female nude, her dress and undergarments thrown down near a basket of luscious fruit in the foreground. She is accompanied by two fully clothed men, while in the middle ground a second woman bathes in a small lake. The visual impact of Manet's style is equally powerful and unexpected, for the

startling lack of modeling in the female nude and the large strokes of thick, rich paint had not been seen in earlier French painting. The abstract passages of paint that create the fruit are especially beautiful. In iconography and composition *Le Déjeuner sur l'herbe* was in part inspired by Renaissance works by Giorgione and Raphael, but does Manet's

updating of earlier artistic sources have a deeper social meaning, representing the polarity of French society, with the natural world confronting the artificial, or does the painting simply represent artists with their models? We shall probably never know the exact meaning or meanings, but we do know that from Manet onward, a new course was set for avant-garde painting of the late nineteenth century, as artists would begin to turn further and further away from prescribed academic rules in painting.

Two years after the French critics and public were shocked by *Le Déjeuner*, they were sent reeling by Manet's entry in the 1865 Salon. The scandal revolved around both Manet's methods of painting, with loose brushstrokes and flat areas of color, and his disrespect for proper subject matter. Here (fig. 499), in the pose usually reserved for the idealized female nude, Manet has realistically painted Victorine, a model. One of Manet's sources was Titian's *Venus of Urbino* (see fig. 349), a painting which helped establish the theme of the reclining nude female figure as a subject and of which Manet had made a copy. The sleeping dog, a symbol of fidelity for Titian, has become a lively black cat, a traditional symbol of lust. Titian's servants attend to their work, but Olympia's maid brings flowers, a gift from a client. The public and critics argued that not only was Manet painting mundane subjects, but that he did not even paint these with the proper technique.

Manet did have his champions, however, and one was the noted author and critic Émile Zola. In writing a defense of Manet, Zola pointed out that Manet's paintings are responsive to life, rather than to academic traditions of art: "M. Manet's temperament is dry, trenchant. He catches his figures vividly, is not afraid of the brusqueness of nature and renders in all their vigour the different objects which stand out against each other. His whole being causes him to see things in splotches, in simple and forceful pieces. . . . Don't bother looking at the neighboring pictures. Look at the living persons in the room. Study the way their bodies look against the floors and walls. Then look at M. Manet's paintings: you will see that there lies truth and strength."

Manet's devotion to painting form as he saw it, irrespective of its meaning, is summarized in Zola's comments as one of Manet's subjects: "I remember posing for hours on end. . . . Now and again, half dozing as I sat there, I looked at the artist standing at his easel, his features taut, his eyes bright, absorbed in his work. He had forgotten me; he no longer realized that I was there." When Manet died in 1883, Zola, Degas, and Monet all served as pallbearers. Renoir and Pissarro paid their respects, and even the reclusive Cézanne came to Paris from Provence.

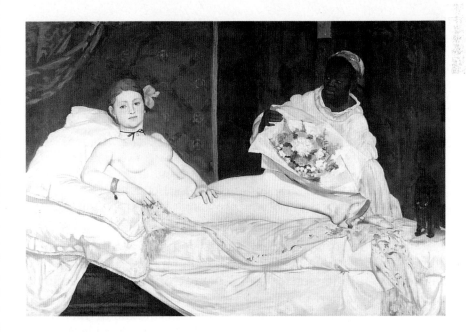

499. ÉDOUARD MANET
Olympia. 1863. Oil on canvas, 51 x 74 3/4". Musée d'Orsay, Paris. Of Manet's *Olympia*, the later painter Cézanne would say, "Our Renaissance dates from it." The source and exact meaning of Manet's title are obscure.

EARLY PHOTOGRAPHY; PHOTOGRAPHIC TECHNIQUE

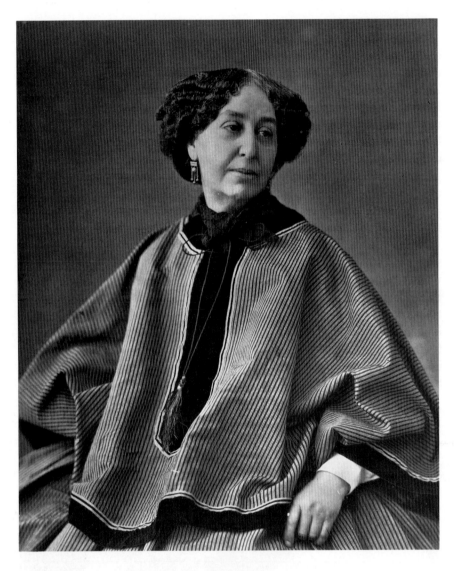

500. NADAR (GASPARD-FÉLIX TOURNACHON)
George Sand. 1864. Albumen print. George Eastman House, Rochester, New York. George Sand was the pen name of Aurore Dupin, an important French novelist and feminist.

Nadar's portrait of George Sand (fig. 500), with its controlled lighting and careful attention to pose and detail, was part of a series which included the major French literary and artistic figures of the mid-nineteenth century. That such a series should be produced is not novel, but that it was produced using the relatively new photographic medium greatly assisted the legitimization of photography. Nadar pioneered the use of interior studio lighting, and even today his portraits communicate the dignity of his sitters with a refined and articulate image.

One of the components of photography (from the Greek *photo*, light, and *graphis*, to write or describe) dates back centuries. The camera obscura (from the Latin, meaning dark room) was an enclosed box with an opening at one end. Rays of light passing through the opening projected an inverted image on the opposite wall. The *camera obscura* had been in use since the Renaissance and was primarily an aid in understanding perspective. Artists traced the projected image inside the "camera." What was lacking, however, was a method to "fix" that image, a process whereby it could be made permanent. In the early eighteenth century it was discovered that silver salts were light sensitive, and, building on this and other, more recent advances, Joseph-Nicéphore Niépce in 1826 created the first photograph using a *camera obscura* and a pewter plate coated with bitumen, a light-sensitive substance. Niépce's first photograph required an eight-hour exposure time.

In 1829 the elderly Niépce formed a partnership with Louis Daguerre, who, in 1837, successfully produced the first daguerreotype, which used a chemically treated silver-plated sheet of copper to retain the image. The result was a far clearer image than Niépce's, with a greatly reduced exposure time. Improvements in the next decade made the daguerreotype practical, with an exposure time of thirty to sixty seconds. Daguerre's excited claim, "I have seized the light, I have arrested its flight," announced the beginning of modern photography.

Developments in photography quickened. In 1839 William

501. Diagram of a camera

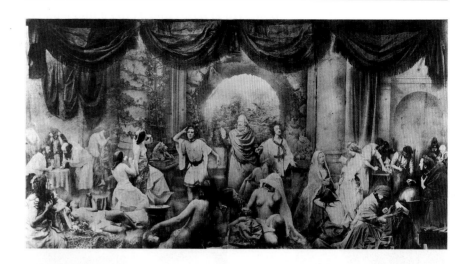

502. OSCAR REJLANDER

The Two Paths of Life. 1857. Combination albumen print, 16 x 31". George Eastman House, Rochester, New York. To achieve this tableau-like effect, Rejlander photographed a model of the set and each of the figures separately. These thirty negatives were then printed on one photographic paper.

Henry Fox Talbot, a British scientist, invented the photographic negative, allowing multiple prints to be made from the same exposed plate, and by mid-century glass-plate negatives were being used to produce remarkably sharp images. Our illustration (fig. 501) shows a modern version of a camera.

The early relationship between photography and art was, at best, a difficult one. Some photographers, such as Oscar Rejlander, sought to make photography an art by copying the traditional themes found in contemporary academic painting. *The Two Paths of Life* (fig. 502) represents an allegorical subject. As a photograph it is impressive for its size and technical achievement, for it was a combination print which consisted of thirty negatives individually printed on a single sheet of paper. The young men on either side of the elderly father must choose between a life of virtue, displayed on our right, or a life of vice. Such an overtly theatrical composition was related to the publicly accepted values of Academic Art (see p.

432). Here photography tried to "copy" painting to win public acceptance.

It was, however, in portraiture that photography found its most immediate and popular use. The reduced exposure time and affordable price made photographic portraits available to almost everyone. Julia Margaret Cameron developed a distinctive style which emphasized the face of the sitter (see fig. 503). Cameron was fully aware that photography is not just a medium which reproduces reality. Speaking of her portraits, she wrote, "When I have such men before my camera, my whole soul has endeavoured to do its duty toward them in recording faithfully the greatness of the inner man as well as the features of the outer man. The photograph thus taken has been almost the embodiment of a prayer."

503. JULIA MARGARET CAMERON

Alfred Lord Tennyson. 1865. Silver print, 10 x 8". Royal Photographic Society, London. Cameron, who began photography only in her late forties, after she had received a camera as a gift, was primarily self-taught. The poet Tennyson was a friend and neighbor.

IMPRESSIONISM

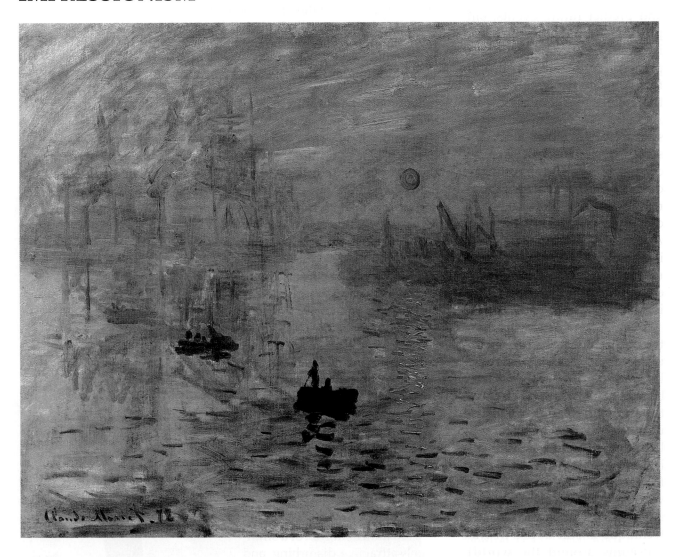

507. CLAUDE MONET

Impression-Sunrise. 1872. Oil on canvas, 19 1/2 x 25 1/2". Musée Marmottan, Paris. When their paintings were rejected for the Salon exhibitions, a group of painters, some of whom we today classify as Impressionists, decided to hold independent exhibitions. The first of a series of eight such exhibitions was held in Paris in 1874; it included this painting. It was sponsored by a group which called itself the "Anonymous Society of Painters, Sculptors, Engravers, etc.," a title which indicates the diverse nature of this group, who had banded together to create independent exhibitions and not because of any notion of stylistic unity. Monet's painting of the *Rue Saint-Denis Festivities on June 30, 1878* (fig. 456) was included in the Fourth Independent Exhibition, in 1879.

Impressionist paintings such as Monet's *Impression-Sunrise* engage us immediately by their ravishing depictions of nature (fig. 507). Here Monet's representation of the interaction of light, atmosphere, and color heightens our awareness of the beauty in the seascape. But it is important to realize that Monet did not set out to paint a beautiful picture. His goal was to create a painting that recorded reality as he saw it. As an Impressionist, he wanted to capture in paint the visual effect of reality as it appeared to him at that moment. Monet was especially sensitive to transitory effects of color—how color changes in response to shifting light and varying atmospheric conditions. In *Impression-Sunrise* the combination of the moving surface of the water and the red/orange rays of the

sun provided a perfect vehicle for his demonstration.

Impressionism had a strong scientific basis, although this is not immediately obvious in looking at Impressionist paintings. A critic of the First Independent Exhibition said that Monet, Renoir, Degas, and Morisot should be called by the "new term impressionists. They are impressionists in the sense that they render not the landscape, but the sensation produced by the landscape." The use of the term Impression by Monet in his title and the painters' adoption of the term Impressionism suggest the influence of new theories about the physiology of perception. The new color theory emphasized the presence of color within shadows and, in asserting that there was no black in nature, inspired the Impressionists to ban black from their palette. In addition, Impressionism is based on an understanding of the interrelated mechanisms of the camera and the eye: just as a photograph is created by light as it passes through a lens to make an impression on light-sensitive paper, so is our vision the

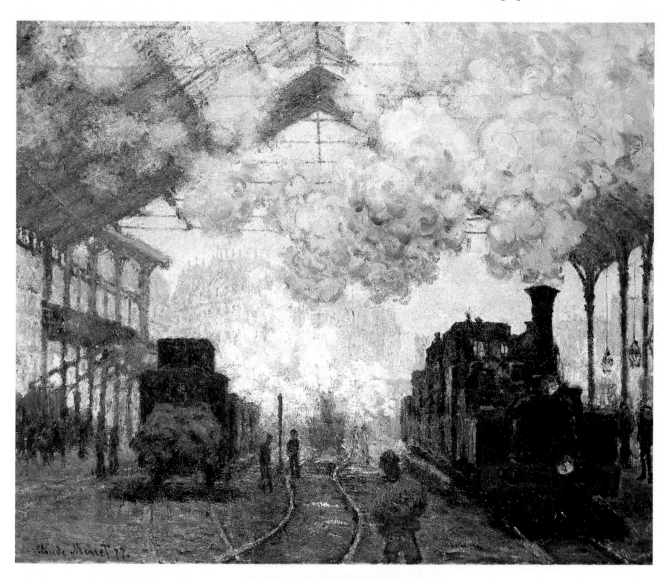

508. CLAUDE MONET
Gare St. Lazare, Paris. 1877. Oil on canvas, 32 1/2 x 39 3/4". Fogg Art Museum, Harvard University, Cambridge, Massachusetts (Maurice Wertheim Collection). This painting was exhibited at the Third Independent Exhibition, in 1877.

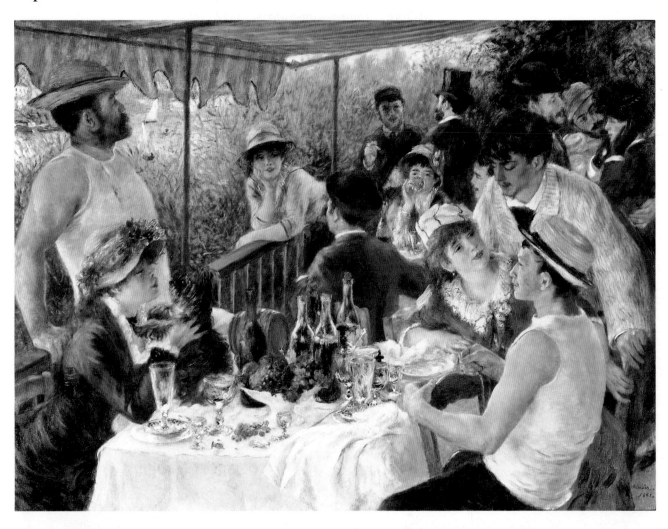

509. AUGUSTE RENOIR
A Luncheon at Bougival (now known as *The Luncheon of the Boating Party*). 1881. Oil on canvas, 51 x 68". The Phillips Collection, Washington, D.C. This work was included in the Seventh Independent Exhibition, in 1882.

result of the light and color which create an "impression" on the back surface of the eyeball. By embracing the principle that subject matter is less important, and in determining that painting should represent as closely as possible what the individual eye sees, the Impressionist painters are clearly related to the realism of Courbet and the innovations of Manet (see pp. 430 and 440). Their works look so different from Courbet's and Manet's because of their scientific interest in how the eye sees, and because of their determination to capture quickly the vivid color that exists in nature, whether in light or in shadow.

Monet's emphasis on painting visual reality means that his subjects are scenes or views of the world around him, but it is not accidental that he was one of the first painters of the modern urban cityscape. By painting the city streets and the railroad station, as in the *Gare St. Lazare* (fig. 508), he emphasized the actuality of modern life. In the railroad station, the open air in the background interacts with the light that filters down through the glass roof and the billowing smoke of the engines to provide another appropriate vehicle for Monet's investigation of the ever-changing patterns of light, color, and atmosphere. An Academic

painter would never have chosen such a subject, of course, and if required to paint it, would have rendered the clouds of smoke in tonalities of gray. Monet sees not merely gray, but shades of blue and lavender as well.

Although Renoir embraced the ideas and employed the techniques of the Impressionists, he was interested in human life and relationships, which led him to favor compositions with human figures rather than landscapes. His masterpiece is certainly *A Luncheon at Bougival,* with its everyday subject, casual composition, strong strokes of arbitrary color, and bold *impasto*—the latter is especially evident in the beautiful shimmering glasses and bottles of wine on the table (figs. 509, 510). *A Luncheon at Bougival* was singled out for praise by critics when it was exhibited in the Seventh Independent Exhibition in 1882, and one critic captured the contemporary, momentary quality of Renoir's subject in writing that the painting is "a charming work, full of gaiety and spirit, its wild youth caught in the act, radiant and lively, frolicking at high noon in the sun, laughing at everything, seeing only today and mocking tomorrow. For them eternity is in their glass, in their boat, and in their songs." It was this emphasis on the momentary that made paintings such as this one unacceptable to the Salon juries, who favored history painting with controlled academic technique.

510. AUGUSTE RENOIR
A Luncheon at Bougival (detail)

IMPRESSIONIST TECHNIQUE

To capture the subtle effects of ever-changing light, Monet and the other Impressionists painted outside, on the spot, working quickly with loose, bold strokes of color to create a representation of the impression of color in nature before the light changed. The increased brightness of Impressionist paintings (one critic complained that they made his eyes hurt!) was in part made possible by the use of a canvas covered with white underpainting rather than the beige, tan-reddish, or even darker ground that had been traditional since the Renaissance. In addition, an invention of the Industrial Revolution—the collapsible, sealable tube—made it possible for the Impressionists to paint outside, while the development of synthetic pigments meant that the intense colors they needed were no longer prohibitively expensive. Monet applied paint in rich, thick strokes of virtually pure color, without black. The bold physical presence of these strokes and the heightened color emphasize the surface of the painting. Monet also used a painting stroke which maximized accidental effects of color. By dipping a relatively wide brush into two or more pigments, he allows the colors to blur and blend as the brush strokes the canvas.

EDGAR DEGAS, BERTHE MORISOT, AND MARY CASSATT

Edgar Degas disliked being referred to as an Impressionist and preferred to call himself a realist or an independent. His work nevertheless demonstrates many similarities to Impressionist works, and he exhibited in numerous Independent Exhibitions. Degas's realism is in part revealed by his subject matter, for, no matter how romantic we may find his representations of ballerinas today, they were considered neither an appropriate nor a beautiful theme for art in his own day. He was often criticized for picking unattractive dancers by critics who did not realize that, like the other Impressionists, he was depicting modern life (see p. 447). He also shared with the Impressionists a taste for strong and even arbitrary color, despite the fact that most of his work represents figures in rather subdued interiors. The subtlety of natural light in an interior space provided him with a distinct challenge.

In addition to his concern with light and color, Degas had a special interest in the interaction between movement and composition. One contemporary critic wrote that "Degas continues to be passionately devoted to movement, pursuing it even in violent and awkwardly contorted forms." He found that movement, especially the repeated, choreographed movement of dancers onstage or in rehearsal, had a greater intensity when seen from an unexpected viewpoint. In *The Rehearsal* (fig. 511), the strong diagonal recession of the dancers' parallel arms and legs and of the

511. EDGAR DEGAS
The Rehearsal. c. 1873–74. Oil on canvas, 18 x 24". Fogg Art Museum, Harvard University, Cambridge, Massachusetts (Bequest of Maurice Wertheim, 1951)

windows in the room creates a thrusting perspective, which is counteracted only by the empty space in the right foreground. The broad brushstrokes reemphasize the pictorial surface. The influence of Japanese prototypes (see fig. 457) for Degas's work is evident in the diagonal recession and in the cutting off of the forms by the edges. Degas's peculiarly realistic viewpoint was discussed by one of his friends, Edmond Duranty, who published a pamphlet on *The New Painting* in 1876 in which he pointed out how our visual field is limited by "the frame that endlessly accompanies us . . . cutting off the external view in the most unexpected ways, achieving that endless variety and surprise that is one of reality's greatest pleasures."

We can see the same unusual viewpoint and the compositional motif of the strong diagonal thrust cut off by the edges in Berthe Morisot's *Marine* (fig. 512). When this work was shown in the First Independent Exhibition, a critic remarked, "What a lovely vagueness [there is] in the distance at sea where the tiny points of masts tilt!" Morisot, who once wrote, "My ambition is limited to the desire to capture something transient," remains true to Impressionist principles in striving to capture the strong visual qualities of an actual view. The parasol shields the face of the woman—Morisot's sister Edma, also a painter—and as a result her features are left a blur; her identity is less important than her significance as a colored form

DEGAS, *The Rehearsal:* c. 1873–74
1873: Jules Verne, *Around the World in Eighty Days*
1874: Women's Christian Temperance Union is founded

512. BERTHE MORISOT
Marine (The Harbor at Lorient). 1869. Oil on canvas, 17 1/8 x 28 3/4". National Gallery of Art, Washington, D.C. (Ailsa Mellon Bruce Collection). Berthe Morisot, one of the founders of the Impressionist movement, exhibited in seven of the eight Independent Exhibitions, and her works were also accepted at many of the Salon exhibitions. The artist presented this work to Manet after he admired it. After her death in 1895, a large exhibition of her work was arranged by Monet, Renoir, Degas, and the poet Stéphane Mallarmé.

within the composition. Light reflects from the warm brown of the stone railing to create a pink shadow on her white dress.

Mary Cassatt, an American who trained in France and spent most of her life working there, exhibited in several of the Independent Exhibitions. In writing about works by Cassatt at the Sixth Independent Exhibition in 1881, a critic defined Impressionist practice: "Like her brothers in independence, Manet and Degas, Cassatt works relentlessly to bring her eyes to a state of sensitivity, nervous excitement, even irritation, so she can seize the smallest flicker of light, the smallest atom of color, and the slightest tint of shadow." Another critic, however, voiced the frequent complaint that Impressionist paintings were unfinished, lamenting that Cassatt had changed her style and was now "aspiring to the partially completed image."

Cassatt's *Boating Party* (fig. 513) reveals the inspiration of both Degas and of Japanese prints in the unexpected but realistic viewpoint it enforces. We are behind the rower, and his dark, bold silhouetted form sets off the pastels of the rest of the composition. Cassatt maximizes realism in the partial profile of the rower and the foreshortening of the child's head. Neither is an attractive view, but both are realistic and skillfully executed. Large areas of unmodeled color and the potent compositional shapes of the green interior of the boat and the partial view of the sail emphasize the two-dimensional quality of her composition. In the greater solidity with which she endows her figures, Cassatt reveals her independence within the Impressionist movement.

513. MARY CASSATT
The Boating Party. 1893–94. Oil on canvas, 35 1/2 x 46 1/8". National Gallery of Art, Washington, D.C. (Chester Dale Collection)

AMERICAN REALISM: THOMAS EAKINS AND HENRY TANNER

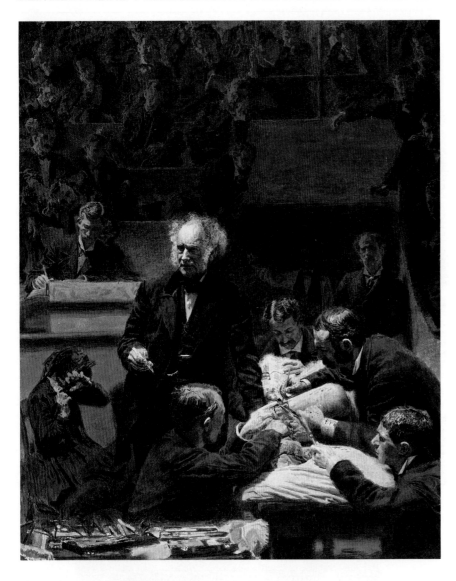

To Thomas Eakins, the Philadelphia physician Samuel Gross was a heroic figure. Gross was a respected surgeon and professor at Jefferson Medical College and a physician with an international reputation. A pioneer in using new techniques in surgery, he was an inspiring educator, teaching medical students both surgical procedures and the human purpose that stood behind the medical profession. Dr. Gross specifically emphasized the significance of clinical instruction, and Eakins represents him in the operating amphitheater at work (fig. 514). He is performing an operation in which he specialized, a new, life-saving treatment for osteomyelitis (infection of the bone), when the diseased bone is cut away. At the same time he is also teaching, and Dr. Gross looks up from the incision in the thigh of the patient, an expression of intense concentration on his face as he searches for words to convey to aspiring doctors the significance of his life's work. He holds a bloody scalpel, the sudden sight of which makes the patient's mother, in the left middle ground, cringe.

Eakins's light is focused and concentrated, and the powerful *chiaroscuro* contrast makes Dr. Gross, teacher and surgeon, a dramatic figure. The sharp overhead light directs our attention to Dr. Gross's head, silhouetting it against the dark background. The craggy features of the face are emphatically three-dimensional, emphasizing the serious line of the mouth and throwing the eyes into meditative shadow. Eakins emphasizes the light as it catches Dr. Gross's bushy gray hair and vigorous sideburns. This visually electrifying effect suggests that Eakins is searching for a concrete metaphor for the intensity of Dr. Gross's thoughts. The original painting has an overall warm harmony, the result of red underpainting which unifies and heightens the limited pal-

ette, with its strong blacks, flesh tones, and areas of white. Punctuation marks of red draw our attention to the pen of the clinical recorder, the incision, and, most importantly, the bloody hand and scalpel of Dr. Gross. In contrast to the abstract treatment of the surgeon's head, his hand and scalpel jump out because they seem to be exactly in focus. Eakins, himself a photographer, seems to have thrown the other parts of his composition out of focus (note especially the loose painting of the instruments in the immediate foreground) to draw attention to the skilled hand and its tool, making them the focal point in his composition. The contrast in treatment between the head and hand is not accidental: while the physical aspect of Dr. Gross's accomplishment is completely comprehensible, the workings of his intellect cannot be discerned.

Eakins painted his *Portrait of Dr. Samuel Gross* specifically to submit to the arts section at the Centennial Exposition, to be held in Philadelphia in 1876. It was rejected, apparently because the subject was not considered appropriate; other, less significant works by Eakins were accepted. Through the influence of Dr. Gross, the painting was exhibited in the medical department of the exposition.

Henry O. Tanner studied with Eakins at the Pennsylvania Academy in 1880–84, but his mature style merged Eakins's realism with some stylistic effects learned from the French Impressionists. Tanner moved permanently to Paris in 1891; in 1896 he received an honorable mention at the Salon; and in 1897 his work was awarded a gold medal. In *The Banjo Lesson* (fig. 515) the choice and interpretation of the theme grow from Eakins's example, but the lighter palette, softer light, and delicacy of brushstroke reveal the influence of the new French style of Impressionism.

EAKINS, *Portrait of Dr. Samuel Gross:* **1875**
1875: Electric dental drill is patented
1875: Bizet, *Carmen*
1876: Bell patents the telephone
1879: Pavlov uses dogs to study the conditioned reflex
1885: First successful appendectomy

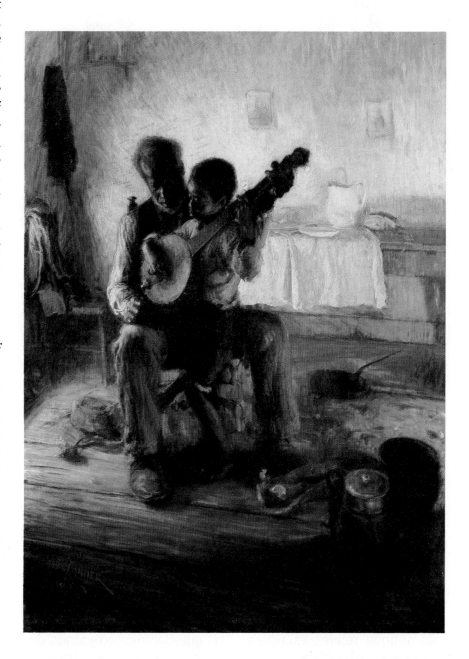

515. HENRY O. TANNER
The Banjo Lesson. c. 1893. Oil on canvas, 48 x 35". Hampton University Museum, Hampton, Virginia. Tanner was the first African-American artist to achieve an international reputation.

AUGUSTE RODIN

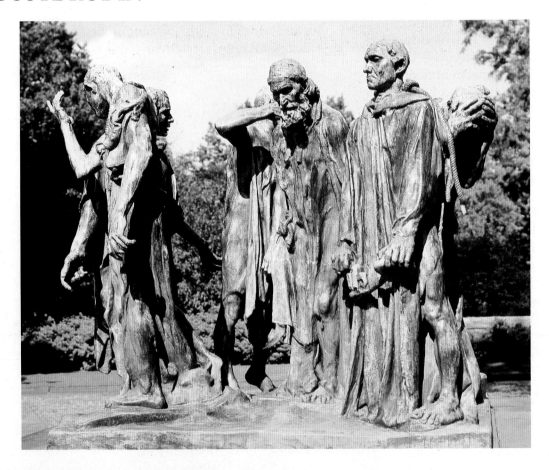

516. AUGUSTE RODIN
The Burghers of Calais. 1884–86. Bronze, height 82 1/2". Hirshhorn Museum and Sculpture Garden, Smithsonian Institution, Washington, D.C. In 1884 the city of Calais in northern France commissioned Rodin to fashion a public monument that would honor six leading citizens (burghers) who, in 1347, had offered themselves as hostages to the English king Edward III, who had laid siege to the city. The burghers were ready to sacrifice their lives if their city would be spared. Edward III was so impressed with their courage that he spared both the burghers and Calais.

Rodin's *Burghers of Calais* (fig. 516), commissioned as a public monument to display the courage and civic virtue of the Calais burghers, disappointed many at first, for it lacked the overtly heroic antique references which then dominated public sculpture. Rodin's re-creation of the six hostages, with its realism and psychological honesty, assisted in bringing a fresh vision of the human figure to late-nineteenth-century sculpture. From his study of the works of such sculptors as Donatello and Michelangelo, Rodin understood how gesture and expression could reveal an inner psychological state. Here the burghers betray philosophical questioning, acceptance, defiance, and sorrow. Through Rodin's sculpture, the burghers are revealed to us as human beings like ourselves, not idealized superheroes.

To understand better the impact of Rodin's work, we must keep in mind that Neoclassical and Romantic attitudes still dominated public sculpture. Rodin's physical and psychological naturalism seemed to run counter to critical and public taste, and the psychological depth of Rodin's work was missed by many critics.

Rodin's *Monument to Balzac* (fig. 517) is an audacious sculpture in both theme and execution. The great novelist is shown wrapped in the heavy robe in

RODIN, *The Burghers of Calais:* **1884–86**
1883: Metropolitan Opera House opens in New York
1883: Brooklyn Bridge opens to traffic
1884: Brahms, Third Symphony
1885: Pasteur introduces rabies vaccine
1886: Eighth and last Independent Exhibition in Paris
1886: *Statue of Liberty* is dedicated
1886: American Federation of Labor is founded

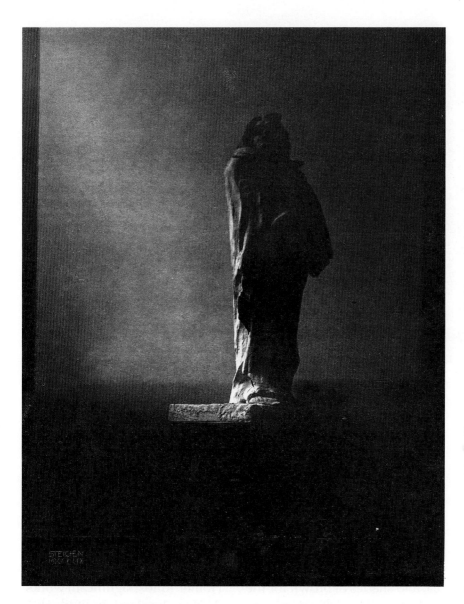

517. AUGUSTE RODIN
Monument to Balzac. 1893–97. Plaster, height 9' 10 1/8". This historic 1908 photograph of the plaster model is by Edward Steichen, one of America's foremost photographers. Steichen so successfully captured the creative ambience of *Balzac* that, on seeing Steichen's photographs, Rodin remarked, "You will make the world understand my *Balzac* through these pictures. They are like Christ walking in the desert."

which he worked late at night. His dramatic posture and penetrating facial features vividly communicate the fury of creative inspiration. Balzac's face and massive robe seem to be emerging from the plaster, from the raw material from which the sculpture was first formed. This unfinished quality contributes to our perception of a transformation; Rodin, in displaying the process of bringing form from the raw material, has visually expressed the creative energy which has seized Balzac.

Stating his philosophy on the relationship of art and the artist to nature, Rodin wrote: "I grant you that the artist does not see Nature as she appears to the vulgar, because his emotion reveals to him the hidden truths beneath appearances. But, after all, the only principle in art is to copy what you see. . . . There is no recipe for improving nature. The only thing is to see. Oh, doubtless a mediocre man copying nature will never produce a work of art, because he really looks without seeing, and though he may have noted each detail minutely, the result will be flat and without character. . . . The artist, on the contrary, sees; that is to say, his eye, grafted on his heart, reads deeply into the bosom of nature."

WINSLOW HOMER

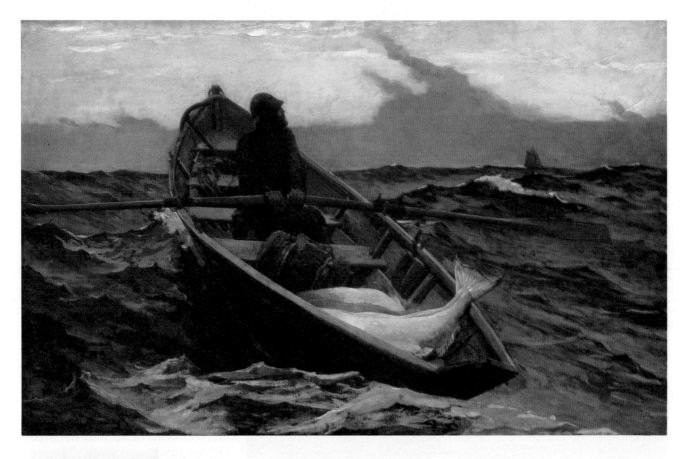

518. WINSLOW HOMER
The Fog Warning. 1885. Oil on canvas, 30 x 48". Museum of Fine Arts, Boston (Otis Norcross Fund)

The unusual cloud bank rolling in in the background of Homer's *Fog Warning* (fig. 518) warns the fisherman that his life is suddenly in danger, for it signals the arrival of a particularly fast-moving and dangerous fog. The hunter, preying on nature, suddenly becomes the hunted. Homer's composition heightens the mood of instability and uncertainty by representing the small rowboat being heaved upward by a large swell. The right-to-left thrust of the rowboat is counter to the movement of the fisherman's home vessel in the background, which is about to sail out of the range of vision. The realistic colors—yellowish-white for the sky, green for the sea, and shades of brown for the boat and the fisherman—are somber and appropriate for this theme. The bold and simple silhouetted composition, the diagonal thrust of the boat, and the truncated oar reveal the influence of Japanese woodcuts. Homer's brushstrokes are broad and simple; note especially the rough strokes in the foreground that represent the foamy waves.

The power of natural forces and their challenge to humanity are themes that reoccur in Homer's most significant works. A New England individualist, Homer spent many winters living in isolation along a particularly dramatic and treacherous stretch of the Maine coastline, where he had many opportunities to observe the power of a turbulent sea.

HOMER, *The Fog Warning:* **1885**
1884: Mark Twain, *Huckleberry Finn*
1885: The modern bicycle is invented
1890: Yosemite National Park is created

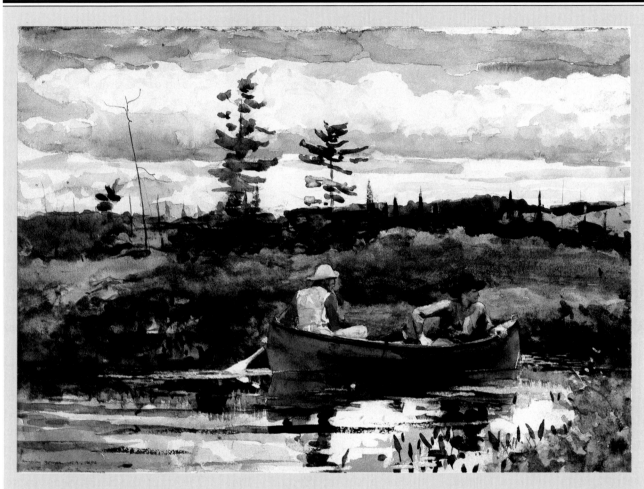

519. WINSLOW HOMER
The Blue Boat. 1892. Watercolor over graphite, 15 1/8 x 21 1/2". Museum of Fine Arts, Boston (Bequest of William Sturgis Bigelow, 1926)

WATERCOLOR AND GOUACHE TECHNIQUE

Watercolor is aptly named, for it is a medium in which ground pigments are mixed with water and, as an adhesive binder, a little gum arabic. It is usually applied to paper. The brilliance possible in watercolor is evident in this example by Homer (fig. 519). The liquidity of the medium is apparent in the broad strokes that so convincingly render sky and water. Watercolor is transparent, and in some areas Homer has laid one color over another, creating veils of transparent color. The natural color of the paper shows through in the clouds and water, and Homer commonly added a few touches of gouache (an opaque watercolor) to strengthen certain areas. As early as the 1780s English artists had begun to work with watercolor. Homer was one of the founders of the American Watercolor Society, an organization which helped popularize watercolor as a medium for serious artists in the United States. Previously it had been used largely by amateurs.

THE POST-IMPRESSIONISM OF PAUL GAUGUIN AND GEORGES SEURAT

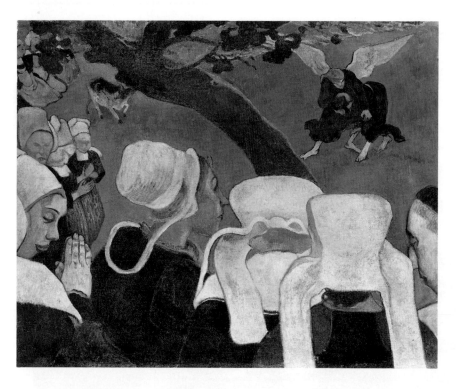

520. PAUL GAUGUIN
The Vision After the Sermon. 1888. Oil on canvas, 28 3/4 x 36 1/2". National
Gallery of Scotland, Edinburgh

Gauguin's *Vision After the Sermon* was painted in the rural area of Brittany, in northern France, which the artist visited in 1888 to divert his mind and art away from what he felt were the restrictive artistic and social pressures of Paris (fig. 520). The painting depicts Breton women, deep in prayer, experiencing a vision. Our viewpoint is from behind the group of women, in native dress, and a priest in the right foreground. A tree limb creates a strong diagonal across the composition, separating the left middle ground from the "vision" to the right, which represents the Old Testament figure Jacob wrestling with an angel, a story

in which God tested Jacob's enduring love. The flat red ground creates a strong planarity that contrasts with the perspective indicated by the diminution of size.

This causes a visual tension. The heavy outlines of the figures combine with the patternlike configuration of the Breton headdresses to create a simple, direct, and forceful composition. While the red ground may have been inspired by a religious festival that included the blessing of horned animals and a night with bonfires that cast a red glow over the fields, Gauguin's choice of color also carries a symbolic content. The red ground symbolizes the theme of struggle, and in choosing it Gauguin has freed himself from the traditional use of color to describe nature. Here it is used in an abstract, expressive way.

Gauguin had left his wife and family, as well as a successful brokerage career in Paris, to seek a more natural, unindustrialized environment, first in Martinique, then in Brittany and later Arles in southern France, and finally in Tahiti, in the South Seas. In attempting to remove himself from Western centers of civilization,

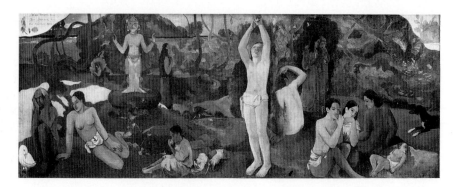

521. PAUL GAUGUIN
Where do we come from? What are we? Where are we going? 1897. Oil on burlap,
4' 6 3/4" x 12' 3 1/2". Museum of Fine Arts, Boston (Tompkins Collection)

GAUGUIN, *The Vision After the Sermon:* **1888**
1887: A. Conan Doyle, first Sherlock Holmes tale is published
1887: Edison and Swan produce electric lamps
1888: J. B. Dunlop invents the pneumatic tire

Gauguin sought an unbridled artistic and psychological response to nature.

During his second Tahitian period, Gauguin, in poor health, nearly broke, severely depressed, and planning suicide, painted what he envisioned as his final masterpiece (fig. 521). His suicide attempt failed and he later detailed the meaning of the painting in a letter. The woman, child, and dog in the right foreground symbolize birth and the innocence of life. The figure near the center tries to pick a fruit from the tree of knowledge in an attempt to understand the meaning of life, while in the left foreground "an old woman approaching death ... reconciled and resigned to her thoughts" is joined by "a strange white bird [that] represents the futility of life." In the right middle ground, two standing clothed figures betray the sorrow that life's knowledge can bring; the idol to our left expresses the forces which rule our primitive passions. Gauguin's abstract language of colors and forms helps communicate his content.

By the time of the last Independent Exhibition in 1886, Impressionism, which a decade earlier had been considered revolutionary, had gained critical and public acceptance. New avant-garde styles were now being explored by Post-Impressionist artists, such as Gauguin, who had moved from Impressionism to more individualized styles. Post-Impressionism is the generic title that covers the diversity of these individual styles—styles which laid the foundation for modern art.

Georges Seurat was the youngest of the Post-Impressionist painters. His monumental painting *A Sunday Afternoon on the Island of La Grande Jatte* (fig. 522), which was two years in preparation and execution, exemplifies his theories of Divisionism, which was also called Neo-Impressionism. The still and transfixed quality of the scene reminds us of works of the Renaissance master Piero della Francesca (see fig. 254), whose work Seurat admired. But the classicism of Renaissance art has been updated, joined with the modern revelation of light and color begun by the Impressionists. Seurat systematized contemporary scientific advances in color theory to create what he termed optical painting. Colored paint is methodically applied in a series of small dots (now popularly known as Pointillism, a term not used by Seurat), usually in complementary colors. The resulting surface, covered with thousands upon thousands of controlled spots of color, is both vibrant and luminous, at once relating to the surface of the picture plane and to forms in an illusory depth bathed in natural light.

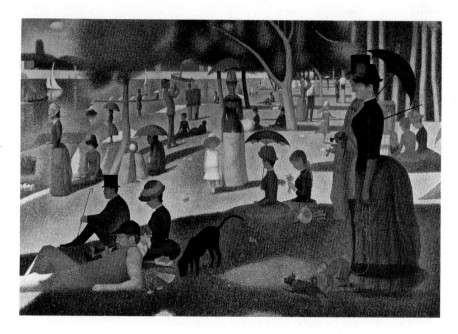

522. GEORGES SEURAT
A Sunday Afternoon on the Island of La Grande Jatte. 1884–86. Oil on canvas, 6' 9 1/2" x 10' 1 1/4". The Art Institute of Chicago (Helen Birch Bartlett Memorial Collection)

THE POST-IMPRESSIONISM OF VINCENT VAN GOGH

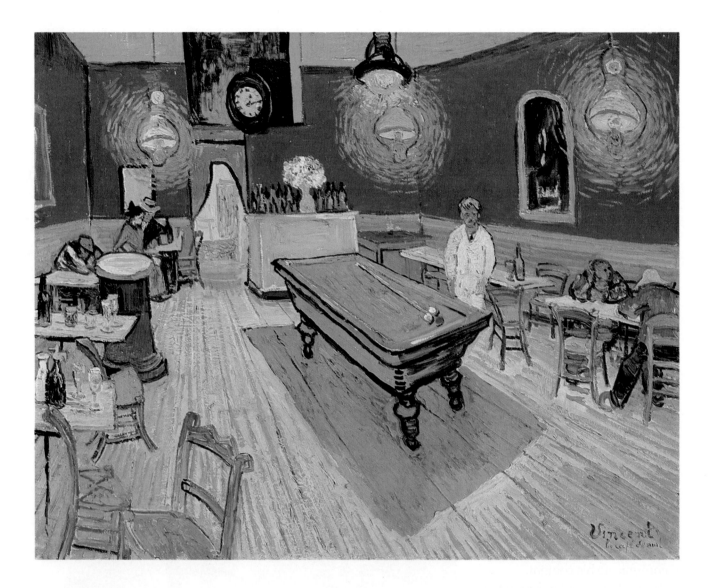

523. VINCENT VAN GOGH
The Night Cafe. September 1888. Oil on canvas, 27 1/2 x 35". Yale University Art Gallery, New Haven, Connecticut (Bequest of Stephen C. Clark). Van Gogh painted *The Night Cafe* in Arles, in the south of France, where he lived in 1888–89. Vincent wrote that when he painted this picture he stayed up three consecutive nights, sleeping only during the day. On September 17, 1888, he wrote to his brother Theo that "the problem of painting night scenes and effects on the spot and actually by night, interests me enormously."

"Today I am probably going to begin the interior of the Cafe where I eat, by gas light, in the evening.

"It is what they call here a *Cafe de Nuit* (they are fairly frequent here), staying open all night. 'Night prowlers' can take refuge there when they have no money to pay for a lodging, or are too tight to be taken in. All those

VAN GOGH, *The Night Cafe:* **1888**
1888: *National Geographic* begins publication
1889: Electric lights are installed in the White House
1889: *Wall Street Journal* begins publication
1895: Oscar Wilde, *The Importance of Being Earnest*

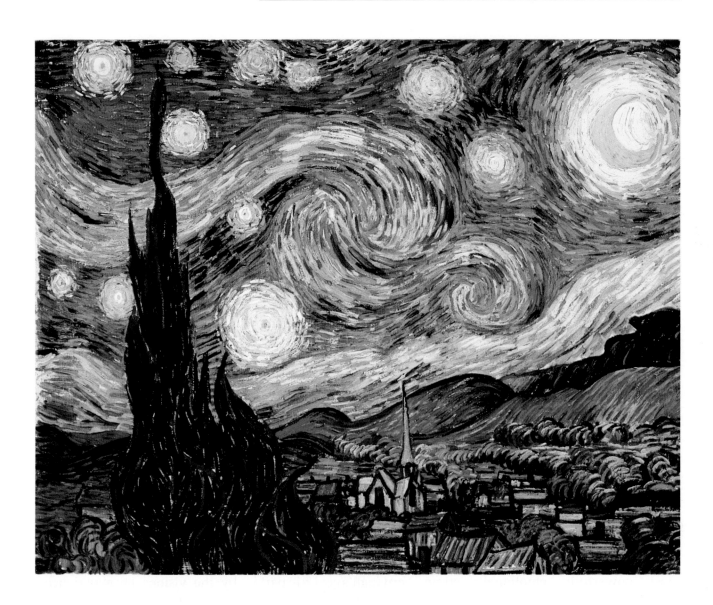

things—family, native land—are perhaps more attractive in the imaginations of such people as us . . . than they are in reality. I always feel I am a traveller, going somewhere and to some destination.

"If I tell myself that the somewhere and the destination do not exist, that seems to me very reasonable and likely enough. . . .

524. VINCENT VAN GOGH
The Starry Night. June 1889. Oil on canvas, 29 x 36 1/4". Collection, The Museum of Modern Art, New York (Acquired through the Lillie P. Bliss Bequest).
Van Gogh can be classified as a Post- or Counter-Impressionist because after painting in the Impressionist style (he saw the Eighth, last Independent Exhibition in 1886 in Paris), he developed his own personal style. Van Gogh eloquently revealed his understanding of his own intense personality and his loneliness by writing, "One may have a blazing hearth in one's soul and yet no one ever comes to sit by it. Passersby see only a wisp of smoke rising from the chimney and continue on their way."

"The room is blood red and dark yellow with a green billiard table in the middle; there are four citron-yellow lamps with a glow of orange and green. Everywhere there is a clash and contrast of the most disparate reds and greens in the figures of little sleeping hooligans, in the empty, dreary room, in violet and blue. The blood-red and the yellow-green of the billiard table, for instance, contrast with the soft tender . . . green of the counter, on which there is a pink nosegay. The white coat of the landlord, awake in a corner of that furnace, turns citron-yellow, or pale luminous green" (Vincent van Gogh, letter to his brother Theo from Arles, September 8, 1888).

The Night Cafe is one of the most powerfully emotional paintings in a series of dramatic works created during Van Gogh's stay in Arles (fig. 523). Van Gogh later referred to Arles as the place where he "attain[ed] the high yellow note," suggesting that this was a particularly strong point in his career. Here he adopted the Japanese belief that the color yellow is symbolic of hope. However, Arles was also a place of intense despair for Van Gogh,

which may help explain the heightened intensity of the Arles works. He said that this painting, given to his landlord in exchange for rent, was "one of the ugliest pictures I have done."

The ugliness of which he writes is intentional, for in this painting color is used arbitrarily, allowing him to express personal meanings and emotions through the "clash and contrast" of glaring yellow, bright green, and "blood" red. In a letter to his brother Theo, who was living in Paris, he explained the psychological impact which he wanted the painting to have: "I have tried to express the terrible passions of humanity by means of red and green . . . the cafe is a place where one can ruin oneself, run mad, or commit a crime." Van Gogh's goal is in part conveyed to us by the claustrophobia of the tense and threatening atmosphere. Drunks slump over tables within a tilted and close perspective space that is unnerving for the viewer. Van Gogh is here experimenting with the relationship between color, space, theme, and emotions. His efforts make him one of the forerunners of Expressionism (see p. 512). He tries to express the mood

he senses at the cafe, and in doing so, he reveals some of his feelings about his own alienation.

In the early 1880s, Van Gogh had been involved briefly in the rapidly changing styles of art. Like many other artists, he began to collect Japanese prints (see fig. 457), and in *The Night Cafe* we sense their influence in the bold delineation of the forms, the intricate patterning of horizontal and vertical lines, the unusual viewpoint, and the vivid, arbitrary colors. The oddly exaggerated perspective of the painting may also be attributed to other influences. Evidence suggests that Van Gogh may have suffered from temporal lobe epilepsy and that some aspects of his art may have been influenced by the visions he experienced during the beginning of a seizure. We also know that Van Gogh often spent his limited money on alcohol, rather than food, and absinthe, one of the artist's common indulgences, is known to affect the occipital lobe, which controls vision.

In *The Starry Night* (fig. 524), painted in 1889, Van Gogh displays his fascination with the earth and sky, and his philoso-

phies of life and death and their connection to nature: "For my own part, I declare I know nothing whatever about it, but to look at the stars always makes me dream, *as simply* as I dream over the black dots of a map representing towns and villages. Why, I ask myself, should the shining dots of the sky not be as accessible as the black dots on the map of France? If we take the train to get to Tarascon or Rouen, we take death to reach a star. One thing undoubtedly true in this reasoning is this, that while we are *alive* we *cannot* get to a star, any more than when we are dead we can take the train" (letter to Theo, mid-July 1888). This depiction of night "in situ," as Van Gogh described it, reveals his continuing interest in a favorite subject, the flamelike cypress tree used in France and Italy to mark graves. Almost black, the tree dominates the foreground. The night sky overwhelms the little town of Saint-Rémy, but the expansiveness of space and the solidity of the earth are formally linked: the tip of the cypress tree crosses the nebula, and the steeple of the church enters the area of the sky.

In a letter to his brother, Van Gogh wrote that he felt that nighttime was more colorful than the day—as is suggested here by the vividness and luminosity of the celestial bodies. Deeply saturated colors—purple and violent green—clash, and a thickly painted "glow" surrounds each star, planet, and the moon. These qualities seem to express Van Gogh's testament that there are lives and colors on other planets, and perhaps even better conditions. Here the artist projects his own destiny: death represents not an ending but a metamorphosis.

The significance of nature for Van Gogh is apparent in the following quotation, from a letter which he wrote to Theo in September 1889, right after Theo was married: "Well, do you know what I hope for, once I let myself begin to hope? It is that a family will be for you what nature, the clods of earth, the grass, the yellow corn, the peasant, are for me, that is to say, that you may find in your love for people something *not only to work for,* but to comfort and restore you, when there is need for it."

The *Self-Portrait* of 1889 (see fig. 464) was probably painted shortly after Van Gogh left the hospital in Saint-Rémy in early January 1889. His ear is still bandaged from the self-mutilation he had inflicted in December, when he cut off part of his ear, probably to punish himself because of a quarrel he had had with Paul Gauguin. Van Gogh sent this painting to his family in the Netherlands, probably to reassure them of his health. The very fact that he could paint again revealed his control of his feelings, and although he does not deny that he damaged his ear, he shows himself as somber, meditative, and smoking his pipe. The placement of the green coat against the red background and the blue cap against orange demonstrates his interest in using complementary colors to achieve rich coloristic and dramatic effects. The violent juxtaposition of the red and orange draws attention to Van Gogh's solemn eyes. As he wrote, "[I find myself filled with] a certain undercurrent of vague sadness, difficult to define. . . . My God, those anxieties—who can live in the modern world without catching his share of them?"

THE POST-IMPRESSIONISM OF PAUL CÉZANNE

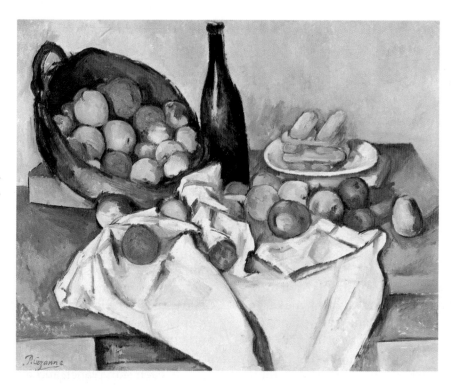

525. PAUL CÉZANNE
Still Life with Basket of Apples. 1890–94. Oil on canvas, 24 3/8 x 31". The Art
Institute of Chicago (Helen Birch Bartlett Memorial Collection)

"I want to make of Impressionism something solid and durable, like the art of the museums" (Cézanne). In his paintings Cézanne set himself an impossible task: he wanted to establish an equilibrium between the vivacious color and solid form of three-dimensional objects and the two-dimensional surface of the picture plane. He sought to achieve both illusionistic solidity and a strong compositional structure in two dimensions. His frustration with Impressionism was twofold: Impressionist painters did not create paintings that were compositionally strong, and they were not interested in endowing painted objects with three-dimensional solidity. Cézanne wrote: "In art, everything is theory, developed and applied in contact with nature." It is the union of nature with the philosophical truth of the flatness of a painting's surface that absorbed Cézanne's attention.

Cézanne's *Still Life with Basket of Apples* (fig. 525) demonstrates his ability to render objects with solidity—note the white napkin, with its deep angular folds and pockets of shadow. The pieces of fruit have a physical presence that is in part the result of an unexpected richness of color, exemplifying Cézanne's dictum that "when color is richest, form is fullest." He modeled the fruit with pure, unmixed colors, juxtaposing, for example, yellow with green and red. He thereby created a richer effect than that produced by the typical academic practice of rendering modeling by reducing coloristic intensity with the addition of white or black. Cézanne does not outline his forms to distinguish them one from another. They have rather loosely painted edges, and it is the internal color that creates their solidity. Cézanne once said, "The secret of drawing and modeling resides in the contrasts and relationships of tone."

If we analyze Cézanne's *Still Life with Basket of Apples* as an illusion or as an exercise in accurate drawing, it is a failure: neither the front nor the back edges of the table, for example, are continuous; the wine bottle, itself tilted, offers a distinctive contour on each side; and the pastries stacked on the plate seem tilted upward. But these observations are based on the wrong questions. In Cézanne's work these visual "inaccuracies" reveal the moving viewpoint of the artist relative to the objects being painted. Renaissance scientific perspective insisted that the artist's (and therefore the viewer's) eye be at a fixed point. Cézanne, on the other hand, expresses a basic fact of vision: our understanding of an object or space is based on our movement relative to that object or space. The difference in the edges of the table, for example, results because the table edge is seen from lower or higher, closer or farther viewpoints. The issues Cézanne has selected to investigate are difficult ones to resolve. Later Pi-

CÉZANNE, *Still Life with Basket of Apples:* 1890–94
1890: Emily Dickinson poems are published
1890: Oscar Wilde, *The Picture of Dorian Gray*
1895: First professional football game

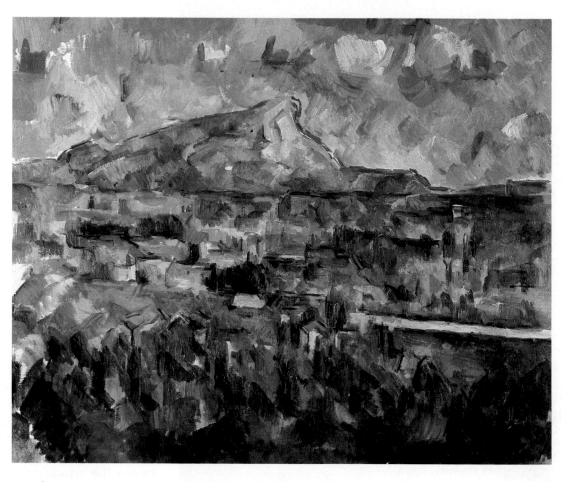

526. PAUL CÉZANNE
Mont Ste.-Victoire. 1904–6. Oil on canvas, 25 5/8 x 31 7/8". Private collection. Mont Ste.-Victoire in Provence, a symbol of Cézanne's local area, is one of his favorite subjects. In 1901–2 he built a study in the countryside with a large window facing the mountain.

casso would praise Cézanne for his "restless striving."

The structured pictorial surface Cézanne accomplished is best expressed in his later works (fig. 526). While the most significant monument in the landscape is the powerful, thrusting mountain, Cézanne has constructed his painting out of blocks of color and no one area or object is less strong than another. Cézanne urged painters to "see in nature the cylinder, the sphere, the cone," and this painting demon-

strates his approach. Surface strength is also accomplished by intermingling blocks of limited color—in this case violet, green, ocher, and blue: the violet of the atmospheric perspective reappears in the foreground, and the green of the middle ground is also found in the sky. When the work is compared to an Impressionist painting, such as *Impression-Sunrise* (fig. 507), two completely different effects can be noted. Cézanne has sacrificed the ravishing, momentary subtlety

of color that forms the foundation of Monet's accomplishment in his attempt to create a landscape that has an enduring strength and power. In ancient times Mont Ste.-Victoire was believed to be a holy mountain, a home of the gods, and in Cézanne's painting it is once again endowed with a mysterious presence. Cézanne's paintings had an important impact on developments in the twentieth century: Matisse called him the "father of us all."

THE BEGINNINGS OF THE SKYSCRAPER

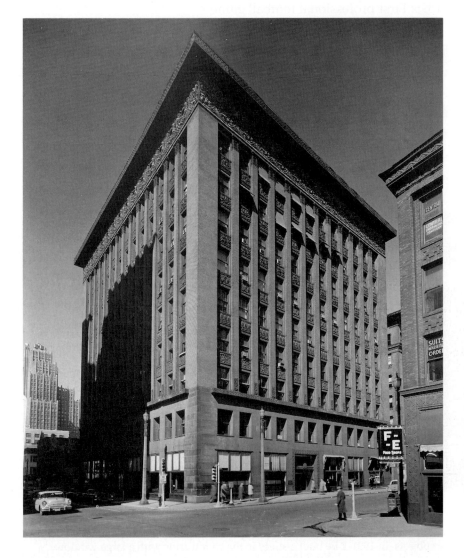

527. **LOUIS SULLIVAN**
Wainwright Building, St. Louis.
1890–91

"What is the chief characteristic of the tall office building? And at once we answer, it is lofty.... The force and power of altitude must be in it.... It must be every inch a proud and soaring thing, rising in sheer exultation that from bottom to top it is a unit without a single dissenting line" (Louis Sullivan, *The Tall Office Building Artistically Considered*, 1896). To accomplish his lofty exaltation, Sullivan based his Wainwright Building on a design concept analogous to that of a column (fig. 527). The first two stories act as a base which supports the unimpeded vertical members, rising like the flutes on the shaft of a column, to support a cornice, decorated with foliage ornament, that crowns the structure like a capital. This intelligible design hides the load-bearing steel-frame construction, which other early skyscraper architects had emphasized by creating a grid of balanced horizontals and verticals (see p. 437). Sullivan chose instead to stress the vertical articulation. Only every other vertical corresponds to the interior

steel cage. In addition, the vertical elements dominate because the windows are recessed between them, and the horizontal membering, hidden behind recessed panels of decorated terra-cotta, is reduced in importance.

The integrity of the design depends on the proportional relationships between the parts and the whole, which Sullivan has carefully calibrated. The wide corners balance and set off the elegant, narrow verticals between the windows, while the effulgent decorative terra-cotta at the cornice level, a full story high, unites with the narrow uppermost cornice to provide an elegant final closure which defines the mass of the structure. The decorated panels below each window provide a typically Sullivanesque touch, offering a pleasant decoration for office workers in adjacent buildings. The total effect is of a finely articulated mass, elegant and substantial at the same time.

The most impressive developments in skyscraper architecture occurred in Chicago, where a devastating fire in 1871 leveled much of the city. During the clos-

SULLIVAN, Wainwright Building: 1890–91
1890: One-third of U.S. population now resides in cities and towns
1890: Los Angeles population is 50,000
1893: Dvořák, *New World Symphony*
1893: Henry Ford builds his first car
1895: H. G. Wells, *The Time Machine*
1900: Half of all U.S. working women are farmhands or domestic servants

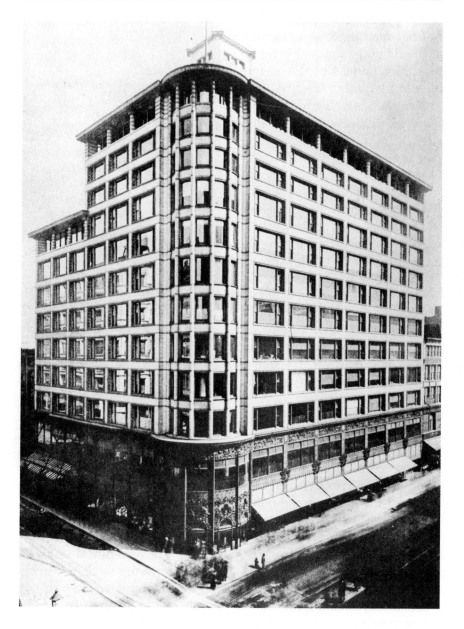

528. LOUIS SULLIVAN
Carson-Pirie-Scott Store (formerly Schlesinger and Meyer Department Store), Chicago. 1899; enlarged 1903–4 and 1906

ing decades of the century, the city's rapidly increasing population spurred a building boom. Sullivan's last major commission was the design for the Schlesinger and Meyer Department Store (fig. 528). The idea of a huge urban store carrying luxury items for middle- and upper-class patrons was novel, and Sullivan emphasized elegant public entrances and huge plate-glass windows on the lower floor by fantastic cast-iron ornamentation of his own design. The upper floors, with their huge "Chicago" windows and very plain terra-cotta decoration, refer in a streamlined fashion to the concealed steel cage, but note that the horizontal members are emphatically wider and therefore dominant. Sullivan's sensitivity to the shape and placement of the building as a whole is evident in the cylindrical tower at the corner, an unexpected element adding a vertical punctuation mark that makes the horizontal sides even more forceful. Here Sullivan completely avoids any historical references, creating a building that is one of the first works of modern architecture.

EDVARD MUNCH

"I was walking along the road with two friends. The sun set. I felt a tinge of melancholy. Suddenly the sky became a bloody red.

"I stopped, leaned against the railing, dead tired, and I looked at the flaming clouds that hung like blood and a sword over the blue-black fjord of the city.

"My friends walked on. I stood there, trembling with fright. And I felt a loud, unending scream piercing nature" (Edvard Munch, *Diary*, 1892).

The composition of *The Scream* (fig. 529) effectively expresses Munch's personal anxiety, creating a formal tension which reinforces the psychological tension that is the theme. As in Munch's description, the sky is a blood red. Its undulating rhythms melt into the blue-black waters of the fjord. The perspective of the bridge is unnatural. Its sharp angle creates a visual tension, for it is caught between the flatness of the picture plane, which is emphasized by the shapes of clouds and water, and the illusory space established by the diminution of Munch's companions and the ships on the fjord. The curving rhythm of Munch's body, transformed into an existential symbol, incorporates itself into the rhythms of the environment. He is becoming one with nature, realizing his worst agoraphobic nightmare. As the figure screams, its face is distorted to resemble a skull, with the iconographic association of death. These visual manipulations communicate an emotional impact not as a representational image, but as a symbol of a schizophrenic psychological state.

The terrifying tension Munch felt that evening was in part the result of his alcoholism and a dread of open spaces. In this condition, Munch experienced himself being pulled into his environment, losing his identity. He heard a scream within him, the scream of nature "dying" in flaming bursts at sunset. The inner scream became so intense that Munch, looking at us, screams to relieve the pain within.

The Scream was one of a series of twenty-two paintings and prints that Munch exhibited as a coordinated group in the opening years of the twentieth cen-

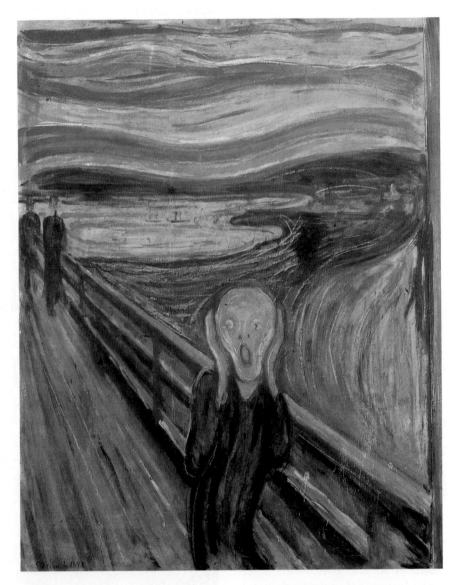

529. EDVARD MUNCH
The Scream. 1893. Oil, pastel, and casein on cardboard, 35 3/4 x 29".
National Gallery, Oslo. Munch originally titled this work *Despair*.

MUNCH, *The Scream:* 1893
1888: Strindberg, *Miss Julie*
1893: Tchaikovsky, *Symphonie pathétique*
1896: First modern Olympic Games held, in Athens
1896: Chekhov, *The Sea Gull*
1898: Pierre and Marie Curie discover radium
1900: World population reaches about 1.65 billion

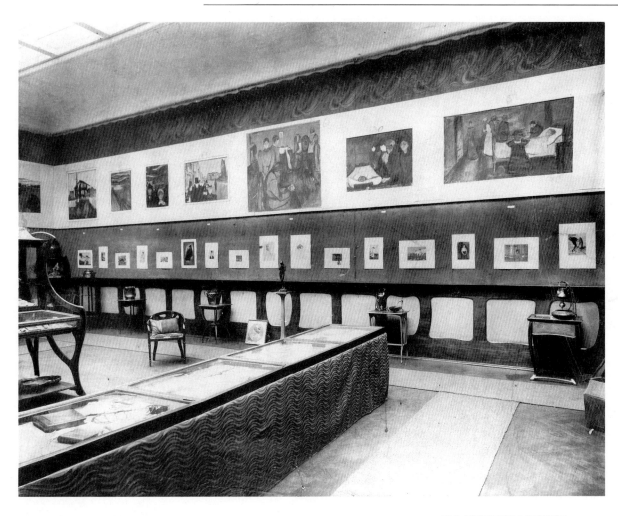

530. EDVARD MUNCH
The Frieze of Life exhibition.
Photograph of the installation
at Leipzig, 1903

tury. The exhibition was titled *Motifs from the Life of a Modern Soul*, yet it more often carried the simpler title *The Frieze of Life* (fig. 530), which better suggests the universal content, intended by Munch, of the flowering and passing of love, life's anxieties, and death. As a young person growing up in Norway, Munch had led a bohemian life, and the ideas for the paintings began with his personal, subjective experiences, which were then transformed into more universally symbolic themes.

For Munch, the emotionally expressive abstraction of forms was a way of creating art which possessed what he termed a "deeper meaning," one which conveyed the content of the human soul. The impact of his art would exert a profound influence on the development of early modern painting.

TWENTIETH-CENTURY ART

INTRODUCTION

531. GIACOMO BALLA
Speeding Automobile–Study of Velocity.
1913. Oil on cardboard, 26 x 37 7/8".
Municipal Gallery of Modern Art,
Milan

"A roaring motorcar which seems to run on machine-gun fire is more beautiful than the *Victory of Samothrace*" (fig. 103), wrote Filippo Marinetti, an Italian poet of the Futurist movement, in 1908–9. The works we have chosen to introduce the twentieth century relate the dynamism of modern art to the vigor of modern life. *Speeding Automobile — Study of Velocity* by the Futurist artist Giacomo Balla (fig. 531) is an abstract representation that can be related to a 1910 *Futurist Manifesto* which declared that "the gesture . . . we would reproduce on canvas shall no longer be a fixed *moment* in universal dynamism. It shall simply be the dynamic sensation itself." Balla's painting represents the propulsive energy of a speeding car; the sequential placement of diagonal lines communicates dynamic force. Balla, an associate of Marinetti's, has visualized the poet's remarks on the new aesthetic of beauty as exemplified by the speed of a "roaring motorcar."

The sleek, aerodynamic design of Pinin Farina's *Cisitalia "202" GT Car* (fig. 532) is both superbly functional—it cuts the wind resistance—and aesthetically elegant. Even standing still, the car gives the impression of movement. In function and appearance, both Balla's painting and Farina's automobile are uniquely modern. They represent one aspect of the complex developments which characterize twentieth-century art.

HISTORY

The poet Marinetti's and the painter Balla's glorification of speed was symbolic of the impact of the technological revolution on the arts. The decades which opened the twentieth century were characterized by a population boom and unprecedented improvements in living conditions in the Western world. By the 1890s, electric lighting and motors were common, and the radio, invented by Guglielmo Marconi in 1895, greatly facilitated communication over vast geographic areas. Television was introduced in the 1920s, computers in the 1940s. But perhaps no more dramatic example can be used to demonstrate the astounding pace of modern technology than air and space flight. The 1903 flight of the Wright brothers at Kitty Hawk, North Carolina, was followed by rapid advances; Charles Lindbergh soloed across the Atlantic in 1927, and in 1969 Neil Armstrong became the first human to set foot on the moon.

Advances in technology were often set against a backdrop of political conflict, war, and violent revolution. By the end of the first decade of the twentieth century, the European nations and Great Britain had built up enormous armed forces. Germany, Austria-Hungary, and Italy were allied against Great Britain, France, and Russia. War became inevitable after Archduke Ferdinand, heir to the throne of Austria-Hungary, was assassinated in 1914. The Great War, now known as World War I, erupted within months. Although all parties hoped it would be of short duration, it lasted, stagnated in trench warfare, until 1918. America committed her armies in 1917. The Treaty of Versailles ended World War I, but the harsh restrictions

532. PININ FARINA
Cisitalia "202" GT Car. 1946. Aluminum body, length 12' 5". Collection, The Museum of Modern Art, New York (Gift of the manufacturer)

533. VLADIMIR TATLIN
Historic photograph of the model of
the Monument to the Third Interna-
tional Communist Conference. 1919–
20. The model, height 16', was of wood
and netting; the final building, of iron
(painted red) and glass, was to have
been more than 1300' high.

imposed on Germany set the foundation for yet another conflict.

Before the war had ended, events in Russia had brought a new political force to the world scene. A populist revolution of 1917 overthrew Czar Nicholas II, and a "dictatorship of the proletariat" was established by a well-organized party of Bolshevik Communists headed by Nikolai Lenin. Lenin withdrew Russia from the war in 1918, but internal civil war only ended in 1921. In 1923 the Union of Soviet Socialist Republics was formed. Communist parties outside of the U.S.S.R. were federated with Soviet Communism in 1919 to form the Third International. In proposing a structure that would provide a center for world communism, Vladimir Tatlin, a Russian artist who had visited the avant-garde art centers of Berlin and Paris in 1913, offered an ambitious spiraling architectural form (fig. 533). The dynamic energy of the Communist party was to be expressed by the glass-enclosed meeting rooms that would revolve around the building's axis. The lowest—a cube—would turn once per year, the pyramid in the center once per month, and the upper, cylindrical chamber once per day.

Following World War I, economic instability arose as nations returned to peacetime industrial production. Prosperity seemed assured by the late twenties, but an economic collapse in 1929 plunged the West into the Great Depression, which, in America, would leave about one in four workers without a job. Compounding the economic ruin in America, a drought in the southwestern states devastated farming.

During the 1930s, as the West struggled to regain economic stability, the Nazi government of Adolf Hitler took control in Germany, and the Fascist dictators Benito Mussolini in Italy and Francisco Franco in Spain seized power. In 1939 a second world war broke out in Europe. World War II reached global involvement following Japan's attack on the American naval base at Pearl Harbor, Hawaii, in 1941. This war ended with the defeat of Germany and Japan, but the explosion of the atomic bomb over Hiroshima, Japan, on August 6, 1945, ushered in our current era, with its constant threat of atomic and nuclear weapons.

Max Beckmann's *Departure* (fig. 534) is a potent image of frustration and inhumanity born from the scars left on Europe from World War I and the growing totalitarian regime of Nazi Germany. The two wings represent scenes of torture and mutilation, while in the center panel the precious realization of freedom is symbolically rendered with the departing queen holding a child. The figurative exaggerations, harsh brushstrokes, and severe colors contribute to the expression of brutality. Beckmann wrote of the painting: "On the right wing you can see yourself trying to find your way in the darkness, lighting the hall and staircase with a miserable lamp dragging along tied to you as part of yourself, the corpse of your memories, of your wrongs, of your failures, the murder everyone commits at some time of his life—you can never free yourself of your past, you have to carry the corpse while Life plays the drum. The Queen carries the greatest treasure—Freedom—as a child in her lap. Freedom is the one thing that matters—it is the departure, the new start."

In America, both foreign and domestic conflicts have marked the

years since 1945. Between 1950 and 1953 America sent the largest contingent of troops to a United Nations force that fought in Korea to stop the aggression of Communist North Korea. The 1950s also witnessed an intensification of the civil rights movement. Led by Martin Luther King, Jr., a Baptist minister who would receive the Nobel Peace Prize in 1964, African-Americans were in the forefront of the struggle to achieve equality and dignity in human and legal rights. By the early 1960s, American combat troops were becoming more deeply involved in a civil war in Vietnam, while at home, efforts to sustain American involvement were met with bitter divisiveness. By 1975 U.S. forces were withdrawn. In Washington, the *Vietnam Veterans Memorial* (fig. 535) offers the more than 58,000 names, etched into black granite, of Americans who lost their lives in that conflict. It is an unprecedented public monument. Simple and direct in design, it creates an almost solemn environment. The polished surface of the granite reflects the transient life before it, while the names immutably impose themselves, constantly reminding us of the human suffering and loss that are the ultimate costs of conflict.

Politically, the pulse of change has quickened even more as we approach the end of the twentieth century. Throughout the world, there have been challenges to autocratic and tyrannical rule. After a military coup in Burma in 1988, opposition demonstrators were shot down in Rangoon. Daw Aung San Suu Kyi, an opposition leader who later, in 1991, was awarded the Nobel Peace Prize, reacted by asserting that "you can't solve political problems by massacring people." In 1989 Chinese troops killed numerous antigovernment demonstrators, mostly workers and students, in Beijing. Yet at the end of that same year, the Berlin Wall, one of the most poignant realities of the cold war, was torn down, and Germany was reunited after forty-five

534. MAX BECKMANN
Departure. 1932–33. Oil on canvas, 84 3/4 x 45 3/8" (center); 84 3/4 x 39 1/4" (each wing). Collection, The Museum of Modern Art, New York (Given anonymously; by exchange)

535. MAYA LIN
Vietnam Veterans Memorial. 1982. Black granite, length 500'. The Mall, Washington, D.C. Commenting on her conception for the memorial, Lin wrote, "I didn't want a static object that people would just look at, but something they could relate to as on a journey, or passage, that would bring each to his own conclusion."

years of separation. One by one, totalitarian regimes in Eastern Europe fell until, on January 1, 1992, the Soviet Union, a center for world Communism for more than seventy years, was formally disbanded. In 1990 Nelson Mandela was released from a South African prison to confront apartheid ever more forcefully. But optimism was again tempered by an increase in regional ethnic violence and a 1991 war in the Persian Gulf.

Another battle arose on the medical front—AIDS. As a memorial to those who had lost their lives to this epidemic, the Names Project began the creation of an enormous quilt. Each three-by-six-foot panel contains the name or image of a person or symbolic references to someone who has died from AIDS. The panels were created by friends or relatives of the deceased. By the fall of 1989, when the *AIDS Memorial Quilt* had expanded to 10,848 panels, it was displayed in its entirety for the final time in Washington, D.C. (fig. 536). Like the *Vietnam Veterans Memorial* (fig. 535), the quilt commemorates individuals. In its vast size and communal spirit, the *AIDS Quilt* acknowledges the nature, scope, and horrifying reality of this modern disease and becomes both a memorial and cogent social commentary.

INTELLECTUAL AND SCIENTIFIC ACTIVITY

Scientific advancements during the twentieth century have been revolutionary in many areas. In physics, Albert Einstein's general theory of relativity demonstrated the relationship of geometry to

536. The Names Project, San Francisco. *AIDS Memorial Quilt*. Displayed on the Ellipse facing the White House, October 6–8, 1989

537. EDWARD HOPPER
Nighthawks. 1942. Oil on canvas,
30 x 60". The Art Institute of Chicago
(Friends of American Art Collection)

gravity and radically modified our concept of space and time. Our understanding of the very essence of matter itself has been altered, as the atom has been reduced to its subatomic components.

Twentieth-century developments in psychology have greatly influenced the course of art, especially in the movements of Surrealism and Abstract Expressionism (see pp. 534 and 544). Utilizing therapeutic approaches which included free association and the interpretation of dreams in treating his patients, Sigmund Freud established the active and even dynamic role of the human unconscious in guiding behavior. To Freud, unmasking the subconscious was the key to understanding the human mind. Carl Jung extended, modified, and at times countered Freud's theories to develop additional psychological insight into human behavior. Jung advanced the notion of a "collective unconscious," a layer of unconscious underlying the personal unconscious that carries the inherited disposition of our species. The "collective unconscious" was revealed by the common use of archetypal images, such as the circle, across diverse cultural traditions.

Radical changes were introduced in twentieth-century music. Igor Stravinsky's ballet music for *The Rite of Spring,* with its driving, primal rhythms and fragmented melodies, nearly caused the audience to riot at its first performance. In Germany the composer Arnold Schönberg devised a new system of musical tonality; Schönberg's pantonality (which is commonly referred to as being atonal) is a free but not unstructured use of musical tones without traditional chord progressions or resolutions. At mid-century, the American composer John Cage began to incorporate elements of chance into his work. One composition from 1952, titled *4'–33,* has a performer come on stage and sit at a piano for four minutes and thirty-three seconds. During this time, the unpredictable sounds from the audience and other accidental noises "create" the musical experience. Cage's avant-garde concept of music has been influential for contemporary poets, painters, and performance artists (see p. 562).

538. ANDY WARHOL
Green Coca-Cola Bottles. 1962. Oil on canvas, 82 1/4 x 57". Whitney Museum of American Art, New York (Purchase, with funds from the Friends of the Whitney Museum of American Art)

539. GEORGIA O'KEEFFE
Evening Star III. 1917. Watercolor, 9 x 11 7/8". Collection, The Museum of Modern Art, New York (Mr. and Mrs. Donald B. Straus Fund)

TWENTIETH-CENTURY ART

Twentieth-century art is often referred to as modern art, although the terms are not exactly synonymous. The concept of modernism is relative within the context of history. It expresses an attitude which distinguishes a current time from the immediate past. Renaissance artists, for example, felt themselves to be working in a "modern style." In the history of art, developments in the nineteenth century countered well-established traditions in art, laying the foundation for the radical and rapid changes which have occurred in this century. These changes in twentieth-century art have been so distinctive that the term modern is applied in both a chronological and a descriptive sense.

The present century has brought a variety of artistic experiences unparalleled in the history of art. Throughout the century, the avant-garde has rapidly been transformed; these new movements and styles can often be related to dramatic historical, cultural, and scientific changes. More traditional currents in art, including realism and illusionism, have also been sustained throughout the century. Edward Hopper developed a personal style and iconography devoted to the theme of the loneliness and isolation of the individual. Hopper's settings could be anywhere in America, and his people are ordinary, nameless figures from the middle class: He aims for an art that is not

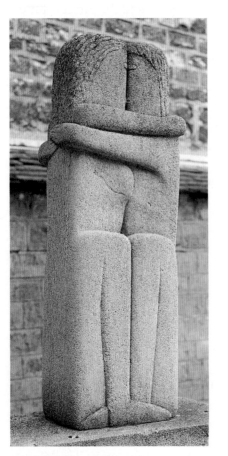

540. CONSTANTIN BRANCUSI
The Kiss. 1909. Limestone, height 22 3/4". Montparnasse Cemetery, Paris

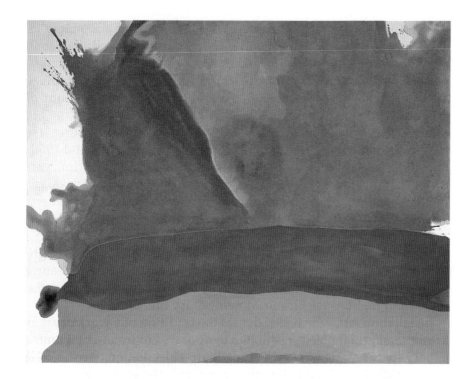

541. HELEN FRANKENTHALER
Tobacco Landscape. 1964. Acrylic
on canvas, 69 1/2 x 89 1/4". Private
collection

local and specific but universal. We have to be careful not to infuse these images with the nostalgia that their settings and costumes now evoke. Hopper intended his paintings to represent the here and now. In *Nighthawks* (fig. 537) we are cut off from the quiet individuals inside the diner, and the harsh interior light exposes the lack of communication that Hopper so often emphasizes in his images of modern urban life. At times, representational art achieved avant-garde status, as in Andy Warhol's *Green Coca-Cola Bottles* (fig. 538), which focused visual attention on consumer commercialism.

It is, however, abstraction and non-objectivity which have become the hallmarks of twentieth-century art. Continuing formal developments advanced by the Post-Impressionist artists, twentieth-century artists expanded the new vocabulary of visual expression. Georgia O'Keeffe's *Evening Star III* (fig. 539) is from a series of watercolors inspired by viewing the evening star at sunset, but representational associations have here been abstracted to express the rhythmic pulsations of the star over the landscape. O'Keeffe's painting communicates a sensation rather than the appearance of a scene. Constantin Brancusi's *Kiss* (fig. 540), with its compact, rectangular masses joining two abstract figures, conveys the essence of unity. For Brancusi, the expression of a concept, which in this sculpture is the wholeness of two individuals as symbolized by the kiss, overrode concerns of naturalism.

Some artists totally denied any representational aspects in their work. Helen Frankenthaler's *Tobacco Landscape* (fig. 541), for example, is a non-objective painting belonging to a style from the sixties called Post-Painterly Abstraction. Using a water-soluble, plastic-based paint known as acrylic, which is flexible and quick-drying, Frankenthaler poured thin washes of this paint onto the raw canvas, creating an expressively fluid composition.

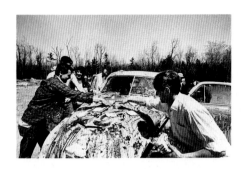

542. ALLAN KAPROW
From *Household*, a Happening commissioned by Yale University, 1964

543. LAURIE ANDERSON
Performance-concert of *Empty Places*. 1990. Utilizing images of modern technology and life, *Empty Places* was a commentary on the loneliness and isolation which can be bred by a technological society and the rapid pace of contemporary existence.

544. JUDY PFAFF
N.Y.C.—B.Q.E. 1987. Painted steel, plastic laminates, and fiberglass, 15 x 35 x 5'. Installation, Whitney Museum of American Art, New York

In viewing twentieth-century art, we shall witness a tremendous expansion of the materials used by artists. Traditional mediums, such as marble, bronze, and wood for sculpture, will be joined by commonplace, found objects, and even discarded junk in creating assemblage works. Even the raw earth will become a significant medium of artistic expression (see fig. 646).

After mid-century, the fashioning of an art object became less important to some artists. In the Happenings of the 1950s and 1960s (see fig. 542), artists, usually without a preconceived script, performed and directed the activity of the audience during a quasi-theatrical event, often outside the confines of a museum or gallery. Happenings and Performance Art have countered traditional definitions of the work of art as a tangible object. Laurie Anderson's performance-concerts (fig. 543) synthesize sight and sound. High-tech light displays and projections are synchronized with a pulsating musical background while Anderson's "talking songs" reflect on the issues and realities we face in contemporary life.

Installation Art, which also denies the tradition of a work of art as a unique, singular object, fashions a temporary environment within a gallery space (see figs. 664, 665). Judy Pfaff's installations (see fig. 544) are each distinctive and thought-provoking; the exuberance of the overlapping, contrasting patterns, shapes, and colors of *N.Y.C.—B.Q.E.*, for example, created a scintillating experience but one that also seemed bittersweet and fleeting because of its temporary nature.

One uniquely modern international medium of artistic expression is cinema. In the late nineteenth century, experimental photographers succeeded in presenting a "moving picture" by projecting a sequential series of photographs taken at exposures as quick as 1/2000 of a second. The forerunner of our motion-picture projector, however, was the Vitascope, invented by Thomas Armat and manufactured by Thomas Edison in 1895. These projectors achieved the illusion of movement by rapidly projecting a series of still photographic images

545, 546. SERGEI EISENSTEIN
Details of film stills from *Potemkin*. 1925. Eisenstein's film dealt with the 1905 mutiny aboard the Russian ship *Potemkin* and the failed anti-czarist uprising.

in sequence. The persistence of our vision, from the image retained on the retina of the eye, lets our minds interpret the rapidly shown still frames as continuous movement. By 1895 the Lumière brothers had opened the first public movie theater in France and soon their *cinématographie* were being shown throughout Europe.

Like those traditional art forms with which we have already become familiar, cinema is primarily a visual experience. Techniques of shooting can effectively manipulate our perspective as we remain stationary. But special to film is the depiction of movement over a course of time. The expression of a continued time has been an important element in many works of art, but with cinema time is not only actual, but our perception of it may be altered by various methods of editing, the "cutting and pasting" of sequences of film together. Sergei Eisenstein's montage editing in *Potemkin* (figs. 545, 546), rapidly shifting us from scenes of Cossacks firing into the crowd to scenes expressing the anguish of the people, conveys the tragedy of the event. The efficacy of the modern medium of cinema was vividly expressed by the noted Swedish director Ingmar Bergman when he stated: "I can transport my audience from a given feeling to the feeling that is diametrically opposed to it, as if each spectator were on a pendulum. I can make an audience laugh, scream with terror, smile, believe in legends, become indignant, take offense, become enthusiastic, lower itself, or yawn with boredom.... I am able to mystify, and I have at my disposal the most astounding device [the motion-picture camera] that has ever, since history began, been put into the hands of the juggler."

As we shall see, the twentieth century will bring us to the position where the artist becomes the work of art, in Performance Art, and the work of art as an object itself will be deemed less important than the concept or idea to create it. Joseph Kosuth's *One and Three Chairs* (fig. 641) only refers to the potential of an art object rather than being one in itself.

POST-MODERNISM

The architectural critic Charles Jencks has argued that the death of modern architecture occurred at 3:32 P.M. on July 15, 1972, in St. Louis, Missouri, when the failed Pruitt-Igoe housing project, which had won a national design award in 1951, was dynamited. With its geometric design, flat roofs, and complete avoidance of ornament, the project had exemplified the purist aesthetic of the International Style (see pp. 542–43), but the impersonal nature of its design fell victim to vandalism and drug dealing. It was becoming clear that modern architecture was meeting neither individual needs nor social realities in a pluralistic world.

Beginning in the 1970s, new architectural styles countered the austere formalism of the International Style. The intense colors and exposed operating systems of the Pompidou Center in Paris and the playful use of classical architectural forms in Moore's Piazza d'Italia in New Orleans (figs. 651, 652) contrast with the rigorous regularity, muted coloration, and "glass box" approach of the preceding period. Michael Graves's Portland Public Service Building (fig. 547) is a significant monument of a new style known as Post-Modernism. Alluding to modernism in its rectangular form, the Portland Building also includes references to historic architectural traditions by its use of giant pilasters, blocklike Doric capitals, and an enormous keystone and by adhering to the concept of the building as an anthropomorphic emblem. Following the tenets of Post-Modernism, Graves's building offers traditional symbols. The distinct areas of green, terra-cotta, and blue into which the structure is divided refer to water, earth, and sky. The huge figure of Portlandia over the main entrance, which is taken from the city's seal, represents a break from the abstract sculpture usually associated with modern public buildings. Here, the symbolism of ornament is wedded to a frolicsome attitude of visual delight.

The term Post-Modernism, first applied to architecture, is also used to refer to developments in other art forms that are characterized by a pluralistic approach to style, media, and interpretation, and a disavowal of the belief in the value of modernism. Post-Modernism's emphasis on plurality makes it difficult to offer a succinct definition of the movement, but it is possible to discuss its primary features.

Post-Modernism, for example, welcomes the artistic past into the present. The process of appropriating, or adapting, traditional art forms into contemporary works allows us to question and examine the role of tradition and context. Post-Modernist art celebrates diversity and is unafraid to examine social, political, and historical issues. It is a vehicle that can help us locate and define ourselves within our culture. As the contemporary architect Robert Stern has written, "The fundamental shift to post-modernism has to do with the reawakening of artists in every field to the public responsibilities of art. Once again art is being regarded as an act of communication."

Such communication may, at times, include facing the reality of one's cultural past. Sigmar Polke is one of a group of German Neo-Expressionist artists who have confronted the legacy of their country's past (see also pp. 574–75). The dark, looming image of the watchtower

547. MICHAEL GRAVES
Portland Public Service Building, Oregon. 1980–82. This model shows one of the architect's designs for the building. When built, the extravagant bows on the side of the structure were flattened and the "acropolis" of structures on the roof, which was originally intended to house the building's mechanical functions, was omitted. The figure of Portlandia over the main entrance was to be designed by the American sculptor Raymond Kaskey.

in Polke's *Hochstand* (fig. 548) calls to mind the concentration camps of World War II and the guarded borders of the divided Germanies. In addition, *Hochstand*, like much Post-Modernist work, involves a complex layering of imagery. The watchtower seems both to be emerging from and sinking into a ground of patterned fabric. In addition to their historical references, Polke's paintings can also refer formally to stages in modern art. Here the fabriclike pattern alludes to both Pop Art and to the P+D (Pattern and Decoration) movement (see pp. 572–73), while the overall darkness and dribbling of the paint may refer to the gestural technique used by the Abstract Expressionist painters (see pp. 544–47). Polke's complex image can remind us of past political realities while at the same time it warns us not to let memory fade behind the numbing onslaught of media culture.

548. SIGMAR POLKE
Hochstand. 1984. Acrylic, lacquer, and cotton, 10' 8" x 7' 4". Private collection, New York

THE TWENTIETH-CENTURY ARTIST

"The thing that interests me today is that painters do not have to go to a subject matter outside themselves. Modern painters work in a different way. They work from within" (Jackson Pollock, 1951). Pollock's statement, made at mid-century, summarizes the unique experience of the artist in this century. The rapidity of social changes, the impact of technology, and new artistic freedoms have altered many traditional notions of the role and identity of the artist. The twentieth-century artist has forged a new independence with diverse materials, and often works of art are imbued with a highly introspective content. This aspect of self-gratification in art leads us to experience many works as a revelation of the artist's inner self. It is almost as if this disclosure of the inner self, which in the past was usually restricted to self-portraits, is the main content of many twentieth-century works of art. But the diversity and subjectivity of this new freedom have also posed problems in the critical evaluation of art and even in the identity of the artist. Having broadened the definition of art, customary notions concerning the education of artists and the parameters of a work of art have been opened to a flood of conjectural questions concerning quality, value, and meaning.

Our self-portraits demonstrate that the twentieth-century artist has maintained a continuing integrity, while countering tradition with complex symbolic and psychological insight. Jacob Lawrence, a contemporary African-American artist (see also p. 531), painted his *Self-Portrait* when he was elected to membership in the National Academy of Design (fig. 549); it joins hundreds of portraits and self-portraits of other members in the Academy's collection. Lawrence's direct and compelling painting alludes to both the physical and the intellectual processes of creativity. He is surrounded by the tools and products of his profession, including, in the upper left background, a work from his *Harriet Tubman* series, which narrated the life of the former slave who, before the Civil War, was responsible for freeing more than three hundred slaves. The laborer below the Harriet Tubman painting and the tools and paintings on the shelf refer to Lawrence's *Builders* theme, which had its roots in the artist's youth in Harlem, where he associ-

549. JACOB LAWRENCE
Self-Portrait. 1977. Gouache on paper,
23 x 31". National Academy of Design,
New York

550. FRIDA KAHLO
The Two Fridas. 1939. Oil on canvas,
69 x 69". Museo de Arte Moderno,
Mexico City

ated with cabinetmakers and carpenters. For Lawrence, this theme symbolized human aspiration, which, in the artist's words, "came from my own observation of the human condition."

The Two Fridas, a double self-portrait by the Mexican artist Frida Kahlo (fig. 550), is a complex image filled with symbolism. Although the two figures hold hands and are joined by a common blood system,

551. ALICE NEEL
Nude Self-Portrait. 1980. Oil
on canvas, 54 x 40". National Portrait
Gallery, Washington, D. C.

the duality Kahlo feels is revealed by the contrasting costumes, Mexican and European. Her dual heritage is likewise expressed in the two hearts, for the figure in the European dress has her chest ripped open in a reference to Aztec sacrificial practices, while the other figure's heart resembles Catholic representations of the Sacred Heart of Jesus. This revealing, if enigmatic, work was painted as Kahlo was being divorced, and the open artery on her lap may refer to her suffering at this time. Such personal self-revelation is not unusual in twentieth-century art.

From later in the century, Alice Neel's *Nude Self-Portrait,* although realistic, does not communicate a faithful naturalism (fig. 551). The adjusted figural proportions, stern modeling, and austere pose portray a psychological presence within a probing, unashamed honesty. Such introspective and deliberate honesty, revealed within a wide variety of visual means, can be one of the keys to understanding the modern artist.

Artists of the twentieth century have had to respond to a different world from that of their predecessors. Technology and the immediacy of communication have brought us into an era in which isolation is increasingly rare and where the developments in ecology, economics, political change, and conflict can have a strong impact on a large part of the world. Artists, like the rest of us, are caught up in global tension, uncertainty, and promise.

Fauvism

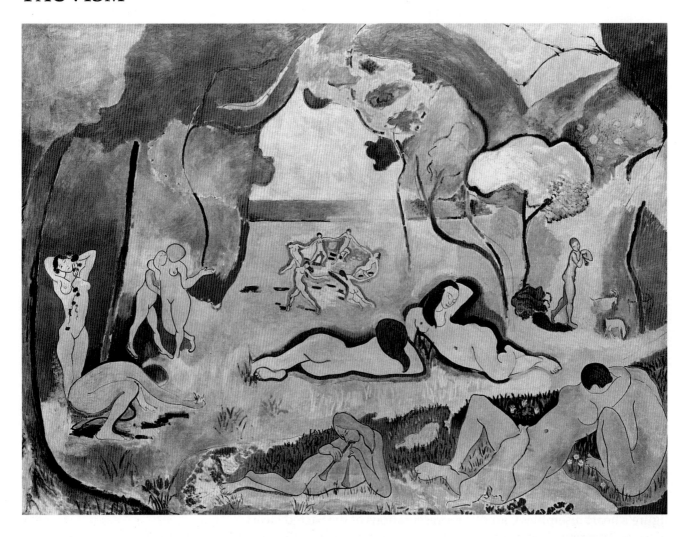

"I cannot copy nature in a servile way, I must interpret nature and submit it to the spirit of the picture—when I have found the relationship of all the tones the result must be a living harmony of tones, a harmony not unlike that of a musical composition. . . .

"The chief aim of color should be to serve expression as well as possible. . . . What I dream of is an art of balance, of purity and serenity devoid of troubling or depressing subject-matter, an art . . . like an appeasing influence, like a mental soother, something like a good armchair in which to rest from physical fatigue" (Henri Matisse, *Notes of a Painter*, 1908).

In Matisse's representation of the mythical land of Arcadia (fig. 552), lovers embrace and dance to the strains of music. The sinuous nudes who inhabit this verdant pasture of pleasure are defined by the same curving, rhythmic lines that describe trees and foliage. This sensuous landscape suggests harmony between humanity and the natural order. As we can judge from the preparatory study, the colors are intense and vibrant (fig. 553). Matisse's monumental painting descends

552. HENRI MATISSE
The Joy of Life. 1905–6. Oil on canvas, 68 1/2 x 93 3/4". The Barnes Foundation, Merion, Pennsylvania. When it was exhibited in 1906, *The Joy of Life* was singled out for criticism. The painter Paul Signac complained that Matisse had "gone to the dogs."

from a tradition of pastoral images that began in antiquity and was revived during the Renaissance and Baroque periods. In this twentieth-century interpretation, the diminution of the figures indicates spatial recession, but the broad areas of unmod-

ulated bold color and the powerful flowing linear rhythms create a patterned, flat composition that adheres to the picture plane.

In the opening years of the present century, Matisse, who during the 1890s had painted with an Impressionist palette, assimilated artistic influences from the Post-Impressionists and began to make paintings in which color, independent of descriptive reality, was exalted for its expressive and sensuous self. Matisse worked in Paris with a group of painters who were exploring this liberation of color, and at a Parisian exhibition in 1905 their works were displayed in a room with a classicizing sculpture, causing the critic Louis Vauxcelles to remark: "Donatello au milieu des fauves!" (Donatello among the wild beasts). This witty denunciation gave the name Fauvism to this new style. Fauvism was short-lived, but its revelling in the freedom of color, as seen in *The Joy of Life*, had an impact still being felt in twentieth-century art.

MATISSE, *The Joy of Life*: 1905–6
1904: Henry James, *The Golden Bowl*
1904: Puccini, *Madame Butterfly* premieres, Milan
1904: Rolls-Royce Company founded

553. HENRI MATISSE
Study for *The Joy of Life*. 1905. Oil on canvas, 18 x 22". Statens Museum for Kunst, Copenhagen. As the Barnes Foundation has not permitted color reproductions of *The Joy of Life*, this sketch has been included to indicate the approximate colors of the final painting.

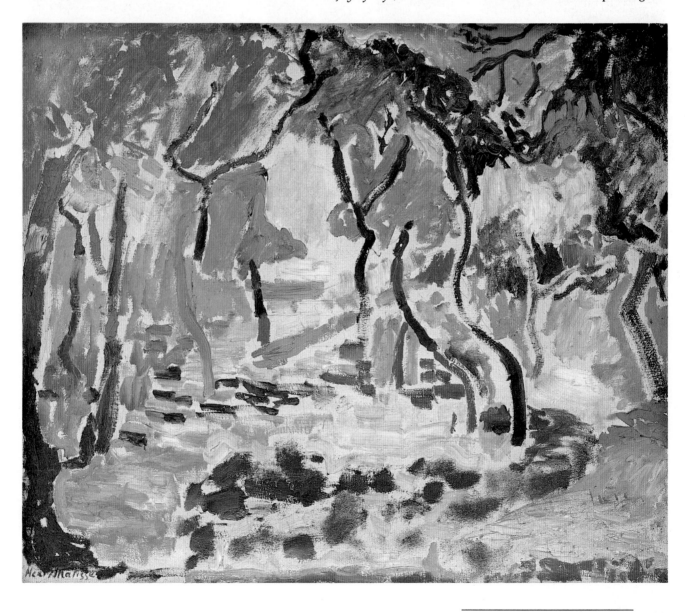

AFRICAN ART: BOBO MASKS

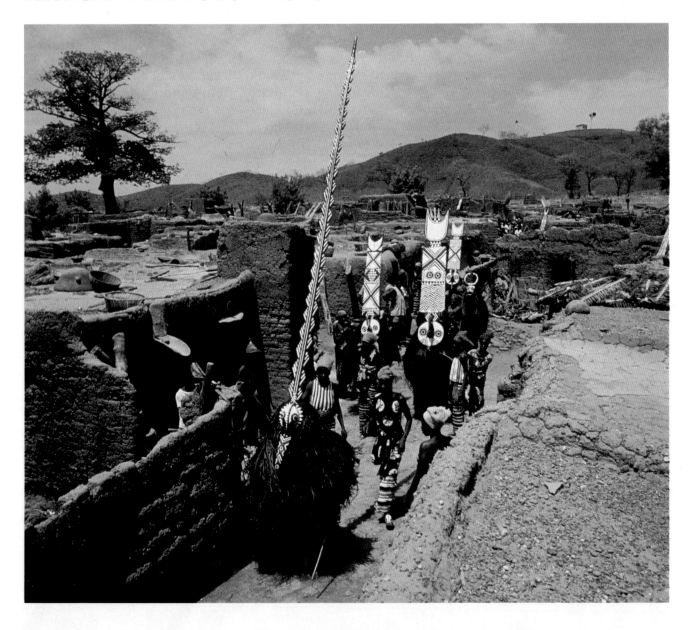

These Bobo masked figures (fig. 554) are about to take part in purification rites, which are believed to be indispensable to the cycle of renewal and rebirth. As with all mask-using societies in Africa, the Bobo have a developed ritual life which has to do with their environment and conduct in daily life. The name Bobo is applied to those people living in an area bounded by Mali and the Niger River on the north and west and by Ghana to the east. They live in one part of a broad zone of open, rather arid savannah which extends across the continent from the Atlantic Ocean to the Red Sea to the south of the Sahara Desert.

The visual arts of sub-Saharan African traditional societies include an ensemble of objects, activities, and performances: masks

554. Bobo masked dancers at annual purification rites, Upper Volta. 20th century

BOBO Masked Dancers: 20th century
1905: Russian sailors mutiny aboard *Potemkin*
1908: Congo Free State becomes the Belgian Congo
1910: Union of South Africa achieves dominion status within
British Empire
1911: Italy occupies Tripoli

555. Leaf Mask. 20th century. Leaves of the *karité* tree, fiber, straw, and colored string. Bobo, Upper Volta

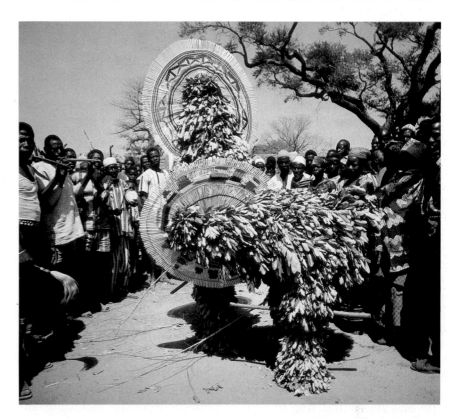

556. *Bird of the Night* (Butterfly) Mask. 20th century. Wood, paint, and raffia. Bobo, Upper Volta

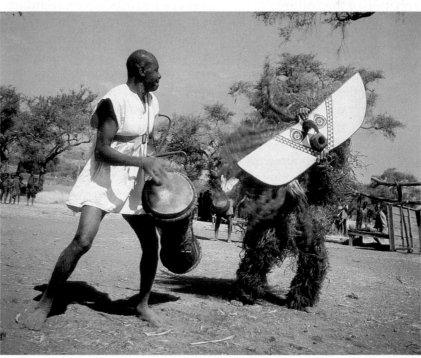

and sculptured figures; body paint and scarification; costumes of all sorts; dance, music, and musical instruments; and the recitation of myths. Every element, from costumes to choreography, from choral to solo singing, has a place in an overall belief system, and every tiny detail of the code carries specific meaning. This strict code links events that are believed to have occurred at creation with their repetition, in symbolic form, in the world of today. The symbolic performances are neither anecdotal nor narrative. The painter or sculptor is not representing an act that has been or will be staged in a transient or fixed period of time. On the contrary, these African arts are meant to ensure the permanence of ceremony in daily life and its central role in continuation of the culture.

Such arts are documents of African thought and action and contribute to the sense of well-being in the parent culture. They are part of the normal experience of the average member of the culture. In most instances the "meaning" of the arts is broadly known to the community to which they belong. In this public sense, one meaning of a work is generally known and refers to present and future security of the individual, the family, the village, or the nation. From this level of commonly held knowledge there arises a pyramid of more detailed and often more sacred meanings. Political and priestly elites are usually the keepers of

such esoteric knowledge. This knowledge can be speculative or mythological, historical or aphoristic (asserting a general truth), of applied science (the medicine givers) or from free association. Such knowledge is the basis of cultural beliefs and the justification for social acts. A higher value is placed on the good of the group than on the needs of the individual. African art exists at the intersection between the human and spirit worlds. It is vital to survival.

Outside the major political centers, the village is the dominant political unit. The Bobo people are divided into as many autonomous political units as there are villages. While not isolated from their neighbors, they maintain a number of distinct and localized patterns of culture, including language and arts. All these groups, however, share the same concept about the relationship of human life to nature and perform a series of ritual activities which are similarly outfitted with costume, dance, and music. In the Bobo region, agriculture is the predominant source of wealth. The fear of drought or even delay in the arrival of the rainy season is a source of great mental stress, which is eased for the farmers of the dry savannah by a highly developed and elaborate scheme of institutions and rites which preserve the relationship between nature, the source of all life, and survival. The Bobo differ from other African societies (Dogon and Yoruba, for example)

in that they do not represent nature as an ambivalent force either generous or dangerous, but see nature as essentially benevolent. The needs, mistakes, and offenses of people upset her, so the function of the ritual performances is to chase away evil, which is bound to occur in human communities. Such rites are necessary at times of transition—at creation, birth, upon entering adult life, death, planting, and harvest.

Wuro, the Supreme Being of the Bobo, installed harmonious order among the sun, rain, and the earth at creation. Human beings, given their lifeways and weaknesses, threaten that equilibrium. The techniques of agriculture involve violation of the soil. This outrages Soxo, the divinity of the bush, and through him, Wuro the Creator. Moreover, if one transgresses the laws (taboos) of society, a sequence of calamities will occur: drought leads to starvation, sickness, sterility, and sometimes death. Wuro gave some of his bounty to Dwo, who acts as mediator between God and human life to restore balance. Dwo is incarnated in the leaf masks of the Bobo.

These leaf masks cover the entire body of the dancer (see fig. 555) and are made in the bush after the millet crop is safely stored. The leaves are those of a local tree, the *karité* (a type of mahogany), and are tied together with vegetable fiber. Feathers or a straw crest indicate that the mask is male. The leaf masks

enter the village at dusk and roam the alleys, lightly brushing against storehouses, huts, and the people of the village. The rustling leaves collect all the dust particles, which represent the offenses of human beings. They cleanse that which they touch of all their impurities and thus absorb the evil that has accumulated throughout the year. They purify the village. The masks themselves are perishable, and their potency is spent in this activity. They, too, are part of the life cycle and are regenerated at the end of the next agricultural season.

The human community also is regenerated by participation in renewal rites of nature which take place at the end of the dry season, before the first rain falls and planting begins. These rites signify the end of the period of mourning. They also constitute purification and appeal to the spirits of the underworld. They require the presence of leaf masks and also of fiber and sculpted masks.

The fiber masks are plaited and dyed by the blacksmiths, and their natural materials are associated with substances of the bush. They are decorated with clan emblems linked to veneration of human lineage. The wooden, sculpted masks are usually rendered in animal form and represent the protective genii of the village. They include the male flat-horned buffalo, the female buffalo with circularly sectioned horns, the warthog, the cock with

its crest, the toucan, the fish, the antelope, and the serpent, which is sometimes as much as ten feet long. The *Bird of the Night*, or butterfly, mask appears after the first rains of the season (fig. 556). The fluttering movements of the butterfly are imitated by the dancer. Clearly a record of the essence of the animal is what is sought by the carver and dancer and not an exact visual representation.

Another important type of mask is the *dodo* or *nwo*. These have round faces and eyes in concentric circles and are topped with a polychrome blade. They combine the face of an owl, a caloo beak, and sometimes a snake skeleton with geometric patterns such as lozenges, checks, triangles, and chevrons. As messengers, the bird connects human life to the realm of the spirits. Such masks are only one part of the whole image, which includes a mask, costume, human bearer, and performance in motion.

Whether made of leaf, fiber, or wood, whether representational or abstract, these images embody the benevolent force of Dwo and thereby the concept of fertility, fecundity, and growth. As with many African arts, masks were collected by Western artists, anthropologists, and collectors in the late nineteenth century because they were moved by their direct and powerful formal expression. Only recently have they begun to be understood in their own context by outsiders.

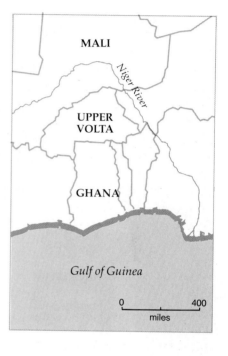

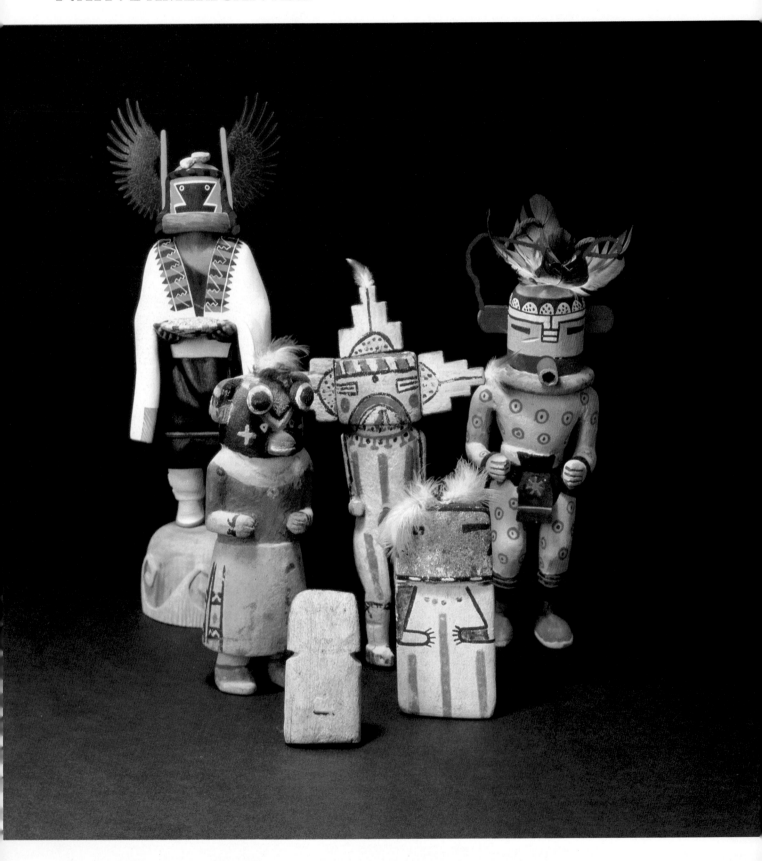

557. HOPI Tribe
Opposite: *Kachina* dolls. Late 1800s to present. Cottonwood roots adorned with mineral paints and other natural materials. The Heard Museum, Phoenix, Arizona (Fred Harvey and Barry Goldwater Collections)

HOPI *kachina* dolls: 20th century
1906: San Francisco earthquake
1907: Oklahoma is admitted as forty-sixth state
1908: Founding of the Boy Scouts
1909: Indian Councils Act increases elected members on Native American councils
1911: Revolution in Mexico

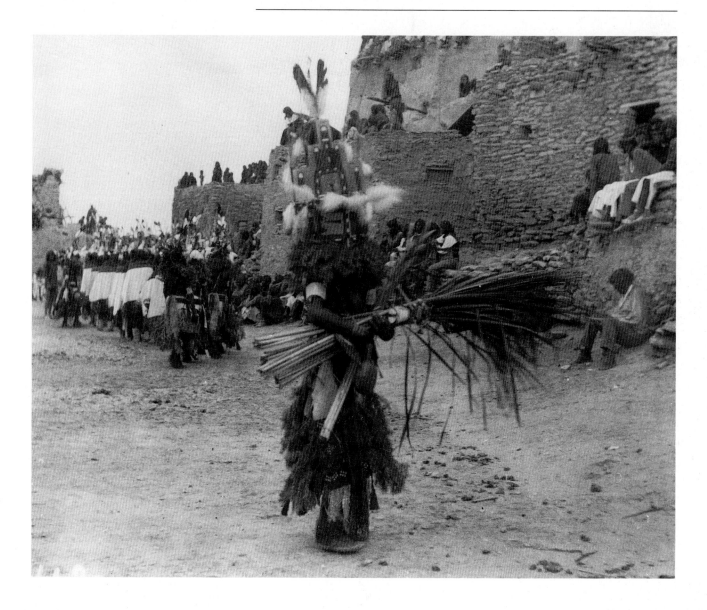

These wooden figurines (fig. 557) are called *kachin-tihu*s (or *kachina* dolls) and were carved by Hopi tribesmen. The elaborate headdresses, some of them fitted with birds' feathers, are thought to assist in transmitting messages to and from the spirits. Another *kachina* represented here (fig. 558) is a human figure wearing a ritual outfit and headdress not unlike those on the wooden figurines. As with most Native American art, these examples must be seen as functional, that is, they were not produced solely for their own sake as decorative objects, but were meant to serve social and

558. HEMIS (JEMEZ) Tribe
Kachina. 20th century. Costume of feathers, yarn, buckskin, and grass. The figure holds cattails.

559. Pueblo, Taos. Carson National Forest, New Mexico

religious purposes. Each example is invested with sacred symbolism.

Kachina are supernatural beings who act as links between the gods and human beings. The spirits (gods) are thought to live in the San Francisco Mountains of California and are believed to visit the Hopis at their current home in northeast Arizona during the first half of the year, when the planting of new crops is being prepared. Among their many powers, these important spirits are thought to exercise control over weather. The Hopi were and

still are farmers who grow corn, beans, and squash. Because of their dependence on agriculture in this arid region, the Hopi have developed a complex religious life centered around rain-making and crop fertility.

In the Hopi religion, there are three manifestations of the *kachinas*: the spirit, a human acting as a spirit, and a carved figurine. The spirit, which, of course, cannot be seen, is impersonated by members of the Hopi tribe. By placing masks over their heads and wearing elaborate costumes and headdresses, these men and women

are regarded as having taken on the supernatural character of the *kachina* spirit. Through special masks, costumes, paint, and actions of the impersonators, the otherworldly spirits are given power, substance, and personality. *Kachina* dolls *(kachin-tihus)* are miniature representations (eight to ten inches in height) of the masked impersonators. There are about two hundred and fifty *kachina* personalities, though a limited number are favored. They personify a variety of natural elements, including clouds, rain, crops, animals, or even abstract concepts such as growth. From archaeological evidence, we know that they have been in use since the Hopi first inhabited the southwestern United States about two thousand years ago.

The Hopi culture was not much disturbed by European influence until the later nineteenth century, and the Hopi claim that they, more than any other North American tribe, live "in the old way." Since 1882 the Hopi have been officially confined to government reservations in northeast Arizona. This is the traditional homeland of the Navajo and the Zuñi as well and is typified by steep-walled canyons and isolated mesas formed by the steady down-cutting of rivers. Hopi communities are based on cooperation, as their survival in such a difficult environment depends on shared responsibility. They count on ceremonies to give them unity and cohesiveness. Group rituals depend on cooperation and are important models for the whole community to witness.

Viewing a Hopi village, one can see that the buildings seem to grow directly out of the mesa top, and their materials and shapes give them continuity with the living rock on which they are built (see fig. 559). This is often called an organic mode of building, for there is little conscious separation between what is made by human hands and what is natural environment.

Village life is organized around the plaza, a central space left open for the performance of ritual dances. Preparation for such rituals takes place in underground chambers called *kiva*. These *kiva* represent the underworld from which the Hopi believe their people emerged in primordial times. Among other beliefs, the *kiva* is where the ritual of growing new food plants for the coming season takes place. Those rituals are performed by men. Upward movement from the dark *kiva* to the open daylight symbolically enacts the Hopi "origin myth," in which they emerged from the chaos of the underworld to begin settled agricultural life on the mesas.

Ceremonies take place over a seven-month period beginning in December. In the winter, when the earth's vegetation is dormant and covered with snow, the *kachina* rituals are held at night in the *kivas*. These dances include warriors and hunters, emphasizing combat and death. Spring and summer rituals take place in the outdoor plaza in daylight and are associated with fertility, themes of growth, and regeneration. These are happy and boisterous occasions involving both men and women in ritual dress who sing and dance in an ordered and stately fashion. Some other *kachina* dancers are ogres whose role is to admonish everyone, especially children, to obey the rules of the Hopi society. In a society based on cooperation rather than authoritarian control, such *kachina*s are important for social stability. The *kachina* figurines serve a didactic purpose: to remind Hopi children of religious and social mores. They are not toys; these art forms are clearly an integral part of life and are thought to ensure Hopi survival.

THE ORIGINS OF CUBISM

560. PABLO PICASSO
Les Demoiselles d'Avignon. 1907. Oil on canvas, 96 x 92". Collection, The Museum of Modern Art, New York (Acquired through the Lillie P. Bliss Bequest). The Avignon to which the title refers is a street in Barcelona's red-light district.

Picasso's *Les Demoiselles d'Avignon* (fig. 560) is a harsh and aggressive painting. Inside a brothel we confront five naked prostitutes with abstract anatomies. Three figures conceal their faces behind vividly painted African masks that both hide their identity and communicate a frighten-ing ferocity. Picasso considered these masks "magic things" that added a mysterious potency to the work. Compounding the psy-chological anxiety communi-cated by these masked figures is a composition which sets formal elements in violent visual com-bat: warm flesh tones and shades of pink and rust are set against icy blues, while spatial illusion-ism seems denied by the flat, ab-stract shapes, despite the man-ner in which the nude entering from behind parted drapes and the *repoussoir* table and still life suggest perspectival recession. The nude figures are discordantly

composed of geometric, angular facets and organic, curving passages. *Les Demoiselles d'Avignon*, a paradox of formal and psychological tensions, threatened the tradition of illusionism that had characterized painting since the Renaissance.

The painting began, however, in a less anguished, more traditional spirit. In the spring of 1907 Picasso, a young Spaniard working in Paris, took up the challenge of painting a monumental modern composition of female nudes. After seeing a 1906 Paris retrospective of Cézanne's paintings, Picasso began to apply the planar, geometric simplifications of Cézanne's forms to the study of the human figure. In a preliminary study for the painting, two clothed male figures were surrounded by five female prostitutes. This confrontation, as well as the still-life arrangement on the table, suggests a traditional *memento mori* theme— all physical pleasure is passing.

Les Demoiselles d'Avignon seemed a brutal and ugly painting to many of Picasso's friends, including the French painter Georges Braque, but Braque was inspired by the manner in which Picasso was wrestling with the question of pictorial structure and the issues raised by Cézanne. In the summer of 1908, Braque was in southern France, the landscape which had earlier been transformed by Cézanne (see fig. 526). Braque's *Houses at L'Estaque* (fig. 561) develops the planar simplification and faceted surface structure of Cézanne's paintings but, in contrast to Cézanne's intention, now the houses seem to lack solidity and weight. Braque's eccentric use

PICASSO, *Les Demoiselles d'Avignon:* **1907**
1906: Upton Sinclair, *The Jungle*
1907: Louis Lumière invents a process for color photography
1907: Mother's Day established in Philadelphia
1908: Ford Motor Company produces the first Model T

561. GEORGES BRAQUE
Houses at L'Estaque. 1908. Oil on canvas, 28 3/4 x 23 5/8". Hermann and Margit Rupf Foundation, Kunstmuseum, Bern

of modeling highlights different areas of the landscape simultaneously and reinforces the planarity of the pictorial surface.

Reviewing a 1908 exhibition of Braque's paintings in Paris, which included *Houses at L'Estaque,* the French art critic Louis Vauxcelles (who had earlier given us the name Fauvism; see p. 487) wrote that Braque "despises form, reduces everything . . . to cubes. Let us not make fun of him, since he is honest. And let us wait." Cubism, the style that would result from these experiments of Picasso and Braque, would become one of the most significant movements of early-twentieth-century art.

FRANK LLOYD WRIGHT

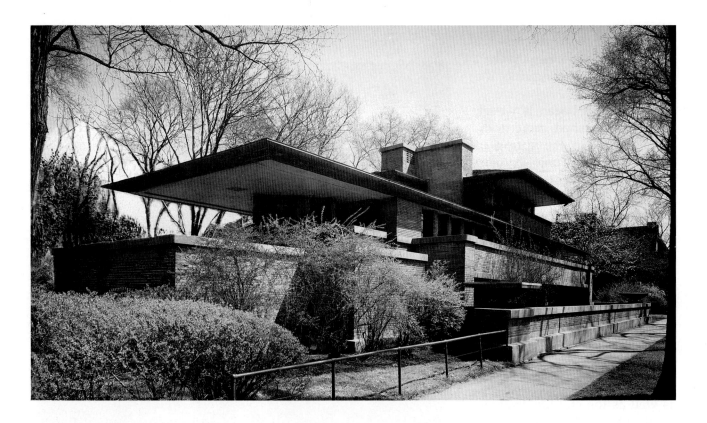

Wright's Robie House (fig. 562) is distinguished by an emphatic horizontal design, with rooms and porches extending out from a central core defined by the chimney mass. It is astonishing to realize that the Robie House, with its contemporary appearance, was actually constructed in the first decade of the twentieth century. The house was designed by Frank Lloyd Wright, an architect who had worked as an assistant to Louis Sullivan from 1888 to 1893. By 1900 Wright had developed a new and personal style, and in the opening years of this century, he designed a series of private homes in the Chicago area that shared similar compositional qualities, one of which was an emphasis on the horizontal features of the design.

Wright's style at this time, which was inspired by the flatness of the terrain where the homes were built, is known as the Prairie style.

In the Prairie style, Wright developed what he termed his organic theory of architecture. The organic concept governs both the design of the structure and its relationship to the site. The cantilevered projections (see below) from the core of the house lessen the distinction between inside and outside, while the abstract, geometric massing of the architectural forms creates a distinctly modern effect.

The interior design of the rooms continues the geometric organization apparent from the outside. Wright's use of furniture, much of which he created

562. FRANK LLOYD WRIGHT
Exterior, Robie House, Chicago. 1909. Wright's Prairie style designs, including this house, were published in Europe in 1910. They influenced later developments in modern European architecture, including De Stijl and the Bauhaus.

particularly for each house, is distinctive for its severely geometric design and its hand-crafted elegance (fig. 564). It reiterates and complements the architectural forms and, in its rich use of wood and modern decorative elements, enhances the intimate scale of the rooms.

Viewing the plan, one becomes aware of another feature of the organic theory (fig. 563). The interior spatial flow from room to room, around the central core of the fireplace and stairway, is free

WRIGHT, Robie House: 1909
1909: Freud lectures in America
1909: Admiral Peary reaches the North Pole

563, 564. FRANK LLOYD WRIGHT
Robie House, Plan and dining room, with original furniture designed by Wright

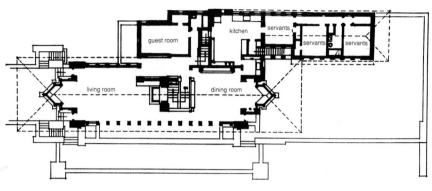

UPPER FLOOR

and unobstructed; rooms are not boxed off. Interior spaces merge one with another. A new continuity of interior spatial design is established.

The decorative features of the house's exterior are minimal. Instead of applied ornamentation, Wright utilizes the color and texture of the materials themselves. On the exterior, red brick contrasts with powerful horizontal accents in stone. The unadorned planarity of the exterior walls will become one of the distinguishing features of modern architecture.

Certain features of Wright's organic theory are antithetical. For example, the desire to merge the house with the environment is countered by the severely geometric and planar design, but it was precisely the harmony of the balancing of antithetical design features which distinguished Wright's achievements.

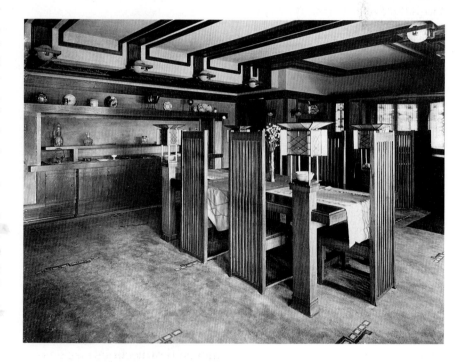

THE CANTILEVER

The cantilever, an architectural support system utilized by Wright in both the Robie House and Fallingwater (see fig. 10), horizontally projects an architectural member out into space without external support. It is counterbalanced by a weight on the interior end. The materials used in the construction of a large cantilever must possess a high tensile strength; usually steel beams and reinforced concrete are used. For this reason, the cantilever as a method of construction reached its fullest expression in modern architecture.

ANALYTICAL CUBISM

The theme of Georges Braque's *Violin and Palette* (fig. 565) is traditional—a still-life arrangement of a violin, a music stand with sheet music, a painter's palette hung on a *trompe l'oeil* nail at the top, and green folds of drapery as a backdrop. Each of these common elements, however, is broken up into disengaged fragments. The violin, for example, is composed of a series of planes or facets which represent parts of the violin as seen from different points of view. These have been reassembled to form a highly abstract composition on the picture plane of the painting.

Braque's fragmented violin is in part the result of influences stemming from Cézanne, who introduced planar modeling and multiple viewpoints in his paintings from the late nineteenth century (see fig. 525). From 1907 onward, Picasso and Braque, working together in Paris, experimented with this analytical abstraction, applying it to figural and landscape representations. By the fall and winter of 1909–10, they had developed Cubism.

Since the Renaissance, naturalistic illusionism had been a primary concern of painting. Cubism confronted that tradition by asserting a new independence for the painted image. Given the visual clues that Braque offers us in *Violin and Palette*, we conceptually understand, for example, that one of the images refers to a violin. The image does not represent a particular violin as seen from a specific viewpoint. Rather, the simultaneous viewpoints

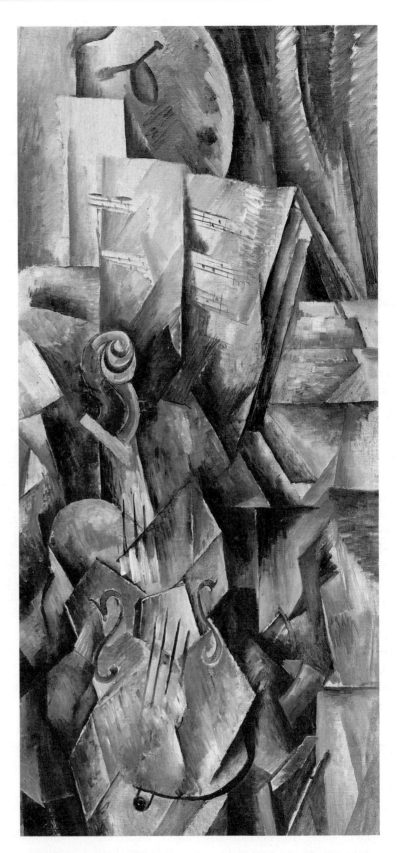

565. GEORGES BRAQUE
Violin and Palette. 1909–10. Oil on canvas, 36 1/8 x 16 7/8".
The Solomon R. Guggenheim Museum, New York

suggest the *essence* of a violin—those shapes, forms, and colors which define a violin as a distinct object, different from the music stand, sheet music, palette, or drapery. In this process of analysis, seeing becomes both visual and conceptual; we perceive time and space as a total experience, unlike the illusionistic tradition of painting, which fixes a viewpoint at a moment in time.

The initial phase of Cubism, which analyzes objects from different viewpoints to re-create them as planar facets on the picture plane, is known as Analytical Cubism. The process of abstraction inherent in this visual and conceptual analysis led to ambiguities of interpretation, but Cubism never became non-objective.

In 1911 a new element—lettered, stenciled shapes—was introduced onto the surfaces of Analytical Cubist paintings. Picasso's *"Ma Jolie"* (fig. 566) contains both letters and musical notations. While the shapes of the letters reinforce the planarity of the painting's surface, they also act as a clue, for they were taken from a current popular song. The words also become a reference for the viewer, for above them we can glimpse shapes that suggest a figure holding a stringed instrument. The color has been reduced because Picasso's primary examination in this work is of form; color, which depends on light, is deemed extraneous to form. However abstract, the painting offers the persistent observer a representation of a posed model. The network of planar shapes has given a new aesthetic to painting, one that asserts the surface as a two-dimensional field for assembling references to the world.

1910: Stravinsky's *Firebird* is performed in Paris
1910: Halley's comet returns
1910: U.S. population reaches 92 million; 13.5 million are foreign-born

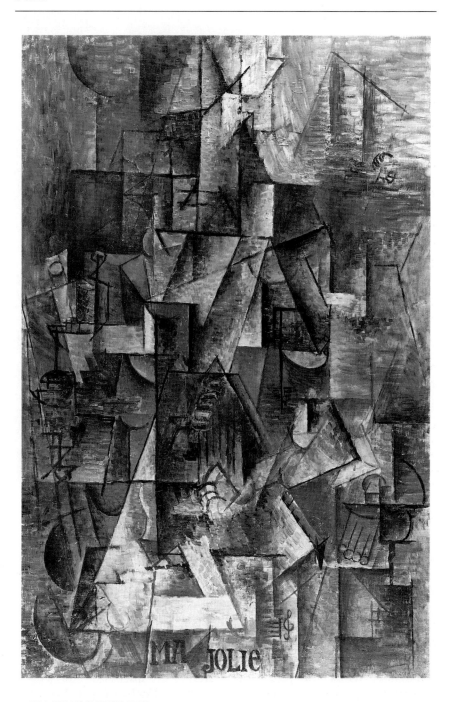

566. PABLO PICASSO
"Ma Jolie" (Woman with Guitar). 1911–12. Oil on canvas, 39 3/8 x 25 3/4". Collection, The Museum of Modern Art, New York (Acquired through the Lillie P. Bliss Bequest). *Ma Jolie* (French for my pretty one) has a double meaning here. It refers both to the words in a popular song and to the name Picasso used for his new lover, Eva, who probably posed for this painting.

SYNTHETIC CUBISM

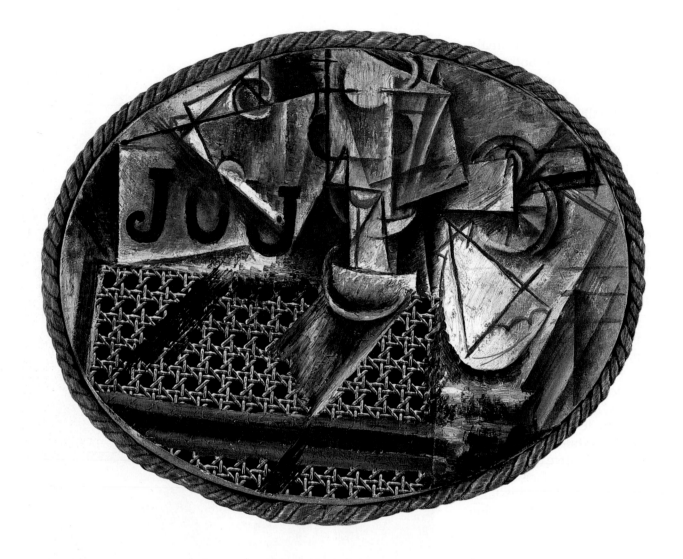

The upper portion of Picasso's *Still Life with Chair Caning* (fig. 567) bears the familiar fragmentation of Analytical Cubism (see p. 500). This arrangement of objects includes an oyster shell, lemon slices, a knife, pipe, and wineglass, while the *JOU*, for *Journal*, indicates the presence of a newspaper. These objects have been painted over chair caning. But this chair caning, which seems to be the most realistic aspect of the work, is itself an illusion, for it is in actuality cheap printed oilcloth

pasted onto the canvas. Even the frame dares us to consider new expectations of painting, for it is common, ordinary rope instead of a traditional frame.

Picasso's use of the collage medium (see below) is an extension of the questions first posed by Analytical Cubism. Now the issues are compounded, for the conceptualized transcription of reality into art demonstrated in the abstract still-life arrangement is joined to printed oilcloth that looks like yet another reality:

567. PABLO PICASSO
Still Life with Chair Caning. 1911–12. Collage of oil and pasted oilcloth, simulating chair caning, on canvas, oval 10 5/8 x 13 3/4". Musée Picasso, Paris

568. PABLO PICASSO
Three Musicians. 1921. Oil on canvas, 79 x 87 3/4". Collection, The Museum of Modern Art, New York (Mrs. Simon Guggenheim Fund)

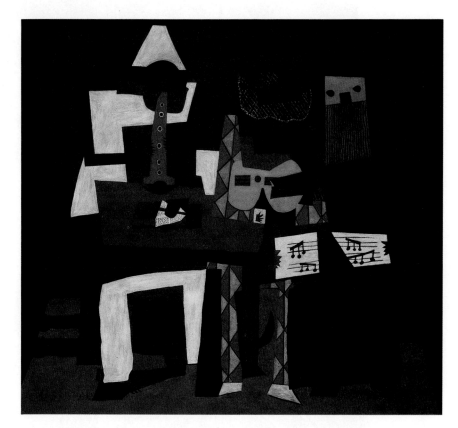

chair caning. With Picasso's Cubist collage, we are exposed to the paradoxical realities of life and art; while we easily recognize the artificial composition of the still-life objects, the oilcloth disguises its reality behind the illusion of chair caning.

Still Life with Chair Caning ushers in a new phase of Cubism in which painted elements are combined with commonplace materials. The resulting works join traditional artistic media with materials previously considered outside the realm of art. This second phase of Cubism is known as Synthetic Cubism.

Soon the effects of the Synthetic Cubist collage were translated wholly into painting, as seen in Picasso's *Three Musicians* (fig. 568). Although some of the flat, patterned areas of this work appear to be collage materials, they are in actuality all painted. The abstract figures retain an objectivity which is clearly recognizable, while the reality of the picture plane is also emphasized. The tradition of the picture plane as an element through which we view an illusion of space has been overturned. Painting now asserts itself as a completely flat surface.

COLLAGE AND ASSEMBLAGE

Collage, from the French word *coller* (to glue), is used to designate works of art which incorporate such materials as pieces of newspaper, cloth, colored paper, and the like. With their Synthetic Cubist collages and assemblage sculptures, Picasso and Braque extended the range of materials accepted in art, while influencing later avant-garde movements, including Futurism, Dada, and Surrealism.

Assemblage has broader connotations than collage, although historically the term has been used to include collage. Assemblage usually involves a combination of actual three-dimensional objects, some of which are "found" objects from the household or the junkyard, into a coherent composition. Examples of assemblage include Duchamp's "ready-mades" (see p. 520).

The influence of cubism

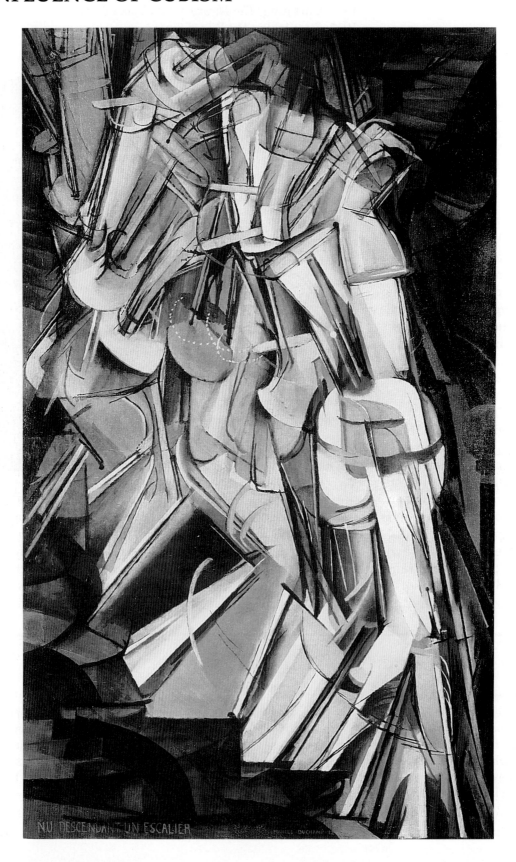

569. MARCEL DUCHAMP
Opposite: *Nude Descending a Staircase, No. 2.* 1912. Oil on canvas, 58 x 35". Philadelphia Museum of Art (Louise and Walter Arensberg Collection). When Duchamp's *Nude* was shown in the Armory Show in America, it became the butt of many jokes and cartoons, including one entitled *The Rude Descending a Staircase (Rush Hour at the Subway)* published in the *New York Evening Sun* on March 20, 1913.

570. UMBERTO BOCCIONI
Unique Forms of Continuity in Space. 1913 (cast 1931). Bronze, height 43 7/8". Collection, The Museum of Modern Art, New York (Acquired through the Lillie P. Bliss Bequest)

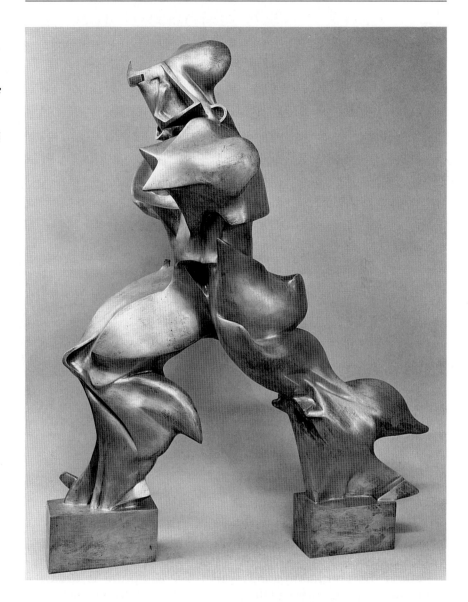

Cubism was tremendously influential on developments in early-twentieth-century art from Paris to New York and Moscow. The techniques of planar fragmentation, used in Cubism to portray a conceptual vision, were adapted to express different artistic philosophies. Marcel Duchamp, for example, utilized a complex sequence of fragmented planes to describe the dynamic movement of a figure descending a staircase (fig. 569).

In Italy the portrayal of the dynamism of modern life was the aim of a group of avant-garde artists who called themselves Futurists. Their task, as expressed in a 1910 *Manifesto*, was to free Italy from its past artistic traditions and thrust it forward into the twentieth century. The Futurist artists also embraced political anarchy. Among other defiant statements, the *Manifesto* declared "THAT ALL SUBJECTS PREVIOUSLY USED MUST BE SWEPT ASIDE IN ORDER TO EXPRESS OUR WHIRLING LIFE OF STEEL, OF PRIDE, OF FEVER AND OF SPEED.

"THAT THE NAME OF 'MADMAN' WITH WHICH IT IS ATTEMPTED TO GAG ALL INNOVATORS SHOULD BE LOOKED UPON AS A TITLE OF HONOR.

"THAT UNIVERSAL DYNAMISM MUST

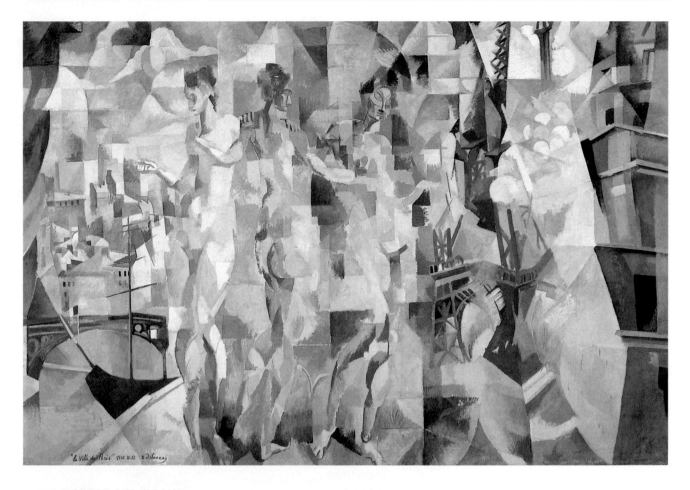

571. ROBERT DELAUNAY
The City of Paris. 1912. Oil on canvas, 8' 9 1/8" x 13' 3 7/8". Musée National d'Art Moderne, Centre Georges Pompidou, Paris. This work was begun in 1910.

BE RENDERED IN PAINTING AS A DY-
NAMIC SENSATION."

Futurist works in painting and sculpture were a response to the challenge established in their *Manifesto*. The intensity of speed suggested in Balla's *Speeding Automobile* (see fig. 531) meets the demand for "dynamic sensation," as does the implied stride of Boccioni's innovative *Unique Forms of Continuity in Space* (fig. 570). Forms that suggest both working, moving muscles and sweeping drapery folds are thrust outward into space in

order to convey the determined energy of a quickly striding figure. The sculpture is dramatically different when seen from varied viewpoints. Boccioni wrote: "No one can any longer believe that an object ends where another begins. . . . We therefore . . . proclaim . . . the complete abolition of definite lines and closed sculpture. We break open the figure and enclose it in the environment."

Cubism continued to have an ever-widening impact in Paris, the city of its origins. Delaunay's

City of Paris (fig. 571) updates a traditional theme; the three central nude women are the Three Graces, ancient Greek mythological goddesses, but here they appear before a Cubist panorama of modern Paris. The city is depicted with the planar faceting familiar to us from Cubism. The Eiffel Tower at the right is fragmented so that we view it both from below and soaring above it simultaneously. Robert Delaunay and his wife, Sonia, also a painter, replaced the somber palette of Picasso and Braque

572. KASIMIR MALEVICH
Suprematist Composition: White on White. c. 1918. Oil on canvas, 31 1/4 x 31 1/4".
Collection, The Museum of Modern Art, New York

573. BLANCHE LAZZELL
Painting No. 10. 1927. Oil on canvas, 50 x 36". West Virginia University Permanent Art Collection, Morgantown

with a vitality of color to create a style that the poet Guillaume Apollinaire named Orphism, after the Greek mythological figure Orpheus.

Included among the avant-garde in Russia was Kasimir Malevich, who developed a series of non-objective paintings. *Suprematist Composition: White on White* (fig. 572) reduces the formal elements of the painting to two squares of white that are separated only by the slightest value contrast. In the geometric and color purity of these works,

Malevich set out to communicate pure uncorrupted emotion. He titled this new style Suprematism, writing: "The Suprematists have deliberately given up the objective representation of their surroundings in order to reach the summit of the true 'unmasked' art and from this vantage point to view life through the prism of pure artistic feeling" (*The Non-Objective World*).

As the influence of Cubism reached east into Russia, it was also felt in the West, especially in America. Blanche Lazzell, an

unusually independent woman from West Virginia, traveled extensively throughout Europe from 1912 to 1914 and studied in Paris when Cubism ruled the avant-garde. *Painting No. 10* (fig. 573), with its emphasis on the abstraction of still-life shapes and the flat reality of the picture plane, displays Lazzell's grasp of the principles of Synthetic Cubism. Later she was among the creators of the Provincetown print, a multicolor print that uses a single woodblock.

ABSTRACTION IN SCULPTURE

574. ALEXANDER ARCHIPENKO
Walking Woman. 1912. Bronze,
height 26 3/8". Collection Mme
Alexander Archipenko

575. NAUM GABO
Constructed Head No. 1. Triple-layered plywood, height 21 1/4". Collection
Miriam Gabo. To retain an identity distinct from his brother, Anton Pevsner,
who was equally influential in the spread of Constructivism, Naum Pevsner
changed his surname to Gabo.

ARCHIPENKO, *Walking Woman:* 1912
1915: Albert Einstein develops the general theory of relativity
1915: First U.S. transcontinental telephone call
1916: John Dewey, *Democracy and Education*

576. CONSTANTIN BRANCUSI
The Newborn. 1915. Marble, height
5 5/8". Philadelphia Museum of Art
(Louise and Walter Arensberg
Collection)

Cubism influenced developments in sculpture as well as in painting. Archipenko's *Walking Woman* (fig. 574) displays the simplified planar abstraction that we associate with Cubism. Note how the dissected lower left leg resembles the forms of Duchamp's *Nude Descending a Staircase* (see fig. 569). What is novel, however, is Archipenko's transformation of the interpretation of mass in space. He has opened voids in the head and torso areas, where previous figural sculptures had always asserted the strongest concentrations of mass.

Within the innovative spirit of early-twentieth-century art, traditional interpretations of mass and space in sculpture were constantly and vigorously questioned. The Russian sculptor Naum Gabo was among the artists who challenged that tradition. Through Cubism, Picasso had introduced construction as a method of sculpture (see p. 502). It was the Russian avant-garde artists of Constructivism, however, who firmly legitimized the approach to modern sculpture.

Gabo was a medical and science student in Munich from 1909 to 1914. While there, he was inspired by an interest in the history of art, and in the artists' group *Der Blaue Reiter* (see p. 515). Working in Norway during World War I, Gabo, through his brother Anton Pevsner, became aware of the revolutionary spatial implications and geometric shapes of Cubism. Late in 1915 Gabo began to create a series of heads (fig. 575) constructed from cardboard, plywood, or thin metal sheets. With these heads, traditional sculptural mass has been altered to a consideration of space. The geometric configuration of the constructed planes, whose edges define surface boundaries,

also creates internal voids, or pockets, of space. These voids now become a positive element in our perception of the head.

Understanding the impact of this approach, as it defied the traditional mass/space relationship of sculpture, Gabo wrote: "We consider space from an entirely different point of view. We consider it as an absolute sculptural element, released from any closed volume, and we represent it from inside with its own specific properties. . . . In our sculpture space has ceased to be for us a logical abstraction or a transcendental idea and has become a malleable material element."

Parallel to these Cubist-inspired developments in abstract

577. CONSTANTIN BRANCUSI
Sleep. 1908. Marble, height 10". National Gallery, Bucharest

578. CONSTANTIN BRANCUSI
Sleeping Muse. 1909–10. Marble, height 11 1/2". Hirschhorn Museum and Sculpture Garden, Smithsonian Institution, Washington, D.C.

sculpture, another evolution in sculpture was occurring. In 1904 Constantin Brancusi, a Romanian artist, took up residence in Paris. Working in a variety of traditional sculptural media, and often guided by a subjective synthesis of diverse traditions, including the simplified, abstract features of Romanian folk and African sculpture, Brancusi reduced representational images to elemental forms. Evolving a style based on organic abstraction, Brancusi noted, "They are imbeciles who call my work abstract; that which they call abstract is the most realist, because what is real is not the exterior form but the idea, the essence of things." Brancusi's concern with portraying the "essence of things," an artistic philosophy that he shared with other members of the European avant-garde, led to the abstraction evident in *The Newborn*

579. CONSTANTIN BRANCUSI
Bird in Space. c. 1924. Polished bronze, height 49 3/4". Philadelphia Museum of Art (Louise and Walter Arensberg Collection)

(fig. 576). The particulars of a baby's head and facial features have been reduced to a primordial egg form with sweeping arcs uniting the forehead with the nose and gaping mouth.

We can follow Brancusi's pioneering journey through abstraction in a series of sculpted heads from 1908 through 1915. *Sleep*, from 1908 (fig. 577), displays representational facial features. Rodin's influence is felt in the consciously unfinished forms of the work and in the manner in which the form of the head seems to evolve from the enveloping marble. Within two years the reduction away from representation had become apparent. The head of the *Sleeping Muse* (fig. 578) has been transformed by a union between the head and the primordial form of an egg. The particulars of the face have become geometric abstractions. By

1915 this transformation, aimed at uncovering an essence, was complete. *The Newborn*, with which we opened this discussion on Brancusi, communicates the essence of the cry of a new life.

One of Brancusi's aphorisms was "simplicity is not an end in art, but one arrives at simplicity in spite of oneself in drawing near to the reality of things." With *Bird in Space* (fig. 579), Brancusi draws us close to another reality, not to the essence of a natural form, such as we have seen above and met earlier with *The Kiss* (see fig. 540), but to the essence of a dynamic sensation. The soaring verticality of the gently swelling bronze form and its mirrorlike surface, which further denies its minimal mass, communicate a propulsive yet graceful energy. Here Brancusi proclaims the essence of flight itself.

GERMAN EXPRESSIONISM *(DIE BRÜCKE)*

580. ERNST LUDWIG KIRCHNER
Street, Berlin. 1913. Oil on canvas, 47 1/2 x 35 7/8". Collection, The Museum of Modern Art, New York (Purchase).
This painting was later included in a 1937 exhibition of "degenerate art" organized by Germany's Nazi government. The exhibition was meant to demonstrate to the public that many works of modern German art were created by artists who were insane and deviant. The show toured Germany until 1941, and Nazi propaganda records state that it was viewed by 3,200,000 persons.

KIRCHNER, *Street, Berlin:* **1913**
1913: Henry Ford introduces assembly-line production
1913: Suffragettes march in Washington, D.C.
1913: First multimotored aircraft
1913: Prentice-Hall, Inc., founded

"The modern light of the cities, the movement in the streets—there are my stimuli. . . . Observing movement excites my pulse of life, the source of creation." For Ernst Ludwig Kirchner, who wrote these words, the dynamic interaction of color and movement on a city street was the paragon of modernity. In *Street, Berlin* (fig. 580), arbitrary, intense colors are joined with sharply stylized figures and a distorted perspective to communicate not only the animation of twentieth-century urban life but also the decadence of wealthy Germans on the brink of World War I.

The seeds of the modern movement known as German Expressionism were planted in the late-nineteenth and early-twentieth centuries by Van Gogh, Munch, Matisse, and the Fauves. Expressionist tendencies, such as distortion of form and intensification of color, had surfaced earlier in the history of German art in the work of artists such as Grünewald and Dürer (figs. 353, 333). In the opening years of the twentieth century, artists looked to these artistic precedents to find forms that would express the intensity of feeling that they believed was part of the Northern cultural tradition.

In 1905 a group of young architectural students in Dresden formed an association that they called *Künstler-Gruppe Brücke*

(The Artists Group of the Bridge). As an association, *Die Brücke* was based on the medieval guilds, and the artists lived and worked together as a community. The symbol of the bridge, adopted from Nietzsche's writings, indicated that they conceived their role as a transitionary force by which "all the revolutionary and surging elements" of modernism could bring German art to a new and fulfilling future. The artists of *Die Brücke* turned away from academicism, looking instead for inspiration to the stylizations and spirituality which they perceived in medieval, African, and Oceanic art. *Die Brücke* held its first exhibition in 1906.

Die Brücke's cultural kinship with earlier German traditions led to an interest in the prints of Dürer, and one aspect of the movement was a revival of the woodcut medium. Emil Nolde's *Prophet* (fig. 581) is a traditional religious subject, but unlike earlier heroic treatments of this theme, such as the prophets on the Sistine Chapel Ceiling (fig. 344), the intentionally rough features and stark black-and-white contrasts communicate an immediate and intensely personal religious experience. In his autobiography, Nolde wrote, "A work becomes a work of art when one re-evaluates the values of nature and adds one's own spirituality."

581. EMIL NOLDE
Prophet. 1912. Woodcut, 13 x 9"

GERMAN EXPRESSIONISM (DER BLAUE REITER)

582. WASSILY KANDINSKY
First Abstract Watercolor. c. 1913.
Watercolor and ink, 19 1/4 x 25".
Musée National d'Art Moderne,
Centre Georges Pompidou, Paris.
Kandinsky identified this as his
first non-objective watercolor,
dating this experiment to 1910, but
later scholars have suggested that
the work more probably dates to
c. 1913.

Vibrant passages of color and
line burst on the surface of Was-
sily Kandinsky's abstract water-
color· (fig. 582). This ebullient
composition of colored shapes
and lines does not correspond to
any reality in nature; the paint-
ing can therefore be termed non-
objective. This important break-
through, which led to many later
developments in twentieth-cen-

tury art, was accomplished by a
number of artists during the sec-
ond decade of the century.

Kandinsky had begun a career
as a law professor when, in 1896,
he left Russia to study painting
in Germany. His education had
included studies in art and mu-
sic, but the decision to become a
professional artist was made in
1895, when he viewed a Moscow
exhibition of Impressionist paint-
ings. Particularly impressed by
the intense color of one of Monet's
Haystack paintings, Kandinsky
wrote, "I had the impression that
here painting itself comes into
the foreground; I wondered if it
would not be possible to go fur-
ther in this direction." As Kan-
dinsky traveled throughout Eu-
rope, he studied German Expres-

sionism and Fauvism and, return-
ing to Munich in 1908, he painted
a series of landscapes which pul-
sate with color.

A chance occurrence assisted
in clarifying Kandinsky's
thoughts about non-objective
painting: "It was the hour of ap-
proaching dusk. I was coming
home with my box of paints after
sketching, still dreaming and
caught up in my thoughts about
the work I had done, when sud-
denly I found myself face to face
with an indescribably beautiful
picture drenched with an inner
glow. At first I hesitated, then I
rushed toward this mysterious
picture in which I could discern
no visible subject, but which ap-
peared to be completely made
up of bright patches of color.

KANDINSKY, *First Abstract Watercolor:* **c. 1913**
1910: Race-car driver Barney Oldfield drives 133 m.p.h.
1911: Schönberg, *Manual of Harmony*
1914: War in Europe

583. FRANZ MARC
The Large Blue Horses. 1911. Oil on canvas, 41 5/16 x 71 1/4". Walker Art Center, Minneapolis (Gift of the T. B. Walker Collection, Gilbert M. Walker Fund, 1942)

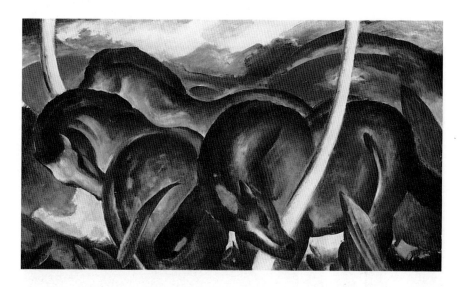

Only then did I discover the key to the puzzle. It was one of my own paintings, standing on its side against the wall. . . . I knew for certain now that the depiction of objects in my paintings was not only unnecessary but indeed harmful."

The realization that painting could communicate an emotional content without recognizable subject matter was a catalyst in Kandinsky's thoughts about art and the expressive values of color. These issues occupied not just his paintings, but also his writings. In late 1911 Kandinsky published *Concerning the Spiritual in Art*, in which he asserted that the function of art was to release us from a "nightmare of materialism" by revealing an "internal truth" which awakens the human spirit. The key to this awakening was the "psychic effect" which colors could evoke: "Color is a power which directly influences the soul. Color is the keyboard, the eyes are the hammers, the soul is the piano with many strings. The artist is the hand which plays, touching one key or another, to cause vibrations in the soul."

In writing *Concerning the Spiritual in Art*, Kandinsky drew from many varied and rich sources, including Expressionism, Fauvism, and African and Oceanic art. Expressing a kinship with non-Western artists, Kandinsky wrote, "Like ourselves, these artists sought to express in their work only internal truths, renouncing in consequence all consideration of external form." The musical innovations of Arnold Schönberg added further inspiration. "[Schönberg's] music leads us into a realm where musical experience is a matter not of the ear but of the soul alone—and from this point begins the music of the future." Kandinsky believed that the emotional power of music could be paralleled by abstraction in painting.

In 1911 Kandinsky, Franz Marc, and other Expressionist artists working in Munich formed an artists' group which they called

Der Blaue Reiter (The Blue Rider; the title was derived from a work by Kandinsky which depicted an abstract rider and horse unified by a single value of blue). *Der Blaue Reiter* was an association of artists who sought to communicate the spiritual values that lie behind the facade of appearances.

In Franz Marc's *Large Blue Horses* (fig. 583), the curving, swelling contours of the landscape intentionally echo the forms of the horses' backs, expressing the artist's belief in the harmony of animal life within nature. For Marc, the blue of the horses communicated a spiritual principle and the ideal of hope, while the red of the landscape symbolized what the artist called "brutal and heavy" matter. Marc's paintings wed line, form, and color in an attempt to express the essential concord in the environment.

Fantasy

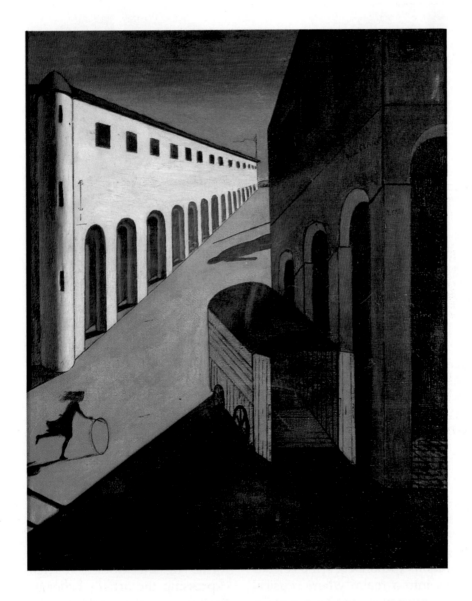

584. GIORGIO DE CHIRICO
The Melancholy and Mystery of a Street. 1914. Oil on canvas, 34 1/4 x 28 1/2". Private collection

"Formerly we used to represent things visible on earth, things we either liked to look at or would have liked to see. Today we reveal the reality that is behind visible things, thus expressing the belief that the visible world is merely an isolated case in relation to the universe and that there are many more other, latent realities" (Paul Klee, 1920). The attempt to express visually a reality which supersedes that of the objective, physical world distinguishes the early-twentieth-century avant-garde movements of Fauvism, German Expressionism, and Cubism. Another approach to this problem is found with the artists of fantasy, painters who, questioning rationalist views, explored the expression of their personal, inner visions.

As its title hints, Giorgio de Chirico's *Melancholy and Mystery of a Street* opens to us a world that is disturbing and possibly even forbidding (fig. 584). The forms are representational. The arcaded buildings, the wagon, and even

DE CHIRICO, *The Melancholy and Mystery of a Street:* **1914**
1914: Panama Canal opens
1915: W. Somerset Maugham, *Of Human Bondage*
1915: D. W. Griffith film, *The Birth of a Nation*
1917: Carl Jung, *Psychology of the Unconscious*
1917: Bolshevik Revolution in Russia

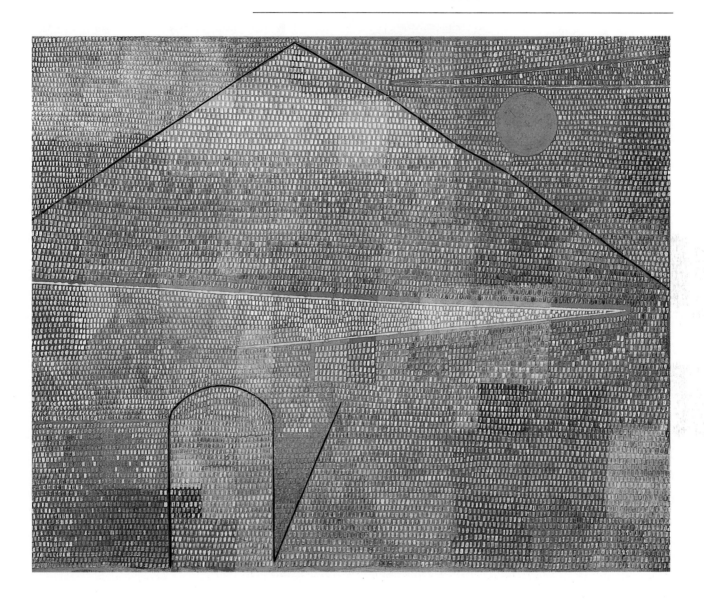

the intense light are features that can be found in many an Italian piazza. In De Chirico's painting, however, stark *chiaroscuro* is joined with an exaggerated perspective to create an unexpectedly dramatic spatial illusion. The anxiety created by the convergence of diagonals is heightened by the iconography. The setting is void of life except for a young girl who innocently plays with a hoop. Her path will take her into the menacing emptiness of the piazza, where the shadow of a large statue falls, almost threateningly, across her path. De Chirico's manipulation of representational forms opens the world of the subconscious,

585. PAUL KLEE
Ad Parnassum. 1932. Oil on canvas, 39 x 42". Kunstmuseum, Bern. Klee's wife was a piano teacher, and the title of this work may derive from *Gradus ad Parnassum* (*Steps to Parnassus*), a series of piano exercises based on scales for the beginning piano pupil.

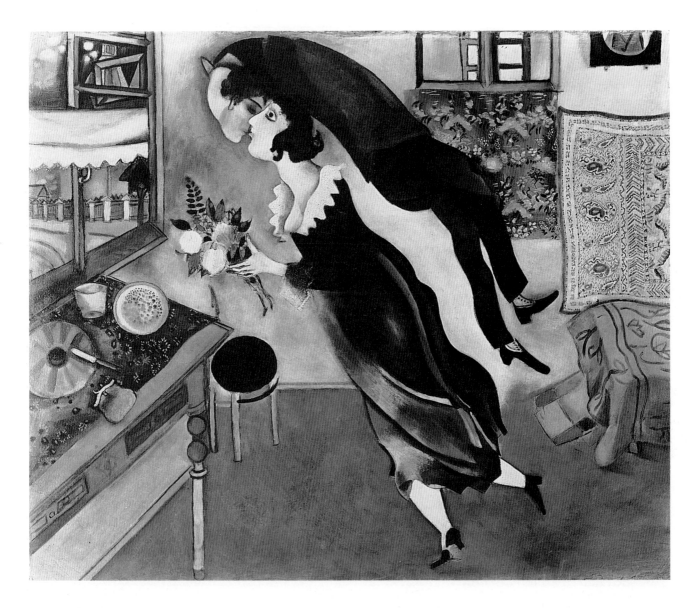

586. MARC CHAGALL
Birthday. 1915. Oil on cardboard,
31 3/4 x 39 1/4". Collection, The
Museum of Modern Art, New York
(Acquired through the Lillie P. Bliss
Bequest)

the frightening exaggeration we often sense in dreams. De Chirico considered his paintings to be metaphysical, that is, they offered encounters with mysterious truths beyond our understanding.

In 1912 De Chirico explored, in words, the process of his creative invention. He wrote, "I believe that as from a certain point of view the sight of someone in a dream is a proof of his metaphysical reality, so, from the same point of view, the revelation of a work of art is the proof of the metaphysical reality of certain chance occurrences that we sometimes experience in the way and manner that *something* appears to us and provokes in us the image of a work of art, an image, which in our souls awakens surprise—sometimes, meditation—often, and always, the joy of creation." The juxtaposition of dissociated objects in De Chirico is intended to beckon the unconscious within us.

Marc Chagall journeyed to Paris from his native Russia in 1910. Remembering his Jewish heritage and the Russian folk-art tradition, Chagall drew from several avant-garde styles invigorating the Parisian art scene. In *Birthday* (fig. 586), he shares with us his celebration of love with

his new wife, the ecstasy of which has elevated the artist off the ground. *Birthday* weds the bright, joyful colors of Fauvism with the multiple viewpoints and simplified planar structure of Cubism. Here these new pictorial freedoms are transformed by an even more liberated, highly personal, aesthetic. Chagall, however, disdained literary associations of "anecdote" and "fairy tales" in his paintings. He later stated that his paintings "are only pictorial arrangements of images that obsess me." Chagall's fantasy is expressed in dreamlike, poetic paintings.

The Swiss artist Paul Klee usually worked on a small scale, but *Ad Parnassum* is one of his larger and most ambitious works (fig. 585). Klee set out to discover elemental symbols: here the pyramid suggests not only the mysteries of ancient Egypt but also, because of the title, Mount Parnassus near Delphi, which was sacred to the ancient Greeks as the home of the Muses, who inspired creative activities. The red circle that suggests the sun may refer to the role of the sun in world religions, as well as to the concept of gradual enlightenment. The division of the surface into tiny squares of pure color creates a precious and beautiful

effect that evokes the shimmering nature of light as it illuminates a form. From a multitude of smaller forms, monumental constructions can be created: from stone blocks come pyramids; from scales, symphonies. But ultimately the full expressive content of Klee's work becomes a matter of individual perception and understanding. Klee believed that there were visual equivalents for spiritual states and, as so often in his work, the few simple forms of *Ad Parnassum* suggest deep and elemental mysteries.

Like Henri Rousseau, whose naïvely direct yet purposeful paintings were championed by young avant-garde artists in Paris (fig. 462), these painters of fantasy often did not view themselves as depicting the bizarre or fanciful. They equated reality with an inner vision. Questioned about this, Chagall responded, "I am against the terms 'fantasy' and 'symbolism' in themselves. All our interior world is a reality—and that perhaps more so than our apparent world." In the visual communication of this "interior world," these artists opened a path of artistic exploration which would lead to Dada (pp. 520–21) and Surrealism (pp. 534–35).

DADA

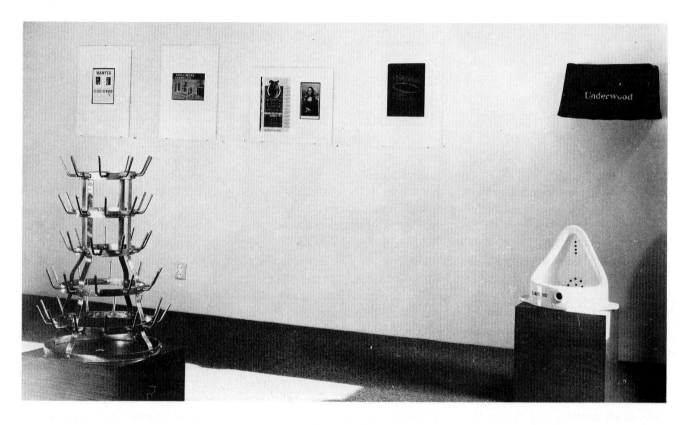

Marcel Duchamp was an artist of unprecedented and unsettling works which still seem shocking to us today, although they were done over seventy years ago (see fig. 587). On the pedestals in the gallery, where we expect to find sculpture, we see a manufactured *Bottle Rack*, a common object used at the time for drying bottles. In 1914 Duchamp felt that he could confer an artistic dignity on a bottle rack by designating it a work of art. Another pedestal supports an upended porcelain urinal, officially titled *Fountain*. Duchamp signed the urinal "R. Mutt," a pun on the name of the company which manufactured it, the Mott Works Company. On the wall behind is a reproduction of Leonardo's "*Mona Lisa*" (see fig. 329), which Duchamp de-

faced by adding a moustache, goatee, and, at the bottom, the letters L.H.O.O.Q., which suggest the French phrase, "She has a hot ass." If all of this appears absurd to you, and it certainly did to critics and the public in the early twentieth century, then you are beginning to understand the function of these objects as works of art. Marcel Duchamp, a Parisian avant-garde artist who came to New York in 1915, asserted that "found objects" or "readymades" could be works of art. Although these were simply mass-produced objects, Duchamp felt that by his saying they were art and by exhibiting them within a gallery, they had entered into the realm of art.

Duchamp never officially declared himself a Dadaist (see be-

587. MARCEL DUCHAMP
Bottle Rack, Fountain, and other works; reproductions of works originally created between 1914 and 1919. Installation, Moderna Museet, Stockholm

low), but his works from 1913 onward, especially the "readymades," are formally and spiritually akin to those produced by Dada artists. As an artistic, musical, and literary movement, Dada was officially consecrated in 1916 at the Cabaret Voltaire in Zurich. Dada bred confusion, and even the origin of the title remains, appropriately, a matter of uncertainty: two of Dada's founders, writers Richard Huelsenbeck and Hugo Ball, state that the word, which is French for hobbyhorse, was discovered by chance in a

DUCHAMP, *Fountain:* **1917**
1917: U.S. enters World War I
1917: Sigmund Freud, *Introduction to Psychoanalysis*
1918: World War I ends; about 8.5 million have been killed;
21 million wounded
1920: In U.S., urban population first exceeds rural population
1921: U.S. population reaches 107 million

German-French dictionary, but another founder, the German painter Hans Richter, holds that it was simply the Slavonic word for "yes," and that "da, da" meant only "yes, yes."

Other theories as to the origin of the term are also advanced, but what defined Dada was a nihilistic mocking of traditional values in the arts and, by extension, Western society as a whole. This artistic anarchy grew from a profound psychological disgust. Dada glorified the irrational. The Swiss artist Jean Arp, for example, created collages by dropping torn pieces of paper randomly onto a paper surface and then gluing them into place (fig. 588). These works were composed according to chance. In the words of Arp: "Dada aimed to destroy the reasonable deceptions of man and recover the natural and unreasonable order. Dada wanted to replace the logical nonsense of men of today by the illogically senseless. That is why we pounded with all our might on the big drum of Dada and trumpeted the praises of unreason. . . . Dada is senseless like nature."

The senselessness and nihilism of Dada, however absurd, were born from an even greater absurdity, World War I. Dada was an art of social protest, a protest against the senseless slaughter and destruction of life and meaning. "We searched for an elementary art that would, we thought, save mankind from the furious madness of these times" (Jean Arp).

588. JEAN (HANS) ARP
Collage Arranged According to the Laws of Chance. 1916–17. Torn and pasted paper, 19 1/8 x 13 5/8". Collection, The Museum of Modern Art, New York (Purchase)

DE STIJL AND THE BAUHAUS

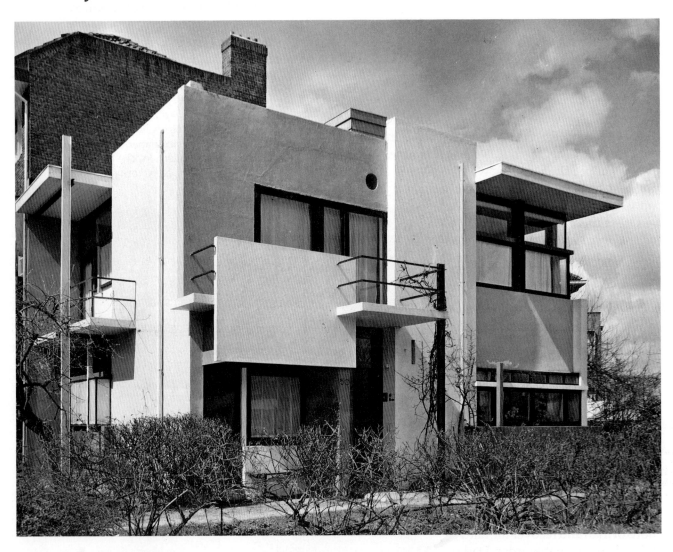

589. GERRIT RIETVELD
Schröder House, Utrecht,
The Netherlands. 1923–24

590. GERRIT RIETVELD
Plan, Schröder House

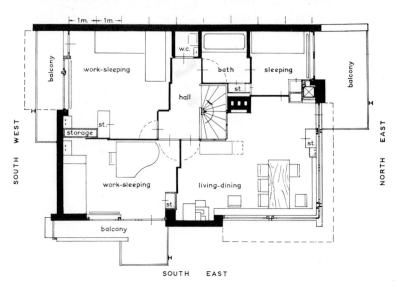

Rietveld's Schröder House is
without historical reference, and
its simplicity and severity of form
make it seem absolutely new,
even today: it offers a timeless
modernity (figs. 589, 590). At the
same time, however, it is neither
simple nor simplistic. The con-
trasts between wall and open-
ing, solid and void, horizontal

RIETVELD, Schröder House: 1923–24
1922: Oswald Spengler, *The Decline of the West*
1922: James Joyce, *Ulysses*
1924: Lenin dies
1924: George Gershwin, *Rhapsody in Blue*
1924: Gandhi fasts for 21 days, protesting the violent conflict between Hindus and Moslems in India
1925: Hitler publishes *Mein Kampf*
1925: F. Scott Fitzgerald, *The Great Gatsby*
1927: Charles Lindbergh becomes the first person to fly the Atlantic alone

591. WALTER GROPIUS
Workshop wing, Bauhaus, Dessau, Germany. 1925–26. The Bauhaus was an influential modern school of architecture and design.

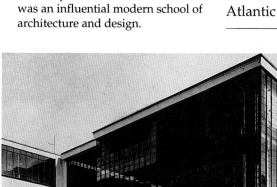

and vertical, aggressive and recessive forms establish complex interrelationships, and the composition, which is determinedly asymmetric in both two and three dimensions, is sharpened and enhanced by the precision with which the forms are defined. On both exterior and interior, openness integrates the forms of the house with the surrounding space. The Schröder House is a powerful and convincing example of the "equilibrium of equivalent relationships" that was one of the aesthetic goals of the De Stijl movement.

The De Stijl (The Style) movement was founded in 1917 in Amsterdam by several Dutch artists who felt a mission to carry abstraction to what they termed "its ultimate goal." The group was motivated in part by the tragic events of World War I and was inspired by such modern philosophical movements as Theosophical Mysticism and Neopositivism. Their utopian aspirations are revealed in the name, which suggests that this is the ultimate style, the perfect style that, mass-produced, could satisfy all humanity for the rest of the world's history. This search to find a visual equivalent for spiritual and philosophical purity led to the development of

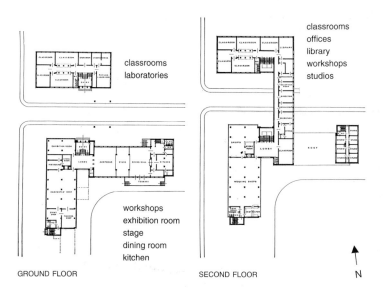

classrooms
laboratories

classrooms
offices
library
workshops
studios

workshops
exhibition room
stage
dining room
kitchen

GROUND FLOOR

SECOND FLOOR

N

592. WALTER GROPIUS
Plan, Bauhaus

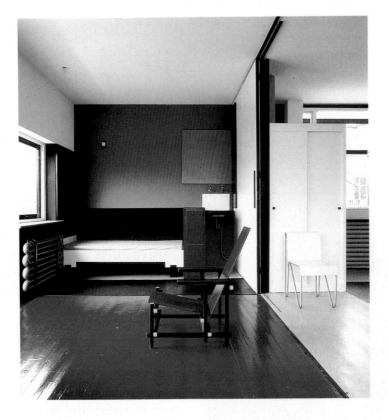

593. GERRIT RIETVELD

Interior, Schröder House. Visible in this interior view are the movable sliding walls and some of the built-in furniture that Rietveld designed for the Schröder House. The goal was a completely unified formal and aesthetic expression—what the *De Stijl Manifesto* called a "structural affinity between object and environment." Also visible here is his famous "red and blue" chair, designed about 1918. The forms of the chair are completely geometric: only the need to make some concession to the requirements of the human body explains the two diagonal forms. A durable formal solution, the chair was designed to be mass-produced at a reasonable price for mass consumption. The colors are carefully controlled, with the structure composed of black bars with yellow ends, and the seat and back given over to one blue and one red plane. The restriction to complementary colors is typical of the De Stijl philosophy.

a completely new and abstract style in architecture, painting, sculpture, and the decorative arts. Their motivation was ethical, for they felt that their perfectly balanced and serene art could carry the qualities of harmony and purity into the very soul and being of the viewer. Their ultimate goal was to bring about world understanding, unity, and peace. They avoided individualism and subjectivity,

arguing that these concepts had led the world into war: "The old tends to the individual. The new tends to the universal. The struggle between the individual and the universal is revealed in both the world war and contemporary art." They wanted to create an art that was universal and comprehendible to all humanity, regardless of nationality or creed. "Man adheres only to what is universal," wrote Piet Mondrian,

one of the movement's founders, in 1919.

These profound goals reached fulfillment in a series of works produced by Mondrian between the two world wars (see fig. 5). In these simple abstractions, which are characterized by a studied balance between forms and colors, Mondrian hoped to accomplish, in his words, an "equilibrium of opposites." The universality of this goal, with its search for worldwide peace, should be related to other modern philosophies and artistic philosophies—such as the Bauhaus (see below)—as well as to the contemporary founding of the World Court and the League of Nations, which led eventually to the establishment of the first worldwide governmental body, the United Nations, after World War II.

Walter Gropius's philosophy on the unity of the arts guided his design for the new home for the Bauhaus at Dessau (figs. 591, 592). The structure at Dessau exemplified the modernist aesthetic. A complex of classrooms,

594. WALTER GROPIUS
Student dormitory room, Bauhaus

library, and offices is externally unified by planes of reinforced concrete walls and vast expanses of windows. A rectilinear design, with verticals and horizontals meeting at right angles, governs the plan and determines the exterior articulation. The plain, unornamented surfaces used throughout the building contribute to its modern, clean appearance. The interior design of the classrooms and even the desks and chairs respond to the design aesthetic which governs the entire structure. Gropius's own office had furniture of his design and a rug, wall hanging, and lighting created in the Bauhaus workshops. The student dormitory room illustrated here reveals how strictly the Bauhaus aesthetic could govern an environment (fig. 594). This is what Gropius meant by the "complete building" when, in 1919, he wrote: "The ultimate aim of all visual arts is the complete building! . . . Today the arts exist in isolation, from which they can be rescued only through the con-

scious, co-operative effort of all craftsmen. . . . Architects, sculptors, painters, we must all return to the crafts! For art is not a 'profession.' There is no essential difference between the artist and the craftsman."

Gropius, a German architect and industrial designer, played a leading role in founding the Bauhaus in 1919 at Weimar. The name Bauhaus, chosen by Gropius, is derived from the *bauhütte*, the medieval German builders' lodge, which housed the masters and craftspeople who built the great cathedrals of the Late Middle Ages. The recent Arts and Crafts Movement and Art Nouveau's unity of design had reinforced Gropius's belief in the total integration of the arts. Unlike those late-nineteenth-century movements, however, the Bauhaus philosophy of design was guided by the technology and materials of industrial production.

The design of the building at Dessau, where the Bauhaus relocated in 1924, was itself inspired by the rectilinear massing of

Frank Lloyd Wright's Prairie style designs (see p. 498) and by the geometric planarity of De Stijl architecture. The resulting building, with its clean, precise, and almost mechanistically tuned appearance, does not display a regional or national identity. The Bauhaus style has reduced the essence of design to a visual common denominator. It promised, with the assistance of modern technology, a future in which a total design aesthetic would not be restricted by cultural or national boundaries. Reacting to the horror of World War I, the Bauhaus offered a utopian vision where art and architecture would assist in the realization of our common human heritage.

In 1933 Adolf Hitler, then chancellor of Germany, manifesting the intolerance which totalitarian regimes commonly share toward the avant-garde, ordered the Bauhaus closed. Like apostles to foreign lands, those who had worked at the Bauhaus carried its philosophy throughout Europe and to America.

DIEGO RIVERA AND MEXICAN MURAL PAINTING

"Only the work of art itself can raise the standard of taste. Art has always been employed by the different social classes who hold the balance of power as one instrument of domination— hence, as a political instrument. One can analyze epoch after epoch—from the stone age to our own day—and see that there is no form of art which does not also play an essential political role.... What is it then that we really need? An art extremely pure, precise, profoundly human, and clarified as to its purpose" (Diego Rivera, 1929).

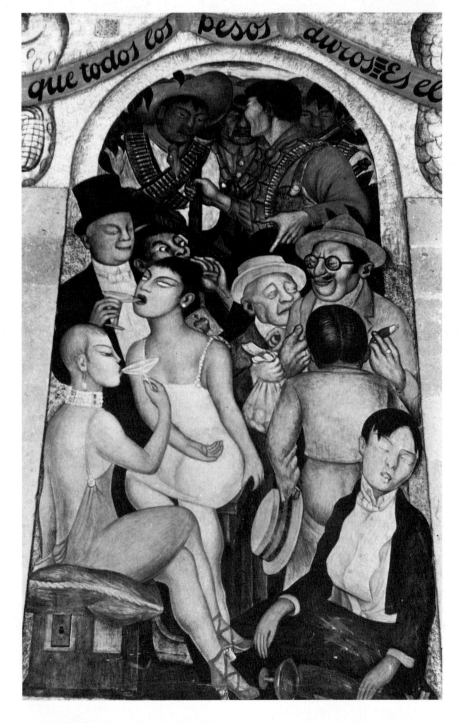

These mural paintings by Diego Rivera (figs. 595, 596) are on the third floor of an open courtyard in the Ministry of Education building in Mexico City. They are but two of one hundred twenty-four which the artist painted throughout the decade of the 1920s. The scenes present a direct and didactic contrast between the debauchery of the rich, which includes excessive drinking and hoarding money, and the quiet, peaceful sleep of the poor peasants after an honest day's work. A few of the peasants remain awake into the night, educating themselves by lamplight. In the left background of *Night of the Poor*, the Marxist content of the mural is reinforced as bourgeois onlookers disdainfully watch, while in *Night of the Rich* revolutionary soldiers observe the decadent behavior of the wealthy ruling class.

These scenes, and indeed the entire cycle of paintings, are unyielding expressions of class struggle. They communicate the purposes and promises of the Mexican Revolution, which began in 1911 with a dramatic demand for economic and social reform. A decade of internal civil strife and bloodshed followed, and only during the twenties and thirties would some of the aims

595. DIEGO RIVERA
Night of the Rich. 1923–28. Fresco. Ministry of Education, Mexico City

596. DIEGO RIVERA

Night of the Poor. 1923–28. Fresco. Ministry of Education, Mexico City. These frescoes are from the final cycle of paintings, begun by Rivera in 1927, for the Ministry of Education. The images in this cycle are loosely related to the words of two revolutionary songs (*corridos*), which appear on the painted festoons. In part, one of the *corridos* reads: "The clock strikes one, two, and the rich keep awake thinking what to do with their money so that it keeps multiplying. It's only seven o'clock at night and the poor have gone to rest. They sleep very peacefully because they are tired. Blessed the tree that yields fruit, but very ripe fruit. Yes, gentlemen, it is worth more than all the hard dollars."

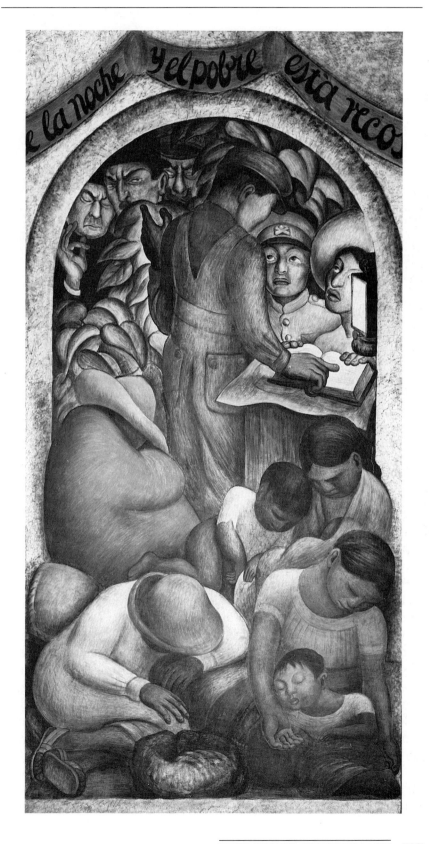

of the 1911 revolution be realized. Rivera's paintings propagandize the causes and goals of the continuing revolution.

The impact of Rivera's murals is direct and immediately comprehendible, for here the artist has eschewed modernist abstraction in favor of an easily understood representational form and content. Rivera, who had traveled in Europe, returned home in 1921 to join with other Mexican artists in creating a unique and forceful style which, while borrowing elements from Expressionism and Cubism, was also rooted in the bold, severe forms of native Indian art. In the hands of the Mexican muralists, art became a vehicle to promote social awareness; in Rivera's words, "Mural painting must help in man's struggle to become a human being, and for that purpose it must live wherever it can; no place is bad for it, so long as it is permitted to fulfill its primary functions of nutrition and enlightenment."

EARLY MODERN PAINTING IN AMERICA

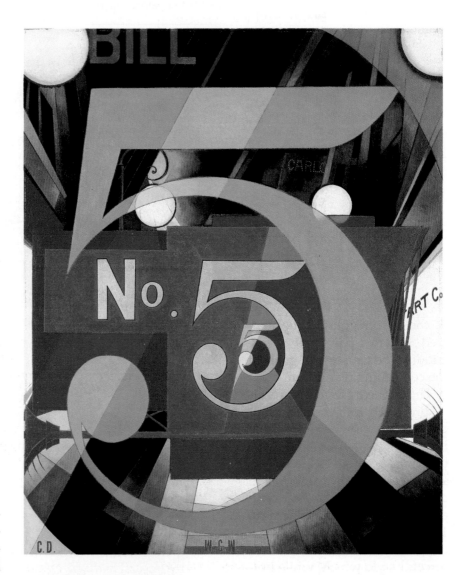

Among the rain
and lights
I saw the figure 5
in gold
on a red
fire truck
moving
tense
unheeded
to gong clangs
siren howls
and wheels rumbling
through the dark city
(William Carlos Williams,
The Great Figure).

597. CHARLES DEMUTH
I Saw the Figure 5 in Gold. 1928. Oil on composition board, 36 x 29 3/4". The
Metropolitan Museum of Art, New York (The Alfred Stieglitz Collection, 1949)

Demuth's painting (fig. 597), inspired by this poem by the distinguished American poet William Carlos Williams, is intended as a modern portrait of the poet; "W.C.W.," "Carlos," and the nickname "Bill" appear in the painting. This is one of Demuth's "poster portraits," a series inspired by the stark forms and lettering of advertising billboards. The vibrant 5 is repeated, just as the accompanying "gong clangs" and "siren howls" would have echoed off the hard surfaces of the city streets. The blocky red forms refer to the fire truck, the white circles suggest the streetlights, and the quickly pulsating forms of the composition as a whole visually suggest the jerky rhythm of the poem. The style, with its sharp edges and flat, unmodeled forms, developed in the 1920s in America and is known as Precisionism.

In the first four decades of the twentieth century, the influence of modern European art played a significant role in the development of modernism in America, aided by exhibitions organized by Alfred Steiglitz at Gallery "291" (see p. 532). At the same time, however, the Americans maintained an independent stance and were less willing to give up subject matter than were their European counterparts. Instead, they searched for contem-

DEMUTH, *I Saw the Figure 5 in Gold:* **1928**
1927: *The Jazz Singer,* first successful full-length motion picture
1928: Penicillin is discovered to have antibacterial properties
1928: Joseph Stalin's first five-year plan
1928: D. H. Lawrence's *Lady Chatterley's Lover* denied publication in England
1929: Stock market crash in America; beginning of the Great Depression

598. CHARLES SHEELER
American Landscape. 1930. Oil on canvas, 24 x 31". Collection, The Museum of Modern Art, New York (Gift of Abby Aldrich Rockefeller). While he was a young art student, Sheeler also worked as an architectural photographer, and this industrial landscape was painted after he was commissioned to document in photographs the Ford Company's River Rouge plant. Sheeler wrote: "Photography is nature seen from the eyes outward, painting from the eyes inward. . . . Photography records inalterably the single image, while painting records a plurality of images willfully directed by the artist."

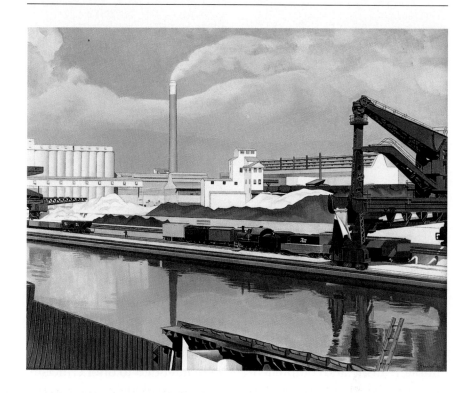

porary American subjects and evolved styles adapted from one or more twentieth-century European styles. Until 1940 American modernism was conservative by European standards.

Precisionist style is evident in Sheeler's *American Landscape* (fig. 598), but here the tradition of illusionism continues to dominate. The precise linear rendering of the machinery and the industrial buildings is more than a stylistic device, for it also suggests the role of efficiency in successful industry. Only smoke, sky, and water—now channeled to serve an industrial function—show transient movement. In the

nineteenth century, the quintessential American landscape had been a wilderness scene that resonated with the painter's wonder before sublime nature (see fig. 484). Following World War I, the machine and industry emerge as heroes. The satisfying nature of Sheeler's composition lies in his carefully calibrated composition, which reveals his idea "that pictures realistically conceived might have an underlying abstract structure."

O'Keeffe's *Lawrence Tree* (fig. 599) forces us to take an unusual viewpoint—looking directly up—on a starry evening in the American Southwest. O'Keeffe's

artistic means as she abstracts from nature are simple, with limited colors and forms that are rendered with almost no modeling. But in the subtle organic shape of the tree, she suggests not only its growth patterns but its arching expansiveness. The poetic, evocative position we assume emphasizes the scope and scale of nature in an almost pantheistic fashion. The appreciation for the majesty of nature that so moved American nineteenth-century artists found a worthy modern successor in O'Keeffe.

Thomas Hart Benton's art is a product of Regionalism, an anti-modern movement that flour-

599. GEORGIA O'KEEFFE
The Lawrence Tree. 1929. Oil on canvas, 31 1/16 x 39 3/16". Wadsworth Atheneum, Hartford (Ella Gallup and Mary Catlin Sumner Collection). The novelist D. H. Lawrence and his wife, Frieda, were friends of O'Keeffe during the summer of 1929 in New Mexico. O'Keeffe has written: "I spent several weeks up at the Lawrence ranch that summer. There was a long weathered carpenter's bench under the tall tree in front of the little old house that Lawrence had lived in there. I often lay on the bench looking up into the tree—past the trunk and up into the branches. It was particularly fine at night with the stars above the tree." Lawrence described this tree as "a great pillar of pale, flaky-ribbed copper" and wrote about the wind "hissing in the needles like a nest of serpents."

ished in midwestern America in the late 1920s and early 1930s. Regionalist American artists painted local subject matter in a simple, realistic, and comprehensible style. Such an art is determinedly chauvinistic and can perhaps be related to a need during the Great Depression for a reassurance which finds comfort in nostalgia. Benton's large, didactic murals exalted the history and folklore of a specific region: among his ambitious programs is a wall dedicated to *Pioneer Days and Early Settlers* (fig. 600) in the Missouri State Capitol. The wall is divided by painted geometric bands that establish an active compositional pattern. The figures, drawn in Benton's unique and energetic style, reenact local history and legend. The heroism of work, conveyed by the figures to the right who were inspired by the nudes of Michelangelo (fig.

342), is a common theme in Benton's art. Such paintings were more than imaginative re-creations of America's past; they were intended to offer criticism, as well as models and inspiration for the future. Benton himself denied the significance of modern art for his work, stating: "I wallowed in every cockeyed 'ism' that came along, and it took me ten years to get all that modernist dirt out of my system." In summarizing his work, he wrote: "I have a sort of inner conviction that . . . I have come to something that is in the image of America and the American people of my time."

Lawrence's *Toussaint L'Ouverture Series* joined historical research with intensely personal memories of history lectures the artist had heard during his youth in Harlem (fig. 601). Lawrence's work communicates his brutal theme with immediacy: harshly

abstract figures, sharp contrast of colors, and even the movement of the tall grass, which is waving like flames, add to the violence of the scene. Like other Social Realist artists in America during the 1930s and 1940s, Lawrence uses his work as a vehicle for protest, demonstrating a brutal historical reality. Discussing the purpose of his art in relation to social justice, Lawrence wrote, "Having no Negro history makes the Negro people feel inferior to the rest of the world. I don't see how a history of the United States can be written honestly without including the Negro. . . . We don't have a physical slavery, but an economic slavery. If these people, who were so much worse off than the people today, could conquer their slavery, we certainly can do the same thing."

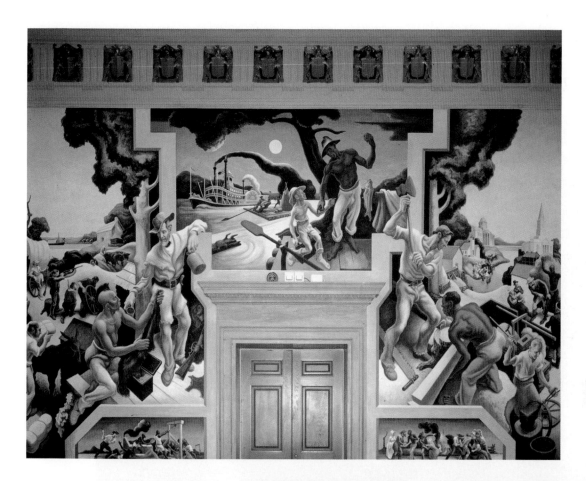

600. THOMAS HART BENTON
Pioneer Days and Early Settlers.
1935–36. Oil and egg tempera on
linen mounted on panel, size of
wall 25 x·14' 2". State Capitol,
Jefferson City, Missouri. The cycle,
which Benton called "A Social
History of Missouri," encompasses
three walls; on this wall Benton
depicted early settlers, including a
trader giving whiskey to an Indian
in exchange for furs, the legend of
Huck Finn and Jim with a paddle-
boat named *Sam Clemens,* and early
construction that leads back to a
view of later governmental
structures. Benton's portrayal is not
completely positive, as is seen in
the smaller scenes below, with a
cruel slave driver and the violent
expulsion of the Mormons. The
public and the Missouri legislature
criticized these works for not being
more idealistic, and Benton was
accused of degrading his state's
history and image.

601. JACOB LAWRENCE
*Toussaint L'Ouverture Series, No. 10: The Cruelty of the Planters Led the Slaves to
Revolt, 1776. These Revolts Kept Springing Up from Time to Time—Finally Came to
a Head in the Rebellion.* 1937–38. Tempera on paper, 11 x 19". Amistad Research
Center's Aaron Douglas Collection, Tulane University, New Orleans. The
forty-one panels of Lawrence's *Toussaint L'Ouverture Series* tell how the hero, a
Haitian slave named Toussaint L'Ouverture, freed his country from French rule
during the late-eighteenth and early-nineteenth centuries. The republic of
Haiti, founded by L'Ouverture, was the first black republic established in the
Western hemisphere.

PHOTOGRAPHY

602. ALFRED STIEGLITZ
Equivalent. 1930. Chloride print. The Art Institute of Chicago (The Alfred Stieglitz Collection)

Equivalent by Alfred Stieglitz (fig. 602) is an evocative image; the moon and its light are diffused through clouds in the upper right, while below, separated by the diagonal thrust of a cloud, an impenetrable darkness enters the composition. The photograph was produced without staging or significant darkroom manipulation, but the emphasis is less on the representational quality of the image than on abstract patterns of light and dark to create a somber, pensive mood.

When Stieglitz began his *Equivalent* series in 1922, he was already established as one of the most significant artists of the

early twentieth century. In 1902 he had broken away from the conservative posture of traditional photography to form the Photo-Secession Group. One year later he founded *Camera Work*, a quarterly publication which stressed, with numerous illustrations, an ever-widening range of photographic innovation.

In 1905 Stieglitz founded an art gallery at 291 Fifth Avenue in New York City. "291," as the gallery was known, brought the art of the European avant-garde to the United States. Exhibitions included works by Cézanne, Brancusi, and Picasso and such American artists as Charles

Demuth and Georgia O'Keeffe. In 1917 Stieglitz began to decrease his gallery and publication involvements to devote fuller attention to photography. Stieglitz's work and vision assisted in establishing photography as an independent artistic medium.

An important advance in photography in the 1920s was the development of the hand-held, lightweight, 35 mm roll-film camera. No longer burdened by bulky equipment, the photographer now had a new freedom of mobility. One artist who took full advantage of this freedom was André Kertész. In 1933

603. ANDRÉ KERTÉSZ
Distortion No. 4. 1933. Gelatin silver print. Estate of Kertész. Kertész's *Distortion* photographs, commissioned by a French magazine in 1933, were not published until 1976.

604. MARGARET BOURKE-WHITE
Fort Peck Dam, photograph for the cover of the first issue of *Life* magazine, November 23, 1936. Bourke-White was one of the original staff photographers for *Life* magazine. During World War II she became the first woman photographer to work with the U. S. armed forces.

STIEGLITZ, *Equivalent:* **1930**
1930: Sinclair Lewis wins Nobel Prize for literature for *Babbitt*
1930: First analog computer is placed in operation
1930: World population nears 2 billion

605. HENRI CARTIER-BRESSON
Sunday on the Banks of the Marne. 1938. Gelatin silver print

Kertész, a leading Hungarian photojournalist working in France, created a series of photographs with figurative distortion reminiscent of expressionist tendencies (see fig. 603) and Surrealism. Kertész achieved these effects by photographing models reflected in "fun house" mirrors with varied surfaces.

Margaret Bourke-White's cover story for the first issue of *Life* magazine was a photo essay about a dam being constructed at Fort Peck, Montana. Her photographs revealed both the strength and promise of industrial development, as is evident in her powerfully abstract compositions of the steel-and-concrete structure, and the dynamics of the lives of the men and women who were bringing the dam into existence (see fig. 604).

The French photographer Henri Cartier-Bresson sought to communicate in his work what he termed "the decisive moment" in an image where overt activity uncovered a deeper psychological understanding. In *Sunday on the Banks of the Marne* (fig. 605), Cartier-Bresson has captured, in a summary manner, the activity of a picnic—wine is being poured and food eaten. From our viewpoint we have joined the picnickers for lunch, but we can also observe, with some wit, how their corpulent bodies contrast with the sleek design of the boat. Cartier-Bresson believed that a photograph should seize both the scene in front of the eye and that which the eye sees as it looks inward, into the self of the photographer.

SURREALISM

In the hallucinatory world before our eyes (fig. 606), watches—sturdy, metallic timekeepers—grow limp and decay like organic refuse; one attracts a fly, ants converge on another. One watch has melted over a biomorphic form that bears a fantastically conceived profile of the artist. A smooth, satiny beach gives on to a limitless expanse of mirror-smooth water abutted by cliffs. Within this landscape of stillness, the limp watches suggest the inevitable decay of the passing of time.

Dali's painting succeeds in conveying its subconscious, dreamlike vision by the uncanny juxtaposition and fantastic manipulation of representational objects. This communication of the subconscious realm introduces us to Surrealism, a literary and artistic avant-garde movement which began in Europe in the early 1920s. The roots of Surrealism grew from the metaphysical paintings of De Chirico and the found-object constructions and collages of Dada (see pp. 516 and 520). Although it

eludes an exact interpretation, Dali's fantasy conveys a frightening psychological oppression.

Surrealism was inexorably bound with the psychoanalytic theories of Sigmund Freud. André Breton, the French writer who authored the first *Surrealist*

606. SALVADOR DALI
The Persistence of Memory. 1931. Oil on canvas, 9 1/2 x 13". Collection, The Museum of Modern Art, New York (Given anonymously)

DALI, *The Persistence of Memory:* **1931**
1931: U.S. population reaches 124 million
1931: Pearl S. Buck, *The Good Earth*
1931: Al "Scarface" Capone jailed for tax evasion
1932: Amelia Earhart becomes the first woman to fly solo across the Atlantic Ocean
1933: Hitler becomes chancellor of Germany
1933: Franklin D. Roosevelt is inaugurated as president

Manifesto in 1924, acknowledged Freud's revolutionary discoveries when, in defining Surrealism, he wrote: "SURREALISM, n. Pure psychic automatism, by which it is intended to express verbally, in writing, or by any other means the real process of thought. Thought's dictation, in the absence of all control exercised by the reason and outside all aesthetic or moral preoccupations." The Surrealist translation of the unconscious into visual form was realized, in one style, in the figurative works of Dali and René Magritte, where representational or fantastically conceived forms are juxtaposed within a spatial illusion.

The abstraction of André Masson's *Battle of Fishes* (fig. 607) is the result of automatism, a concept which relates to Freud's use of "free association" to divulge the subconscious. Breton used the word automatism in his definition of Surrealism, and in describing the process for writing an automatist Surrealist composition, Breton suggested that you should "write quickly without any previously chosen subject, quickly enough not to dwell on, and not to be tempted to read over, what you have written." This process of "automatic" writing was viewed as a revelation of the subconscious. In art, lines or colors were quickly set down

607. ANDRÉ MASSON
Battle of Fishes. 1926. Sand, gesso, oil, pencil, and charcoal on canvas, 14 1/4 x 28 3/4". Collection, The Museum of Modern Art, New York (Purchase)

on a surface, without reference to a preconceived theme. The conscious mind would then associate these non-objective marks with objective forms. In Masson's work, a ferocious battle among fishes has evolved, exhibiting his intense anxieties about the brutality of nature, feelings which were born of the physical and mental wounds he received in World War I.

SCULPTURE IN THE 1930s AND 1940s

608. ALBERTO GIACOMETTI
The Palace at 4 A.M. 1932–33.
Construction in wood, glass, wire,
and string, height 25". Collection,
The Museum of Modern Art, New
York (Purchase)

In Giacometti's surrealist *Palace at 4 A.M.*, the palace enclosure is defined by slender forms that outline shapes and spaces (fig. 608). Within this airy structure a number of evocative forms are shown in haunting isolation: an armless woman in a long gown, a skeleton-like bird, a spinal column enclosed within a box, three repeated rectangular forms, and a highly abstract form against a vertical slab that represents, according to the sculptor himself, a self-portrait. The woman was identified by the artist as his own mother, "just as she appears in my earliest memories," while the spinal column stands for a woman with whom Giacometti had a relationship, and the pterodactylian skeleton represents the bird which sang at 4 A.M. on "the very night before the morning in which our life together collapsed." Such personal revelations become more and more common in modern art, but while they elucidate some of the origins of Giacometti's work, the sculpture remains evocative and enigmatic. The thin forms and frail materials create a mood of secretive mystery and hesitant uncertainty that is heightened by the choice and juxtaposition of objects. The artist has both revealed and hidden his feelings.

During the 1930s and 1940s, sculptors' interest in abstraction took a number of forms. Moore's *Recumbent Figure* (fig. 609) is immediately recognizable as a reclining female figure—one of the great traditional themes that has inspired Western artists. Like its distinguished antecedents, it suggests the voluptuous nature of the forms of the female figure. While the positions of the head and breasts are evident and the figure seems propped up on one elbow, the torso below the breasts is an open cavity, and other forms suggest hips, a knee, and legs, without informing us of the exact pose. Moore's rugged, simple forms also suggest the hills and gullies of a landscape. The sculpture interrelates with its environment through the powerful masses and unexpected openings that surround and mold space.

GIACOMETTI, *The Palace at 4 A.M.*: 1932–33
1933: Books by Jewish and non-Nazi authors are burned in Germany
1933: Approximately 60,000 artists, writers, and musicians leave Germany

609. HENRY MOORE
Recumbent Figure. 1938. Gray-green Hornton stone, length about 54". The Tate Gallery, London. Moore's sources for this style encompass not only modern European sculpture, but also the powerfully abstract forms of African and Pre-Hispanic art.

611. ALEXANDER CALDER
Lobster Trap and Fish Tail. 1939. Hanging mobile: painted steel wire and sheet aluminum, 8' 6" x 9' 6". Collection, The Museum of Modern Art, New York (Commissioned by the Advisory Committee for the stairwell of the Museum)

610. BARBARA HEPWORTH
Sculpture with Color (Oval Form), Pale Blue and Red. 1943. Painted wood with strings, length 18". Private collection

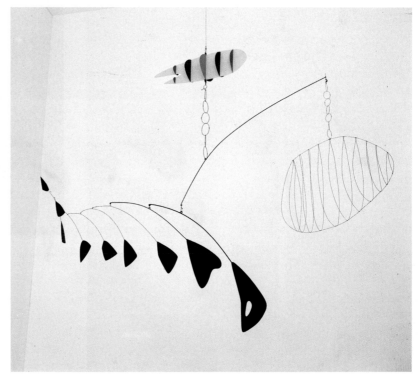

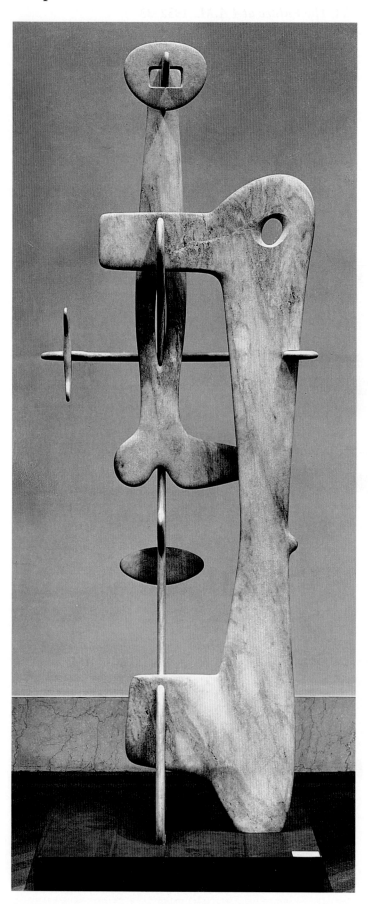

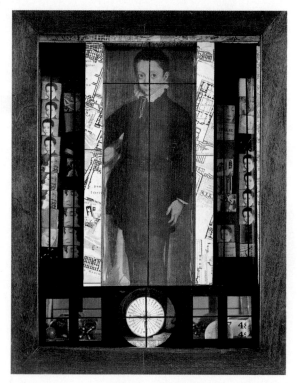

612. ISAMU NOGUCHI
Kouros. 1944–45. Pink Georgia marble, height 9' 9". The Metropolitan Museum of Art, New York (Fletcher Fund, 1953). The slabs of stone are not fastened together, and the sculpture can be disassembled. Noguchi's involvement with Greek themes came in part from his collaboration as a set designer with Martha Graham, the innovative American dancer whose modern ballets were often based on mythic themes.

613. JOSEPH CORNELL
Medici Slot Machine. 1942. Construction, 13 1/2 x 12 x 4 1/4". Private collection. Cornell intended that his boxes be held in the hands and moved so that the loose elements could rattle and be rearranged.

Moore has written that "sculpture in air is possible, where the stone contains only the hole, which is the intended and considered form." The abstract forms, however, are interrelated in a manner that suggests the organic qualities of a living, breathing figure with a potential for movement. Moore never denies the dignity and beauty of the human body, and many of his figures are heroic in scale and in content.

Henry Moore and Barbara Hepworth guided the development of British abstract art in the 1930s, but Hepworth's sculpture moved further into abstraction. In *Sculpture with Color (Oval Form)*, mass and space become integral elements in a composition that simultaneously reveals itself as exterior form and interior structure (fig. 610). The contrast between exterior and interior is reinforced by color, while the taut strings relate the interior cavity to the exterior surface. Hepworth wrote that this structural relationship of color and string was associated with her perception of nature: "The colour in the concavities plunged me into the depth of water, caves, or shadows deeper than the carved concavities themselves. The strings were the tension I felt between myself and the sea, the wind or the hills." In a later comment, she elaborated on the significance of nature: "In the contemplation of Nature we are perpetually renewed, our sense of mystery and our imagination is kept alive, and rightly understood, it gives us the power to project into a plastic medium some universal or abstract vision of beauty."

A new type of sculpture, named "mobiles" by the artist Marcel Duchamp, was shown at an exhibition in 1932 by the American artist Alexander Calder, who had first been trained as an engineer. Calder's earliest mobiles were moved by hand cranks or motors, but by 1932 they evolved into the lightweight, delicately balanced, suspended sculptures, moved by air currents, that have spawned so many popular variations. While most of Calder's mobiles are completely abstract, the title of the present example suggests that the graceful movements of the curvilinear forms are a reference to swimming fish (fig. 611). In Calder's mobiles, the intimate relationship between form and space attains a new complexity as air currents move the forms slowly through space to create ever new compositions.

Noguchi's title for his over-lifesize *Kouros* reveals that these abstract forms refer to a standing male figure (fig. 612), and we are encouraged to compare the sculpture with idealized ancient Greek statues of the sixth and fifth centuries B.C. As a modern artist, Noguchi reinvents the human form, substituting thin slabs of stone that interlock at right angles as support for the solid, rounded mass that is central to the body. The individual slabs, however, offer organic shapes and subtly rounded edges that are related to the flowing interpenetration of forms that characterizes a living human form. The frailty of forms and the instability of structure may be intended to convey the emotional anxiety Noguchi sensed in 1944–45, near the end of World War II, when he felt a need for "constant transfusions of human meaning into the encroaching void."

Joseph Cornell's boxes are combinations of three-dimensional objects and two-dimensional charts, photographs, maps, and/or reproductions of works of art, all joined within shallow, glass-fronted enclosures. His unexpected juxtapositions of the concrete with the illusory can be poignant, enigmatic, and nostalgic. Each becomes a secluded and private universe intended to stimulate a viewer's imagination and memories. In speaking of a box that made a reference to soap bubbles, Cornell said, "Shadow boxes become poetic theatres or settings wherein are metamorphosed the elements of a childhood pastime." In *Medici Slot Machine*, a reproduction of a sixteenth-century painting of a young nobleman is viewed through a glass with crossed lines, like a telescope, perhaps to suggest how we view the past from a distance (fig. 613). A compass and a watch spring in the circular opening below suggest both space and time. The frame around the boy is covered with old maps of ancient Rome, perhaps a reference to the Renaissance interest in antiquity, while the ball, jacks, and game pieces below refer to the entertainments enjoyed by youth in all periods. These are at best suggestions of Cornell's meanings—the true modernity of Cornell's boxes lies in how they encourage individual, unconscious interpretations. Even the name enhances this quality of personal meaning. Like many modern artists, Cornell avoids reference to specific meaning by selecting names that increase a viewer's sense of wonderment and expectation.

PABLO PICASSO, *GUERNICA*

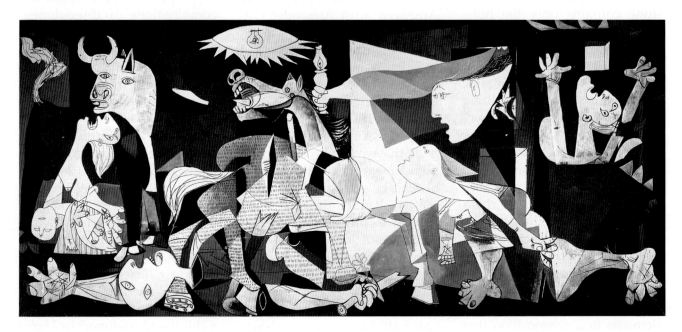

Despite the perplexity of highly abstract shapes, which owe a formal debt to Synthetic Cubism, the *Guernica* mural, inspired by the bombing of an innocent Spanish town during the civil war, achieves an immediate impact (fig. 614). An architectonically stable composition underlies the surface tumult, for the verticality of the two side figures, the woman with upraised arms to the right and the woman cradling the dead child on the left, acts to secure the central group, which is resolved in the shape of a triangle. This simplified geometric order imparts an underlying strength to the composition.

The restriction of the color palette to black, white, and values of gray, and the newsprint-like lines across the body of the horse, remind us of the reporting of disastrous events in newspapers. It was by reading such reports that Picasso learned of the disaster at Guernica. Writing later, the American painter Ad Reinhardt considered the *Guernica* a "design that diagrams our whole present dark age," and of the limited color range Picasso used, Reinhardt stated, "The dead have no color."

Picasso refused to elaborate on the particular intentions he invested in each figure, preferring to encourage the viewer to understand the work on an emotional and intuitive level. On the right and left sides of the composition two women, shrieking in anguish with eyes transformed to the shape of tears, look toward the heavens, source of their pain and death. The left figure holding a dead child adapts the *Pietà* theme (see fig. 314) to this nightmare while the woman to the right cries from the flames which have engulfed her house. Below her, another woman drags her mangled leg and, with arms outstretched, pleads for help and understanding. Above, an oil

614. PABLO PICASSO
Guernica. May 1–June 4, 1937. Oil on canvas, 11' 6" x 25' 8". The Prado, Madrid. Picasso placed the painting on extended loan to the Museum of Modern Art in New York for many years, stipulating that it be given to Spain and her people only when democracy was restored. The painting was returned to Spain in 1981.

lamp, reminiscent of the light held by allegorical figures of Truth and Liberty, is thrust into the chaos. This light, however, is overwhelmed by the harsh radiance from the bare electric bulb, added to the composition only in the final stages of painting (see fig. 615). Previously this area had represented the sun or an eye. The change to the electric light is most likely an allusion to technology, which, during the bombing of Guernica, was unleashed as a malevolent and destructive force.

In the central group, a horse has been lanced; its head is

twisted back and the pointed tongue becomes a silent scream of pain and accusation. While the horse may symbolize the suffering of Spain, it also expresses the totality of a conflict that involves all of nature. The bull suggests brute power, perhaps in reference to Franco and Fascism (see below). Below the horse are the dismembered remains of a fallen soldier. His hand, while still clutching a broken sword, also clings to a delicate flower, the only promise of hope in this image of suffering and death.

The brutal Spanish Civil War (1936–39) was the result of conflicting political ideologies and of internal tensions that were centuries old. In 1931 the Bourbon monarchy that had ruled Spain since 1700 was replaced by a republican government that promised social and economic reform, including the redistribution of land and the secularization of certain governmental functions controlled by the church. Such reforms, which were aimed at countering the political power of wealthy landowners and the clergy, provoked the formation of conservative alliances. During the increasing civil disorder after the elections of 1936 (won by the republicans), General Francisco Franco, claiming allegiance to his nation rather than to any political group, led an insurrection which immersed Spain in civil war. Nazi Germany and Fascist Italy aided Franco, while the U.S.S.R. assisted the leftist coalition, which included the Communists. The major Western democracies maintained an official position of neutrality, but many individuals supported the republican cause as the cruel reality of Franco's oppression became apparent. After three years

PICASSO, *Guernica*: 1937
1937: Jean-Paul Sartre, *La Nausée*
1939: John Steinbeck, *The Grapes of Wrath*
1940: World population reaches 2.3 billion, with 500 million in China

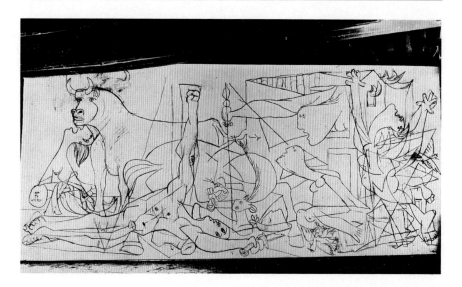

615. PABLO PICASSO
Guernica. Photograph of the painting on May 11, 1937, by Dora Maar. This is the first of seven photographs made of the work in progress. Many of the main themes are already established, but virtually all will be dramatically reworked. Note that at this early point defiance on the part of the dead warrior is expressed by his upraised arm and fist.

and the loss of hundreds of thousands of lives, Franco established an authoritarian rule which continued until his death in 1975.

In January 1937, in the midst of the civil war, the republican government commissioned Picasso, who was living and working in France, to paint a mural for the Spanish Pavilion at the World's Fair scheduled to open in Paris that year. Picasso had yet to settle upon an exact theme when news of the events of April 26 reached him. On that day, Franco had used his Nazi allies to conduct the first "total" air raid. In what seems to have been an experiment in saturation bombing, the historic city of Guernica, a town of no military significance, was bombarded for more than three hours. When Picasso learned of the bombing, he started to paint a work which would be an invective against both the particular event and the senseless brutality of conflict.

Picasso, whose republican sympathies had already been manifested in satirical etchings called the *Dream and Lie of Franco*, wrote: "In the panel on which I am working which I shall call *Guernica*, and in all my recent works of art, I clearly express my abhorrence of the military caste which has sunk Spain into an ocean of pain and death." The story is told that while viewing a photograph of *Guernica*, a Nazi official queried Picasso, "So it was you who did this?" The reply came sharply, "No, you did!"

INTERNATIONAL-STYLE ARCHITECTURE

616. PHILIP JOHNSON
Glass House, New Canaan, Connecticut. 1949. The Glass House, the architect's own home, is secluded on a large estate, and privacy is not a problem. A brick cylinder placed asymmetrically provides the fireplace and the enclosure necessary for the bathroom and mechanical equipment. A counter forms the kitchen area, and a freestanding block of closets provides storage space and gives the bedroom privacy.

Philip Johnson's Glass House (fig. 616), a satisfying combination of pure geometric form, subtle proportional relationships, and elegant materials, is an outstanding example of the modern architectural movement known as the International Style. This style, named by Philip Johnson in 1932 in the context of an architectural exhibition held at the Museum of Modern Art in New York, is based on the refined glass box. It was expressed as early as the 1920s in works by the German architect Mies van der Rohe, who later became the director of the Bauhaus (see

p. 525). Mies emigrated to America in 1937, becoming a citizen in 1944. The International Style only came to full fruition after World War II, when Mies was commissioned to create a number of works, including skyscrapers in Chicago and New York and an entire campus for the Illinois Institute of Technology in Chicago. These popularized the style and led to its adaptation throughout the Western world. By the 1960s virtually every Western capital had many metal and glass skyscrapers.

Even while it was under construction, the Seagram Building

was recognized as an especially elegant and impressive modern structure (fig. 617). Mies's choice of materials reveals his goals of harmony and elegance, for the exposed structural I-beams are composed of bronze which exactly matches the amber-tinted glass. The building is tall and wide when seen from the front, but its relative thinness gives it a soaring refinement. The proportions of the design are based on a simple modular system much like the satisfying Early Renaissance architecture of Brunelleschi. The open lower stories, where there is a bank of elevators

JOHNSON, Glass House: 1949
1945: World War II ends; almost 55 million people have died
1949: U.S. minimum wage raised from 40 to 75 cents an hour
1949: George Orwell, *1984*
1950: World population exceeds 2.5 billion

and a small glassed lobby, lighten the structure and help establish the proportional integrity of the whole. The building in every way reflects Mies's personal motto, "Less is more." Because it occupies less than one-half of the site, the building does not have to conform to the restrictions of the set-back law, which explains the staggered rooflines of so many Manhattan buildings. The structure is placed on a large plaza that sets it off as a gigantic sculptural form.

The glass box represents a pure ideological statement without historical precedent or references, but in its materials it is a product of the machine culture. Its origins lie in mass production, prefabrication, and the glorification of the precision of the machine. Even more importantly, it shares in the utopian ideals that had inspired De Stijl (see p. 522), one of its sources; as pure architecture, expressing the Platonic ideal with thoroughly modern materials, it shares in the idealism of much twentieth-century thought.

Despite the purist, reductive beauty of Johnson's Glass House and Mies's Seagram Building, the International Style quickly reached a dead end. The glass box is an impersonal object, and as cities all over the world became crowded with such buildings, many people felt that their environment had become a cold and sterile place in which to live and work. Because the emphasis is on purity of design at the expense of function, such buildings, all of which look similar, demonstrate little interest in the needs of the client or of the people who work in them. In their modern purity they ignore the subtle relationships to site, climate, or local architectural tradition that were crucial for earlier masterpieces of architecture.

617. MIES VAN DER ROHE
Seagram Building, New York. 1956–58. The International Style glass-box skyscraper became popular with corporate America because it projected a modern, up-to-date image for the business it housed. Few buildings in this style, however, have the sophisticated elegance of the Seagram Building, Mies's masterpiece. Philip Johnson, who assisted Mies in the design of the building, was largely responsible for the creation of the interior spaces.

ABSTRACT EXPRESSIONISM AND POST-PAINTERLY ABSTRACTION

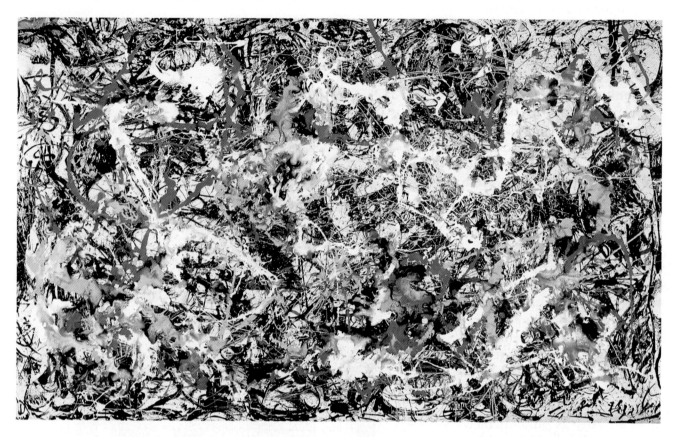

618. JACKSON POLLOCK
Convergence. 1952. Oil on canvas, 8 x 13'. Albright-Knox Art Gallery, Buffalo (Gift of Seymour H. Knox, 1956)

"My painting does not come from the easel. I hardly ever stretch my canvas before painting. I prefer to tack the unstretched canvas to the hard wall or the floor. I need the resistance of a hard surface. On the floor I am more at ease. I feel nearer, more a part of the painting, since this way I can walk around it, work from the four sides and literally be in the painting. . . .

"I continue to get further away from the usual painter's tools . . . I prefer sticks, trowels, knives and dripping fluid paint or a heavy impasto with sand, broken glass, and other foreign matter added.

"When I am in my painting, I'm not aware of what I'm doing. It is only after a sort of 'get acquainted' period that I see what I have been about. I have no fears about making changes, destroying the image, etc., because the painting has a life of its own. I try to let it come through. It is only when I lose contact with the painting that the result is a mess. Otherwise there is pure harmony, an easy give and take, and the painting comes out well" (Jackson Pollock, 1947).

Convergence bursts forth with the dynamism of exuberant colors and interpenetrating layers of undulating paint (fig. 618).

This weblike mass of colors and rhythms offers a new and provocative approach to painting; it records the process by which the artist's unconscious has been laid bare. Pollock's method of painting is derived from Surrealist automatism, and while creating these innovative works, Pollock, often described as being in a trancelike state and moving with the grace of a dancer, aggressively flung paint onto the canvas, the action of his arm being guided by his unconscious (see fig. 620).

POLLOCK, *Convergence:* **1952**
1950: Korean War begins
1951: J. D. Salinger, *The Catcher in the Rye*
1951: Rodgers and Hammerstein, *The King and I* musical opens in New York
1951: Color TV is introduced in America
1952: Ernest Hemingway, *The Old Man and the Sea*

619. MARK ROTHKO
White and Greens in Blue. 1957.
Oil on canvas, 8' 6" x 7'. Private
collection, New York

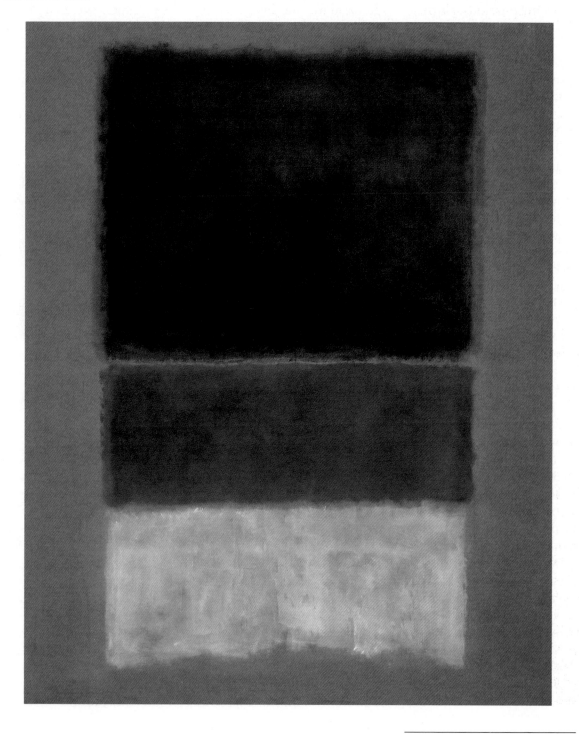

But unlike Surrealist automatism, Pollock has not consciously completed the image to bring it within the realm of objectivity. The painting communicates a raw, expressive energy.

But what are we to make of all this? What does it mean for us to confront this painterly record of an artist's unconscious? Surrealism, one of the roots of Abstract Expressionism (defined below), was bound to the psychoanalytical investigations of Freud, but Carl Jung's concept of a "collective unconscious" is equally significant here. As Pollock has exposed his human unconscious, we should be able to draw meaning intuitively from the painting, as its large scale, abstract rhythms, and intense colors meet an unconscious response in us.

Pollock's drip paintings exemplify one style within Abstract Expressionism, a movement that, beginning in New York after World War II, thrust America into the avant-garde of Western art. As we have seen, the roots of Abstract Expressionism were grounded in the psychoanalytical theories of Freud and Jung and in Surrealism. During the 1930s, with the rise of Nazi Germany casting an increasingly foreboding shadow over Europe, many leading European artists came to America. The impact of their work and their presence was felt in a major 1936 exhibition of Dada and Surrealism at New York's Museum of Modern Art. European artists, some of whom opened their studios as teachers, found a particularly responsive audience among a younger gen-

eration of American artists who, bound with a collective American identity resulting from the common hardships of the Depression, were searching for new avenues of expression. With Surrealism illuminating one of the avenues, these American artists assumed control of the avant-garde in the late 1940s.

The term Abstract Expressionism had been used earlier in the century to designate the non-objective paintings of Kandinsky, but it was resurrected in 1946 to describe the works of a group of American painters centered in

New York (these artists are also sometimes referred to as the New York School). What joined these artists was not a unified style, but a common attitude that stressed the unique individuality of each creative act.

Within the stylistic differences of the Abstract Expressionist painters, we can discern two fundamental approaches; one, termed Action Painting by the critic Harold Rosenberg in 1952, was a free, gestural expression of paint on the canvas, as demonstrated by the paintings of Jackson Pollock. Another mode, ex-

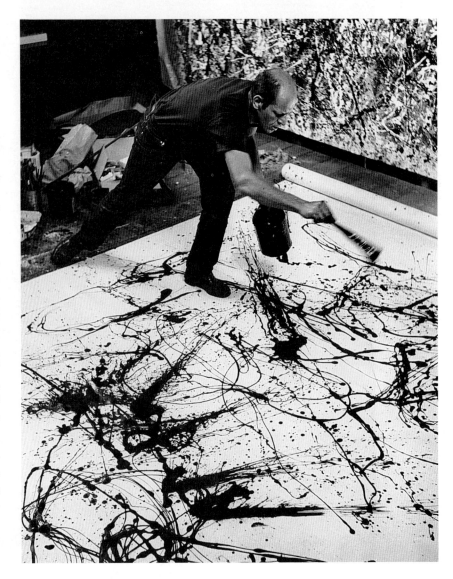

620. Photograph of Jackson Pollock painting

emplified by the work of Mark Rothko, is referred to as Color Field Painting. It displayed limited areas of color within simple and controlled, non-objective compositions, leaving the shapes and colors to communicate an aesthetic and/or emotional experience.

Rothko, who arrived at this mode of expression after experimenting with the human form and with Surrealist biomorphic compositions, always insisted that paintings must be about something, that they must have a strong content: "It is a widely accepted notion among painters that it does not matter what one paints as long as it is well painted. This is the essence of academicism. There is no such thing as a good painting about nothing. We assert that subject matter is crucial and only that subject matter is valid which is tragic and timeless."

In Rothko's *White and Greens in Blue* (fig. 619), horizontal planes stacked vertically carry associations of nature, such as landscape and sky, while also establishing a hierarchical order. The interplay of these elements is joined to an emotive use of color. We draw a melancholic sensation from the sobriety of the colors. The densely darkened green rectangles which weigh down the bottom rectangle of white seem to convey unconsciously the suppression of hope.

Rothko, believing in the evocative nature of his paintings, became increasingly sensitive to charges that his work lacked content, that it was only an exercise in color relationships. An interviewer once posed the question of content to Rothko, who replied: "I'm interested in expressing only basic human emotions—tragedy, ecstasy, doom, and so

621. MORRIS LOUIS
Saraband. 1959. Acrylic resin on canvas, 8' 5 1/8" x 12' 5". The Solomon R. Guggenheim Museum, New York. The title of the painting is derived from a stately European court dance of the seventeenth and eighteenth centuries. This abstract work would have been titled after it was completed. Perhaps the repeated rhythmic patterns and flowing shapes of the composition suggested this title to the artist.

on—and the fact that lots of people break down and cry when confronted with my pictures shows that I communicate these basic human emotions. . . . The people who weep before my pictures are having the same religious experience I had when I painted them, and if you, as you say, are moved only by their color relationships, then you miss the point."

The development of Abstract Expressionism provoked the exploration of new techniques. Both Pollock and Rothko experimented by staining raw or unprepared artists' canvas with highly liquid acrylic paint, a technique that produced different effects from the traditional application of brushed paint. Among the artists who adopted the resulting style, which was named Post-Painterly Abstraction by the art critic Clement Greenberg, were Helen Frank-

enthaler (see fig. 541) and Morris Louis. In creating *Saraband*, Louis poured acrylic resin onto the canvas and then inclined it at different angles as the paint flowed over and soaked into the canvas (fig. 621). The result is a luminous painting composed of rhythmic color veils whose transparency and overlapping forms deny traditional figure/ground distinctions. The staining technique negates the autographic movements of the artist that had been so important in Abstract Expressionism. In *Saraband*, color and canvas are wed in a planarity whose only texture is that of the canvas itself. Even the white color of the canvas becomes an important element of the composition. By questioning the roles of picture plane and illusory space, the artists of this group achieved a reductive purity in abstract painting.

LE CORBUSIER

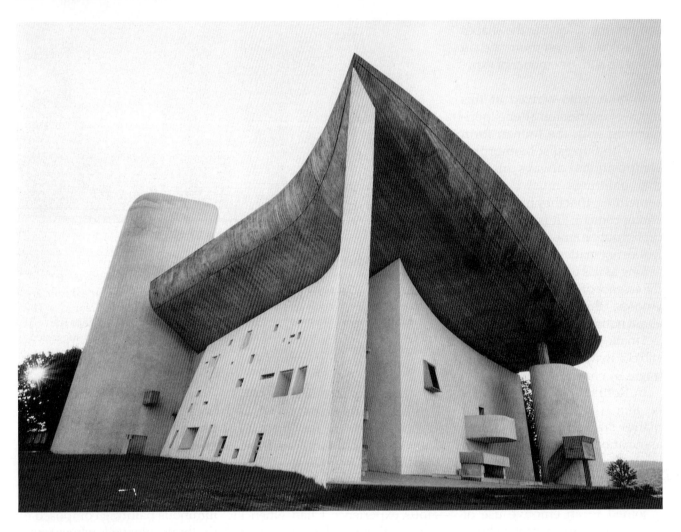

622. LE CORBUSIER
Exterior, Notre-Dame-du-Haut, Ronchamp, near Belfort, France. 1950–54. Le Corbusier, "the crowlike one," is the nickname of the French architect Charles-Edouard Jeanneret. Notre-Dame-du-Haut is built in the foothills of the Alps, on the edge of a high promontory overlooking the town of Ronchamp. It marks the site of an earlier chapel, destroyed in World War II, that had displayed a miracle-working statue of the Madonna, now incorporated into the new structure. In ancient times this area had been sanctified by a pagan shrine. An outside altar and pulpit are used when pilgrimage crowds become too large to be accommodated within the chapel. The building is constructed of reinforced concrete.

In its highly personal, non-repeating forms, Le Corbusier's chapel at Ronchamp (figs. 622, 624) offers a dramatic, individualized alternative to the geometric purity of the contemporary International Style in architecture. Like the great French Gothic cathedrals, this structure sets out to astonish and move us by its unexpected and mysterious form and structure. The sweeping roof seems thin and billowing, like an air-filled sail. Although the roof is made of natural brown-gray cement, its detachment from the thick, curving walls below gives it a particular lightness. The sail-like roof of Notre-Dame-du-Haut creates a relationship with nature, for it seems to respond to the winds that sweep the promontory site. The structural system is based on nature, for Le Corbusier was inspired by a crab shell he picked up on a beach.

On the interior (fig. 623), the darkness and the thick, roughly textured walls suggest a mysterious cave, while a slit of light

LE CORBUSIER, Notre-Dame-du-Haut: 1950–54
1951: U.S. population reaches 153 million
1952: First hydrogen device is exploded
1952: First pocket-sized transistor radios

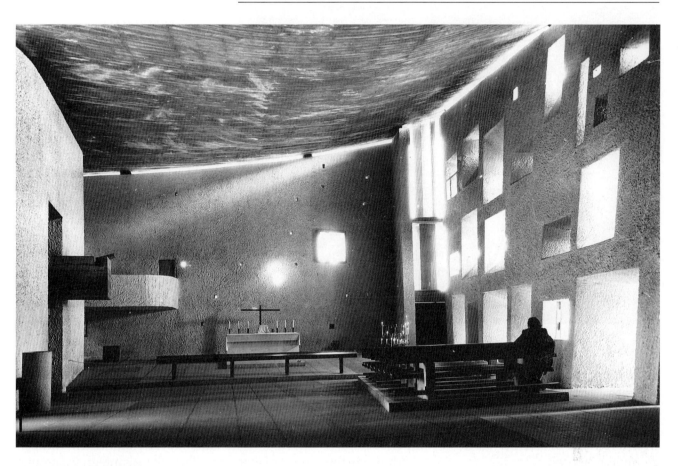

623. LE CORBUSIER
Interior, Notre-Dame-du-Haut. The interior, approximately 43 x 82', has pews for only about fifty worshippers.

624. LE CORBUSIER
Axonometric projection,
Notre-Dame-du-Haut

between wall and ceiling and the sagging shape of the ceiling itself reinforce the billowing sail effect of the exterior. The thick wall is pierced by irregularly sized and spaced windows filled with stained glass on which traditional religious symbols (a dove, the sun) and phrases ("Marie," "Blessed among Women") have been painted. Like sculpture in the round, the building forces us to move to understand it, and as we explore the structure, three chapels, mysteriously lit by hidden windows in towers, are discovered. The building becomes an adventure and, for some, a journey of personal religious discovery. In discussing the building, Le Corbusier called it "totally free architecture," describing it as "sculpture 'of an acoustical nature,' that is to say projecting afar the effect of its forms and, in return, receiving the pressure of the surrounding spaces. The key is light and light illuminates shapes and shapes have emotional power."

FILM IN JAPAN

625. YASUJIRO OZU
(director)
Tokyo Story. 1953. Shukichi (the father) and Tomi (the mother). Script by Kogo Noda and Yasujiro Ozu; photographed by Yuharu Atsuta. The running time of the film is 135 minutes.

Tokyo Story, by the filmmaker Yasujiro Ozu, was released on November 3, 1953. Popular in Japan, it was also one of very few Japanese films of this period to be shown abroad. The film focuses on a modern, middle-class Japanese family, the relationships among its members, and how they are affected by events in their everyday lives. Ozu's message concerns how events gradually lead to the dissolution of the traditional family structure that is so important in Japanese life and society. Rather than stressing the cause of domestic turbulence, he emphasizes its effect on individual family members. Incidents in everyday life gradually reveal the nature of the characters. These confrontations of family members within the context of daily life are subtle, familiar, and easy for Japanese as well as Western audiences to

appreciate. The subject crossed cultural boundaries and allowed viewers in the West a glimpse of Japan not common in the postwar period.

Produced in the context of war weariness and disillusion, this film appeared only one year after the end of the Allied occupation of Japan. The reforms carried out during the postwar period were drastic. Land-reform programs had made owner-farmers out of tenants, the new "peace constitution" had defined the emperor as a "symbol of state" instead of a source of sovereignty, and a long bill of rights gave certain privileges to individuals. The abandonment of war as an "instrument of national policy" meant the renouncement of any buildup of weapons and armies. The civil code was revised in accordance with the sentiments of the new democratic constitution,

and as a result the traditional powers of the family head, which were built into the old code, were supposed to disappear. Such reforms had a profound effect on both national policy and everyday life. Made in the midst of these sweeping reforms, *Tokyo Story* reveals the inevitable and unresolved conflict between the demands of life in the modern industrial era and traditional Japanese cultural mores and values, especially those centered around family life. The film examines that conflict thematically and cinematically.

Tokyo Story is integrated around three elements: story, theme, and cinematography. The simple story is a complex three-part tale that focuses on the parents' relationships with their children. The first section is set in the town of Onomichi, where the old couple lives. The middle section sees the parents at a reunion with their children in Tokyo. Both their son and daughter are busy with their own lives and send the parents off to a hot-springs resort, ostensibly as a treat but actually to get rid of them. The only kindness they experience in Tokyo is found with the widow of their third son, who had been killed in the war. The third section, back in Onomichi, de-

OZU, *Tokyo Story:* 1953
1953: Arthur Miller, *The Crucible*
1953: Eisenhower is inaugurated as president of the U.S.
1953: Simone de Beauvoir, *The Second Sex*
1953: Korean armistice is signed

626. YASUJIRO OZU
(director)
Tokyo Story. The family at the
funeral of the mother

picts the death and funeral of the mother. The children are called to her deathbed, but she is so ill that she cannot recognize them. The children hurry away after the funeral, but the daughter-in-law stays behind to see the old father settled in. Then she, too, must return to Tokyo, leaving the father in the empty house to contemplate the lonely years ahead.

Ozu's central theme is how one comes to terms with the dissolution of the family and, ultimately, with death. Three alternative solutions are examined, each described in the reactions of the children. Several of the characters are resigned and accept these conditions with sensitivity. Others lack compassion, are indifferent, and regard separation of the family as inevitable. The youngest refuses to accept the dissolution and tries to shore up the family once again. These choices are presented as complementary to one another, and dynamic conflict never arises. Resolution is never reached, and the theme of transience triumphs. The psychological tension created by this thematic and visual structure keeps the viewer aware of the conflicts inherent in modern life.

Given his attachment to daily family scenes and events, Ozu sets a slow pace that echoes the unfolding of life in the everyday world. The camera is literally fixed at the eye level of someone seated on the floor on a straw *tatami* mat in a traditional Japanese house. He uses only three standard shots—long, medium, and close-up—repeating them again and again. The medium shot is the basic unit, and the scenery in each frame is presented with austere formal symmetry (fig. 625). Although these standard shots are repeated, they frame the subtle psychological and emotional relationships of the moment (fig. 626).

Both the framing and the pacing of the film confirm the aesthetic standards that had been held for centuries among Japanese artists and support Ozu's reputation as the most traditional of Japan's filmmakers. His visual and thematic sensibilities—an emphasis on simplicity and directness and an interest in the notion of the transience or impermanence in life—closely resemble those of Zen artists. His black-and-white films have been compared to Zen temple gardens, where simple, unadorned arrangements of dry rocks and raked sand are meant to elicit complex responses (see fig. 383). Ozu's tale, told in the modern medium of film and focused on a problem common to the modern world, expresses unmistakably traditional Japanese values.

THE RETURN TO THE OBJECT: JASPER JOHNS AND ROBERT RAUSCHENBERG

Jasper Johns's *Flag* (fig. 627) strikes us as a blatantly representational image, even more so when we consider that it was created in the mid-1950s, when various modes of non-objectivity ruled the avant-garde in painting. The composition is clearly and intentionally recognizable, but in place of the solid colored shapes of red, white, and blue that we expect in a flag, Johns has substituted a painterly texture whose thinness in places reveals collage elements underneath. Johns's painting is not a flag of the United States. The art-

ist has carefully manipulated the surface to emphasize the reality of the painting as a mixed media work of paint and collage. This artistic transformation is intended to drain the image of its immediate symbolic content. Johns thus forces us to realize that the painting itself is first and foremost a composition of shapes and colors—an object.

During the early 1950s, a group of artists reacted to the non-objective aesthetic that had dominated the American avant-garde with Abstract Expressionism and Hard-Edge Painting. Art-

ists such as Johns and Robert Rauschenberg began to incorporate, in the most literal of ways at times, representational imagery and recognizable objects in their work. This served at least two purposes: It avoided the sometimes uncomfortable defensiveness viewers felt with non-objective art, while simultaneously offering the image, or its combination with actual

627. JASPER JOHNS
Flag. 1954. Encaustic, oil, and collage on fabric mounted on plywood, 42 1/4 x 60 5/8". Collection, The Museum of Modern Art, New York (Gift of Philip Johnson in honor of Alfred H. Barr, Jr.)

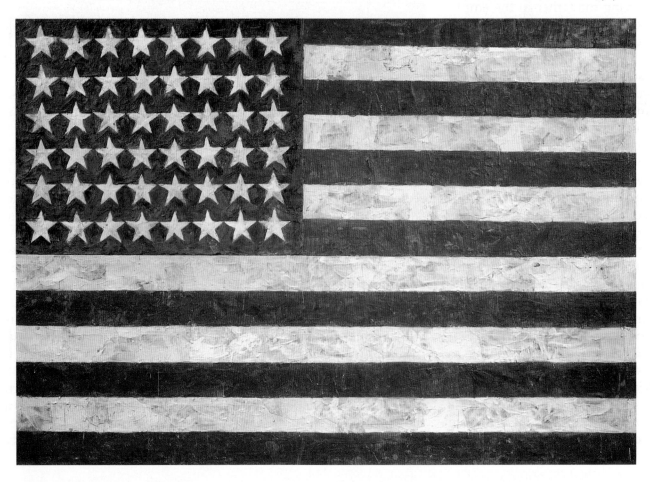

JOHNS, *Flag:* 1954
1954: *Brown vs. Board of Education,* U.S. Supreme Court rules against school segregation
1954: Tennessee Williams, *Cat on a Hot Tin Roof*

628. ROBERT RAUSCHENBERG
Monogram. 1959. Construction, 42 x 72 x 72". Moderna Museet, Stockholm

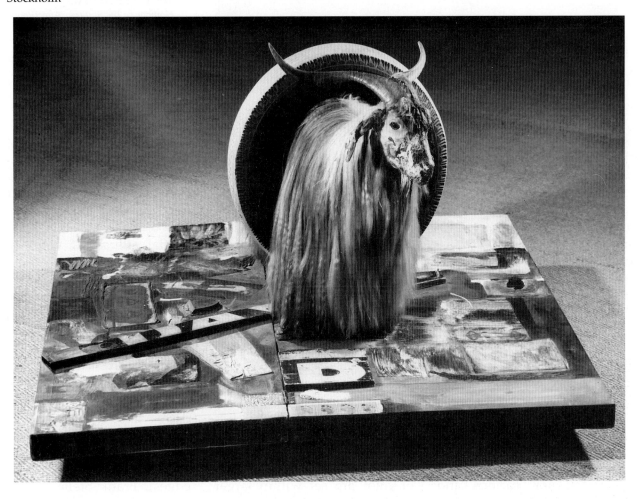

"found objects," as a given fact of our experience, without reference to symbolic comment. There is no precise name for this artistic activity of Johns and Rauschenberg in the mid-fifties. It is sometimes referred to as Neo-Dada, but although there is a similarity to Dada in the use of "found objects," the artistic transformation of common images and objects and the different philosophical context of the fifties make these works distinct from earlier Dada.

In *Monogram* (fig. 628), Robert Rauschenberg attached a stuffed

Angora goat that had a used tire around its midsection to a base which joined collage elements with broad, gestural strokes of paint. Rauschenberg referred to these works as "combines," for they associated elements of life with those of art in a "matter of fact" manner which was inspired by the avant-garde musical compositions of John Cage (see p. 477). In the words of Rauschenberg:

"Any incentive to paint is as good as any other. There is no poor subject.

"Painting is always strongest when in spite of composition,

color, etc., it appears as a fact, or an inevitability, as opposed to a souvenir or arrangement.

"Painting relates to both art and life. Neither can be made. (I try to act in the gap between the two.)

"A pair of socks is no less suitable to make a painting with than wood, nails, turpentine, oil, and fabric.

"A canvas is never empty."

Amid the abstraction of the American avant-garde, these works of Johns and Rauschenberg emphasized the literal role of the object in the work of art.

HARD-EDGE AND OP ART

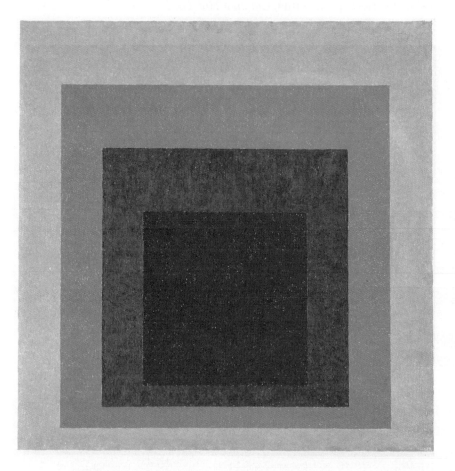

629. JOSEF ALBERS
Homage to the Square: Affectionate.
1954. Oil on canvas 31 7/8 x
31 7/8". Musée National d'Art
Moderne, Centre Georges Pompi-
dou, Paris

"The colors in my paintings are juxtaposed for various and changing effects. They are to challenge or to echo each other, to support or oppose one another. The contrasts, respectively boundaries, between them may vary from soft to hard touches, may mean pull and push besides clashes, but also embracing, intersecting, penetrating.

"Despite an even and mostly opaque application, the colors will appear above or below each other, in front or behind, or side by side on the same level" (Josef Albers, c. 1964).

Albers's *Affectionate* (fig. 629) is one of a series of paintings of virtually identical composition.

In all these works square planes of color are set within larger square planes. Differences of color lead to varying perceptions of spatial illusion created without reference to representational forms. In our painting, the red square of the center appears suspended in advance of the darker, burgundy-colored square behind. This spatial configuration, however, is confounded by the lighter colors of the outer two squares, creating a complicated spatial illusion.

Albers, who studied and then taught at the Bauhaus, moved to America in 1933. His preference for controlled, geometric compositions derives from the Bau-

haus design aesthetic. Early in his career, Albers studied the process of how we perceive and understand illusionism in painting, beginning to work on a series of paintings that created spatial illusions with nonrepresentational, geometric elements. Albers's studies continued throughout his distinguished career, culminating in a series of paintings in the 1950s titled *Homage to the Square*. In America, generations of artists were influenced by his teaching and his works.

Within the realm of Hard-Edge Abstraction in the 1960s (the term was coined in 1958 to indicate a type of abstract painting whose shapes met in clearly defined edges), Frank Stella began to work with a series of shaped canvases that broke the rectangular format traditional for paintings. In *Empress of India* (fig. 630), the angular outward movement of the lines seems to have determined the boundaries, or shape, of the canvas. To Stella, the destruction of the traditional pictorial format opened to the viewer a greater understanding of the painting as a physical object—a support with colors attached. As Stella said in 1966: "I always get into arguments with people who want to retain the old values in painting—the humanistic values they always find on the canvas.

630. FRANK STELLA
Empress of India. 1965. Metallic powder in polyester emulsion on shaped canvas, 6' 5" x 18' 8". Collection, The Museum of Modern Art, New York (Gift of S. I. Newhouse, Jr.)

ALBERS, *Homage to the Square: Affectionate:* **1954**
1954: J. R. Tolkein, *The Lord of the Rings*
1955: A.F.L. and C.I.O. merge

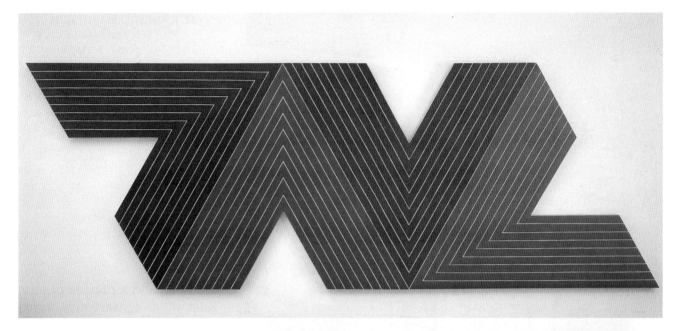

My painting is based on the fact that only what can be seen is there. It is really an object. . . . All I want anyone to get out of my paintings, and all I ever get out of them is the fact that you can see the whole idea without any confusion. What you see is what you see."

Bridget Riley's *Drift 2* (fig. 631) exemplifies another movement from the 1960s known as Op Art, short for Optical Art. It was a descendant of Albers's non-objective illusory compositions and Hard-Edge Abstraction. Its medium is emulsion, a liquid mixture in which one of the elements does not mix with the others but remains suspended in minute droplets. Although *Drift 2* is a flat canvas, its pattern is composed so that it seems to surge and undulate before our eyes. This illusion of movement, however, is dependent on our perception of the optical effects of pattern. Op Art questions the very process by which we see and understand.

631. BRIDGET RILEY
Drift 2. 1966. Emulsion on canvas, 91 1/2 x 89 1/2". Albright-Knox Art Gallery, Buffalo, New York

POP ART

632. RICHARD HAMILTON
Just What Is It That Makes Today's Homes So Different, So Appealing? 1956. Collage, 10 1/4 x 9 3/4". Kunsthalle, Tübingen. Hamilton's collage was part of a 1956 London exhibition titled "This is Tomorrow."

"Popular (designed for mass audience); Transient (short-term solution); Expendable (easily forgotten); Low Cost; Mass Produced; Young (aimed at Youth); Witty; Sexy; Gimmicky; Glamorous; Big Business." These words were used by the British artist Richard Hamilton to describe Pop Art. Hamilton's collage *Just What Is It That Makes Today's Homes So Different, So Appealing?* was both a visual manifesto and a prophetic statement of Pop Art (fig. 632). The inspiration for Pop Art was found in the commercialism which developed, particularly in America, after World War II. Hamilton's work engages us on different levels; the almost nude figures "update" the tradition of the nude in Western art, yet here they also represent a modern couple and they remind us of one of the rules of advertising—sex sells. They are surrounded by the conveniences and products of modern life, while the "fine arts" include a comic book as a framed picture and a canned ham as a table sculpture. The collage is laced with witticisms, including the use of the word POP on the Tootsie Roll wrapper, and a portrait of John Ruskin, a conservative nineteenth-century British art critic. Yet within this environment of commercially produced images and intellectual puns, we are greeted with more profound considerations. The ceiling design is actually a photo of the earth taken from space, and the floor pattern represents densely packed humanity on a beach.

In America, the literal objectivity of artists like Johns and Rauschenberg (see pp. 552–53) assisted in the development of Pop Art. Lichtenstein's *As I Opened Fire* is fashioned after a drawing in an out-of-date adventure comic book that the artist has blown up to an enormous size (fig. 633). The expression of the thoughts of the pilot across the top and the emblazoned BRAT! are a natural adjunct to the bold and simple style of the planes and blazing guns. The strong areas of flat color, contained by heavy black outlines, are in places created by enlarged patterns of dots inspired by the process used

HAMILTON, *Just What Is It . . . :* 1956
1956: "Rock and roll" is popular
1956: Castro begins campaign to oust Cuban dictator Batista

633. ROY LICHTENSTEIN
As I Opened Fire. 1964. Magna on canvas, each panel 68 x 56". Stedelijk Museum, Amsterdam

634. CLAES OLDENBURG
Standing Trowel. 1971. Painted steel, height approx. 40'. Kröller-Müller Museum, Otterlo, The Netherlands

to print color illustrations in comic books and newspapers. Lichtenstein thus draws our attention not only to the overtly melodramatic imagery of the comic book, itself a representative subject of post–World War II culture, but also to the processes by which images are created for mass consumption.

Pop Art celebrated objects and ideas which were not only familiar, but banal in their content. Nowhere was the habitual repetition of commercialization felt more fully than in the works of Andy Warhol (see fig. 538), who wrote, "The reason I'm painting this way is that I want to be a machine, and I feel that whatever I do and do machine-like is what I want to do." Many of Warhol's images were silkscreened by assistants at "The Factory," suggesting an equation between the processes of art

and consumer production. But if Warhol's rows upon rows of Coke bottles, Campbell soup cans, images of Marilyn Monroe, or accident scenes are born from an aesthetic numbness produced by the commercial environment, they also communicate how we are in danger of becoming unfeeling "products" within an industrialized environment.

In the realm of public sculpture, Pop Art overturned traditional values associated with monumental sculpture in public spaces. Claes Oldenburg altered the scale or texture of commonplace, manufactured objects (fig. 634). But there is more than wit involved here; Oldenburg once remarked, "The important thing about humor is that it opens people. They relax their guard and you can get your serious intention across."

PHOTOGRAPHY SINCE 1945

635. ROBERT FRANK
Trolley, New Orleans, published in *The Americans*. 1958. Gelatin silver print,
7 1/2 x 8 1/2". The Art Institute of Chicago

Robert Frank's photograph of a trolley in New Orleans has the appearance of a common "snapshot" (fig. 635). The image is at an angle to the picture plane, yet the effect is precisely calculated. The windows create a grid pattern that formally separates the people, who engage our attention. The formal divisions caused by the windows reinforce the apparent psychological separateness of the people; they do not communicate with each other. Frank's photograph is a poignant statement both of human alienation and of segregation in the American South during the 1950s.

Frank, who was born in Switzerland and came to the United States in 1946, traveled thousands of miles throughout America, armed with his 35 mm camera, in 1955 and 1956. His photographic essay *The Americans*, which demonstrated the vigor of a new photographic aesthetic that revealed the reality often hidden behind the facade of commercial glamour in postwar America, had an enormous impact on American photographers. His new "snapshot aesthetic" is one of a number of developments that have distinguished photography since World War II.

We see a similar approach in the work of Diane Arbus. Like Frank, she worked in fashion photography. In the late 1950s, she turned toward a more introspective use of the medium. Arbus's photograph, taken at a home for developmentally disabled women, is both disturbing and compelling (fig. 636). Arbus

takes us into a realm that is too often ignored. She once commented, "I really believe there are things which nobody would see unless I photographed them."

The works of Frank and Arbus are "straight" photographs; the image has not been altered by extensive darkroom manipulation. Artistic and technical creativity in the darkroom, however, has led other artists to unexpected and even surreal results. Jerry Uelsmann, for example, has written that "for me the darkroom functions as a research laboratory." Uelsmann's photograph (fig. 637) was created through the use of multiple enlargers and exposures to a sheet of photographic paper. By masking parts of images on the easels of different enlargers

FRANK, *Trolley, New Orleans:* 1958
1957: Soviet Union launches first satellites in earth's atmosphere
1958: Tensions rise from school desegregation in the American South
1959: World Refugee Year
1961: Berlin Wall is built
1962: World population reaches 3.1 billion
1962: Cuban missile crisis
1962: Rachel Carson, *Silent Spring*
1963: Massive civil rights demonstration in Washington, D.C.
1963: U.S. President John F. Kennedy is assassinated

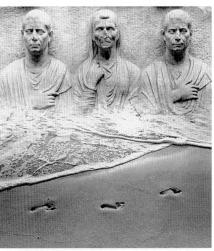

637. JERRY N. UELSMANN
Untitled. 1984. Photograph.
Courtesy of the artist

636. DIANE ARBUS
"Untitled (6). 1970–71." Gelatin silver print. Copyright ©, The Estate of Diane Arbus, 1972. Courtesy, Robert Miller Gallery, New York

and exposing the same piece of photographic paper on one easel and then another, Uelsmann constructs photographs of composite images. Uelsmann's photographs often reach to our subconscious in a surrealist manner; here, three stoic faces from an ancient Roman grave sculpture and three footprints on a beach remind us of the transitory nature of life. The aesthetic and technical achievements of recent photographers have helped us appreciate a new and far-reaching potential in photography. Much of their work creatively denies the popular axiom that "photographs don't lie."

SCULPTURE AT MID-CENTURY

The concept of Assemblage sculpture reaches back to the earlier part of the twentieth century (see p. 520). In composing *Sky Cathedral* (fig. 638), Nevelson assembled cut and scrap pieces of wood—parts of furniture, architectural decoration, and the like—in each box. The individual boxes were then arranged to form a wall-like construction. The overall black paint unites the piece, integrating the multiple, diverse forms. Shadows within and among the boxes increase a sense of mystery. In Nevelson's assemblage sculptures, the commonplace has been transfigured.

Nevelson's *Sky Cathedral* confirms the variety and inventiveness which have characterized developments in sculpture following World War II. An impetus for expansion and change, influenced by both the evolution of earlier modern sculpture and current concepts in painting, especially the geometric composi-

638. LOUISE NEVELSON
Sky Cathedral. 1958. Wood painted black, height 9' 7". Albright-Knox Art Gallery, Buffalo, New York (George B. and Jenny R. Mathews Fund, 1970)

tions of Hard-Edge and Minimal Art (see pp. 554 and 564), led artists to realize vitally creative approaches to sculpture. The geometric, non-objective constructed sculptures of David Smith (see fig. 8) at mid-century

1957: Leonard Bernstein's musical *West Side Story* opens in New York
1958: European Common Market is formed
1958: National Aeronautics and Space Administration (NASA) is established
1959: Hawaii is admitted as fiftieth state
1959: Richard Rodgers, *The Sound of Music*
1959: Fidel Castro becomes premier of Cuba
1960: World population exceeds 3 billion
1961: Population of New York City is 14.2 million

639. ISAMU NOGUCHI
Cube. 1968. Steel subframe with aluminum panels, height 28'. Marine Midland Building, New York

640. PETER VOULKOS
Plate A. 1978. Glazed stoneware, diameter 23". Courtesy Braunstein/Quay Gallery, San Francisco

are powerful yet visually economical stainless-steel configurations. Their wire-brushed surface treatment imparts an impulsive energy while the empathetic composition vigorously asserts a dynamic relationship between sculptural mass and space.

Smith's *Cubi* sculptures, along with the impact of Hard-Edge Abstraction, influenced developments in Minimal and Primary sculpture during the 1960s. Primary Structures is a specific term used for sculpture on an architectural scale; often Primary Structures exhibit the geometric purity of Minimal Art.

Noguchi's *Cube* is a bold, direct sculptural form (fig. 639). Its elemental composition refers to Minimal Art while its enormous size simultaneously lets us understand the impact of Primary Structures. Noguchi's unique interpretation, however, contrasts the visually massive weight of the form with a precarious, teetering balance. For an earlier work by Noguchi, see fig. 612.

Another revolution of post–World War II sculpture affected the medium of clay. Traditionally, clay had served primarily for the fashioning of utilitarian vessels and the construction of sculptors' models. In the 1950s, Peter Voulkos, a ceramic artist, began deliberately distorting functional clay works. The scars and slashes on *Plate A* (fig. 640) remind us of the gestural record of Abstract Expressionism. In using clay as an intimately expressive medium, Voulkos contributed greatly to the expansion of ceramic art that we have witnessed recently.

CONCEPTUAL, PERFORMANCE, AND VIDEO ART

Joseph Kosuth's *One and Three Chairs* (fig. 641) informs us of three different realities. First, there is the reality of the folding chair placed between a full-scale photograph of the same chair and a printed definition of chair taken from a dictionary. The photograph is a second reality, but it bears an illusory image of the chair. Finally, the definition communicates a verbal description of a chair. The idea that we form from the definition exists in our minds and might therefore be termed a "conceptual reality." *One and Three Chairs* presents the actuality, the image, and the idea of a chair, thus demonstrating the relationship between an object and communicative methods of signifying that object.

Kosuth's emphasis on the creative idea and the process of expressing that idea are characteristic of Conceptual Art. This term was first used in the early 1960s to designate an artistic philosophy which held the supremacy of the artist's concept and the process intended to achieve it over the actual execution of the work. This modern tradition of stressing the intellectual creative act begins with Dada, and especially the "ready-mades" of Marcel Duchamp.

Conceptual Art requires that the concept for a work of art be documented, but that documentation need not take the form of a finished, crafted work. It might, for example, be expressed verbally or in another visual medium. In 1967 another conceptual artist, Sol Lewitt, wrote, "In Conceptual Art the Idea or concept is

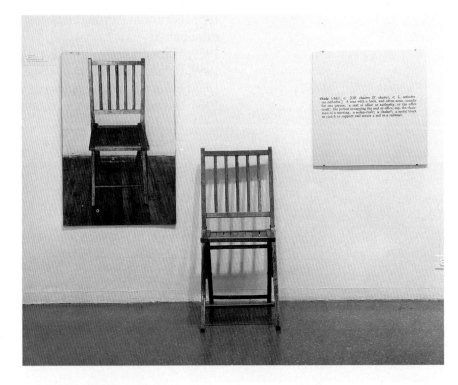

641. JOSEPH KOSUTH
One and Three Chairs. 1965. Wooden folding chair, height 32 3/8"; photograph of chair, 36 x 24"; photographic enlargement of dictionary definition of chair, 24 x 25". Collection, The Museum of Modern Art, New York (Larry Aldrich Foundation Fund)

the most important aspect of the work . . . all planning and decision are made beforehand and the execution is a perfunctory affair. The idea becomes the machine that makes the art."

Another contribution from the 1960s which continues to expand the definitions of art is Performance Art (see p. 480). Historically, such art is related to the Happenings of the fifties. Performance Art, which celebrates a temporal experience for an audience, was not geared toward the making of an object; rather, the artist became the work of art, freely acting within a theatrical environment. Performance artists often utilize a multi-media approach.

Joseph Beuys, a German artist who was a major practitioner of Performance Art, incorporated a wide variety of "props" in his "actions" (as he termed his performances), from found objects to live animals. Beuys, a pilot shot down in a barren frozen area of the Crimea during World War II, used Performance Art as a means to communicate autobiographical experiences in a symbolic manner, causing us to question the deeper values in our lives. Beuys believed that Performance Art could reawaken the mind and soul (see fig. 642).

With Video Art, television becomes a medium of artistic enterprise. Nam June Paik, a Ko-

rean artist, once remarked, "As collage technique replaced oil paint the cathode ray tube will replace the canvas." *Edgar Allan Poe* (fig. 643) is one of a number of video sculptures created by Paik with reference to historical figures. The robotlike form is assembled from old TV sets and electronic cabinets. A stuffed raven and a lit candelabrum recall the writings and ambiance of Poe, giving the sculpture a defining presence. Viewing the work, we focus simultaneously on multiple associations of reality and time. The video montage of ab-

stract patterns and representational imagery, reminding us of the fast-paced gloss of MTV, is bound to the immediate past of the electronic age through the use of TV sets and cabinets which now might be considered antique. An even wider gap in time

is bridged by juxtapositioning references to the nineteenth-century American writer with a seemingly anthropomorphic automaton. Conceptual, Performance, and Video Art have broadened the boundaries of art beyond any traditional definitions, raising intriguing questions about the nature of art as we approach the end of the twentieth century.

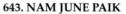

KOSUTH, *One and Three Chairs:* **1965**
1964: Vietnam War escalates
1965: World population reaches 3.3 billion
1965: *Help,* a Beatles film, is released
1967: First human heart transplant
1967: U.S. population exceeds 200 million

642. JOSEPH BEUYS
Photograph documenting various aspects of Beuys's *Iphigenie/Titus Andronicus.* May 1969. This work premiered during an avant-garde theater festival in Frankfurt in 1969. The performance consisted of selected simultaneous readings of Goethe's *Iphigenie* and Shakespeare's *Titus Andronicus* while Beuys, who designed the "set," acted on stage. Beuys's actions included spreading margarine on the stage floor and occasionally clashing cymbals.

643. NAM JUNE PAIK
Edgar Allan Poe. 1990. Video sculpture, 74 x 60 x 19".
Courtesy of Holly Solomon Gallery, New York

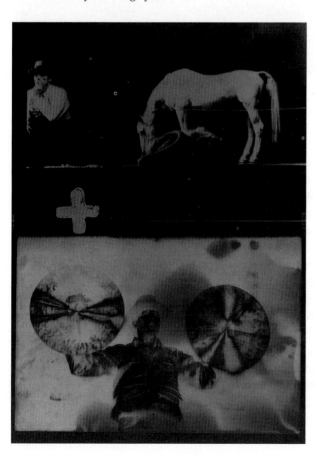

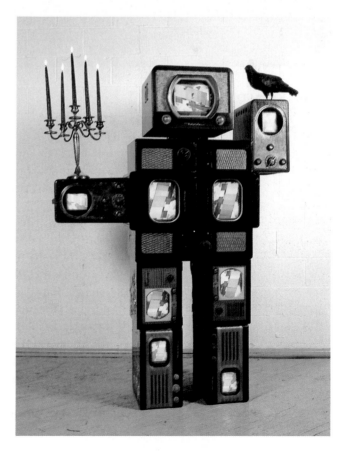

THE DEVELOPMENT OF MINIMAL ART

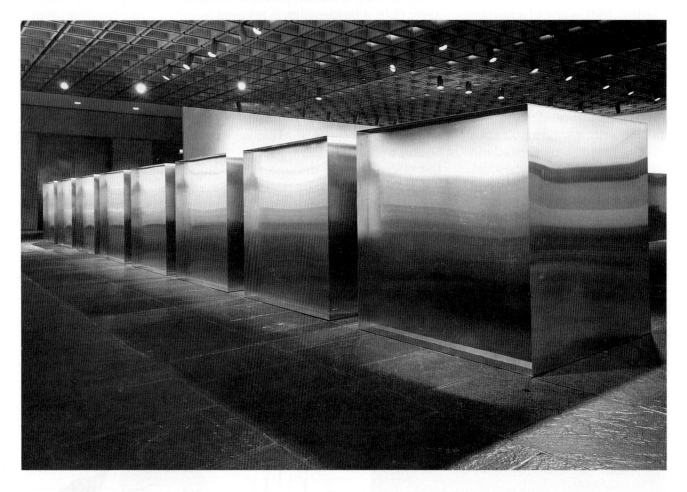

644. DONALD JUDD
Untitled. 1968. Eight stainless-steel
boxes, each 48" square and placed
12" apart. Private collection

A series of eight stainless-steel boxes is set directly on the floor, without the pedestals common to the display of sculpture (fig. 644). Identical in size and finish, they have been fabricated by metalworkers to the artist's specifications, and the placement of each box and its position in the series have been precisely calibrated. Each box displaces an identical amount of space. While it might be said that each box retains an individual and objective integrity, the set of eight boxes becomes an indivisible sculptural unit. The highly finished surfaces, the precise manner in which they are related, and the purity of the geometric compositions deny the autographic quality of the hand of the artist in their creation. Such art disassociates itself from those qualities that we usually ascribe to sculpture. These boxes are, simply, visual facts, and they remind us of our own existence in space and the visual nature of our own being.

Donald Judd is the artist of this series of boxes, which exemplifies a style that developed in the 1960s known as Minimalism.

JUDD, *Untitled:* **1968**
1967: Racial unrest in the United States
1968: Student unrest on university and college campuses

645. AGNES MARTIN
Night Sea. 1963. Oil on canvas with gold leaf, 6 x 6'. Saatchi Collection, London. Agnes Martin's work is fundamental for the development of Minimalism, but she does not refer to herself as a Minimal artist.

The roots of Minimal Art extend back in the twentieth century, to the structural and spatial considerations of Russian Constructivism, the manufactured "readymades" of Duchamp (fig. 587), and the Hard-Edge Abstraction of such artists as Frank Stella (fig. 630). As an alternative to the emphatic personal emotionalism of Abstract Expressionism, Minimalism presented the work of art as an object of elemental form with the least amount of visual components and divorced from either symbolic or personal expression. Judd, who holds aca-

demic degrees in philosophy and art history and was well known as an art critic before the advent of Minimalism, wrote in 1965, "It isn't necessary for a work to have a lot of things to look at, to compare, to analyze one by one, to contemplate. The thing as a whole, its quality as a whole, is what is interesting. The main things are alone and are more intense, clear, and powerful."

In the late 1950s, Agnes Martin began a series of paintings based on simple grid patterns. Although her work was influential for later Minimalists, her po-

sition within Minimal Art is unique. *Night Sea* (fig. 645) is composed of a grid of shimmering gold leaf over a soft, almost atmospheric, veil of shaded blue. Her composition is formally related to the structured approach of Minimalism; however, the interaction of the radiant geometric lines against the subtle changes of the ground color creates a surface and an effect that are atypical of the objective, planar surfaces of most Minimal painting. Agnes Martin's paintings encourage an intuitive, almost meditative, response from the viewer.

EARTH AND LAND ART

646. ROBERT SMITHSON
Spiral Jetty. 1969–70. Black rock, salt crystals, earth, and red water (algae), diameter 160'; coil length 1500'; width 15'. Great Salt Lake, Utah. This photograph shows the jetty soon after it was first completed. Smithson died in 1973 in an airplane crash while working on a later project.

Robert Smithson's *Spiral Jetty* in the Great Salt Lake is an aggressive and dramatic gesture in the natural landscape (fig. 646). The artist used assistants and huge earth-moving equipment to create the work. The top of the jetty functioned as the roadbed as the rock was moved into place in the lake. The jetty was meant to be walked on and to be seen from the shore and the sky. The resulting form, which is both regular and open, transformed the quality and color of the water within the jetty, for the encircled areas of water heated to a higher temperature, changing the amount and color of the local algae. But Smithson's mark on the landscape was not meant to be permanent. He knew it was a temporary structure that would eventually be transformed, if not obliterated, by the forces of nature. Recently it has been hidden by an unexpected rise in the water level of the lake. Although the geometric purity of the spiral form can be related to formalism and Minimalist Art, it also has a historical and iconographic content. Smithson learned that early Mormon settlers believed that the Great Salt Lake was bottomless and connected to the Pacific Ocean by an underground canal and that from time to time Pacific currents would cause huge whirlpools to form on the lake's surface. His choice of design was based on this legend.

Beginning in the 1960s, a number of American artists became interested in producing large-scale works of art in the natural environment. This type of art became known as Earth Art, Land Art, or Environmental Art. Some artists moved large amounts of earth, creating a personal statement and transforming the land in a manner offensive to environmentally minded citizens. Others were determined to reassert and even re-create the natural quality of nature. Some projects took advantage of the natural forces in nature: ice, flowing water, wind, even animals and birds.

SMITHSON, *Spiral Jetty:* **1969–70**
1968: Assassination of Martin Luther King, Jr.
1968: First successful heart transplant operation
1969: Human beings land on the moon
1969: *Sesame Street* program is introduced on P.B.S.
1969: Woodstock music festival

647. CHRISTO
Running Fence, Sonoma and Marin Counties, California. 1976 (now removed). 2,050 steel poles set 62' apart; 65,000 yards of white woven synthetic fabric, height 18'; total length 24 1/2 miles. © Christo and Running Fence Corporation. The planning stages of this work began in 1972. The project was completed in four days and remained standing for fourteen.

All redirected attention to nature, making us see it with new eyes and a new awareness, and raising the issue of the importance of nature in modern, industrialized society.

Christo's *Running Fence* (fig. 647) crossed the hills of California to run into the sea, highlighting by its existence not only the forms of the landscape but also, as it caught the changing effects of light and the shifting winds, the constant movement inherent in nature. Perhaps its best vantage point was from an airplane, for only thus could the enormous scope of the project be encompassed in a single view. Part of the creative act for Christo is not just conceiving and executing the project, but raising the funds (through lecturing and the sale of preparatory drawings and prints), acquiring the legal permissions required, and finding workers who will help with the intensive, large-scale labor of the project, and creating a reasonable timetable so that the project can be completed on schedule. Christo's early works included projects in which objects were stacked (a project to create a great mastaba form by stacking two million oil barrels has not yet been completed) or the wrapping of objects or buildings in fabric that was then bound with ropes, including the wrapping of more than one million square feet of the cliffs of the coast of Australia. In 1971–72 he closed off a valley in Colorado with an orange nylon curtain 365 feet high and 1,368 feet long (documented in a film, *Valley Curtain*), and in 1983 he surrounded eleven small islands in Biscayne Bay off Miami with six million square feet of bright pink polypropylene fabric, exaggerating their natural shapes and turning them into a sequence of enormous pink flowers.

THE NEW REALISM

The interaction between art and life, and our perception of both, take on new meaning with the sculptures of Duane Hanson. The figures seem as real as the actual clothing, camera, and other "props." At exhibitions of Hanson's works, viewers commonly speak to the works of art, having mistaken them for living individuals. Hanson casts these fiberglass-reinforced polyester resin figures from molds made from the models and paints the "skin" with meticulous attention to pores, surface blemishes, and other individualistic details. While the resulting figures share in the visual world of reality, their mute presence and arrested poses create an uncanny gulf between the sculpture and ourselves. Hanson's figures approach, but cannot participate in, life.

Tourists (fig. 648) is an example of Hyper-Realist sculpture, itself part of a broader movement known as New Realism that emerged in the late 1960s and early 1970s. Actually, realism in art had never left the twentieth century; Pop Art, for example, was first greeted with the label "New Realism." To many artists, critics, and connoisseurs, realism seemed outmoded when compared to avant-garde abstract and non-objective art, but, given the visual and psychological dearth left by Minimalism, the public and many art dealers embraced this resurgent realism. The meticulous crafting of a work of art again became an element to be enjoyed, even if, on a more profound level, it forced viewers to confront the banality of modern life.

648. DUANE HANSON
Tourists. 1970. Fiberglass and polyester, polychromed, 64 x 65 x 47". National Gallery of Scotland, Edinburgh. As time passes and clothing styles change, Hanson's figures seem more historic and less naturalistic, but when first created they were meticulous re-creations of individuals whom one might meet on the street. Other figures by Hanson include *Traveler with Sunburn*, *Couple with Shopping Bag*, and *Football Player*.

The call to realism was met by painters, many of whom developed techniques that utilized photographs. In Richard Estes's *Double Self-Portrait* (fig. 649) we seem to be standing on an urban sidewalk, facing the large glass windows and doors of a diner. In these panes of glass a myriad of forms—cars, buildings, and street signs—are reflected. It is as if we can "see" in two directions at the same time. Reflected in the lower right area of the central pane of glass is Estes with his camera on a tripod. To the left

you can see the second, smaller reflection of the artist that explains the work's title. Estes's camera alerts us that the vivid *trompe l'oeil* realism of the painting is in part based on Estes's photographs of the different elements of the scene. In the final composition he combined these images with a sharp-focus painted realism, leaving us to explore the conflict between visual reality, photographic information, and the painted surface.

Audrey Flack, who invests her Photo-Realist paintings with psy-

1970: Vietnam War protests lead to deaths of four youths at Kent State University
1970: Alexander Solzhenitsyn wins Nobel Prize for literature
1971: Vietnam War escalates
1971: Swiss women granted the right to vote

649. RICHARD ESTES
Double Self-Portrait. 1976. Oil on canvas, 24 x 36". Collection, The Museum of Modern Art, New York (Mr. and Mrs. Stuart M. Speiser Fund)

chological and emotional content, begins by arranging a still-life composition that combines objects suggesting both personal and universal meaning. The series of paintings from the mid-1970s that included *Queen* (fig. 650) can be related to traditional *Vanitas* iconography (see fig. 426). The watch and the transient beauty of the flower and fruit stress the passage of time, while more personal objects—makeup, photographs, a key chain, a card, and a chess piece—suggest additional layers of meaning. When she is pleased with her arrangement, Flack photographs it with color-slide film. She then projects slides onto the canvas and paints following the guidelines offered by the projected image. Her use of an airbrush (a small, high-quality paint sprayer) softens the contours of the objects, giving the finished painting a suggestive and even sensual effect. This soft focus combines with the iconography of the objects to appeal to our emotions in a way that is quite different from the sharp focus and detached objectivity of Estes's urban scene. The fact that Flack's huge, dazzling objects leap out toward us by overlapping the gray border gives them a compelling presence. These modern *trompe l'oeil* artists delight and intrigue us, just as their ancient Roman counterparts entertained Philostratus the Younger (see p. 133).

650. AUDREY FLACK
Queen. 1975–76. Oil and acrylic on canvas, 80 x 80". Private collection

ARCHITECTURE SINCE 1970

651. RENZO PIANO AND RICHARD ROGERS
Georges Pompidou National Arts and Cultural Center, Paris. 1971–78. The center incorporates not only museum spaces for permanent and temporary exhibitions, but a public library and an audiovisual center. One critic, Charles Jencks, categorized the Pompidou Center as "Bizarre Architecture."

At first glance the architecture of the Pompidou Center in Paris seems to be completely honest (fig. 651). Not only are the structural elements completely exposed—without and within—but air-circulation ducting, escalators, and other mechanical equipment are brought into public view and even emphasized. Bright colors are used to designate each different mechanical function, so that we are constantly aware of the operating systems needed to keep the building functioning; in such a program, the mechanical systems also function as decoration. Inside, all the walls are movable, and each space can be redesigned as needed. It is not only an adventure in architecture, but a demonstration in understanding the complex workings of the advanced technology of a huge contemporary building. Leaving the mechanicals on the exterior allows for their easy replacement when they wear out or new technology is available. Rogers recently wrote, "I believe in the rich potential of a modern industrial society. Aesthetically one can do what one likes with technology for it is a tool, not an end in itself, but we ignore it at our peril. To our practice its natural functionalism has an intrinsic beauty." Architects have been inspired by the direct bluntness

PIANO and ROGERS, Georges Pompidou National Arts and Cultural Center: 1971–78
1972: Nixon visits China and U.S.S.R.
1973: Picasso dies

of industrial "architecture," such as oil refineries and grain elevators, where function forms the design.

In the recent style known as Post-Modern (see pp. 482–83; a term that equates the earlier abstract glass box of the International Style with modernity), architects have revived historical architectural vocabulary and references in a creative and even playful non-traditional manner. In Charles Moore's Piazza d'Italia (fig. 652), columns and capitals representing numerous orders (see p. 91), arches, including a triumphal arch, and inscriptions from the classical tradition are transformed by the bright and unexpected colors, neon outlining, stainless steel, and varied scale. Some of the "columns" are composed of flowing water, with the streams of water wittily suggesting fluting, and two human masks that spout water into the fountain from a Roman arch are versions of Moore's self-portrait. When viewed from above, the center of the composition is the island of Sicily, the area from which most New Orleans Italians have come. At night, dramatic lighting gives the piazza a dazzling, commercial quality.

652. CHARLES MOORE (in collaboration with U.I.G. and Perez Associates, Inc.)
Piazza d'Italia, New Orleans. 1975–80. The piazza was designed to provide the Italo-American population of New Orleans with a piazza where the annual festival of St. Joseph could be celebrated. The central fountain is in the shape of the map of Italy, with the water from the fountain flowing down courses shaped like the major Italian rivers.

PATTERN AND DECORATION

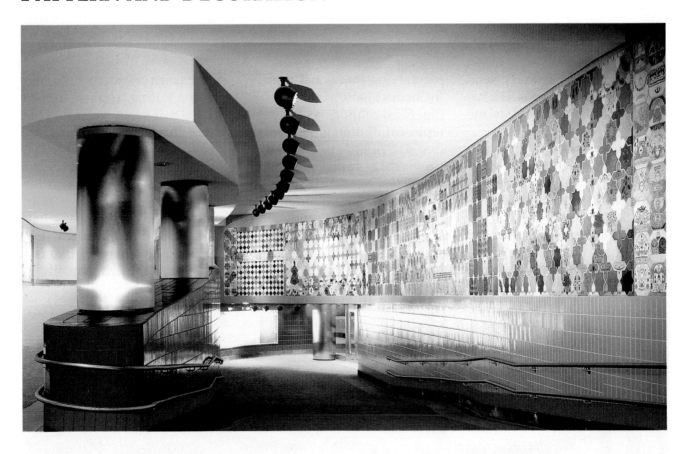

653. JOYCE KOZLOFF
Mural for Harvard Square Subway
Station. *New England Decorative
Arts.* 1984. Painted and glazed tiles,
8 x 83' overall. Public Transport
Station, Cambridge, Massachusetts

Joyce Kozloff's tile mural for the
Harvard Square subway station
is a delightfully encyclopedic and
joyfully colorful composition of
representational images and ab-
stract patterns (fig. 653). The
mural details the cultural, social,
ecological, and economic life of
New England. Its representa-
tional images of homes, facto-
ries, and plants are rendered with
a naïve realism reminiscent of
early American painting, while
the decorative areas remind us of
the patterned patchwork of a
quilt. For the artist, this tile in-

stallation works "on the bound-
ary between high art and craft."
It is intended to provide a pleas-
ing, engaging, and humane en-
vironment within the utilitarian
structure of the subway station.

Kozloff's vibrant mural be-
longs to a style often referred to
as P+D, an abbreviation for Pat-
tern and Decoration. P+D utilizes
repeated non-objective shapes
inherent in decorative motifs,
some of which, as here, have
been derived from traditional
sources. Unlike the severe, imper-
sonal abstraction of Hard-Edge
or Minimal Art (see pp. 554-55;
564-65), P+D revels in bold
colors and less-constrained com-
positions.

For Kozloff, and other artists
in this movement, P+D joined a

Post-Modern concern for content
with artistic traditions drawn
from all over the world. Over the
past centuries, as Western art
academies developed a qualita-
tive hierarchy of themes in paint-
ing, pattern and decorative work
was relegated to an inferior posi-
tion, outside the realm of fine art.
Yet decorative and patterned
compositions, with their implied
planarity, have been at the core
of many artistic traditions, in-
cluding Anglo and Hiberno-
Saxon art, Islamic art, and Native
American art. In addition, P+D
has drawn strength from popular
and domestic art forms, such as
textiles, which historically have
been associated with women.

The rise of P+D in the 1970s
coincided with the impact of

KOZLOFF, Mural, *New England Decorative Arts:* **1984**
1984: Bishop Desmond Tutu of South Africa is awarded the Nobel Peace Prize
1986: Halley's comet returns

feminism on art history, contemporary art, and art criticism. One goal of feminist art and criticism is to recover the significant, yet too often neglected, contributions of women in art. Another goal is to explore the issue of a female aesthetic. The principles of feminism influenced the works of Kozloff and many other artists, including Miriam Schapiro.

Schapiro's multi-media *Heartland* exemplifies what she has termed a "femmage" (fig. 654).

"Femmage," a contraction of "female" and "image," is also related to the French words *femme* (woman) and *hommage* (homage or respect). The iconography of *Heartland* is specifically feminine; Schapiro writes that her femmages "explore and express a part of my life which I had always dismissed—my homemaking, my nesting. . . . The collagists who came before me were men who lived in cities and often roamed the streets at night scav-

enging, collecting material, their junk, from urban spaces. My world, my mother's and grandmother's world, was a different one. My 'junk,' my fabrics allude to a particular universe, which I wish to make real, to represent." *Heartland* complements Schapiro's feminist sensibility in the large scale of the work, its incorporation of fabric, its decorative composition, and the traditional association of the fiber arts with women artists.

NEO-EXPRESSIONISM

655. ANSELM KIEFER
Midgard. 1980–85. Oil and emulsion on canvas, 11' 10" x 19' 9 3/4". The Carnegie Museum of Art, Pittsburgh. The broken palette in the center relates to Kiefer's performance art; in one performance he would drop a clay palette so that it would shatter. As a symbol, this may refer to the Nazi suppression of German artists during the 1930s.

Anselm Kiefer's panoramic painting draws inspiration from Nordic mythology (fig. 655). Its title, *Midgard*, means middle garden, a name traditionally given to the earth by the ancient Norse gods. In Norse mythology, the destruction of the earth comes after three years of winter, when the Midgard serpent and other demons destroy all life in a process that can then lead to regeneration. Using enormous scale, a comfortless composition, and barren colors (the artist employed a blowtorch to achieve a scorched

effect), Kiefer explores and expands one of the initial and invigorating currents of twentieth-century art, Expressionism. *Midgard* is a dramatic painting of a traditional mythological subject which, in Kiefer's reinterpretation, has the power to grip the contemporary imagination.

Countering the impersonal traits of recent abstraction, Neo-Expressionism reinvests an emotional and empathetic content in painting. *Midgard* expresses dread and desolation in the vast scorched earth that stretches before us. It is

as if our worst nightmares of nuclear holocaust have become manifest. Waves froth at the top of the painting and the somber colors of destruction are everywhere. The only sign of life is the snake in the central foreground, which is moving slowly but inexorably toward a labyrinth-like circular area of land that also represents a broken artist's palette. We are overwhelmed by a sense of loss and doom.

Within the pluralistic world of Post-Modernism, Neo-Expressionism arose in the early 1980s

KIEFER, *Midgard:* 1980–85
1986: Nuclear disaster at Chernobyl
1987: Missile treaty between U.S. and U.S.S.R. is signed

656. GEORG BASELITZ
Veronika. 1983. Oil on canvas, 98 1/2" x 78 3/4". Stedelijk Museum, Amsterdam. As a German artist, Baselitz is acutely aware of the artistic heritage of his native country, especially the formative works of the early modern *Die Brücke* artists (see pp. 512–13). The name Veronika is certainly meant as a reference to St. Veronica, who wiped Christ's sweaty brow with her veil; Baselitz's use of religious themes may be related to the work of Emil Nolde.

as a reaction to what some artists perceived to be the emotional aridness of Minimalism and Conceptualism. Neo-Expressionism is an international movement. Nourished in Germany and Italy, it then found adherents in the United States. These artists revived the emotionally laden gestural brushwork and intense colors of Europe's earlier Expressionist painters. Appropriation of imagery, as we have already seen in the work of Sigmar Polke (fig. 548), became a means of defining contemporary conflict on many levels, from personal through global.

The paintings of Georg Baselitz are metaphors for anxiety and separation (fig. 656). The large scale of the paintings, the simple yet harsh abstraction of the figures, the slashing brushstrokes, and the vivid colors continue the psychologically penetrating communication that we have already met in the paintings of Kirchner and the prints of Nolde. But un-like these earlier works, Baselitz's painting purposefully inverts the figures. By composing the characters of his painted dramas upside down, Baselitz increases their separation and isolation from us. For Baselitz, the separatism speaks to the issue of what was, before 1990, the political division of the artist's native Germany. But for us, his paintings are jarring reminders of the disassociation of modern life.

RECENT DEVELOPMENTS

657. NANCY GRAVES
Canoptic Legerdemain. 1990. Stainless steel, aluminum mesh, resin, and paper, 85 x 95 x 37". National Gallery of Art, Washington, D.C. (Gift of Graphic Studio/University of South Florida and the artist, in honor of the fiftieth anniversary of the National Gallery). The title refers to the representation of Egyptian canopic burial jars in the relief and to the artful trickery with which the artist has hidden references to past cultures in a single work.

Canoptic Legerdemain by Nancy Graves (fig. 657) is a complex three-dimensional interweaving of formal and iconographic elements. In many ways, it is an adroit and erudite summation of recent developments in art. Based on the appropriation of art-historical, archaeological, and mytho-logical imagery from the ancient Egyptian, Early Christian, and Byzantine civilizations, some imagery in the work, such as the head of the Empress Theodora (see fig. 175) and the Egyptian hunting scene (see fig. 55), already is familiar to us. The uncoiling snake near the center of the composition has associations with many ancient beliefs, particularly in the biblical account of the temptation of Adam and Eve.

While *Canoptic Legerdemain* is a visual and psychological feast, it is also exemplary of the use of modern technology in art. Laser-cut steel, which was produced from a computer program of Graves's drawings, is joined by a host of materials, from cast and molded resins to more traditional lithographs. Here the mix of painting and sculpture demonstrates the breakdown of barriers between mediums that is typical of Post-Modernism. The composition relates art to technology, dynamic two-dimensional to three-dimensional forces, and unites the past to the present in art. In its expansive vitality, *Canoptic Legerdemain* exemplifies many of the issues which we shall meet in contemporary art.

From the late 1980s into the early 1990s, the tempo of artistic innovation has continued to accelerate while the diversity of forms and purposes of art have, at the same time, widened. To give order to the breadth and complexity of contemporary art, we have chosen a topical approach to discuss works whose primary focus relates to formal considerations, social commentary, and Post-Modernism. We take this didactic approach fully realizing that many recent works of art share qualities among these categories, while still others require different structures of analysis. Our attempt in this con-

1989: Chinese armed forces crush pro-democracy demonstrations in Tiananmen Square
1989: Berlin Wall comes down
1990: Reunification of East and West Germany
1991: War in the Persian Gulf
1991: Yugoslavian ethnic war begins
1992: New Commonwealth replaces Soviet Union
1993: Strategic Arms Reduction Treaty (II) signed

658. SUSANA SOLANO
Què Duda Cabe #3. 1987. Iron, steel, and lead, 32 1/2 x 32 1/2". Collection Mera and Donald Rubell

cluding section is to illuminate, rather than exhaust, the internationalization and multifaceted communication of "art present."

One of the strengths of recent sculpture is its ability to draw our attention to subtle and intuitive relationships of form and space. The work of Susana Solano (fig. 658), while structurally akin to the formalist doctrine of Minimalism, is more about the delineation of space than form. The object she has created out of some of the heaviest and coldest of

659. NOBUO SEKINE
Plaza of Mother Earth. 1989. Basalt
and environmental sound. Navel
Park, Showa-machi, Japan

660. ELIZABETH MURRAY
Cracked Question. 1987. Oil on six
canvases, 13' 5 1/4" x 16' 2" x
1' 11 1/2". Saatchi Collection,
London

661. EDWARD KIENHOLZ AND NANCY REDDIN KIENHOLZ
The Potlatch. 1988. Mixed media, 96 x 96 x 57". Courtesy, Edward Kienholz and Nancy Reddin Kienholz, Louver Gallery, New York

arts and especially those of Zen Buddhist inspiration, such as the garden and the tea ceremony (see pp. 340–41). But unlike traditional Zen gardens, which were exclusive, private places, Nobuo Sekine's spaces are constructed for the public. In this sense, he shares a concern of present-day environmental artists worldwide.

The shaped canvas paintings of Elizabeth Murray, which traverse the boundaries between painting and sculpture, have their roots in the formalism of the 1960s, particularly the shaped canvases of Frank Stella. Unlike the Hard-Edge abstraction of Stella, however, Murray's shaped canvases interact with strong colors to create a dramatic and even an emotional impact. In their complex, vital spatiality and surging, often aggressive forms, they suggest the tensions that are part of everyday life. *Cracked Question* engages us both visually and intellectually (fig. 660). The intense colors and three-dimensional seething of the canvas create a tension that is reinforced by the fragmentation of a common and easily recognized symbol; the question mark itself becomes the source of questions. We are led away from old bonds or ideas to search for new relationships and meaning. Murray has asserted a deeper and more personal content of her work, for when she was asked if her paintings are political, she replied, "I

materials defines a physical space but does not enclose it. It offers the evocative and mysterious qualities so often sensed in an empty space. In this and other works by Solano, the reference to a cage seems intentional, suggesting that the distinctions between confinement and freedom are subtle. Solano once described her perception of space by saying, "Space doesn't exist for me, it is something so ambiguous that I feel the need to delimit it. . . . Space [is also] where we are or what is around me . . . when I am with my daughter in her room I can hear her breathe. These are spaces that are delimited, defined, and, above all, experienced. The void is like closing your eyes, like darkness."

Space, realized on an environmental scale by Nobuo Sekine of Japan, is handled in a way that draws from both traditional Japa-

nese conceptions of landscape gardening and from contemporary concerns for preparing an environment which shares pleasure with the public. In *Plaza of Mother Earth* (fig. 659), monumental basalt sculptures, resembling megalithic formations from Japanese prehistory, are set within a gardenlike space. The juxtaposition of the rough "natural" state of the rock and the regularly designed spiral floor with its meticulously "finished" set-stone base create an aesthetic tension (or vitality) which was often thought to approximate *ki* (*qi*, in Chinese, see p. 34), or the universal life force. The essential features (potential) of the rock itself are emphasized—they are both roughhewn and polished and were left showing the process of being worked and changed. Application of this concept is well known in many Japanese

662. LOTHAR BAUMGARTEN
The Tongue of the Cherokee (detail). 1985–88. Painted, laminated, and sandblasted glass, 100 x 43'. Permanently installed at the Carnegie Museum of Art, Pittsburgh

want my work to reflect my feelings about the society we live in; [they're] political in that sense."

Edward Kienholz and Nancy Reddin Kienholz have created a series of sculptural constructs incorporating painting and found objects whose purpose targets our social consciousness. *The Potlatch* (fig. 661) represents, both through photographs and symbolism, Chief Joseph of the Native American Nez Percé tribe. The figure of Chief Joseph, with its humanly representational body and stag head, stands erect and eminent, recalling ancient personifications of deities. The title *Potlatch* refers to a practice among Northwest Native American tribes. As a display of wealth and status, the chief of one tribe would confer gifts upon the chief of another, antagonistic tribe. While we are struck by the dignity of this ceremonial practice, embodied in the standing figure of Chief Joseph, we are soon consumed by a tragic drama. The hands of the proud chief clasp only cigars, a reference to the economic deprivation of his displaced tribe and to a prejudiced and stereotypical view of Native Americans in earlier advertising. The tableau leads us to contemplate the costs of our history.

Lothar Baumgarten is a contemporary German artist. His site-specific installation celebrates the achievements of a Native American of the early nineteenth century named Sequoyah. Baum-

663. ILYA KABAKOV
We Are Leaving Here Forever. 1991–92. Mixed media. Installation at the Carnegie International Exhibition at the Carnegie Museum of Art, Pittsburgh

garten's installation (fig. 662) is viewed by looking up to a glass ceiling where letter shapes appear on many of the glass panels. These are the eighty-four letters of the Cherokee alphabet as it was invented by Sequoyah, who seems to have been the only person in history to develop his own alphabet; he did not understand English, but he used English letters, without a knowledge of their relationship to sound, as a basis and he added additional letters of his devising. In the nineteenth century, Sequoyah's alphabet was widely used by the Cherokees, and between 1828 and 1834, the *Cherokee Phoenix* was published in two languages—Cherokee and English. The Cherokee language largely died out with the suppression of the Native American population, and Baumgarten's monumental work, which scatters the letters and their accents like random decoration, comments on its demise. This installation informs us both of personal achievements and the consumption of one culture by another.

We Are Leaving Here Forever (fig. 663) is an installation by the Ukranian artist Ilya Kabakov. Entering the darkened rooms with flashlights in hand, we become something of archaeological intruders witnessing the remnants of a former collective human presence. In a two-story structure constructed inside the museum, large rectangular openings in the upper-level corridors look down on a central space. The installation represents an orphanage in the moments just after the children have left, never to return. All that remains are furniture, trash, and pieces of paper, some of which are scattered in corners or posted on the

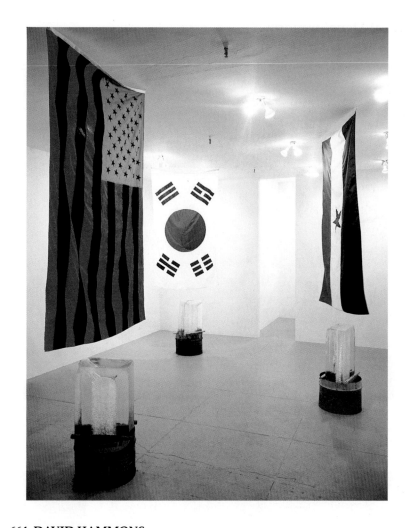

664. DAVID HAMMONS
Who's Ice is Colder? 1990. Flags, oil drums, and ice. Installation at the Jack Tilton Gallery

walls. In the large central space, pieces of trash and scraps of paper with phrases in Ukranian and English are suspended from clotheslines. The words and phrases refer to the anxious voices of the departed occupants or to the faceted network of bureaucratic and personal existence.

Kabakov's installations are haunting and evocative. The suspended bits of paper and trash, all sharing common spaces, recall the Stalinist decrees of forced communalization which denied privacy to self and family. But the installation also speaks to us on a symbolic level of that time between the immediacy of the past and the apprehensive doubts

about the future. Of this anxious time, Kabakov writes, "Nothing remains but a sea of useless papers, in which merciless orders, precise timetables, touching letters and notes are all mixed together. Some recall the past and mourn for it. Almost all are full of terror before the imminent uncertainty that awaits them." On another level, Kabakov's installation reminds us of the insecurity that former Soviets face now that the U.S.S.R. no longer exists.

At first sight, *Who's Ice is Colder?*, an installation by the African-American artist David Hammons, greets us with familiarity (fig. 664). Our initial ease,

665. JENNY HOLZER
Selections from Truisms, Inflammatory Essays, The Living Series, The Survival Series, Under a Rock, Laments, and New Writing. Installation at the Solomon R. Guggenheim Museum, New York, 1989–90. Extended helical tricolor L.E.D. electronic display signboard, 11" x 162' x 4". The Solomon R. Guggenheim Museum, New York (partial gift of the artist, 1989)

666. FAITH RINGGOLD
Tar Beach. 1988. Acrylic on canvas, tie-dyed and pieced fabric, 74 x 69". The Solomon R. Guggenheim Museum, New York

667. LOUISE BOURGEOIS
Cell II (detail). 1991. Mixed media, 83 x 60 x 60". The Carnegie Museum of Art, Pittsburgh

however, quickly gives way to questions whose answers remain evasive. Three national flags are suspended over blocks of ice set on washtubs. The flags of South Korea and Yemen are the actual flags of these nations, but the American flag is rendered in the black, red, and green colors of the black liberation movement. Hammons created this installation during a time of uneasy, recriminating relations among Korean and Arab shopkeepers and the African-American community in Brooklyn. The title of Hammons's work suggests a competition among these groups, yet the melting ice may refer to the insubstantial nature of such strife when we are all facing the broader issues of human interaction.

The installations of Jenny Holzer employ the high-tech media of electronic advertising to present continuous series of short statements that she calls truisms. Prompted by graffiti art in the 1970s, Holzer clandestinely placed posters in public areas near where she lived in New York City; each poster contained a philosophical or popular maxim. Clichés such as "Absolute Submission Can Be a Form of Freedom," "Money Creates Taste," and "Dying for Love is Beautiful but Stupid" seemed to offer a trenchant commentary on contemporary social issues. Gradually Holzer developed a conceptual art utilizing computer-controlled light-emitting diode (L.E.D.) machines (fig. 665). Here, the media of popular advertising is turned upon itself, revealing how we are manipu-lated by language, especially the media world's use of it. Holzer gets inside the system, using light bars and short, snappy, visual "sound bites," to critique it and to deconstruct or reveal the mode of manipulation.

"I will always remember when the stars fell down around me and lifted me up above the George Washington Bridge. . . . Sleeping on Tar Beach was magical. Laying on the roof in the night with stars and skyscraper buildings all around me made me feel rich, like I owned all that I could see." These words form part of the narrative text that enframes Faith Ringgold's multimedia work *Tar Beach* (fig. 666). Tar Beach is the colloquial name given to a rooftop in the inner city at night. Ringgold's work shares with us the realities and dreams of the African-American experience in Harlem. Rich in the complexity of its visual, thematic, and psychological association, *Tar Beach* is composed of acrylic paint on canvas, with tie-dyed and pieced fabric attached to the surface. The quilt reminiscences recall the work of feminist artists in P+D painting, while the abrupt but purposeful transitions of perspective communicate the naïveté of children as they stare at buildings and stars from the roof. Ringgold's work visually is simple and direct, yet its human message is multilayered.

Unlike the contemporary artists discussed previously, Louise Bourgeois belongs to a generation of earlier modern artists. An accomplished painter and sculptor who was thoroughly schooled in Surrealism, she first achieved prominence in the 1940s and 1950s. For the Carnegie International in 1991–92, Bourgeois created a series of six *Cells*; each *Cell*, or unit, was enclosed by a grouping of old, hinged doors of various sizes. Inside the *Cells*, combinations of found objects and precisely sculpted forms created an almost surrealistic atmosphere. Viewers were not permitted to enter the *Cells*. Our vision of the interiors was confined, in a way, to peering through windows and narrow openings between the doors.

In *Cell II* (fig. 667), old perfume bottles and a white marble sculpture of hands, with fingers tightly intertwined, were arranged on a circular glass mirror. Bourgeois has revealed that for her the clenched hands symbolize the indestructibility of pain, while the perfume bottles represent the fleeting scents of pleasure. This juxtaposition of opposite, intense sensations gives, in Bourgeois's words, "meaning and shape to frustration and suffering." By making us voyeurs, Bourgeois not only reveals this private drama of pain, but also our inability to mediate or help. Finally, the *Cells* remind us of our ultimate isolation from one another. Drawn from personal experiences and remembrances, Bourgeois's *Cells* communicate the inescapable fact of human pain: "What happens to my body has to be given a formal abstract shape. So you might say, pain is the ransom of formalism."

Human and animal suffering

668. SUE COE
Wall Street Makes a Killing. 1988. Watercolor and graphite on paper, 40 x 30". Copyright © Sue Coe. Courtesy Galerie St. Etienne, New York

669. CINDY SHERMAN
Untitled. 1990. Color photograph, 4' x 3' 2". Courtesy Metro Pictures, New York

and death are the themes of Sue Coe's *Wall Street Makes a Killing* (fig. 668). The title refers both to the early history of Wall Street as a stock market and the phrase "making a killing" in reference to making a great deal of money. In the painting the gruesome remains of animals that flood Wall Street with their blood are unobserved by the businessmen, who are absorbed in the financial news. *Wall Street Makes a Killing* was part of an exhibition titled "Porkopolis—Animals and Industry" that documented, with overtones of Surrealism and art-historical references, abuses in the treatment of animals by the meat industry. For Coe, these abuses extend to us, for in our complacency, we also are victims. The works of Sue Coe continue the purposeful tradition of indefatigable social protest in art.

As we have stated earlier, many contemporary works of art belie a singular classification. Coe's "Porkopolis" works, with their unyielding indignation, relate, on a formal level, to the appropriation of art and cultural history, which is one feature of Post-Modernism. Cindy Sherman's untitled color photograph (fig. 669) is direct in its visual appropriation of a Baroque painting by Caravaggio. With makeup and props, Sherman has re-created and then photographed herself as Caravaggio's *Bacchus.* This contemporary photographic utilization of images from art history poses many questions concerning the multiple levels of artifice in our society and the different personae we may assume to meet this arti-

fice. Sherman's photographs lead us from simple visual statements to complex psychological and sociological issues.

Contemporary architecture is as "wide open" and experimental as other art forms of the 1990s. Aldo Rossi's design for the projected South Bronx Academy of Art continues the inventive vocabulary of Post-Modernism (fig. 670). The basic design, with its ordered regularity of solids and voids, is classical in its architectonic stability. The applied decoration on the central structure, the playful cone in front, the brilliant colors and the quotation of, or appropriation of, elements from architectural history create the pluralistic juxtapositions of style which are part of the delight and definition of Post-Modern architecture.

Peter Eisenman's design for the Alteka Office Building in Tokyo introduces us to a new architectural aesthetic, Deconstructivism (fig. 671). Paralleling Deconstructivist theory and criticism, Eisenman's design challenges the rationalist approach to modern architecture, even though it uses such modern elements as the curtain wall grid and glass construction. The Alteka Office Building design, with its apparent visual instability, is based on an L shape which has been manipulated through a variety of designs. The effect of the design is disquieting and seemingly irrational, yet the dynamism imparted by the emphatic diagonal facets creates a vigorous perception of growth; in the architect's words, the concept of the design "is related to the perpetual state of becoming."

670. ALDO ROSSI
Project for the South Bronx Academy of Art. 1991

671. PETER EISENMAN and EISENMAN ARCHITECTS
Project for the Alteka Office Building, Tokyo. 1991

GLOSSARY

Definitions in the glossary are intentionally short; for further information and illustrations consult the references listed. Words in capital letters within an entry are defined in the glossary. An abbreviation used here is e.g., meaning for example.

ABACUS: on a DORIC capital, the flat slab between the rounded ECHINUS and the ENTABLATURE; see fig. 84 and p. 91.

ACID BATH: a shallow tray of acid used in the ETCHING technique; see pp. 374–75.

ACRYLIC PAINT: a fast-drying synthetic paint MEDIUM developed about 1960; see fig. 541.

AERIAL PERSPECTIVE: see ATMOSPHERIC PERSPECTIVE.

AIRBRUSH: a device for spraying paint or other liquid media. The medium is mixed with compressed air and sprayed through a nozzle; see fig. 650.

AISLES: corridors flanking a large central area; Old St. Peter's Basilica has two aisles on either side of its central NAVE (figs. 160–61). Also known as side aisles.

ALTARPIECE: a painted and/or sculpted work of art that stands as a religious image upon and at the back of an altar; see the Van Eycks' *Altarpiece of the Lamb* (figs. 277–78).

AMBULATORY: a circular or semicircular vaulted passage, as at Chartres (fig. 230).

AMPHITHEATER: a circular or oval building with tiered seats for sports and entertainment, developed by the ancient Romans; e.g., the Colosseum or Flavian Amphitheater (figs. 135–37).

AMPHORA: an ancient Greek vase used to store olive oil, honey, or wine; see fig. 79.

ANICONIC: the representation of a deity by symbols rather than by figural form, as at Sanchi (fig. 109).

ANNULAR VAULT: a structural system composed of a series of vaults arranged in a curving or circular configuration; for examples see the ancient Roman Colosseum (figs. 135–37) and the AMBULATORY at Chartres (fig. 230).

APSE: in architecture, an area composed of a half cylinder or semipolygonal form surmounted by a half dome or vaulting, as at Old St. Peter's (fig. 161) and Chartres (fig. 230).

AQUEDUCT: a structure used to transport water in ancient Roman times; e.g., the Pont du Gard (fig. 141).

ARCADE: a series of ARCHES with their supporting COLUMNS or PIERS, as in the nave arcades at Chartres (fig. 228) and Santo Spirito (fig. 285).

ARCH: a means of construction in which an opening, usually semicircular, is spanned by a series of wedge-shaped elements (VOUSSOIRS and a KEYSTONE); see fig. 140 and p. 136.

ARCHITECTURE: a structure, usually functional, that encloses and defines space.

ARCHITRAVE: in architecture, the lowest part of an ENTABLATURE; see fig. 84 and p. 91.

ARCHIVOLTS: the moldings that enframe the TYMPANUM in a Romanesque or Gothic church; often decorated with sculptures, as at Vézelay (fig. 213).

ART: traditionally, defined as an object made by a person or persons that communicated a message, concept, or belief. Today art includes so many different kinds of products (including ephemeral performances, for example) that an all-encompassing definition is no longer possible.

ART THEORY: the discussion and establishment of philosophical ideals concerning the goals of art.

ASSEMBLAGE: a work of art which combines actual three-dimensional objects, some of which may be "found" objects from the household or the junkyard; see fig. 628.

ATMOSPHERIC PERSPECTIVE: a device, used in painting to suggest PERSPECTIVE, in which forms nearer the horizon are blurred and their color is less intense and higher in VALUE, while the sky gradually shades from blue toward white above the horizon, as in Perugino's *Christ Giving the Keys* (figs. 4, 274). Also known as aerial perspective.

ATRIUM: an open courtyard, sometimes surrounded by a COLONNADE, found at the entrance to a Roman house (figs. 114–15) or a Christian church (fig. 161).

AVANT-GARDE: a French term meaning advanced guard, which, in the nineteenth century, was applied to artists or movements considered to be new, radical, and often revolutionary. For example, the ideas and work of Gustave Courbet were regarded as avant-garde within the context of mid-nineteenth-century French painting; see pp. 430–31.

AVATAR: the descent of a deity into our time and space; an incarnation of a Hindu god; see the *Descent of the Ganges* (fig. 151).

AXIAL COMPOSITION or ORGANIZATION: a compositional pattern with a central AXIS and bilateral symmetry, giving an impression of balance; see Botticelli's *Birth of Venus* (fig. 306).

AXIS: the imaginary straight line that passes through the center of figures or forms, or through an architectural composition. An analysis of the axes of a work helps establish its COMPOSITION.

AXONOMETRIC PROJECTION: a geometrical drawing that depicts a building in three dimensions; see the ancient Roman sanctuary at Praeneste (fig. 114).

BALDACCHINO: a canopy over an altar or throne; e.g., Bernini's at St. Peter's (fig. 403).

BALLOON FRAME: an architectural structure in which wooden beams are joined horizontally and vertically to create a gridlike structural system; e.g., Davis's wooden house (fig. 483).

BARREL VAULT: a deep arch that normally requires continuous BUTTRESSING; see fig. 140 and pp. 136–39. Also known as a tunnel vault.

BASILICA: to the ancient Romans, a large building used for public administration, as in the Basilica Ulpia in Rome (fig. 147). In Christian times, a specific type of structure, with a central NAVE, CLERESTORY, flanking AISLES, and APSE, as at Old St. Peter's (figs. 160–61).

BAS-RELIEF: relief sculpture in which flattened figures or forms project only very slightly from the background; e.g., the *Palette of Narmer* (figs. 38–39). Also known as low relief.

BATTERED WALL: a wall that slopes or slants inward, as in ancient Egyptian MASTABAS (fig. 46) and PYLONS (fig. 50).

BAYS: individual units of space defined by the PIERS and VAULTS in a vaulted structural system; the plan of the Gothic cathedral of Chartres (fig. 230), for example, reveals that the NAVE is seven bays long. Bays also refer to the vertical divisions of the exterior or interior surfaces of a building, as marked by such elements as windows, BUTTRESSES, COLUMNS, etc.

BOOK OF HOURS: a book of private devotions with prayers for the seven canonical hours of the Roman Catholic church. Sometimes contains a calendar and is illustrated with illuminations

(figs. 263–64).

BUON FRESCO: see FRESCO.

BURIN: a tool with a sharp metal point used in the decoration of Greek vases (fig. 78) and in making ETCHINGS (see pp. 374–75).

BURR: the tiny raised masses of copper on either side of the groove created in the DRYPOINT technique; the burr catches the ink and creates rich areas of deep, soft shadow; see pp. 374–75.

BUTTRESS, BUTTRESSING: the projecting support that counteracts the outward thrust of an ARCH or wall; see figs. 140, 232, and pp. 228–29.

CALLIGRAPHY: fine penmanship or beautiful writing (figs. 179, 227).

CALYX KRATER: an ancient Greek bowl with handles used for mixing wine with water; see fig. 79.

CAMERA OBSCURA: an enclosed box with an opening that allows an image to be projected inside the box; sometimes used by artists, including Vermeer (fig. 399), as a tool for understanding PERSPECTIVE recession.

CANTILEVER: a support system in which an architectural member projects horizontally into space, beyond its supports, as in Wright's Fallingwater (fig. 10).

CAPITAL: the decorated top of a COLUMN, PIER, or PILASTER; often helps effect an aesthetic transition from the vertical COLUMN to the horizontal ENTABLATURE; for examples from the Greek and Roman ORDERS, see fig. 84.

CARITYA: a sacred Buddhist site, complete with a shrine, MONASTERY, lecture hall, and other structures, as at Nara (figs. 180–82).

CARPET PAGE: a manuscript page with complex, abstract, decorative patterns, usually Hiberno-Saxon, as in the page from the *Lindisfarne Gospels* (fig. 178).

CARTOON: a full-size drawing for a painting, as in Leonardo's cartoon of the *Virgin and Child* (fig. 308).

CARVING: in sculpture, a subtractive process in which form is created by cutting into a medium, usually stone or wood, thereby releasing, or subtracting, excess parts of the medium (see fig. 325). The term also may refer to works of art fashioned by this technique. See also MODELING.

CARYATIDS: supports in POST-AND-LINTEL construction that are carved to represent female figures; their rarer male counterparts are sometimes also called caryatids, but more correctly are known as atlantes or telemones.

CASEIN: a technique of painting in which PIGMENTS are mixed with a milk protein; see fig. 529.

CAST SHADOWS: the shadows cast by an object onto surrounding surfaces and objects. In a painting, these shadows help increase the ILLUSIONISM, as in the ancient Roman still life (fig. 133).

CASTING: a method of producing a copy of a three-dimensional object by pouring a hardening material into a mold; see fig. 90 and p. 95.

CATACOMB: an underground complex of tunnels and rooms, used in ancient Roman times by Romans, Jews, and Christians for burial purposes; for a painting from a catacomb, see fig. 157.

CATHEDRAL: in western Christianity, a church which marks the residence of a bishop; for example, Chartres (figs. 228–31).

CENTERING: the temporary wooden support upon which an ARCH or VAULT is constructed; see fig. 140 and p. 136.

CENTRALLY PLANNED: denotes an architectural design in which regularized units radiate, usually at 90° angles, from a central area, often surmounted by a dome, as in the original High Renaissance design for St. Peter's in Rome (fig. 338).

CHAITYA HALL: an Indian Buddhist architectural form with a pillared, central nave, two side aisles, an ambulatory, and a high barrel vault; many are carved out of living rock with a STUPA in the apse; see the Great Stupa at Sanchi, pp. 110–13, and the Kailasantha Temple (fig. 192).

CHA NO YA: the Japanese tea ceremony; see the art of Zen, pp. 340–41.

CHIAROSCURO: in painting and printmaking, the use of a contrast of VALUES to create effects of MODELING; see the Roman still life (figs. 133, 359).

CHOIR: in a Christian church, an enclosed area near the altar where the monks or nuns chant the services, as at Chartres (fig. 230).

CHUMON: the entrance gate to a Japanese Buddhist temple area, as at Horyuji (figs. 180, 182).

CLERESTORY: in architecture, an area elevated above adjacent rooftops, usually along a central AXIS. Its purpose is to allow light into the interior, and it has windows on the sides, as in the Egyptian HYPOSTYLE hall (fig. 49), Old St. Peter's (fig. 160), Chartres (figs. 228–29), Santo Spirito (fig. 285), and elsewhere.

CLOISTER: an open court within a monastery, usually with an open ARCADE or COLONNADE; see figs. 201–2.

CLUSTER PIER: in the Gothic structural system (fig. 232), a pier with groups of COLONNETTES, as at Chartres (fig. 229). Also known as a compound pier.

COFFERING, COFFERS: in architecture, recessed geometrical panels—often square—that decorate the interior surface of a VAULT; see the coffers of the DOME of the ancient Roman Pantheon (fig. 142) and elsewhere (fig. 407).

COLLAGE: a composition in which pieces of materials such as newspaper, cloth, or colored paper are glued to a canvas, paper, or other surface, as in Picasso's *Still Life with Chair Caning* (fig. 567).

COLLOCATION: the idea that an artist created a specific work for a specific location and that it is adjusted for that location and the spectator's viewpoint, as in Caravaggio's *Conversion of St. Paul* (fig. 394), Rembrandt's *Militia Company of Captain Cocq* (fig. 406), and Bartlett's *Sea Wall* (fig. 1).

COLONNADE: a continuous row of columns supporting an ENTABLATURE or ARCHES; see the Parthenon (figs. 93, 95).

COLONNETTE: a slender, columnar decorative motif, common in Gothic architecture, as at Chartres (fig. 229), where groups of colonnettes create COMPOUND PIERS that support the NAVE ARCADE.

COLOR PALETTE: the selection of colors used by an artist; for an example of a restricted color palette, see Mondrian's *Diamond Painting* (fig. 5).

COLOSSAL ORDER: see GIANT ORDER.

COLUMN: a freestanding cylindrical support, often FLUTED and with a CAPITAL, used in POST-AND-LINTEL construction, as at the Parthenon (fig. 95).

COMPLEMENTARY COLORS: colors found opposite each other on the color wheel (see fig. 6) which form a neutral gray when mixed but create a vibrant contrast when placed side by side. The complementary color of each of the primary colors (red, yellow, and blue) is obtained by mixing the remaining two primaries; the complementary of red is green (yellow and blue); the complementary of yellow is violet (red and blue); and the complementary of blue is orange (red and yellow).

COMPOSITION: the arrangement or organization of the various elements of a work of art; e.g., the balanced symmetry of Perugino's *Christ Giving the Keys to St. Peter* (fig. 4).

COMPOUND PIER: see CLUSTER PIER.

CONCRETE: as developed by the ancient Romans, fast-drying hardening volcanic sand used in architectural construction; see pp. 136–39.

CONTRAPPOSTO: a term describing the position assumed by the human body when the weight is borne on one leg while the other is relaxed; e.g., the *Doryphorus* (fig. 91). Contrapposto creates a figure that seems to be relaxed and yet suggests the potential for movement.

CORBEL: an architectural member created as each successive vertical layer of building material, e.g., stone, brick, or wood, projects from the previous layer. It often supports a cornice; see pp. 136–39.

CORINTHIAN ORDER: one of the ancient Greek architectural ORDERS; see fig. 84 and p. 91.

CORNICE: a projecting MOLDING surmounting and emphasizing a WALL or ARCH. Note the prominent interior cornices of the Pantheon (fig. 142) and the heavy cornice capping the Medici Palace (fig. 289).

CROSS-HATCHING: in drawings and PRINTS, superimposed layers of parallel lines (HATCHING) at an angle to one another, used to create shadows and MODELING, as in fig. 334.

CROSS SECTION: an architectural diagram that shows how a building would look from the inside if it were cut by a vertical plane from side to side; for a cross section of the Parthenon, see fig. 96. See also LONGITUDINAL SECTION.

CROSS VAULT: a structural system formed by two TUNNEL VAULTS intersecting at right angles; see fig. 140 and pp. 136–39.

CROSSING: in a Christian church, the area where the NAVE intersects the TRANSEPTS; for diagrams see figs. 161, 230.

CRUCIFORM BASILICA: a BASILICA with TRANSEPTS, forming a Latin cross plan, as at Old St. Peter's (fig. 161).

CUN: in Chinese painting, small brushstrokes dabbed on quickly to create the sense of a particular texture, as in Li Cheng's painting (fig. 190).

DAGUERREOTYPE: the earliest practical photographic process; see pp. 442–43.

DEVARAJA: cult of the god-king in the Khmer kingdoms in Cambodia; an amalgam of a state cult and religion. See Angkor Wat, pp. 216–17.

DIMINUTION: a device used in drawing and painting to help suggest PERSPECTIVE. Forms are represented as progressively smaller to suggest their distance from the viewer; see Perugino's *Christ Giving the Keys to St. Peter* (fig. 4).

DOME: an architectural structural system that can be understood as an ARCH rotated 180° around a central axis; see fig. 140 and p. 137.

DORIC ORDER: the most vigorous and austere of the ancient Greek architectural ORDERS; see fig. 84 and p. 91.

DRESSED STONE: blocks of stone used for construction, each of which is carefully cut and trimmed for its specific place and purpose, as at the ancient Roman Pont du Gard (fig. 141).

DRUM: a cylindrical or polygonal wall set atop a building and used to support a DOME; see fig. 287.

DRUMS: the individual cylindrical units that are combined to create the SHAFT of a COLUMN; due to the ravages of time, the drums of the columns of the Parthenon are clearly visible today (fig. 95).

DRYPOINT: an intaglio printmaking process; see fig. 419 and pp. 374–75.

ECHINUS: on a DORIC CAPITAL, the rounded, cushion-shaped MOLDING below the ABACUS; see fig. 84 and p. 91.

EDITION: a group of prints made from a single PRINT FORM in one of the printmaking processes; see figs. 336, 419, 480. In current practice, artists sign and number each print in an edition.

ELEVATION: an architectural diagram that shows the exterior or interior surfaces of a building and their decoration diagramatically, without the recession and distortion that would result from a single viewpoint; see figs. 340–41. Elevation can also refer to one exterior side of a building.

EMULSION TECHNIQUE: a painting technique using a liquid mixture in which one of the elements is suspended as minute droplets, as in fig. 631.

ENCAUSTIC: a technique of painting using PIGMENTS dissolved in hot wax; see fig. 169.

ENGAGED COLUMN: see HALF COLUMN.

ENGRAVING: an intaglio printmaking process; see fig. 336 and pp. 308–9.

ENTABLATURE: the upper part of an architectural ORDER, usually includes ARCHITRAVE, FRIEZE, and CORNICE; see fig. 84.

ENTASIS: the bulging of a DORIC column about one-third of the way up from the base, creating an effect of muscular elasticity; for a subtle example of entasis see the columns of the Parthenon (fig. 95).

ETCHING: an intaglio printmaking process; see fig. 419 and pp. 374–75.

ETCHING GROUND: the acid-resistant, resinous mixture used to coat the PRINT FORM (a metal plate) in the ETCHING process; see pp. 374–75.

ETCHING NEEDLE: the sharp steel instrument used in the ETCHING technique; see pp. 374–75.

EXPRESSIVE CONTENT: the emotions and feelings communicated by a work of art.

FACADE: the front or principal face of a building, as in Palladio's San Giorgio Maggiore (fig. 373).

FAIENCE: colorfully glazed earthenware or pottery, whether in the form of sculpture, decorative tiles, or functional vessels; see the Minoan *Snake Goddess* (fig. 60).

FERROCONCRETE: see REINFORCED CONCRETE.

FIGURE-GROUND RELATIONSHIP: the contrast between form (or positive elements) and background (or negative ground) in a work of art; see Piero's *Duke of Urbino* (fig. 257).

FLUTES, FLUTING: shallow vertical grooves on the SHAFT of a COLUMN that accentuate the column's cylindrical quality; see fig. 84.

FLYING BUTTRESS: a structural element in the form of an open half arch that counteracts the outward thrust of an arch or vault; see fig. 232.

FORESHORTENING: the technique used in a painting or RELIEF SCULPTURE to suggest that figures, parts of the body, or other forms are shown in sharp recession, as in Mantegna's *Foreshortened Christ* (fig. 300).

FORMAL ANALYSIS: a visual examination and analysis of a work of art that studies how the integral parts of a work of art are united to produce its historical and/or individual style. Introductory formal analyses of works of art are offered for figs. 1, 3–5, 7–13.

FORUM: the official center of an ancient Roman town, with temple, marketplace, and governmental buildings; see the forum in Rome (fig. 122).

FREESTANDING: see SCULPTURE IN THE ROUND.

FRESCO: a technique of painting directly on a plaster wall or ceiling, usu-

ally when the plaster is still wet, as in Giotto's Arena Chapel (fig. 247) and Michelangelo's Sistine Chapel ceiling (fig. 344); see figs. 134, 249. Also known as buon fresco. See also FRESCO SECCO.

FRESCO SECCO: a technique of FRESCO painting in which the paint is applied to dry plaster.

FRIEZE: the middle section of the horizontal ENTABLATURE in the ancient Greek and Roman ORDERS; see fig. 84 and p. 91.

FUNCTION: the purpose for which a work of art was created; e.g., the function of the Egyptian sculpture of *Menkure and His Queen* (fig. 2) was to provide a home for the souls of the pharaoh and his queen throughout eternity.

GABLE ROOF: the most common type of roof, formed by two planes which slope downward from a central beam, as on the Parthenon (fig. 93). Also known as a pitched roof.

GENRE PAINTING or SCULPTURE: a representation of everyday life, as in Leyster's *Gay Cavaliers* (fig. 397).

GIANT ORDER: PILASTERS or COLUMNS that span more than one story of a structure; e.g., the pilasters on the exterior and interior of Michelangelo's design for New St. Peter's in Rome (figs. 340–41). Also known as colossal order.

GILDING: the covering of a work of art or part of a work of art with gold leaf or some other gold-colored substance; the background of Giotto's *Madonna* is gilded (fig. 243).

GIORNATA: from the Italian word meaning day. Giornata lines are produced when areas of plaster *(intonaco)* overlap one another in a FRESCO. In the true fresco technique, these areas of *intonaco* would be painted in one day, before the plaster dried, hence the term giornata; see figs. 134 and 269.

GLAZES: in the art of oil painting, thin layers of superimposed translucent varnish, often with a small amount of pigment added, to modify color and to build up a rich, sonorous color effect; used by Jan van Eyck (figs. 283–84), Titian (figs. 355–57), and others. In pottery, the glaze is a thin layer of a colored material that fuses with the surface when heated; the glaze provides the hard and colorful surface of a pottery vessel.

GOLDEN RECTANGLE: see GOLDEN SECTION.

GOLDEN SECTION: the proportional relationship of approximately 5:8, used by the ancient Greeks as the key to visual harmony; see fig. 92 and p. 97.

GOUACHE: opaque WATERCOLOR paint.

GREEK CROSS PLAN: a central plan with four arms of equal dimension placed at 90° angles, usually surrounding a DOME, as in Bramante's and Michelangelo's design for New St. Peter's (figs. 338–39).

GRISAILLE: the monochromatic painting of objects, often to simulate stone sculpture; see fig. 278.

GROIN VAULT: see CROSS VAULT.

GROUND PLAN: an architectural diagram that shows how a building would look from above if it were truncated by a horizontal plane approximately one meter above floor level; see figs. 230, 408.

GUILDS: legal organizations of merchants, craftspeople, and artists, rather like trade unions, that flourished in the later Middle Ages and the Renaissance. Guilds established standards for training and production and commissioned works of art; see the niches at Orsanmichele in Florence (figs. 261–62).

HALF COLUMN: a half-round decorative column attached to a supporting wall. Also known as an engaged column.

HALF-HIPPED ROOF: a type of roof construction in which the ends are vertical and partly HIPPED, or they are hipped using two different angles, as at Nara (fig. 180).

HALO: a radiance of light, visually represented as a golden circle or disc, surrounding the head of a holy figure, as in the Byzantine mosaic at Mount Sinai (fig. 167).

HAPPENING: a quasi-theatrical event, common in the 1950s and 1960s, in which artists, usually without a preconceived script, performed and encouraged the spontaneous participation of the audience; see fig. 542.

HATCHING: in drawings and prints, closely spaced series of parallel lines that create effects of MODELING, as in fig. 334. See also CROSS-HATCHING.

HIERARCHICAL SCALE: the representation of figures who are more important politically (or socially) as larger than less important figures, as in the Egyptian *Hunting Scene* (fig. 55).

HIGH RELIEF: RELIEF SCULPTURE in which the forms project substantially from the background; e.g., the altar of Zeus at Pergamon (fig. 107).

HIGH VALUE: a relatively light color, as in the high value of the yellow trousers in Goya's *Execution of Madrilenos on the Third of May* (fig. 471).

HIGHLIGHTS: in painting, areas of HIGH VALUE color which suggest light hitting the form to create MODELING; see the highlights on the metal pitcher in the Roman still life (fig. 133).

HIPPED ROOF: a type of roof construction in which the ends are sloped instead of being vertical.

HISTORICAL CONTEXT: the ideas, beliefs, or attitudes current in the period when a work of art was created. Historical context also encompasses how the work of art was perceived by its audience.

HISTORICAL SIGNIFICANCE: an understanding of how a work of art reveals the ideas, beliefs, or attitudes current in the period when that work of art was created.

HISTORICAL STYLE: a clearly recognizable artistic tradition (see FORMAL ANALYSIS) characteristic of a particular historical or artistic period.

HUE: the property of a color that distinguishes it from others; also the name of a color; see fig. 6.

HYPOSTYLE: a type of architectural construction in which the interior space is crowded with continuous rows of COLUMNS or posts, as in the Egyptian hypostyle hall (fig. 49) and the Mosque at Córdoba (fig. 194).

ICON: a special term used in Orthodox Christianity to refer to a painting of a religious subject, as in fig. 169.

ICONOGRAPHY: the art-historical study of the subject matter of a work of art, including the investigation of the symbolism and the meaning of the subject in the culture which produced it.

ICONOLOGY: the investigation of how the iconography of a work is related to the HISTORICAL CONTEXT.

IDEALIZATION, IDEALIZED: the improvement and abstraction of forms to conform to contemporary cultural standards of perfection and beauty; e.g., *Menkure and His Queen* (fig. 2).

ILLUMINATED MANUSCRIPT: a handwritten book with painted decoration, common in medieval and Renaissance Europe; see figs. 168, 178, 179, 197–99, 208, 227, 263, 264.

ILLUSIONISM, ILLUSIONISTIC: when the objects represented in a work of art (usually a painting) seem to be tangible and weighty, existing within actual space; e.g., Perugino's *Christ Giving the Keys* (fig. 4); see pp. 130–33.

IMPASTO: raised brushstrokes of thick paint, usually oil, as in Titian's *Rape of Europa* (fig. 360).

INCISED RELIEF: see SUNKEN RELIEF.

INDIVIDUAL STYLE: the particular formal qualities (see FORMAL ANALYSIS) used by an individual artist; e.g., the bold colors, thick paint, and heavy brushstrokes characteristic of the works of Van Gogh (figs. 464, 523, 524).

INFILLING: see WEB.

INSTALLATION: a work of art that consists of an ensemble of objects, often three-dimensional, that are especially arranged by the artist for a particular location or site (see fig. 1).

INTAGLIO PROCESS: a printmaking process in which the lines to be printed are incised into the surface of the PRINT FORM, such as in the engraving, etching, and drypoint processes; see figs. 336, 419.

INTENSITY: the level of richness or saturation of a color; note the very intense red used in Van Gogh's *Night Cafe* (fig. 523).

IONIC ORDER: one of the ancient Greek architectural ORDERS; see fig. 84 and p. 91.

ISOCEPHALY: a COMPOSITION, usually relatively unnaturalistic, in which the heads of the figures form a horizontal line; see the mosaic of *Theodora and Attendants* at Ravenna (fig. 175).

ISOMETRIC PROJECTION: an architectural diagram that includes both a ground plan and a view of the exterior and/or interior from a specific point of view below or above the structure; for an isometric projection of a temple at Karnak, see fig. 53.

JAMBS: the areas flanking an ARCH, doorway, or window; in Romanesque and Gothic churches, the jambs are often decorated with sculpted figures, as at Amiens (fig. 238).

KACHIN-TIHU: a small wooden figure or doll (also known as a kachina doll) made by members of the Hopi tribe (fig. 557).

KAMI: in the Shinto religion, Japanese nature spirits thought to endow all things; see the Shinto Shrine at Ise, pp. 164–65.

KEYSTONE: the central VOUSSOIR of an arch, rib, or vault; see fig. 140.

KONDO: the main hall at a Japanese Buddhist temple-MONASTERY complex, as at Horyu-ji (figs. 180–82).

KUFIC: a style of Arabic calligraphy, sometimes used as virtually pure ornament.

KYLIX: an ancient Greek drinking cup; see fig. 79.

LAY ARTIST: during periods when much artistic production was controlled by monks and nuns, a lay artist was one who lived and worked in the city, outside of the MONASTERY, and was often a member of a GUILD.

LEKYTHOS: an ancient Greek container to hold olive oil; see fig. 79.

LINEAR: the technique in painting, drawing, or printmaking of creating sharply defined forms or precisely delineated contours, as in Leonardo da Vinci's *Vitruvian Man* (fig. 309).

LINGAM: a phallic symbol in the Hindu religion associated with the God Siva; see the Kailasantha Temple, Ellora, India (fig. 192).

LINTEL: the horizontal beam spanning an opening, as in the POST-AND-LINTEL SYSTEM (fig. 51).

LITHOGRAPHY: a printmaking process; see fig. 480 and p. 425.

LONGITUDINAL SECTION: an architectural diagram that shows how a building would look from the inside if it were sliced by a vertical plane from front to back; see the Pantheon (fig. 143) and New St. Peter's (fig. 340).

LOST-WAX BRONZE CASTING: a technique of casting bronze and other metals; see fig. 90 and p. 95.

LOW RELIEF: relief sculpture in which flattened figures or forms project only very slightly from the background, as in the *Palette of Narmer* (figs. 38–39). Also known as BAS-RELIEF.

LOW VALUE: a relatively dark color, as in the low value of the background in Goya's *Execution of Madrilenos on the Third of May* (fig. 471).

LUNETTE: a semicircular area enclosed by an ARCH, as at the Byzantine church of San Vitale (fig. 173).

MADKSOURAH: a special enclosure in a MOSQUE reserved for the calif (ruler), as at Córdoba (fig. 196).

MANDALA: a diagram of the Buddhist cosmos, used as a basic design motif in Buddhist art, as at Sanchi (fig. 110).

MANDORLA: an oval or almond-shaped HALO that surrounds the body of a holy figure, as in the Byzantine mosaic at Mount Sinai (fig. 167).

MANUSCRIPT: a handwritten book produced in medieval and Renaissance Europe. If it has painted decoration, it is known as an ILLUMINATED MANUSCRIPT; see figs. 178–79 and 263–64.

MASTABA: a rectangular Egyptian burial monument, with BATTERED WALLS and a flat roof; see fig. 46.

MEDIUM/MEDIA: the material or materials of which a work of art is composed, or the technique used to create it; e.g., oil paint on canvas (fig. 524), bronze (fig. 292), and etching (fig. 418).

MEGALITH: a very large stone of irregular shape (not DRESSED) used in prehistoric monuments; see Stonehenge (fig. 57).

METOPES: the square areas between the TRIGLYPHS in the FRIEZE area of the ENTABLATURE of the DORIC ORDER; sometimes decorated with sculpture, as at the Parthenon (fig. 93); see fig. 84 and p. 91.

MIHRAB: in a MOSQUE, the ARCH or niche on the QIBLA wall that indicates the direction of Mecca, to which Muslims must turn in prayer, as at Córdoba (figs. 194–96).

MINARET: the tower in a MOSQUE complex, usually tall and slender, from which the Muslim faithful are called to prayer five times a day; see Hagia Sophia (fig. 171).

MIXED-MEDIA: a term used to describe a work composed of a variety of different materials, usually encompassing elements of painting, sculpture, and even architecture (see figs. 1, 628).

MOBILE: a sculpture that moves, usually a lightweight, delicately balanced suspended work; see the example by Calder (fig. 611).

MODELING/TO MODEL: in painting, drawing, or printmaking, the creation of an effect of weight and mass in an object by the manipulation of VALUE to create HIGHLIGHTS and SHADING, as in fig. 308; in sculpture, an additive process in which form is created with a malleable medium such as clay; see CARVING as a subtractive process.

MOLDING: an ornamental band, depressed or projecting, that gives definition to an architectural surface.

MONASTERY: a religious establishment which houses a community of persons who have withdrawn from the world to pursue the religious life; see examples from St. Gall and Cluny (figs. 201–202).

MONOCHROMATIC: term used to describe a painting or drawing created by shades of black and white or values of a single color, as in Picasso's *Guernica* (fig. 614).

MOSAIC: a pattern made of small pieces (TESSERAE) of stone, tile, or glass, used on floors, walls, or ceilings; see Roman floor mosaics (figs. 105, 117) and the wall and ceiling mosaics at San Vitale (figs. 173–76).

MOSQUE: a place of worship in the

Islamic religion, as at Córdoba (figs. 194–96).

MOUND ARCHITECTURE: an early type of architectural construction characterized by the creation of a solid mass, as in the Sumerian ZIGGURAT (fig. 42) and the Egyptian pyramids (fig. 43).

MUDRAH: a hand gesture of Buddha, as in fig. 183. Each traditional gesture conveys its own meaning.

MURAL PAINTING: large wall decorations; e.g., those at the Villa of the Mysteries (fig. 130) and Giotto's Arena Chapel (fig. 247).

NAOS: the walled inner sanctuary of a Greek temple, where the cult statue is housed (fig. 96).

NARTHEX: an entrance hall or vestibule, often found in Christian churches, as at Old St. Peter's Basilica (fig. 161).

NATURALISM, NATURALISTIC: when the elements or forms within a work of art closely resemble the appearance of those forms in nature; e.g., Bernini's *Apollo and Daphne* (fig. 3).

NAVE: the large central hall, usually AXIAL and often with a CLERESTORY, that characterizes the BASILICA plan (see Old St. Peter's, fig. 161, and many Christian churches).

NAVE ARCADE: the series of ARCHES that divide the NAVE from the AISLES; see fig. 232.

NON-OBJECTIVE: when the forms in a work of art do not resemble forms in the visual world; e.g., Mondrian's *Diamond Painting* (fig. 5). Also known as non-representational.

NON-REPRESENTATIONAL: see NON-OBJECTIVE.

NUNNERY: a religious establishment which houses a community of women who have withdrawn from the world to pursue the religious life.

OBA: the name of the monarch in Benin society when the Portuguese arrived there in 1485; see the royal ancestral shrine at Benin (fig. 253) and pp. 240–41.

OCULUS: a circular opening in a wall or at the apex of a dome, as in the ancient Roman Pantheon (fig. 142).

OIL PAINT TECHNIQUE: a technique developed in the fifteenth century in which the pigments are mixed with the slow-drying and flexible medium of oil; see figs. 282, 284 and pp. 270–71.

ORDERS: a series of Greek and Roman architectural systems that give aesthetic definition and decoration to the POST-AND-LINTEL system; see fig. 84.

ORTHOGONALS: the converging diagonal lines that meet at the vanishing point in the SCIENTIFIC PERSPECTIVE system, as in Donatello's *Feast of Herod* (fig. 275). In reality these lines would be parallel; see fig. 276 and p. 263.

OVERLAPPING: a device used in painting and relief sculpture to help suggest perspective. Forms are placed in front of other forms to suggest their relative placement within the illusion of space.

PAGODA: the European name for a tall tower, often with a series of roofs in successive layers, that marks sacred Buddhist sites in China and Japan, as at the Horyu-ji complex (figs. 180, 182).

PAINTERLY: in painting, the technique of using large brushstrokes and flecks of paint to define form; see figs. 358, 405.

PANATHENAIC AMPHORA: an ancient Greek vase awarded as a prize at the Olympic Games; see fig. 79.

PARCHMENT: the skin on a calf, sheep, or other animal which is scraped, stretched, and dried to be used as a surface for writing. Used in the medieval period for MANUSCRIPTS.

PASTEL: a drawing medium made of ground pigments mixed with gum water.

PATRON: the person, persons, or organization that asks an artist or artists to create a work of art. Usually they pay for the work.

PATTERN BOOK: a book of images, prepared as an artist's tool, that preserves a tradition of images that can be copied; see fig. 155.

PEDIMENT: the triangular end of a GABLE ROOF; in a Greek temple this area is often decorated with sculpture; see figs. 73, 97–99.

PENDENTIVES: in a domed structure, the curved triangular segments that provide a transition from the four supporting piers to the circular base of the dome, as at the Byzantine church of Hagia Sophia (fig. 170). For a diagram see fig. 140.

PERIPTERAL: a term that describes a building with an exterior PERISTYLE; e.g., the Parthenon (fig. 93).

PERISTYLE: a continuous row of columns that completely surrounds the exterior of a structure, e.g., the ancient Greek Parthenon (fig. 93), or an inner courtyard, as in fig. 115.

PERSPECTIVE: depth. An illusion of perspective is suggested in many paintings; e.g., Perugino's *Christ Giving the Keys to St. Peter* (fig. 4). Devices that help suggest the illusion of perspective include SCIENTIFIC PERSPECTIVE, ATMOSPHERIC PERSPECTIVE, DIMINUTION, and OVERLAPPING.

PICTORIAL RELIEF: relief sculpture that conveys an illusion of depth by using a subtle transition from high to progressively lower relief. See Donatello's *Feast of Herod* (fig. 275) and Ghiberti's *Story of Jacob and Esau* (fig. 279).

PICTURE PLANE: the flat surface of a picture. The picture plane, denied in such illusionistic works as Perugino's *Christ Giving the Keys to St. Peter* (fig. 4), is emphasized as a positive element in many nineteenth- and twentieth-century paintings, such as Mondrian's *Diamond Painting* (fig. 5).

PIER: the vertical supports used in an arched or vaulted structural system; see the supports of the ancient Roman Pont du Gard (fig. 141) and the nave piers of the Gothic cathedral at Chartres (figs. 228–32).

PIETÀ: an iconographic theme in which the dead Christ is shown being held by his mother, as in Michelangelo's *Pietà* (fig. 314).

PIGMENT: the substance, usually ground, that is used to give color in the TEMPERA, FRESCO, and early OIL painting techniques.

PILASTER: a shallow, virtually flat version of the columns of the Greek and Roman ORDERS; pilasters are usually decorative, not structural. See fig. 434.

PITCHED ROOF: see GABLE ROOF.

PLAN: see GROUND PLAN.

PLATE: the thin metallic plate used as a PRINT FORM in ENGRAVING and ETCHING; see figs. 336, 419.

POESIE: the Venetian name for a theme from mythology treated in a nostalgic and romantic manner; see Titian's *Rape of Europa* (fig. 360).

POINTED ARCH: an ARCH in which the sides rise to a point at the apex, as in Gothic architecture (figs. 228, 232, 233).

POST-AND-LINTEL SYSTEM: a simple system of architectural construction in which horizontal architectural members (LINTELS) are supported by vertical supports (posts); see fig. 51 and p. 66.

POTTER'S WHEEL: a revolving platform on which clay vessels of regular and often graceful shape are formed. Examples of wheel-produced vessels include the ancient Greek pots shown in fig. 79.

PRESENTATION DRAWING: a finely finished drawing made to be given to a

collector or friend.

PRIMARY COLORS: red, yellow, and blue. These are HUES that in theory are pure and not the combination of any other hues. On the color wheel (fig. 6), all other colors are understood as mixtures of these three hues.

PRINT: a work of art produced by one of the printmaking processes, including WOODCUT, ENGRAVING, ETCHING, DRYPOINT, LITHOGRAPHY, and silkscreen.

PRINT FORM: the surface—wood, copper, steel, glass, stone, etc.—to which ink is applied in any of the PRINTMAKING processes; see figs. 336, 419, 480.

PRINTMAKING: a series of techniques (WOODCUT, ENGRAVING, ETCHING, DRYPOINT, LITHOGRAPHY, silkscreen, and others) by which prints are produced.

PSALTER: a manuscript of the Psalms of David, as in the Paris Psalter (fig. 168).

PSEUDO-PERIPTERAL: a building that seems to have a PERISTYLE, but many of the COLUMNS are HALF COLUMNS or PILASTERS; e.g., the Roman Temple of Portunus (fig. 113).

PURE COLOR: a color at maximum or full intensity; a HUE without the addition of white, black, or other colors that would reduce the INTENSITY of the color; e.g., the colors used by Mondrian in his Diamond Painting (fig. 5).

PUTTI: figures of male babies, sometimes male baby angels, popular in Renaissance art, as in Mantegna's frescoes in the Camera Picta (figs. 298–99).

PYLON: the entrance gate to an Egyptian temple complex, with broad BATTERED towers and flagpoles; see fig. 50.

QI: Chinese cosmic spirit; used in aesthetics to describe the "life" or spirit of a painting; see Chinese landscape painting, pp. 188–91.

QIBLA: in a MOSQUE, the wall that indicates the direction of Mecca, toward which Muslims must turn in prayer; see Córdoba (figs. 195–96).

QUADRIGA: a sculptural monument that consists of a figure in a chariot with four horses; the Charioteer (fig. 89) was part of a quadriga.

REALISM, REALISTIC: the use of subject matter drawn from actual life and experience; e.g., fig. 396. Not to be confused with the nineteenth-century movement known as Realism (figs. 486–87, 514).

REFECTORY: the dining hall in a MONASTERY or NUNNERY; the location for Leonardo da Vinci's painting of the Last Supper (fig. 311).

REINFORCED CONCRETE: concrete strengthened with embedded wire rods or mesh; see fig. 494. Also known as ferroconcrete.

RELIEF PROCESS: a PRINTMAKING process in which the lines and surfaces to which the ink adheres are higher than the parts that are not to be printed; e.g., the WOODCUT process; see fig. 336 and pp. 308–9.

RELIEF SCULPTURE: sculpture in which the figures or forms are united with a background; examples of relief sculpture types include LOW or BAS-RELIEF (figs. 38–39), HIGH RELIEF (fig. 107), SUNKEN RELIEF (fig. 33), and PICTORIAL RELIEF (fig. 275).

RELIQUARY: a container for a sacred relic, as in fig. 152.

REPOUSSOIR: an object in the immediate foreground of a painting that establishes the frontal plane of the illusionistic space; e.g., the low fence in the FRESCOED room known as Livia's Garden (fig. 132).

REPRESENTATIONAL: when a work of art reproduces the appearance of forms in nature; see Bernini's Apollo and Daphne (fig. 3).

RIBS: raised structural elements that outline and help support a ribbed VAULT, as at the Gothic cathedral of Chartres (figs. 228–29); see fig. 233 and p. 228.

SARCOPHAGUS: a stone coffin, sometimes decorated with sculpture; see fig. 159.

SCIENTIFIC PERSPECTIVE: a mathematical system used to create illusionistic depth in Renaissance paintings (see figs. 4, 311) and RELIEF SCULPTURE (figs. 275, 279). Lines that in reality would be parallel to each other become ORTHOGONALS that converge toward a VANISHING POINT when projected onto a two-dimensional surface.

SCREEN WALL: a non-supporting wall, usually with broad expanses of windows, that fills the opening under an ARCH or VAULT, as at the Byzantine church of Hagia Sophia (fig. 170). It is screen walls that sheathe the exterior of a modern steel-frame skyscraper.

SCRIPTORIUM: the room or rooms in a MONASTERY where MANUSCRIPTS are copied and illustrated, as in the St. Gall plan (fig. 201).

SCULPTURE IN THE ROUND: sculpture that is fully three-dimensional and finished on all sides; e.g., French's Minuteman (fig. 7). Also known as freestanding.

SECONDARY COLORS: colors created by mixing two of the primary colors; the secondary colors are orange (red and yellow), green (yellow and blue), and violet (red and blue).

SHADING: in painting, drawing, and printmaking, progressive decreases in the VALUE and INTENSITY of colors to suggest the changes that result when light hits a form; note the progressive darkening on the face of the Mona Lisa (fig. 329). See also MODELING.

SHAFT: in architecture, the vertical cylindrical form that supports the ENTABLATURE; for example, Doric columns are shafts (fig. 94).

SHIFTING PERSPECTIVE: the use of multiple viewpoints in a painting or drawing, as in Li Cheng's and Cézanne's paintings (figs. 189, 525) or in Cubism (figs. 565–66).

SHIN NO MIHASHIRA: a heart pillar buried deep in the ground below the Inner Shinto Shrine at Ise; thought to be the place where the KAMI reside; see pp. 164–65.

SHINTO: indigenous Japanese nature religion with a central focus on reverence for KAMI; see pp. 164–65.

SHODEN: the main shrine building at Ise dedicated to the National Shinto Cult at the Naiku (Inner) Shrine; see pp. 164–65 and fig. 165.

SIDE AISLE: see AISLE.

SILVERPOINT: a drawing technique using a sharpened point of silver on specially prepared paper or parchment; e.g., Rembrandt's drawing of his fiancée Saskia (fig. 413).

SITE: the specific setting or location for which a work of art or architecture was designed; e.g., the location of Wright's Fallingwater over a waterfall (fig. 10).

SIVA: one of the three main Hindu gods, known as the Preserver; see Hindu art at Ellora, pp. 192–93.

SLIP: clay particles and water, sometimes used to decorate a pottery vessel, as in figs 78, 80.

SPOLIA: materials taken from an earlier structure and reused, as in the columns and capitals at Old St. Peter's (fig. 160) and the Mosque in Córdoba (fig. 194).

SPRINGING: the level at which an ARCH or VAULT begins to curve inward and upward; see fig. 140 and pp. 136–39.

SQUINCH: ARCHES, LINTELS, and/or CORBELS that jut across the corners of a square space to support a dome and to make the transition from the square space to a polygonal or round one; see

the squinches that support the dome at Córdoba (fig. 195). See also fig. 140.

STAINED-GLASS WINDOWS: windows composed of pieces of colored glass joined by lead strips; see fig. 242 and p. 233.

STATES: the successive printed stages of a print, especially common in Rembrandt's ETCHINGS and DRYPOINTS (figs. 418, 420).

STEEL-FRAME CONSTRUCTION: an architectural structure in which steel beams are joined horizontally and vertically to create a gridlike structural system; see fig. 493.

STEREOBATE: the stepped platform that forms the base for a Greek temple; the top step is known as the stylobate; see fig. 84.

STUPA: a large hemispherical Buddhist shrine, erected to hold a relic or mark a holy site, as in the Great Stupa at Sanchi (fig. 108); the form evolved from earlier burial mounds.

STYLE: a complex concept with several meanings, including HISTORICAL STYLE and INDIVIDUAL STYLE.

SUBJECT MATTER: see ICONOGRAPHY.

SUNKEN RELIEF: an Egyptian style of RELIEF SCULPTURE in which the figures are recessed into the surface (fig. 33). Also known as incised relief.

TABLERO: in Mesoamerican architecture, a heavy, projecting, rectangular MOLDING outlined by a thick frame, as in the Pyramid of Quetzalcóatl at Teotihuacán (fig. 149).

TAOTIE: the stylized monster mask that decorates early Chinese bronzes (figs. 27, 29).

TECHNIQUE: how an artist or artists uses materials (the MEDIUM or MEDIA) to create a work of art; e.g., the vigorous, heavy OIL brushstrokes of Van Gogh (figs. 523–24) or the highly polished finish of Michelangelo's *Pietà* (fig. 314).

TEMPERA PAINT TECHNIQUE: a painting technique in which the pigments are combined with egg. The support is usually plaster-coated wood and the background is often decorated with gold leaf, as in Giotto's *Madonna* (fig. 243). See also fig. 248.

TENEBRISM: a dramatic contrast of light and dark used by Caravaggio and his followers; see pp. 354–57.

TENSILE STRENGTH: the internal longitudinal strength in a stone, steel, or wood beam which enables it to support itself without breaking.

TERRA-COTTA: a hard earthenware, glazed or unglazed.

TESSERAE: the individual cut pieces of stone, glass or other materials used in the MOSAIC technique (see fig. 176). One piece is a tessera.

THRUST: the outward force created by an ARCH or VAULT; this must be counterbalanced by BUTTRESSING; see fig. 141 and pp. 136–39.

TOU-KUNG BRACKET: in Chinese and Japanese architecture, CANTILEVERED brackets, often multiple and complex, that support the beams and roof of a structure, as at Horyu-ji (fig. 180).

TRANSEPT: in a cross-shaped Christian church, cross arms placed perpendicular to the NAVE; see fig. 161 and p. 162.

TRANSVERSALS: lines that are parallel to each other in reality that recede parallel to the picture frame in the SCIENTIFIC PERSPECTIVE system; see fig. 276 and pp. 262–63.

TRIFORIUM: in Gothic construction, an arcaded passageway above the NAVE ARCADE (fig. 232) and below the CLERESTORY, as in the cathedral at Chartres (figs. 228, 229).

TRIGLYPH: in the Doric FRIEZE, the area between the METOPES, decorated with vertical grooves; see fig. 84 and p. 91.

TRIPTYCH: a three-part altarpiece or work of art.

TROMPE L'OEIL: illusionistic painting which emphasizes realistic effects to convince the viewer that the painted scene or object is actually real and not painted, as in Mantegna's Camera Picta frescoes (figs. 298–99).

TRUMEAU: the central supporting post between the two sides of a double door, which in Renaissance and Gothic churches is often decorated with sculpture, as at Amiens (figs. 237, 240).

TUFA: a soft, porous rock that hardens with exposure to air; used in construction.

TUNNEL VAULT: see BARREL VAULT.

TYMPANUM: the LUNETTE over the doorway of a church, which is often decorated with sculpture, as in Romanesque (figs. 213–15) and Gothic (fig. 238) structures.

UNDERDRAWING: a preparatory drawing done directly on the plaster or canvas and over which the artist paints the finished work.

VALUE: the relative darkness (LOW VALUE) or lightness (HIGH VALUE) of a HUE.

VANISHING POINT: in a work created using the SCIENTIFIC PERSPECTIVE system, the vanishing point is the place where the converging ORTHOGONALS would converge if continued, as in Donatello's *Feast of Herod* (fig. 276).

VAULT, VAULTING: a structural system based on the ARCH, including the TUNNEL (or BARREL) VAULT, the CROSS (or GROIN) VAULT, and the DOME; see fig. 140 and pp. 136–39.

VEHICLE: the drying liquid in which painting pigments are suspended; as it dries, it adheres the color to the surface.

VELLUM: fine PARCHMENT prepared from calfskin used for the pages in MANUSCRIPTS.

VILLA: a country house, as in the Villa Rotonda by Palladio (fig. 9).

VISHNU: one of the three main Hindu gods, known as the Creator; see Hindu art at Ellora, pp. 192–93.

VOLUTE: the spiral scroll motif that characterizes the capital of the IONIC ORDER; see fig. 84.

VOLUTE KRATER: an ancient Greek vase used for the mixing of wine with water; see fig. 79.

VOUSSOIRS: the individual blocks of stone (or bricks) which compose an ARCH; see fig. 140 and pp. 136–39.

WASH: ink thinned with water, applied with a brush to add effects of shadow, as in Rembrandt's *A Man Rowing* (fig. 412).

WATERCOLOR: pigments mixed with water (and gum arabic as a drying agent); used in Homer's watercolor *The Blue Boat* (fig. 519).

WEB: the surfaces of a Gothic RIB VAULT; see fig. 233. Also known as infilling.

WESTWORK: a church entrance with a centralized APSE enclosing a chapel on the second story and two flanking towers, typical of Carolingian churches, as in the St. Gall monastery plan (fig. 201).

WOODCUT: a relief printmaking process; for a diagram see fig. 336 and pp. 308–9.

YAKSHA, YAKSHI: ancient Indian nature spirits which became gods and goddesses of fertility, as at Sanchi (fig. 109).

ZEN: a form of Buddhism (known in China as Chan) which teaches that there is no Buddha except that in one's own nature; only through meditation can one reach one's own Buddha nature; see Zen art, pp. 340–41.

ZIGGURAT: a stepped pyramid of mud brick, used by the Sumerians and the Assyrians as a sacred site; see fig. 42.

BIBLIOGRAPHY

This is a general, broad bibliography intended to lead the reader to more specific books on individual sites, monuments, artists, and movements. As a rule, it includes only the most important sources, and only those in English.

GENERAL

Broude, Norma, and Mary D. Garrard. *Feminism and Art History: Questioning the Litany.* New York: Harper & Row, 1982.

de la Croix, Horst, and Richard G. Tansey. *Gardner's Art Through the Ages.* New York: Harcourt Brace Jovanovich, 1986.

Elsen, Albert E. *Purposes of Art.* New York: Holt, Rinehart and Winston, 1972.

Encyclopedia of World Art. 15 vols. New York: McGraw-Hill, 1959–68.

Fleming, John, Hugh Honour, and Nikolaus Pevsner. *The Penguin Dictionary of Architecture.* Harmondsworth: Penguin, 1980.

Goldwater, Robert J., and Marco Treves. *Artists on Art.* New York: Pantheon, 1974.

Gombrich, E. H. *Art and Illusion.* New York: Pantheon, 1972.

————— . *The Story of Art.* Oxford: Phaidon, 1984.

Hartt, Frederick. *Art: A History of Painting, Sculpture, Architecture.* New York: Abrams, 1992.

Holt, Elizabeth G. *A Documentary History of Art.* 2 vols. Garden City, N.Y.: Doubleday, 1981.

Honour, Hugh, and John Fleming. *The Visual Arts: A History.* Englewood Cliffs, N.J.: Prentice Hall, 1991.

Janson, H. W. *History of Art.* New York: Abrams, 1990.

Kemal, Salim, and Ivan Gaskell. *The Language of Art History.* Cambridge, Eng.: Cambridge University Press, 1991.

Kemp, Martin. *The Science of Art: Optical Themes in Western Art from Brunelleschi to Seurat.* New Haven: Yale University Press, 1989.

Kostof, Spiro. *The Architect: Chapters in the History of the Profession.* New York: Oxford University Press, 1977.

————— . *A History of Architecture: Settings and Rituals.* New York: Oxford University Press, 1985.

Lee, Sherman E. *A History of Far Eastern Art.* New York: Abrams, 1994.

Nochlin, Linda. *Women, Art, and Power and Other Essays.* New York: Harper & Row, 1988.

————— , and Ann S. Harris. *Women Artists: 1550–1950.* Los Angeles: Los Angeles County Museum of Art; New York: distributed by Random House, 1976.

Roberts, Laurence P. *A Dictionary of Japanese Artists: Painting, Sculpture, Ceramics, Prints, Lacquer.* New York: Weatherhill, 1976.

Sayre, Henry M. *Writing About Art.* Englewood Cliffs, N.J.: Prentice Hall, 1992.

Sullivan, Michael. *The Arts of China.* Berkeley: University of California Press, 1984.

Trachtenberg, Marvin, and Isabelle Hyman. *Architecture from Prehistory to Post-Modernism.* New York: Abrams, 1986.

Wittkower, Rudolf and Margot. *Born Under Saturn.* New York: Norton, 1969.

PREHISTORIC AND ANCIENT

Adams, Richard E. W. *Prehistoric Mesoamerica.* Boston: Little, Brown, 1977.

Aldred, Cyril. *Egyptian Art in the Days of the Pharaohs 3100–320 B.C.* New York: Oxford University Press, 1980.

Amiet, Pierre. *The Ancient Art of the Near East.* New York: Abrams, 1980.

Boardman, John. *Greek Art.* London: Thames and Hudson, 1985.

————— . *The Parthenon and Its Sculptures.* Austin: University of Texas Press, 1985.

Boëthius, Alexander. *Etruscan and Early Roman Architecture.* Harmondsworth: Penguin, 1978.

Brendel, Otto. *Etruscan Art.* Harmondsworth: Penguin, 1978.

Brilliant, Richard. *Arts of the Ancient Greeks.* New York: McGraw-Hill, 1973.

————— . *Roman Art from the Republic to Constantine.* London: Phaidon; New York: distributed by Praeger, 1974.

Grand, Paule M. *Prehistoric Art: Paleolithic Painting and Sculpture.* Greenwich, Conn.: New York Graphic Society, 1967.

Groenewegen-Frankfort, H.A., and Bernard Ashmole. *Art of the Ancient World.* Englewood Cliffs, N.J.: Prentice Hall, 1972.

Kubler, George. *Art and Architecture of Ancient America.* Harmondsworth: Penguin, 1975.

MacDonald, William L. *The Architecture of the Roman Empire.* 2 vols. New Haven: Yale University Press, 1982.

Pollitt, J. J. *The Art of Greece 1400–31 B.C.* (Sources and Documents). Englewood Cliffs, N.J.: Prentice Hall, 1965.

————— . *Art and Experience in Classical Greece.* Cambridge, Eng.: Cambridge University Press, 1972.

————— . *The Ancient View of Greek Art.* New Haven: Yale University Press, 1974.

————— . *The Art of Rome c. 753 B.C.– A.D. 337* (Sources and Documents). New York: Cambridge University Press, 1983.

————— . *Art in the Hellenistic Age.* Cambridge, Eng.: Cambridge University Press, 1986.

Strong, Donald. *Roman Art.* Harmondsworth: Penguin, 1988.

Ward-Perkins. J. B. *Roman Architecture.* New York: Abrams, 1977.

————— . *Roman Imperial Architecture.* Harmondsworth: Penguin, 1981.

ART FROM 200 TO 1400

Conant, Kenneth J. *Carolingian and Romanesque Architecture.* Harmondsworth: Penguin, 1978.

Davis-Weyer, C. *Early Medieval Art 300–1150* (Sources and Documents). Englewood Cliffs, N.J.: Prentice Hall, 1971.

Ettinghausen, Richard, and Oleg Grabar. *The Art and Architecture of Islam, 650–1250.* New York: Viking Penguin, 1987.

Frisch, T.G. *Gothic Art 1140–ca. 1450* (Sources and Documents). Toronto: University of Toronto Press, 1987.

Grodecki, Louis. *Gothic Architecture.* New York: Abrams, 1977.

Hearn, M.F. *Romanesque Sculpture.* Ithaca: Cornell University Press, 1981.

Huntington, Susan. A*rt of Ancient India: Buddhist, Hindu, Jain.* New York: Weatherhill, 1985.

Krautheimer, Richard. *Early Christian and Byzantine Architecture.* Harmondsworth: Penguin, 1986.

Mango, Cyril. *The Art of the Byzantine Empire 312–1453* (Sources and Documents). Englewood Cliffs, N.J.: Prentice Hall, 1972.

————— . *Byzantium.* London: Weidenfeld and Nicolson, 1980.

————— . *Byzantine Architecture.* New York: Rizzoli, 1985.

Snyder, James. *Medieval Art: Painting Sculpture Architecture 4th–14th Century.* New York: Abrams, 1989.

Stokstad, Marilyn. *Medieval Art.* New York: Harper & Row, 1986.

Swaan, Wim. *The Gothic Cathedral.* New York: Park Lane, 1981.

White, John. *Art and Architecture in Italy, 1250–1400.* Harmondsworth: Penguin, 1987.

Wilson, David M. *Anglo-Saxon Art from the Seventh Century to the Norman Conquest.* Woodstock, N.Y.: Overlook Press, 1984.

FIFTEENTH AND SIXTEENTH CENTURIES

Cole, Bruce. *The Renaissance Artist at Work.* New York: Harper & Row, 1983.

Gilbert, Creighton. *Italian Art 1400–1500 (Sources and Documents).* Englewood Cliffs, N.J.: Prentice Hall, 1980.

Hartt, Frederick. *History of Italian Renaissance Art.* New York: Abrams, 1994.

Heydenreich, Ludwig, and W. Lotz. *Architecture in Italy 1400–1600.* Baltimore: Penguin, 1974.

Klein, Robert, and Henri Zerner. *Italian Art, 1500–1600 (Sources and Documents).* Englewood Cliffs. N.J.: Prentice Hall, 1966.

Kristeller, Paul O. *Renaissance Thought and the Arts: Collected Essays.* Princeton, N.J.: Princeton University Press, 1990.

Rosand, David. *Painting in Cinquecento Venice: Titian, Veronese, Tintoretto.* New Haven: Yale University Press, 1986.

Snyder, James. *Northern Renaissance Art.* New York: Abrams, 1985.

Stechow, Wolfgang. *Northern Renaissance Art 1400–1600 (Sources and Documents).* Englewood Cliffs, N.J.: Prentice Hall, 1966.

Wittkower, Rudolf. *Architectural Principles in the Age of Humanism.* New York: St. Martin's Press, 1988.

SEVENTEENTH AND EIGHTEENTH CENTURIES

Blunt, Anthony. *Art and Architecture in France 1500–1700.* Harmondsworth: Penguin, 1973.

Crow, Thomas E. *Painters and Public Life in Eighteenth-Century Paris.* New Haven: Yale University Press, 1985.

Enggass, Robert, and Jonathan Brown. *Italy and Spain 1600–1750 (Sources and Documents).* Englewood Cliffs, N.J.: Prentice Hall, 1970.

Gerson, H., and E.H. ter Kuile. *Art and Architecture in Belgium 1600–1800.* Baltimore: Penguin, 1978.

Haskell, Francis. *Patrons and Painters: A Study in the Relations Between Italian Art and Society in the Age of the Baroque.* New Haven: Yale University Press, 1980.

Held, Julius, and Donald Posner. *Seventeenth and Eighteenth Century Art: Baroque Painting, Sculpture, Architecture.* New York: Abrams, 1971.

Rosenberg, Jakob, Seymour Slive, and E. H. ter Kuile. *Dutch Art and Architecture 1600–1800.* Harmondsworth: Penguin, 1977.

Schama, Simon. *The Embarrassment of Riches: An Interpretation of Dutch Culture in the Golden Age.* New York: Knopf, 1987.

Varriano, John. *Italian Baroque and Rococo Architecture.* New York: Oxford University Press, 1986.

Wittkower, Rudolf. *Art and Architecture in Italy 1600 to 1750.* Harmondsworth: Penguin, 1973.

NINETEENTH AND TWENTIETH CENTURIES

Arnason, H. H. *History of Modern Art.* New York: Abrams, 1986.

Baigell, Matthew. *A Concise History of American Painting and Sculpture.* New York: Harper & Row, 1984.

Boimé, Albert. *A Social History of Modern Art.* Chicago: University of Chicago Press, 1987.

Clark, T. J. *Image of the People: Gustave Courbet and the 1848 Revolution.* Princeton: Princeton University Press, 1982.

―――――― . *The Painting of Modern Life: Paris in the Art of Manet and His Followers.* Princeton: Princeton University Press, 1986.

Curtis, William J.R. *Modern Architecture Since 1900.* Englewood Cliffs, N.J.: Prentice Hall, 1983.

Daval, Jean-Luc. *Photography: History of an Art.* New York: Rizzoli, 1982.

Eitner, Lorenz. *Neoclassicism and Romanticism 1750–1850 (Sources and Documents).* Englewood Cliffs, N.J.: Prentice Hall, 1970.

―――――― . *An Outline of 19th Century European Painting: From David Through Cézanne.* New York: Harper & Row, 1987.

Fry, Edward. *Cubism.* London: Thames and Hudson, 1966.

Gaggi, Silvio. *Modern-Postmodern: A Study in Twentieth-Century Arts and Ideas.* Philadelphia: University of Pennsylvania Press, 1989.

Hamilton, George H. *Nineteenth and Twentieth Century Art.* Englewood Cliffs, N.J.: Prentice Hall, 1971.

―――――― . *Painting and Sculpture in Europe 1880–1940.* Baltimore: Penguin, 1981.

Herbert, Robert L. *Modern Artists on Art.* Englewood Cliffs, N.J.: Prentice Hall, 1964.

―――――― . *Impressionism.* New Haven: Yale University Press, 1988.

Holt, Elizabeth G. *From the Classicists to the Impressionists.* Garden City, N.Y.: Doubleday, 1966.

Hopi Kachina, Spirit of Life. The California Academy of Sciences. Seattle: distributed by University of Washington Press, 1980.

Hughes, Robert. *The Shock of the New.* New York: Knopf, 1992.

Hunter, Sam, and John Jacobus. *Modern Art: Painting, Sculpture, Architecture.* New York: Abrams, 1991.

Janson, H. W. *19th-Century Sculpture.* New York: Abrams, 1985.

Kasson, Joy S. *Marble Queens and Captives: Women in Nineteenth-Century American Sculpture.* New Haven: Yale University Press, 1990.

Levin, Kim. *Beyond Modernism: Essays on Art from the '70s to '80s.* New York: Harper & Row, 1988.

Lucie-Smith, Edward. *Movements in Art Since 1945.* New York: Thames and Hudson, 1984.

―――――― . *American Art Now.* New York: Morrow, 1985.

McCoubrey, John. *American Art 1700–1960 (Sources and Documents).* Englewood Cliffs, N.J.: Prentice Hall, 1965.

Newhall, Beaumont. *The History of Photography, from 1839 to the Present Day.* New York: Museum of Modern Art, 1982.

Nochlin, Linda. *Impressionism and Post-Impressionism (Sources and Documents).* Englewood Cliffs, N.J.: Prentice Hall, 1966.

―――――― . *Realism and Tradition in Art 1848–1900 (Sources and Documents).* Englewood Cliffs, N.J.: Prentice Hall, 1966.

Noever, Peter, and Regina Haslinger, eds. *Architecture in Transition: Between Deconstruction and New Modernism.* Munich: Prestel, 1991.

Rewald, John. *Post-Impressionism: From Van Gogh to Gauguin.* New York: Museum of Modern Art; Boston: distributed by New York Graphic Society, 1978.

―――――― . *The History of Impressionism.* New York: Museum of Modern Art; Boston: distributed by New York Graphic Society, 1980.

―――――― . *Studies in Impressionism.* New York: Abrams, 1986.

―――――― . *Studies in Post-Impressionism.* New York: Abrams, 1986.

Rosenblum, Robert, and H. W. Janson. *Nineteenth-Century Art.* New York: Abrams, 1984.

Selz, Peter. *Art in Our Times.* New York: Abrams, 1981.

Smagula, Howard. *Currents, Contemporary Directions in the Visual Arts.* Englewood Cliffs, N.J.: Prentice Hall, 1989.

Thompson, Robert Farris. *African Art in Motion: Icon and Act.* Los Angeles: University of California Press, 1974.

Wheeler, Daniel. *Art Since Mid-Century.* Englewood Cliffs, N.J.: Prentice Hall, 1991.

Wilmerding, John. *American Art.* Harmondsworth: Penguin, 1976.

INDEX

LIST OF CREDITS

The authors and publishers wish to thank the museums, galleries, libraries, and churches for permitting the reproduction of works of art in their collections. Photographs have been supplied by the owners or custodians of the works of art, except for the following, whose courtesy is gratefully acknowledged. Numbers refer to the illustrations.

Peter Aaron/ESTO: 535; Harry N. Abrams, Inc., archives, N.Y.: 11, 20, 130, 180, 182, 277, 278, 314, 350; ACL Brussels: 271, 277, 278; Agence TOP, Paris, Michel Desjardins: 299; Menachem Alderman: 670; Alinari, Florence: 3, 73, 91, 106, 117, 119, 125, 159, 218, 258, 260–62, 279, 285, 287, 288, 298, 300, 316, 327, 328, 362, 363, 366, 387, 396, 403, 407, 409; Ancient Art and Architecture Collection, London: 131; Fred Anderegg (by permission of Princeton University Press): 155, 156; Wayne Andrews/ESTO: 434, 483; Annan, Glasgow: 520; Ferdinand Anton, Munich: 149; © 1993 Art Institute of Chicago, All rights reserved: 453, 522, 525, 537, 602, 635; James Austin: 215; Courtesy The Avery Library, Columbia University, New York: 138; Dirk Baaker: 540; Bauhaus Archiv, Berlin © 1969: 594; © Carol Beckwith/Estall Photograph: 18; Peter Bellamy: 667; Bibliothèque Nationale, Paris: 478, 479; Raffaello Bencini, Florence: 195; Hedrich Blessing, Chicago: 13, 527; A. Boethius and J.B. Ward-Perkins, *Etruscan and Early Roman Architecture,* 1970: 139; Victor Boswell © National Geographic Society: 311, 312; British Museum, London: 16; British Tourist Authority, N.Y.: 57, 481; F. Bruckmann, Munich: 322; Caisse Nationale des Monuments Historiques et des Sites, Paris: 210, 212-14, 231, 240, 433, 504; Ludovico Canali, Rome: 4, 71, 111, 122, 123, 132, 136, 176, 243, 244, 246, 256, 267, 347, 379, 392, 394, 410; Eugenio Cassin, Florence: 280; Leo Castelli Gallery, New York: 644; Chicago Architectural Photo Co.: 564; Chicago Historical Society: 493; © Christo 1976, photo Jeanne-Claude: 647; Geoffrey Clements, N.Y.: 538, 630; Piero Codato, Cameraphoto, Venice: 247, 355-57, 378; Michael D. Coe, *Mexico* © 1962, 1966: 150; Kenneth J. Conant, *Cluny* © 1968: 202; A.C. Cooper, Ltd., London: 391; Paula Cooper Gallery, New York: 660; Jeffrey Crespi: 557; Deutsche Fotothek, Dresden: 486; Deutschen Archäologischen Institut, Rome: 112, 116, 120, 163; Deutscher Kunstverlag, Munich: 442; Doesser Fotos, Laren, Neth.: 589; Eliot Elisofon: 253; Edmund B. Feldman, *Thinking About Art* © 1985: 97, 232; Bruce Fleischer: 251; Fotocielo, Rome: 404; Fotostudio C.N.B., Bologna: 254, 321; Fototeca Unione, Rome: 113, 121, 129, 144–46; Framton and Futugawa, *Modern Architecture 1851–1945* © 1931, 1983: 494; Dick Frank Studio: 671; Alfred Frazer and Henry A. Millon, *Key Monuments of Architecture* © 1965: 86, 128; French Tourist Board, N.Y.: 58, 495; Gabinetto Fotografico, Florence: 345; Gabinetto Fotografico Nazionale, Rome: 384; Ewing Galloway, N.Y.: 44; GEMS, N.Y.: 171; Giraudon, Paris: 238, 239, 264, 307, 400, 435; Gianfranco Gorgoni, N.Y.: 646; Greek National Tourist Office: 59; *Guernica/Pablo Picasso* © 1947: 615; Susan Harder Gallery, N.Y.: 603; Cyril M. Harris, *History of Architecture Sourcebook* © 1977: 137; Frederick Hartt, *Art:*

A History of Painting, Sculpture, and Architecture © 1989: 46, 47, 52, 63; Hassia: 61; David Heald, © The Solomon R. Guggenheim Foundation, New York: 621, 665; Biff Heinrich: 618; Greg Heinz: 360, 361; Hickey-Robertson, Houston: 613; Color Photo Hinz, Alschwil-Basel, Switz.: 19, 24; Hirmer Verlag Munchen: 31, 38, 42, 43, 48, 60, 65, 75, 81, 83, 88, 89, 95, 101, 104, 157, 173; Hirschl & Adler Modern, N.Y.: 642; HOA-QUI, Paris: 554–56; Stephen Huyler: 109; Irish Historical Series © 1977: 242; Italian State Tourist Office, N.Y.: 135; H.W. Janson, *History of Art* © 1986: 143, 375; Thomas Jefferson Memorial Foundation, Inc.: 451; Ohmichi Jiichi: 383; S.W. Kenyon, Wellington, Eng.: 21; Studio Kontos, Athens: 62, 82; Kurt Lange: 39; Sherman E. Lee, *A History of Far Eastern Art* © 1982: 192, 220, 221, 222, 380; E. Levy, Paris: 468; Library of Congress, Washington, D.C.: 482, 491; Life Picture Service, N.Y.: 604; Jannes Linders, Rotterdam: 593; MAGNUM Photos, N.Y.: 605; Bildarchiv Foto Marburg, Marburg, Ger.: 34, 200, 205, 444; Gene Markowski: 108; Matar Studio, N.Y.: 639; Robert Mates: 1, 565; MAS, Barcelona: 206, 255, 351; Photo Mayer, Vienna: 365, 367; Louis K. Meisel Gallery, N.Y.: 650; James Mellart, *Çatal Hüyük,* 1967: 22; The Metropolitan Museum of Art, N.Y.: 331, 333, 341; Michigan-Princeton-Alexandria Expedition to Mt. Sinai © 1969: 169; Robert Miller Gallery, N.Y.: 551; Allan Mitchell, New Canaan, Conn.: 584; Collection, The Museum of Modern Art, N.Y.: 517; The Pierpont Morgan Library, N.Y.: 418; Hans Namuth, N.Y.: 620; National Gallery of Art, Washington, D.C.: 219; National Museum of Tokyo, 381; Prints Division, New York Public Library, Astor, Lenox and Tilden Foundations: 237; Nippon Television Network Corporation, Tokyo: 342, 344; Paschall/Taylor: 342; Robert Paine and Alexander Soper, *The Art and Architecture of Japan,* 1955 © Yale University Press Pelican History of Art: 181; Cymie Payne: 653; Hans Petersen, Hornbaek, Den.: 553; Eric Pollitzer: 340; Mario Quattrone, Florence: 257, 268, 270, 306, 320, 323, 349, 402; Lois Fichner Rathus, *Understanding Art* © 1989: 160, 161, 233; Gerhard Reinhold, Leipzig-Molkan: 348; Rijksmuseum, Amsterdam: 420; © Faith Ringgold: 666; Ebet Roberts, New York: 543; Roger-Viollet, Paris: 456; Jean Roubier: 141; Routhier, Paris: 507; Scala, Rome: 105, 174, 175, 324, 346, 386; Service Photographique Réunion des Musées Nationaux, Paris: 66, 103, 226, 294, 319, 329, 401, 415, 424, 425, 439, 455, 473, 487, 498, 499; Smithsonian Institution, Washington, D.C.: 558; Society for the Preservation of New England Antiquities, Boston: 7; Holly Solomon Gallery, N.Y.: 544; Soprintendenza Archeologica all'Etruria Meridionale: 72; Ezra Stoller/ESTO: 617; Richard Stoner, New York: 663; Wim Swaan, N.Y.: 237, 241; C.Z. Swiechowski: 211; Marvin Trachtenberg, N.Y.: 9, 76, 86, 124, 126, 170, 194, 223, 229, 235, 492, 622; U.S. Department of Agriculture: 559; Jean Vertut, Paris: 35; Vincent van Gogh Foundation/National Museum Vincent van Gogh, Amsterdam: 457; Virginia Chamber of Commerce: 449; Vizzavona, Paris: 428, 429; Leonard von Matt, Buochs, Switz.: 207; Ron Warren: 548; H. Wehmeyer, Hildesheim, Germany: 204; Yasatuda Watanabe, *Shinto Art: Ise and Izumo Shrines,* 1974: 164; Achille Weider, Zurich: 25; Etienne Weill, Paris: 541, 651; Kurt Weitzmann, Department of Art and Archaeology, Princeton Uni-

versity: 167; Michael Werner Gallery, New York and Cologne: 656; David G. Wilkins: 51, 292, 296, 325, 326, 373; Nina and Graham Williams: 575; Ellen Page Wilson: 664; ZEFA, Dusseldorf: 148.

Artists' Copyrights
© The Estate of Diane Arbus, 1972: 636; © 1993 ARS, NY/ADAGP, Paris; 513, 540, 561, 565, 569, 571, 576–79, 582, 586, 587, 608, 611; © 1993 ARS, NY/Bild-Kunst, Bonn: 516, 534, 585, 588; © 1993 ARS, NY/Demart Pro Arte, Geneva: 606; © 1993 ARS, NY/Pro Litteris, Zurich: 629; © 1993 ARS, NY/SPADEM, Paris: 560, 566–68, 607, 614, 615; © Louise Bourgeois/VAGA, NY 1993: 667; © Giorgio de Chirico/VAGA, NY/SIAE/Rome 1993: 584; © Christo 1993: 647; © Robert Este/Louis Meisel 1993: 649; © Helen Frankenthaler/VAGA, NY 1993: 541; © Nancy Graves/VAGA, NY 1993: 657; © Jasper Johns/VAGA, NY 1993: 627; © Joyce Kozloff: front jacket, 653; Jacob Lawrence/VAGA, NY 1993: 549; © Roy Lichtenstein, NY 1993: 633; © 1993 Sucession H. Matisse/ARS, NY: 552, 553; © P. Mondrian Estate/E.M. Holtzman Trust, NY: 5; © Stiftung Nolde, Seebüll, Germany: 581; © Claes Oldenburg: 634; © 1993 Pollock-Krasner Foundation/ARS, NY: 618; © Robert Rauschenberg/VAGA, NY 1993: 628; © Faith Ringgold: 666; © Kate Rothko-Prizel and Christopher Rothko/ARS, NY 1993: 619; © Estate of David Smith/VAGA, NY 1993: 8; © Frank Stella/ARS, NY 1993: 630; © The Estate and Foundation of Andy Warhol/ARS, NY: 538; © Nina Williams: 575.

Diagrams 12, 36, 50, 79, 87, 90, 92, 99, 134, 140, 248, 249, 269, 274, 276, 282, 336, 419, 480, and 501 by Marlene Boyle.

Maps by Paul J. Pugliese.

The authors and publishers wish to acknowledge the following publications, from which quotations were taken: p. 20: Ovid, *Metamorphoses,* trans. by R. Humphries, Bloomington: Indiana University Press, 1969; p. 82: Susan Woodford, *The Parthenon,* Cambridge, Eng.: Cambridge University Press, 1981; p. 289: Giorgio Vasari, *Lives of the Most Eminent Painters, Sculptors and Architects,* trans. by Gaston Du C. de Vere, New York: Harry N. Abrams, Inc., 1979. All rights reserved; p. 301: Giorgio Vasari, *The Lives of the Artists,* vol. 1, trans. by George Bull, Harmondsworth: Penguin Classics, 1987. © George Bull, 1965; p. 302: *The Complete Poems of Michelangelo,* trans. by J. Tusiani, New York: The Noonday Press, 1960; p. 312: Translation by Creighton Gilbert, from *Complete Poems and Selected Letters of Michelangelo,* Princeton: Princeton University Press, 1980; p. 392: Sir Joshua Reynolds, *Fifteen Discourses Delivered in the Royal Academy,* New York: E.P. Dutton, 1911; pp. 402, 430, 431, 455, 486, 526: Robert Goldwater and Marco Treves, *Artists on Art: From the XIV—XX Century,* New York: Pantheon Books. © 1945 by Pantheon Books, Inc. Renewed 1973 by Goldwater and Treves. By permission of Pantheon books, a division of Random House, Inc.; pp. 445, 449, 450, 451: Translation from Charles S. Moffett et al., *The New Painting: Impressionism 1874–1886.* © 1986 by The Fine Arts Museums of San Francisco. Reprinted with permission.